*Catalogue of*

# BRITISH
# OIL PAINTINGS
# 1820 – 1860

*Front cover*
Detail from *View across Sandown Bay,*
*Isle of Wight*
Richard Burchett (1815–1875)

*Back cover*
*The Governess*
Richard Redgrave (1804–1888)

*Frontispiece*
*Palpitation*
Charles West Cope (1811–1890)

*Title page*
Detail from *Buildings in the Grounds of*
*the South Kensington Museum in 1862*
Robert Collinson (1832–after 1890)

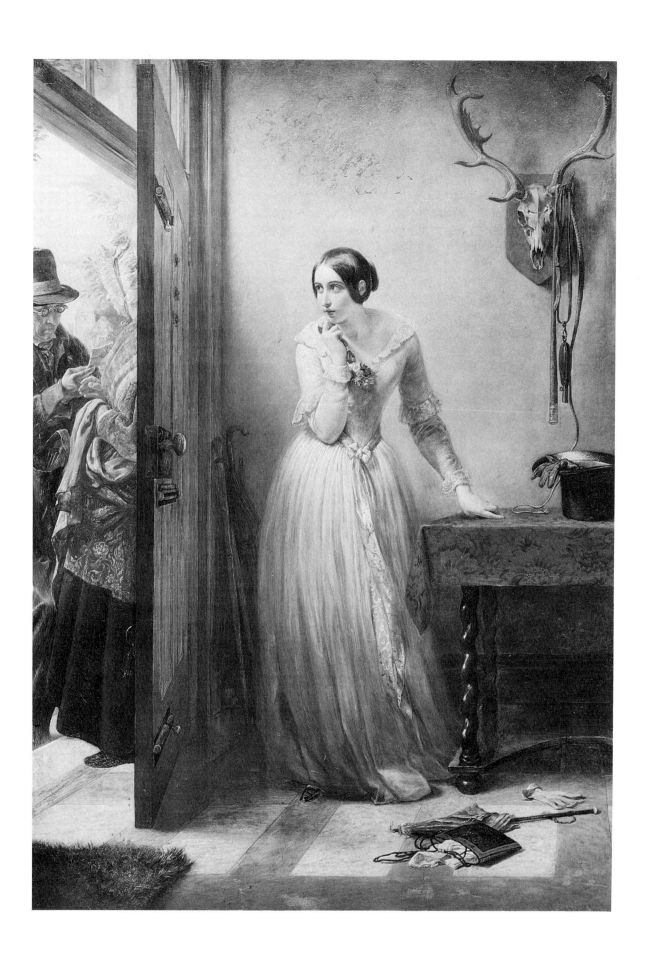

VICTORIA & ALBERT MUSEUM

*Catalogue of*

# BRITISH
# OIL PAINTINGS
# 1820 – 1860

Ronald Parkinson

LONDON : HMSO

© Crown copyright 1990
First published 1990

HMSO publications are available from:

**HMSO Publications Centre**
(Mail and telephone orders only)
PO Box 276, London, SW8 5DT
Telephone orders 01-873 9090
General enquiries 01-873 0011
(queuing system in operation for both numbers)

**HMSO Bookshops**
49 High Holborn, London, WC1V 6HB   01-873 0011 (Counter service only)
258 Broad Street, Birmingham, B1 2HE   021-643 3740
Southey House, 33 Wine Street, Bristol, BS1 2BQ   (0272) 264306
9–21 Princess Street, Manchester, M60 8AS   061-834 7201
80 Chichester Street, Belfast, BT1 4JY   (0232) 238451
71 Lothian Road, Edinburgh, EH3 9AZ   031-228 4181

**HMSO's Accredited Agents**
(see Yellow Pages)

*and through good booksellers*

From 6 May 1990 the London telephone numbers above carry the prefix '071' instead of '01'.

**ISBN 0 11 290463 7**

British Library Cataloguing in Publication Data

A CIP catalogue record for this book
is available from the British Library

Printed in the UK for HMSO
Dd 289381   C20   3/90 36145

# Contents

# Preface

In 1857 John Sheepshanks announced his intention of giving to the new Museum at South Kensington the 233 paintings and drawings which he had bought, mostly from the artists themselves, over the previous 25 years. It was his specified intention to found a National Gallery of British Art and he hoped that other collectors would follow him, contributing their pictures to provide an expanding record of the national achievement. Others did, and their names – particularly that of John Jones, otherwise known primarily as a collector of the French 18th century – occur frequently in the following pages. Collecting and giving in the great age of museum building were competitive activities and in 1909, with London torn apart over the destiny of George Salting's collection, the government was becoming minded to inter-vene. A Treasury minute directed that the great London museums should specialise in particular fields: the Victoria & Albert as it had become known, would take the national collections of the applied arts together with certain other collections such as watercolours and miniatures, and a new foundation, an offshoot of the National Gallery, should henceforth be the national collection of British painting, down on the river at Millbank.

The characteristic Victorian vision – we can also call it Morrisite – of human creativity as a seamless whole, passed from the national museums at that moment and, almost simultaneously, Roger Fry's first Post-Impressionist exhibition at the Grafton Galleries taught the metropolitan elite that English Victorian painting was not a spectacle for nationalistic pride but was an index of provincialism.

Eighty years later the challenge is not so much to revalue 19th-century British painting, as to challenge the philistine division between 'imaginative' and 'utilitarian' design, between the fine and the decorative arts. To put it at its most practical, the challenge is to demonstrate that a museum which addresses the history of design in public and domestic spaces must include paintings. From the 17th century, framed paintings have been crucial to the articulation of wall surfaces in all considered buildings. Especially since the 18th century they have been the bearers of complex messages about wealth and civic values, and since the 19th century they have become, at all social levels, as basic an accoutrement of socialised existence as perhaps a table and chairs or clothing. In this sense, the equivalence of painting with the other arts and crafts, and the role of paintings as assembled objects taking their place alongside the work of other creative people, changing their signification according to context and function, have tended to be lost in the art galleries of the present century. Pictures have been placed in a narrative about artists, and the questions we ask of them have been largely about authorship and *facture*, or about content, as though the latter could be contained absolutely in the framed space of the picture itself.

For this reason publication of the present catalogue, the purpose of which is to treat fully those issues of authorship and internal structure of the paintings, is timed to coincide with the rehanging and rearrangement of the collection as a whole.

The strength of the V&A collections must be seen to lie not, as

John Sheepshanks intended, in their former status as a National Gallery of British Art, but as a commentary on the way in which the art of painting was constructed into our culture, both on the domestic level and in the great public spaces which have come down to us from the last century. Many of the paintings were designed to be seen en masse, to achieve their effect and claim the attention of the spectator from high up on a crowded exhibition wall. The narrative strategies of the paintings, their deployment of unresolved and open-ended situations, were aimed at forcing the spectator to pause and the reviewer to attempt exegesis. Stories of rivalry between painters to achieve visual pre-eminence are familiar enough – that between Turner and Clarkson Stanfield in 1834 is famous – and it is self-evident that C R Leslie's colouring, the structure of harmony and disharmony, simply works best as a sensory experience when as it were the full orchestra plays. *Autolycus selling his Wares*, or Mulready's *Seven Ages of Man* are not solo parts, and it is a relatively flat experience to see these paintings in their rich gold frames with only yards of empty pallid wall around them.

Such conditions in the 20th-century picture gallery may be right for attempting to decide questions of attribution, but it was precisely to avoid questions of attribution that the 19th-century collectors like Sheepshanks and Vernon turned with such relief to modern British art from the uncertainties of the old and continental. In this catalogue, questions of attribution hardly ever arise and the labour of compilation has centred mainly on the reassembly of the contextual and the contingent – the details of exhibition history, of early responses and subsequent scholarship. Paintings, of course, exist in time and the intention of the cataloguer is never simplistically archaeological – there is no level of absolute truth to be disinterred, no particular virtue in discovering the artist's intention or the meaning attached to a picture at its first appearance, unless as part of the continuity linking the past to the present. Other questions about variables such as the condition and the effects of age on a picture, are, like attribution, barely relevant for mid-19th-century pictures. English pictures post-1820 are mostly extraordinarily stable – the quality of materials and level of technical competence in the artists' studios had improved enormously since the early days of the Academy. The South Kensington policy of keeping pictures under glass has helped to maintain the collection in excellent condition. Turner's *Venice* is only the most celebrated example of a painting which, protected in an airtight container from atmospheric pollution and from the effects of conservation since the 1860s, still looks as it did on the walls of the Academy in 1840.

Part of the continuity between the past and the present is expressed in the relationship between scholars of one generation and another. Ronald Parkinson is the latest in the line of those who have added continuously to the files on the paintings, from Richard Redgrave, (who actually painted quite a lot of them) the first systematic cataloguer of the collection, through the great Basil Long who transcribed reviews from the *Art Journal* and *Athenaeum*, to Jonathan Mayne who drafted the original entries for this catalogue in the 1950s, following the model established by Martin Davies at the National Gallery. Ronald is more vociferous than anyone in pointing to this continuous tradition of scholarship at South Kensington, and he himself is a worthy member of it. Supported by Lionel Lambourne

and by Stephen Calloway, who have between them carried out the redisplay of the paintings, Ronald has worked with extraordinary concentration to bring the project to this fruition. Intended as volume II, it clearly implies the existence of a volume I, and I very much hope that it will not be too long before the earlier pictures have a similarly distinguished catalogue in print.

JOHN MURDOCH
*Assistant Director*
Victoria & Albert Museum

# Acknowledgements

The author's greatest debts are owed to the curators of paintings at South Kensington, from Richard Redgrave in the 1860s and 1870s to Lionel Lambourne in the 1970s and 1980s. In the years between, other curators have steadily added material to the departmental files – notably B S Long, Graham Reynolds, Jonathan Mayne, and Michael Kauffmann. Many notes on the files are anonymous, and the author is also grateful to their writers. Thanks as well as debts are also due to John Murdoch, previously Keeper of the Department of Designs, Prints and Drawings and now Deputy Director of the V&A, and his successor as Keeper, Susan Lambert, for their advice and encouragement.

Lionel Lambourne especially will instantly recognise many of his words, phrases, observations and ideas in this book. The author would also like to thank other colleagues in the paintings section of the Department of Designs, Prints and Drawings, in particular Stephen Calloway and Katherine Coombs for their discussion of, suggestions for, and corrections to this catalogue. They will all surely welcome my change of conversation in future away from the subject of British oil painting between 1820 and 1860. Invaluable help with the problems of photography has been given by Gill Saunders and Moira Thunder, and advice on matters of conservation by Peter Young, Susannah Edmunds and Lucia Scalisi. Thanks are also due to Judy Egerton, who carefully read most of the text. The following have helped in many different ways: Geoffrey Ashton, David Blayney Brown, Martin Butlin, Susan P Casteras, Krzysztof Cieszkowski, Malcolm Cormack, Kevin Edge, James Fowler, Levi Fox, David Fuller, Michael Gluck, Francis Greenacre, Helen Guitermann, Robin Hamlyn, Briony Llewellyn, John Munday, Terence O'Kelly, David Oldrey, David Parker, John Physick, Miklos Rajnai, Stella Ruff, John Steer, James Taylor, Malcolm Warner, Joe Wiebkin and Alison Winter. Finally, gratitude must be recorded to my indefatigable typist Georgina Spelvin.

RONALD PARKINSON

# Structure of the Entries

**Title**
As far as possible the original title under which the painting was first exhibited, or the artist's own recorded title. Any change made from a previously published title is explained in the text.

**Museum Inventory Number**

**Museum Negative Number(s)**
These follow inventory numbers. Prints may be ordered from the V&A Picture Library. 'CT' preceding a negative number indicates a colour transparency.

**Support**
Canvas, panel, millboard, paper, etc.

**Measurements**
Given first in centimetres, then inches, height before width.

**Signed, Dated, Inscribed**

**Mode and Date of Acquisition**

**Catalogue Entry**
Principal information given may include the date and whereabouts of the work's first exhibition, the circumstances of its commission, contemporary critical reaction (mainly in the *Art Union*, later called the *Art Journal*, and the *Athenaeum*), discussion of the subject, details of preliminary studies and other versions or replicas where known, and later critical comments.

**Provenance** (PROV)

**Exhibited** (EXH)
When and where the work has been publicly exhibited up to 1989.

**Engraved** (ENGR)
Details of a print after the work, with name of artist, date and technique where known, and reference to any impression (impr) in the V&A collections.

**Literature** (LIT)
Books and articles that deal specifically with the work, or alternative versions as noted. (Books and articles in LIT following artists' biographies appear in an abbreviated form in LIT following individual entries.)

**Reproduced** (REPR)
Details of published reproductions of the works are mainly only given when they are recorded on the Departmental files.

**Department/Departmental**
The terms 'the Department' and 'Departmental' refer throughout this text to the department in the Victoria and Albert Museum now called the Collection of Prints, Drawings and Paintings.

# Abbreviations

| | |
|---|---|
| ARA | Associate of the Royal Academy |
| | |
| bc | bottom centre |
| BI | British Institution |
| bl | bottom left |
| br | bottom right |
| bt | bought |
| | |
| c | circa |
| cat | catalogue |
| CB | Companion of the Bath |
| cl | centre left |
| cm | centimetres |
| cr | centre right |
| | |
| DNB | Dictionary of National Biography |
| | |
| engr | engraved |
| exh | exhibited, exhibition |
| | |
| fig | figure |
| FRS | Fellow of the Royal Society |
| FSA | Fellow of the Society of Antiquaries |
| | |
| HPRI | Honorary President of the Royal Institution |
| | |
| impr | impression |
| ins | inches |
| | |
| l | left |
| lit | literature |
| | |
| max | maximum |
| | |
| n | note |
| nd | no date |
| Neg | Museum Negative number |
| NG | National Gallery |
| NGS | National Gallery of Scotland |
| no | number |
| NPG | National Portrait Gallery |
| NWS | New Watercolour Society |
| | |
| obit | obituary |
| OED | Oxford English Dictionary |
| OWS | Old Watercolour Society |
| | |
| pl | plate |
| P | President |
| p | page |

| | |
|---|---|
| PRA | President of the Royal Academy |
| PRHA | President of the Royal Hibernian Academy |
| prov | provenance |
| PRSA | President of the Royal Scottish Academy |
| PRWS | President of the Royal Watercolour Society |
| r | right |
| RA | Royal Academician, Royal Academy |
| RBA | Royal Society of British Artists |
| repr | reproduced |
| RHA | Royal Hibernian Academy |
| RI | Royal Institute of Painters in Watercolours |
| RSA | Royal Scottish Academician, Royal Scottish Academy |
| RSW | Royal Scottish Watercolour Society |
| RWS | Royal Watercolour Society |
| | |
| SBA | Society of British Artists |
| SNPG | Scottish National Portrait Gallery |
| | |
| tl | top left |
| tr | top right |
| | |
| V&A | Victoria and Albert Museum |

## Bibliographical Abbreviations

| | |
|---|---|
| DNB | *Dictionary of National Biography.* |
| Grant OELP | Col. M H Grant *The Old English Landscape Painters* 3 vols, 1925 and 8 vols, 1957–61. |
| Graves *Sales* | Algernon Graves *Art Sales* 1918. |
| Redford *Sales* | George Redford *Art Sales* 1628–1887; 2 vols, 1888. |
| Redgrave *Cent* | Samuel and Richard Redgrave *A Century of British Painters* 1866. |
| Redgrave *Dict* | Samuel Redgrave *A Dictionary of Artists of the English School* 2 vols, 1878. |
| Sheepshanks Gallery | Richard Redgrave *The Sheepshanks Gallery: A series of twenty pictures from this celebrated collection . . .* 1870. |
| Wood *Dict* | Christopher Wood *A Dictionary of Victorian Painters* 1971. |

# Introduction

This catalogue deals with some 500 pictures (approximately half the V&A's collection of British oil paintings) by artists working between 1820 and 1860. Works outside that period are included only if the museum also possesses paintings by the artist from within it.

Many of the works are published and reproduced here for the first time. The catalogue is arranged alphabetically according to artist; the works are then given chronologically according to the date of their acquisition by the museum. Catalogue entries are preceded by a summary biography of the artist which aims to present the most up-to-date and accurate information and bibliography (Lit); more details are given of the lives and careers of lesser-known artists (such as Margaret Carpenter) than of the famous (J M W Turner). The stress in these biographies is on contemporary sources; the fullest include the occupation of the artist's father and/or mother, early training, the number and chronology of works exhibited at the major societies, any other activities, published works, membership of institutions and societies, and dates of studio sales. However, as John Munday has pointed out to the author in the case of E W Cooke RA, even an artist's own testimonies may be inaccurate; writing his autobiography for the *Art Journal*, Cooke seems not to have consulted his own diaries or account books.

In most cases, the provenances of the works are satisfyingly simple: from the artist's easel to a contemporary purchaser and then to the V&A. The earliest example is the remarkable Sheepshanks Gift of 1857. Other gifts and bequests followed, providing South Kensington with works which in many cases rival those later brought together in the Tate Gallery. Sheepshanks (for whom see p xviii) encouraged others by making the first and most extensive gift to the museum of 233 oil paintings, of which 30 were by William Mulready RA, whom Sheepshanks knew from 1826 until they both died in 1863. He not only bought Mulready's works straight from the easel or the Royal Academy, but acquired earlier works from their first owners, and commissioned copies or versions of paintings unavailable to him for purchase. He also directly commissioned pictures. It is not surprising that no less than one-third of Mulready's paintings in the V&A's 1986–7 exhibition of that artist once belonged to Sheepshanks. Of the other principal collectors and benefactors to the museum, strangely little is known; a short account of some of them is given below. Few of the works in this catalogue were purchased by the V&A. In the early years of the museum's history, and in the 1860s especially, some works by contemporary artists were bought (and others given) as models or examples to inspire and instruct the students of the college of art at South Kensington (later, of course, to be the Royal College of Art).

In her famous *Novels of the Eighteen-forties* (1954), Kathleen Tillotson began her first chapter by stating that 'It is now, I think, too late to talk about "Victorian novels"; their range is too vast and vague to lead to any useful generalisation'. The same may be written today of 19th-century British paintings. It must often have seemed at Royal Academy exhibitions that all human – and animal and vegetable – life was there.

The range of subject matter in the works in this catalogue to some extent reflects what was shown at the exhibiting societies – that is, what artists thought would (or ought to) sell – between 1820 and 1860. Portraits (usually already commissioned and sold) and landscapes; the latter by the early 19th century ranging all over Britain, Europe, and far beyond, with or without toiling peasants.

Another popular theme was the depiction of great events: the drama of the shipwrecked *Cleopatra's Needle* or the Queen opening the Great Exhibition, as well as of more domestic occasions, such as preparations for an impending wedding or a young governess receiving unhappy news from home.

Genre paintings of most kinds and from all the social classes figured strongly: village life with its novelties (such as an improved post-office system) and its essential traditions (such as haymaking, flirtation and courtship); children's games (sometimes with a moral message for adults, as in Dutch 17th-century art); the care of the very young and the very old; the plight of the destitute; the deaths of the famous and the unknown. Of episodes from everyday life, only crime seems usually to have been considered unsuitable for representation.

Interestingly, the heroes and heroines of history (William Tell, Mary Queen of Scots, the little princes in the Tower) were mostly viewed from a literary standpoint. E M Ward's 'Charles II and Nell Gwyn', for example, is based on John Evelyn's account in his famous diary (again, interestingly, first published in 1818). Many literary works, always already famous, were illustrated in oil paintings. Strangely, Le Sage's *Gil Blas* enjoyed considerable popularity both in the bookshops and in the artist's studio. Don Quixote and Sancho Panza feature, as do the works of Molière (although his plays were rarely performed in England in the 19th century). Milton and Shakespeare appear, though not as overwhelmingly as one might expect. Goldsmith's works were reinterpreted from 18th-century sentiment into 19th-century sentimentality, and Dickens's novels are represented, although not as widely as his immense readership would suggest. Perhaps his readers constituted a different public from that of RA visitors, or possibly Dickens's novels were already too well illustrated and his subjects too contemporary.

Most of the leading RAs and ARAs are included in this catalogue, although artists working in the 'Grand Manner' are not well represented in the V&A's collections and may well not have appealed to the increasing number of middle-class collectors such as Sheepshanks. But the number of 'missing' RAs and ARAs from the V&A collections for the period between 1820 and 1860 is only ten: Richard Ansdell, Henry Briggs, Alfred Elmore, John Herbert, George Jones, John Knight, John Phillip, Thomas Phillipps, George Richmond, and Frank Stone. The greatest omission is that of the works in oil by John Constable. These have been catalogued fully by Graham Reynolds (second edition 1973). Although the five Turners are included in the present volume, the entries are of course based on the scholarship of Martin Butlin and Evelyn Joll's 1977 catalogue.

Among the 19th-century comments recorded in this catalogue are those of Dr Gustav Waagen in the 1850s and the Redgrave brothers (both closely associated with the museum) in the 1870s. Their comments are often usefully factual, but their 'readings' in the modern sense are also interesting: they are critical – they tell us whether or not they like and/or approve a particular painting or the works of a particular artist, and give their reasons.

More than 100 years later, it is considered inappropriate for a cataloguer to comment on the quality of works under discussion. While the present writer concurs for the most part with the Victorian values of Mr Gradgrind back in those *Hard Times* of Charles Dickens in 1854 ('Now, what I want is, Facts . . . Facts alone are wanted in life'), future readers, curators and historians will search in vain in this volume for evidence of what we think and feel in 1990 about the works of art in our care. If Thomas Webster RA or William Mulready RA, for example, were to come across this catalogue, they would surely be astounded that so few qualitative judgements have been given. Perhaps only the choice of colour plates here will give the reader of 2089 some idea of the priorities – and taste – of the present compiler and his colleagues.

RONALD PARKINSON
*Collection of Prints, Drawings and Paintings*

# Biographies of Principal Donors

## The Sheepshanks Gift of 1857

### John Sheepshanks   1784–1863

Born Leeds 1787, son of Joseph Sheepshanks, a wealthy cloth manufacturer, and brother of the eminent astronomer Richard Sheepshanks (whose entry in the *DNB* is more than three times as long as that of John). He entered the family business, but his great early enthusiasms were for gardening (he was elected Fellow of the Royal Horticultural Society, and discovered the new species of geranium named after him *Sheepshanksiana grandiflora*) and the collecting of Dutch and Flemish prints, and he retired from business at the age of about 40. He had also begun buying copies after Italian old master paintings, but his major collecting activity was to be predominantly in the field of modern British art. Sheepshanks told Richard Redgrave RA, then a curator in the South Kensington Museum, of his intention to give his collection to the nation in 1856; his first proposal was to open his house at 24 Rutland Gate (just round the corner from the site of the V&A) as a public gallery, with Redgrave as resident curator, but he was dissuaded. The gallery built to house the collection was the first permanent structure on the V&A site, and all concerned saw the Sheepshanks Gift as forming the nucleus of a National Gallery of British Art. The importance of the collection is twofold and lies in the quality of the paintings themselves, as well as reflecting the status and character of the collector and his tastes. He was one of the *Victorian Patrons of the Arts: Twelve Famous Collections and Their Owners* discussed by Frank Davis in 1963, and there and very often elsewhere he is cited as the paradigm of the new middle-class collector of the Victorian period. Although he collected paintings before Queen Victoria ascended to the throne in 1837, Sheepshanks does seem to represent a certain type of 'Victorian' collector, in that he bought works by 'typical' Victorian artists such as Landseer, Leslie, Mulready, Collins, Callcott and Cooke (again, whose first exhibited works were in 1815, 1813, 1804, 1807, 1799, and 1835 respectively). It is also important historically that he commissioned works directly from the artists, bought their paintings from RA summer exhibitions, as well as in the saleroom, and struck up strong friendships with the artists themselves. However, it seems inaccurate to link Sheepshanks's social background, which was wealthy if industrial, with a 'middle-class' taste, and to relate them to the actuality of his collection. All five of the oil paintings by Turner in the V&A are from the Sheepshanks Gift: two bought in the saleroom, two bought from the RA or possibly commissioned, and one certainly commissioned from the artist. Six of the finest Constable oils are from Sheepshanks: again four bought at auction and two possibly from the artist. And it may well be that Sheepshanks's friendships contributed a great deal to the nature of his collecting, as for example with the marine painter E W Cooke, who gave as well as sold his patron and friend works of art. What is certain is that the Sheepshanks Gift is the bedrock of the V&A's collection of British oil paintings, and – as is discussed in the *Preface* here – served to encourage many other collectors to make donations and bequests.

# The Townshend Bequest of 1869

## Chauncey Hare Townshend   1798–1868

Born 20 April 1798 of a wealthy family, only son of Henry Hare Townsend of Busbridge Hall, Godalming, Surrey. Educated at Eton and Trinity Hall, Cambridge (BA, 1821). Succeeded to the family estates 1827, when he added 'h' to the Townsend name. He had taken holy orders, but while he always referred to himself as 'Rev.' on the title pages of his books, he never practised his vocation, probably because he suffered from chronic melancholia and hypochondria. Very much a dilettante in the eighteenth-century sense, he moved in the highest social and literary circles; a great friend of Charles Dickens (he was the dedicatee of *Great Expectations*) with whom he shared a fascination for mesmerism, he was probably also the model for the retiring connoisseur Mr Fairlie in Wilkie Collins's novel *The Woman in White*, and the interior of his house is described as 'Limmeridge House' in that book. Bulwer Lytton described his life's '*beau-ideal* of happiness' as 'elegant rest, travel, lots of money – and he is always ill and melancholy'. He died 25 February 1868. Of the many watercolours and British and continental oil paintings he bequeathed to the V&A, the majority are landscapes. He is the first identifiable British collector of early photographs apart from the Prince Consort, particularly landscape photography, and also collected gems and geological specimens.

# The Forster Bequest of 1876

## John Forster   1812–1876

Born Newcastle 1812, eldest son of Robert Forster, a cattle dealer. Educated at Newcastle Grammar School and University College London; student in the Inner Temple 1828, and qualified as a barrister January 1843. Began his career as a journalist as dramatic critic of the *True Sun* 1832; he later edited the *Foreign Quarterly Review* (1842–3), the *Daily News* (1846), and most famously the *Examiner* (1847–55). He was the author of numerous works, notably the *Life and Adventures of Oliver Goldsmith* (1848) and the *Life of Charles Dickens* (1872–4). Died 1 February 1876. Bequeathed his extensive collection of books, pamphlets, manuscripts, prints, drawings, watercolours and oil paintings to the V&A. There are three oil portraits of Forster in the V&A, by Maclise and Ward (see P35–1935 and P74–1935, pp184, 295) and Perugini. Also in the V&A collections are two sketches in pen and ink by Maclise, a watercolour group portrait (with Dickens, Maclise, and the artist) by Charles Stanfield, and a photograph *carte de visite*. Further details of Forster's career and personality are given in Morley's preface to the *Handbook of the Forster and Dyce Collections* (1877) and Elwin's introduction to *A Catalogue of the Printed Books bequeathed by John Forster* (1888).

# The Jones Bequest of 1882

## John Jones   1800–1882

Born Middlesex probably in 1800. Set up in business as a tailor and army clothier in London 1825, and opened a branch in Dublin 1840. Often visited Ireland, travelled to Europe and particularly France. He retired in 1850, but retained an interest in his firm. Lived quietly at 95 Piccadilly from 1865 to his death in January 1882. After the Marquess of Hertford and his son Sir

Richard Wallace, Jones was the principal collector in Britain of French 18th-century fine and decorative arts; among the British watercolours and oil paintings he bequeathed to the V&A are subjects which reflect his interest in France (see Frith 537–1882 p103, for example). Jones also bequeathed an important collection of French 18th-century furniture and porcelain to the V&A.

## The Dixon Bequest of 1885

### Joshua Dixon    1811–1885

Born 1811, son of Abraham Dixon of Whitehaven and brother of George Dixon (who was head of the foreign merchants firm of Rabone Brothers in Birmingham 1883–98). Educated at Leeds Grammar School, and was deputy chairman of the London, Chatham and Dover Railway Company 1869–70. Died Winslade, near Exeter, 7 December 1885. Bequeathed all his collection of drawings, watercolours and oil paintings to the Bethnal Green Museum; they have been transferred to the V&A. He also collected engravings, Japanese vases and panels, and bronze and marble sculpture.

## The Ashbee Bequest of 1900

### Henry Spencer Ashbee    1834–1900

Born London 21 April 1834, only child of Robert Ashbee, manager of the gunpowder makers Carter and Harvey of Hounslow. Educated at schools in Esher and Kensington; apprenticed to Groucock, Copestakes, Moor and Company, warehousemen, for whom he travelled extensively for some years. Founder and senior partner of the merchants Charles Lavy and Company of London, who specialised in silks from 1871, and organised the opening of a branch in Paris 1867. Elected Fellow of the Society of Arts 1877. Travelled around the world 1881, and was the author of numerous articles, particularly on bibliographical subjects. Died Hawkhurst, Kent, 29 July 1900. He collected the finest library concerning the life and work of Cervantes outside Spain, and his bequest of watercolours and oil paintings to the V&A includes many illustrations to *Don Quixote*. He also assembled a library, including many humorous works, of over fifteen thousand volumes, which he bequeathed to the British Museum. He catalogued his vast collection of erotica under the title *The Index of Forbidden Books*. He was the father of the famous arts and crafts designer C R Ashbee.

# The Catalogue

# ADAMS, J J (working 1836/7)

No artist with this name and initials seems to be listed in any of the directories of exhibiting painters; presumably he was related to the sitter in the portrait catalogued below, probably his father.

**Portrait of George Gammon Adams**
P43-1982  Neg HJ788
Cardboard, 37.5 × 30.4 cm (14 × 12 ins)
Given by Miss I D Adams 1982

George Gammon Adams was born in Staines, Middlesex, 21 April 1821. According to a manuscript label on the back, the work shows him at the age of 15, on the occasion of his entry to the Royal Mint (where he studied under William Wyon RA), dating the portrait to 1836/7. Adams entered the RA Schools 1840 and studied with John Gibson RA in Rome 1846–7. He designed prize medals for the Great Exhibition of 1851, and was selected to take the death mask of the Duke of Wellington 1852. Adams became a highly successful medallist and sculptor, exhibiting 119 works at the RA between 1841 and 1885 and producing several public sculptures in London and elsewhere. However, R Gunnis, in his *Dictionary of British Sculptors 1660–1851*, 1953 describes them as of 'unequal merit' (his statue of General Napier in Trafalgar Square was described by the *Art Journal* (1862, p98) as 'perhaps the worst piece of sculpture in England').

He is shown in this portrait wearing a sculptor's cap and holding a modelling tool; on the plinth is a (barely visible) sculptured bust. He died at Chiswick, Middlesex, 4 March 1898. For another portrait, by J B Burgess, see P44-1982, p15).

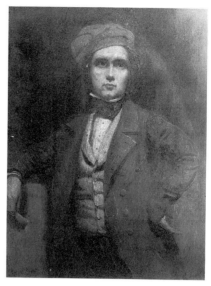

*Portrait of George Gammon Adams*
P43-1982

# ALLEN, Joseph William (1803–1852)

Born Lambeth, London, son of a schoolmaster; educated at St Paul's School, and worked as an usher in a school in Taunton, Devon. Painted first in watercolours, mainly views in Cheshire and North Wales (two examples in the V&A collections). Scene painter with Charles Tomkins and Clarkson Stanfield. Exhibited 11 works at the RA between 1826 and 1833, 17 at the BI 1827–53 and 329 at the SBA 1827–53. His works were favoured by several eminent patrons, notably Lord Northwick. Died Hammersmith, London, 26 August 1852.

LIT:  *Gentleman's Magazine* October 1852, pp431–2 (obit); *Art Journal* 1852, p316 (obit); Redgrave *Dict*

*Italian Landscape   622-1901*

**Italian Landscape**
622-1901  Neg CT18995
Canvas, 49.6 × 59.7 cm (19½ × 23½ ins)
Signed and dated 'J.W. Allen, 1839' bl
Given by Sir Edwin Durning-Lawrence, Bart, 1901

Possibly the work exhibited at the SBA in 1839 (290) titled '*The Last Gleam of Day*'.

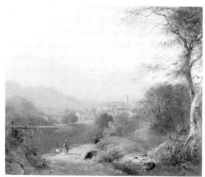

## ANDREWS, Henry (died 1868)

Exhibited eight works at the RA between 1830 and 1838, 17 at the BI 1831–47, and 14 at the SBA 1827–63; subjects were historical, literary and landscape, but he seems to have specialised in imitations of, and variations on, the works of Watteau. The *Art Journal* described him as 'an artist of considerable talent, and might have acquired a good reputation had he studied quality rather than quantity'. According to Redgrave 'He had talent and might have acquired reputation, but he fell into the hands of unscrupulous dealers . . . and his art became degraded.' He died 30 November 1868.

Lɪᴛ: *Art Journal* 1869, p29; Redgrave *Dict*

*A Garden Scene, in the Manner of Watteau* 354-1886

### A Garden Scene, in the Manner of Watteau
354-1886  Neg HF134
Canvas, 61.6 × 73.7 cm (24¼ × 29 ins)
Signed and dated 'H Andrews [?pxt]/1849' on base of fountain bl
Purchased 1886

This is not certainly identifiable with any of the artist's exhibited works, although he exhibited similar subjects such as 'Garden Scene' (RA 1838) and 'Fête Champêtre, Siècle de Louis XIV' (BI 1847). Although the inspiration of Watteau is evident both in the subject and the landscaped park setting, Andrews's figure groups are less lively and more decorous; the work is not a copy after Watteau. A companion painting was recorded in a London private collection in 1910; similar works were sold at Sotheby's Belgravia 20 November 1973 (58), Sotheby's 18 February 1987 (265) and Christie's New York 25 February 1988 (311, 312).

Pʀᴏᴠ: Edward Harrison of Shortlands (according to printed label on back); his sale, Christie's 8 May 1886 (93, as 'A Fête Champêtre'), bought Parsons £17 17s; bought by the museum 1886 £25

## ARNALD, George, ARA (1763–1841)

According to Farington's *Diary* (14 May 1808), born at Farndip near Northampton; Redgrave (*Dict*) gives Berkshire as his birthplace. After working as a domestic servant, he became the pupil of Abraham Pether, whose style he at first closely imitated. Exhibited 176 works, mostly landscapes, at the RA between 1788 and 1841, and 63 at the BI 1807–42. Elected ARA 1810, and won the BI prize 1825 for his 'Battle of the Nile' (National Maritime Museum). His work was engraved in *The Border Antiquities of England and Scotland* (1814). Grant (OELP) believed his masterpiece to be 'The Castle of Gloom' (RA 1814); it is shown in the background of his self-portrait (NPG). Died Pentonville, London, 21 November 1841; his son and daughter were also exhibiting artists.

*Landscape* 804-1904

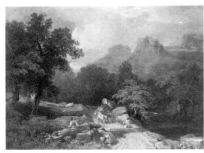

### Landscape
804-1904  Neg HF952
Panel, 15.2 × 33 cm (6 × 13 ins)
Signed and dated 'Arnald/1826' br
Given by W S Terry 1904

The painting is not identifiable with any exhibited work.

# BARRET, George, junior (1767/8–1842)

Born London in 1767 or early 1768, one of the four children – also artists – of the landscape painter George Barret, whose style and subjects he imitated in his early career and whose fame he was to exceed. He was most admired for his poetic effects of sunrise, sunset and moonlight (Orrock wrote in 1898, 'As a painter of light he has had no rival, save and except Cuyp'), and also for his classical landscapes inspired by the works of Claude. Exhibited four oils at the RA between 1800 and 1802, and another in 1821, and 19 at the BI 1820–43. But he was almost exclusively a painter in watercolours. A founder member of the OWS 1804/5, he exhibited there each year for the rest of his life – a total of 581 works. Thirty watercolours are in the V&A collections. Published *The Theory and and Practice of Watercolour Paintings, elucidated in a series of letters* (1840). Bury states that he visited Italy. Died London 19 March 1842. His self-portrait is in the National Gallery of Ireland.

LIT: J Orrock 'George Barret', *Art Journal* 1898, pp129–32; B Webber *James Orrock, Painter, Connoisseur, Collector*, 2 vols, 1903, I, pp135–46; A Bury 'George Barret Junior: A Classic Water-colour Painter', *Connoisseur* CV, 1940, pp237–41; 'Some Letters of George Barret, Junr . . .', *OWS* XXVI, 1948, pp1–5

## Landscape with Classical Ruins, Figures and Goats
1001-1886   Neg 58950
Canvas, 75 × 62.2 cm (29½ × 24½ ins)
Signed and dated 'G Barret/1832'
Dixon Bequest 1886

An essay in the classicism of Claude, it may also owe something to the composition of Turner's 'Crossing the Brook' (exhibited RA 1815 and Turner's Gallery 1835, now Tate Gallery). Barret's Italianate landscapes were compared to those of Claude by his contemporaries, including Ruskin; the present work does not seem to be based on a specific Claude painting. Barret wrote about ideal landscape in his 1840 book: 'Imitation which employs the hand and eye only can never produce a work of art of elevated character'.

*Landscape with Classical Ruins, Figures and Goats* 1001-1886

REPR: *Bury*, p238

## Italianate Landscape with Shepherds
4-1887   Neg 31840
Canvas, 149.9 × 228.6 cm (59 × 90 ins)
Given by James Orrock RI, 1887

Evidently inspired by the paintings of Claude, with whom Barret was compared by his contemporaries including Ruskin, but does not seem to be based on a specific Claude work.

Webber quotes James Orrock relating the donation of the picture:

*Italianate Landscape with Shepherds* 4-1887

> My friend Dr Marshall was paying me one of his welcome visits in London when I showed him an unusually large oil picture by George Barret the younger, the celebrated water-colourist. I observed that such a magnificent work as that ought rightly to belong to the nation, and I thought that, one day, I would present it to South Kensington Museum. He exclaimed in his racy Scottish way, 'Man, why not do it now?'. On brief consideration, I followed his advice. Having always felt a deep interest in the history of the two celebrated De Wints in oil, which, in consequence of their having been executed by a watercolour painter, for a long time found no worthy resting-place – although they were offered to the National Gallery – until they were finally located at South Kensington, I felt that this grand Barret in oil, also painted by a master

in my beloved art, ought by right to keep them company. I therefore made it a condition of my gift, one that every artist will thoroughly appreciate, that the Barret should be hung alongside the two De Wints. The gift was accepted on these terms, and the three pictures are grouped together to this day in what may be called a truly English section of our National Gallery. To see them, and them only, will repay a pilgrimage to South Kensington on the part of any one who would dwell delightedly on what two masters in water-colour can accomplish in oil.

Chancellor admired the painting in 1910:

This remarkable canvas is very Claudeian in conception and treatment; it is suffused with that golden tone which the great Frenchman loved to put into his work, and in this respect it exemplifies what Ruskin wrote of Barret's 'glorious and exalted passages of light' and you will remember that the critic once exclaimed that 'one careless blot of Barret was worth all the Caraccis in Europe'. The foreground of this work is rather conventional and 'tight', rather factitious, in a word, but this was due to the particular treatment of the subject (one wonders if Barret produced the work in a frank competition with Claude), but could the distance be better, could even Claude or Turner (even he) have produced anything more ethereal or more poetic?

A watercolour replica, with some alterations, was sold from the Stephen G Holland collection at Christie's 25–29 June 1908 (131, as 'A Landscape: sunrise, peasants and horses in the foreground; a distant view of a town on the left', 51 × 82.5 cm/20 × 32½ ins), bought Agnew £283 10s.

PROV: Sold ('property of a gentleman') Christie's 30 June 1883 (208, as 'A Classical Lake Scene, with figures, sheep, and goats', 152.4 × 23 cm/60 × 89 ins), bought Cannin £420; presented to the museum by James Orrock 1887

ENGR: Walker and Cockerell, for Webber I, facing p142

LIT: C Monkhouse *Earlier English Watercolour Painters* 1890, p101; *Webber II*, pp183–4; E B Chancellor, *Walks Among London's Pictures* 1910, p250

**Returning from Work**
1842-1900    HF3977
Canvas, 35.6 × 44.5 cm (14 × 17½ ins)
Signed and dated 'Geo Barret 1840' br
H S Ashbee Bequest 1900

*Returning From Work    1842-1900*

Possibly the work exhibited at the BI in 1840 (21, as 'Drovers', size given in catalogue as 18 by 22 inches (presumably including the frame)

EXH: ?BI 1840 (21); RBA 1971

# BAXTER, Charles (1809–1879)

Born Little Britain, London, 9 March 1809, son of a bookclasp maker. Apprenticed to a bookbinder, then worked as a portrait and miniature painter, encouraged by George Clint ARA, whom he met 1834. Joined the Clipstone Street Society 1839. Exhibited 45 works, mostly portraits, at the RA between 1834 and 1872, three at the BI 1846–49, and 154 at the SBA 1837–79, of which he was elected Member in 1842. Best known for his poetic and rustic subjects, and particularly his 'fancy' portraits based on the style of Sir Thomas Lawrence. Submitted paintings to the RA from Edinburgh in

1843 and 1845, and apparently visited Denmark around 1845. Died Lewisham, London, 10 January 1879. His studio sale was at Christie's 15 March 1879. There is no relation with the George Baxter of 'Baxter Prints' fame.

Lit: *Art Journal* 1864, pp145–7, 1879, p73 (obit); *Illustrated London News* 25 January 1879, p72 (obit with engr self-portrait)

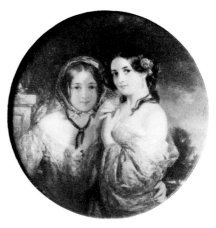

*The Sisters   548-1882*

**The Sisters**
548-1882   Neg 51453
Canvas, circular, diameter 32.4 cm (12¾ ins)
Jones Bequest 1882

Evidently a favourite subject, as Baxter painted it several times with variations, in both circular and rectangular format. Examples include those sold at Christie's 25 May 1889 (44, 52 × 42 cm/20½ × 16½ ins), bought Polak £26 5s, and 29 April 1911 (88, 54.6 × 43.2 cm/21½ × 17 ins), bought Mitchell £24 3s, A painting titled 'The Sisters' was shown at the SBA in 1865 (47).

Baxter's inspiration may well have been works by Sir Thomas Lawrence such as his portrait of Emily and Laura Anne Calmady (exhibited at the RA 1824, now Metropolitan Museum of Art, New York).

Maas describes this kind of painting as 'hovering on the brink of genre painting . . . merely a framed version of "The Keepsake" beauties'; he also links Baxter's work with that of E T Parris (see 57–1908 and 58–1908, p224).

Lit: J Maas *Victorian Painters* 1969, p107, repr p111

**Industry**
P4-1935   Negs HF953, HF4880
Canvas, 35.6 × 30.5 cm (14 × 12 ins)
Signed and dated 'C Baxter/1867' diagonally br
Given by Mrs A C Taylor in memory of her husband, John Easton Taylor, 1935

Possibly lot 46, 'Knitting', in the artist's studio sale at Christie's 15 March 1879, bought Hoare £27 6s. Two paintings titled 'Knitting' were exhibited at the SBA, in 1852 (67) and 1873/4 (284, 'a sketch').

*Industry   P4-1935*

# BLAKE, Benjamin (1788–1830)

*Still Life   739-1897*

Born Park Street, London, 1788, the son of a perfumer. Exhibited 13 works at the RA between 1807 and 1825, 17 at the BI 1809–28, and 26 at the SBA (of which he was a founder member in 1824) 1824–34/5. Most of his RA exhibits were landscapes, but the rest of his exhibited paintings were of dead game. Died 6 July 1830.

**Still Life**
739-1897   Neg HG1882
Panel, 32.4 × 26.1 cm (12¾ × 10¼ ins)
Signed and dated 'B Blake/1823' on card in basket on table
Bequeathed by F A Blake 1897

*Interior with Figures and Still Life*    P6-1910

**Interior with Figures and Still Life**
P6-1910    Neg HF4803
Panel, 64.5 × 5.5 cm (25⅜ × 21⅝ ins)
Signed and dated 'B Blake/1826' diagonally on barrel at 1
Bequeathed by Richard Blake 1910

A label on the back indicates that Richard Blake, the artist's son, bought the picture from Alfred Gritten of 9 King Street, St James's, London, 24 June 1853 for £31.

The composition is reminiscent of the work of George Morland, with the addition of a display of vegetables and a good deal of dead game.

# BOADEN, John (died 1839)

Son of the dramatist and critic James Boaden (1762–1839). Painted principally portraits and also theatrical subjects. Exhibited 40 works at the RA between 1810 and 1833, 90 at the BI 1810–39, and 59 at the SBA 1827–40 (when he was described in the catalogue as 'the late . . .'). All works were submitted from London addresses.

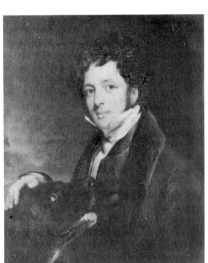

*The Rev Chauncey Hare Townshend*
1411-1869

**The Rev Chauncey Hare Townshend**
1411-1869    Neg 51759
Canvas, 75.6 × 62.9 cm (29¾ × 24¾ ins)
Townshend Bequest 1869

Presumably the portrait exhibited at the RA in 1828. For the sitter, see pxix. M Haworth-Booth draws attention to the writer Edward Bulwer's description of Townshend after their meeting in about 1825: '. . . singularly calm and pure. In spite of a beauty of face, which at that time attracted the admiration of all who even passed him in the streets, his manner and conversation were characterised by an almost feminine modesty', and he adds that Townshend's 'beauty of countenance' was so spectacular that 'those who knew Byron said it was Byron with bloom and health' ('The Dawning of an Age; Chauncey Hare Townshend: Eyewitness' in *The Golden Age of British Photography, 1839–1900* 1984, p12). This contemporary description accords with Townshend's appearance in the present portrait, and it is interesting to compare it with Wilkie Collins's characterisation of him some 30 years later, as Mr Fairlie in the novel *The Woman in White*. The sitter is shown with his dog; for a portrait of another dog owned by Townshend, in the 1850s, see the painting by Francois Bocion also in the V&A collections from the Townshend Bequest (1621–1869, C M Kaufmann *Catalogue of Foreign Paintings: II. 1800–1900* 1973, p9, cat no23).

*Constantine Soteres*    1415-1869

**Constantine Soteres**
1415-1869    Neg HF854
Canvas, 91.5 × 71.1 cm (36 × 28 ins)
Townshend Bequest 1869

The identity of this youth in Albanian costume has not been established, but, to judge from the name and the temple in the right background, he was presumably of Greek family. The national dress perhaps reflects the pride of the Greeks at home and abroad during the war of independence against the Turks.

# BODDINGTON, Henry John (1811–1865)

Born 1811 into a large and famous family of artists, the second son of the landscape painter Edward Williams, he (like two of his brothers) changed his name, taking his wife Clara Boddington's name after their marriage in 1832. Worked from childhood in his father's studio, eventually specialising in scenes on the Thames and in Surrey; favourite later subjects included Yorkshire, Devon, the Lake District, Scotland, and particularly, after his first visit in 1847, North Wales. Exhibited 51 works at the RA between 1837 and 1869, 60 at the BI 1837–67, and 244 at the SBA 1837–67, becoming a Member of the last in 1842. Ruskin praised his exhibited work in 1857 and 1858, and the *Art Journal* obituary recorded that his 'feeling for nature constantly led him to lengthened periods of out-door study'. Died Barnes, 11 April 1865. His only child, Edwin, was also a painter.

LIT: *Art Journal* 1865, p191 (obit)

**Landscape with Gypsies and Haymakers**
1023-1886    Neg 56354
Canvas, 69.9 × 89.2 cm (27½ × 35⅛ ins)
Dixon Bequest 1886

Boddington exhibited several gypsy and haymaking subjects, especially early in his career, but not a picture with this title, although the present title may not be original.

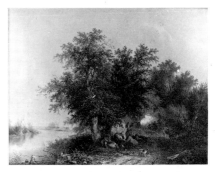

*Landscape with Gypsies and Haymakers   1023-1886*

# BOXALL, Sir William, RA, FRS (1800–1879)

Born Oxford, 29 June 1800, son of a customs official. Educated at Abingdon Grammar School and entered RA Schools 1819. Visited Italy 1827 for about two years to study Italian old masters. Exhibited 85 works at the RA between 1818 and 1866 (and one posthumously in 1880); almost all were portraits of the artistic, literary and ecclesiastical establishment. Also exhibited other subjects: 11 at the BI 1826–44, and 7 at the SBA 1827–32. Elected ARA 1851, RA 1863. Director of the NG 1866–74. Knighted 1871. Died London 6 December 1879. His studio sale was at Christie's 8 June 1880.

LIT: *Art Journal* 1880, p83 (obit); *Portfolio* 1880, p17 (obit); *The Fortnightly Review* 1 February 1880 (memoir by Lord Coleridge); M Levey 'A Little-Known Director: Sir William Boxall', *Apollo* May 1975, pp354–9

*Walter Savage Landor   F3*

**Walter Savage Landor**
F3    Neg 76972
Panel, 60.2 × 45 cm (23½ × 17½ ins)
Forster Bequest 1876

Commissioned by John Forster in January 1852, and exhibited at the RA in 1853. The portrait shows Walter Savage Landor (1775–1864) at the age of 77. Landor, although he said 'I neither am not ever shall be popular', is still remembered today for his innovatory literary form, the *Imaginary Conversations*, in which he described imagined meetings between famous people at crucial junctures in their careers. A poet, and always a controversial figure, he was a member of the Romantic circle of Byron, Shelley, Southey and Wordsworth, and later a friend of Forster and Dickens, who portrayed him in the character of Boythorne in *Bleak House*. Richard Renton called him 'one of John Forster's warmest friends', although they seem to have

quarrelled in later years (*John Forster and His Friendships* 1912, p164)

Early in 1852 there was a scheme to publish the *Imaginary Conversations* between classical speakers in a single and separate volume; Super suggests this was possibly Forster's idea. Forster wanted a portrait of Landor to be engraved as a frontispiece, and in January 1852 he commissioned Boxall. The volume was printed by July 1852 but was not published until April 1853; Super suggests this delay was caused by the fact that Boxall had not finished the portrait, although in the event his portrait was not engraved for the volume. Boxall visited Landor in Bath in early December 1852 to complete the portrait, the last sitting being 8 December. Landor wrote to Forster late in 1852 (quoted by Super, p411) that 'The price of Boxall for a portrait I believe is high, but he is incomparably our best painter. I have seen pictures by him which would have done honour to Titian. His hands are full at present'. He also wrote to Forster that he was not to publish the portrait 'until I have left the world', an indication of his reclusive nature. The portrait was engraved, after Landor's death, for the 1869 edition of Forster's biography of Landor.

Landor told his friend Anthony Rosenhagen that the portrait was 'considered to be a very good likeness' (Super, p415), but when it was exhibited at the RA in 1853 he did not leave Bath for London to see it. The *Examiner* thought it 'a masterpiece both in truth of likeness and beauty of painting', and the *Athenaeum* critic could 'vouch for the perfect resemblance no less than for the artistical skill'. The *Art Journal*, however, called it 'a small study, very simple in treatment, and we think unhealthy in complexion'.

On 15 December 1856 the diarist Henry Crabb Robinson received a gift of what he thought was Boxall's portrait – 'a handsome present' – but realised two days later that it was the portrait by William Fisher, 'more striking as a likeness'. Super believes the portrait to be a failure, and rendered worse in the 'rather simpering head' engraved for Forster's 1869 biography. Super (pp594, n95) quotes Dickens from *All The Year Round* (24 July 1869, pp181–2): Dickens noted that Landor had peculiar arms, rather short, and 'curiously restrained and checked in their action at the elbows; in the action of the hands, even when separately clenched, there was the same kind of pause . . . Let the face be never so intense or fierce, there was a commentary of gentleness in the hands, essential to be taken along with it . . .'.

There are several portraits of Landor, including the William Fisher mentioned above, which Crabb Robinson eventually gave to the NPG; for a full iconography, see R Walker *Regency Portraits* 1985, I, pp307–9.

EXH: RA 1853 (159); an exhibition for National Library Week, Central Library, Museum and Art Gallery, Stafford, 1969; *Charles Dickens* V&A 1970 (P17)

ENGR: J Brown 1852, for publishers Chapman and Hall, in J Forster *Walter Savage Landor, a Biography* 1869, frontispiece to vol II

LIT: *Athenaeum* 28 May 1853, p654; *Art Journal* 1853, p141; *Examiner* 1853, p294; ed E J Morley *Henry Crabb Robinson on Books and their Writers* III, 1938, p764; R H Super *Walter Savage Landor* New York 1954, pp410–1, 415, 594 n95

## Mrs Cardwell

P3-1917
Canvas, 91.5 × 71.2 cm (36 × 28 ins)
Bequeathed by Miss F M Cardwell 1917

Exhibited at the RA in 1865. The *Art Journal* critic thought it 'a good example of the artist's mode . . . grey, vaporous, suggestive and cloudy, as if the head were "out of focus" ', while the *Athenaeum* said it 'shows nobly, with its quiet breadth, refinement of style', and contrasts his work strangely with the solidity of Mr Richmond in the portrait of 'The Bishop of Oxford'.

*Mrs Cardwell* P3-1917

The sitter was identified in the 1893 and 1901 RA catalogues as Elizabeth, daughter of Richard Birley, and widow of John Cardwell of Liverpool (1781–1831); their son, Edward Cardwell MP (1813–86, created a Viscount 1874) owned the painting in 1867.

EXH:   RA 1865 (62); *Exposition Universelle* Paris 1867 (8, lent by the Rt Hon E Cardwell, MP); *Works by the Old Masters . . .* RA Winter 1893 (32, lent by Miss Cardwell); *Works by British Artists . . .* RA Winter 1901 (70, lent by Miss Cardwell)

LIT:   *Athenaeum* 27 May 1865, p723; *Art Journal* 1865, p168

**Mrs John Forster**
P36-1935    Neg HJ793
Panel, 60.7 × 46.4 cm (23⅞ × 18¼ ins)
Inscribed in ink on a label on the back of the stretcher 'W Boxall ARA No1'
Given by D R Crawfurth Smith 1935

*Mrs John Forster*    P36-1935

Presumably commissioned from the artist by John Forster (1812–76), the husband of the sitter: for further details and a portrait of him, see under Daniel Maclise P35–1935 (also given to the Museum by Crawfurth Smith) and E M Ward P74–1935. He married the wealthy Eliza Ann Crosbie (born 1819), daughter of Captain Robert Crosbie RN and widow of the publisher Henry Colburn (died 1855), on 24 September 1856. From the apparent age of the sitter, the portrait was painted soon after the marriage.

Richard Renton described Mrs Forster as 'the truest and best helpmeet man ever had', and 'the most charming, the sweetest-natured woman it is possible to conceive. Petite, dainty in form and feature, she was, at the same time, clever and shrewd beyond the average woman of her day . . .' (*John Forster and His Friendships* 1912, pp94, 96). Renton reproduces (facing p96) a crayon sketch by Boxall of Mrs Forster which Crawfurth Smith also gave to the museum in 1935 (E440–1935). It is different in pose from the present painting, but may well be a preliminary sketch.

The Forster collection in the National Art Library has a photograph of a drawing by John Watkins, 'The Library of John Forster, Esq, Palace Gate House, Kensington', in which the present painting is shown on an easel in the right hand corner of the room (repr Renton facing p194)

PROV:   John Forster; his niece Miss Fannie Crosbie; given by D R Crawfurth Smith to the museum for incorporation in the Forster Bequest 1935

EXH:   'Charles Dickens', V&A 1970 (D29)

# BRADLEY, William (1801–1857)

Born Manchester, 16 January 1801. Apparently painting portraits and giving drawing lessons at the age of 16. Received some tuition from Mather Brown in about 1822, and moved to London where he was encouraged by Sir Thomas Lawrence. His portrait practice in London seems to have been successful: he painted some of the distinguished people of the day, for example, the art patron Robert Vernon (RA 1827). Exhibited 22 portraits at the RA between 1823 and 1845, 13 works (mostly 'fancy' pictures) at the BI 1824–46, and seven at the SBA 1830–32/3. In 1833 he and the portrait painter Benjamin Faulkner (1787–1849) returned to Manchester for a long visit, working in the studio of the landscape painter Charles Calvert, whose daughter Bradley married. Finally settled permanently in Manchester 1847. He died, apparently in poverty, 4 July 1857.

LIT:   *L'Artiste* Paris 1857, p153 (obit, as William Brandley)

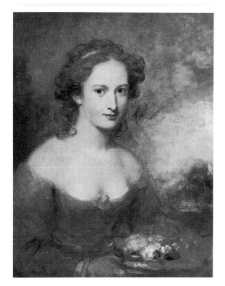

*Early Fruit* 694-1891

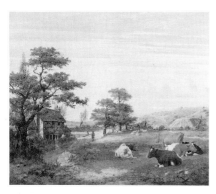

*Landscape with Cattle and Sheep*
1049-1886

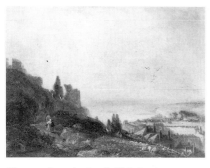

*Hastings from the Castle Hill, Looking Towards St Leonards* FA2

*The East Cliff, Hastings* FA3

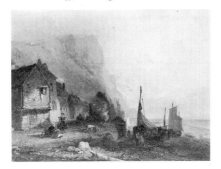

**Early Fruit**
694-1891   Neg HB2554
Canvas, 74.3 × 61 cm (29¼ × 24 ins)
Given by T H Wilkinson 1891

Not identifiable with any exhibited work, but presumably typical of Bradley's 'fancy' pictures such as the 'Flower Girl' exhibited at the BI in 1827.

# BRAGGE (working c1850)

No artist by this name is recorded, and he may well have been a provincial or amateur painter. Graves (*Sales*) lists a C W Bragg exhibiting a flower painting in London, and an A Bragg exhibiting a figure subject, but neither is identifiable with the present artist.

**Landscape with Cattle and Sheep**
1049-1886   Neg HF3889
Canvas, 44.2 × 54.3 cm (17⅜ × 21⅜ ins)
Dixon Bequest 1886

Although the work has a good deal of engaging *naïveté*, charm and closely observed detail, the disparities of scale between the animals, people and landscape, support the proposition that the artist was a provincial or amateur painter.

# BRANDARD, Robert (1805–1862)

Born Birmingham 1805; his brothers Edward and John, and sister Annie Caroline, were also artists. Studied with J V Barber from the age of 11 (according to a note in the Department's MS *Register*). Moved to London 1824 and studied with the landscape engraver Edward Goodall for a year. Principally known as an engraver, etcher, lithographer and watercolourist, he also exhibited three oils at the RA between 1838 and 1852, 21 works, mainly landscapes, at the BI 1835–58, and 32 at the SBA 1831–47. He engraved plates for many books, including J M W Turner's *Annual Tour* of 1833 and 1834; two of his engravings after paintings by Turner were exhibited at the 1862 International Exhibition. A volume of his prints after his own work was published 1844. This volume, many other prints and four watercolours, are in the V&A collections. Died Campden Hill, Kensington, London, 7 January 1862.

**Hastings from the Castle Hill, Looking Towards St Leonards**
FA2   Neg HB2555
Canvas, 29.8 × 40.7 cm (11¾ × 16 ins)
Signed
Sheepshanks Gift 1857

**The East Cliff, Hastings**
FA3   Neg HB2556
Canvas, 30.5 × 40.7 cm (12 × 16 ins)
Signed and dated 'Brandard 1834' br
Sheepshanks Gift 1857

**The Priory, Hastings**
FA4   Neg HF137
Canvas, 45.7 × 61 cm (18 × 24 ins)
Sheepshanks Gift 1857

Brandard exhibited only two Hastings subjects, at the SBA: *Hastings* in 1836
(40) and *Scene near Hastings, Sussex* in 1840 (20). Hastings was a favoured
site for landscape painters throughout the 19th century, and the V&A
collections include views painted by J J Chalon, E W Cooke, Joshua Cristall
and J M W Turner. The view in FA4 is looking towards the old town of
Hastings.

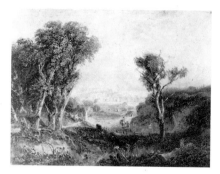

*The Priory, Hastings*   FA4

# BROOKS, Thomas (1818–1891)

Born Hull 1818, went to London 1838, studied at Sass's art school for six
months and then at the RA. After a year in the studio of Henry Perronet
Briggs, he studied in Paris, returning to Hull to work as a portrait painter for
five years. Moved permanently to London 1845 and became a successful
genre painter. Also painted marine subjects after 1860. Some 40 of his works
were popular through engravings. Exhibited 55 genre pictures at the RA
between 1843 and 1882, 19 at the BI 1846–67, and 11 at the SBA 1846–68.
Died 1891, in June according to *The Year's Art* (1892); his death was noted in
the July 1891 issue of the *Art Journal* (p224).

L_IT_:   *Art Journal* 1872, pp197–9

**The Dawn of Love**
FA241
Canvas, 111.7 × 86.4 cm (44 × 34 ins)
Signed and dated 'T Brooks 1846' bl
Given by Christopher Pearse 1864

Presumably the painting exhibited at the RA in 1846, with no title, but the
following quotation from Robert Burns's song 'There was a Lass', verses 10
and 12:

> O Jeannie fair. I lo'e thee dear;
> O canst thou think to fancy me?
> Or wilt thou leave thy mammie's cot,
> And learn to tent the farms wi' me?
>
> Now what could artless Jeannie do?
> She had nae will to say him na;
> At length she blushed a sweet consent,
> And love was aye between them tha.

The *Art Union* recorded of the RA painting that 'the composition consists of
two figures at a spring – Jeannie listens with a modest and retiring air to the
confession of her lover, who is not less timid than herself. The picture is
brilliant, well drawn, and judiciously treated; at least it seems to have all
those qualities, for it is placed high, and is assuredly worthy of a better
position'. The 1872 article on Brooks in the *Art Journal* paraphrased those
comments, adding that the picture 'might have been called "The Dawn of
Love", for it shows Burns's "Jeannie" with her lover . . .'. Brooks exhibited
several Burns subjects in the 1840s.

*The Dawn of Love*   FA241

E_XH_:   RA 1846 (627)

E_NGR_:   1 June 1847, published by Henry Meeson, Hanover Galleries,
George Street, Hanover Square, London W1

L_IT_:   *Art Union* 1846, p184; *Art Journal* 1872, p197

11

## BUCHANAN, George F (exhibiting 1848–1865)

Exhibited 27 works at the RA between 1848 and 1864, 17 at the BI 1850–63, and eight at the SBA 1851–65. All were submitted from London addresses, and almost all were exclusively Scottish scenes. In 1865 a Mrs G F Buchanan exhibited a Scottish landscape at the RA.

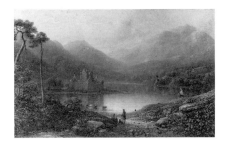

**Kilchurn Castle, Loch Awe**
1021-1886
Canvas, 79.1 × 129.5 cm (31⅛ × 51 ins)
Signed and dated 'G F Buchanan 1854' bl
Dixon Bequest 1886

The 15th-century castle, now ruined, stands on a peninsula on Loch Awe, near Dalmally, Argyllshire; Ben Cruachan is seen on the right. Another view of the same scene, a watercolour by Caleb Robert Stanley (c1795–1868) is also in the V&A collections (1586–1871).

*Kilchurn Castle, Loch Awe*    1021-1886

## BUCKNER, Richard (1812–1883)

Born Woolwich, London, 25 October 1812, son of an army officer, member of a distinguished Chichester family. After a short time in the army, he studied painting in Rome with the painter of miniatures, portraits and copies of old masters G B Canevari. First painted miniatures, but soon specialised in portraits, particularly of ladies of fashion (winning great reputation and patronage), ballet dancers, and also Italian subjects. Exhibited 77 portraits at the RA between 1842 and 1877, 32 Italian subjects at the BI 1850–65, 44 works (nearly all portraits) at the SBA 1840–76/7, and three paintings at the Grosvenor Gallery 1879; also exhibited in Rome. Lived at Cleveland Row, St James's, from 1847 till his death 12 August 1883. A sale of his collections, including his own works, was at Christie's 22–26 February 1873. Maas describes him as 'one of the best and most typical' painters of his kind.

LIT:   *Vanity Fair* 1 September 1883, p119 (obit); J Maas *Victorian Painters* 1969, pp212–3; B Stewart and M Cutten *Chichester Artists 1530–1900* Canterbury 1987, pp3–6 (with full bibliography and portrait photograph); B Stewart and M Cutten 'The Forgotten Genius of Richard Buckner' *Antique Collector* April 1989, pp34–41

*Portrait of a Boy*    P29-1962

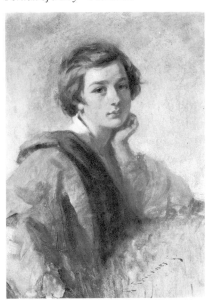

**Portrait of a Boy**
P29-1962    Neg HB2557
Canvas, 43.2 × 28 cm (17 × 11 ins)
Signed 'R Buckner f' diagonally br
Claude D Rotch Bequest 1862

**Portrait of a Boy Chorister of the Chapel Royal**
P30-1962    Neg HF955
Panel, 45.1 × 29.2 cm (17¾ × 11½ ins)
Signed 'R Buckner f' diagonally br
Claude D Rotch Bequest 1962

Possibly the 'Portrait of Master Wood, of Her Majesty's Chapel Royal, St James's exhibited at the SBA in 1874. Unlike most of the exhibits, no price for this is given in the catalogue; presumably the work was painted on commission. Brian Stewart provides the information that Buckner's account books list under 19 November 1873 'Portrait of Wood (posthumous) £210';

this was a high price for a portrait, and the present work seems likely to be a sketch for the finished and exhibited picture. Another entry in Buckner's account books concerns the Wood family: 16 April 1875 lists Mrs Wood of 25 Baker Street for £130. The directories for that address around 1870 have John Henry Wood, glass manufacturer to the Queen, presumably Master Wood's father; he died in 1875.

When acquired, the portrait bore the title 'A Boy Chorister of the Chapel Royal, Windsor'; this is incorrect, as the Chapel Royal is opposite St James's Palace. The choristers, always 12 in number, began wearing the distinctive frogged scarlet frock coat and breeches in the early 18th century, and continue to do so today. The artist had his studio in Cleveland Row, opposite St James's Palace.

EXH: ?SBA 1874 (202); *19th Century English Art* New Metropole Arts Centre, Folkestone, 1965 (44)

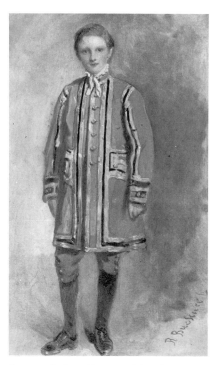

*Portrait of a Boy Chorister of the Chapel Royal*   P30-1962

# BURCHETT, Richard (1815–1875)

Born Brighton, Sussex, 30 January 1815; studied art at Birkbeck Mechanics Institute in Chancery Lane, London. In about 1841, he joined the Government School of Design at Somerset House, becoming an Assistant Master 1845. In 1851, after the School's move to South Kensington, he was appointed Headmaster of the Department of Practical Art for training art teachers. Exhibited five works at the RA between 1847 and 1873, and one at the BI in 1855. Worked on the decorations of the Palace of Westminster 1855–9, the dome of the 1862 Great Exhibition building, and painted a window for Greenwich Hospital. Primarily a teacher and administrator; Reynolds sees him as having led 'in a minor key the same sort of career as that of Redgrave'. Published *Practical Geometry* (1855), and *Linear Perspective* (1856). Converted to Roman Catholicism in about 1855, in which year he was living with the painter James Collinson. Died on a visit to Dublin, 27 May 1875. There is a portrait bust and tablet to his memory, erected by his pupils, in the Royal College of Art; his portrait also appears in Val Prinsep's painting 'Distribution of Art Prizes', in the centre next to Lord Leighton.

LIT: *Athenaeum* 5 June 1875, p758 (obit); *Art Journal* 1875, pp232 (obit), 254; *Graphic* 26 June 1875, pp606 (obit), 621 (engr portrait); W B Scott *Autobiographical Notes* 1892, II, pp272–5; G Reynolds *Victorian Painting* 1966, pp152–3; A Staley *The Pre-Raphaelite Landscape* 1973, p80; C Frayling *The Royal College of Art: One hundred and fifty years of art and design* 1987, p25 etc

**View Across Sandown Bay, Isle of Wight**
9108-1863   Neg S683, CT13228
Canvas, 34.3 × 57.2 cm (13½ × 22½ ins)
Purchased 1863

Presumably purchased from the artist. The view is from above Shanklin Down, behind the church of St Blasius, looking across Sandown Bay to Culver Cliff. On the down above the cliff, the memorial obelisk to the Earl of Yarborough is visible.

The evident influence of Pre-Raphaelite painting, and the style of the women's costume, suggest a date in the 1850s. Grigson connects the picture with those of almost the same view, in watercolour, by Burchett's ex-teacher and colleague at South Kensington William Dyce (c1855, private collection) and in oil by James Collinson, with whom Burchett lived in 1855 ('Mother and Child' c1855, Yale Center for British Art, New Haven, USA). He suggests that the three artists may have made a visit together to the Isle of Wight.

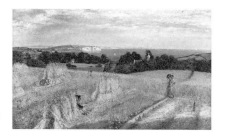

*View Across Sandown Bay, Isle of Wight*   9108-1863

The work is, as Staley comments, the artist's 'one memorable landscape'; Staley finds the treatment of detail 'daintily precise', but the whole lacking Pre-Raphaelite brilliance and vibrancy.

Exh: *Victorian Paintings* Art Council 1962 (4)

Lit: *Staley* p60; G Grigson *Britain Observed* 1975, pp134, 136, 137 (repr).

### William Torrel
873-1868
Canvas, arched top, 111.8 × 43.2 cm (44 × 17 ins)
Purchased ? 1868

Presumably a first design for 1762–1869 'William Torrel', (below), but see also 1141–1868 (below).

### William Torrel
1141-1868
Canvas, 249.6 × 87.6 cm (98¼ × 34½ ins)
Purchased ? 1868

An alternative design for 'William Torrel', (1762–1862 above).

### William Torrel
1762-1869
Canvas, 265.4 × 87.6 cm (104½ × 34½ ins)
Inscribed 'R Burchett' on gold background at r
Purchased 1869

The details of the history and circumstances of the commission, have been discussed by J Physick (*The Victoria and Albert Museum: the history of its building* 1982). The design was executed in English ceramic mosaic by W B Simpson and Sons, and was finished in 1869. Burchett also designed the 'William of Wykeham' panel (see P15–1934).

William Torrel (or Torel) was a sculptor and goldsmith working 1291–1303. His most famous works are the monuments in Westminster Abbey to Henry III, Edward I and Eleanor of Castile. In the first design, Burchett shows the Eleanor monument and one of the famous Eleanor crosses; Torrel's features are evidently painted from a contemporary model. The final design omits the cross, and generalises the image of the sculptor.

### William of Wykeham
P15-1934
Canvas, 265.5 × 89.5 cm (104½ × 35¼ ins)
Transferred to the Department 1934

For details of the history and circumstances of the commission see 1762–1869 above.

The design was executed in Italian mosaic by Salviati, whose fee was £180, and completed in 1867.

William of Wykeham (1324–1404), Bishop of Winchester and Chancellor of England, was the founder of Winchester College and New College, Oxford, and patron of the rebuilding of the nave of Winchester Cathedral. Work in transforming the Norman nave at Winchester was undertaken by the master mason William Wynford, but Burchett presents Wykeham as the 'architect' in the widest sense of the word. Wykeham is one of three architects in this series of great artists: the others being Inigo Jones and Sir Christopher Wren. Wykeham is presumably the representative of medieval art, as manifested in the masterpiece of Winchester Cathedral.

Wykeham is represented by Burchett in the traditional way of a bishop-saint, holding a model of his cathedral (see for example Crivelli's altarpiece panel of St Jerome, V&A 765–1865). The likeness of Wykeham is

*William Torrel*   873-1868

probably taken from the effigy on his tomb in Winchester Cathedral.

LIT: J Physick *The Victoria and Albert Museum: the history of its building 1982*, p65

# BURGESS, John Bagnold, RA (1830–1897)

Born Chelsea, London, 21 October 1830 of a family of artists: his great-grandfather was the art teacher Thomas Burgess, his grandfather the portrait painter William Burgess, and his father the landscapist Henry W Burgess. Studied at J M Leigh's art school from 1848, and entered RA Schools 1851 where he won a medal for life drawing. Exhibited 73 works at the RA between 1850 and 1896 (elected ARA 1877, RA 1888), 15 at the BI 1853–65, and four at the SBA 1851–9. His subjects were various, but most famously Spanish: he is supposed to have visited Spain (often with Edwin Long RA) annually for 30 years from 1858; the *Magazine of Art* commented that he favoured the 'rough, rugged, dirty, sheepskin-clad, parched-up peasantry, gipsies and *contrabandistas* of the Sierra Morena, with the surroundings of the low *venta* and *posada*', offering an obvious comparison with John 'Spanish' Phillip RA. Died 12 November 1897; his studio sale was at Christie's 25 March 1898.

LIT: *Illustrated London News* 14 July 1877, p37 (with engr portrait); *Art Journal* 1880, pp297–300; *Magazine of Art* 1882, pp133–7; *Illustrated London News* 20 November 1897, p719 (obit with engr portrait); J Chapel *Victorian Taste* 1982, pp70–1

**Portrait of George Gammon Adams**
P44-1982
Millboard, 37.8 × 30.5 cm (14⅞ × 12 ins)
Given by Miss I D Adams 1982

Possibly the painting exhibited at the RA in 1857 (1119) with the title 'George G Adams, Esq, Sculptor'. A manuscript label on the back, similar to that on the portrait of Adams, P43–1982, states that the sitter is aged 40, dating the painting to around 1861; however, this information – probably written by the donor – may well be inaccurate. For fuller details about the sitter, see the entry on the portrait by J J Adams (P43-1982, p1).

# BUSS, Robert William (1804–1875)

Born London August 1804, the son of William C Buss, an engraver and enameller in Cripplegate, with whom he served an apprenticeship of about six years. Studied next under George Clint ARA, specialising in theatrical portraiture. Fifteen of his works were engraved for publication in Cumberland's *British Drama* and exhibited later at the Colosseum in Regent's Park. Exhibited mainly humorous genre, literary and theatrical subjects (many of which were engraved); 25 at the RA between 1826 and 1855, 20 at the BI 1830–50, and 45 at the SBA 1827–59. Also exhibited five works in the competitions for the decoration of the new Palace of Westminster 1844 and 1845. His best known picture is 'Christmas in the Time of Queen Elizabeth' (exhibited SBA 1838); he also painted, probably about 1845, two large frescos at Wimpole Hall. He was equally well known for his book illustrations, beginning with his brief employment in 1836 on *Pickwick*

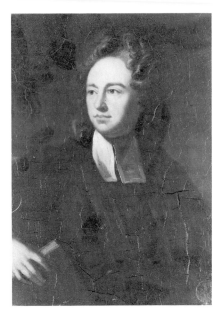

*Richard Bentley*  D39

*Papers.* He gave and published lectures in London and the provinces, edited *The Fine Art Almanac* (1850–2), and his *English Graphic Satire*, which he also illustrated, and which was privately printed 1874. Died Camden Town, London, 26 February 1875. His wife and daughter founded 1850 the North London Collegiate School for Ladies, where Buss also taught.

LIT: *Athenaeum* 16 March 1875, p366 (obit); *Art Journal* 1875, pp178–9 (obit); G Everitt *English Caricaturists and Graphic Humourists of the Nineteenth Century* 1886, pp363–6; F G Kitton *Dickens and his Illustrators* 1899, pp47–57; G S Layard 'Our Graphic Humourists: Robert William Buss', *Magazine of Art* XXVI, 1902, pp361–4

**Richard Bentley**
D39   Neg HB2561
Canvas, 24.1 × 19.1 cm (9½ × 7½ ins)
Dyce Bequest 1869

A small copy of Sir James Thornhill's portrait of 1710 at Trinity College, Cambridge. Richard Bentley (1662–1742), scholar and critic, was Master of Trinity College. There are several copies and derivations from Thornhill's 1710 portrait; an early copy is in the NPG.

In Alexander Dyce's library, bequeathed like this painting to the museum, were many books by Bentley and items of Bentleiana. Dyce may well have commissioned this copy from Buss.

LIT: A T Bartholomew *Richard Bentley DD, A Bibliography* 1908; D Piper *Catalogue of Seventeenth-century Portraits in the National Portrait Gallery 1625–1714* 1963, p26

*John Jackson the Wood-Engraver at Work*  E3100-1931

**John Jackson the Wood-Engraver at Work (attributed to R W Buss)**
E3100-1931   Neg L1319
Panel, 31.1 × 36.2 cm (12¼ × 14¼ ins)
Purchased 1931

John Jackson (1801–1848) was one of the earliest wood-engravers to illustrate popular books and magazines and he published a *Treatise on Wood-Engraving* in 1839. It was Jackson who suggested Buss to the publishers Chapman and Hall as the successor to Robert Seymour as illustrator of Charles Dickens's *Pickwick Papers* in 1936. Jackson also engraved on wood a design by Buss for Dickens's 'A Little Talk about Spring and the Sweeps', published in *The Library of Fiction* (1836); when the story was reprinted in *Sketches by Boz* in 1839 as 'The First of May', Buss's illustration was replaced by an etching by George Cruikshank.

The authorship and subject of this painting remain uncertain; the odd and carefully delineated perspective may be compared with that of Buss's late and unfinished picture of Dickens at work (present whereabouts unknown; repr in Kitton facing p52). It is interesting to note that the engraver is working at night, and the painting includes an engraver's light and globe.

## BUTLER, ? Richard Butler (exhibiting 1859–1886)

This artist is probably Richard Butler, who lived at Sevenoaks, Kent, and exhibited 33 landscapes at the RA between 1859 and 1886. The titles of his works indicate that he specialised in woodland scenes, particularly in the parks of Knole and Eridge.

**Landscape with Woodcutters**
1032-1886
Canvas, 39.4 × 59.7 cm (15½ × 23½ ins)
Dixon Bequest 1886

---

# CALLCOTT, Sir Augustus Wall, RA (1779–1844)

Born Kensington Gravel Pits, London, 20 February 1779, son of a builder.
First studied music in the Westminster Abbey choir, then painting with John
Hoppner RA; entered RA Schools 1797. Exhibited 129 works at the RA
between 1799 and 1844, and 14 at the BI 1806–38. A few early exhibits were
portraits, but he soon achieved success with picturesque landscapes
influenced by Gainsborough and 17th-century Dutch painting. From about
1815 exhibited principally coastal and marine subjects; his work was
compared to that of Aelbert Cuyp and, especially, Turner, with whom he
had a close association. Also painted classical landscapes in the manner of
Claude, and a variety of genre, humorous, literary and historical subjects.
Travelled abroad, notably in 1827–8 following his marriage to Maria
Graham, a writer of art and travel books and most famous for *Little Arthur's
History of England* (1835). Elected ARA 1806, RA 1810, knighted 1837.
Served on committees for the Government Schools of Design and the
National Gallery, and was appointed Surveyor of the Queen's Pictures 1843.
Died Kensington 25 November 1844; his studio sales of drawings and
watercolours were at Christie's 8–12 May 1845 and 22 June 1863. Although
in his lifetime his work commanded high prices and attracted the leading
patrons of the day, it was not always well received by the critics, particularly
in later years; Ruskin wrote that 'he painted everything tolerably, and
nothing excellently'.

LIT:   *Athenaeum* 17 December 1831, pp817–8, 30 November 1844, pp1097–
8 (obit); *Art Union* 1845, p15 (obit); *Art Journal* 1856, p9, 1866, p99,
1896, p334; J Dafforne *Pictures of Sir A W Callcott . . .* nd [1875]
(referred to below as Dafforne); *Portfolio* 1875, p161; D B Brown
*Augustus Wall Callcott* Tate Gallery exhibition catalogue 1981 (with
full bibliography and list of archival sources) (referred to below as
Brown)

**Italian Landscape, with Cows Watering**
FA8   Negs HF3978, HF4867
Millboard, 18.5 × 22.3 cm (7¼ × 8¾ ins)
Sheepshanks Gift 1857

The work has not been identified with any of the artist's exhibited paintings.
A 'Landscape, Cows Watering' is recorded by Redford (*Sales*) as being sold in
1847 by Callcott, bought Rought £189.

ENGR:   T C Dibdin *Sir Augustus Wall Callcott's Italian and English
Landscapes. Lithographed by T C Dibdin* 1847.

**A Brisk Gale – A Dutch East-Indiaman Landing Passengers**
FA9   Neg 59315
Canvas, 66.7 × 104.1 cm (26¼ × 41 ins)
Sheepshanks Gift 1857

Exhibited with the above title at the RA in 1830. The *Gentleman's Magazine*
found 'the distant sea view . . . charmingly given, and the fore-part of the
picture presents all the reality of a sandy beach covered with muddied water'.
Dafforne describes the action: 'At the entrance of a port or harbour, the two

*Italian Landscape, with Cows
Watering*   FA8

*A Brisk Gale – A Dutch East-Indiaman
Landing Passengers*   FA9

extremities of which are in the foreground of the composition; some small Dutch-built vessels are making for the shelter: these are on the left of the picture; on the right lies the Indiaman broadside to the spectator. The ship is of enormous length, and low down in the water, as if heavily laden with merchandise from the Dutch settlements in the East; a small sailing-boat with passengers has, apparently, just left her; a row-boat has reached the end of one pier and the boatmen are landing a single passenger with his luggage. There is effective play of cloud and sunshine in the sky, nicely reflected as light and shade on the water'.

The painting, and particularly the low viewpoint, is reminiscent of the work of J M W Turner 1800–10, such as his 'Calais Pier' of 1803 (NG).

EXH: RA 1830 (172)

LIT: *Gentleman's Magazine* 100, part 1, 1830, p446; *Dafforne* p49

REPR: T C Dibdin *Sir Augustus Wall Callcott's Italian and English Landscapes. Lithographed by T C Dibdin* 1847, plX; *Sheepshanks Gallery* 1870

## Slender and Anne Page

FA10   Neg 31842
Panel, 50.8 × 71.1 cm (20 × 28 ins)
Sheepshanks Gift 1857

*Slender and Anne Page*   FA10

The subject is taken from Shakespeare's *The Merry Wives of Windsor* act 1 scene 1:

| | |
|---|---|
| *Anne:* | Will't please your worship to come in, Sir? |
| *Slender:* | No, I thank you, forsooth, heartily; I am very well. |
| *Anne:* | The dinner attends you, Sir. |
| *Slender:* | I am not a-hungry, I thank you, forsooth. Go, sirrah, for all you are my man; go wait upon my cousin Shallow. |

There seem to be two other versions of the subject. 'Scene from the Merry Wives of Windsor' was exhibited at the BI in 1834 (236), most of the above quotation given in the catalogue and the size recorded as '15 by 18 inches'; a still smaller version is in the Royal Shakespeare Company collection at Stratford-upon-Avon.

After the artist's marriage to Maria Graham in 1827, he painted several scenes with literary and theatrical subjects. For another scene by Callcott from *The Merry Wives of Windsor*, for example, see 'Falstaff and Simple', FA10. The Buxton Museum and Art Gallery exhibition catalogue comments on the popularity of Slender's inept courtship of Mistress Page as a subject for painters; in addition to Bonington's well-known depiction (c1815, Wallace Collection) several pictures were exhibited at the RA in the 19th century, including those by H P Briggs (1821), H Milling (1832), S Drummond (1834), T Duncan (1836), J C Horsley (1852), W P Frith (1854), H S Marks (1855), and C W Cope (1875 and 1882). There is also a painting by Robert Smirke in the Royal Shakespeare Company collection. C R Leslie exhibited a version of the subject at the BI in 1819, and invented a new scene to paint in which Slender accepts Anne Page's invitation and sits down to dinner with the whole cast of the play; this new scene was exhibited in two versions, at the RA in 1831 and 1838, and the latter is also in the V&A collections (see FA110, p158).

Dafforne's suggestion that 'Callcott evidently designed this composition with a view to the theatrical representation, for at each side are stage-hangings' does not seem likely to be true.

Two sketches, one for Slender and the other for Anne Page, were lots 113 and 114 in C J Palmer's sale at Christie's 16 May 1868, bought Dott £2 2s and Graves £9 10s respectively.

EXH: *Shakespeare's Heroines in the Nineteenth Century* Buxton Museum and Art Gallery 1980 (2)

ENGR:    Frederick Bacon, for *Finden's Royal Gallery of British Art* 1838 (three
         states in V&A collections)

LIT:     *Dafforne* p23; G Ashton *Shakespeare's Heroines in the Nineteenth
         Century* Buxton Museum and Art Gallery exhibition catalogue 1980,
         p8, repr p9

REPR:    *The Sheepshanks Gallery* 1870, pl 10; *Abridged Catalogue of Oil
         Paintings* 1908, pl V; *The Studio* spring special number 1916
         ('Shakespeare in Pictorial Art') pl 87 colour

## Dort (Dordrecht)
FA11    Neg GK5682
Panel, 31.7 × 76.2 cm (12½ × 30 ins)
Signed and dated 'A W Callcott 1841' br
Sheepshanks Gift 1857

Dort (Dordrecht)    FA11

Exhibited at the RA in 1842, and acquired by John Sheepshanks before
1847, when a lithograph was published by Dibdin (see *Engr.* below). Brown
comments that the painting must have appealed particularly to Sheepshanks,
who collected Dutch 17th-century prints, and that it is 'a cabinet picture
designed to appeal to a specific "old master" taste'.
    The *Art Union* critic wrote:

> Surely this is beating Albert Cuyp on his own ground; there is the same
> spire and other lofty objects in the distance; and – not the same cows,
> but their descendants fully as well-favoured as they – which Cuyp has
> painted twenty times in an atmosphere not so palpable as in this
> picture, which is in short a Callcott with figures, every whit as Dutch as
> even Cuyp made his, and without any balancing between Dutch nature
> and human nature.

Cuyp was born and worked in Dort (Dordrecht), in the south-west
Netherlands, and painted views of the town several times. The present
painting may be compared with 'A Distant View of Dordrecht' (the so-called
'Small Dort'), which was shown in an old master exhibition at the BI in 1818
(81), bought by Wynn Ellis in about 1840, and bequeathed by him to the NG
in 1876. Other recorded paintings of Dort by Callcott include 'A Distant
View of Dort, a group of figures and horses, in the front ground, on the bank
of the river', signed and dated 1830, painted for General Phipps and sold at
Christie's 25 June 1859 (94), bought Ford for £283 10s.
    Brown comments that 1842 was 'a year when Callcott summarised his
lifetime's achievements in landscape'.

EXH:     RA 1842 (262); *Augustus Wall Callcott* Tate Gallery 1981 (23)

ENGR:    T C Dibdin *Sir Augustus Wall Callcott's Italian and English Landscapes.*
         *Lithographed by T C Dibdin* 1847, pl III

Falstaff and Simple    FA12

LIT:     *Art Union* 1942, p124; pp49–50; *Brown* p89

## Falstaff and Simple
FA12    Neg V1936
Paper on canvas, 45.1 × 37.5 cm (17¾ × 14¾ ins)
Sheepshanks Gift 1857

Exhibited at the BI in 1835, and listed in the printed handlist of the
Sheepshanks collection of about 1850. The size is given in the BI catalogue at
'26 by 24 inches', including the frame.
    The title of the work in the BI catalogue is also recorded on a label on
the backboard in the artist's hand:

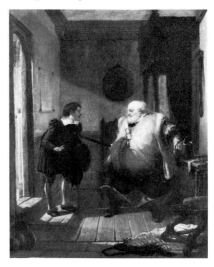

> No 1/Falstaff when escaping from Ford's house/in the disguise of the
> Old Woman of Brainford [Brentford]/is followed by Simple to know if
> Slender/is to have Ann Page or no./Falstaff. It is his fortune to have

her/or no. Go say the woman told/me so. Simple. May I be so bold as say so sit?/A W Callcott.

The subject is from Shakespeare's *The Merry Wives of Windsor* act 4 scene 5. For another subject from the same play painted by Callcott see 'Slender and Anne Page' (FA10 p18).

EXH: BI 1835 (252); *Victorian Narrative Painting*, V&A circulating exhibition 1961

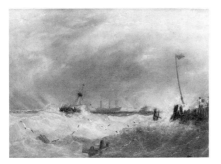
*A Sea Port – Gale Rising*   FA13

## A Sea Port – Gale Rising

FA13   Neg HF3979
Canvas, 30.5 × 40.6 cm (12 × 16 ins)
Sheepshanks Gift 1857

As Dafforne noted, 'There is nothing in the painter's exhibited works which affords an index to its date'. It was acquired by Sheepshanks before 1847, when Dibdin's lithograph was published.

ENGR: T C Dibdin *Sir Augustus Wall Callcott's Italian and English Landscapes. Lithographed by T C Dibdin* 1847, pl XV, as 'Ships in a Stormy Sea'.

LIT: *Dafforne p39*

*An Inn Door Near Gravesend*   FA14

## An Inn Door Near Gravesend

FA14   Neg GK5683
Millboard, 11.5 × 29.9 cm (4½ × 11¾ ins)
Sheepshanks Gift 1857

Identified by Brown as one of the '3 small sketches painted of various subjects at Gravesend purchased by John Sheepshanks Esqr.' listed in the artist's manuscript catalogue sometimes in the 1830s, and dated to the years 1830–5. It was certainly in Sheepshanks's collection by 1847, when Dibdin's lithograph was published.

Brown comments that 'despite the precise topographical origin, it is characteristic of Callcott's later cabinet pictures in avoiding any contemporary features and rather evoking the Dutch seventeenth century'. Dafforne doubted it was an English subject, the figures suggesting to him a Dutch scene; however, Gravesend was already associated with the title in the entry for the picture in the 1857 *MS Register*, and the landscape accords with that of Gravesend, a port in Kent on the River Thames.

EXH: *Augustus Wall Callcott* Tate Gallery 1981 (21)

ENGR: T C Dibdin *Sir Augustus Wall Callcott's Italian and English Landscapes. Lithographed by T C Dibdin* 1847, pl IX, as 'Inn Door on the Roadside'

LIT: *Dafforne p37; Brown p87*

*A Sunny Morning*   FA15

*Coast Scene with Shrimper*   FA16

## A Sunny Morning

FA15   Neg 55142
Canvas, 68.6 × 90.9 cm (27 × 35¾ ins)
Sheepshanks Gift 1857

Acquired by John Sheepshanks before 1847, when Dibdin's lithograph was published. In previous V&A catalogues it is wrongly stated to have been exhibited at the RA in 1813, a year in which Callcott did not exhibit. It is probably the painting exhibited at the RA in 1811 with the title 'Morning' (but see *Exh:* below). As Brown has pointed out, it reproduces almost exactly but in reverse J M W Turner's 'Union of the Thames and Isis' (exhibited at Turner's Gallery 1808, now Tate Gallery). Brown comments that 'Callcott was in fact far from an uncritical or passive copyist of his friend's work; both artists were prepared to learn or borrow from each other . . .'

It may also be the painting mentioned by Joseph Farington in his *Diary* on 4 July 1809 (presumably 'The Watering Place', exhibited as (6) at the RA that year): 'His large picture "A Morning Scene" had no strength of colour, – no freshness, – foggy – weak – a crowd of cattle ill-suited to it. – He had done some coast scenes, imitating Turner, pretty well; He now does not look at nature'.

EXH:    ?RA 1811 (367 or 459, both titled 'Morning', or possibly 277, 'Cattle at the Watering-place') or RA 1809 (6, 'The Watering Place')

ENGR:   T C Dibdin *Sir Augustus Wall Callcott's Italian and English Landscapes. Lithographed by T C Dibdin 1847, pl VII*

LIT:    *Dafforne* p37; *Brown* p30

REPR:   M H Grant *Old English Landscape Painters* 1925, pl 148

*Landscape – A Wood and Cattle under a Stormy Sky    1422-1869*

**Coast Scene with Shrimper**
FA16    Neg HF3980
Canvas, 25.4 × 36.9 cm (10 × 14½ ins)
Sheepshanks Gift 1857

**Landscape – A Wood and Cattle Under a Stormy Sky**
1422-1869    Neg HF136
Panel, 23.8 × 31.7 cm (9⅜ × 12½ ins)
Townshend Bequest 1869

**Classical Landscape**
1848-1900    Neg HJ791
Canvas, 146.1 × 149.9 cm (57½ × 59 ins)
Signed and dated 'A W Callcott/1817' (or '1811') br
Ashbee Bequest 1900

Possibly the 'Grand Classical Landscape, with buildings and figures near a river' sold at Christie's 30 May 1868 (138), bought Cox for £593 5s; according to Redford (*Sales*) the sale was of the collection of P Doyle. Redford (*Sales*) also records a 'Grand Classical Landscape' sold in 1830 and bought Rought for £472 10s.

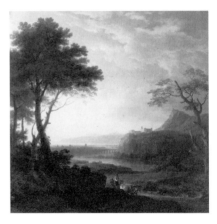

*Classical Landscape    1848-1900*

# CARPENTER, Margaret Sarah, née Geddes (1793–1872)

Second daughter of Captain Alexander Geddes, born 1793 in Salisbury where she studied art with a drawing master and by copying from the collection of Lord Radnor at Longford Castle. Sent three works to the Society of Arts and won a gold medal for a study of a boy's head. Practised as a portrait painter from 1812. Moved to London 1814, and in 1817 married William Hookham Carpenter (1792–1866) bookseller, publisher, artist, and from 1845 Keeper of Prints and Drawings at the British Museum. She seems to have had some connection with Sir Thomas Lawrence; she finished one of his portraits after his death in 1830 ('Mrs Brandling', exhibited SBA 1832, 164), and at least one of her portraits has been attributed to him ('Major-General John Fremantle', exhibited 'The Portrait Surveyed', Agnew's 1980, 17). She exhibited 147 portraits at the RA between 1818 and 1866 (nine as Miss Geddes 1814–17), 50 works at the BI 1819–53 (11 as Miss Geddes 1814–17) – mostly 'fancy' pictures, and 19 at the SBA 1831–6. Several of her works were engraved. Died London 13 November 1872. Her sister married William Collins RA, and two of her children, William and Henrietta Carpenter, were also painters. There may also be a family connection with

*Devotion*  FA17

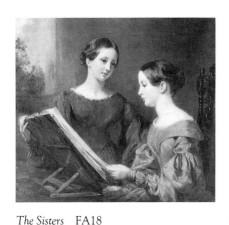

*The Sisters*  FA18

*Ockham Church, Surrey*  FA19

Andrew Geddes ARA. Three of her portraits are in the NPG; two watercolours are in the V&A collections. Clayton believed her 'one of the most distinguished portrait painters in England', and her husband's obituarist wrote that she 'would certainly have been a Royal Academician but for her sex' (*Gentleman's Magazine* September 1866, p410).

LIT:  *Art Journal* 1873, p6 (obit); E C Clayton *English Female Artists* 2 vols, 1876, I, pp386–8; *List of Pictures and Drawings by Margaret Carpenter from the year 1812 to 1864 with the prices paid for them*, MS transcript made 1899 for NPG (referred to below as *List*); C Yeldham *Women Artists in Nineteenth-Century France and England* 1984, I, pp254–7; P Gerrish Nunn *Victorian Women Artists* 1987, p36 etc

### Devotion
FA17  Neg 69489
Canvas, 76.2 × 63.5 cm (30 × 25 ins)
Signed and dated 'Margaret Carpenter/1821' br
Sheepshanks Gift 1857

Exhibited at the BI in 1822, the size given in the catalogue as '42 by 37 inches', and at the loan exhibition there in 1825 lent by the then owner John Wilton. The *List* records a Mr Wilton paying £31 10s. in 1822 for 'Cheerfulness' (presumably the painting of that title exhibited at the BI in 1823, 186); in 1823 'Devotion' appears alongside the name of the Marquis of Stafford, but should presumably refer to the same immediately above in the list – Mr Wilton, who paid £36 15s.

The figure, traditionally called St Francis, seems to be drawn from a model, who was identified in the *Art Journal* obituary as the miniature painter Anthony Stewart (1773–1846). It may be compared with the 1812 portrait of him by Andrew Geddes (SNPG), which was probably lot 54 in the W H Carpenter sale at Christie's 16 February 1867, and with his miniature self-portrait in the V&A (P2–1967). The composition may be based on an old master painting, perhaps in the Radnor collection where the artist made copies in early life. A replica or copy measuring 73.6 × 61 cm (29 × 24 ins) was lot 158 at Christie's 12 June 1959.

PROV:  Bought from the artist by Mr Wilton 1823; ?John Wilton sale, Phillips, 16 May 1835; given by John Sheepshanks 1857

EXH:  BI 1822 (199), 1825 (29)

### The Sisters
FA18  Neg GA1190
Panel, 30.5 × 35.6 cm (12 × 14 ins)
Signed and dated 'Margaret Carpenter/Dec' [?Del'] 1839' bl
Sheepshanks Gift 1857

Presumably the painting exhibited at the BI in 1840, the size given in the catalogue as '18 by 21 inches', (including frame). The *List* records a payment of £42 by Sheepshanks in 1842 for 'Henrietta and Jane', and 'The Sisters' has traditionally been identified as a portrait of the artist's daughters. In W H Carpenter's posthumous sale at Christie's 16 February 1867, lot 92 was 'The Sisters – a circle – lifesize'; this picture is recorded in the *List* number 1866 and identified as the Misses Brandling.

EXH:  BI 1840 (9)

LIT:  *Gerrish Nunn* pp36, 69, repr fig 9

### Ockham Church, Surrey
FA19  Neg HF3974
Panel, 25.4 × 20.3 cm (10 × 8 ins)
Sheepshanks Gift 1857

This sketch showing the 13th-century tower of Ockham Church among trees is somewhat reminiscent of Constable's work, a few of which were owned by the artist's husband. No payment by Sheepshanks to the artist for this painting is recorded in the *List*.

### An Old Woman Spinning
512-1870   Neg HF4812
Canvas, 76.2 × 66.1 cm (30 × 26 ins)
Parsons Bequest 1870

Presumably the painting 'An Old Woman Spinning Silk' exhibited at the BI in 1816, the size given in the catalogue as '40 by 37 inches'. The *List* records a payment of £10 10s by Mr Parsons in 1817. Another picture, 'Old Woman Spinning', is listed under 1866 as sold for £2 12s 6d after the artist's husband's death; it was lot 86 in his posthumous sale at Christie's 16 February 1876, sold to Brown for £2 12s 6d.

PROV:   Bought from the artist by Parsons 1817; bequeathed by John Meeson Parsons 1870

EXH:   BI 1816 (21); *British Art Fifty Years Ago* Whitechapel Art Gallery 1905 (34)

### Portrait of a Young Child
P32-1962
Canvas, 45.4 × 45.1 cm (17⅞ × 17¾ ins)
C D Rotch Bequest 1962

### Portrait of ?Alexander Boyd
P33-1962
Panel, 25.4 × 18.2 cm (10 × 7⅛ ins)
C D Rotch Bequest 1962

The identity of the sitter is uncertain. The background is a view of Eton College; the artist painted several Eton 'leaving' portraits, some of which are still at Eton (see L Cust *Eton College Portraits* 1910, pl XL). The *List* records two payments, of £63 and £20, by a Mr Boyde in 1845; another of £15 15s marked '(Eton)' alongside, by a Mr Cotron in 1832.

*An Old Woman Spinning*   512-1870

*Portrait of a Young Child*   P32-1962

# CHALON, Henry Bernard (or Barnard) (1770–1849)

Born 1770, son of a Dutch engraver and musician; there seems to be no relation with the landscape painter J J Chalon and his brother the portrait painter A E Chalon. Entered RA Schools, and exhibited there 199 works between 1792 and 1847, 28 at the BI 1807–49, and 21 at the SBA 1827–47. Mainly portraits of horses and dogs, influenced by George Stubbs in colouring, composition and interest in animal anatomy. Appointed Animal Painter to, successively, the Duchess of York, the Prince Regent, and William IV. According to Joseph Farington's *Diary*, was candidate for ARA 1811. Many of his works were published in mezzotint; published *Studies from Nature*, dealing with equine muscular systems with anatomical tables, *Passions of the Horse*, illustrated with lithographs 1837, and *Drawing Book of Animals and Birds of Every Description*, a primer in the art of soft-ground etching. After a severe accident in 1845 (an appeal for money was made in the *Art Journal* 1845, pp265, 285), he died 15 August 1849. Married sister of James Ward RA; their daughter Maria was a miniature painter.

LIT:   J C Wood *A Dictionary of British Animal Painters* Leigh-on-Sea 1973

*Portrait of ?Alexander Boyd*   P33-1962

*The English Blood-Horse 'Fidget'*
1127-1898

## The English Blood-Horse 'Fidget'

1127-1898   Neg HH3822
Canvas, 133.4 × 191.8 cm (52½ × 75½ ins)
Given by Surgeon-General Sir James Mouat Bt, VC, KCB 1898

According to the Departmental files, the subject of this picture was bred in Yorkshire, bought by the donor's father Colonel Sir James Mouat Bt for 1000 guineas, and taken to India where the horse created a great sensation – the Nawab of Bengal was so struck by the beauty of the animal that he paid £10,000 for it. Chalon exhibited a portrait of the horse on two occasions: 'Fidget, a Famous Blood-horse, the Property of Major J Mouat' at the RA in 1811, and 'Portrait of a Famous Blood-horse, the Property of Colonel Sir James Mouat, Bart' at the RA in 1827. The two exhibits may well have been the same picture; on the other hand, it was not unusual for a great horse to be painted twice in its lifetime, first in its young prime as a three year old and then as a magnificent stud. But apart from the confusion over the two Chalon exhibits, the identity of the present 'Fidget' is far from clear.

The famous 'Fidget' was a bay bred by Richard 'Jockey' Vernon in 1783 and bought by the 3rd Duke of Bedford. He won the Jockey Club Stakes and went to stud at the Duke's seat at Woburn, siring in 1797 the only unnamed winner of the Derby Stakes, listed as 'the colt by Fidget' (see R Mortimer *The History of the Derby Stakes* 1973, p31). Before the stud farm at Woburn was closed in 1804, the *Racing Calendar* of 1803, which advertised the services of top stallions at stud, listed 'Fidget', at 5gs and a half [that is £5 77½p]. He has but few blood mares, from which are several good runners, and has got a better stock of hunters and road horses than any stallion in England'. The Vernon-Bedford horse called 'Fidget' is thus well documented. The subject of the present work, although endowed with the same name, is unlikely to be the same horse. Even 'the colt by Fidget', presumably born in about 1794 (winning the Derby in 1797), would have been 17 years old in 1811 (the date of Chalon's first RA 'Fidget' exhibit) and 33 in 1827 (the second RA picture).

The present work shows a vigorous stallion, with awaiting mares in the middle distance, in what could well be a Yorkshire landscape setting. It seems most probable that the fine horse 'Fidget' belonging to the Mouat family and depicted here was named after the Bedford horse, and indeed was descended from him or 'the colt'. Other evidence of a connection between the Bedford and Mouat horses called 'Fidget' is that the breeder, 'Jockey' Vernon, was a Yorkshireman (the Mouat 'Fidget' was bred in Yorkshire). The Bedford 'Fidget' does not appear in the recorded obituary lists of stallions (which implies that the horse had been exported, although, unfortunately, records of exported horses did not begin until 1805/6).

But though the identity of the stallion has thus not been completely established, the painting takes a distinguished place in the traditional genre of depictions of an excited horse going to stud in which 18th-century artists like Sawrey Gilpin, Charles Towne and especially George Garrard excelled. The present work may also be compared with Chalon's set of six lithographs entitled 'The Passions of the Horse' (impr in V&A collections, 28267.1–6), which was published between February and October 1827, the same year as the RA exhibit mentioned above.

Exh:   ?RA 1827 (355)

# CHAMBERS, George (1803–1840)

Born Whitby 1803, the son of a local seaman. Went to sea at the age of ten, then worked as a house-painter, studying art with a drawing-master called Bird. Moved to London in about 1822; worked for Thomas Horner on the panorama of London seen from the dome of St Paul's which opened in the Colosseum, Regent's Park, in 1829, and as a scene-painter at the Pavilion Theatre. Exhibited three paintings at the RA between 1828 and 1838, 15 at the BI 1827–40, and 27 at the Society of British Artists 1829–38. All were marine and coastal scenes, and naval engagements; two visits to Holland in the late 1830s resulted in Dutch views. Visited Madeira in 1840, but, never in good health, died in Brighton 28 or 29 October 1840. There are eleven watercolours by him in the V&A collections. The painter George Chambers junior, exhibiting in the 1850s, was his son. Although his works were auctioned after his death (details of the sale are unknown), a subscription had to be raised in the *Art Union* to support his family.

Lit: J Watkins *Memoir of George Chambers*, Whitby 1837; *Art Union* 1840, pp186–7 (obit), 1841, pp8, 34, 122–3; J Watkins *Life and Career of George Chambers* 1841

## Seascape
1823-1900    Neg HF958
Canvas, 52.1 × 64.8 cm (20½ × 25¼ ins)
Signed and dated 'G Chambers, 1833' br, and inscribed 'G C 1833' on centre boat
Ashbee Bequest 1900

A letter from Chambers to John Watkins in September 1833 indicates that the artist had just spent some time in Sussex, 'At Tunbridge Wells, Lewes, Brighton, Shoreham, etc' (Watkins 1841, pp73–4); this painting may be a result of that trip. Also in 1833, he exhibited 'A Portsmouth Ferry-boat Crossing to the Isle of Wight' at the SBA (361).

*Seascape    1823-1900*

# CHILDE, Elias (active 1798–1848)

*Moonlight – A Composition    1388-1869*

A prolific painter of landscape and rustic genre in oil and watercolour. Exhibited 59 works at the RA between 1798 and 1837, 114 at the BI 1810–46, and 314 at the SBA 1824–48 of which he was elected a Member in 1825. He shared a London address 1798–1801 with the painter James Warren Childe (1780–1862), presumably his brother. Grant comments that the single small work in the V&A, and the four lines accorded it in the museum catalogue, were 'poor enough reward for a life's work unequalled, we believe, in volume by any known painter of our School'. Grant also states that his forte was 'small and highly finished rustic intimacies', presumably judging from 'The Cottage Yard' of 1820, which he illustrates (fig 504).

Lit: M H Grant *Old English Landscape Painters* vol 6, 1961, pp486–8

## Moonlight – A Composition
1388-1869    Neg HF959
Panel, 22.2 × 17.2 cm (8¾ × 6¾ ins)
Townshend Bequest 1869

Childe seems to have favoured moonlight scenes later in his career, exhibiting seven at the RA 1830–37, and many at the BI and the SBA from

the mid-1820s onwards. Grant describes the present work as 'nothing more than one of Childe's frequent adaptations from the manner of J B Crome, whose rather washy and unsubstantial "Moonlights" . . . were much considered at the time when Childe was at work'. He also opines that Childe produced such pastiches to loosen the characteristic tightness of his own style, which is possible, but seems unlikely in view of their frequency of production and public exhibition.

## CLAXTON, Marshall (1813–1881)

Born Bolton, Lancashire, 12 May 1813, the son of a Wesleyan minister, studied with John Jackson RA, and from 1831 at the RA. Won the first prize medal at the RA for painting 1834, and the gold medal of the Society of Arts 1835. Exhibited portraits, historical and biblical subjects: 32 at the RA between 1832 and 1876, 31 at the BI 1833–67, and 26 at the SBA 1832–76. Entered cartoon competitions for the Palace of Westminster decorations in 1843 (winning a £100 prize), 1844 and 1847. Visited Rome 1837, Australia 1850, where he organised one of the first exhibitions of works of art, and India and Egypt. He received a commission from Queen Victoria for a 'General View of the Harbour and City of Sidney'. Returned to England 1858. Died Maida Vale, London, 28 July 1881. His two daughters were both artists. Florence Claxton's watercolour parody of the PRB, the 'Judgement of Paris', was acquired by the V&A in 1989.

Lit: *Athenaeum* 13 August 1881, p216 (obit)

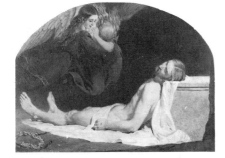

*The Sepulchre*   FA251

**The Sepulchre**
FA251   Neg 5642
Canvas, 126.4 × 174.7 cm (49¾ × 68¾ ins)
Signed 'M Claxton' bl
Given by the artist 1867

Exhibited at the RA in 1843, it was adversely received by the critics. The *Athenaeum* found 'the figure well-drawn, well foreshortened, the angels commonplace; and the solemnity of effect which ought to give the poetry and religion of the subject, wanting', while the *Art Union* criticised 'his method of treating the subject. Such a display of the anatomy of the human form, with every appearance of attention from disease, is certainly revolting. Apart from this objection, there is much excellent work in this picture'. The criticism of the anatomy anticipates Charles Dickens's famous attack on Millais's 'Christ in the House of His Parents' (*Household Words* 15 June 1850, pp265–6).

A later critic in the *Art Journal* was more sympathetic:

The disposition of the figure of the dead Christ is so far novel, that we do not remember it treated in a similar way in any picture by an old master; that is, with the body in a half-recumbent position, and the head resting on a raised block of stone, while *in the sepulchre*. The drawing, moreover, of the figure is good and the anatomical expression well-developed; the arrangement of the drapery is simple, natural, and without heaviness. The sentiment of the two angels flying down to take their places as watchers by the tomb is poetical; one, as if in agony of grief at the fearful sight, appears to hide from her [sic]. There is much elegance in the grouping of these figures. How far the introduction of the objects identified with the crucifixion – the crown of thorns, the mock-sceptre of reeds, the sponge, and the nails – are admissive, so far as the scriptural narrative warrants, is doubtless questionable; but they form a kind of episode in the composition which is impressive as well as pictorially valuable . . .

The iconography of the painting is certainly unusual; Claxton seems to have adapted the account in the Bible by St John (chapter 20 verses 11–13) in which Mary Magdalene came to the sepulchre and found two angels where the body of Christ had been lain. The 'half-recumbent position' of Christ is not unusual in Pietà compositions from the Renaissance onwards, and the immediacy of the figure derives ultimately from Caravaggio in the early 17th century. Perhaps the present work may be most closely compared with Jusepe de Ribera's 'Lamentation', which probably dates from the early 1620s and was presented to the NG in 1853 (its earlier provenance is unclear, but there are several versions of the composition and an etching, one of which Claxton may have seen); the facial expression of Claxton's angel and that of Ribera's Virgin Mary are in particular very similar. There is also a resemblance to the 'Dead Christ' of Philippe de Champaigne (two versions, Louvre and St Médard, Paris).

The 1869 *Art Journal* commentary on the picture, which accompanied an engraving of the painting, concluded: 'Mr Claxton's liberality has made the nation the proud possessor of this interesting work: he recently presented it to the Museum at South Kensington, where it forms one – and not the least attractive – of the ornaments of the Picture Gallery'.

Exh: RA 1843 (377); *International Exhibition* 1862 (520, lent by the artist)

Engr: S Smith, for the *Art Journal* 1869, facing p 368

Lit: *Athenaeum* 27 May 1843, p511; *Art Union* 1843, p176; *Art Journal* 1869, p368

### The Evening Star (Child's head)
905-1875   Neg HF 960
Canvas, 52.1 × 41.9 cm (20½ × 16½ ins)
Purchased 1875

*The Evening Star (Child's Head)*   905-1875

Exhibited at the RA in 1833. On the back of the relined canvas is written: *'Copy of inscription on Original Canvas/"The Evening Star"/The first Picture Exhibited by me,/at Somerset House 1833/Marshall Claxton'*. In fact he had already exhibited a portrait, 'Rev Marshall Claxton', presumably his father the Methodist minister, at the RA in 1832 (46). The source of Claxton's image derives in the 16th-century work of Correggio, and Maratta in the 17th century, but a more immediate influence was probably Reynold's 'portrait' of Frances Ker Gordon, the 'Angels' Heads' of 1787 (now in the Tate Gallery). Claxton's interest in Reynolds is demonstrated by his imaginary group portrait 'Sir Joshua Reynolds and His Friends' exhibited at the RA in 1843 (315).

The subject of the 'evening star', that is the planet Venus – the first light in the sky after sunset – was celebrated in Virgil's *Georgics*, Turner's painting (and draft verses) of about 1830 (see M Butlin and E Joll *The Paintings of J M W Turner* I, 1977, p255, cat no 453), and William Etty's 1828 RA exhibit 'Venus, the Evening Star'.

Exh: RA 1833 (302)

# CLINT, Alfred (1807–1883)

Born Bedford Square, London, 22 March 1807, the son of George Clint ARA. A prolific painter of landscapes and coastal scenes, exhibited 24 works at the RA between 1829 and 1871, and 35 at the BI 1828–52. Mainly exhibited at the SBA, 410 works 1828–81, of which he was a Member from 1843 and held various offices including President 1870–81. He illustrated Bennett's *Pedestrian Guide through North Wales*, and wrote a practical manual,

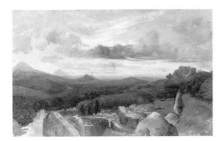

*Landscape with Mountains and Rocks* 9109-1863

*Beech Trees* 9110-1863

*Charles Young as Hamlet and Miss Glover as Ophelia* FA20

*A Guide to Oil Painting; Part II Landscape from Nature* nd [1855]. Died Notting Hill, London, 22 March 1883. His studio sale was at Christie's 23 February 1884.

LIT: *Illustrated London News* 7 April 1883, pp332 (engr portrait), 334 (obit)

### Landscape with Mountains and Rocks
9109-1863   Neg HF956
Canvas, 31.8 × 49.6 cm (12½ × 19½ ins)
Purchased 1863

The scene has not been located, and it is impossible to identify the painting with any of the artist's exhibited works.

LIT: J Maas *Victorian Painters* 1969, p48, repr p49

### Beech Trees
9110-1863   Negs HF957, HF4814
Canvas, 61 × 48.3 cm (24 × 19 ins)
Purchased 1863

Titled in the V&A 1907 catalogue 'Beech Trees, from nature', the painting has not been identified with any of the artist's exhibited works.

---

# CLINT, George, ARA (1770–1854)

---

Born Brownlow Street, Drury Lane, London, 12 April 1770, son of a hairdresser. After school in Yorkshire, worked in turn for a fishmonger, attorney, housepainter, and bookseller. Trained first as a miniature painter; acquaintance with John Bell (see FA253, p31) and his nephew Edward Bell led him to produce mezzotints; also made coloured copies from prints after George Morland and others. First oil painting was a portrait of his wife, which resulted in an introduction to Sir William Beechey RA. Exhibited 99 works at the RA between 1802 and 1845, nine at the BI 1815–42, and 15 at the SBA 1831–47. Almost all were portraits, and after 1816 many were of actors and theatrical scenes in the tradition of Zoffany and Samuel de Wilde. His studio in Gower Street became a rendezvous for the leading actors and actresses of the day. Elected ARA 1821; repeated failure to be elected RA resulted in his resignation 1836. Died Kensington, London, 10 May 1854.

LIT: *Art Journal* 1854, pp212–3 (obit by his pupil R W Buss)

### Charles Young as Hamlet and Miss Glover as Ophelia
FA20   Neg 70312
Canvas, 128.9 × 96.5 cm (50¾ × 38 ins)
Sheepshanks Gift 1857

Exhibited at the RA in 1831, with the following title and quotation (from Shakespeare's *Hamlet*, act 3 scene 1) in the catalogue:

> Mr Young in Hamlet
> *Ophelia:*   My Lord, I have remembrances of yours that I have longed
>                    long to re-deliver. I pray you now receive them.
> *Hamlet:*   No, not I, I never gave you aught.

The identification of the actress as Miss Glover dates from the printed handlist of the Sheepshanks collection in about 1850, and has been retained in all the museum's printed catalogues except that of 1907, where she is described as Mrs Glover (as she is in the 1868 exhibition catalogue). It is not

known why this alteration was made, and there is no evidence that Young ever played Hamlet to the Ophelia of the well-known actress Mrs Glover (1779–1850); he did play the part opposite Miss M Glover at Covent Garden on a number of occasions between 16 October 1826 and 8 October 1827. In the absence of further evidence, it seems likely that this painting records one of those performances. However, the identity of Miss M Glover is far from clear; according to Oxberry, none of Mrs Glover's daughters surviving in 1826 had a name with the initial M.

The catalogue of the 1868 exhibition refers to another portrait of Miss Glover by Clint in 'Scene from Paul Pry' (FA21 below); although there is some facial similarity between the two actresses, the 'Scene from Paul Pry' is known to represent Miss Phillis Glover, a daughter of Mrs Glover.

In F M Redgrave's *Memoir* of her father Richard (1891), a visit by him and Lord Palmerston to Sheepshanks's house at Rutland Gate is recorded on 12 December 1856; in the dining-room 'They were all interested in Clint's works, particularly with "Miss Glover" '. This is presumably the present work, or the 'Scene from Paul Pry' (FA21, below).

EXH:  RA 1831 (281); *National Portraits* South Kensington Museum 1868 (571); *Royal Opera House Retrospective 1732–1982* RA 1982–3 (152)

LIT:  *Oxberry's Dramatic Biography* IV, 1826, p27; G Ashton and I Mackintosh *Royal Opera House Retrospective 1732–1982* RA exhibition catalogue 1982, p96

## Scene from 'Paul Pry'
FA21  Neg J1226
Canvas, 127 × 61 cm (50 × 24 ins)
Sheepshanks Gift 1857

Exhibited at the RA in 1827 (not, as stated in previous V&A catalogues, in 1831) with the following title and quotation in the catalogue:

> Scene from Mr Poole's Comedy of Paul Pry, with Portraits of Madame Vestris, Miss P Glover, Mr Williams, and Mr Liston
> *Phoebe:*   No one shall enter this room. We stand here upon our honour; and, if you doubt my young lady's, what is to become of mine I should like to know?
> *Paul Pry:*   I can't possibly say Mrs Phoebe; but I would advise you to look well after it, for, I protest – there he is

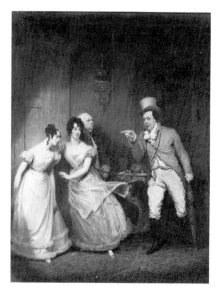

*Scene From 'Paul Pry'*   FA21

The quotation is from act 2 scene 2 of the comedy in three acts *Paul Pry* by John Poole (1786/7–1872), first produced 13 September 1825. The first performance with the players represented here was at the Theatre Royal, Haymarket, on 26 September 1825; Mr Williams took over the part originally played by William Farren. Miss P[hyllis] Glover (1807–31) was the daughter of the well-known actress Mrs Glover (see also FA20 above). Madame Vestris (1797–1856) played Pheobe, and John Liston (?1776–1846) the title role.

The play was extremely popular in the 19th century; Paul Pry was Liston's most successful role, and Derby porcelain figures and Staffordshire pottery figures of him were produced (exhibited in *The Georgian Playhouse* 1975), and that image may be the original of the Johnny Walker whisky label figure. A mezzotint engraving by Clint's pupil Thomas Lupton, published 1 July 1828, is lettered 'from the original picture in the possession of T Griffiths, Esq.' The *Art Journal* obituary of Clint records that 'For Mr Griffiths of Norwood, Clint commenced and painted many portraits for a theatrical gallery, viz., Munden, Grimaldy, Fawcett, Knight, Cooper, Liston . . .', some being later destroyed by a fire at Griffiths' house. The obituary also lists *Paul Pry* among the artist's principal works.

The chair, side table, and wall bracket, which may record the stage

setting, have been identified by John Hardy as taken from designs by J A Meissonnier for furniture and interiors published in about 1745.

PROV: ?painted for T Griffiths of Norwood in 1828; given to the museum by John Sheepshanks 1857

EXH: RA 1827 (222); *National Portraits* South Kensington Museum 1868 (566)

ENGR: Mezzotint by Thomas Lupton, 1 July 1828

LIT: *Art Journal* 1854, pp212–3 (obit by his pupil R W Buss); G Ashton and I Mackintosh *The Georgian Playhouse*, Arts Council Hayward Gallery exhibition catalogue 1975 (171, 178–188)

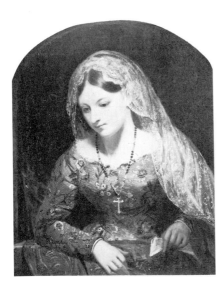

*La Palermitana*   FA22

## La Palermitana
FA22   Neg 75948
Canvas, 76.2 × 62.2 cm (30 × 24½ ins)
Sheepshanks Gift 1857

A woman from Palermo in local costume. Exhibited at the RA in 1834. A unique type of subject in the artist's *œuvre*, but the motif of a woman leaning from a window or balcony is traditional, particularly in Dutch 17th-century painting. There is no evidence that Clint travelled abroad.

EXH: RA 1834 (231)

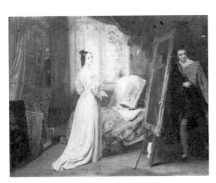

*Scene from 'The Honeymoon'*   FA23

## Scene from 'The Honeymoon'
FA23   Neg V1938
Canvas, 54.6 × 71.1 cm (21½ × 28 ins)
Sheepshanks Gift 1857

Exhibited at the RA in 1835, with the following title and quotation in the catalogue:

> A scene from the comedy of 'The Honeymoon'
> *Volante*:  Confess that I love him! – Now there is only his picture, I'll see
>         if I can't play the confessor a little better than he did.
>         Act 2 Scene 3

*The Honeymoon*, a romantic comedy in five acts, was written in 1804 by John Tobin (1770–1804), published posthumously in 1805, and first performed 31 January 1805 at the Theatre Royal, Drury Lane. It was a great success, and remained popular for over ten years. In the play, set in Spain in the early 17th century (judging from the costumes in the painting), the scene depicted is the painter Balthazar's studio. Count Montalbon conceals himself behind his portrait, while his beloved, the painter's daughter Volante, looks at the portrait, and Balthazar watches behind the door. The Count reveals himself, and in the last scene of the play Volante accepts his proposal of marriage. The play was revived at Drury Lane on 30 June 1827 (the playbill stating that it had not been played for ten years); it was republished in the *Cumberland's British Theatre* series in 1829.

Previous museum catalogues have given the following extract from the same scene:

> Confess that I love the Count! A woman may do a more foolish thing than fall in love with such a man, and a wiser one than to tell him of it. (Looks at the picture). 'Tis very like him.

These lines are from Volante's opening speech; those quoted in the 1835 RA catalogue are from half-way through the speech.

For another painting of the play, see under Michael W Sharp, D36 p263.

EXH: RA 1835 (326); *Victorian Narrative Paintings* V&A circulating exhibition 1961

### Portrait of John Bell, Publisher

FA253   Neg 69987
Canvas, 127 × 101.6 cm (50 × 40 ins)
Given by Charles Masters 1868

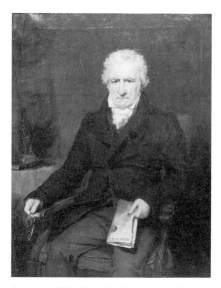

*Portrait of John Bell, Publisher*   FA253

Exhibited at the RA in 1826. John Bell (1745–1831) was a famous printer
and publisher, notable for discarding the long 'ſ' (for 's') from his fount of
type, for his numerous popular editions of British poetry and drama (his
*Pantheon* and *Shakespeare* are shown on his desk), and for his highly successful
*Bell's Weekly Messenger*. He holds a copy of this in the portrait, of which the
date may be read as 'no. 1011 October 28'; this might be the issue of 1805
which reported the Battle of Trafalgar and the death of Nelson which
occurred a week before. Mayes comments that 'where he deserves more
recognition than he has so far received is as a vigorously creative patron and a
populariser of British art – especially theatrical art – largely through the
medium of past-publications . . .' (p100).

The artist was well acquainted with Bell. An engraving by Thomas
Lupton after the painting was published as representing the sitter at the age of
80, that is, in about 1825. The donor was a part-proprietor of *Bell's Weekly
Messenger*; the portrait was in his possession by 1868, when he lent it to the
National Portraits exhibition before giving it to the museum.

Other portraits of Bell include a print by George Arnald, a pencil and
watercolour drawing by William Douglas (SNPG), and a coloured etched
caricature entitled 'A Real TB' (that is, a 'true blue', a Tory royalist) by
Richard Dighton (1821; republished in *City Characters* as pl 39, 1824).
Morison refers to Bell having 'a handsome, affectionate and mellow
countenance'.

Exh:   RA 1826 (4); *National Portraits* South Kensington Museum 1868
       (239)

Engr:  Thomas Lupton 1825

Lit:   S Morison *John Bell, 1745–1831* 1930, p86; I Mayes 'John Bell, The
       British Theatre and Samuel De Wilde', *Apollo* February 1981,
       pp100–3 (repr fig 1, as 'present whereabouts unknown').

### William Charles Macready as Macbeth

D74   Neg H1608
Panel, 29.2 × 24.1 cm (11½ × 9½ ins)
Dyce Bequest 1869

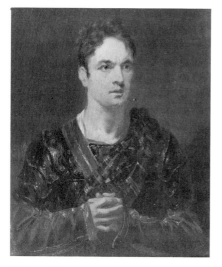

*William Charles Macready as Macbeth*   D74

When received with the remainder of the Dyce Bequest in 1869, it was
catalogued as by an unknown artist; the 1893 catalogue tentatively suggested
an attribution to George Clint. An engraving by W Coutts, published in
1821 as after Clint, corresponds in detail with this painting, and there seems
no reason to doubt that it is by Clint.

William Charles Macready (1793–1873) from his London debut in 1816
became the leading tragic actor of the day. In the Covent Garden season of
1819–20, which made his reputation, he played Richard III, Coriolanus,
King Lear, and for the first time, at his benefit performance on 9 June 1820,
Macbeth. In his *Reminiscences*, Macready quotes the critic of the *Morning
Herald* (10 June 1820): 'The pathos which he infused into Macbeth was a
principal merit in its delineation'. Clint is only mentioned once in the
*Reminiscences*, as introducing Macready to John Forster at Edmund Kean's
funeral in 1833. Macready was painted several times by other artists (for a full
iconography, see Ormond), including John Jackson, who also painted him in
the role of Macbeth (Royal Shakespeare Company collection, repr in
*Reminiscences* II, facing p224), and as Henry IV in 1821 (NPG). In the V&A
collections there is a portrait of him as Werner by Daniel Maclise, as well as a
sepia study by Maclise for his 1836 painting of Macready as Macbeth with the
witches (whereabouts unknown).

ENGR: W Coutts (1821)

LIT: ed Sir F Pollock *Macready's Reminiscences, and selections from his diaries and letters*, 2 vols, 1875, I, pp213–4; W Archer *William Charles Macready* 1890 pp49–55; ed W Toynbee *The Diaries of W C Macready 1833–1851* 2 vols, 1912, I, p36; R Ormond *Early Victorian Portraits* 2 vols, 1973, I, pp296–9

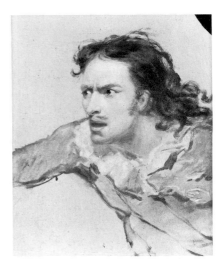

*Edmund Kean as Sir Giles Overreach* D79

### Edmund Kean as Sir Giles Overreach
D79  Neg 70315
Canvas, 28 × 22.9 cm (11 × 9 ins)
Dyce Bequest 1869

The painting has been previously catalogued as by an unknown artist, but it is clearly a sketch for the head and shoulders of Kean in the painting exhibited by Clint at the RA in 1820 (311) and now in the Garrick Club collection. In the RA catalogue, the following title and quotation are given:

> The last scene in Massinger's play of 'A New Way to pay Old Debts', with portraits
> *Sir Giles Overreach:* Village nurses revenge their wrongs with curses: I'll not wast a syllable; but thus I take the life which, wretche, I gave to thee (offers to kill Margaret).

A very similar oil sketch (51.4 × 41.2 cm/20¼ × 16¼ ins), also in the Garrick Club collection, shows Kean as Shakespeare's *Richard III*.

Philip Massinger's comedy of 1633 deals with the deception and ultimate fall of the unscrupulous Sir Giles Overreach; in the last scene, finding he has helped unwittingly to marry his daughter to the wrong man and has lost all his property, he goes insane. The finished painting shows him drawing his sword to kill his daughter: 'This moment and the ensuing fit brought the strongest reaction from audiences and Lord Byron was one of the many, both on and off the stage, who had hysterics on the first night' (*The Georgian Playhouse*). Edmund Kean (1787–1833) made the sensational debut at Drury Lane in 1841, and became the leading and most controversial actor of the day. He played Sir Giles at Drury Lane for the first time on 12 January 1816; that role and in April 1920 his King Lear, were among his greatest triumphs. There are several portraits of Keen in various roles, but this brilliant sketch perhaps best captures the mercurial passion of the acting style for which he was famous. William Hazlitt believed that as Sir Giles 'he had no equal' in the 'soul and spirit of the part'; it was Charles Dickens's favourite role as an amateur actor.

A mezzotint engraving by Clint's pupil Thomas Lupton from the finished picture was published in 1833; Lupton himself appears in the painting, fourth from the left.

EXH: *The Georgian Playhouse* Arts Council Hayward Gallery 1975 (204)

LIT: C K Adams *A Catalogue of the Pictures in the Garrick Club* 1936 (408, 465); G Ashton and I Mackintosh *The Georgian Playhouse* Arts Council Hayward Gallery exhibition catalogue 1975 (204)

## COLLINS, Charles Allston (1828–1873)

Born Hampstead, London, 25 January 1828, the son of William Collins RA and younger brother of the novelist Wilkie Collins. Studied with his father and from 1844 at the RA Schools, and was an early friend and associate of the Pre-Raphaelite Brotherhood, particularly Hunt and Millais (he was actually proposed for membership). Exhibited 14 works at the RA between 1847 and at the 1857 Pre-Raphaelite exhibitions at Russell Place and in

Liverpool. His style of painting was based on Pre-Raphaelite theories, and his subjects reflect his interest in High Anglicanism. In the later 1850s he abandoned painting for writing, contributing articles to periodicals and publishing several novels and travel books. Married Charles Dickens's daughter Kate 1860, and designed the cover for the monthly parts of *The Mystery of Edwin Drood* 1870. Died Brompton, London, 9 April 1873.

LIT:    *Art Journal* 1904, pp281–4; S M Ellis *Wilkie Collins*, *Le Fanu*, *and others* 1931, pp54–73

## The Good Harvest of 1854

1394-1869    Neg HD1616
Canvas, 43.8 × 34.9 cm (17¼ × 13¾ ins)
Signed and dated 'CA Collins 1854' [CAC in monogram] diagonally in red br
Townshend Bequest 1869

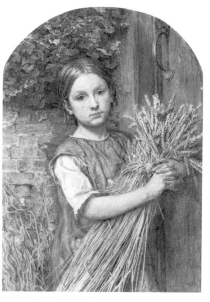

*The Good Harvest of 1854    1394-1869*

Exhibited at the RA in 1855 as 'The Good Harvest of '54', his last work before giving up painting for a literary career. It was presumably painted mainly in the summer of 1854, before going to Scotland in the autumn with Millais (J G Millais *The Life and Letters of Sir John Everett Millais* 1899, I, p243). In 1854 Millais was working on 'The Blind Girl' at Winchelsea, Sussex, and also several small pictures of single female figures.

It was hung in the Octagon Room at the RA; Ruskin wrote in his *Academy Notes* for 1855 that 'There is much careful painting in this little study, and it was a wicked thing to put it into a room in which, while its modest subject could draw no attention, its good painting was of necessity utterly invisible'. The picture was not noticed by the critics of the *Art Journal* and *Athenaeum*.

As Staley points out, it shows Collins's continuing dependence on the work of his friend Millais; the background of ivy on a brick wall is taken from 'A Huguenot, on St Bartholomew's Day, refusing to shield himself from danger by wearing the Roman Catholic badge' (1851–2, private collection). The motif of a figure at an ivy-clad door might also relate to Holman Hunt's *The Light of the World* (1851–3, Keble College, Oxford).

The 1850s saw a series of splendid harvests following the 'hungry 'forties', perhaps inspiring several landscape paintings, notably Ford Madox Brown's 'Carrying Corn' and 'The Hayfield' (1854–5 and 1855–6, Tate Gallery). (For further comment and references on this subject, see K D Kriz 'An English Arcadia revisited and reassessed: Holman Hunt's *The Hireling Shepherd* and the rural tradition' in *Art History* December 1987, pp485–8.) Collins's painting may also have a larger meaning. The bound sheaf is a traditional symbol of concord, one of the minor virtues, and also relates to Ceres, the goddess of agriculture, as a symbol of abundance. The ivy was traditionally sacred to Bacchus, the god of wine, so the combination implied – of bread and wine – might well refer to the eucharist. Many of Collins's subjects are associated with his High Anglican beliefs.

EXH:    RA 1855 (1334); *Victorian Paintings* Arts Council 1962 (7)

LIT:    ed E T Cook and A Wedderburn *The Works of John Ruskin* vol XIV, 1904, p29; A Staley *The Pre-Raphaelite Landscape* 1973, p83, repr pl 40b; S. Casteras *Images of Victorian Womanhood in English Art* 1987, p44

# COLLINS, William, RA (1788–1847)

Born London 8 September 1788, the son of the Irish writer William Collins, author of a memoir of George Morland RA, who encouraged the boy's interest in painting. In 1807 he entered the RA schools, and exhibited his first painting there. Made his name with 'The Disposal of a Favourite Lamb' in 1813; elected ARA 1814, RA 1820. Achieved great popularity with his landscapes and, particularly, rustic genre scenes in the 1820s; Ruskin highly praised his works in the 1840s. Married in 1822 the sister of the portrait painter Margaret Carpenter. Travelled extensively in Britain and abroad, especially in Italy 1836–38; these visits are reflected in the subjects he painted. Exhibited 124 works at the RA between 1807 and 1846, and 45 at the BI 1808–43. Librarian at the RA 1840–2. Died London 17 February 1847. His studio sale was at Christie's 31 May–5 June 1847. His two sons were the novelist William Wilkie Collins and the painter Charles Allston Collins. There are watercolours and a sketchbook in the V&A collections.

LIT:   William Collins 'List of Pictures and Patrons', two MS volumes 1808–27 and 1827–46, National Art Library, V&A (referred to below as *Lists*); *Athenaeum* 20 February 1847, p200 (obit); *Art Journal* 1847, p137 (obit); W Wilkie Collins *Memoirs of the Life of William Collins, Esq, RA* 2 vols, 1848 (referred to below as *Memoirs*); *Art Journal* 1855, p141 W. Clarke *The Secret Life of Wilkie Collins* 1988

*The Villa D'Esté, Tivoli*   FA24

## The Villa D'Esté, Tivoli
FA24   Neg V650
Panel, 40.6 × 30.2 cm (16 × 11⅞ ins)
Sheepshanks Gift 1857

Painted for Sheepshanks in the early months of 1842, and exhibited at the RA that year; it is the last entry in the *Lists* under 'Pictures printed from April 1841 to April 1842', the price being £52 10s.

Collins visited Tivoli in early Spring 1837; one coloured drawing was lot 490 in his posthumous sale at Christie's 3 June 1847. The *Memoirs* (p205) describe the Sheepshanks painting as a companion to 'Sorrento – Bay of Naples' (see FA26, p35) and as depicting 'the famous avenue of cypresses, four hundred years old, with the terraces and the palace at the upper end of it . . . executed with great vigour and brilliancy'.

EXH:   RA 1842 (241); *Italian Art and Britain* RA 1960 (220); *Victorian Painting* Arts Council 1962 (8); *The Victorian Vision of Italy* Leicester Museum and Art Gallery 1968 (86)

LIT:   *Lists; Memoirs* II, pp105, 205

## The Caves of Ulysses at Sorrento, Naples
FA25   Negs Z157, 4617
Panel, 40.6 × 63.5 cm (16 × 25 ins)
Signed and dated 'W Collins/1843' bl
Sheepshanks Gift 1857

A reduced replica of the painting (31½ × 47½ ins), exhibited at the RA in 1841 (384) under the title 'A Scene taken from the Caves of Ulysses at Sorrento, the Birthplace of Tasso' and the following quotation from Samuel Rogers's *Italy*:

> Not a cliff but flings
> On the clear wave some image of delight.
> there methinks,
> Truth wants no ornament, in her own shape
> Filling the mind, by turns, with awe and dread

*The Caves of Ulysses at Sorrento, Naples*   FA25

The original was bought by John Gibbons and was later lot 88 in his posthumous sale at Christie's 29 November 1912 (bought Eames for £73 10s; present whereabouts unknown). The replica appears in Collins *Lists* among work done between April 1943 and April 1844, as painted for Sheepshanks for £73 10s.

Collins stayed in Sorrento from April to July 1837 to escape the cholera epidemic in Naples. Several paintings resulted from the studies made there during the years after his return to London in 1838. Wilkie Collins (*Memoirs*, p108) declares that

> If he set forth to study the coast, he could descend to the beach from the cliff on which his house stood, through the winding caverns consecrated by Ulysses to the Syrens, and, arrived at the sea, could look one way towards the noble promontory of MASSA, the ancient dominion of the Syren Queens, and could see in the other direction the clear outline of the classic VESUVIUS, ever crowned, even on fairest days, with its twin volcanic cloud of white smoke.

He goes on to describe two large sketches with 'the appearance of finished pictures'; for the first, see 'Sorrento – Bay of Naples', below, while the second

> Looks towards Vesuvius also, but from a different point. Here the smooth limpid sea, with gay market-boats floating idly on its surface, ripples into the foreground, tinged with the clear Italian reflections of the hour and scene. A strip of beach, an extremity of rocky cliff, and the point of VICO, presented the rest of the composition in Nature, and supply it in the sketch. The airy delicacy and daylight of the effect thus produced proved so popular in England, that the painter was commissioned to paint two pictures from it. The original study, (for which many offers have been made), remains . . . a treasured heirloom in the family of the painter.

This treasured original study was presumably lot 775, the mounted oil sketch 'Cave of Ulysses, Sorrento', in the artist's posthumous sale at Christie's 5 June 1847. Wilkie Collins (*Memoirs*, p190) describes the 1841 exhibited painting as 'a copy, on a large scale, of the sketch'.

Sorrento, on the south side of the Bay of Naples, is where the Greek hero Ulysses encountered the Sirens; to avoid the fatal lure of their song, he had himself lashed to his ship's mast and his crew's ears plugged with wax. The story is most famously told in book 12 of Homer's *Odyssey*. The caves of the Sirens (properly called) are still a tourist attraction.

The Redgraves, while describing the picture as 'a work of great truth and beauty', express doubts on whether Collins forsaking English for Italian scenes was of benefit to his reputation, and add that over-exposure to the sun while painting at Sorrento caused the illness that eventually led to his death.

EXH: *Victorian Painting* Arts Council 1962 (9)

LIT: *Lists*; *Memoirs* II, pp108–9, 190–1; Redgrave *Cent*, p417

## Sorrento – Bay of Naples
FA26   Neg HB2566
Panel, 40.6 × 29.8 cm (16 × 11¾ ins)
Signed and dated 'W Collins/1841' bl
Sheepshanks Gift 1857

For the artist's visit to Sorrento, see FA25, p34. According to the *Lists*, painted for Sheepshanks in June 1841 for £52 10s: 'small picture, A Scene at Sorrento'. Collins had already listed a 'Sorrento Bay of Naples' as sold to a Mr Gibbons for £200 on 15 May 1840. Wilkie Collins (*Memoirs*, p205) describes the Sheepshanks painting as

> A repetition of the study from the upper end of the plain of Sorrento, mentioned in the account of the painter's residence there, as containing

*Sorrento – Bay of Naples*   FA26

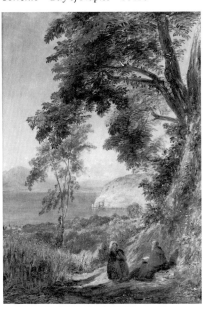

in the foreground a strip of cornfield overhung by a large chestnut-tree; and in the distance, olive gardens, the Mediterranean, and Vesuvius beyond. This picture and its companion, 'The Villa D'Esté, Tivoli' [see FA24, p34] were both executed with great vigour and brilliancy; and were painted for Mr Sheepshanks.

Earlier (*Memoirs*, pp108), Wilkie Collins describes the original study as one of two large sketches, made in Sorrento, the first 'coloured with surpassing brilliancy and vigour . . . as a piece of landscape-painting, it yields to nothing of its class that he ever produced' (the second sketch relates to 'The Caves of Ulysses at Sorrento, Naples', see FA25, p34). The original study may have been in the artist's posthumous sale at Christie's 31 May–5 June 1847, but is not identifiable from the several Sorrento subjects in the catalogue. It was presumably the Sheepshanks painting that was exhibited at the RA in 1842 (240), and described by the critic in the *Art Union* 1842 (p123) as 'a small upright landscape painted with infinite sweetness. We have in it a mere sketch of the Bay, but (*che vorreste?*) with such a foreground we do not miss it'.

LIT:    *Lists*; *Memoirs* II, pp108, 205

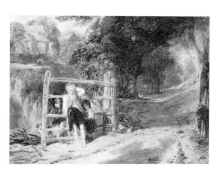

*Rustic Civility*    FA27

### Rustic Civility
FA27    Neg GJ688
Panel, 45.6 × 61 cm (18 × 24 ins)
Signed and dated 'W Collins 1833' on bottom bar of gate bl
Sheepshanks Gift 1857

One of Collins's most famous works, a reduced replica of the painting (71.1 × 91.5 cm/28 × 36 ins) exhibited at the RA in 1832 (29), where it was admired by the *Athenaeum* critic (12 May 1832, p309) as 'much to our liking in all things', and where it was bought by the 6th Duke of Devonshire for £262 10s. It is still in the Devonshire collection at Chatsworth, and is now titled 'Coming Events'. According to the *Lists*, Sheepshanks commissioned this replica, 'to be about half the size', from Collins on 16 June 1833 for £157 10s; it was begun that summer and finished in December.

The 6th Duke wrote of his painting (in his *Handbook of Chatsworth and Hardwick* 1845, p63): 'People are amused at having to find out what is coming through the gate, which few do, till the shadow on the ground is pointed out to them'. A great part of the charm and popularity of the picture is indeed due to the way two of the village children (one touching his forelock in deference) gaze at the approaching gentleman on horseback, whose shadow only is included in the painting, while the smallest child looks directly out at the spectator.

A watercolour sketch (13.4 × 17.2 cm/5¼ × 6¾ ins), for the painting was lot 110, as 'Rustic Courtesy', in the J P Heseltine sale at Sotheby's 25 March 1920; it had been sold earlier at the artist's posthumous sale at Christie's 2 June 1847 (364; lot 412 was two studies also for 'Rustic Civility'). An oil sketch (38 × 55 cm/15 × 21⅝ ins) was sold by Phillips and Swetenham at Chester 30 September 1981 (134); to judge from the catalogue illustration, this could be a copy by another hand.

ENGR:    J Outrim, for *The Cabinet of Modern Art, and Literary Souvenir* 1836 (1835), frontispiece; A Gusnand, as 'L'Ombre du Cavalier', wood engraving after a drawing by K Girardet, for the *Album du Magazin Pittoresque* 1862, pl 12; G Cousen, for the *Art Journal* 1865, facing p234

LIT:    *Lists*; *English Art in the Public Galleries of London* 1888, repr p121

### Hall Sands, Devonshire

FA28    Neg GG146
Canvas, 41.9 × 54.6 cm (16½ × 21½ ins)
Signed and dated 'W Collins 1846' br
Sheepshanks Gift 1857

According to the *Lists*, Sheepshanks first requested a seashore painting in 1839, and commissioned one, 'A Sea Shore (?Hall Sands)', in 1843. 'Hall Sands, Devonshire' appears among work done between April 1845 and April 1846 as painted for Sheepshanks for £105. Wilkie Collins quotes the artist in his journal for the early months of 1846, as working on the picture despite his illness. One of the artist's last four paintings, it was exhibited at the RA in 1846. Wilkie Collins wrote that its 'purity and truth of effect, once seen, could not be easily forgotten. As a union of delicacy of execution, transparency of tone, and breadth of effect, it is one of the painter's most successful works'. Colins visited Devonshire in the autumn of 1819, exhibiting a few Devon subjects in subsequent years, and convalesced at Torquay in autumn 1845. Hall Sands are south of Torquay, on the east side of the peninsula of Start Point.

*Hall Sands, Devonshire* FA28

EXH:  RA 1846 (90)

### The Stray Kitten

FA29    Neg V1933
Panel, 45.7 × 61 cm (18 × 24 ins)
Signed and dated 'W Collins 1835' br
Sheepshanks Gift 1857

A replica of the picture exhibited at the RA in 1833 (133); according to the *Lists*, painted for Sheepshanks between April 1834 and April 1835 for £157 10s. The original was painted for Mr Holden for £180 two years before; the *Lists* also note another replica in August 1833, 'done to be engraved', for £84. According to the *Memoirs*, the latter was bought by Sir Francis Shuckburgh Bt, and the print was 'widely circulated'.

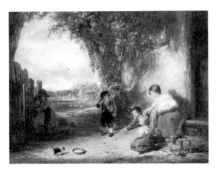

*The Stray Kitten* FA29

The *Athenaeum* critic (11 May 1833, p298) thought the RA painting 'in his best manner; it is a picture that many will covet, for it cannot but be felt by all'.

EXH:  *Victorian Narrative Paintings* V&A circulating exhibition 1961

ENGR:  H.C. Shenton; Jane A Hunt, coloured lithograph

LIT:  *Lists*; *Memoirs* II, pp26–7

### Bayham Abbey, Near Tunbridge Wells

FA30    Neg HB2567
Panel, 34.9 × 45.7 cm (13¾ × 18 ins)
Signed and dated 'W Collins 1836' bl
Sheepshanks Gift 1857

According to the *Lists*, painted for Sheepshanks in July 1836 for £36 15s. Previously catalogued wrongly as a sketch for 'a large picture in the possession of the Marquis of Camden'; that picture was exhibited at the RA in 1822 (208) and depicted in the middle distance a celebration of the coming of age of the Marquis's son, Lord Brecknock.

*Bayham Abbey, Near Tunbridge Wells* FA30

Bayham Abbey is an impressive ruined 13th-century monastery and church in Sussex, much admired by seekers after the Picturesque in the 18th century. Collins was there from 1–3 May 1820 sketching at Lord Brecknock's birthday fête; he wrote to his mother from Rye on 14 August that 'Lord Camden will bring the sketch I made of the Abbey to town, as it was not sufficiently dry to be removed when I left him'.

A tinted drawing of Bayham Abbey was lot 720 in the artist's

posthumous sale at Christie's 5 June 1847, and another, in crayon, lot 182 on 1 June.

LIT:   *Lists; Memoirs* I, pp166–7, II pp69, 90–1

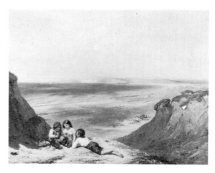

*Seaford, Sussex*   FA31

## Seaford, Sussex

FA31   Neg 67992
Canvas, 69.9 × 92.7 cm (27½ × 36½ ins)
Signed and dated 'W Collins 1844 bl
Sheepshanks Gift 1857

According to the *Lists*, painted between April 1843 and April 1844, and sold to John Sheepshanks for £36 15s. It was exhibited at the RA in 1844. Collins visited Seaford in September 1841 and made several outdoor sketches; the *Memoirs* note that the artist used them for this picture, described as 'perhaps as strikingly original a work of its class, as he ever produced'. The *Art Union* critic thought 'the line of water meets the sand in a manner too hard. This may be intended to show the tide flowing, but it is yet too severe. The group in the foreground is peculiarly happy – one of the artist's most felicitous copies of simple facts.' The artist James Smetham wrote to J H Hall on 24 March 1862:

> How well do I remember in 1844 the first sight of Collins's pictures and the others . . . the picture I then saw of Collins's is now, I am thankful to say, in the South Kensington collection – the 'Seaford', with the cloud shadows chasing each other on the windy sands, and the lovely group of children in the foreground.

He discusses the painting further in a letter of 29 March 1875. Eleven drawings of Seaford were in the artist's posthumous sale in 1847. A drawing in pencil heightened with white for two of the three foreground figures in the painting is in the V&A collections also from the Sheepshanks Gift (FA10). A watercolour version, signed and dated 1837, was sold at Sotheby's 27 February 1985 (178, 26.5 × 71 cm).

EXH:   RA 1844 (141)

LIT:   *Art Union* 1844, p156; *Lists; Memoirs* II, pp197–8, 252–3; S Smetham and W Davies *Letters of James Smetham . . .* 1891, pp103, 309–10

*A Country Kitchen*   FA32

## A Country Kitchen

FA32   Neg G1879
Panel, 29.5 × 38.4 cm (11⅝ × 15⅛ ins)
Signed and dated 'W Collins 181[1]'
Sheepshanks Gift 1857

Previously catalogued as 'Cottage Interior', and the date read as 1814, the final figure being unclear. However, Wilkie Collins records a 'Study of a Country Kitchen', in the possession of Sheepshanks, exhibited at the RA in 1811 as 'A Country Kitchen'. The panel is inscribed on the back 'Wm Collins Jun'; the 1811 exhibition was the last at which he was referred to as 'Junior'. An 'interior of a Kitchen' appears in the *Lists* under 1810; the price was £26 5s, but no purchaser's name is given. It is not recorded when the painting was acquired by Sheepshanks, and it is not included in the printed list of about 1850. The MS *Register* in the Department states that the female figure is 'said to be a portrait of the artist's mother'.

EXH:   RA 1811 (124)

LIT:   *Lists; Memoirs* II, p39

### Eel Pots
1383-1869  Neg HB2568
Panel, 22.2 × 30.2 cm (8¾ × 11⅞ ins)
Townshend Bequest 1869

### Landscape – The Gypsy Camp
1393-1869  Neg HB2569
Panel, 17.8 × 33.7 cm (7 × 13¼ ins)
Townshend Bequest 1869

There is a tradition that the figures were painted by Frederick Goodall.

### Crossing the Bridge
1418-1869  Neg HB2562
Panel, 21.3 × 19.7 cm (8⅜ × 7¾ ins)
Townshend Bequest 1869

The work has the appearance of a sketch, and an oil sketch with the title 'A Cart on a Bridge' was lot 226 in the artist's posthumous sale at Christie's 1 June 1847.

### Fisherwomen on the Coast Near Boulogne
569-1882  Neg 52996
Panel, 63.5 × 81.3 cm (25 × 32 ins)
Signed and dated 'W Collins/1830' on rock br
Jones Bequest 1882

The artist exhibited three Boulogne subjects at the RA in 1830; this picture does not accord with Wilkie Collins's description of any of them (*Memoirs* I, pp333–5).

Collins and his family visited Boulogne in August and September 1829. His attention

> was principally turned to the scenery and inhabitants of the sea-shore. For the former, he carefully explored the Coast, for many miles, on each side of Boulogne; and, in the latter, the differences in physiognomy, manners and habits, between the French fishermen whom he was then studying, and the English fishermen . . . These men, with their wives and families, formed the subjects of many of the most highly finished water-colour drawings that he ever executed (*Memoirs* I, p327).

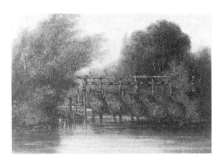
*Eel Pots*  1383-1869

*Landscape – The Gypsy Camp*  1393-1869

*Crossing the Bridge*  1418-1869

*Fisherwomen on the Coast near Boulogne*  569-1882

# COLLINSON, Robert (1832–after 1890)

Born Cheshire July 1832; student at Government School of Design, Manchester, 1847–53. First exhibited at Royal Institution, Manchester, 1851; his address in the SBA catalogue 1854 was the School of Art, Warrington. Exhibited 31 works at the RA between 1858 and 1890, 10 at the BI 1861–67, 14 (including three watercolours) at the SBA 1854–81/2, and 17 elsewhere. Subjects principally genre and landscape. His 1862 'Ordered on Foreign Service' (RA 1864) was engraved by C A Tomkins 1865; that, and his etching of his 1868 project for the Royal Horticultural Society's buildings, are in the V&A collections. Taught at the Government School of Design, South Kensington, from before 1866 to 1875; elected Member of the Manchester Academy of Fine Arts 1881. Ruskin found his 'Sunday Afternoon' (RA 1875) 'extremely delightful'. He does not seem to have been related to the Pre-Raphaelite painter James Collinson.

LIT:  H Ottley *A Biographical and Critical Dictionary* 1866; J Ruskin *Academy Notes 1875* Cook and Wedderburn 14, 1904

*Stray Rabbits    9100-1863*

*Buildings in the Grounds of the South
Kensington Museum in 1862    117-1865*

**Stray Rabbits**
9100-1863    Negs X2131, HG1883
Millboard, 38.1 × 48.2 cm (15 × 19 ins)
Signed and dated 'Rob'. Collinson 1857' bl
Purchased 1863

Presumably the painting with the same title exhibited at the RA in 1858, his
first RA exhibit. It was not noticed by the *Art Journal* and *Athenaeum* critics.
The woodland setting reflects the acuity of observation and high-key
colouring of Pre-Raphaelite painting of the 1850s.

EXH:   RA 1858 (802)

**Buildings in the Grounds of the South Kensington Museum in 1862**
117-1865    Neg 78947
Canvas, 35.6 × 59.1 cm (14 × 23¼ ins)
Purchased 1865

The view is of the front of Brompton Park House seen from the east, on the
site of the present main block of the museum (see J Physick *The Victoria and
Albert Museum: the history of its building* 1982, pp22–3, 26, 97). The dome
prominently featured behind the museum buildings is of the temporary
structure of the 1862 International Exhibition. The figures in the foreground
are probably students and teachers of the South Kensington School of Art
rather than the staffage of pictorial convention.

A watercolour by Anthony Stannus of 1863 showing the façade from the
west is also in the V&A collections (AL2812, repr in colour by Physick as
pl II facing p32). Plans for redeveloping the site were being made in the early
1860s, and these views may have been painted as records of the old buildings.
A replica of the present work, with minor variations in detail, signed and
dated 1865, was recorded in a London private collection in 1933.

## COOKE, Edward William, RA, FRS, FSA (1811–1880)

Born Pentonville, London, 27 March 1811, the second son of the engraver
George Cooke (1781–1834). As a boy, drew plants for his father's engravings
for Loddiges's monthly *The Botanical Cabinet* (1817–33). Also made
preliminary drawings for his father's *London and its Vicinity* (1820–34) which
were used by illustrators such as Stanfield, Prout, Cotman and Callcott, and
worked on John Loudon's *Encyclopaedia of Plants* (1829). Etched his own
illustrations for *Shipping and Craft* (1828–9) and with his father for *Views of
the Old and the New London Bridges* (1833). Evidently made preliminary
drawings for Stanfield. Painted in watercolours until 1834, when, after one
lesson with James Stark, a family friend, he was inspired to paint in oils.
Exhibited mostly marine and coastal subjects; 130 at the RA between 1835
and 1879, 115 at the BI 1835–67, and three at the SBA 1835, 1838, 1876.
Elected ARA 1851, RA 1863. Travelled extensively in Britain and abroad,
most frequently in France from 1833, Holland from 1837, and Venice from
1850; also Italy 1845–6, Spain 1860–61, Egypt 1874. His inherited interest
in natural history led to membership of several learned societies, notably FRS
1863, and his publication of *Grotesque Animals* (1872). Also published
*Landscapes British and Foreign* (1874) and *Leaves from my Sketchbooks* (1876,
1877). Died Groombridge, Kent, 4 January 1880; his studio sales were at
Christie's 22 May 1880 and 11 March 1882.

LIT:   Edited transcript of the artist's MS Diary, National Maritime Museum;
        MS Ledger of paintings completed 1829–78 (referred to below as
        *Ledger*), RA Library; *Illustrated London News* 13 August 1864, pp173–4

(with engr portrait); *Art Journal* 1869, pp253–5; J Munday 'E W Cooke, Marine Painter' *Mariner's Mirror* (Society for Nautical Research) 1967, vol 53, pp99–113); *Edward William Cooke* Guildhall Art Gallery exhibition catalogue 1970, information also kindly supplied by John Munday

## Lobster Pots, Ventnor
FA39   Neg 76820
Canvas, 39.4 × 53.3 cm (15½ × 21 ins)
Sheepshanks Gift 1857

*Lobster Pots, Ventnor*   FA39

In the *Ledger* as 'Lobster Pots, Ventnor, painted on the spot', and bought by Sheepshanks for £26 5s. In September 1835, Cooke went on a sketching tour of Portsmouth and the Isle of Wight, where he stayed at the Crab and Lobster Inn, Ventnor. He recorded in his diary on 1 October that 'in afternoon made sketch of interior of the fisher hut with its gear etc. In evening rigged out baskets, buoys, corks etc'. He had been instructed in basket and lobster pot making by a local fisherman who had also made him some scale models of them. Back at Barnes, he noted on 3 December 'began Lobster pots in oil', presumably, in the light of the *Ledger* entry, another version of the subject.

It was exhibited at the BI in 1836, the size given in the catalogue as 24 by 29 inches. There is a watercolour study dated 12 October 1835 in the V&A collections, also from the Sheepshanks Gift (FA17). Waagen incorrectly states that this was the artist's first oil painting.

Exh:   BI 1836 (307)

Lit:   G Waagen *Treasures of Art in Great Britain* 1854, II, p303

## Mending the Bait-Nets, Shanklin
FA40   Neg S973
Canvas, 41.9 × 78.7 cm (16¾ × 31 ins)
Signed and dated 'E W C March/1836' br
Sheepshanks Gift 1857

*Mending the Bait-Net, Shanklin*   FA40

In the *Ledger* as painted at Barnes, finished March 1836, and bought by Sheepshanks for £36 15s. He recorded in his diary on 10 March 1836: 'Packed up picture of Shanklin and took it with me to town at 11, rode to Blackheath' (that is, Sheepshanks's house). Exhibited at the RA in 1836. There is a watercolour study in the V&A collections, also from the Sheepshanks Gift (FA18). Presumably painted from studies made on his visit to the Isle of Wight in 1835 (see 'Lobster Pots, Ventnor', FA39, above).

Exh:   RA 1836 (208); *Edward William Cooke* Guildhall Art Gallery 1970 (14)

## Brighton Sands
FA41   Neg GA1191
Canvas, 54.6 × 76.2 cm (21½ × 30 ins)
Signed and dated 'E W Cooke 1837'
Sheepshanks Gift 1857

*Brighton Sands*   FA41

In the *Ledger* as 'Hogg-boat [that is, a Hag-boat: for definition, see OED] on the beach at Brighton', painted at Redleaf, finished July 1837, and bought by Sheepshanks for 50 guineas. The diary however records him beginning the painting in August. Exhibited at the BI in 1838, the size given in the catalogue as '32 by 41 inches'. A watercolour sketch is in the V&A collections, also from the Sheepshanks Gift (FA15); it is signed and dated April 1835, and was presumably made during his stay at Hastings (see FA46, p43) along the Sussex coast in the same month. There is a chalk sketch for the painting on the back of 'Mont St Michel, Normandy', (FA43, p42).

Waagen wrote that it is 'very picturesquely conceived and carefully executed in a warm, true, and clear tone . . . resembles a Van de Capelle in effect'; the composition and treatment are certainly reminiscent of Dutch 17th-century marine painting.

EXH:   BI 1838 (68); *Victorian Painting* Mitsukoshi Gallery, Tokyo, 1967; *Edward William Cooke* Guildhall Art Gallery 1970 (20)

LIT:   G Waagen *Treasures of Art in Great Britain* II, p305

*The Antiquary's Cell*   FA42

### The Antiquary's Cell
FA42   Neg GD2505
Panel, 57.8 × 75.6 cm (22¾ × 29¾ ins)
Sheepshanks Gift 1857

In the *Ledger* as bought by Sheepshanks for £47 5s, and showing the 'interior of my own study at Barnes'. Exhibited at the BI in 1836, the size given in the catalogue as '34 by 42 inches' (presumably including the frame). Cooke, later elected FSA in 1876, displays here some of his own interests such as botany and zoology. In about 1835 Cooke was visiting antique dealers in Wardour Street with his friend and the watercolourist Thomas Cromek, selecting items to be included in this picture. In May 1835 he made colour sketches of his room, borrowing china jars from his neighbours, and, according to his diary, 'went to several Jews shops and bought silk for my old chair'; on 28 May, 'to Town . . . I took up old pictures and old clothes, made exchanges with Jews in Princes St for China Jar, Carvings, Helmet &c'. He also records Sheepshanks inspecting the progress of the painting.

Wainwright has suggested that Cooke based his idea on the description of Jonathan Oldbuck's study in Sir Walter Scott's novel *The Antiquary* first published in 1816, a room 'obscurely lighted . . . a chaos of maps, engravings, scraps of parchments, bundles of papers, pieces of old armour . . . the floor as well as the table and chairs was overflowed by the same *mare magnum* of miscellaneous trumpery'. As Wainwright comments, it is 'a dreadful warning of how collections can take over the lives of their creators . . . Cooke's painting depicts the centre of Oldbuck's study and portrays in great detail the chaos of a collection already out of control'.

There is a watercolour study for the centre of the painting in the V&A collections, and a study of armour possibly also related, both from the Sheepshanks Gift (FA105 and 107). For a similar antiquarian interior, see under William Fettes Douglas, 'The Alchemist', 67-1873, p71.

EXH:   BI 1836 (24); *Edward William Cooke* Guildhall Art Gallery 1970 (131)

LIT:   *Connoisseur* January 1977, pi (detail repr in colour on cover); C Wainwright 'Myth and Reality: Sir Walter Scott and his Collection – 1' *Country Life* 16 September 1982, p806 (repr fig 6); C Wainwright *The Romantic Interior in England 1750–1850* (1989)

*Mont Saint Michel, Normandy*   FA43

### Mont Saint Michel, Normandy
FA43   Neg FD897
Canvas, 54.6 × 80 cm (21½ × 31½ ins)
Signed and dated
Sheepshanks Gift 1857

In the *Ledger* as painted at Barnes and Redleaf, and bought by Sheepshanks for 60 guineas. Exhibited at the BI in 1838, the size given in the catalogue as '32 by 42 inches'. Cooke made the first of many trips to Normandy in 1830; he first visited Mont Saint Michel in 1833. On the back of the canvas is a chalk sketch for 'Brighton Sands', (FA41, p41).

EXH:   BI 1838 (78)

### A Mackerel on the Seashore
FA44    Neg HB2563
Panel, 17.3 × 25.4 cm (7 × 10 ins)
Signed and dated 'E W Cooke./May 1837.' diagonally bl
Sheepshanks Gift 1857

In the *Ledger* with works of 1837, as painted at Barnes as a gift to
Sheepshanks, who paid for the frame (£1 4s). The date on the painting has
been previously incorrectly read as 1827. The diary records on 26 May 'Made
a study of Mackerel on a small panel', probably in preparation for the picture
'Net Profit'.

*A Mackerel on the Seashore*    FA44

### Portsmouth Harbour – The Hulks
FA45    Neg 59314
Panel, 29.9 × 40.6 cm (11¾ × 16 ins)
Sheepshanks Gift 1857

In the *Ledger* among works of 1836 as 'The Topaze Hulk. Ports<sup>mo</sup> Harbour
with Frigate alongside', painted at Barnes, and bought by Sheepshanks for
£30. Cooke recorded in his diary on 10 June 1836: 'I began picture of hulks in
Portsmouth Harbour' and on 29 June 'to Blackheath with picture of Hulks to
show Mr Sheepshanks. He became its purchaser'. On 30 June he took it to
Finden, who was to engrave it. It was exhibited at the BI in 1837 as 'Rigging
– Hulk and Frigate at Portsmouth', the size given in the catalogue as '21 by 24
inches'. There is a watercolour sketch for the painting in the V&A
collections, also from the Sheepshanks Gift (FA106).

*Portsmouth Harbour – The Hulks*    FA45

Exh:   BI 1837 (19); *Op de Rede: het leven aan de waterkant in Europese
        Havens* (Life on the Waterside in European Harbours) Antwerp 1973
        (E22)

Engr:  E F and W Finden, in *Ports, Harbours and Watering Places* 1838

### Old Hastings
FA46    Neg HB2564
Millboard, 25.4 × 35.6 cm (10 × 14 ins)
Sheepshanks Gift 1857

In the *Ledger* with paintings of 1835 as 'Hastings from Minnis Rock', painted
at Hastings and bought by Sheepshanks for £21. Cooke reported in his diary
on 9 October 1834 that he began a 'picture on the spot of Hastings from the
Minnis Rock'; he had been invited to Hastings by John Sheepshanks. He
visited Hastings again in April 1835. The view is towards the sea, past All
Saints church on the left.

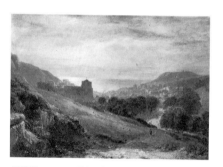

*Old Hastings*    FA46

### Windmills, Blackheath
FA47    Neg HB2565
Paper, 17.8 × 28 cm (7 × 11 ins)
Sheepshanks Gift 1857

In the *Ledger* as 'Mills at Blackheath. Sketch from Nature', painted at
Blackheath 4 September 1835 as a gift to Sheepshanks. According to his
diary, he had gone to stay with Sheepshanks at Blackheath on 11 August,
and recorded that he painted 'Drewitt's Mill' and copied Constable's
'Hampstead Heath' (presumably either FA35 or 36, also in the Sheepshanks
Gift to the museum). There is also a watercolour of the subject in the V&A
collections, from the Sheepshanks Gift; this, and the watercolours relating to
FA39, 40, 41, 42, and 45 (pp41–43) may well have been gifts from Cooke to
his patron Sheepshanks.

*Windmills, Blackheath*    FA47

Lit:   T H Ward *English Art in the Public Galleries of London* 1888, II, repr
        p173

*Chub*   FA48

*Portsmouth Harbour, with the
'Victory'*   FA49

*The Cleopatra Cylinder Vessel*   1294-1886

## Chub

FA48   Negs HF3975, HF4868
Millboard, 38.1 × 50.8 cm (15 × 20 ins)
Sheepshanks Gift 1857

In the *Ledger* as 'Fish subject. Chub', painted at Redleaf as a gift for
Sheepshanks.

Exh:   *19th Century English Art* New Metropole Arts Centre, Folkestone,
1965 (104)

## Portsmouth Harbour, with the 'Victory'

FA49   Neg 70995
Panel, 29.8 × 40.6 cm (11¾ × 16 ins)
Sheepshanks Gift 1857

In the *Ledger* among paintings of 1836 as 'Entrance to Ports$^{mo}$ Harbour',
bought by Sheepshanks for 25 guineas. He made an etching of the same
subject in 1828, published in the volume *Shipping and Craft* in 1829 (in the
V&A collections, E4556-4605-1902).

Exh:   *British Empire Exhibition* Wembley 1924; *Victorian Painting* Mitsukoshi
Gallery, Tokyo, 1967

## The Cleopatra Cylinder Vessel

1294–1886   Neg 71022
Canvas, 87.6 × 137.2 cm (34½ × 54 ins)
Signed and dated 'E W Cooke/1878 br
Bequeathed by Sir Erasmus Wilson FRS 1886

In the *Ledger* under 1878, as painted at his home in Glen Aldred,
Groombridge, Kent; no 'possessor' is listed. The diary records work beginning
on the design on 14 January 1878, and on the painting itself on 7 February;
on 2 April he was painting 'till dark' to complete it for the RA exhibition.
Exhibited at the RA in 1878 with the full title 'The "Cleopatra" in the Bay of
Biscay, on the 14th October, 1877, signalling the "Olga" to cast off the
tow-rope', together with a quotation from Longfellow's *The Building of the
Ship* (1849):

> Staunch and strong, a goodly vessel,
> That can laugh at all disaster,
> And with wave and whirlwind wrestle.

The donor, Sir William James Erasmus Wilson (1809–84), an eminent
surgeon, was an amateur Egyptologist who defrayed the expenses – about
£10,000 – of transporting the obelisk known as Cleopatra's Needle to
London. The obelisk, which dates from about 1500 BC, the reign of
Thutmose III, was sent as a gift by the Egyptian government, and is now on
the Embankment of the Thames. The journey of the 180-ton obelisk from
Alexandria proved hazardous; Sir James Sexton wrote in his autobiography:

> We were homeward bound in the tramp steamer *Fitzmaurice* when we
> sighted, in the Bay of Biscay, what appeared to be some strange derelict,
> or possibly the carcass of a huge whale . . . we found the derelict was
> really a huge steel case, ship-shaped, with the name 'Cleopatra' painted
> on it . . . We took the thing in tow, two of my mates and myself
> remaining on it as a kind of prize crew, and got it into a Spanish port,
> where we left it for whoever could establish ownership rights . . . We
> learned, afterwards, that the ocean tug *Olga* had been compelled to
> abandon the relic, which she was towing from Alexandria, after she had
> lost several men (*Sir James Sexton, Agitator* 1936, pp64–5).

Cooke shared Sir Erasmus Wilson's interest in Egyptian artefacts. Sir Erasmus

is supposed to have commissioned the artist to paint the picture; however, he is not listed in the *Ledger*, and the painting was for sale in Liverpool (for £630) in 1878 (see *Exh*: below). What is presumably the same picture, with the title 'The "Cleopatra" Cylinder Vessel in a hurricane in the Bay of Biscay, on the 14th October, 1877, signalling the steamship "Olga" to cast off the tow-rope', was sold by the artist's executors at Christie's 11 March 1882 for £162 15s. The sale catalogue, like the *Ledger*, records that the painting had been exhibited in Sydney, Australia, in 1879. Cooke was awarded a bronze medal at this International Exhibition for this picture, and two others.

PROV:   Christie's 11 March 1882 (150), bought Vokins for £162 15s;
        presumably bought from the dealer Vokins by Sir Erasmus Wilson,
        and bequeathed to the museum 1886

EXH:    RA 1878 (330); *Autumn Exhibition of Modern Pictures* Walker Art
        Gallery, Liverpool, 1878 (332); Sydney, Australia, 1879; *Edward
        William Cooke* Guildhall Art Gallery 1970 (13)

# COPE, Charles West, RA (1811–1890)

Born Leeds, Yorkshire, 28 July 1811, son of Charles Cope, a landscape watercolourist and friend of the collector John Sheepshanks. Briefly at school in London, then Leeds Grammar School. Returned to London 1827 to study at Sass's art school and 1828 at RA Schools. Travelled to Paris 1832 and Italy 1833–5. Exhibited 134 works at the RA between 1833 and 1882, 14 at the BI 1836–43, and one at the SBA 1837. Nearly all his paintings were literary, biblical or historical subjects and domestic genre; the fact that he was Roman Catholic may explain his choice of many of the subjects. Founder member of the Etching Club in about 1840. Awarded one of the three first prizes in the 1843 competition for the new Palace of Westminster decorations with 'An Early Trial by Jury'; travelled again to Italy to study fresco painting before painting several frescos at Westminster. Elected ARA 1843, RA 1848; appointed Professor of Painting at the RA 1867, and examiner in painting for the South Kensington Schools of Art 1870. Visited America and Canada 1876. Died Bournemouth, Hampshire, 21 August 1890.

LIT:    *Art Journal* 1869, pp177–9; C H Cope *Reminiscences of Charles West
        Cope RA* 1891 (referred to below as *Reminiscences*)

**Palpitation**
FA52   Neg 78099
Panel, 76.2 × 57.8 cm (30 × 22¾ ins)
Signed and dated 'C W Cope 1844' on the tablecloth
Sheepshanks Gift 1857

*Palpitation   FA52*

According to the *Reminiscences*, sold to John Sheepshanks before being exhibited at the RA in 1844. It is described in the *Reminiscences* as 'a young lady waiting for her letter, while the postman and servant are gossiping on the doorstep', but there is a deliberate ambiguity in the situation depicted which is typical of Cope's work in this genre, an ambiguity that would have been enjoyed by his audience if not by art historians today.

The *Athenaeum* called Cope 'almost the only man of his day who can be praised as the possessor of an affluent fancy', while the *Art Union* commented on the subject:

> The receipt of letters is at all times a home subject of anxiety to the
> female bosom. Here, we may presume the little hope indulged under
> circumstances not uncommon to young ladies . . . the extreme anxiety
> pictured in the girl's countenance enlists the best wishes of the spectator

on her side – he shares her solicitude: and this is a good criterion of the excellent of the picture.

It is unclear whether the palpitation of the title is caused by the woman awaiting a letter from her illicit lover which she was hoping to intercept (the whip hanging from the stag's horns and the hat on the table suggest a man already in the household) or from a more legitimate suitor.

Other details in the picture may be significant. The decorative phial of smelling salts (presumably) that she is holding, and the bag, umbrella and glove dropped on the floor, heighten the sensation of suspense. The glove may be a symbol of open self-expression, as well as challenge, as was traditional. On the door, the lock, chain casing, and two bolts attract the viewer's attention. The antlers mounted on the wall may refer to the traditional symbol of fertility or cuckoldry. There is a chalk study (22.2 × 20.4 cm/8⅞ × 8⅛ ins), for the principal figure's head in the V&A collections (FA20).

Exh:　RA 1844 (264); *Victorian Narrative Paintings* V&A circulating exhibition 1961; *Victorian Painting* Mitsukoshi Gallery, Tokyo, 1967

Lit:　*Athenaeum* 25 May 1844, p483; *Art Union* 1844, p159; *Reminiscences* pp165, 378

*The Young Mother*　FA53

### The Young Mother
FA53　Neg S1715
Panel, painted on a gesso ground, 30.5 × 25.4 cm (12 × 10 ins)
Signed and dated 'C W Cope 1845' br
Sheepshanks Gift 1857

According to the *Reminiscences*, exhibited at the RA in 1846 where it was 'well hung in corner of great room' and sold to John Sheepshanks.

The *Art Union* critic thought it 'a simple subject, which is treated with infinite sweetness'; the *Athenaeum*, 'simple and unpretending though it be, [it] is full of the gentle refinement which springs under the brush when the artist unaffectedly gives way to the feelings of tenderness inspired by maternal affection nursing the baby in its fond embrace'. It seems to be an unusual subject for painting in the mid-19th century.

Exh:　RA 1846 (102); *Exposition Universelle* Paris 1855 (769 or 770, both 'Une Mère et Son Enfant' lent by J Sheepshanks)

Lit:　*Athenaeum* 16 May 1846, p504; *Art Union* 1846, p174; *Reminiscences*, pp165, 379

*The Hawthorn Bush*　FA54

### The Hawthorn Bush
FA54　Neg V1937
Canvas, 87.6 × 106.7 cm (34½ × 42 ins)
Signed and dated 'C W Cope 1842' br
Sheepshanks Gift 1857

Exhibited at the RA in 1842, where, according to the *Reminiscences*, it was hung in the right corner of the middle room (the West Room according to the RA catalogue), and was bought by John Sheepshanks.

No title was given in the exhibition catalogue, but the quotation:

The hawthorn bush, with seats beneath the shade,
For talking age and whispering lovers made – Goldsmith.

The quotation is from the opening verse of Oliver Goldsmith's famous poem *The Deserted Village* (1770). Cope first treated the subject as one of a series of etched illustrations to the poem published by the Etching Club in 1841; a copy of the etching is in the V&A collections. Another etching in the series 'The Schoolmaster', was also worked up into a painting and exhibited at the RA in 1842 (8).

The *Art Journal* critic described it as 'perhaps the best of his lighter poetical subjects'. The picture was painted with mastic megilp, and has badly cracked, notably around the heads of the young lovers. The paint is also badly rubbed for half an inch along the top and bottom edges of the canvas.

Exh:   RA 1842 (507)

Lit:   *Art Journal* 1857, p240; *Reminiscences*, pp136, 378

## Maiden Meditation
FA55   Neg HF4821
Canvas, on a gesso ground, arched top, 54 × 39.4 cm (21¼ × 15½ ins)
Signed and dated
Sheepshanks Gift 1857

*Maiden Meditation   FA55*

According to the *Reminiscences*, sold to John Sheepshanks before being exhibited at the RA in 1847.

The *Athenaeum* thought the artist's 'power is not fairly displayed' in this or his other 1847 exhibit, 'A Subject from the Psalms'. The *Art Journal* critic was more admiring:

> This work is painted from a passage from *Isaiah*: 'I will greatly rejoice in the Lord, for he hath clothed me with a robe of righteousness'. The principal figure – a maiden kneeling in the attitude of devotion – is more allusive to prayer than to meditation; 'the robe of righteousness' is about to be cast over her by a retiring figure behind her impersonating the Redeemer. This literal rendering of the text is beautiful and impressive in its touching simplicity. The features of the maiden are lighted up with the fervour of admiration; but it is to be observed that it is extremely stiff and formal – the only weakness in this strikingly original production.

The full text, from *Isaiah* chapter 61 verse 10, is: 'I will greatly rejoice in the Lord, my soul shall be joyful in my God; for He hath clothed me with the garments of salvation, He hath covered me with the robe of righteousness, as a bridegroom decketh himself with ornaments, and as a bride adorneth herself with her jewels'.

Exh:   RA 1847 (43) ; *Exposition Universelle* Paris 1855 (767, as 'Jeune Fille en Meditation', lent by J Sheepshanks)

Lit:   *Athenaeum* 22 May 1847, p552; *Art Journal* 1847, p186; *Reminiscences* pp166, 379

## Beneficence
FA56
Panel, 69.9 × 45.1 cm (27½ × 17¾ ins)
Signed and dated 'C W Cope 1840' br
Sheepshanks Gift 1857

*Beneficence   FA56*

Painted for John Sheepshanks, and exhibited at the RA in 1840 with no title given in the catalogue, but the quotation 'Help thy father in his age, and despise him not when thou art in thy full strength'. No source for the quotation is given, but a similar sentiment is expressed in the Apocrypha, *Book of Ecclesiasticus* Chapter 3 verse 12: 'My son, help thy father in his age, and grieve him not as long as he liveth'.

It is a pendant with 'Almsgiving' (see FA57, p48); according to the *Reminiscences* they were hung together under the line (that is, below eye-level) in the Great Room at the 1840 RA exhibition. The *Athenaeum* critic noted that the picture illustrated the virtue of obedience, but preferred and discussed more fully the pendant.

The 1977 Bristol exhibition catalogue notes that the ivy in the foreground is a symbol of longevity and also of dependence, 'typically of

female dependence, but here used to comment on the reversal of roles that ageing compels between the generations'. The setting and the costumes suggest Italy in the Renaissance, 16th century in general style.

Exh: RA 1840 (198); *Victorian Narrative Painting* Bristol Cathedral 1977 (10)

Lit: *Athenaeum* 16 May 1840, p401; *Reminiscences* p377

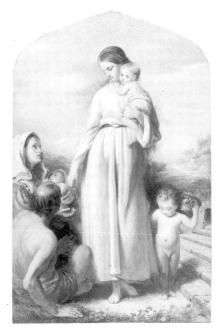

*Almsgiving* FA57

**Almsgiving**
FA57   Neg HF3976
Panel, 69.9 × 45.7 cm (27½ × 18 ins)
Signed and dated 'C W Cope/1839' on bottom step br
Sheepshanks Gift 1857

Painted for John Sheepshanks, and exhibited at the RA in 1840 with the following quotation appended to the title in the catalogue: 'Reject not the affliction of the afflicted, neither turn away thy face from a poor man'. No source for the quotation is given, but it may be an adaptation from the Apocrypha, *Book of Ecclesiasticus* Chapter 4 verse 5: 'Turn not away thine eyes from the needy, and give him none occasion to curse thee'.

It is a pendant with 'Beneficence' (FA56, p47). The *Athenaeum* critic commented:

Stothard might have designed that delicate white-robed figure, with one babe in her arms, and another creeping close at her side . . . The old head behind her is beautiful in its contrast – more than beautiful, even pleasing . . . More than one technical defect might be charged upon this picture; but the feeling displayed in it must soften and elevate those who look on it; and in as much effect is wrought on the gazer, the artist's work is a good one, and his spirit worthy of all praise. The simple and holy affections are too rarely touched – how much more rarely expressed – by our painters!

The head of the woman giving alms and the pose of the male beggar may have been adapted from Raphael's famous cartoon for the Sistine tapestry, 'The Healing of the Lame Man at the Gates of the Temple', then in the Royal Collection (since 1865 on loan to the V&A).

Exh: RA 1840 (204); *Artist at Work* Hampstead Arts Centre 1966 (47)

Lit: *Athenaeum* 16 May 1840, p401; *Reminiscences* p377

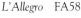

*L'Allegro* FA58

**L'Allegro**
FA58   Neg 54207
Panel, 71.1 × 46.4 cm (28 × 18¼ ins)
Signed and dated 'C W Cope 1848' br
Sheepshanks Gift 1857

Exhibited at the RA in 1848 (the year of the artist's election to full Academician), and according to the *Reminiscences* sold to John Sheepshanks before the exhibition opened. Appended to the title in the RA catalogue was line 24 of Milton's 1632 poem: 'So buxom, blithe, and debonair'. Milton is calling upon Euphrosyne the goddess of Mirth. It is a companion to 'Il Penseroso' (see FA59, p49), which is painted on canvas.

The *Art Union* commented:

To his conception of Euphrosyne (so called in Heaven) the artist adds a pleasant and original conceit, that of the nymph determinedly closing her ear with her hand against the counsels of Love; and thus are illustrated in the lines 'Haste thee nymph, and bring with thee/Jest and youthful Jollity,/Quips and Cranks, and wanton Wiles,/Nods and Becks, and Wreathed Smiles' [lines 25–8]. There is a classic taste in the reading

of the subject, which consists with the spirit of the verse. The drapery of the figure is blue, but it clings too closely to the form, which downwards would have been improved and supported by greater breadth. It is however a production of a high degree of merit; indeed, to realise after Milton with any amount of success, is an evidence of no common standard.

For the *Examiner*'s comments, see FA59, below.

While Waagen in 1854 thought 'The brilliant colouring of this attractive picture shows the study of Paul Veronese and of Mulready', Pointon in 1970 considered it, and 'Il Penseroso', 'very sentimental'.

EXH:   RA 1848 (240)

LIT:   *Examiner* 1848, p325; *Art Union* 1848, p170; *Reminiscences* p379; G Waagen *Treasures of Art in Great Britain* 1854, II, p305; M Pointon *Milton and English Art* 1970, p208

REPR:   F T Palgrave *Gems of English Art* 1869, colour frontispiece

## Il Penseroso
FA59   Neg 54208
Canvas, 71.1 × 46.4 cm (28 × 18¼ ins)
Signed and dated 'C W Cope/1848' bl (not 1847 as in the 1907 catalogue)
Sheepshanks Gift 1857

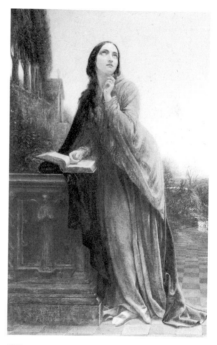

*Il Penseroso*   FA59

Exhibited at the RA in 1848, and according to the *Reminiscences* sold to John Sheepshanks before the exhibition opened. The RA catalogue gives the title as 'From Il Penseroso', with lines 11–12 and 37–42 from Milton's 1632 poem:

But hail, thou goddess, sage and holy,
Hail, divinest Melancholy.

* * *

Come, but keep thy wonted state,
With even step, and musing gait;
And looks commercing with the skies,
Thy rapt soul sitting in thine eyes:
There, held in holy passion still,
Forget thyself to marble.

The poem is an invocation to the goddess Melancholy to bring the poet a life of quiet study and meditation. Like the poem, it is a companion to 'L'Allegro' (see FA58, p48, which is painted on panel).

The *Examiner* critic believed it 'seems to promise that time and study will impart to future compositions, as able in the mechanical details as his "Wolsey" [also exhibited at the 1848 RA], that imaginative sentiment in which the latter is deficient. His "Allegro", a good piece of painting, is not equal to the "Penseroso". Allegory has weakened it'. The *Art Union* thought it

The most profoundly sentimental figure that the artist has ever painted; it is a pendant to 'L'Allegro', but more successful. It is evening – deepening twilight – and the figure is seen leaning on a tomb, having a book before her, from which she has raised her eyes, and looks upwards. This picture is a passage of true poetry, an embodiment of the spirit of the verse, which cannot be excelled in pathetic truth.

Cope exhibited a painting entitled 'Penserosa' at the RA in 1855; he also exhibited there 'Milton's Dream' in 1850. Subjects for the competitions for the decoration of the new Palace of Westminster in the 1840s included the life and work of Milton, along with Shakespeare, Spenser, and British history. For an extensive survey of the interpretation of Milton's works by English artists, and a list of lesser-known artists who exhibited Milton subjects 1820–50, see Pointon's book cited below.

ExH:   RA 1848 (262)

Lit:   *Examiner* 1848, p325; *Art Union* 1848, p170; Waagen *Treasures* 1854,
       II, p303; M Pointon *Milton and English Art* 1970, p208

## Mother and Child

FA60   Neg 59104
Canvas, on a gesso ground, 36.2 × 25.4 cm (14¼ × 10 ins)
Signed and dated 'C W Cope 1852' bl
Sheepshanks Gift 1857

According to the *Reminiscences*, exhibited at the RA in 1853, where it was
hung in the left-hand corner of the large room, and bought by John
Sheepshanks. The *Art Journal* critic called it 'simple, substantial, and worked
out with scrupulous nicety'.

The picture was lined in an unfinished state, turning the greys brown-
green, so they had to be repainted.

ExH:   RA 1853 (80); *Exposition Universelle* Paris 1855 (769 or 770, both
       'Une Mère et Son Enfant', lent by J Sheepshanks)

Lit:   *Art Journal* 1853, p143; *Reminiscences* pp202, 381

## Fra Angelico (?after C W Cope)

1142-1868
Canvas, 265.5 × 87.6 cm (104¼ × 34½ ins)
Inscribed
Transferred to the Department

For details of the history and circumstances of the commission see p14.

This is most likely the enlarged copy by Francis Woolaston Moody
(1824–86) after a design by Cope, referred to in a letter dated 24 March 1865
in the museum files. Cope exhibited 'Fra Beato Angelico. Study of a figure to
be executed in mosaic' at the RA in 1865 (171); this is noted in the
*Reminiscences* as 'A small figure of Fra Angelico for a wall at South
Kensington, afterwards executed, life-size, in mosaic, sent to the Royal
Academy [exhibition], and presented to that body . . . '

Cope's 'study', which has the appearance of a finished painting, is still in
the RA collection (oil on canvas, arched top, 130.8 × 40.6 cm/(51½ × 16
ins), signed and dated 'CWC [in monogram]/1865' on gold background br).
The *Athenaeum* critic thought that 'although but a sketch, [it] promises
nothing that is excellent, whether as regards colour or character; it is badly
drawn and inapt to the subject'. The description of the work as a sketch is
puzzling: Cope perhaps worked further on the painting before presenting it to
the RA. The other criticisms have some foundation; the structure of the
figure is rather flaccid, and the loose contrapposto is unlike anything in Fra
Angelico's own work.

There are at least three known and comparatively reliable images
depicting the Italian Renaissance painter Frate Giovanni da Fiesole (c1400–
55), better known as Fra Angelico or 'Il Beato', as well as a tomb effigy in
Santa Maria Sopra Minerva, Rome. His portrait as a young man was painted
by Luca Signorelli in a fresco in Orvieto Cathedral (in which the features are
very similar to Cope's depiction), in Raphael's 'Disputa' in the Vatican
Stanze, and was engraved as a prefatory illustration to Giorgio Vasari's life of
the artist. Perhaps the last would have been the most accessible image for
Cope's portrait.

The lilies, on the left, are a traditional symbol of chastity and are also
associated with the Annunciation, a subject often painted by Fra Angelico.
The lily is also the attribute of St Dominic, the founder of the Order in which
Fra Angelico was a friar.

Lit:   *Athenaeum* 6 May 1865, p627; *Reminiscences* p254

*Mother and Child*   FA60

# CORBOULD, Alfred Hitchens (active 1844–1864)

Although very little is known about this artist, he was presumably related to the Corbould family of painters (see Edward Henry Corbould, below). They sent works to the RA from the same London address (Eldon Lodge, Victoria Road): Alfred between 1852 and 1864, and Edward between 1870 and 1874. Alfred Corbould exhibited twenty works at the RA between 1844 and 1864: portraits, landscapes, but mostly sporting subjects. Confusingly, another Alfred Corbould, exhibiting between 1831 and 1875, was also a sporting painter.

**Thomas Walford Grieve Aged 11**
P38-1981   Neg HJ787
Canvas, oval, 35 × 26.5 cm (13¾ × 10⅜ ins)
Signed and dated 'ALFRED H. CORBOULD. 1852' br
Given by Mrs Audrey Grieve 1981

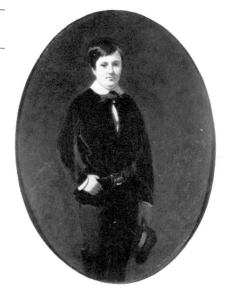

*Thomas Walford Grieve Aged 11*
P38-1981

**Bessie Grieve**
P39-1981   Neg HJ786
Canvas, oval, 30 × 25 cm (11¹³⁄₁₆ × 9⅞ ins)
Given by Mrs Audrey Grieve 1981

Both sitters were members of the famous family of theatrical designers. The Department holds a large collection of designs by the Grieves for Charles Kean's productions of Shakespeare and other plays at the Princess's Theatre, London, dating between 1853 and 1859. Miss Grieve, later Mrs Peter Hicks, compiled the Grieve family tree now in the British Library. Mrs Audrey Grieve also gave two watercolours to the Museum in 1981 by T W Grieve, both of Margate subjects (P36, P37-1981). Despite the difference in the size of the two portraits, it seems probable that they were painted at the same time and as companion pictures.

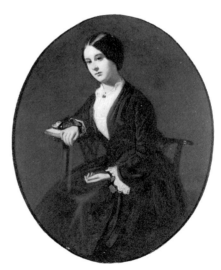

*Bessie Grieve*   P39-1981

*At Eglinton*   P5-1981

# CORBOULD, Edward Henry, RI (1815–1905)

Born London 5 December 1815, of a family of artists: grandson of Richard Corbould and son of Henry Corbould. Studied at Sass's art school and RA Schools (won medals at the Society of Arts 1834–56). Exhibited 17 works at the RA between 1835 and 1845, and 1870 and 1874, one at the BI 1846, and 11 (including sculptures and watercolours); at the SBA 1835–42. Principally a watercolourist, exhibiting about 250 works in a long career, his subjects included literature, mainly Chaucer, Spenser and Shakespeare, the Bible, and genre. Patronised by Prince Albert and appointed 'Instructor of Historical Painting' to the Royal family 1851. Designed many illustrations for books; several watercolours and drawings are in the V&A collections.

LIT:   *Art Journal* 1864, p98, 1905, p286 (obit)

**At Eglinton**
P5-1981   Neg HF814
Panel, 53.3 × 42.5 cm (21 × 16¾ ins)
Purchased 1981

Purchased as a portrait of Archibald William Montgomerie, 13th Earl of Eglinton and 1st Earl of Winton, dressed as Lord of the Tournament, but probably the work exhibited at the RA with the title 'At Eglinton' and the following quotation in the catalogue:

A Knight there was, and that a worthy man,
That fro the time that he firste began
To riden out, he loved chivalrie,
Trouthe and honour, freedom and curtesie.

The lines are from Chaucer's 'The Knight's Tale', one of the *Canterbury Tales*. That story concerns a tournament, and is surely quoted because of the famous Eglinton Tournament organised by the earl in 1839, a remarkable event which is described by Anstruther (see *Lit:* below). The DNB describes the earl as 'a high-minded nobleman and a thorough sportsman, with frank and genial manners, and no particular ability'. He was born in 1812, and died 1861. The painting was not noticed by the *Art Union* or *Athenaeum* critics.

The work was purchased in 1981 for its valuable depiction of Eglinton armour, an important phenomenon of the Gothic Revival. Oil paintings are now only acquired by the museum if they relate to some aspect of the decorative arts.

PROV: Purchased from the Christopher Wood Gallery 1981

EXH: ?RA 1842 (269); *William Morris and the Middle Ages* Whitworth Art Gallery, Manchester, 1984 (repr in cat, 10)

LIT: E H Corbould *The Tournament at Eglinton Castle* 1840; I Anstruther *The Knight and the Umbrella: An Account of the Eglinton Tournament 1839* 1963; *Van Dyck in Check Trousers* SNPG exhibition catalogue 1978, pp105–14

# CRESWICK, Thomas, RA (1811–1869)

Born Sheffield 5 February 1811; educated at Hazelwood, near Birmingham. Studied art with the landscape painter John Vincent Barber in Birmingham, and settled in London 1828. Exhibited 139 works at the RA between 1828 and 1870, 80 at the BI 1828–55, and 46 at the SBA 1829–38. Early landscapes were principally in Wales, Yorkshire and Cornwall, then Ireland (after a visit in 1837), and coastal scenes after 1848. An early member of the Etching Club, many of his works were engraved. Commissioned 1851 to paint an extensive series of views in north Wales. Elected ARA 1842, RA 1851. Admired particularly in the later 1840s and 1850s for his truth to nature and the charm of his compositions; later works were criticised for being too dark and brown in tone. Occasionally worked in collaboration with other artists such as Richard Ansdell and W P Frith. Died Bayswater, London, 28 December 1869; his studio sale was at Christie's 6–7 May 1870. The *Illustrated London News* obituarist wrote that his life and work were 'comparatively monotonous and devoid of incident'.

LIT: *Art Journal* 1856, pp141–4, 1870, p53 (obit); *The Graphic* 8 January 1870, pp121–2 (obit with engr portrait); *Illustrated London News* 8 January 1870, p53 (obit with engr portrait); C Collins Baker 'Thomas Creswick RA and Mid-Victorian Landscape Painters' *Art Journal* 1908, pp104–7

## Scene on the Tummel, Perthshire
FA61   Neg FF1310
Canvas, 91.5 × 71.1 cm (36 × 28 ins)
Sheepshanks Gift 1857

Exhibited at the RA in 1844. The well-known view is of the falls of the River Tummel, near Pitlochry. The Pass of Killicrankie is in the background, while the promontory on the left is the 'Giant's Steps'. This is a characteristic

*Scene on the Tummel, Perthshire*   FA61

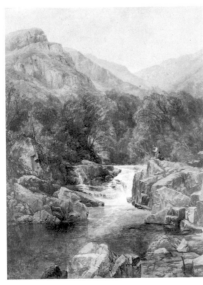

example of a favourite theme of the artist – a stream flowing through hilly landscape. Creswick specialised in such scenes in north Wales, the north of England, and Scotland. The *Art Union* critic wrote that 'the objects take their places in the composition with a more agreeable ease than in many of the painter's more imposing works'.

Exh:   RA 1844 (344)

Lit:   *Art Union* 1844, p161

### A Summer's Afternoon
FA62
Canvas, 101.6 × 127 cm (40 × 50 ins)
Signed and dated 'THO CRESWICK 1844'
Sheepshanks Gift 1857

Exhibited at the RA in 1844, and acquired by John Sheepshanks before 1850.

The *Art Union* critic was 'glad to observe that Mr Creswick is returning to colour in his foliage; and it is to be hoped he will resume the winning freshness of tint which characterised his productions a few years ago'. The *Athenaeum* was more enthusiastic: 'The painter has been called our English Hobbema, and in right of his "Summer's Afternoon" (486) he well deserves the name . . . It struck us, however, that this picture which, though of a chaste richness, is rather low in tone, suffers more than the generality of landscapes from its compeers'. In 1908, Collins Baker thought 'this striking example travelled for its inspiration back to the solemn tone and almost the classic sentiment of Wilson or Paul Sandby'; the clothes of the foreground figure and the arched bridge in the middle distance are also reminiscent of Richard Wilson.
   Like the 'Scene on the Tummel' (see FA61, p52), also exhibited in 1844, Creswick is painting a favourite theme, but in this case perhaps a generalised rather than an actual location.
   A smaller replica, said to have been painted in about 1869, was recorded in a London private collection in 1924.

Exh:   RA 1844 (486)

Lit:   *Athenaeum* 25 May 1844, p482; *Art Union* 1844, p161; *Collins Baker*, p106

### Mount Tom, Massachusetts, USA
580-1882   Neg GX2521
Panel, 17.8 × 25.4 cm (7 × 10 ins)
Jones Bequest 1882

An engraving by J T Willmore in N P Willis's *American Scenery* . . . (1840, II, facing p27) exactly reproduces this painting, and the lettering states that Creswick based it on a sketch by W H Bartlett. Most of the other illustrations in the two volumes were by Bartlett himself but a few were by Creswick after Bartlett. Mount Tom is situated at Easthampton, Hampshire County, West Central Massachusetts.
   There is no evidence that Creswick ever visited the USA. In the present case the painting presumably was based on Bartlett's sketch; there are two slightly larger pictures in the Yale Center for British Art, New Haven, USA: 'Figures on a Balcony, Westpoint' (which also seems to relate in some way to the engraving after a drawing by Bartlett for *American Scenery* . . ., and 'View on the Hudson River' (which was presumably the painting exhibited at the 1873 London International Exhibition (1268, 23 × 30.5 cm/9 × 12 ins, undated)). Another oil, the same size, relating to a plate in *American Scenery*, is in the Walker Art Gallery, Liverpool.

*Mount Tom, Massachusetts, USA*
580-1882

*Landscape with Classical Ruins* 1029-1886

**Landscape with Classical Ruins**
1029-1886
Canvas, 47.9 × 69.5 cm (18⅞ × 27⅜ ins)
Signed and dated 'T CRESWICK/1830.' bl
Dixon Bequest 1886

Only two similar subjects by this artist are recorded: 'An Italian Scene' exhibited at the RA in 1832 (368), and 'Ruins, Sunrise' at the BI in 1831 (242, size given as '15 by 18 inches', presumably including frame). The overall mood of the painting – a classically composed Italianate landscape with a woman in ancient costume seated on a fallen column, listening to a shepherd's pipes – is that of Claude (see for example 'The Marriage of Isaac and Rebekah', which had been bought by the NG in 1824), and of works by Richard Wilson.

*Land's End, Cornwall* 232-1890

**Land's End, Cornwall**
232-1890
Canvas, 92.1 × 130.2 cm (36¼ × 51¼ ins)
Signed and dated '1842' indistinctly on rock bl
Bequeathed by Miss Eleanor Robinson 1890

Exhibited at the BI in 1843 as 'Rocks at the Land's End'. The *Athenaeum* critic wrote that it depicted 'the last bleak rocks of England, and, beyond, an all but illimitable horizon of rippling green waters, suggesting the power and vastness of Nature's barrier . . . We have not often seen a more poetical picture . . .' The *Art Union*, however, thought 'parts of this production are very like nature, but, as a whole, it is the least interesting of all the accomplished painter's works. The sea does not to our minds look like sea'. When Collins Baker saw it at the V&A in 1908, he called it 'as conscientiously dull a seascape as any in that gallery. It is painted with extraordinary mechanical tightness, from inch to inch'. Spectators today find more to admire in the work; the handling is not as tight as Collins Baker believed, and the viewpoint of the scene is unusually powerful for a painting of its date.

Exh: BI 1843 (387); *Bicentenary exhibition 1768–1968* RA 1968 (215)

Lit: *Athenaeum* 18 February 1843, p165; *Art Union* 1843, p69; *Collins Baker*, p106; G Reynolds *Victorian Painting* 1966, p175 (repr pl 101)

# CRUIKSHANK, George (1792–1878)

Born London 27 September 1792, son of the caricaturist Isaac Cruikshank, with whom he trained as a graphic artist perhaps as early as 1799. After James Gillray's death 1815, he became the leading political caricaturist of the day. In the 1820s he turned to book illustration, receiving many commissions to provide plates for novels; the success of Dickens's *Sketches by Boz* (1830) was largely due to Cruikshank's designs. In the 1840s his success and reputation declined, especially with the advent of *Punch* (1841). Many of his later works are concerned with the cause of temperance, and he enjoyed considerable success with his series of prints 'The Bottle' (1847). A prolific maker of prints during a long working life (there is an extensive collection in the V&A), the number of works in oil is small; he exhibited eight at the RA between 1830 and 1867 and 15 at the BI 1833–60, the subjects principally literary and genre. Died London 1 February 1878; a good deal of his studio collection was presented to the V&A by his second wife Eliza.

LIT: G Reid *A Descriptive Catalogue of the Works of George Cruikshank*
3 vols, 1871; W Bates *George Cruikshank* 1878; B Jerrold *The Life of
George Cruikshank* new ed 1898; A Cohn *George Cruikshank: a
Catalogue Raisonné* 1924; *The Inimitable George Cruikshank* University
of Louisville Libraries, Kentucky, USA, exhibition catalogue 1968;
W Feaver *George Cruikshank V&A exhibition catalogue* 1974; H and M
Evans *The Man Who Drew the Drunkard's Daughter . . .* 1978; M Wynn
*George Cruikshank: His Life and London* 1978; G Buchanan-Brown *The
Book Illustrations of George Cruikshank* Newton Abbot 1980

## Cinderella

1405-1869   Neg 64360
Panel, 43.2 × 53.3 cm (17 × 21 ins)
Signed and dated 'George/Cruikshank/1854' on mousetrap bl
Townshend Bequest 1869

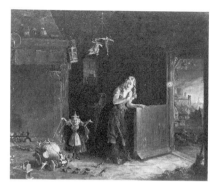

*Cinderella   1405-1869*

Exhibited at the RA in 1854. Cruikshank's *Fairy Library* was to be published
in monthly parts in 1853; in the event, four stories appeared: 'Hop O'my
Thumb' in 1853, 'Jack and the Bean Stalk' and 'Cinderella and the Glass
Slipper' in 1854, and 'Puss in Boots' in 1864. The stories were rewritten and
illustrated by the artist, as Jerrold states, 'with all the naughty things omitted,
and a strong dash of teetotalism added'. The first volume was attacked by
Charles Dickens in his magazine *Household Words* (October 1853); he
believed Cruikshank – 'our dear moralist' – had 'in a rash moment'
appropriated the stories 'as a means of propagating the doctrines of Total
Abstinence, Prohibition of the Sale of Spirituous Liquors, Free Trade and
Popular Education'. 'Cinderella' was illustrated with ten subjects in six
etched plates.

Cruikshank was aware of his shortcomings as a painter in oils; in April
1853 he briefly enrolled – at the age of 61 – as a student in the RA antique
class. A letter to George Putford in April 1854 (Huntington Library, San
Marino, California, quoted by Jones (pp104–5) refers to the painting of
'Cinderella':

> I have *just* finished a picture which I am just going to take to the Royal
> Academy. It is more like a picture than anything I have ever done – and
> everyone who has seen it pronounces it to be my *best*. You would be
> surprised at my improvement in oil, as indeed I am myself. I have got
> several commissions for pictures and so I shall dash on.

The *Art Journal* critic wrote of the painting that 'He develops as he
approaches seriousness – his real powers lie in severe narrative . . . It is
certainly, in every point, the very best production of the painter'. The
*Illustrated London News*, which reproduced 'Cinderella' in an engraving,
commented at some length:

> Not content with achieving great excellence as a designer, and an etcher
> or engraver of his own works, Mr Cruikshank, in his new lease of life, is
> determined to excel in painting in oils. He properly considers that a
> design which is good as an etching or engraving, will look as well upon
> canvas as upon paper. There is great truth in this position. But he is apt
> to forget that crude or ill-placed colours too often injure the effect of a
> design; that there are good pictures which will never engrave – and good
> engravings that will not engrave to any additional advantage.
> The admirers of Mr Cruikshank – and he has many, and none warmer
> than ourselves – have been pleased to see of late that he has chosen to
> dwell in fairy land – that he prefers Queen Mab and Cinderella, to
> Bond-Street dandies and the follies of the day. It would be difficult
> indeed to find a fitter artist to introduce to the Fairy Queen.

Cruikshank exhibited another 'Cinderella' at the RA in 1859 (842),
which seems to have been a watercolour (present whereabouts unknown).

Exh:　RA 1854 (9); *George Cruikshank* Arts Council 1974 (378)

Lit:　*Art Journal* 1854, p158; *Illustrated London News* 29 July 1854, p85
(repr p84); Jerrold, II, p259; M W Jones *George Cruikshank: His Life
and London* 1978, pp103–5

*Tam O'Shanter　72-1880*

### Tam O'Shanter

72-1880　Neg 57165
Canvas, 54.6 × 67.3 cm (21½ × 26½ ins)
Signed and dated 'GEORGE CRU[IK]SHANK [18]54' on window ledge tl
Presented by Mrs George Cruikshank 1880

Cruikshank exhibited two paintings of Tam O'Shanter in 1852, which may
be one and the same painting. At the BI, the catalogue gives the
measurements including frame as '29 by 34 inches', and the following
quotation appended to the title:

> And wow! Tom saw an unco sight!
> Warlocks and witches in a dance;
> A winnock-bunker in the east,
> There sat auld Nick, in shape o'beast;
> A Towzie tyke, black, grim and large,
> To gie them music was his charge.

The RA catalogue for 1852 gives another quotation: 'And scarcely had he
Maggie rallied,/When out the hellish legion sallied'.
　　Either quotation – from Robert Burns's famous poem *Tam O'Shanter*
(first published in 1793) – could apply to the present picture; the inscribed
date of 1854 may have been added later, although it seems unlikely.
　　The *Art Journal* described the BI painting as 'one of those highly-
coloured eccentricities which this artist has recently exhibited'.
　　The story of Tom O'Shanter suits Cruikshank's interests in both the
supernatural and the perils of alcohol. Tam, returning from market day in
Ayr, rides drunkenly through a storm; as he passes the haunted Kirk-
Alloway, he sees a scantily-clad girl dancing among a crowd of witches and
warlocks led by the devil playing the bagpipes. They chase Tam: he rallies his
horse Maggie, but 'out the hellish legion sallied'.

Exh:　?BI 1852 (421) and/or RA 1852 (1272); *George Cruikshank* Arts
Council 1974 (380, as undated but c1855); *Victorian Narrative
Painting* Bristol Cathedral 1977

Lit:　*Art Journal* 1852, p74

*Mrs George Cruikshank　AL8769*

### Mrs George Cruikshank

AL8769
Cardboard, 22.6 × 17.5 cm (8⅞ × 6⅞ ins)
Signed 'George Cruikshank' br
Presented by Mrs George Cruikshank 1891

The artist married his second wife, Eliza Widdison, in 1850. His epitaph in St
Paul's Cathedral concludes with lines written by her, dated 9 February 1880:
'This Monument/Is humbly placed within this sacred Fane/By her who loved
him best, his widowed wife'.
　　A portrait of the artist's mother, by an unknown artist, also bequeathed
by Mrs George Cruikshank, is also in the V&A collections (366-1891).

*Hades　9569*

### Hades

9569　Neg HF3740
Millboard, 20 × 25.4 cm (7⅞ × 10 ins)
Signed 'George Cruikshank' bl and inscribed on the back as below
Given by Mrs George Cruikshank 1884

As mentioned in the entry for 'Tam O'Shanter' (72-1880, p56), Cruikshank was very interested in the supernatural, and particularly the *diablerie* of texts such as Chamisso's *Peter Schlemiel* (which he illustrated for the edition of 1823-4). The present work is inscribed 'Tam O'Shanter' twice on the upper stretcher, presumably by the artist's wife, first in pen and then in pencil.

### Venus Rising from the Froth of the Sea
AL9570
Canvas, painted surface has an arched top, 30.5 × 25.1 cm (12 × 9⅞ ins)
Signed 'George Cruikshank' br and inscribed on the back as below
Given by Mrs George Cruikshank 1884

The title is that given on a label on the back, written in both pen and pencil, presumably by the artist's wife, and pasted on to the upper stretcher: 'Venus rising from the Froth of the Sea/By George Cruikshank and Signed'.

EXH: *George Cruikshank* V&A 1974 (383)

### Two Sketches of Colney Hatch, Hertfordshire
AL9770 A and B    Neg HF3739
Canvas, both 23.5 × 32.1 cm (9¼ × 12⅝ ins)
Inscribed on the back as below
Given by Mrs George Cruikshank 1884

Both works are inscribed by the artist's wife on a label pasted on to the upper stretcher. AL9770A is inscribed: 'This early Painting by the late George Cruikshank; and in the year 1828, the/little Wooden Bridge in it, was called Smith's Bridge at Colney Hatch, Herts./Septber. 2nd. 1884. E/Liza/.C.'.

The inscription for AL9770B reads: 'In the year 1828, at Colney Hatch/Herts, in a cottage within the Garden at the right hand side of the Oil/Painting (by George Cruikshank Artist) where the Gate Post and Palings are situated, he and his first wife/Mary Cruikshank resided for some time. E.C. Sept. 2nd. 1884'.

# DANBY, Francis, ARA (1793–1861)

Born Barony of Forth, near Wexford, Ireland, 16 November 1793, the son of a small farmer-landowner. Studied at the drawing schools, Royal Dublin Society; exhibited his first oil-painting there, moved briefly to London June 1813, then settled in Bristol, until returning to London probably early 1824. Exhibited 48 works at the RA between 1821 and 1860, and 17 at the BI 1820–52. His earlier Bristol works were landscapes and topographical views, but in about 1820 began literary and mythological themes, and biblical subjects in the epic manner of John Martin. Elected ARA 1825, and visited Norway. After difficulties with money, his marriage and the RA, moved abroad 1829, living in Paris and Geneva, until returning to London 1838. Exhibited 'The Deluge' (1837–40, now Tate Gallery) in 1840 with great success. Moved to Exmouth, Devon, 1847, where he died 9 February 1861. His studio sale was at Foster's 15 May 1861. Described in the *Athenaeum* obituary as 'England's most distinguished painter of the Romantic School'; his most characteristic works are 'poetical' landscapes, often depicting a sunrise or sunset and with a melancholic or stormy subject.

LIT:  *Art Journal* 1855, pp77–80, 1861, p118 (obit); *Athenaeum* 2 March 1861, p294 (obit); G Grigson *The Harp of Aeolus* 1947 [1948], pp66–78; H W Häusermann 'Francis Danby at Geneva', *Burlington Magazine* August 1949, pp227–30; E Adams *Francis Danby: Varieties of*

*Venus Rising from the Froth of the Sea*   AL9570

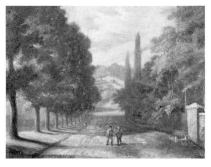

*Two Sketches of Colney Hatch, Hertfordshire*   AL9770 A and B

*Poetic Landscape* 1973; F Greenacre *The Bristol School of Artists* City of Bristol Museum and Art Gallery exhibition catalogue 1973, pp33–41; A Staley 'Francis Danby' (review of Adams's book), *Burlington Magazine* November 1975, pp732–5; F Greenacre *Francis Danby* Tate Gallery and City of Bristol Museum and Art Gallery exhibition catalogue 1988 (with full bibliography)

*Disappointed Love*   FA65

## Disappointed Love

FA65   Neg 56059
Panel, 62.8 × 81.2 cm (24¾ × 32 ins)
Signed 'F Danby'
Sheepshanks Gift 1857

The artist's first exhibited work at the RA, in 1821, and one of his best-known paintings. Adams suggests that the landscape was studied on the outskirts of Bristol on the banks of the River Frome, while the figure may have been taken from a model at the Bristol artists' newly founded Life Academy.

From the beginning, critics admired the picture's 'poetical invention' while attacking its technical faults, particularly the lack of proportion in the foreground plants, the drawing of the figure, and the overall heaviness of colouring. Ackermann thought 'A deep, gloomy and pathetic influence pervades the picture . . . There are, however, defects in the executive part of his work, which might be obviated by more attention'. The Redgraves agreed, and in 1833 Horne gave this detailed account of the Academicians' original reaction:

> An unknown artist about ten years ago, sent a very badly painted picture for the exhibition. The committee laughed, but were struck by 'something' in it, and gave it admission. The subject was this. It was a queer-coloured landscape, and a strange doldrum figure of a girl was seated on a bank, leaning over a dingy duck-weed pool. Over the stagnant smeary green, lay scattered the fragments of a letter she had torn to pieces, and she seemed considering whether she should plump herself in upon it. Now, in *this* case, the Academicians judged by the same feelings that influence the public. There was more 'touching' invention in that than in nine-tenth of the best pictures exhibited there the last we do not know how many years. The artist is now eminent.

As Adams points out, the unnatural size and wilting condition of the plants are deliberate and symmetric, while the 'frail angularity of the girl . . . is indispensable to the mood of the picture and is one of the things that save it from sliding out of pathos into sentimentality'. The symbolism of the foreground vegetation is heightened by its botanical detail, and Adams proposes the influence of Erasmus Darwin's poem *The Loves of the Plants* (published in two parts, 1789 and 1791) which seems to have suggested the subject of Danby's 1820 painting of 'The Upas, or Poison-Tree' (see 1382-1869, p62). The poem deals with the sexual reproduction of plants, and put forward Darwin's theory that plants could experience pleasure and pain; Adams convincingly suggests that 'Disappointed Love' 'is in part a romantic illustration of Darwin's parallel between human and vegetable love'.

The contemporary 19th-century comments on the unattractiveness of the girl are difficult to justify or even understand today, and culminated in the dreadful story told by Redgrave (12 December 1856): 'Stopping before Danby's "Disappointed Love"; Lord Palmerston, though he was evidently impressed by the deep gloom of the scene, said that it was a pity the girl was so ugly. "Yes", replied Mr Sheepshanks, "one feels that the sooner she drowns herself the better" '. A seated woman is a traditional representation of melancholy, and Greenacre (1973) stresses the importance of J G Zimmerman's *Treatise on Solitude*, which Danby very possibly knew.

Adams discusses fully the sources for Danby's painting: the influences of

Bristol artists such as E V Rippingille on the anecdotal details (the torn letter, the locket with a miniature portrait), of Wright of Derby's 'Lady in "Comus" ' (1784, Walker Art Gallery, Liverpool) on the relationship between the figure and the landscape, and even of certain figures in William Blake's illustrated books. George Cumberland was a friend of both Blake and Danby, and owned many of Blake's illustrated books. There is also an obvious connection with English Romantic poetry, especially the introspective melancholy of Shelley, Keats and Coleridge; Adams cites particularly the latter's *The Picture: or the Lover's Resolution* (1802, republished Bristol 1817). Greenacre draws attention to George Cumberland's illustrated poem *Lewina, the Maid of Snowdon* 1793 and its frontispiece, and to an engraving after a drawing by Edward Bird (a friend of Danby) published in 1809 illustrating the lines from James Thomson's *The Seasons* – 'With firm, clasp'd hands and visage downward bent . . .'

PROV: John Sheepshanks by 1850 (included in 1850 handlist); given by him to the museum 1857

EXH: RA 1821 (210); *Exhibition of a Selection of Works by Irish Painters* Guildhall 1904 (83); *Irish International Exhibition* Dublin 1907 (188); *English Romantic Art* Arts Council 1947 (68); *The First Hundred Years of the Royal Academy* RA 1951-2 (313); *The Romantic Movement* Arts Council and Council of Europe, Tate Gallery, 1959 (93); *Francis Danby* Arts Council, Bristol, Birmingham, Bradford, 1961 (3); *The British School of Artists* City of Bristol Museum and Art Gallery 1973 (7); *Francis Danby* Tate Gallery and City of Bristol Museum and Art Gallery 1988–9 (19)

ENGR: Adams notes an otherwise unrecorded engraving, an unlettered proof of 1825 or later, in the British Museum; it is inscribed in the margin 'Francis Danby A.R.A. pinxt,' and on the plate 'F. Danby 1831' (repr Greenacre 1988, p159)

LIT: *Ackermann's Repository of the Fine Arts* XI, 1821, p367; R H Horne *Exposition of the False Medium and Barriers excluding Men of Genius from the Public* 1833, p267; *Redgrave Cent*, pp440–2; F M Redgrave *Richard Redgrave, CB, RA: A Memoir* 1891, p170; *Adams* pp17–26, no 6; *Greenacre* 1973, pp48–9; *Greenacre* 1988, pp91–3

## The Enchanted Castle

FA66   Negs 71925, GE2731
Canvas, 83.8 × 116.8 cm (33 × 46 ins)
Signed 'F. Danby' bl
Sheepshanks Gift 1957

*The Enchanted Castle*   FA66

Previously catalogued as 'Calypso Grieving for her Lost Lover' and dated about 1825, but correctly identified by Adams as 'The Enchanted Castle – sunset' exhibited at the RA in 1841 with the unattributed quotation appended to the title in the catalogue: 'O! how can mortals hope for bliss,/When fairies grieve in place like this'.

The new identification rests on the fact that the subject of Psyche, Eros, and the enchanted castle, fits the painting, while that of Calypso does not; the confusion seems to have begun with the mis-cataloguing of the picture prior to its sale in 1852 (see *Prov:* below). Furthermore, the *Athenaeum* review of the 1841 exhibition described Danby's painting as 'very affected, too, in its orange tones and the formal shapes of the trees. Nevertheless, it is a picture to which Tennyson might write a ballad – so rich an air of Faëryism is diffused over it'.

The story of Psyche is taken from *The Golden Ass*, a satirical allegory by the 2nd-century author Apuleius. According to legend, the god Eros loved the princess Psyche, and incognito took her to his palace where he would visit her at night; while he slept, Psyche took a lamp and discovered his

identity. Eros woke, and banished her from the castle, although they were eventually reunited. This subject was most famously painted by Claude in 1664, 'Psyche outside the Palace of Cupid' (now in NG). Claude's picture was retitled 'The Enchanted Castle' when it was engraved by William Woollett in 1782; John Keats wrote a poem inspired by the picture in 1818, and the subject also inspired his *Ode to Psyche* and lines in *Ode to a Nightingale* of 1819, when Claude's painting was exhibited at the BI.

For Romantic responses to Claude's picture, see C. Pace 'Claude the Enchanted: Interpretations of Claude in England in the earlier nineteenth century', *Burlington Magazine* December 1969, pp 733–40; see also M Levey 'The Enchanted Castle by Claude: subject, significance and interpretation', *Burlington Magazine* November 1988, pp812–20.

Wilson calls Danby's picture a late homage to Claude: 'It is representative of its period in its straining after effects – a dazzling sunset, a monolithic palace of hybrid classical oriental character, and a languishing heroine. Compositionally it bears no relation to Claude's painting of the subject, although it can be regarded as a distant descendant of Claude's seaport compositions'. As Adams points out, Danby's sunset and grieving figure also recall Claude's '*Ezekiel Mourning over the Destruction of Tyre* (1667, Bridgwater House collection), while the castle itself is similar to the buildings in Turner's 'Dido Building Carthage' (1815, NG).

The source of the two lines of verse quoted in the 1841 BI catalogue is unknown, and may have been invented by Danby himself. They seem close to the sub-Keatsian poetry of 'LEL', Letitia Elizabeth Landon, who had written a poetical sketch, inspired by and titled after Danby's 1825 painting 'The Enchanted Island', published in the same year and aspiring to the same melancholic vein.

Adams discusses two other similar subjects with which 'The Enchanted Castle' has been confused: 'An Enchanted Island', exhibited at the BI in 1825 (59), and now in a private collection (Adams, 19), and 'Calypso's Grotto – The Goddess weeps the departure of Ulysses', exhibited at the BI in 1844 (118), and destroyed in a fire in about 1940 (Adams, 178). The composition of the latter is known from the small oil study dated 1843 (Yale Center for British Art, New Haven, USA; Adams 50). Both compositions are different from 'The Enchanted Castle'. There may be some connection, however, between the exhibiting of 'The Enchanted Castle' in 1841 and the republication in March of the same year of the 1825 mezzotint of 'An Enchanted Island'.

PROV: Probably bought from the artist by William Jones; his sale, Christie's 8 May 1852 (lot 123, as 'Calypso on the Enchanted Isle', but the *Art Journal* report of the sale (1852, p152) refers to the painting as 'The Enchanted Castle'), bought by Smith, who is known to have sometimes acted as agent for John Sheepshanks; Sheepshanks by 1857 (the picture is not in the 1850 list)

EXH: RA 1841 (549); *Exhibition of a Selection of works by Irish Painters* Guildhall 1904 (108, as 'Calypso's Island'); *Francis Danby* Arts Council, Bristol, Birmingham, Bradford, 1961 (15, as 'Calypso Grieving for her Lost Lover'); *Royal Academy of Arts Bicentary exhibition* RA 1968–9 (210, as 'Calypso Grieving'); *The Art of Claude Lorrain* Arts Council, Newcastle and Hayward Gallery, 1969 (142); *Irish Art in the 19th Century* Crawford Municipal School of Art, Cork, 1971 (31); *Francis Danby* Tate Gallery and City of Bristol Museum and Art Gallery 1988–9 (42)

LIT: *Athenaeum* 5 June 1841, p443; *Adams*, pp120–2, no 19; M Wilson *Claude: The Enchanted Castle* 1982, p17; *Greenacre* 1988, pp115–6

## Liensfiord Lake, Norway
FA67    Neg D225
Canvas, 82.5 × 116.7 cm (32½ × 46 ins)
Signed 'F. DANBY' diagonally bl
Sheepshanks Gift 1857

*Liensfiord Lake, Norway*    FA67

Exhibited at the RA in 1841 with the fuller title 'Liensfiord Lake, in Norway; a sudden storm, called a flanger, passing off – an effect which in [not 'on', as is usually quoted] their lonely lakes occurs nearly every day in autumn'. The *Athenaeum* critic, comparing it with 'The Enchanted Castle' (FA66, p59) also exhibited at the RA in 1841, described it as 'a sterner scene of beetling rocks and black waters, canopied by a passing storm, Nature is again poetized – but finely and forcibly'.

Danby was in Norway in 1825 and possibly, although there is no evidence, again in 1840. He left London 21 June 1825 and was away for two months. Dr E H Schiötz has pointed out (in correspondence with the V&A) that the artist was recorded in Norway in a newspaper article by the Rev Niels Hertzberg: 'An English painter Danby, a resident of London, came here [Hardangerfjord] from Stavanger via Odda three years ago. He was sent by a wealthy Englishman, for whom he should paint Norwegian views. He showed me some interesting sketches which he had drawn in these regions' (*Morgen bladet*, no 336, 1 December 1828, translated by Dr Schiötz). Hertzberg also recorded Danby's visit to Hardanger in his diary on 4 August 1825 (published in *Årbok for Den Norske Turistforening* 1929, p17). Greenacre (1973) quotes from a letter from Danby to his patron John Gibbons of 26 August 1825:

> I was much disappointed with Norway, it is of a totally different character from what I expected, yet there are *very* beautiful scenes and extremely picturesque on a small scale, indeed by far the most beautiful I ever saw but in Grandure they fall short. God knows the country is *wild enough*, these kind of scenes are better in pictures than in reality, and faith I own I was heartily sick of them, from the extreme difficulty of travelling and the distance that I went in a short time, my sketches have been forced to be very slight, yet as they are new I shall make a set of drawings as well as I can, endeavouring to preserve the effect that I saw.

Greenacre (1988) also quotes the following passage from Edward Price, who visited Norway in 1826, a year after Danby:

> Mr Danby, the painter, was very awkwardly situated on one of the western fiords . . . The mountains on all sides rose abruptly from the water, which was perfectly still, and canopied by an azure heaven. The boat was resting under the stillness of the day. At this moment the silver line of a cloud rose above the lofty barrier in front, the fiord heaved its bosom, and an approaching gale flapped the sail; fear was depicted on the faces of the boatmen, who lowered the sail and lashed the mast and a pair of oars across the boat; immediately the heavens were black with clouds, and the fiord boiled like a cauldron; destruction seemed inevitable, when the boat swung against the rock, the projecting mast snapped, and the boat whirled again into the ebullition. The violence of the storm was now over, and at length the fiord resumed its wonted quiet (*Norway, Views of Wild Scenery* . . . 1834, pp43–4).

The location of Liensfiord Lake is problematic, as there is no place of this name in Norway; moreover, the combination of a fiord (salt water) and a lake (fresh water) is unusual. Dr Schiötz has suggested the Lifjord, near Rutledal, which is near other locations certainly visited by Danby, or, less likely, the Loen Lake, between Bergen and Ålesund. Dr Schiötz finds Adams's suggestion of Fensfjord unlikely. However, Danby seems to have been sure of the name; a letter to Gibbons of 19 May 1831, cited by Greenacre (1973, p89) mentions a drawing 'Approach of a Storm on Liensford in Norway £3' (see also the inscription on the Tate Gallery version discussed below).

There is no convincing evidence that Danby made a second visit to Norway in about 1840, and it does seem unlikely in the light of his opinion of the scenery quoted above, so the present work must have been painted from memory and the 1825 sketches. Apart from the drawing mentioned above, a 'Vue d'un Lac en Norvege, avant que le soleil ait dissipé les vapeurs du matin', exhibited at the Geneva Salon in 1835, owned by a J Audeoud and much admired (see Häusermann, p228), and several sketches survive. One was in his posthumous studio sale (lot 7), and others are listed by Adams (see, for example, 104, 106, 141 and 186). A reduced version with variations of detail, the mood calmer and the colouring lighter and brighter, is in the Tate Gallery (oil on panel, 41.1 × 54.2 cm/(16⅛ × 21⅜ ins); it was sold from a private collection, Switzerland, at Sotheby's 21 November 1984 (71, as 'A Lake in Norway, possibly Fensfiord, near Bergen') and is reproduced in the catalogue in colour but before cleaning). For a full discussion of the Tate Gallery version see *The Tate Gallery: Illustrated Catalogue of Acquisitions 1984–6*.

Adams draws attention to the influence of Jacob van Ruysdael's more gloomy landscapes, particularly 'Storm off the Dykes of Holland' (about 1670, Louvre) which Danby had copied for William Gibbons in 1838, and of the rocky coast scenes of the Norwegian artist John Christian Dahl.

As Greenacre (1988) points out, none of Danby's darker paintings has survived as well as the present work: 'There is an impressive richness and translucency to the blacks, and a confidence in the technique which enhances the expressive character of the painting'. Greenacre continues:

There was a feeling of remoteness in the smaller, earlier work [the Tate Gallery version; it is not certain that it is earlier]. Here there is a more terrifying sense of a desolate and inhospitable landscape where the only animal presence is the skeleton of a seal. In the foreground a small inlet is unruffled by the wind and waterlilies grow, and, behind the storm, the sky is brighter, but these intimations of the coming calm are dwarfed by the overpowering gloom.

PROV: Bought from the artist by William Jones; his sale, Christie's 8 May 1852 (118, as 'View on the Coast of Norway') bought Smith (who sometimes acted as agent for Sheepshanks); given by John Sheepshanks to the museum 1857

EXH: RA 1841 (527); *Irish International Exhibition* Dublin 1907 (194); *Francis Danby* Arts Council 1961 (28); *Dvě století britskéhomalířství* (British Art 1650–1850), Národní Galerie, Prague, 1969 (41); *Lookalike* NGS 1982; *James Arthur O'Connor* National Gallery of Ireland 1985–6 (18); *Francis Danby* Tate Gallery and City of Bristol Museum and Art Gallery 1988–9 (41)

LIT: *Athenaeum* 5 June 1841, p443; *Adams* pp122–3, no 48; *Greenacre* 1973, p41 n25; J Hutchinson *James Arthur O'Connor* exhibition catalogue, p58; *Greenacre* 1988, pp25, 33, 115(repr)

*The Upas, or Poison-Tree, in the Island of Java*   1382-1869

## The Upas, or Poison-Tree, in the Island of Java
1382-1869   Neg S645
Canvas, 16.8 × 235.4 cm (66½ × 92¾ ins)
Townshend Bequest 1869

Exhibited at the BI in 1820, with the note 'Vide Darwin in his Loves of the Plants' appended to the title in the catalogue, and the size given as '66 × 90 inches'. It was Danby's first exhibited work in London.

Adams points out that the first contemporary record of Danby's work to survive concerns this painting: the writer and patron George Cumberland senior wrote from Bristol to his son George in London on 2 January 1820:

Mr Danby is going to send up a landscape in oil of 9 feet by 8, called The

Upas Tree of Java – it is a grand scene of desolate rocks by moonlight. I will write to Mr Rogers [the painter Philip Hutchins Rogers] about it to befriend him – take it yourself and say it has great merit and he not one friend in London. We want a good place for him for his first exhibition at the Institution. He can speak for him.

Adams also quotes a letter of 9 January from Cumberland to his other son Sydney, repeating the appeal, and another of 23 February reporting that the painting was 'in a good place and much admired'.

As Adams states, the picture, although it attracted attention, probably failed to sell because of its size; John Young, Director of the BI, wrote to Danby recommending him to submit something smaller the next year. Ackermann reviewed it: 'There is a grand and solemn tone in this picture, which partakes much of Mr Martin's style. It has a desolate appearance, which is characteristic; the drawing is correct'. In 1866, the Redgraves (*Cent*) vividly described the painting at length, concluding 'It is a wonderful first attempt, and shows the original poetry of Danby's mind'.

Adams suggests that the subject of the painting derived from discussions in the British Drawing Society circle, which would have been interested in the writings of Erasmus Darwin (1731–1802). His *Loves of the Plants* is the second part of a poem *The Botanic Garden* (first published 1789; the first part, *The Economy of Vegetation*, not published until 1791), written in heroic couplets in imitation of Alexander Pope, expounding the Linnaean botanical system. This work may also have had a significance in the painting of 'Disappointed Love' (see FA65, p58). Adams discusses Danby's interest in Darwin's poem in the context of that painting (pp24–5).

Darwin's account of the Upas tree is given as a note on lines 237–8 of canto III: 'Fierce is dread silence, on the blasted heath,/Fell upas sits, the hydra-tree of death'. The note reads:

> There is a poison-tree in the island of Java, which is said by its effluvia to have depopulated the country for twelve or fourteen miles round the place of its growth. It is called, in the Malayan language, Bohun-Upas; with the juice of it the most poisonous arrows are prepared; and, to gain this, the condemned criminals are sent to the tree with proper direction both to get the juice and to secure themselves from the malignant exhalations of the tree; and are pardoned if they bring back a certain quantity of the poison. But by the registers kept there, not one in four are said to return. Not only animals of all kinds, both quadrupeds, fish and birds, but all kinds of vegetables also are destroyed by the effluvia of the noxious tree; so that in a district of twelve or fourteen miles round it, the face of the earth is quite barren and rocky intermixed only with the skeletons of men and animals, affording a scene of melancholy beyond what poets have described or painters have delineated.

Additional notes at the end of the volume go into further detail. Danby follows Darwin's description, depicting a desolate rocky landscape with the skeletons of criminals and animals, and two criminals, one dead and the other hiding his face in horror, with their boxes for collecting the poison.

Greenacre (1988) relates the 1817 Bristol episode of Mary Willcocks, who pretended to be a Javanese princess, which would have added to the topical and local interest of the Upas tree subject.

Grigson discusses the significance of the Upas tree to Romantic thought in the 18th and early 19th centuries; Blake, Byron, Coleridge and Southey were among writers who were inspired by the image. Byron, for example, uses it as a metaphor of the 'ineradicable taint of sin' in human life in canto IV of *Childe Harold's Pilgrimage* first published in 1818. Grigson states that a diorama of the Upas tree was on view in London at about the time Danby was working on his painting: 'Danby was interested in a diorama, and it may have been on his picture that the peep-show was based'. The influence may have been in reverse. Grigson also draws attention to a musical drama devised by

George Colman, *Law of Java*, presented at Covent Garden in 1822; although the tree itself did not appear, an atmosphere on stage was created: 'Finely dismal and romantic, for many miles round the Upas; nothing but poison'd air, mountains, and melancholy'. Grigson traces the Upas as far as its use in political oratory, first by Gladstone in a speech of 1868, where the tree serves as an image for Protestant ascendancy in Ireland.

Danby may have been influenced by the paintings of John Martin, although Adams thinks it unlikely; Martin's 'Sadak in Search of the Waters of Oblivion' (exhibited RA 1812) for example was not engraved until 1828. However, it is not known whether Danby visited London between 1813 and 1824, and such a visit is not out of the question. Adams also suggests similarities with Washington Allston's 'Elijah Fed by the Ravens' (exhibited BI 1818), but proposes the principal influence of the painter Francis Gold in Bristol, whose work 'was concerned with the grand and terrible' and who sent a painting of Hagar in the desert to the BI in 1820 (now private collection). Turner, especially in paintings such as the reworked 'Rizpah Watching the Bodies of her Sons' (c1808, engr 1812), may also have been significant for Danby.

Danby painted it with lavish use of bitumen, and the painting had already when Waagen saw it in 1854 'much darkened on account of defective technical treatment'; he added that in a few years time it would hardly be visible. That prophecy was fulfilled, and the canvas has become until recently almost uniformly dark; Adams treated it as an almost lost work. After the removal of several layers of discoloured varnish in 1987–8, the extraordinary quality and dramatic tonality of the work are once again evident.

Another painting of this very rare subject, by William Daniell, was lot 465 in the Allnutts sale at Christie's 20 June 1863.

PROV:  In Danby's studio 1826, according to a letter of Sir Thomas Lawrence (*Artist's and Amateur's Magazine*, I [1843] p45); Rev Chauncey Hare Townshend by 1854 or 1856 (seen in his dining-room by Waagen, *Treasures of Art in Great Britain* suppl p177); Townshend Bequest to the museum 1868

EXH:  BI 1820 (246); Northern Academy; Newcastle, 1828; Carlisle Academy 1828 (101); 1828 (154); *Francis Danby* Tate Gallery and City of Bristol Museum and Art Gallery 1988–9 (18)

LIT:  *London Magazine* I, 1820, pp448–9; *Ackermann's Repository of the Fine Arts* IX, 1820, p180; G Grigson *The Harp of Aeolus* 1947 [1948], pp56–65; *Adams* pp14–17; *Greenacre* 1988, pp89–91

# DANIELS, William (1813–1880)

Born Liverpool, 9 May 1813, the son of a brickmaker. As an apprentice to his father, he made figures in clay, attracting the interest of the portrait painter Alexander Mosses (1793–1837). Studied in his spare time at the drawing school of the Royal Institution, Liverpool, and apprenticed to a local painter and engraver. Achieved local success as a portrait painter and for his 'candlelight' studies, and exhibited frequently at the Liverpool Academy from 1831, although he did not become a member. Exhibited seven works at the RA in 1840 and 1846, all single figure studies such as a beggar and a friar, except for the portrait of 'Sir Joshua Walmsley' (see p65) who seems to have been his chief patron. The *Magazine of Art* writer recorded that he 'lived boisterously . . . But he also felt the fascination of strong drink'; he is supposed to have declined to paint Prince Albert. He died at Everton, 13 October 1880.

LIT:  *Magazine of Art* June 1882, pp341–3; H C Marillier *The Liverpool School of Painters* 1904, pp95–8

## George Stephenson

364-1872   Neg H313
Canvas, 55.4 × 38.7 cm (21¾ × 15¼ ins)
Given by Sir Joshua Walmsley 1872

George Stephenson (1781–1848) was the famous inventor of steam
locomotion and founder of the railway; the Liverpool and Manchester
Railway opened in 1830. He is holding a design for a viaduct.

The following inscription, written by the donor, was on the backboard of
the painting:

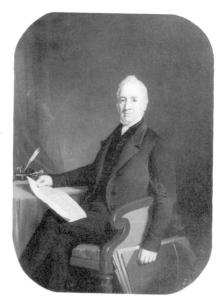

> This portrait of the Eminent Engineer George Stephenson Was painted
> from life in 1846 for Sir Joshua Walmsley by Wm. Daniels; The likeness
> in earnest discussion was eminently successful: It has never been copied
> and must eventually become an object of great interest: The name of
> Stephenson like that of Shakespeare will live in the grateful recollection
> of his Countrymen and this Effigy of the Mechanic of the Tyne will be as
> much esteemed as that of the far famed 'Bard of Avon'.
>
> The painter's power of illustration were only exceeded by his
> eccentricities of character: Like Morland many of his pictures were
> pronounced 'Gems of Art' In troubles oft, In prisons not unfrequent, he
> was another instance of Great Talents being sacrificed to debasing
> Habits.

*George Stephenson   364-1872*

Joshua Walmsley

There are many portraits of Stephenson, including the family group by an
unknown artist in the Science Museum; for a full iconography see R Walker
*Regency Portraits* 1985, I, pp479–81. Walker suggests that Daniels's painting
was copied from Mrs Mary Hamilton's miniature (exhibited RA 1836 (735),
now Science Museum), which shows Stephenson in a somewhat similar pose
holding a roll of drawings of which the top one is for the Sankey Valley
viaduct. The drawing held by Stephenson in the present painting may also be
for that viaduct. Walker's suggestion is unlikely; Stephenson and the donor
were friends and business associates, and Walmsley's son recorded that 'It was
during one of his [Stephenson's] visits to Ranton [Ranton Abbey, Walmsley's
house near Stafford] that the portrait was painted that now hangs in the
South Kensington Museum, and considered by the "old man" the best
likeness ever taken of him'.

In his 1857 biography of Stephenson, Samuel Smiles wrote that 'His fair,
clear countenance was ruddy and seemingly glowed with health . . . The
mouth was firmly marked and shrewdness and humour lurked there as well as
in the keen grey eye'.

EXH:   *National Portraits* South Kensington Museum 1868 (490, lent by Sir
         Joshua Walmsley)

LIT:   H M Walmsley *The Life of Sir Joshua Walmsley* 1879, pp76–7, 142

*Sir Joshua Walmsley*, MP   368-1872

## Sir Joshua Walmsley, MP

368-1872   Neg H311
Canvas, 92.7 × 70.5 cm (36½ × 27¾ ins)
Bequeathed by Sir Joshua Walmsley 1872

Presumably the portrait exhibited at the RA in 1846.

Sir Joshua Walmsley (1794–1871) was a corn merchant, advocate of the
repeal of the corn laws, and friend and business associate of George
Stephenson (see 364-1872, above). Elected member of Liverpool town
council 1835, Mayor 1838, knighted 1840; as a Liberal, unsuccessfully
contested Liverpool for Parliament 1841, elected for Leicester 1847 (but soon
unseated), Bolton 1849, and Leicester again 1852–7. In 1855/6 introduced a
Bill, unsuccessfully, to open the British Museum and other public institutions
on Sundays. He was Daniels's chief patron; according to his son's biography,

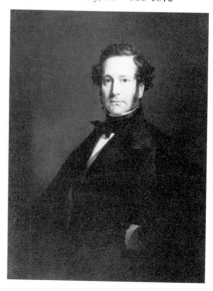

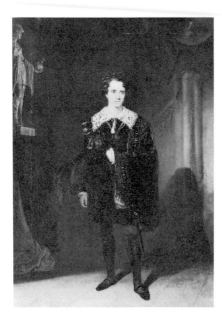

*Charles Kean as Hamlet*   369-1872

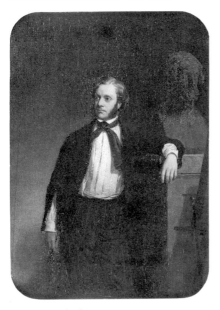

*Captain Walmsley*, RN, NVC, FRGS
370-1872

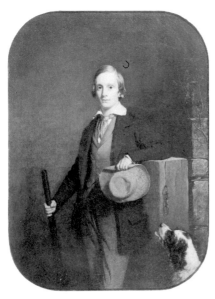

Sir Joshua expected 'great things' from the artist. In 1846, Daniels sent paintings, including a portrait of Sir Joshua, to the RA from the Walmsley home address at Ranton (not Rauton, as misprinted in the RA catalogue) Abbey, Eccleshall, Staffordshire.

Marillier considered this portrait 'powerful and vivid'. According to his son, another portrait of Sir Joshua, by Illidge (presumably Thomas Henry Illidge), was given to Lady Walmsley.

EXH:   RA 1846 (461)

LIT:   H M Walmsley *The Life of Sir Joshua Walmsley* 1879, pp76–7

### Charles Kean as Hamlet
369-1872    Neg 70313
Canvas, 59.7 × 43.8 cm (23½ × 17¼ ins)
Signed and dated 'Daniels/1835' in shadow r
Bequeathed by Sir Joshua Walmsley 1872

Exhibited at the Liverpool Academy in 1835. Charles John Kean (1811–68) was the second son of the famous actor Edmund Kean; he first appeared on the stage at Drury Lane in 1827, and became one of the leading actors of the day, his Hamlet being particularly admired. He first played Hamlet in Liverpool in October 1833, and again in 1835, the year of this portrait; he played the role at Drury Lane in 1837/8. He made his last public appearance at Liverpool, on 28 May 1867. There are many recorded portraits of Kean, including two as Hamlet: one attributed to William Mulready, the other by Richard Dadd (R Ormond *Early Victorian Portraits* 1973, I, pp245–7; P Allderidge *The Late Richard Dadd* Tate Gallery exhibition catalogue 1974 (38); the Theatre Museum has a half-length portrait of Kean by Samuel John Stamp dated 1838.

EXH:   Liverpool Academy 1835 (101); *The Liverpool Academy 1810–1867* Walker Art Gallery, Liverpool 1960 (41)

LIT:   G Ashton 'Paintings in the Theatre Museum', *Apollo* April 1987, p259, repr fig 3

### Captain Walmsley RN, NVC, FRGS
370-1872    Neg H314
Canvas, 62.9 × 44.5 cm (23¾ × 17½ ins)
Signed and dated 'W. Daniels/1848' diagonally bl
Bequeathed by Sir Joshua Walmsley 1872

Presumably a son of Sir Joshua Walmsley, and perhaps an amateur artist, judging from the presence of a paintbrush and easel. The classical bust on the plinth seems to be a copy of the famous marble 'Homer' collected by Charles Townley and represented in Zoffany's painting of his collection (1782, Townley Hall Art Gallery and Museum, Burnley, now in the British Museum).

### James M Walmsley as a Boy
371-1872    Neg H312
Canvas, 50.8 × 37.5 cm (20 × 14¾ ins)
Bequeathed by Sir Joshua Walmsley 1872

Presumably also a son of Sir Joshua Walmsley.

*James M Walmsley as a Boy*   371-1872

# DAWSON, Henry (1811–1878)

Born Waterhouse Lane, Hull, 3 April 1811, the younger son of a flax-dresser. Worked from the age of seven in a lace factory in Nottingham, but painted in his spare time, mainly portraits; seeing prints by John Martin inspired him to paint landscape. Began as a professional painter 1835, visited London 1836, and received his only formal training there 1838 – twelve lessons from the landscape painter and watercolourist James Baker Pyne. Exhibited 28 landscapes at the RA between 1838 and 1874; he always complained, with some reason it seems, that his work was badly hung. Also exhibited 33 works at the BI 1841–67 and six at the SBA 1851–78 (elected Member 1875). Moved to Liverpool 1844, exhibiting at the Liverpool Academy 1845–51 (elected Member 1847). Entered (unsuccessfully) 1847 competition for decoration of new Palace of Westminster, with 'Charles I Raising his Standard . . .' (now Nottingham Castle Museum and Art Gallery); achieved great success with one of his large views of London, 'The New Houses of Parliament, Westminster', at the BI 1858. Later works achieved high prices, his popularity culminating in the exhibition of 57 paintings to mark the opening of the Nottingham Castle Museum and Art Gallery 1878. Lived in Croydon, Surrey, 1850–3, and Thorpe Green, near Chertsey, Surrey, until 1861; finally settled in Chiswick, Middlesex, where he died 13 December 1878; his studio sale was at Christie's 23–5 March 1882. His two sons, Alfred (1844–93) and Henry Thomas (c1842–78) were also painters.

Lit: *Art Journal* 1869, p112, 1879, p48 (obit); A Dawson *The Life of Henry Dawson Landscape Painter* 1891; B Webber *James Orrock, RI, Painter, Connoisseur, Collector* 2 vols, 1903, I, pp25–42, II p237; H C Marillier *The Liverpool School of Painters* 1904, pp114–8, 259; H Williams *Henry Dawson* Nottingham University Art Gallery exhibition catalogue 1978

## Rocky Landscape with River and Sheep
177-1894    Neg GF706
Canvas, 69.2 × 89.5 cm (27¼ × 35¼ ins)
Signed 'H Dawson' br
Given by James Orrock RI 1894

Although undated, this painting is similar in style to 'Landscape' (see 1857-1900, p68) which is dated 1840. It is reminiscent of the work of Richard Wilson, with which Dawson was familiar through the collection of his friend and patron, the Nottingham artist Frederick Carter Cooper. After Cooper's death in 1875, Dawson bought a painting by Wilson which he had seen and admired at Cooper's house early in his career.

*Rocky Landscape with River and Sheep*   177-1894

James Orrock saw Dawson's paintings when he was living in Nottingham in 1856, at the house of William Wild, a lock-keeper and early patron of Dawson. He became a friend and patron, also acting as agent securing sales of Dawson's work to other collectors. According to Webber (I, pp29–30) Dawson painted four pictures for Orrock in 1857 and subsequent years; from their titles none are identifiable with the present work. Dawson recorded that he gave Orrock a painting in 1872, quoting a note made by Orrock: 'The Wild sunset was given to me for commissions of 200 [pounds] . . . Mr Dawson saying he had never had such commissions before in his life. At first I refused any reward whatever, but Mr Dawson said he wished to present me with a picture of 20 by 30 size'. It is not recorded how or when Orrock acquired the present work.

Exh: *Henry Dawson* Nottingham University Art Gallery 1978 (16)

Lit: H Williams *Henry Dawson* Nottingham University Art Gallery exhibition catalogue 1978, pp27, 42–3

*Shipping at Sunset    501-1896*

**Shipping at Sunset**
501-1896
Canvas, 49.5 × 74.8 cm (19½ × 29½ ins)
Signed and dated 'HD [in monogram] 61' bl
Given by J D Paul 1896

Presumably the 'Sunset at Sea' exhibited at the BI in 1861 and priced at 20 guineas. This was described by the *Art Journal* critic (1861, p70): 'The phase is similar to that in the harvest picture, – the sun is dipping behind a cloud. We are not far "at sea", for there is even in the foresea a frigate at anchor. The sky and the water are unexceptionable'. Lot 508 in the artist's studio sale at Christie's 23–5 March 1882 was 'A Marine Sunset' (size given as 30 × 20 ins sold to Innes £294); 'A Stormy Sunset' was engraved by W Chapman for the *Art Journal* in 1869 (facing p112), the picture having been exhibited at the Dudley Gallery 1867 and owned by J Orrocks (presumably the artist and collector James Orrock).

EXH:    ?BI 1861 (110)

*Landscape    1857-1900*

**Landscape**
1857-1900    Neg GG1480
Canvas, 58.4 × 82.5 cm (23 × 32½ ins)
Signed and dated 'H Dawson 1840'
Ashbee Bequest 1900

Not identifiable with any exhibited work of 1840. A label on the back of the frame is inscribed 'HSA 8/6/94', that is, the owner's initials and possibly the date of acquisition.

# DE WINT, Peter (1784–1849)

Born Stone, Staffordshire, 21 January 1784, son of a doctor of Dutch extraction. Pupil of the portraitist in crayons and engraver John Raphael Smith 1802–6; entered RA Schools 1807. Exhibited 13 landscapes and topographical views at the RA between 1807 and 1828 and 11 at the BI 1808–24, but principally watercolours – 417 at the OWS 1808–49. Also worked for engravers of topographical books. Married the sister of his friend William Hilton RA. Lived many years in Lincoln, where the Usher Art Gallery has a fine collection of his work. Many watercolours and drawings also in the V&A collections. Died London 30 June 1849; his studio sale was at Christie's 22–28 May 1850.

LIT:    *Art Journal* 1849, p260 (obit); W Armstrong *Memoir of Peter De Wint* 1888; H De Wint *A Short Memoir . . .* privately printed c1900, reprinted in *Smith*; H Smith *Peter De Wint* 1982 (and for fuller bibliography)

*A Cornfield    258-1872*

**A Cornfield**
258-1872    Neg GD1122
Canvas, 104.8 × 163.8 cm (41¼ × 64¼ ins)
Given by Mrs P Tatlock (the artist's daughter) 1872

Possibly 'A Cornfield' exhibited at the RA in 1815 (W Whitley *Art in England 1800–1820* 1928, p245, states without evidence that it was); he also exhibited a smaller picture (91.5 × 124.5 cm/36 × 49 ins including the frame, according to the catalogue) with the same title as the BI in 1816. Harvesting scenes were a favourite subject with the artist early in his career, and particularly the panoramic view (compare the watercolour 'Cornfield

with Harvesters' also in the V&A collections (1201-1886), for example, and 'Haymaking', 260-1872, below).

The work, together with 'Wooded Landscape', (261-1872, below) was offered by the artist's daughter first to the NG; the Director, Sir William Boxall, apparently refused both paintings without inspecting them, and they were soon after accepted by the Keeper of Art at South Kensington, Richard Redgrave, who confessed they were 'the first oil paintings by de Wint I have seen'. If this work were indeed exhibited at the RA in 1815, it would have hung in the company of Constable's 'Boatbuilding . . .' (V&A FA37); the 1969 Norwich exhibition catalogue described the De Wint as a 'masterpiece of naturalism on a large scale'.

A replica of almost the same size (102.9 × 166.4 cm/40½ × 56½ ins) is in the Usher Gallery, Lincoln (repr Smith pl 69). Smith also records a copy (94 × 152.4 cm/37 × 60 ins) and a small sketch (also not autograph), both formerly in the Yale Center for British Art (Paul Mellon Collection), New Haven, USA, sold Sotheby Parke Bernet 18 November 1981 (174, 175).

Exh: RA 1815 (222); Peter de Wint Agnew 1966 (63); *A Decade of English Naturalism 1810–20 Castle Museum, Norwich, 1969, and V&A 1970 (22); English Landscape Painting Tokyo and Kyoto 1970–1*

Engr: Sir Frank Short, V&A collections, E1122–1920 (etched state), E1123–1920 (mezzotint)

Lit: Armstrong, p45, repr fig 22; Smith, pp65–9

Repr: *Studio special summer number 1903, pl* 1

## Landscape with Lightning and a Hermit
259-1872   Neg H-532
Canvas, 74.3 × 104.4 cm (29¼ × 41 ins)
Given by Mrs P Tatlock (the artist's daughter) 1872

The work does not seem to have been exhibited. Dated by Smith to between 1812 and 1816, and, as he comments, a most uncharacteristic work, based principally on the compositions of Salvator Rosa (many of whose works were shown in old master exhibitions at the BI between 1816 and 1824) and Gaspar Poussin (one example was 'Storm' purchased by NG in 1824). Smith comments that it 'might be described as a parody of the picturesque', and rightly draws attention to the possible influence of Richard Wilson's (uncharacteristically dramatic) 'Destruction of Niobe's Children' (then in Sir George Beaumont's collection and exhibited at the BI in 1814; later NG and Tate Gallery, since destroyed; but see the 1760 version now in the Yale Center for British Art, New Haven, USA).

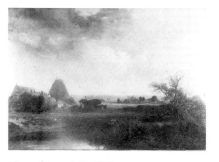

*Landscape with Lightning and a Hermit   259-1872*

Exh: *Peter de Wint* Agnew 1966 (64)

Lit: *Smith* pp61, 69, repr pl 66; H. Smith 'Some recently discovered studies for Peter de Wint's "Elijah"' *Burlington Magazine* September 1979, pp 582–3 (repr.)

*Haymaking   260-1872*

## Haymaking
260-1872   Neg M1076
Canvas, 66.1 × 97.2 cm (26 × 38¼ ins)
Given by Mrs P Tatlock (the artist's daughter) 1872

Exh: *Peter de Wint* Agnew 1966 (17)

*Wooded Landscape   261-1872*

## Wooded Landscape
261-1872   Neg 60752
Canvas, 104.1 × 160.7 cm (41 × 63¼ ins)
Given by Mrs P Tatlock (the artist's daughter) 1872

An oil study for the present work was recorded in a private collection in 1903

(millboard, 44.8 × 58.4 cm/17⅝ × 23 ins; repr *Studio* special summer number 1903, pl W2); the owner identified the location of the scene as Cliveden, Buckinghamshire. A version of the present work showing the same view was recorded in 1912 in a private collection, the view identified as over the Thames Valley seen from the high ground near Taplow or Cliveden; that also related to an oil study lent from a private collection to the V&A in 1912. A watercolour of a similar view in the possession of T W Bacon was reproduced in *Apollo* in 1934 (XIX, p88) as 'Valley of the Thames with Cliveden Woods'.

Exh:  *British Art c1000-1860* RA 1934 (605)

Engr:  Mezzotint, Sir Frank Short RA (exh RA 1908), impr, etching, original plate, and preparatory watercolour, all in the V&A collections

Lit:  *Armstrong* p45; *English Art in the Public Galleries of London* II, 1888, p151, repr facing p150; *Studio* special summer number 1903, repr fig W3; C H Collins Baker *British Painting* 1933, repr pl 119; *Smith* p66, repr pl 70

*Black Gang Chine, Isle of Wight*   1036-1886

### Black Gang Chine, Isle of Wight
1036-1886    Neg 57163
Canvas, 61 × 74 cm (24 × 29⅛ ins)
Dixon Bequest 1886

The chines (defined by OED as 'deep and narrow ravines cut in soft rock strata by a stream descending steeply to the sea') on the Isle of Wight and the Hampshire coast, were much admired geological features in the early 19th century. De Wint contributed an illustration of the subject to W B Cooke's 'Picturesque Views on the Southern Coast of England'; a copy of the etching (by G Cooke) of April 1816 is in the V&A collections (E2670-1928), although the volume was not published until 1826. Other volumes illustrated by the Cookes were 'A New Picture of the Isle of Wight . . .' (1808) and Sir H C Englefield's 'A Description of the Principal Picturesque Beauties . . . of the Isle of Wight . . .' (1816). The engraved views of Black Gang Chine are different from the present work. De Wint exhibited only two Isle of Wight subjects, at the OWS in 1827 and 1843; a few were sold in his studio sale.

Lit:  W Shaw Sparrow 'Peter De Wint' *Studio* special summer number 1903, p(W)ix

*Landscape with Waggon*    P56-1921

*Greenwich Park*    P57-1921

### Landscape with Waggon
P56-1921    Neg 36160
Canvas, 106.2 × 163.4 cm (41¹³⁄₁₆ × 64⁵⁄₁₆ ins)
Bequeathed by Miss Harriet Helen Tatlock (the artist's granddaughter) 1921

The view has not been identified, nor is the work identifiable with the title of any painting exhibited in the artist's lifetime. The waggon is of the same type as that depicted in Constable's 'Salisbury Cathedral from the Meadows' (exhibited RA 1831, now NG).

Exh:  *19th Century English Art* New Metropole Arts Centre, Folkestone, 1965 (73); *Peter De Wint* Agnew 1966 (2)

### Greenwich Park
P57-1921    Neg 38437
Millboard, 42.9 × 57.6 cm (16⅞ × 22¹¹⁄₁₆ ins)
Bequeathed by Miss Harriet Helen Tatlock (the artist's granddaughter) 1921

The view, from the hill down to Greenwich Hospital and across the Thames to St Paul's in the distance, is similar to that in De Wint's drawing engraved by W B Cooke for his 'Thames Scenery' (impr in the V&A collections

E4113-1905, published 1 June 1822, and stated to be from a drawing in the possesion of the Duke of Argyll). The trees in the foreground are differently composed. The artist exhibited a watercolour of Greenwich at the OWS in 1818 (349, titled 'Greenwich – (for Cooke's work of 'Thames Scenery')'; it was described by the critic of the *Examiner* (1818, p285): 'The most energetically touched and naturally greyish green trees have a sprightly effect given to them by the different coloured dresses of the ambulating company, and by the bright masses of light'.

On the reverse is a study of a brace of grouse.

EXH:   *The Artist at Work* Hampstead Arts Centre 1966 (37), where it is dated c1835

LIT:   *Connoisseur* March 1928, repr facing p168

### Old Houses on the High Bridge, Lincoln
P58-1921   Neg 36162
Millboard, 30.5 × 45.7 cm (12 × 18 ins)
Bequeathed by Miss Harriet Helen Tatlock (the artist's granddaughter) 1921

A watercolour of the same composition is also in the V&A collections (179-1898), although there are differences in the figures and the buildings on the left side. The view seems to be from the west; the central part of the High Bridge (one of the most celebrated sites in Lincoln, where De Wint lived for many years) on the river Witham dates from the 12th century, although the structure was extended to support a 16th-century timber-framed house. Smith records a larger, more finished watercolour of the subject, formerly in the J Leslie Wright collection.

*Old Houses on the High Bridge,*
*Lincoln   P58-1921*

EXH:   *Peter De Wint* Lincoln Art Gallery 1937 (66); *Peter De Wint* Agnew 1966 (43)

LIT:   *Smith* p38

# DOUGLAS, Sir William Fettes, PRSA (1822–1891)

Born Edinburgh 29 March 1822, the son of a bank accountant and amateur watercolour painter. Worked in a bank from 1836 for about ten years, drawing in his spare time; turned to professional painting 1847, first portraits, eventually specialising in genre and historical scenes, particularly antiquarian and occult subjects, and later some landscapes. Exhibited nine works at the RA between 1862 and 1875, two at the BI in 1849, but principally at the RSA: 206 paintings 1845–1888, elected Associate 1851, Member 1854, and President 1882. Curator of the NGS 1877–82; knighted 1882. He made a sketching tour of England 1851, visited Italy 1857, where he began his collection of antiquities of all kinds (but especially medals), Sweden 1861, and France and Italy 1866–7. Died Newburgh, Fife, 20 July 1891. Sales of his collections were at Edinburgh 18 and 25 February 1865 and 10–12 December 1891, and at Christie's 10 May 1883.

*The Alchemist   67-1873*

LIT:   *Eight Photogravures from the Works of Sir William Fettes Douglas . . .* (with an essay by J M Gray) 1885; *The Scotsman* 21 July 1891 (obit); *The Academy* 25 July 1891, p81 (obit); W D McKay *The Scottish School of Painting* 1906, pp334–40; J W Caw *Scottish Painting Past and Present* 1908, pp172–4

### The Alchemist
67-1873   Neg 51456
Canvas, 130.7 × 100.3 cm (51½ × 39½ ins)
Signed and dated '1855 [the Douglas crest of a heart, crossed swords, and a

crown] fecit' in red on box in centre foreground
Bequeathed by Mrs Jane Clara Focchetti (in memory of her deceased mother,
Mary Lebrun, and brother-in-law, Thomas Darcey) 1873

Presumably the picture of the same title exhibited at the RSA in 1857, lent
according to the catalogue by an unnamed Liverpool owner. It is described by
Gray as painted in 1854:

> Its two figures are placed in a lofty and spacious room such as Gerard Dou
> loved. The grey-bearded alchemist stands surrounded by his books and
> his instruments, bending humbly, waiting deferentially upon his visitor,
> a stalwart, soldierly man of action, who, seeking the aid of wealth for the
> furtherance of his schemes of quite practical and mundane advancement,
> raises with both hands, high to the light, a great flask of golden-tinted
> liquid which bids fair to realise his dreams of power.

With its wealth of antiquarian detail (the artist was himself a considerable
collector) and meticulous painting, it is characteristic of this painter's work.
The subject of an alchemist in his 'laboratory' is most commonly found in the
work of Thomas Wyck (c1616–77). The subject was presumably also inspired
by Sir Walter Scott's novel *The Antiquary* and its character of Jonathan
Oldbuck, from which Douglas later painted a scene ('The Invasion of the
Sanctum Sanctorum', 1874, Dundee Museum and Art Gallery).

# DUNCAN, Thomas, ARA, RSA (1807–1845)

Born Kinclaven, Perthshire, 24 May 1807. Worked in a professional
letter-writer's office before studying art at the Trustees' Academy in
Edinburgh under Sir William Allan, where he became headmaster. Exhibited
eight works at the RA between 1836 and 1846, one at the SBA 1832, five at
the Institute for the Encouragement of the Fine Arts in Scotland 1828–9, and
98 at the RSA 1828–47. Elected RSA 1829, ARA 1843; Professor of Colour,
then of Drawing, at the RSA. Painted portraits, and genre, historical and
literary subjects, always Scottish. Several of his works were engraved. Died
young, of a brain tumour, Edinburgh 25 April 1845.

LIT: *Art Union* 1847, p380 (with engr self-portrait)

**The Waefu' Heart**
FA69   Neg 59216
Panel, 77.4 × 59.6 cm (30½ × 23½ ins)
Signed and dated 'Thos Duncan Pinxt 1841' in red bl
Sheepshanks Gift 1857

Exhibited at the RA in 1841 with the following quotation appended to the
title in the catalogue:

> I gang like a ghaist, and I carena to spin;
> I darena think on Jamie, for that would be a sin.
>
> I wish I were deed, but I'm no like to dee,
> And why do I live to say, Wae's me.
>
> Lady Anne Lindsay, *Auld Robin Gray*

Lady Anne Lindsay (1750–1825) wrote the popular ballad *Auld Robin Gray* in
1772. It was published anonymously in 1776, and in a corrected, but very
limited (26 copies) edition in 1825; it seems to have been best known in the
1776 edition, although it was presumably reprinted in other volumes of
collected verse.
    The *Art Union* reviewer called it 'A most painful, but most arresting

*The Waefu' Heart*   FA69

picture: poor Jenny, the heart-stricken wife of "Auld Robin Gray". It touches almost as newly and powerfully as the lines copied from the ballad. There are few better works of its class in this or any other collection'. Waagen was more critical: 'The expression of the girl is very noble, but the lower part of the person too undesigned'. The influence of Sir David Wilkie is very marked in the handling of the heads of the girl and dog, and strong chiaroscuro and heightened use of colour.

A note in the *MS Register*, possibly by Richard Redgrave, reads 'It is simply and broadly painted for general effect with but little detail'.

EXH:   RA 1841 (518)

LIT:   *Art Union* 1841, p47; G Waagen *Treasures of Art in Great Britain* 1854, II, p300

# DYCE, William, RA (1806–1864)

Born Aberdeen 19 September 1806, son of a physician and university lecturer. Studied medicine and theology at Marischal College, and for a few months at the RA Schools in 1825, before making his first visit to Rome, where he presumably made contact with the 'Nazarene' painters. Exhibited 41 works at the RA between 1827 and 1861, four at the BI 1828–41, and 58 at the RSA. Specialised in mythological, historical and biblical subjects, also portraits and landscapes. Elected ARA 1844, RA 1848. Influenced by the Pre-Raphaelites, notably in 'Pegwell Bay' (1858, Tate Gallery). Involved in reorganisation of art education; appointed Superintendent of the School of Design 1837, resigned 1843. Active as ecclesiologist and musicologist. Several fresco paintings for Prince Albert and the Palace of Westminster. Died 15 February 1864 Streatham, London; studio sale at Christie's 5 May 1865. A typed transcript of selected correspondence is in the Dyce Papers, Aberdeen Art Gallery.

LIT:   M Pointon *William Dyce* Oxford 1979 (with full bibliography)

*Life Study (head of Christ)*   156-1865

*Design for a Fresco for All Saints, Margaret Street*   164-1894

### Life Study (head of Christ)
156-1865   Neg HF4876
Canvas, 50.7 × 36.8 cm (20 × 14½ ins)
Purchased 1865

The model for this life study seems to be that used by Dyce for 'St Joseph' (1846–7, Royal Collection), and is similar to the head of Christ in both 'The Man of Sorrows' (RS 1860, private collection) and 'Christ and the Woman of Samaria' (1860, Birmingham City Art Gallery). The head of the Christ in glory in the design for All Saints, Margaret Street, also shares this resemblance (see 164–1894, below).

PROV:   Artist's studio sale, Christie's 5 May 1865 (135 'head of a man with a beard, bought de Tocte £5 15s 6d, or 138 'head of Christ', bought Chaffers £1 11s 6d).

### Design for a Fresco for All Saints, Margaret Street
164-1894   Neg X1431
Canvas, 130.1 × 87 cm (51¼ × 34¼ ins)
Purchased 1894

A study for the fresco on the east wall, behind and above the altar, of the chancel in All Saints, Margaret Street. All Saints was designed by William Butterfield as a model ecclesiologist church and built between 1850 and 1859. Dyce's design for the wall accords with the principles of the building

and contrasts with the more Pre-Raphaelite and naturalistic style – particularly in terms of a 'contemporary Christ' – of his religious easel paintings (see M Pointon 'William Dyce as a painter of Biblical subjects', *Art Bulletin* 1976, pp260–8), and with the greater monumentality of his Palace of Westminster frescos. The 1964 Aberdeen exhibition catalogue quotes the artist Edward Armitage (no source cited) commenting: 'For correct and careful drawing, for taste and style in the arrangement of drapery, and for honest and conscientious labour I know nothing in England to equal them'.

While Thompson suggests that Butterfield's choice of Dyce for the commission reflected the architect's progressiveness, Pointon disagrees on the grounds that Dyce's ideas were more conservative. Pointon cites the patron of the church, Alexander Beresford Hope, corresponding with Dyce by 1851 about the iconography of the fresco; the artist's consent to paint the fresco was described by Hope as a 'piece of success unlooked for and surprising'. Pointon comments that it was also surprising that Dyce should have accepted the commission having made so little progress with the great project for the Queen's Robing Room at the Palace of Westminster, particularly as the church was originally due to be completed in 1853. The fresco was still unfinished in 1857, when Cope refused to assist with the painting (C W Cope *Reminiscences* 1891, p224). Presumably the present oil study dates from about 1851. It is not possible to see Dyce's fresco itself, because of Comper's later screening of the wall (see below).

Pointon rightly stresses that the painting was intended to act as both a reredos and an east window as well as a wall fresco. The structure of the design is based on 15th and 16th-century examples, although the figures and their disposition are more 14th-century Italian in origin (see, for example, Nardo di Cione's 'Three Saints' bought by NG 1857). In the late 'thirties Dyce had studied the school of Giotto, and Pointon suggests that he followed Ruskin's urging in *The Seven Lamps of Architecture* (1849) towards the Italian Gothic and knew Mrs Jameson's *Legends of the Madonna* (1852). A copy of Zanotti's '*Pinacoteca . . .*', which was illustrated with engravings after Italian Gothic altarpieces, was lot 211 in his studio sale.

The iconography of the work is fully discussed by Pointon. The three horizontal zones of the wall show the Virgin and Child on the first level with the Crucifixion above, the scenes surrounded by the twelve Apostles standing in niches, while the uppermost level shows Christ in Glory, flanked by figures referring to Christ's life as a man on earth.

The fresco deteriorated rapidly soon after completion, and in 1908 J Ninian Comper was commissioned to make oil copies which were superimposed on Dyce's work.

There is a family tradition that the model for the Virgin was the artist's niece, Elizabeth Cay, and Pointon (p135) comments that 'the warmth, realism, and degree of finish in this part of the oil study bears out such a claim'. For a life study possibly for the head of Christ, see 156–1865, p73.

PROV: Purchased from Agnew's March 1894 (possibly agents for the museum at the James Brand sale, Christie's 10 March 1894, although the work does not appear in the catalogue)

EXH: *Ecclesiastical Art* Imperial Institute 1933; *William Dyce* Aberdeen Art Gallery 1964 (27)

LIT: P Thompson *William Butterfield* 1971 (pp349, 458); M Pointon *William Dyce* Oxford 1979, pp128–36, repr pl 138

# EASTLAKE, Sir Charles Lock, PRA (1793–1865)

Born Plymouth, Devon, 17 November 1793, son of an admiralty agent. Studied drawing with Samuel Prout and entered RA Schools 1809. Won silver medal of the Society of Arts 1810. Travelled to Paris 1815, and lived in Rome 1816–30. Exhibited 51 works at the RA between 1823 and 1855, and 18 at the BI 1813–40. Subjects principally classical, historical and biblical, but also later Italian genre subjects. Elected ARA 1827, RA 1830. Also pursued a distinguished administrative career, notably after election to PRA 1850, and his directorship of the NG 1855–65. Several publications, notably *Materials for the History of Oil-painting* (1847), and translations of German art treatises. Married the author Elizabeth Rigby 1849; died Pisa, Italy, 24 December 1865; his wife refused a public funeral for him in St Paul's Cathedral.

LIT: *Art Journal* 1855, p277, 1865, p60 (obit); Lady Eastlake *A Memoir of Sir Charles Lock Eastlake*; 1870 W Monkhouse *Pictures by Sir Charles Lock Eastlake* 1875; D Robertson *Sir Charles Eastlake and the Victorian Art World* 1978 (with full bibliography)

## A Peasant Woman Fainting from the Bite of a Serpent
FA70    Neg L1862
Canvas, 55.9 × 47.6 cm (22 × 18¾ ins)
Signed and dated 'C L Eastlake/1831' bl
Sheepshanks Gift 1857

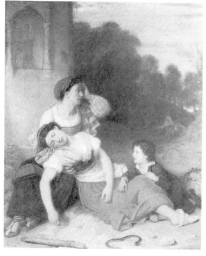

*A Peasant Woman Fainting from the Bite of a Serpent* FA70

Exhibited at the RA in 1831, and listed by Lady Eastlake as painted for John Sheepshanks in the same year. The back of the canvas is inscribed by the artist: 'No.2. Nina Ranieri, a young peasant woman of the Roman State, while kneeling before a chapel of the Madonna was bit by a viper: she sank into a lethargy in a short time and, it is said, died two days after. C L Eastlake 1831'. The *Examiner* critic thought it 'choice . . . carefully drawn after nature, in the purest taste, and forcible without violence . . . the expression and action . . . are singularly appropriate'.

Sheepshanks wrote to the artist Andrew Geddes in Rome 17 May 1830:

'If you happen to be acquainted with Mr Eastlake, now, I believe, residing in Rome, and who was elected Academician last month, I should be obliged if you would mention that, by an ancient arrangement, I am to have a Picture painted by him, at some period (but not very long hence), when it is convenient. The dimensions or subject are neither of them very material, provided the latter is an agreeable one, and provided it is calculated for engraving, so that I may be enabled to forward the views of my little friend in that line, the more desirable; a large picture would be objectionable, as I am not likely to settle in a house soon' (quoted in D Laing *Etchings by Sir David Wilkie . . . and by Andrew Geddes ARA . . .* Edinburgh 1875, p25).

Sheepshanks had already bought a painting by Eastlake in 1823 (see FA71, p.76); presumably his letter refers to the present work, although it does not appear to have been engraved.

Academic art-historical references are made in the poses of both principal figures: the older woman's features and turn of head probably to the figure of St Elizabeth in Raphael's 'Canigiani Holy Family' (1507, Alte Pinakotek, Munich), while the injured peasant is adapted from Giulio Romano's 'Sleeping Psyche' (1528, Palazzo del Tè, Mantua) which had also inspired Sir Joshua Reynold's 'The Death of Dido' (1781, Royal Collection).

EXH:  RA1831 (125); *Italian Art and Britain* RA 1960 (230); *Sir Charles Lock Eastlake* City Art Gallery, Plymouth, 1965 (14)

LIT:    *Examiner* 1831, p309; *Art Journal* 1857, p240; G Waagen *Treasures of Art in Great Britain* 1854, II, p 302; Lady Eastlake, *A Memoir . . .* 1870, p195

*An Italian Contadina and her Children*   FA71

## An Italian Contadina and her Children
FA71   Neg L1861
Canvas, 46.3 × 36.8 cm (18¼ × 14½ ins)
Signed and dated
Sheepshanks Gift 1857

Exhibited at the BI in 1824 as 'An Italian Scene; a contadina and her children', the size given in the catalogue as '26 by 21 inches'. It is listed by Lady Eastlake as painted for John Sheepshanks in 1823.

She lists another, 'A Contadina and Children', painted for N G Phillips in 1825; that was exhibited at the RA in 1831, and engraved for the *Art Journal* in 1867 (facing p244) by S S Smith (signed and dated 'CLE ROME 1826', in 1867 in the collection of Thomas Birchall of Preston). The engraving shows a different composition from the present work.

The *Art Journal* (1867, p244) commented that Eastlake's residence in Rome, between 1816 and 1830

> Fostered, if it did not actually create, that feeling for Italian Art – reproducing Italian scenes and customs – which so large a proportion of his works exhibits. In all, or most, of these one observes a grace and tenderness of expression, a quiet, subdued tone of colouring, and an absence of everything that would produce strong emotion or extort admiration. They are attractive and winning, not by an original conception, nor by vigour of treatment, nor by bold effects, but by unobtrusive graces that stand in the stead of these, and which may be summed up under the generic term 'refinement'.

Reviewing the Sheepshanks collection in 1857, the *Art Journal* found this and 'A Peasant Woman Fainting from the Bite of a Serpent' (FA70, p75) 'distinguished by the vigour and colour which characterise all the Italian subjects by him'.

*Contadina* is Italian for a peasant woman; here she seems to be wearing traditional costume, perhaps Roman in origin.

EXH:    BI 1824 (74); *British Art Fifty Years Ago* Whitechapel Art Gallery, Spring 1905 (71)

ENGR:   J Mitchell, as 'The Contadina', for *The Literary Souvenir* 1827, p244, with accompanying verses

LIT:    *Art Journal* 1857, p240; *Lady Eastlake* p194; *Robertson*, pp256–7

*The Trajan Forum, Rome*   F5

## The Trajan Forum, Rome
F5   Neg GA3017
Canvas, 39.6 × 91.7 cm (15⅝ × 36⅛ ins)
Forster Bequest 1876

Two paintings of this subject are listed by Lady Eastlake under 1821. One is stated to have been painted for Miss Catherine Fanshawe (the present work, see *Prov*: below); the other, smaller, for Mr Boileau, is presumably that now in the Yale Center for British Art, New Haven, USA (61.9 × 51.1 cm/24⅜ × 20⅛ ins; signed).

Eastlake lived abroad, mainly in Rome, from 1816 to 1830; his best views of the city were painted between 1819 and 1822. Lady Eastlake records that they remained in Rome in the summers of 1821 and 1822, and in the latter year Eastlake painted the two views of the Colosseum (now in the Tate Gallery). He met the poetess Catharine Fanshawe (1765–1834) in Rome in about 1820.

The Emperor Trajan (AD 53–117) built a new forum in Rome designed

by Apollodorus of Damascus, now ruined apart from the famous Trajan's Column, seen on the right of the painting.

Prov:  Painted for Catherine Fanshawe 1821 and bequeathed by her younger sister Miss E Fanshawe to the Rev William Harness 1856; his sale, Christie's 19 March 1870 (14) as 'The Forum of Trajan' ('Painted for Miss Fanshawe'), bought Foster [sic] £37 16s; bequeathed by John Forster to the museum 1876

Exh:  *International Exhibition* 1872 (114, lent by J Forster); *Sir Charles Lock Eastlake* City Art Gallery, Plymouth, 1965 (4)

Lit:  *Eastlake*, p194; *Robertson*, pp18–19

## The 'Cumaean' Sibyl
F6
Paper on canvas, 29.8 × 24.1 cm (11¾ × 9½ ins)
Forster Bequest 1876

Painted over an engraving after Domenichino's painting of 1616–17 in the Borghese Gallery, Rome. R E Spear reproduces and discusses the painting (*Domenichino* 1982, text vol pp191–2, pl171); it was evidently much admired and well known, as he lists 17 copies and five engravings (the latter by M Benedetti, P Fontana, T Marcucci, C Zocchi, and G Folo). In the painting, there is musical notation on the scroll of paper. Spear comments that the classic female type in the painting marks the beginning of a long tradition in which Eastlake presumably saw himself participating.

Prov:  Given to John Forster by Lady Eastlake, the artist's wife

# EGG, Angustus Leopold, RA (1816–1863)

Born Piccadilly, London, 2 May 1816, the son of a well-known gunmaker. Studied at Sass's art school 1834, and entered the RA Schools 1835; joined the sketching society known as The Clique 1837. Exhibited 28 paintings at the RA between 1838 and 1860, nine at the BI 1838–47, and also at the SBA from 1837 to 1842. His subjects were taken from literature, particularly Shakespeare, and later, influenced by the Pre-Raphaelites with whom he was closely associated, scenes from everyday modern life, sometimes with a moral theme. Elected ARA 1848, RA 1860. For reasons of bad health, he travelled to Algiers, but died there 26 March 1863. His studio sale was at Christie's 18 May 1863.

*A Girl with Clasped Hands*   8465-1863

Lit:  *Art Union* 1847, p312; *Art Journal* 1863, p87 (obit); *Athenaeum* 11 April 1863, pp491–2 (obit)

## A Girl with Clasped Hands
8465-1863   Neg FH1075
Canvas, 35.5 × 30.5 cm (14 × 12 ins)
Purchased 1863

Presumably a study for a larger composition, which has not been identified, although possibly 'Contemplation' (Forbes Magazine collection).

Prov:  The artist's sale, Christie's 18 May 1863 (73, 'A Girl with her Hands Clasped'), bought Burchett (presumably Richard Burchett, for the museum) £11 15s

A Girl's Head    8466-1863

**A Girl's Head**
8466-1863    Neg FH1076
Canvas, 13.9 × 12.7 cm (5½ × 5 ins)
Purchased 1863

Presumably a study for a larger composition, which has not been identified.

PROV:   The artist's sale, Christie's 18 May 1863 (77, 'A Girl's Head'),
bought Burchett (presumably Richard Burchett, for the museum) £9
19s 6d

EXH:    *19th Century British Painting* New Metropole Arts Centre,
Folkestone, 1965 (13)

# EGLEY, William Maw (1826–1916)

Born 2 October 1826, son of the miniature painter William Egley (1798–
1870). Worked as assistant to his father by the age of 15. Exhibited 34 works
at the RA between 1843 and 1898, 18 at the BI 1844–67, and 25 at the SBA
1846–94. Early works mainly subjects from English history, and from
literature, particularly Shakespeare and Molière. Influenced by the Pre-
Raphaelites in the 1850s, in both technique and subject matter; painted
several scenes of modern life, notably 'Omnibus Life in London' (1859, Tate
Gallery). Later works are mostly 18th-century costume subjects. Designed
one of the first Christmas cards, an etched greeting dated 1848. Friend of
W P Frith, for whom he painted backgrounds on occasion. Died Chiswick,
London, 20 February 1916.

LIT:    W M Egley *Catalogue of Pictures . . .* MS List 1840–1903, National
Art Library, V&A; (referred to below as *Catalogue*); W M Egley Diary
MS 1844–63, National Art Library, V&A; D Fincham 'Three Painters
of the Victorian Scene' *Apollo* May 1936, pp241–4; R Dorment *British
Painting in the Philadelphia Museum of Art* 1986, p101

*Florence Dombey in Captain Cuttle's
Parlour*    1824-1900

**Florence Dombey in Captain Cuttle's Parlour**
1824-1900    Neg 71475
Canvas, 61 × 45.7 cm (24 × 18 ins)
Signed and dated '1888/W Maw Egley' br
Ashbee Bequest 1900

According to the artist's *Catalogue*, painted between 16 July and 6 November
1888, and retouched 1890; pencil sketches of 1886 and 1888 are also
recorded. Unusually, it does not seem to have been exhibited in any of the
major shows such as the RA, but toured the country between 1889 and 1895,
its price, apparently, being reduced en route from £40 to £15.
    The work is described as no 928 in the artist's *Catalogue*:

The picture represents Florence Dombey on the day after she had fled
from the cruelty of her father to take refuge in the house of Solomon
Gills, the nautical instrument maker, of which Captain Cuttle had taken
charge. 'Florence, being busy with her needle in the little parlour, was
more calm and tranquil than she had been on the day preceding'.

After a detailed description of the composition, Egley adds: 'Florence was, at
this time, presumably, under twenty years of age; and the costume is that of a
young girl in 1848, the date of the publication of *Dombey and Son*'. The
episode depicted is taken from chapter 49 of Charles Dickens's novel *Dombey
and Son*, first published in monthly parts between 1846 and 1848.

PROV:   Bought by H S Ashbee for £25 1898, and bequeathed by him to the
museum 1900

Exh: Leeds 1889; Liverpool 1889; Manchester 1890; Nottingham 1890; Birmingham 1891; Crystal Palace 1892; Southport 1894; Brighton 1895; *An Exhibition of Paintings and Drawings by Victorian Artists in England* National Gallery of Canada, Ottawa, 1965 (36)

Engr: A chromolithograph of 1893 is recorded

## Scene from Molière's 'Monsieur de Pourceaugnac'

1847-1900   Neg GF2272
Millboard, 14.6 × 20.3 cm (5¾ × 8 ins)
Signed and dated 'W Maw Egley. 1870.' bl
Ashbee Bequest 1900

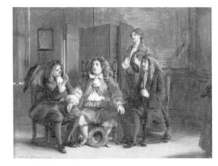

*Scene from Molière's 'Monsieur de Pourceaugnac'* 1847-1900

According to the artist's *Catalogue* (in which it is no 543), painted in a day in June 1868 and half a day in October 1870; it is a sketch for the painting exhibited at the RA in 1872 (896). The RA work is no 568 in the artist's *Catalogue*. In th RA catalogue, several lines of dialogue, in French, were appended to the title; the lines are given in translation in the artist's *Catalogue*, and are taken from act 2 scene 2 of Molière's comedy, first performed in 1669:

| | |
|---|---|
| *1st physician:* | Here's a clever man, one of my brethren, with whom I will consult concerning the manner of our treating you. Now, Sir, take a seat, Sir (the two physicians make M de P sit between them. Each physician takes one of his hands and feels his pulse). |
| M *de P:* | Your very humble servant. |
| *1st physician:* | Do you eat well, Sir? |
| M *de P:* | Yes: and drink still better |
| *1st physician:* | So much the worse. We will reason upon your affair in your presence; and we will do it in the vulgar tongue, so that you may understand better. |

At the opening of the play, Oronte has arranged a marriage between his daughter Julie and the lawyer Pourceaugnac; she and her lover Éraste try to prevent it by various tricks, and in this episode have persuaded a physician to treat Pourceaugnac for insanity. It is evident that the figure of the Apothecary was originally further to the right; the pentimenti are clearly visible.

The RA painting was bought by E K Muspratt; its present whereabouts are unknown. Egley painted several scenes from plays by Molière which were popular on the 19th-century London stage; for others in the V&A collections see below. The present subject seems rare: another episode from the same play was exhibited by Gilbert Stuart Newton at the RA in 1824.

Prov: Bought by H S Ashbee 1898, and bequeathed by him to the museum 1900

## Scene from Molière's 'Le Malade Imaginaire'

1850-1900   Neg GA1198
Millboard, 14.6 × 22.1 cm (5¾ × 8¾ ins)
Signed and dated 'W Maw Egley: 1857' in red bl
Ashbee Bequest 1900

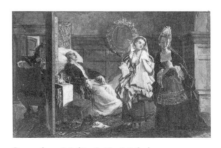

*Scene from Molière's 'Le Malade Imaginaire'* 1850-1900

According to the artist's *Catalogue* (in which it is no283), started 1 October 1857 and took three days to paint. It is a sketch for 'Argan Feigning Death' exhibited at the RA in 1858 (169); that is no 295 in the *Catalogue*, and the following lines, in translation, are quoted from act 3 scene 18 of Molière's last play, first performed in 1673. Argan is pretending to be dead in order to test the affection of his wife:

| | |
|---|---|
| *Toinette:* | Stretch yourself full-length in this armchair, and pretend to be dead. (To Beralde) Hide yourself in that corner. Here is |

my mistress. Ah heavens! Ah! what a misfortune!

| Beline: | What is the matter, Toinette? What ails you? |
| Toinette: | Your husband is dead. |
| Beline: | Heaven be praised. I am delivered from a most grievous burden. How silly of you, Toinette, to be so afflicted at his death. |
| Toinette: | Ah! Ma'am, I thought I ought to cry. |

The RA painting was bought by John Lomax, but its present whereabouts are unknown.

PROV:   Bought by H S Ashbee 1898, and bequeathed by him to the museum 1900

*Scene from Molière's 'Le Malade Imaginaire'*   1851-1900

### Scene from Molière's 'Le Malade Imaginaire'
1851-1900   Neg GF2273
Millboard, 15.8 × 19.4 cm (6¼ × 7⅝ ins)
Signed and dated 'W Maw Egley. 1871' br
Ashbee Bequest 1900

According to the artist's *Catalogue* (in which it is no 561), painted in three days from 4 August 1871, and a sketch for the picture (no564 in the *Catalogue*) exhibited at the French Gallery in 1871 (*Cabinet Pictures by British and Foreign Artists*, Winter 1871–2, no121). A preliminary pencil sketch and a perspective diagram are also recorded.

In the French Gallery exhibition catalogue, lines from the play are appended to the title, in French, and given in Wall's translation in the artist's *Catalogue* as follows:

| Argan: | (Threatening Toinette with his cane) Come here, come here, let me teach you how to speak. |
| Toinette: | (Running to other side of the chair) I interest myself in your affairs, as I ought to do, and I don't wish to see you commit any folly. |
| Argan: | Jade! |
| Toinette: | No, I will never consent to this marriage. |
| Argan: | Worthless hussy! |
| Toinette: | I won't have her marry your Thomas Diafoirus. |
| Argan: | Angélique, won't you stop that jade for me? |
| Angélique: | Ah! father, don't make yourself ill. |

The lines are from act 1 scene 5 of Molière's play, first performed in 1673; Argan, the hypochondriac of the title, aims to marry his daughter Angélique to a doctor's son in order to save his medical bills. In this scene, the servant Toinette has a long argument with him about this until Angélique intervenes.

PROV:   Bought by H S Ashbee 1898, and bequeathed by him to the museum 1900

*Scene from Molière's 'Le Tartuffe'*
1853-1900

### Scene from Molière's 'Le Tartuffe'
1853–1900   Neg GA119
Millboard, 14.6 × 22.1 cm (5¾ × 8¾ ins)
Signed and dated 1850
Ashbee Bequest 1900

According to the artist's *Catalogue* (in which it is no 293), started 18 August, worked on for three and a half days, and finished with a day's work 23 February 1858. Pencil sketches are also recorded in 1853. This scene is a sketch for the painting 'Tartuffe at Supper' exhibited at the RA in 1857 (517), (no268 in the artist's *Catalogue*, sold Sotheby's 18 December 1985 (99, signed and dated 1857, 63.5 × 95 cm (25 × 37½ ins), repr in colour in the catalogue). The finished painting shows the three figures in the same poses, but almost all the details of their surroundings are different.

In the RA catalogue, several lines of dialogue, in French, are appended

to the title; the episode depicted is described in act 1 scene 5 of Molière's play, first performed in 1664. The hypocritically pious Tartuffe has talked his way into Orgon's household to obtain his property including his wife. In this scene, Orgon is informed by the maid Dorine that his wife is ill, but Orgon enquires with more interest after Tartuffe, and is told that he has eaten a heavy supper; the lines are given in translation in the artist's *Catalogue*:

*Dorine:*    The day before yesterday our mistress was very feverish from morning to night, and suffered from a most extraordinary headache.
*Orgon:*    And Tartuffe?
*Dorine:*    Tartuffe! He is wonderfully well, stout and fat, with blooming cheeks and ruddy lips.
*Orgon:*    Poor man!
*Dorine:*    In the evening she felt very faint, and the pain in her head was so great that she could not touch anything at supper.
*Orgon:*    And Tartuffe?
*Dorine:*    He ate his supper by himself before her; and very devoutly devoured a brace of partridges and half a leg of mutton hashed.
*Orgon:*    Poor man!

The *Art Journal* critic (1857, p173) thought of the RA painting that 'the execution is careful, even to extreme hardness; and the characters want point'.

PROV:    Bought by H S Ashbee 20 August 1898 for £6, and bequeathed by him to the museum 1900

## Scene from Molière's 'Le Medecin Malgré Lui'
1854–1900  Neg GF2274
Canvas, 16.5 × 22.8 cm (6½ × 9 ins)
Signed and dated 'W Maw Egley. 1878. 80' in brown br
Ashbee Bequest 1900

According to the artist's *Catalogue* (in which it is no 806), painted in four and a half days between November 1878 and 9 March 1880. It is listed as 'the *second* sketch for No 786/the finished picture, exhibited at the RA 1879/, but differs from the *first* sketch, No791, in having another arrangement of the figures, with a different background'.

In the 1879 RA catalogue, the finished painting (1011) is 'Scene from "Le Medicin Malgré Lui" ', with several lines in French appended to the title; the episode depicted is from almost the end (act 3 scene 6) of Molière's play, first performed in 1666, and the lines are given in translation in the artist's *Catalogue*:

*Géronte:*      My daughter speaks! Oh! great power of medicine!
*Sganarelle:*   (Walking about the stage and fanning herself with his hat) Really, this illness has given me a great deal of trouble.
*Lucinde:*      Yes, father, I have recovered my speech, but only to tell you that I will have no other husband than Léandre.
*Géronte:*      Oh! What a rush of words! One can't stand it.

In the play, Géronte's daughter Lucinde has pretended to be dumb, and Sganarelle, a 'miracle worker', is employed to cure her; she is in love with Léandre, who disguises himself as an apothecary and with Sganarelle's help tricks Géronte and Lucinde's speech is restored (the scene in the painting). Géronte then in the last scene allows the marriage when Léandre announces he has inherited a fortune. The characters shown in the painting are, from left to right, Léandre, Géronte, Lucinde, Sganarelle, Lucas and his wife Jacquéline.

PROV:    Bought by H S Ashbee 1898, and bequeathed by him to the museum 1900

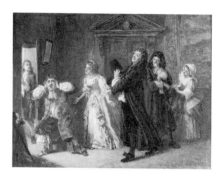

*Scene from Molière's 'Le Medecin Malgré Lui'*  1854-1900

# ETTY, William, RA (1787–1849)

Born York 10 March 1787, the son of a baker. Apprenticed to a printer at Hull, moved to London 1805, entered the RA Schools 1807 and studied with Sir Thomas Lawrence. Early works were mainly portraits and nude studies; his first large figure composition was 'The Coral Finder' (1820). Exhibited 138 works at the RA between 1811 and 1850, and 77 at the BI 1811–47. Travelled abroad in 1815/6, 1822, and 1830, principally to Paris and Italy. Elected ARA 1824, RA 1828. A retrospective exhibition was held at the Society of Arts 1849. Died York 13 November 1849. His studio sale was at Christie's 6–10 and 13–14 May 1850. Most admired in his lifetime for his large mythological subjects, but now perhaps more appreciated for his less finished and smaller studies of the nude.

LIT:  A Gilchrist *Life of William Etty* 2 vols, 1855; W Gaunt and F G Roe *Etty and the Nude* Leigh-on-sea 1943; D Farr *William Etty* 1958

*Head of a Cardinal*   FA72

**Head of a Cardinal**
FA72   Neg L895
Millboard inlaid in oak panel, 23.8 × 17.7 cm (9⅜ × 7 ins)
Sheepshanks Gift 1857

Exhibited at the RA in 1844 as 'The Cardinal' and owned by Sheepshanks by 1849. Describing another painting with the same title exhibited at the RA in 1834, Gilchrist (II, p2) records that it was a title 'wherewith Etty dubbed more than one male study'. Farr notes that Etty produced a long series of head-and-shoulders or half-length studies of men in costume, from 'The Jew's Head' exhibited in 1827; the most ambitious and finished was 'The Warrior Arming' exhibited in 1835. Etty may have employed the same model for several of these; the present work seems to depict the same as 'The Warrior Arming'. Etty's painting also resembles the early studies of heads of Apostles by Van Dyck, particularly the oil sketch now in the Louvre.

The *Art Union* critic wrote that it was 'a small and admirable head, but a painful misnomer, unless the artist may intend it to represent a character from Dante's College of Hypocrites. If the red cape were painted out, and other appropriate style of habiliment substituted, the wearer would sufficiently well represent a chief of banditti'.

EXH:  RA 1844 (146); Society of Arts 1849 (LII, lent Sheepshanks); *British Art Fifty Years Ago* Whitechapel Art Gallery 1905 (69)

LIT:  *Art Union* 1844, p156; G Waagen *Treasures of Art in Great Britain* 1854; *Farr* no 4, pp92, 131

**Cupid Sheltering his Darling from the Approaching Storm**
FA73   Neg 76797
Panel, oval, 43.1 × 33.6 cm (17 × 13¼ ins)
Sheepshanks Gift 1857

Exhibited at the RA in 1822, and again in 1823 at the BI (the size given in the catalogue as '24 by 17 inches', presumably including the frame). Etty exhibited other similar subjects at the BI: 'Cupid and Psyche' (with a quotation from Milton's *Comus*) in 1821 (36.8 × 41.2 cm/14½ × 16¼ ins, Farr no 50) and 'Cupid and Psyche Descending' in 1822 (96.5 × 73.6 cm/38 × 29 ins, Farr under no 98).

The representation of Psyche as an infant is unusual, and the composition may have been inspired by paintings of the infant Jesus and St John the Baptist, or of putti; an early painting by Van Dyck of two putti is similar (National Museum, Stockholm) and was engraved in 1750 by J Daulle as 'L'Enfant Qui Joue Avec L'Amour'.

*Cupid Sheltering his Darling from the Approaching Storm*   FA73

Gilchrist recorded that Etty 'set much store by this small picture; and with cause. It is a flawless piece of painter's-work, inimitably lovely; in sentiment, fresh, and captivating, as a Fancy of Drayton's or Herrick's.' He also noted the artist's dissatisfaction at the hanging of this picture at the RA, quoting a letter from Etty to the President Sir Thomas Lawrence: 'After having studied so many years, and with such application: a Picture I had spent three months about, – and carefully studied each part from Nature, – should be judged worthy no better place than the Floor: to be hid by the legs of the spectators of a neighbouring and celebrated picture, and reflect its colour on their Boots'.

PROV: According to the *Art Journal* of 1863, said to have been painted for Sir Francis Freeling, but this is presumably a confusion with 'Cupid and Psyche Descending' which was commissioned by him. Owned by Sheepshanks by 1849

EXH: RA 1822 (7); BI 1823 (120); Society of Arts 1849 (LIV, lent by Sheepshanks)

ENGR: W H Simmons, in S C Hall *Book of Gems* 1836, p71, as illustration to Sir Philip Sidney's 'Astrophel and Stella'; C Rolls, in A A Watts *Lyrics of the Heart* 1851, p207; F Joubert, in *Art Journal* 1863, facing p92

## Standing Female Nude with Helmet
872-1868   Neg 82643
Millboard, 64.7 × 46.9 cm (25½ × 18½ ins)

Dated about 1835–40 by Farr. Two copies exist, both approximately the same size and on millboard: by B R Haydon (Graves Art Gallery, Sheffield) and by an unknown contemporary (City of York Art Gallery).

Etty collected armour, and used it as accessories; Gaunt and Roe comment on this painting:

> It might be puzzling to suggest any essential association between a nude woman of the first half of the nineteenth century and a close helmet of some two centuries earlier. Yet (probably with an eye on the Old Masters) this is precisely what Etty achieved . . . a relation between Venus and the discarded trappings of Mars is not so abstruse after all

Old masters of the Venetian Renaissance such as Titian – whom Etty so much admired – were particularly fond of juxtaposing the contrasting textures of metal armour and human flesh; Etty's most elaborate essay in this vein is 'Britomart Redeemes Faire Amoret' (formerly Lady Lever Art Gallery, Port Sunlight, now Tate Gallery). The pose of the model may have been suggested by figures in the 16th-century decorations at Fontainebleau, which had been engraved.

*Standing Female Nude with Helmet*
872-1868

*Study of a Man's Head*   1390-1869

PROV: Purchased presumably as a model for the students, and transferred to the museum 1868

EXH: *19th Century British Painting* New Metropole Arts Centre, Folkestone, 1965 (76); *The Nude in Victorian Art* Harrogate City Art Gallery 1966 (12)

LIT: *Gaunt and Roe* pp63–4, pl 39; *Farr* no 214, p173

## Study of a Man's Head
1390-1869   Neg L896
Panel, diameter 26.6 cm (10½ ins)
Townshend Bequest 1869

Dated about 1840–1 by Farr. Presumably the same model as depicted in the 'Head of a Cardinal', (page 82), and perhaps a study for the head of Christ, or connected with the 1838 painting 'The Good Samaritan'.

*Head of a Monk   1392-1869*

**Head of a Monk**
1392-1869   Neg L897
Canvas, 30.5 × 26.6 cm (12 × 10½ ins)
Townshend Bequest 1869

Farr dates this study to about 1841–2, drawing attention to Etty's two visits to a Trappist monastery near Antwerp where he bought a monk's habit for use as a studio accessory. In a letter to his niece of 6 July 1841 quoted by Gilchrist, he saw 'several of the Brotherhood, – each of fine old Picture, – . . . very fine studies. I should like to have sketched some of them.' He shows the monk peering from the window of (presumably) his cell, in the manner of a Dutch 17th-century painting. A 'Head of a Monk – a study for the Joan of Arc' was lot 786 in Etty's studio sale at Christie's 13 May 1850.

LIT: *Gilchrist* II, pp122–3; *Farr* no 17, pp91–2, 134

**Study of a Nude Male Figure**
1421-1869
Millboard lined with canvas, 30.5 × 26.6 cm (12 × 10½ ins)
Townshend Bequest 1869

Clearly a study from the life, and dated by Farr to around 1820.

LIT: *Farr* no 213, p173

*Study of a Nude Male Figure   1421-1869*

**The Deluge**
225-1871   Negs GJ836, 69198
Millboard laid on panel, enlarged on all sides, 63.5 × 68.6 cm (25 × 27 ins)
Given by Charles T Maud 1871

Dated by Farr to about 1835–45 on stylistic grounds. This kind of 'bather' picture was favoured by Etty particularly in the 1840s. In the 1907 catalogue, it is described as being signed on the back, and dated 1815; this is presumably a reference to the two autograph letters which were given with the painting in 1871. The letters, now almost illegible, are from Coney Street, York, (where in 1845 Etty visited a house which he bought the following year), to ?W H Ealy, and dated 'Monday 18th Dec 1815' and 'Shortest Day' respectively. The letters were transcribed by Basil Long earlier this century:

> My Dear Sir
> I have just completed your Picture and if it turns up 'a Trump' it has proved itself worth the trouble and expense of its extension [see medium description above] – [–?] when it is dry enough to travel, am I to send it to you or Mr. Peel? Pray tell me –
> Yours truly, Wm Etty

> Mr Dear Sir,
> Your half note *safely* arrived this morning. Mr Andrews [–?] Mr Wass the Engraver from London and the cognoscenti here are delighted with the Deluge Figure and efforts will I think be made to get it – but I will tell you candidly – you will be a *Donkey* if you part with it that is *flat* – as we say in Yorkshire – it is a fine thing – tho I say it so take care of it – and dont fool it away.
> Yours sincerely, Wm Etty

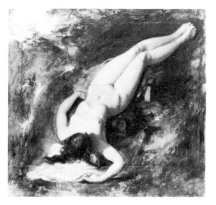

*The Deluge   225-1871*

PROV: Probably Charles Oddie, his sale, Christie's 18 March 1854 (115, 'The Deluge: a female figure, drawn and coloured with grand effect, and 3 ALs.s [autograph letters] of Etty related to it'), bought in £31 10s; William Wethered, his sale, Christie's 27 February 1858 (60, 'The Deluge: female lying on a rock'), bought by the dealer Richard

Colls £24 3s; not in the C T Maud sale, Christie's 21 May 1864, but presented by him to the museum 1871

REPR:  C H Collins Baker *British Painting* 1933, pl 120

## Nude Female Figure
1607-1871    Neg 82641
Panel, 63.1 × 47.9 cm (24⅞ × 17⅞ ins)
Purchased 1871

Dated by Farr to about 1835–40.

PROV:  Purchased from S J B Haydon, presumably a dealer, 10 Parliament Street, for £7, 1871

LIT:  *Gaunt and Roe* pl 40; *Farr* no 216, p174

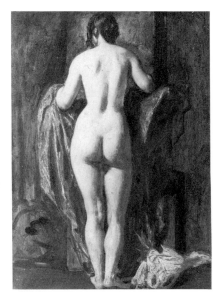

*Nude Female Figure    1607-1871*

## Study of a Magdalen
811-1873    Neg 82642
Canvas, 53.9 × 63.5 cm (21¼ × 25 ins)
Purchased 1873

Although described in previous catalogues as a 'nude female contemplating a crucifix', the 1873 *Inventory of Art Objects* adds that it is a study of a Magdalen, which is clearly evident. Gilchrist listed six paintings of the subject, of which only one, painted in 1845 and exhibited at the Society of Arts in 1849, could possibly be the present work.

The iconography is unusual in that it combines the nudity and elaborate earring of the courtesan Magdalen with the more traditional book, skull and crucifix of the penitent.

PROV:  Presumably William Wethered, his sale Christie's 27 February 1858 (105, 'The Magdalene Reclining, a skull and crucifix before her'), bought Hoskins £11 11s; acquired for £15 by the museum 1873.

EXH:  ?Society of Arts 1849 (CXXI)

LIT:  *Gilchrist* II, p340; *Gaunt and Roe* pl 38; *Farr* no 29, p137

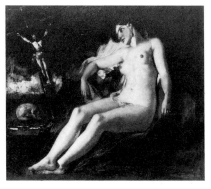

*Study of a Magdalen    811-1873*

## Innocence: Head of a Young Girl
498-1882    Neg L898
Canvas, oval, 43.1 × 33 cm (17 × 13 ins)
Jones Bequest 1882

Farr dates the painting to about 1820 on stylistic grounds, and suggests it is the portrait of Miss Wallace painted in 1820 and exhibited at the Society of Arts in 1849. It is similar to works by Sir Thomas Lawrence, with whom Etty studied, such as the portrait of the Calmady sisters (exhibited at the RA 1824; now Metropolitan Museum of Art, New York).

A variant canvas, 39.4 × 34.3 cm (15½ × 13½ ins), is owned by the RA; a similar painting 42 × 32.4 cm (16½ × 12¾ ins), was sold at Christie's 28 April 1933 (87), as 'Lawrence', 'Head of a Lady, with white decollete dress'.

PROV:  ?C W Wass (see *Exh*: below); ?Henry Wallis, his sale Christie's 17 November 1860 (127, 'Innocence') bought by the dealer Richard Colls £13; bequeathed by John Jones to the museum 1882

EXH:  ?Society of Arts 1849 (LXI, 'Portrait of Miss Wallace', lent by C W Wass)

LIT:  *Farr* no 195, p172, repr pl 11b

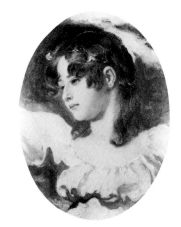

*Innocence: Head of a Young Girl    498-1882*

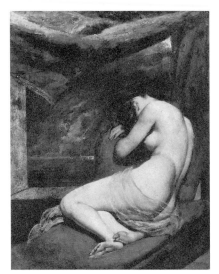

*The Ring* 997-1886

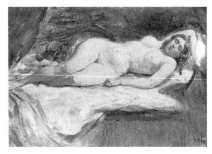

*Study of a Nude Female Sleeping* D37

*Woman at a Fountain* D52

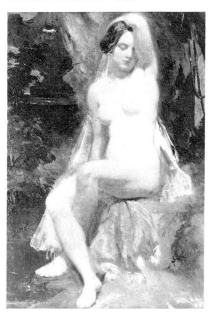

### The Ring

997-1886   Neg 58955

Millboard stuck on canvas, 58.1 × 47.6 cm (22⅞ × 18¾ ins)

Dixon Bequest 1886

Farr suggests that it is 'almost certainly a Hero and Leander subject', and that 'the figure enclosed within a ring in the sky above the sea may be an attempt at symbolizing the death of Leander'. He dates the work to about 1835, and also suggests it may have been 'The Signal' exhibited at the Society of Arts in 1849, which Gilchrist lists as 'The Signal; or, "Hero and Leander". (Nude reclining figure)' under the year 1844. Gilchrist's dating is probably based on the fact that the Society of Arts catalogue incorrectly states the picture was exhibited at the RA in 1844. Etty exhibited two related subjects: 'The Parting of Hero and Leander' (RA 1827, Farr no 77) and 'Hero, having thrown herself from the tower at the sight of Leander drowned, dies on his body' (RA 1829, *Farr* no 62).

Alternatively, it is possible that the subject is connected with the fairy romance of the sea nymph and the fisherman, told by De la Motte Fouqué in 1811 (English cheap edition 1842) and interpreted variously in the opera *Masaniello* by Auber (performed in London 1829–35), the ballet *Ondine* (London 1843–8), and in Turner's painting 'Undine . . .' (RA 1846, Tate Gallery). Etty was certainly interested in such legends; apart from Hero and Leander subjects, he also exhibited such works as 'The Shipwrecked Mariner' (RA 1831) and 'The Sirens and Ulysses' (RA 1837). Although Etty's image does not precisely accord with the Undine story nor does it accord with the Hero and Leander myth. However, it is curious that there seems to be no contemporary mention of an Undine subject, which would have been both topical and popular, in Etty's *oeuvre*.

PROV:   ?The dealer Richard Colls in 1849 (see *Exh*: below); Joshua Dixon

EXH:   ?Society of Arts 1849 (CX, 'The Signal', lent by R Colls)

LIT:   *Farr* no 61 as '*Hero Awaiting Leander*', p145

### Study of a Nude Female Sleeping

D37   Neg L899

Canvas, 24.1 × 31.7 cm (9½ × 12½ ins)

Dyce Bequest 1869

Farr dates the work to about 1845–9, and mentions possible retouching on the hands and feet. The pose is faintly reminiscent of the antique Belvedere Cleopatra, while the swelling thigh may be compared with those of the odalisques of Ingres, such as that in the museum collection (CAI 57).

EXH:   *The Artist at Work* Hampstead Arts Centre 1966 (34)

LIT:   *Farr* no 217

### Woman at a Fountain

D52   Neg 68570

Millboard, 61.5 × 46.3 cm (24¼ × 18¼ ins)

Dyce Bequest 1869

Unattributed in the Dyce collection and the 1907 catalogue. According to a note on the Departmental files, Grant in 1914 seems to have been the first to suggest Etty's hand, although he thought the background was by a different artist, W D Kennedy. Farr dates the work to about 1840–5. A correspondent to the museum in 1913 believed the work to be by John Constable, which seems unlikely.

LIT:   *Gaunt and Roe*, repr colour pl 1; *Farr* no 218 p174

PROV:   *Drawing and Design* July 1928, p180; *Connoisseur* LXXIX, 1927, facing p168 (colour); *Illustrated London News* 18 June 1838 (it was the museum's 'Masterpiece of the Week')

**Study of a Nude Female Figure**
D1807-1908
Millboard, 61.2 × 48.2 cm (24⅛ × 19 ins)
Purchased 1908

There are two pen and ink life studies on the back. Also inscribed on the back is: 'This belongs to Philip Norman, 45 Evelyn Gardens', and on a label the number 346 (see *Prov*: below).

PROV:   Presumably lot 346 in the artist's studio sale, Christie's 6–14 May 1850, 'A Nymph at the Bath; a sketch on the reverse', bought £10 15s

**Youth on the Prow, and Pleasure at the Helm (after W ETTY)**
249-1866
Canvas, 61 × 44.1 cm (24 × 17⅜ ins)
Purchased 1866

A reduced copy by Alfred Morgan of William Etty's painting exhibited at the RA in 1832, which was bought by Robert Vernon and given by him to the NG in 1847 (now Tate Gallery; 158.7 × 117.5 cm/62½ × 46¼ ins; Farr no 109). Etty's original was engraved by C W Sharpe for both *The Vernon Gallery* and the *Art Journal* (p128) in 1850. Etty explained the subject (quoted in *The Vernon Gallery* 1850): 'The view I took of it as a general allegory of Human Life, morally, where what we see here portrayed in its fabulous sense, is often real'. The title is a quotation from Thomas Gray's poem *The Bard* (first published 1757), part 2 verse 2:

> Thy son is gone. He rests among the dead.
> The swarm that in thy noon-tide beam were born?
> Gone to salute the rising morn.
> Fair laughs the morn and soft the zephyr blows,
> While proudly riding o'er the azure realm
> In gallant trim the gilded vessel goes;
> Youth on the prow and Pleasure at the helm;
> Regardless of the sweeping whirlwind's sway,
> That, hushed in grim repose, expects his evening-prey.

Alfred Morgan (exhibited 1862–1917, died after 1925) exhibited various kinds of subject, 44 at the RA between 1864 and 1917, 7 at the BI 1862–67, and 35 at the SBA 1865–86, also at the Grosvenor Gallery and elsewhere. He was still listed in *The Year's Art* directory in 1925. His son, Alfred Kedington Morgan, and daughter, Edith M Morgan, were also artists.

A label on the back of the copy indicates that the work was circulating outside London in the 1890s: Weymouth and Margate (1890), Blackburn and Dorchester (1891), and Hastings (1892). Another copy after Etty was sold at Christie's 13 February 1869 (147).

PROV:   The artist and teacher at the South Kensington Schools Richard Burchett; purchased from him by the museum 1866, presumably for teaching purposes

*Study of a Nude Female Figure*
D1807-1908

# EVANS, Richard (1784–1871)

Born 1784; pupil of and assistant to Sir Thomas Lawrence, painting for him drapery, backgrounds and replicas. Exhibited 42 works, mostly portraits, at the RA between 1816 and 1845 (when he is supposed to have had a dispute when his pictures were refused) and six subject pictures at the BI 1831–56. Visited Paris in 1814, copying paintings in the Louvre, and lived for many years in Rome, where he copied old masters and attempted fresco painting. He painted copies of Raphael's arabesque decorations and panels in the Vatican Loggia for the V&A which were acquired in 1843. Died Southampton, November 1871.

LIT:  *Art Journal* 1872, p75 (obit); *The Times* 30 May 1958

### Ganymede Feeding the Eagle
159-1865   Neg GJ5988
Fresco, 61 × 49.5 cm (24 × 19½ ins)
Given by Sir Matthew White Ridley BI 1865

*Ganymede Feeding the Eagle*   159-1865

According to an old label (see below), painted in Rome, in the manner of an antique Roman fresco. The *Art Journal* gave a fuller account quoting an obituary of Evans in the *Hampshire Telegraph* published late in 1871:

> During his residence in Rome he experimentally practised fresco-painting, and, on giving up his studio there, presented one of these paintings, which he did not care to take with him, to the attendant who swept out the studio. Many years afterwards, when on a visit to the Kensington Museum, he was astonished to find this identical fresco hanging up there, it having been presented by the executors of a wealthy connoisseur as a genuine piece of antique fresco-painting from a tomb in the neighbourhood of Rome. He examined his original sketch of the subject [presumably 36–1870 p89], made a special journey to London, convinced Mr Redgrave, the Director-General for Art, that the fresco was really his work, and not an antique, and the picture now hangs at the foot of one of the staircases in the Kensington Museum, with its real history attached to it.

The most famous modern depiction of the god Jupiter and his youthful companion and cup-bearer Ganymede is also a fresco, painted by Anton Mengs in 1758–9 in imitation of antique Herculanaeum wall-painting and intended to deceive his friend, the connoisseur Winckelmann. Evans, however, seems to base the pose of Ganymede on Michelangelo's famous marble sculpture of 'Bacchus' (Bargello, Florence). He depicts Jupiter in the traditional guise of an eagle.

The old label reads:

> Ganymede feeding the Eagle. /Fresco, painted at Rome, by Richard Evans, in the manner of the antique Roman frescoes./Presented by Sir M W Ridley, Bart, MP, with relation to the durability of modern fresco painting./This work was purchased in 1836, by the late Sir M W Ridley, Bart, from Capranesi of Rome,/together with another fresco, now in the British Museum, which is a true work of antiquity./Capranesi stated that they were taken from a tomb in the Via-Appia./This fresco was however subsequently recognized by Mr R Evans, as his own work.

Sir Matthew Ridley (1807–77) gave two fresco paintings to the British Museum in 1865. Of the first, the head and torso of a man, the 1933 catalogue states: 'This fragment is said to have come from the "Baths of Titus" (ie the Golden House of Nero). It is much repainted and the style and accessories are not antique in feeling'. Of the other, a flute-player, the catalogue records:

This fragment is said to have been found in a columbarium on the Via Appia in 1823. The whole surface is so completely covered with modern paint that no trace of ancient work is visible; and in view of the exceptionally large scale, and the sentimental pose, it is very probable that the whole figure is a 19th century fabrication, and not merely a heavily restored original (A P Hinks *Catalogue of the Greek Etruscan and Roman Paintings and Mosaics in the British Museum* 1933, p62, nos 91 and 92, repr figs 69, 70).

It seems likely that the latter painting is also the work of Richard Evans, as there are similarities in style and mood to the present work.

LIT: *Art Journal* 1872, p75

### Ganymede Feeding the Eagle
36-1870  Negs GB424, GB425 (with part of frame)
Paper on canvas, 58.4 × 42.1 cm (23 × 16⅝ ins)
Given by the artist 1870

An oil sketch, said to have been painted in 1822, for the fresco (see 159–1865, p88).

*Ganymede Feeding the Eagle*    36-1870

# FAED, John, RSA (1819–1902)

Born Gatehouse-of-Fleet, Kirkcudbrightshire, 31 August 1819, son of a millwright and engineer, and elder brother of the painter Thomas Faed RA. Worked as a miniature painter by the age of nine. Moved to Edinburgh 1839/40, and studied at the RSA. Exhibited 40 works at the RA between 1855 and 1893, three at the SBA in 1879, but principally at the RSA: 234 works 1841–95 (elected ARSA 1847, RSA 1851). Early works were miniature portraits, then, in 1850s, subjects from Shakespeare, the Bible, Burns, Scott, and Scottish ballads, and also landscapes; achieved a considerable reputation by 1860. Founder member of the sketching club 'The Smashers', continued in London as 'Auld Lang Syne'. Toured Middle East 1857, moved to London 1864, retired to Gatehouse 1880. Studio sale at Christie's 11 June 1880. Several of his works were engraved. Died Gatehouse 22 October 1902.

LIT: *Art Journal* 1871, pp237–9; *Scotsman* 23 October 1902 (obit); *DNB*; Wood *Dict*; M McKerrow *The Faeds – A Biography* 1982

### The Great Hall at Haddon
104-1900
Millboard, 35.5 × 50.7 cm (14 × 20 ins)
Signed and dated '.Faed 1860.' br
Purchased 1900

Haddon Hall, Derbyshire, home of the Vernon family, now Dukes of Rutland, was principally built from 1370 onwards; the great Banqueting Hall, typically medieval in plan, is the oldest room of which the original structure is still substantially intact. Faed shows the entrance screen with the minstrels' gallery above (compare the photograph repr in the 1977 guide book, p12, which shows almost the same view with some of the furniture in the same position). Because of features such as the castellated towers, the Picturesque aspect of Haddon Hall was much admired by painters, and – particularly in the 19th century – used inside and outside for backgrounds for pictures (see for example J C Horsley's 'Rival Performers', FA83 p129). In the artist's 1880 sale there were numerous sketches of Haddon; in his list of works, 'Haddon Hall in Old Times' is given under 1865 and as bought by the dealer Gambart

*The Great Hall at Haddon*    104-1900

for £250, and he exhibited 'Haddon Hall in the Olden Time' at the RSA in 1869. A painting identified as the 1865 work was sold at Sotheby's 16 April 1865 (199, as 'Haddon Hall in the Olden Time', 51 × 40.5 cm/20 × 16 ins, repr in catalogue); it shows an exterior scene with two figures in Romantic-medieval costume. The present work may be a study for the background of another painting, and was presumably studied on the spot. The subject may have been inspired by books such as Baroness de Calabrella's *Evenings at Haddon Hall* (illustrated by George Cattermole) published in 1846.

PROV: The artist's sale, Christie's 11 June 1880 (138), bought White £24 3s; Edward Fox White sale, Christie's 24 March 1900 (21), bought Agnew's for the museum £7 17s 6

## FARRIER, Robert (1796–1879)

Born Chelsea, London, 1796; apprenticed to an engraver and worked as a portrait miniaturist before entering RA Schools. Exhibited 35 paintings at the RA between 1818 and 1859, 50 at the BI 1820–66, and 32 at the SBA 1828–72. Specialised in domestic genre and scenes of schoolboy life, sometimes humorous; many of his works were engraved. Died Uxbridge, Middlesex, 19 April 1879. His sister, Charlotte Farrier, was a miniature painter.

*The Parting – A Recruit Taking Leave of his Family   229-1879*

### The Parting – A Recruit Taking Leave of his Family
229-1879
Canvas, 73.6 × 62.1 cm (29 × 24½ ins)
Given by Miss Mary Farrier 1879

Farrier exhibited several subjects of this kind: one critic wrote of 'Preparing for War', exhibited at the RA in 1847 (23): 'The very same boys that, time out of mind, have disported themselves upon the canvases of this artist . . . preparing for war, as they did long ago, parading funnels as helmets and pot-lids as shields. The picture is, in other respects, similar to most of those we remember of the productions of the painter' (*Art Journal* 1847, p186).

The present painting may be that exhibited at the RA in 1844, 'The Parting: "Life was New and Hope was Young" '; he also exhibited 'Taking Leave: "Life was New, and Hope was Young" ' at the BI in 1827 (329, measurements including frame given in the catalogue as '33 by 30 inches'). The former work was described in the *Art Journal* (1844, p167) as 'the old story of a young man having enlisted, and now taking leave of his mother and sisters. The style of work is hard and edgy, but there is some point in the leave-taking'.

EXH: ?RA 1844 (616)

## FIELDING, Anthony Vandyke Copley (1787–1855)

Born 1787, second son of the portrait painter Nathan Theodore Fielding; his four brothers were also painters. Pupil of his father and John Varley, and joined the circle of Dr Monro. Principally known as a watercolour painter of land and seascapes and as a drawing master. In a long and prolific career, exhibited 17 works at the RA between 1811 and 1842, 100 at the BI 1812–55, but principally at the OWS where from 1810 he showed about 1700 paintings (elected Associate 1810, Member 1813, Treasurer 1817, Secretary 1818, and President 1831). Won gold medal at the Paris Salon

1824, and influenced French painters including Delacroix. Died Worthing, Sussex, 3 March 1855. There are many watercolours in the V&A collections.

LIT:     *Art Journal* 1855, p108 (obit); Redgrave *Cent*, p509–13; Redgrave *Dict*; J Sherer *A Gallery of British Artists* II, 1880, pp57–8; S Kaines Smith 'Anthony Vandyke Copley Fielding' (and list of works) *OWS* III, 1925, pp8–30; M Hardie *Watercolour Painting in Britain*, *II The Romantic Period* 1967, pp43 etc, *III The Victorian Period* 1968, pp36, etc

### Mountain Landscape
1408-1869   Neg Z429
Panel, 12.7 × 21.6 cm (5 × 8½ ins)
Townshend Bequest 1869

### Yanwath Hall, on the Eamont, Westmorland
545-1882   Neg 81261
Canvas, 19.4 × 26.1 cm (7⅝ × 10¼ ins)
Jones Bequest 1882

*Mountain Landscape*   1408-1869

Previously catalogued as 'Brougham Castle' (except in the *Summary Catalogue of British Paintings* (in the V&A), 1973) the work has a MS label on the back inscribed 'No.4 Copley Fielding/View of Yanwath Hall/on the River Eamont near/Ullswater Cumberland/Liverp'. The last word suggests the work may have been exhibited in Liverpool.

   Yanwath Hall, described by Pevsner as 'splendidly preserved', is some 20 miles south of Penrith, and dates from the 14th and 15th centuries. The battlemented tower is most clearly visible in the painting. The work does not seem to have been exhibited in London; Fielding showed several other Westmorland and Cumberland subjects, at the BI 1815–6 and 1837, and at the RA in 1818. He also exhibited three paintings of Naworth Castle, some 25 miles north of Yanwath, at the BI in 1839, 1846, and 1847.

*Yanwath Hall, on the Eamont, Westmorland*   545-1882

PROV:   W Shand, sold Christie's 17 June 1871 (109, as 'The River Emont, near Ullswater'), bought the dealer Vokins £36 15s, who presumably sold it to John Jones, by whom bequeathed to the museum 1882

### Landscape (A V Copley Fielding and John Linnell)
1849-1900   Neg 53592
Canvas, 74.3 × 133.5 cm (29½ × 53 ins)
Ashbee Bequest 1900

The cattle and two drovers are probably by Linnell, the landscape by Fielding.

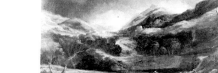

*Landscape (A V Copley Fielding and John Linnell)*   1849-1900

# FINCH, Francis Oliver (1802–1862)

Born London 22 November 1802, son of a city merchant. Studied with watercolourist John Varley 1814–19, then toured Scotland, returning to study at Sass's art school. Exhibited 14 landscapes at the RA between 1817 and 1832, but was principally a watercolourist, exhibiting 286 works at the OWS, becoming Associate 1822, Member 1827. Visited Paris 1852. Also painted portraits and miniatures, and was a singer and poet, publishing a volume of sonnets and a long poem, *An Artist's Dream*, 1863. Died London 27 August 1862. There are 17 watercolours in the V&A collections. The *Art Journal* obituarist admired the 'quiet delicacy of execution and classic, poetical feeling'; the *Athenaeum* thought 'with him the old school of painting may be said to die'.

LIT:  *Athenaeum* 6 September 1862, p315 (obit); *Art Journal* 1862, p207; Mrs E Finch *Memorials of the late Francis Oliver Finch . . . with selections from his writings* 1865 (with engr portrait by A Roffe, after a photograph by T M Richardson); T S R Boase *English Art 1800–1870*, 1959; *DNB*; J Maas *Victorian Painters* 1969; M Hardie *Watercolour Painting in Britain, II The Romantic Period* 1967, pp171–2

### Landscape Composition
442-1888   Neg FF412
Millboard, 20.9 × 30.5 cm (8¼ × 12 ins)
Purchased 1888

*Landscape Composition   442-1888*

The scene, with figures walking by a lake or river in what seems to be the ornamental garden of a classical mansion, was a favourite subject of the artist; a similar view is seen in the watercolour 'The Twilight Walk' also in the V&A collections (FA646). The Italianate, Claudian composition is in the style of artists such as George Barret, with whom Finch was compared; according to the *Memorials* (p91), Finch most admired Claude, and copied a painting by him in the Louvre. The most Romantic mood may be compared with that of certain works by Francis Danby and his circle, and it is also worth remembering that Finch wrote poetry. Finch's master, John Varley, also worked on occasion in this 'poetic' style, for example the 'Illustration to Byron's "Bride of Abydos" ' in the V&A collections (1515–1882). Finch's early patron was Lord Northwick, for whom he worked on views of his house and grounds. Northwick Park, and his other property at Thirlstane Place, may have been an inspiration for paintings such as the present work (compare for example Anne Rushout's *Picturesque Views* of Northwick Park published in 1815).

# FRITH, William Powell, RA (1819–1909)

Born Aldfield, near Ripon, Yorkshire, 9 January 1819, son of a butler (an amateur artist) and a cook. Studied at Sass's Academy from 1835; entered RA Schools. In a long, prolific, and highly successful career, exhibited 107 works at the RA between 1840 and 1906, 13 at the BI 1838–1857, and 12 at the Society of British Artists 1838–1883. Subjects predominantly literary, historical, and – most notably – scenes of contemporary life, with which he achieved his greatest popular fame, amplified by many engraved reproductions, beginning with *Ramsgate Sands* (exh RA 1854 and bought by Queen Victoria). In 1875 his *Dinner at Boswell's . . .* of 1869 sold at Christie's for £4567, the highest price ever achieved by a living artist. Member of 'The Clique' in the 1840s; elected ARA 1845, RA 1852. Died St John's Wood, London, 2 November 1909; there had been a studio sale at Christie's 14 June 1884. The *Art Journal* obituarist wrote: 'the artist will be missed: he was an institution'.

LIT:  *Art Journal* 1856, pp237–40 (for other references to Frith in the *Art Union* and *Art Journal*, see the entry in C Wood *Dictionary of Victorian Painters* 1971); W P Frith My *Autobiography and Reminiscences* 3 vols 1887–8; *Times* 4 November 1909 (obit); *Art Journal* 1910, p14 (obit); Mrs J Panton *Leaves from a Life* 1909, *More Leaves from a Life* 1911; W P Frith Whitechapel Art Gallery exhibition catalogue 1951; N Wallis *A Victorian Canvas* 1957; J Mass *Gambart: Prince of the Victorian art world* 1975; A Noakes *William Frith: Extraordinary Victorian Painter* 1978.

**Mr Honeywood Introduces the Bailiffs to Miss Richland as his Friends**
FA74   Neg 31848
Canvas, 71.1 × 104.2 cm (28 × 41 ins)
Signed and dated 'W P Frith 1850'
Sheepshanks Gift 1857

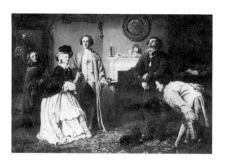

*Mr Honeywood Introduces the Bailiffs to Miss
Richland as his Friends*   FA74

Commissioned by John Sheepshanks in 1850, and, according to the artist, the last picture he was to commission; Frith quotes Sheepshanks as saying: 'Never sold a picture, and I never will; and if what I hear of the prices that you gentlemen are getting now is true, I can't pay them, so my picture-buying days are over'. The painting was exhibited at the RA in 1850, with the following lines quoted in the catalogue:

| | |
|---|---|
| *Honeywood:* | Two of my very good friends, Mr Twitch and Mr Flanigan. Pray, gentlemen, sit without ceremony. |
| *Miss Richland:* | Who can these odd-looking men be? I fear it is as I was informed. It must be so (aside). |

The subject is from Oliver Goldsmith's play *The Good-natur'd Man*, first produced in 1768. In act 3 scene 1, Honeywood, the 'good-natur'd man', has been taught a lesson in the foolishness of generosity by his uncle, who has him arrested for debt. When the bailiffs arrive to take possession, Honeywood bribes them to pretend to be his friends in front of his beloved Miss Richland, who nevertheless guesses their identity. As G S Rousseau (*Goldsmith: the Critical Heritage* 1974, p7) comments, the author's reputation reached its zenith in the 1820s – that is, in Frith's childhood – and then slowly declined; however, the simple pathos, humour, and wealth of incident (particularly in 'The Vicar of Wakefield',) ensured his continuing appeal to painters.

The *Art Journal* critic in 1850 thought 'the point of the work is the contrast between Honeywood and his friends, who are the veriest off-scourings of the lowest spunging-house in Chancery Lane . . . The drawing and colouring are both masterly'.

In the 1857 review of the Sheepshanks Gift, the *Art Journal* found that 'the bailiffs are slightly caricatured, and have, perhaps, too much of that of which Honeywood has too little – that is, spirit'. The *Athenaeum* critic noted 'a spirit in the touch that contributes to the look of vivacity where this quality is essential'. The popularity of the work with patrons is confirmed by the existence of perhaps as many as six other versions of the subject (see *Versions* below).

John Woodward has pointed out that the figure of Miss Richland is very similar in pose and costume to Sir Joshua Reynolds' portrait of Miss Keppel (about 1782, engraved 1820, now Ashmolean Museum, Oxford). The clock on the mantelpiece (which also appears in William Holman Hunt's 'The Awakening Conscience', 1853, now Tate Gallery) belonged to Augustus Egg, a friend of Frith.

The 'original sketch for the picture at the South Kensington Museum' was sold at Christie's 22 June 1865 (150, bought Grundy £147), presumably the sale listed in Redford *Sales* as the property of Hinde, the lot as bought in at £147.

EXH:   RA 1850 (534); *Exposition Universelle* Paris 1855 (799, lent by Sheepshanks); *Victorian Narrative Painting* V&A circulating exhibition 1961

LIT:   *Art Journal* 1850, p176; *Athenaeum* 25 May 1850, p559; G Waagen *Treasures of Art in Great Britain* II, p302; *Art Journal* 1856, p240, 1857, p240; *London Society* XI, 1867, pp247–52; *Autobiography* I, pp205–6

Versions:   1   Sold Christie's (W F Bolckow sale) 5 May 1888 (42, 71.1 × 104.1 cm (28 × 41 ins), as exhibited RA 1850), bought Vokins £462; Christie's (Lady Lampson sale) 8 June 1901 (19, 69 ×

101.6 cm (27 × 40 ins), as ex-Bolckow collection, dated 1866), bought Lister £194 5s

2 Redford *Sales* lists a 1864 sale, property of Fitzpatrick, bought in £472

3 Sold Christie's 1 April 1881 (256), bought Agnew £420; private collection; bought University of Kentucky Art Museum (as 'School for Scandal') 1984 [28 × 40.6 cm (11 × 16 ins)]

4 Sold Christie's (S G Holland sale) 25 June 1908 (34, 44.4 × 66 cm (17½ × 26 ins), signed and dated 1886), bought Gooden £168; sold Sotheby's Belgravia 10 July 1973 (58, 44.5 × 65 cm (17½ × 25½ ins), signed and dated 1886, repr)

5 Small version, signed and dated, recorded in private collection 1933; possibly identical with version 4 or 6

6 Exhibited *W P Frith RA* Whitechapel Art Gallery 1951 (16, panel, 28 × 40.6 cm (11 × 16 ins), signed and dated 1850), lent by Sir Ernest Makins

## Charles Dickens in his Study

F7    Neg GX2496
Canvas, 69.9 × 55.9 cm (27½ × 22 ins)
Signed and dated 'W P Frith fecit 1859' bl
Forster Bequest 1876

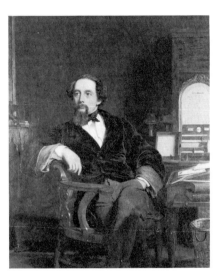

*Charles Dickens in his Study*    F7

Painted for John Forster, friend and biographer of Dickens, and exhibited at the RA in 1859. Frith had first met Dickens in 1842, when he commissioned paintings of Dolly Varden and Kate Nickleby; he met Forster – he thought in 1854 – when he was called on and asked to paint Dickens's portrait.

Dickens had grown a moustache soon after the commission was offered, to Forster's dismay: 'This is a whim – the fancy will pass' (Frith recalls Forster's words), 'we will wait till the hideous disfigurement is removed'. But a beard followed the moustache, and after a wait of four years, 'as I had heard that portrait-painters had often desired advantage from photography, I asked Dickens to give me a meeting at Mr Watkin's [probably Herbert Watkins, who had taken over Beard's studio in Parliament Street shortly after 1852], who was thought one of the best photographers of that day'. Dickens made this appointment in January 1859: 'Table also shall be there, and chair – velvet coat likewise, if the tailor should have sent it home' (letter from Dickens 12 January 1859, quoted by Frith). However, Frith found the photograph unsuccessful, 'nor did I derive the slightest assistance from it in the prosecution of the portrait'. A print of the photograph is in the Dickens House Museum (repr R Ormond *Early Victorian Portraits* 1973, II, fig 264); the pose is different and indeed rather uninspiring. Frith describes the progress of the portrait in some detail, recording sittings on 21 and 28 January ('a good and long sitting. Feel quite assured of success . . .'). It was finished by the end of March.

Dickens is shown in his study at Tavistock House in Bloomsbury, where he lived 1851–9, 'writing under the window, his desk and papers with a framed address to him – from Brimingham, I think'. Some of the first chapter of *A Tale of Two Cities* (first published in *All the Year Round* in 1859) is on the desk. By this time, aged nearly 47, Dickens was at the height of his fame and popularity. The pose is very similar to that of Sebastiano del Piombo's celebrated portrait of Pope Clement VII (1526/7, Gallerie Nazionali, Capodimonte, Naples) which was engraved; it lends to Dickens an imperious severity noticed by the *Art Journal* critic (see below).

Frith noted the changes in Dickens's appearance since the famous portrait of 1839 by Maclise (NPG): 'The change . . . was very striking. The sallow skin had become florid, the long hair of 1835 [sic] had become shorter and darker, and the expression settled into that of one who had reached the topmost rung of a very high ladder, and was perfectly aware of his position'. Forster seems to have been delighted with the portrait; Frith quotes his letters

of appreciation of 29 March and 8 April: 'The picture is, indeed, all I wished – more than I dared hope'; and 'Assuming I am warranted in saying . . . that Dickens so consented to sit as a special favour to me, I hope that, without any particular selfishness, I may venture, in so far as this portrait is concerned, to put forward some claim to share in that origination or invention of the subject . . ..' In the latter letter, Forster offered Frith double the fee of 150 guineas in exchange for the copyright. This was because he did not wish the portrait to be engraved, although he relented under pressure from his friends the following month.

Dickens himself seems to have been less enthusiastic: 'It has received every conceivable pains at Frith's hands, and ought on this account to be good. It is a little too much (to my thinking) as if my next door neighbour were my deadly foe, uninsured, and I had just received tidings of his house being afire; otherwise very good' (letter to the Hon Mrs Richard Watson 31 May 1859, ed W. Dexter *The letters of Charles Dickens* 1938, III, p104). The critics also had mixed feelings. The *Athenaeum* thought it:

> The best likeness by far that has yet appeared. It was difficult to associate the author of 'Pickwick' with the juvenile head that Mr Maclise painted . . . Mr Frith now steps in and presents the wistful public a culminating portrait, perfect in colour and likeness. We have the author at his moment of ease . . . just as the curious public want to see him. The artist has caught the author's blunt, pleasant, rather defiant look, and the healthy red and yellow of his face, where sun and rain have replaced all the bright, fresh tints that thought and the throes of invention too often bleach from the thinker's 'dark, pale face', as Ben Jonson called it.

The *Art Journal* on the other hand did not like the pose:

> Mr Dickens, when sitting for this portrait, has mistaken the sentiment wherewith he should have invested the author of 'Pickwick' and the 'Old Curiosity Shop'; who must in his nature overflow with the milk of human kindness. He wears a velveteen wrapper, and appears to have put his left hand hastily, and significantly, into his pocket, as turning round with an expression of countenance somewhat severe, he seems to negative some application we are quite sure he would have answered in the affirmative. The action is certainly ungraceful, if not unbecoming; it is, to say the least, 'a mistake' so to picture such a man, – an error on the part of the author as well as on that of the artist. The portrait, therefore, although admirably painted, is one we do not desire to see multiplied, the more especially as the accessories are by no means in good taste'.

This last remark may well refer to the desk furniture and the frame above, and the fringed drapery on the mantelpiece, which would suggest a bourgeois taste to a mid-19th century aesthete. The candlestick on the mantelpiece has been identified as an example of the Wedgwood 'Sphinx'. There seem to be two if not three further versions of the work, (see *Versions*: below), and Noakes reproduces an oil sketch on panel (35.6 × 28.6 cm/14 × 11¼ ins) in which the pose is somewhat different, notably the position of the hands. The latter was sold at Sotheby's Belgravia, on 20 November 1973 (as painted in 1859). Dickens's children, Mrs Perugini and Sir Henry Dickens, believed version 1 to be a better likeness than Frith's original. There are many portraits of Dickens in various media; for a full iconography, see R Ormond *Early Victorian Portraits* (1973, I, pp138–45) and F G Kitton *Dickens by Pen and Pencil* (1890–1).

Exh:    RA 1859 (210); *Charles Dickens* V&A 1970 (010)
Engr:   T O Barlow, published by McLean 1862, exh RA 1862 (935); R
        Graves, exh RA 1873 (1252).

Versions:    1  Painted for Cosens 1859, exh *Royal Jubilee Exhibition*
                Manchester 1887 (940), lent by F W Cosens; sold Christie's
                (Cosens's sale) 17 May 1890 (105, 53.3 × 40.6 cm (21 × 16

ins), as painted in 1886), bought Spielmann £38 17s and retouched for him by Frith about 1904 (Spielmann later recorded, in a letter to *The Times* 20 October 1928, that it was an early copy painted for Cosens); possibly exh *Victorian Exhibition* New Gallery 1892 (261); Dickens House Museum (dated 1886)

2 Collection of the artist, bought Maggs Bros 1910, 47 × 34.3 cm (18½ × 13½ ins), signed (repr *Connoisseur* XXIX, 1911, p205)

3 Dated 1898, Van Sweringen collection, Ohio, USA (possibly identical with version 2)

LIT: *Athenaeum* 30 April 1859, p587; *Art Journal* 1859, p165; *Autobiography* I, pp307–17, II, pp184–92; J Forster *Life of Dickens* 1911, II, p252; *Charles Dickens* V&A exhibition catalogue 1970, p109 (repr); G Reynolds 'Charles Dickens and the World of Art' *Apollo* June 1970, pp422–9, (repr); *Noakes* pp142–5

REPR: F P Brown *London Paintings* 1933, p102

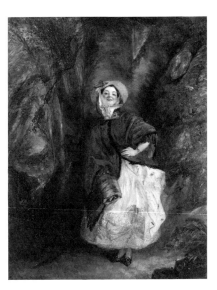

*Dolly Varden*   F8

## Dolly Varden

F8

Canvas, 54.6 × 44.5 cm (21½ × 17½ ins)

Signed and dated 'W P Frith 1842' bl

Forster Bequest 1876

One of the artist's most famous and popular works, and a subject of which he painted at least six versions. Frith recorded in his *Autobiography*: 'One of the greatest difficulties besetting me has always been the choice of subject. My inclination being strongly towards the illustration of modern life, I had read the works of Dickens in the hope of finding material for the exercise of any talent I might possess; but at that time the ugliness of modern dress frightened me, and it was not till the publication of "Barnaby Rudge" [in 1841], and the delightful Dolly Varden was presented to us, that I felt my opportunity had come, with the cherry-coloured mantle and the hat and pink ribbons . . . I found a capital model for Dolly, and I painted her in a variety of attitudes. First where she is admiring a bracelet given her by Miss Haredale; then as she leans laughing against a tree; then again, in an interview with Miss Haredale, where she is the bearer of a letter from that lady's lover; and again when on being accused of a penchant for Joe, she declares indignantly, "She hoped she could do better than that, indeed!" These pictures easily found purchasers, though for sums small enough. The laughing Dolly, afterwards engraved, became very popular, replicas of it being made for Dickens's friend John Forster [the present work], and others'.

The novel is set in the late eighteenth century, so enabling Frith to illustrate a Dickens subject without having to deal with 'the ugliness of modern dress'; Frith noted also in his *Autobiography* that his maternal grandmother's wedding-dress was 'an excellent "property" as a piece of costume', which he used for Dolly Varden as well as Sophia in *Measuring Heights* (see 511–1882, p100) and *The Bride of Lammermoor* (see 514–1882, p102). The episode is related in chapter 19 of *Barnaby Rudge*: 'As to Dolly, there she was again, the very pink and pattern of good looks, in a smart little cherry-coloured mantle, with a hood of the same drawn over her head, and upon the top of that hood, a little straw hat trimmed with cherry-coloured ribbons, and worn the merest trifle on one side . . . And she wore such a cruel little muff, and such a heart-rending pair of shoes, and was so surrounded and hemmed in, as it were, by aggravations of all kinds . . .'. Indeed Frith seems to have popularised Dolly Varden as a subject: within three years of the publication of *Barnaby Rudge*, when Robert Buss showed *Joe Willett taking leave of Dolly Varden* . . . at the RA in 1844, the *Athenaeum* critic (25 May 1844, p483) commented that 'the maiden has become quite a painter's heroine'.

The original painting was bought by the collector Henry Cooper through the dealer Charles Hawker by 31 January 1842; a letter of that date from Hawker to Cooper, one of a series in a private collection, accompanied the painting: 'a more lovely picture never left my house. I hope it will afford Mrs. Cooper and yourself as much pleasure as it has us'. Frith later borrowed it back for the exhibition of the Society of British Artists at Suffolk Street; he wrote to Hawker on 6 May 1842: 'If you went to the Suffolk St. Gallery you would perceive that they have not given my picture a very first rate place, yet in spite of that I have got 2 commissions to make duplicates of it. This I could not conscientiously do without first asking permission from the Gentleman who owns the picture and as I do not know his address I am forced to trouble you to be again the medium of communication. It is at any time a great compliment to be asked to make a copy of a picture of one's own, but it is more particularly so in the present instance, as the persons who desire it are eminent artists quite strangers to me. Creswick and Stone . . . If the owner of "Dolly" should object to the copies being similar in all respects to the original I will pledge myself that the background shall be entirely different, in short nothing shall be exactly like except the face – tho' artists certainly copy their sold pictures unknown to the purchasers I do not think it fair to do so especially in a case like the present when I am indebted to the owner so much. All the best artists however Wilkie, Leslie, Landseer etc have been allowed to repeat some of their best pictures to a great extent, as it is not considered to injure the original at all, as a work of declaration that such is the original is usually given by the artist'. Frith concludes with news of the success of *Measuring Heights* at the Royal Academy, which 'will I know give pleasure both to yourself and the gentleman to whom Dolly apertains, as it, of course, increases the value of his Picture'.

On 15 May he assured Hawker that he would supply Cooper with a 'voucher of Dolly's originality' and wrote to Cooper on 22 August:

'I cannot let your Picture of Dolly Varden return to you, without expressing my warmest thanks for your kindness in allowing me to make the copies of it and your kind permission has not only been the means of profit to me in a pecuniary sense but has gained me the acquaintance of men who may be of the greatest ultimate advantage to me – I am happy to say the copies have been made without the slightest disadvantage to the original as they are in all respects entirely different, the dress being altered, the figure shortened, and the whole painted afresh from nature. I am sure you will be glad to hear, as it is a high compliment to your picture that the commission for one of the copies was given me by a particular friend of Mr Dickens, with a view of presenting it to him, and the other copy is for Mr Creswick the eminent landscape painter. I did not until after I had repacked the Picture remember your request to write on the back I will do that however when I reach Birmingham . . . I was obliged before I exhibited the picture in Suffolk St to rub off some writing in pencil on the back, about the transfer of the Picture as if they know a picture is sold they make a point of not exhibiting it'.

A descendant of Cooper informed the Museum in 1951 that he owned a label, intended to be pasted on to the back of his picture, inscribed: 'I made two copies of this Picture for Mr. Creswick and Mr. Stone, August 1842. Frith'. It seems from a letter from Frith to Cooper of 6 December 1855 that the artist borrowed the original *Dolly Varden* for a second time. Stone, the 'particular friend' of Charles Dickens, was Frank Stone ARA, and it was Stone who gave the present work to John Forster. In a letter to Forster in 1856 (quoted in Lady B. Balfour *Personal and Literary Letters of Robert first Earl of Lytton* 1906), Lord Lytton recorded 'Ah, those memories of Lincoln's Inn Fields [Forster's home] . . . you with your strong forehead bowed over that relentless *Examiner* [of which Forster was editor from 1847 to 1856] table . . . Macready gazing at you across the witch's cauldron [see Maclise F21, p181], and Dolly Varden holding her pretty sides and laughing behind you'.

Frith records in his *Autobiography* (I, pp83–4) that B R Haydon much admired Cooper's painting when it was shown at the Society of British Artists, and the *Art Union* critic called it 'a small contribution, by an artist who will ere long play a "premiere role" upon a higher stage', a prophecy that was to be fulfilled. As Frith related in a letter to Cooper of 4 July 1856, when he had nearly finished a companion piece for his *Dolly Varden*: 'Many years ago Dickens saw your picture of Dolly and gave me a commission from it to paint him two pictures, one to be a Dolly the other Kate Nickleby – I made at that time many sketches of different points in the latter young lady's history and one was during her residence at Madame Mantalini's where she is described as holding different articles of dress whilst Madame Mantalini tries them on the fashionable ladies – this I have selected for your picture'. Cooper confirmed this suggested commission, and paid £210 for his version of *Kate Nickleby* which was delivered in July 1856.

Frith had written to Dickens on 9 August 1841 (quoted in *The Letters of Charles Dickens* ed. M House et al, III, 1974, p373): 'Having painted 2 Pictures from "Barnaby Rudge" which a great many of my artist friends tell me are successful, I am naturally most anxious to hear yr. opinion . . . The subject in each picture is that exquisite creation Dolly Varden – one when she is *admiring the Bracelet* – the other when she is leaning against the tree'. Dickens does not seem to have answered this letter, or visited Frith to see the paintings. But according to a letter to Frith of 17 November 1842 (National Art Library, Victoria and Albert Museum), Dickens had seen the 'Bracelet' picture, and, some months before, an unfinished print of the 'laughing Dolly', and in a short letter of 15 November 1842 (also National Art Library) offered Frith a commission: 'I shall be very glad if you will do me the favour to paint me two little companion pictures; one, a Dolly Varden (whom you have so exquisitely done already), the other a Kate Nickleby . . . P.S. I take it for granted that the original picture of Dolly with the Bracelet is sold?' Dickens called to see his painting, commenting 'All I can say is, they are exactly what I meant', and paid for them in August 1843. The Kate Nickleby painting, showing her sitting in the Mantalini house with her dressmaking on her lap, was later engraved. The two pictures were hung as pendants in the dining room at Gad's Hill Place, as is shown by a photograph (repr. by Reynolds p429).

C Cunnington (in *English Women's Clothing in the Nineteenth Century* p261) notes that a tipped-forward hat and a sort of 'polonaise' skirt became very fashionable in the summer of 1871, and that the fashion was known as a 'Dolly Varden'. This fashion must surely have arisen as a result of the Dickens sale which included his version of Frith's picture. There was a further revival of eighteenth-century skirts and tipped-forward hats in 1915–6 (see C Beaton *The Glass of Fashion* p97).

Versions:
1 (the original) bought by Henry Cooper through the dealer Charles Hawker by 31 January 1842 (see above); . . . by family descent to P R Bedford, who lent it to Whitechapel exh 1951 (5, panel, 21¼ × 17¼ ins).
Exh: Society of British Artists 1842 (193)

2 (the present work) replica painted by August 1842 commissioned by Frank Stone, who gave it to John Forster, who bequeathed it to the Museum 1876.

3 replica painted by August 1842 commissioned by Thomas Creswick RA; . . . Charles Birch sale, Foster's 15 February 1855 (repr. in catalogue described by *Gentleman's Magazine* (xliii, p276) as a 'little gem', bt £210

4 replica for Mr Phillips
? Christie's 5 March 1871 (87), signed and dated 1876
? Sotheby's Belgravia 11 July 1972 (124), 17 × 13 ins, signed and dated 1876

5 Exh. RA winter 1911 (36), 22 × 18 ins, dated 1843, lent Lord

Airedale (described in the catalogue).
6 Tate Gallery (T41), panel, 10¾ × 8½ ins, bequeathed by Mrs
  E J T Thwaites 1955 (see *Auckland Art Gallery Quarterly* May
  1976)
7 Sold Christie's 4 October 1973 (89), signed and dated 1902,
  16½ × 13¼ ins, bt Ross Galleries £199–10–0

Exh: *Charles Dickens* V&A 1970 (F18, repr. plate 43)

Lit: *Strand Magazine* 1907 (repr. in colour); A. Dayot *La Peinture Anglaise*
     . . . Paris 1908, repr. facing p216; Noakes pp40, 44, repr. in colour
     facing p105; G Reynolds 'Charles Dickens and the World of Art',
     *Apollo* June 1970, p427, repr, in colour on the cover.

## An English Merry-Making, a Hundred Years Ago
510-1882   Neg H306
Canvas, 24.1 × 40.6 cm (9½ × 16 ins)
Jones Bequest 1882

*An English Merry-Making, a Hundred Years Ago   510-1882*

Presumably a preliminary sketch for the large (113 × 185.4 cm/44½ × 73
ins) picture begun in 1846, exhibited at the RA in 1847, and now in the
Proby collection at Elton Hall near Peterborough. In the RA catalogue, the
title was followed by a quotation from Milton's 1632 poem *L'Allegro*:

When merry bells ring round,
And the jocund rebecks sound,
To many a youth, and many a maid,
Dancing in the checquered shade;
And young and old come forth to play
On a sunshine holiday.

Frith seems to have paid especial attention to this painting in order to justify
his election to ARA in 1845 (see 538–1882, p105).

Frith describes his work on the RA picture in his *Autobiography*:

I put no trust in fancy for the smallest detail of the picture. The oak-tree
is a portrait of a patriarch of Windsor Forest, whom I recognised the
other day unchanged in the slightest degree; could the tree have seen
me, I am sure he would not have known me again . . . The cottages are
studies from nature, and every figure in the picture is more or less a
portrait of the model who sat for it. The old woman sitting at the
tea-table by the cottage-door was a Mrs King, who followed the
respectable calling of a washerwoman . . . I used my wife's sisters and
some friends rather remorselessly, but, I think, with good effect.

However, he continues: 'The bits of distance and the grass and sky bothered
me terribly. Creswick, who had become my intimate friend – and who was
good-nature personified – offered to mend the distance for me, and the result
of his doing so was very satisfactory'. Frith also records that the painting was
'hung in one of the angles of the middle room at Trafalgar Square, and was
very successful. Previous to its going to the Exhibition, it was sold to a
picture-dealer for three hundred and fifty pounds; since then it has changed
hands many times, and is now an heirloom in a large collection in the north'
(presumably the Bolckow collection – see *Versions*: below).

The painting was indeed successful. Frith records that J M W Turner
admired it. The *Art Union* critic thought 'We have never seen anything in
genuineness of feeling so especially realize the descriptions given by our poets
of an English holiday of this period . . . not only the best which this artist has
painted, but worthy of being cited among valuable examples of the English
school'. The *Athenaeum* agreed: 'One of the most complete and successful
pictures of the season . . . the colour is rich and brilliant . . . there is a great
improvement in the mode of painting over Mr Frith's previous works'.

99

As was his habit with successful compositions, Frith made other versions at various times (see *Versions:* below).

ENGR: (RA picture) William Holl Jr 1852

LIT: (RA picture) *Athenaeum* 29 May 1847, p576; *Art Union* 1847, p191; *Autobiography* I, pp122–7; T Borenius and J Hodgson *Catalogue of the Pictures at Elton Hall* 1925, repr facing p104

Versions: 1 Exh RA 1847 (251), sold to a dealer; owned by John Nagler in 1852, according to lettering on Holl's print; exh *Art-Treasures Exhibition* Manchester 1857 (320, lent by John Naylor); exh *International Exhibition* 1862 (662, lent by J Graham); exh *Royal Jubilee Exhibition* Manchester 1887 (334, lent by Mrs Bolckow); Christie's (partly W W F Bolckow collection) 18 June 1892 (159) 110.5 × 183 cm, (43½ × 72 ins) bought Lord £451 10s; Proby collection, Elton Hall, nr Peterborough, Cambridgeshire, 113 × 185.4 cm (44½ × 73 ins), signed and dated 'W P Frith 1847'

2 Canvas, 52 × 85.1 cm (20½ × 33½ ins), signed and dated 1887, in collection of artist's great-grandson in 1951

3 Canvas, 52 × 87.5 cm (20½ × 33¾ ins), signed, said to have been painted in 1889, exh Whitechapel Art Gallery 1951 (13, lent by Josiah Rhodes)

4 Christie's 7 December 1962 (20), 52 × 85.1 cm (20½ × 33½ ins), signed, property of Miss Kathleen M Kay, repr in catalogue

5 Walter Frith (in 'A Talk with my Father', *Cornhill Magazine* 119, May 1906, p597) describes him at the time of writing as having just finished another version

6 Sold Gemmell, Tuckett and Co, Melbourne, Australia 23 May 1902; private collection, Australia, 86.4 × 141 cm (34 × 55⅝ ins), not inscribed

*'Measuring Heights': A Scene from the 'Vicar of Wakefield'* 511-1882

## 'Measuring Heights': A Scene from the 'Vicar of Wakefield'
511-1882   Neg 52986
Panel, 22.8 × 30.5 cm (9 × 12 ins)
Jones Bequest 1882

Presumably a sketch for, rather than a replica of, 'A Scene from the Vicar of Wakefield', exhibited at the RA in 1842, and now in the National Gallery of Victoria, Melbourne, Australia. In the RA catalogue, the title was followed by a quotation from chapter 16 of Oliver Goldsmith's most famous novel (published 1766): 'It must be owned that my wife laid a thousand schemes to entrap him. . . . Then the poor woman would sometimes tell the Squire that she thought him and Olivia extremely of a size and mould, and would bid both stand up to see who was the tallest'. Mrs Primrose, the vicar's wife, is aiming to marry her daughter Olivia to their landlord, Squire Thornhill. For fuller comment on Goldsmith's works as subjects for painters, see FA74 above.

The RA painting was Frith's first great success. He wrote to Charles Hawker on 6 May 1842: 'I am sure you will be glad to hear that my reputation may now (I flatter myself) be said to be fixed, as I have a picture of some size and importance, containing 8 figures, in one of *the centre places on the line/*that is, at eye level/at the *Academy* – As you may imagine from its situation it was sold within half an hour of the first opening of the Exhibition –'. Frith also describes this success in his *Autobiography*.

The *Art Union* critic was enthusiastic: 'The main characters of Goldsmith's novel are here charmingly portrayed . . . The author of this work studies profitably the characters he transfers to canvass. He is not a mere picture-maker; but thinks, and thinks long and deeply over what he does. His abilities to execute are not inferior to his powers to conceive . . . [it] cannot

fail of being appreciated by "the mass", while it will as certainly satisfy "the critic".' It did not satisfy the *Athenaeum* critic, who thought the facial expressions too exaggerated; noting Frith as 'a rising artist', the writer thought 'he has already risen to the heights of affectation'. This review inspired Frith in his *Autobiography* (I, p98) to 'here advise all artists, young and old, never to read art criticism. Nothing is to be learnt from it'.

There are several versions of the composition, with differences in detail as was Frith's practice; the versions are listed below. A 'back to back' subject was also exhibited at the RA in 1868 (340); it was sold at Christie's 9 May 1870 (115), signed and dated 1867, as 'Measuring heights: Scene from She Stoops to Conquer', bought by Pocock for £120–15–0 (according to *Redford*, bought by Agnew's from Pocock for £125–15–0).

PROV:    Presumably sold Christie's 22 June 1867 (96), bt Bourne (probably for John Jones; Bourne also bought E M Ward's *Charles II and Nell Gwyn* which also came to the Museum in the Jones Bequest – see 528–1882 below).

*Versions:*    1   Exh RA 1842 (454), bt there by Zouch Troughton for £105; sold Christie's 23 June 1860 (111), according to Redford (*Sales*) owned by Troughton and bt in at £840; . . . sold Knight, Frank and Rutley at Maiden Erlegh (collection of the late S B Joel) 8 December 1931 (271), size given as 37 × 50 ins, signed, repr in catalogue as plate XIII (see also repr in the *Studio* spring 1932, p89), bt 1932 by the National Gallery of Victoria, Melbourne, Australia.
   2   sold Bonham's 1 March 1979 (120), panel 23 × 33 (9 × 13 ins), signed and dated 1842, repr in catalogue; Christie's 12 February 1988 (93).
   3   sold Christie's (Marquis de Santurce sale) 25 April 1891 (38), size given as 12 × 20 ins, signed and dated 1866, bt Innes £131–5–0.
   4   sold Christie's 22 February 1985 (82), panel 10.8 × 16.5 (4½ × 6½ ins), bt £345, repr, in catalogue.
   5   Exh *Gainsborough to Grant* Agnew's 1934 (30), no measurements given in catalogue, as 'a sketch for the large picture painted for C F Huth' (this may be a confusion with the Don Quixote subject commissioned by Frederick Huth in 1840 (see under 513 1880 below).
   6   Redford (*Sales*) lists two pictures: the first sold 1865, size given as 10 × 13 ins, Robinson sale, bt by the dealer Vokins £252; the second sold 1866, also 10 × 13 ins, bt in at £278–5–0, and presumably the same painting.
   7   An oval version depicting the two principal figures, dated 1845, is repr by Noakes (p27), and was possibly the work listed by Redford (*Sales*) as in the E Dixon sale of 1873, 13 × 10 ins, bt Permain £115–10–0.

## Sancho Panza Tells a Tale to the Duke and Duchess
513-1882
Panel, 20.3 × 33 cm (8 × 13 ins)
Signed and dated 'W P Frith 1850' br
Jones Bequest 1882

A sketch for (or possibly a replica of) the painting commissioned by the merchant banker Frederick Huth and exhibited at the RA in 1850 (not, as the *Autoiography* incorrectly states, in 1849). Unusually, no other version of this subject by Frith seems to be recorded, so the present work is probably the sketch shown to Huth as referred to below. The present whereabouts of the RA picture are unknown; for its early history see under *Prov:* below.

The RA catalogue gives the title and accompanying quotation as follows:

*Sancho Panza Tells a Tale to the Duke and Duchess*   513-1882

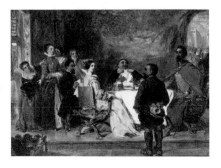

Sancho tells a tale to the Duke and Duchess, to prove that Don Quixote is at the bottom of the table: 'Then thus, (quoth Sancho,) both of them being ready to sit down, the husbandman contended with the gentleman not to sit uppermost, and he with the other that he should, as meaning to command in his own house; but the husbandman, presuming to be mannerly and courteous, never would, till the gentleman, very moody, laying hands upon him, made him sit down perforce, saying "Sit down, you thresher; for wheresoe'er I sit, that shall be the table's end to thee". And now you have my tale; and, truly, I believe it was brought in here pretty well to the purpose. Don Quixote's face was in a thousand colours, that jaspered on his brow'.

The quotation is from chapter 31 of the second part of Cervantes' satirical romance *Don Quixote* published 1605–15.

Frith wrote of the commission:

It is always agreeable to be able to note instances of liberality, as well as intelligent critical supervision, during the execution of a work; and in my commission from Mr Huth I experienced both. When I produced my sketch my employer asked me to name a price for the picture that would be satisfactory to me, and on my hesitating he named one himself, much in excess of what I should have demanded.

He continued:

I think I succeeded in some respects very well in my 'Quixote' picture; the Sancho and the Chaplain being thought successful, the Don less so, from the extreme – almost insurmountable – difficulty of giving to his figure the dignity that his appearance, the lank jaw and attenuated form, are so apt to destroy; and it is only in such hands as [C R] Leslie's that the difficulty disappears. On the whole, my reputation was advanced . . .

The *Athenaeum* critic found the RA painting 'of great beauty in colour', while the *Art Journal* thought 'the definite variety and appropriate felicity of character in this picture are evidently a result of assiduous study and research . . . The colour and texture are of great excellence; on the whole, there are few more admirable pictures in the Exhibition'.

Frith exhibited one other Don Quixote subject, 'Altsidora, Pretending Love for Don Quixote, Feigns a Swoon at the Sight of Him' at the RA in 1869.

Prov: (RA picture) commissioned by Frederick Huth, exhibited at the RA 1850 (332), still in his family collection 1887; sold Christie's (C F Huth sale) 6 July 1895 (82) 85.1 × 115.6 cm (33½ × 45½ ins), signed and dated 1850), bought Vokins £252

Engr: (RA picture) J and G P Nicholls in *Art Journal* 1856, p239

Lit: (RA picture) *Athenaeum* 25 May 1850, p559; *Art Journal* 1850, p171, 1856, p240; *Autobiography* I, pp196–8; E B Chancellor *Walks among London's Pictures* 1910, p244

## The Bride of Lammermoor

514-1882   Neg 53002
Panel, 36.8 × 28 cm (14½ × 11 ins)
Jones Bequest 1882

Painted about 1852, when it was engraved for an edition of Scott's works (see below). The subject is taken from chapter 20 of Sir Walter Scott's novel *The Bride of Lammermoor*, first published in 1819. In the novel, which takes place in the late seventeenth century, the Master of Ravenswood falls in love with, and becomes secretly betrothed to, Lucy, the daughter of his late father's greatest enemy Sir William Ashton: 'They broke between them the thin broadpiece of gold which Alice had refused to receive from Ravenswood. "And never shall this leave my bosom", said Lucy, as she hung the piece of

*The Bride of Lammermoor*   514-1882

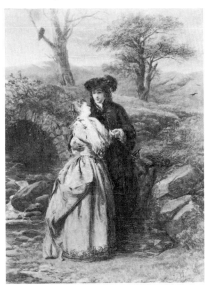

gold round his neck, and concealed it in her handkerchief, "until you, Edgar Ravenswood, ask me to resign it to you – and, while I wear it, never shall my heart acknowledge another love than yours". With like protestations, Ravenswood placed his portion of the coin opposite to his heart'. Frith follows Scott's description of the landscape ('the bubbling murmur of the clear fountain, the waving of the trees, the profusion of grass and wild-flowers') although not the description of Lucy ('her long hair, escaping partly from the snood and falling upon her silver neck'), and includes the raven in the tree which is to be killed by an arrow shot by Lucy's brother immediately after the engagement scene.

Another, larger version of the present work was exhibited at the RA in 1886 (178) as *The troth plight*, with the passage quoted above appended to the title in the catalogue; it was lent by Mrs London to the 1851 Whitechapel Art Gallery exhibition (45, 30¾ × 20½, signed and dated 1886). Another *Bride of Lammermoor* subject, 'The love token', taken from chapter 33 in which the engagement is annulled and the gold coin returned, was exhibited at the RA in 1854 (468); both the figures of Lucy and Ravenswood are clearly taken from the same models as in the present work. That painting was exhibited at the International Exhibition of 1862 (662, as 'Scene from the Bride of Lammermoor', sold Christie's 23 May 1873 (306), lent by L Butters to the RA winter exhibition 1911 (48), in the sale of Mrs J Butter's collection at Christie's 28 March 1930 (46, bought Pawsey-Payne £33–12–0), and is now in the Graves Art Gallery, Sheffield (17½ × 13½, signed 'W P Frith' bottom left).

Scott's novels were extremely popular sources of subject-matter for British painters in the first half of the nineteenth century (see C Gordon 'Scott's Impact on Art' *Apollo* July 1973, pp36–9); a series of engravings published by Charles Heath in 1841, *The Waverley Gallery of the Principal Female Characters in Sir Walter Scott's Romances*, included the Bride of Lammermoor among the heroines – 'whose heart does not bleed for the cruel wrongs of the gentle Lucy Ashton'. Scott's work had already provided a source for Romantic opera composers, notably Rossini's *La Donna del Lago* (1819) and Donizetti's *Elisabetta al Castello di Kenilworth* (1829; Frith exhibited a Kenilworth subject at the RA in 1841); Carafa's *Le Nozze di Lammermoor* was first performed in Paris in 1829, Bredal's *A bruden fra Lammermoor* (adapted by Hans Christian Andersen) was written in 1832, and Mazzucato's *La Fidenzata di Lammermoor* was staged in 1834. The most famous *Lucia* opera, which re-aroused British interest in the subject, was written of course by Donizetti, first performed in Naples 1835, and in London at Covent Garden on 15 April 1838.

ENGR: Lumb Stocks, for the title page of the Black edition of the Waverley novels, vol VIII, Edinburgh 1852 (the only other illustration in the volume was Lumb Stocks's engraving after the Sheffield painting of the *Love Token*).

## Scene from 'Le Bourgeois Gentilhomme': Monsieur Jourdain Receiving his Guests

537-1882   Neg L810
Canvas, 31.7 × 55.9 cm (12½ × 22 ins)
Signed and dated 'W P Frith 1860' br
Jones Bequest 1882

A reduced replica of the painting exhibited at the RA in 1848 and now in the Harris Museum and Art Gallery, Preston (see *Versions*: below). Frith wrote:

> I received a hundred and sixty pounds for this picture, but at what price it was acquired by Mr Newsham, of Preston, I have no means of knowing. At the death of that gentleman the picture passed, with the whole of his fine collection, into the possession of the Corporation of Preston, as a free gift to the people of that town. At the South Kensington Museum there are small copies of the Molière pictures in the Jones Collection.

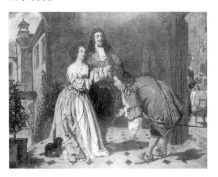

*Scene from 'Le Bourgeois Gentilhomme':*
*Monsieur Jourdain Receiving his Guests*
537-1882

103

Frith continues by relating the story of the model for the Marquise ('one of three sisters who were all favourite models at that time') who later married a nobleman.

The RA catalogue gives the title and accompanying quotation as follows:
Scene from 'The Bourgeois Gentilhomme'
Monsieur Jourdain, après avoir fait deux revérénces, se trouvent trop près de Dorimène.

| | |
|---|---|
| M Jourdain: | Un peu plus loin, Madame. |
| Dorimène: | Comment? |
| M Jourdain: | Un pas, s'il vous plait. |
| Dorimène: | Quoi donc? |
| M Jourdain: | Reculez un peu pour la troisième. |

The scene is from the end of act 3 of Molière's play (first performed in 1670), in which the 'would-be gentleman', in his new clothes, tries out an elaborate series of bows of greeting to his aristocratic dinner guests. For Frith's earlier painting of the dining-room scene in act 4, see 538–1882 p105.

The *Art Union* critic wrote of the RA picture: 'In costume and character the figures are remarkable, and not less in drawing and solidity of painting'. It was also, interestingly, admired by Théophile Gautier at the Exposition Universelle in Paris in 1855: 'Il est intéressant de voir comment un Anglais comprend une scène de Molière. – Il la comprend très-bien, à en juger par le tableau par M. Frith, qu'on croirait avoir vingt ans d'orchestre à la Comédie-Francaise'. Of the setting, it is worth noting that the sculpture in the hallway is the much-reproduced classical marble of 'Cupid and Psyche' (Capitoline Museum, Rome).

Molière's plays were popular as subjects for artists in England in the 19th century: see the entries in this catalogue for the paintings by W M Egley and C R Leslie, for example. Far more popular, it seems, than with theatre audiences; John Wood notes that 'in the nineteenth century romance and sentiment were supreme, and Molière was relegated to the school and the study. The recorded professional performances in English between 1850 and 1900 can be counted on the fingers of two hands' (*Five Plays* 1953, pxxv).

Frith seems to have painted another pair of replicas, almost the same size, also in 1860, of the two 'Bourgeois Gentilhomme' scenes (see *Versions:* below). What may be other versions, but are simply described as scenes from the play, or scenes from Molière, are: Christie's (Thomas Creswick's sale) 6–7 May 1870 (364), bought Agnew's £241 10s; Christie's (Francis Broderip's sale) 10 February 1872 (668, dated 1860 and painted for Broderip), bought Addington £399; Christie's 26 April 1890 (81, from John Hunt collection, 30.5 × 38 cm (12 × 15 ins), signed and dated 1860), bought Innes £52 10s; Christie's (Marquis de Santurce sale) 25 April 1891 (39, 29 × 30.5 cm (9 × 12 ins), bought Innes £68 5s). Several other paintings have gone through the saleroom since 1900.

LIT:    (RA picture) *Art Union* 1848, p176; and T Gautier *Les Beaux Arts en Europe* 1855, pp50–1; *Autobiography* I, p213

ENGR:    (RA picture) J and P Nicholls, *Art Journal* 1856, p238

*Versions:*    1  Exhibited RA 1848 (591); *Exposition Universelle* Paris 1855 (800) lent by J Fairrie; *Art-Treasures Exhibition* Manchester 1857 (540) lent by S Mendel; bequeathed by Richard Newsham 1884 to the Harris Museum and Art Gallery, Preston. Canvas, 71.1 × 91.4 cm (28 × 36 ins)

              2  (Paired with replica of 'Scene from Le Bourgeois Gentilhomme' 538–1882, p105) Christie's (F W Cosens sale) 17 May 1890 (87, 88) 47 × 59.7 cm (18½ × 23½ ins), signed and dated 1860), bought Cosens £157 10s and £136 10s; Christie's (F Cosens sale) 5 May 1916 (145, 146, 45.1 × 57.8 cm and 45.1 × 57.1 cm (17¾ × 22¾ and 17¾ × 22½ ins), signed and dated 1860), bought Smith £68 5s and £57 15s; art market, Sheffield 1953; Christie's 29 July 1954 (310, 44.5 × 58.4 cm

(17½ × 23ins), signed and dated 1860), ? bought in £126; private collection 1961

## Scene from 'Le Bourgeois Gentilhomme': Madame Jourdain finds her Husband Entertaining Dorimène and Dorante

538-1882   Neg L811
Canvas, 44.5 × 57.2 cm (17½ × 22½ ins)
Jones Bequest 1882

*Scene from 'Le Bourgeois Gentilhomme': Madame Jourdain finds her Husband Entertaining Dorimène and Dorante*
*538-1882*

A reduced replica of the painting exhibited at the RA in 1846 (496); its present whereabouts are unknown (but see below) and what is presumably the oil sketch (18.4 × 23.8 cm (7¼ × 9 ins, not inscribed) is in the City Art Gallery, Manchester. The RA picture was commissioned by the Birmingham banker John Gibbons, who had also commissioned the 'Village Pastor' exhibited at the RA in 1845. Frith records that an 'eccentric gentleman' paid Gibbons three times the price soon after, from which Gibbons gave Frith 50 guineas.

Frith was working on the painting for Gibbons when he was elected ARA in 1845, and wrote: 'I think neither of these pictures [the other was 'The Return from Labour', also exhibited at the RA in 1846] fulfilled the expectations raised by the 'Village Pastor', either in my friends or myself; and I felt the imperative necessity of immediately embarking on some subject of such importance as should justify my election, by the manner in which I should execute the work'. That subject seems to have been 'An English Merry-making' (see 510–1882 p99.)

In the RA catalogue the title and accompanying quotation is given as follows:

> Madame Jourdain discovers her husband at the dinner which he gave to the Belle Marquise and the Count Dorante.
>
> Mme Jourdain:   Ah, ah! Je trouve ici bonne compagnie, et je vois bien qu'on ne m'y attendait pas. C'est donc pour cette belle affaire-ci, monsieur mon mari, que vous avez en tant d'empressment à m'envoyer diner chez ma soeur? Voila comme vous dépensez votre bien; et c'est ainsi que vous festiniez les dames en mon absence.

The lines are from act 4 scene 2 of Molière's play *Le Bourgeois Gentilhomme*. For comment on Frith's Molière subjects see 537–1882 p103.

The *Athenaeum* critic thought of the RA work: 'The story is well represented, for those who know it . . . to others this picture does not tell its tale'. This remark bears out that Molière's plays were not popular in the 19th-century London theatre (see the comments on 537–1882 p103). The *Art Union* was more enthusiastic: 'The characters are admirably made out, are sustained most efficiently, and the scene has the great merit of rather representing real life than dramatic superficialities . . . This picture is assuredly one of the best of the dramatic series that was for years hung upon these walls'.

It seems certain that this replica and the 'Scene from The Bourgeois Gentilhomme' (537–1882 p103) were painted as pendants; they are almost the same size, and correspond in details such as costume (except that Jourdain seems to have lost his moustache between the entrance hall and the dining-room). It is tempting to suggest that the characters are portraits of actors, but as Molière was so rarely performed, and Frith only mentioned in his autobiography the model for Dorimène, it seems unlikely.

ENGR:   Lithograph J H Maguire

LIT:   (RA picture) *Athenaeum* 16 May 1846, p503; *Art Union* 1846, p182; *A Picture Gallery of British Art* 1873, p69; *Autobiography* I, pp113–4, 117, 122, 213

Version:   Exhibited RA 1846 (496); Phillip's 25 July 1983 (182, 79 × 100 cm (31⅛ × 38⅜ ins), signed and dated 1846, repr in colour), bought £5200. For other versions see 537–1882 p103.

**Scene from 'A Sentimental Journey'**
556-1882   Negs 52979, CT135564
Canvas, 90.2 × 69.9 cm (35½ × 27½ ins)
Signed and dated 'W P Frith 1841' bl
Jones Bequest 1882

Exhibited at the BI in 1842 as 'Scene from Sterne's Sentimental Journey', the measurements given as '48 by 41 inches', and the following quotation in the catalogue:

> I had counted twenty pulsations, and was going on fast towards the fortieth, when the husband, coming unexpectedly from a back-parlour into the shop, put me a little out in my reckoning. – 'Twas nobody but her husband, she said – so I began a fresh score. – Monsieur is so good, quoth she, as to give himself the trouble of feeling my pulse. – The husband took off his hat, and making me a bow, said, I did him too much honour . . .

Frith wrote to Charles Hawker, presumably a dealer, in Birmingham: 'Did you see my picture at the British Institution of "Sterne"? It was infamously hung, indeed it looked wretched tho it is thought quite equal and in some respect superior to the one in the RA. It is the only picture I have by me unsold . . . ' (15 May 1842). The *Autobiography* records that he sent it to Birmingham where it was sold for £30.

The *Art Union* critic remarked that it was

> Placed where it will inevitably escape the notice of all who do not already know sufficient of his abilities . . . Fair play would have made him a candidate for one of the prizes instead of the dark nook to which he has been condemned . . . beautifully conceived; the countenances of the group are perfect in character and expression; it is elaborately finished, and yet in a free style: as a whole it may vie with any production of our younger school of art.

The likeness of Laurence Sterne seems to be a more animated version of the famous portrait by Sir Joshua Reynolds (1760, NPG). Sterne is the hero, Mr Yorick, of his novel, first published in 1768. In the chapters 'The Pulse' and 'The Husband', he enters a Paris shop to ask the way, and flirts with the owner's wife – 'the handsomest Grisset [that is, grisette], I think, I ever saw' – by sitting beside her and taking her pulse; her husband enters, as related in the passage quoted above. The passage continues '. . . and having said that, he put on his hat and walked out'.

Frith painted the same subject in a different composition titled 'The Pulse, the Husband, Paris', exhibited at the RA in 1870 (267, 107 × 128 cm (42 × 50½ ins), signed and dated 1869), now Johannesburg Art Gallery). The artist presumably refers to this in his *Autobiography*: 'My second treatment of the Sterne was changed, and so was the price I received for it, for, instead of thirty pounds, I received nine hundred from Mr. Coope, in whose collection it still remains'. Frith also depicted the immediately subsequent incident of trying on the gloves, in 'A Scene from the Sentimental Journey' exhibited at the BI in 1845 (442).

There is an evident pentimento behind the lady's head, the top of the chair having been altered.

PROV:  According to the *Autobiography*, sold in Birmingham perhaps via Charles Hawker (see above), and 'In due time the picture appeared at Christie's, where it was sold for six hundred guineas', presumably 6 May 1871, lot 124, the property of a gentleman in Ireland (Rev E Seymour, according to Redford *Sales*), 'bought from the artist, and never engraved', sold to King for £525; bequeathed by John Jones 1882

EXH:  BI 1842 (416)

LIT:  *Art Union* 1842, p77; *Autobiography* II, pp13–4

## Sketch for 'The Derby Day'

1038-1886   Negs 70118, GK3103
Canvas, 28.2 × 44.8 cm (11⅛ × 17⅞ ins)
Signed and dated 'W P Frith 1858' bl
Dixon Bequest 1886

*Sketch for 'The Derby Day'   1038-1886*

The third sketch for the famous painting exhibited at the RA in 1858 (218), and now in the Tate Gallery. Full details of the finished work are given in M Davies *National Gallery Catalogue: The British School* 1946, pp53–4, and more recently and extensively by Connor and Lambourne. As Lambourne has pointed out, 'the race itself had not interest for him, and his chronology in his book is at complete variance with the real historical facts'. It seems sure that Frith visited Epsom on Derby Day in both 1856 and 1857, and began work on a first sketch, a charcoal drawing, numerous figure studies, and a 'small careful oil-sketch' which he painted on holiday at Folkestone. His friend, the wealthy pharmacist Jacob Bell, saw that oil sketch and commissioned a picture 'five or six feet long'. Frith then worked on a large oil sketch, and a third sketch – the present work – in which he tried a different arrangement of the principal and central group. Although inscribed '1858', it appears to date, to judge from Frith's own account, from 1856. He began the final canvas in January 1857, and finished it in time for the RA exhibition in May 1858. He made a replica in 1893–4, now in the City Art Gallery, Manchester.

Several auction references are listed by Davies, all of which relate to studies for 'The Derby Day', but it is not possible to identify the present work among them; it is not known when it was acquired by Joshua Dixon.

Exh:   ?*Winter Exhibition* French Gallery 1858 (48;47 was the 'First Study')
*W P Frith* Whitechapel Art Gallery 1951 (31)

Lit:   *Autobiography* I, pp268–303, III, pp156–8; P Connor and L Lambourne *Derby Day 200* RA exhibition catalogue 1979, pp71–8

## Scene from Molière's 'Le Bourgeois Gentilhomme': Monsieur Jourdain Learning to Dance (attributed to W P Frith)

P6-1979
Canvas, 63.5 × 72.2 cm (25 × 30 ins)
Given by Michael Hall, in memory of the late William Mills, 1979

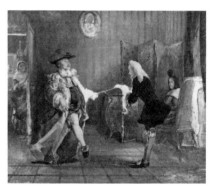

*Scene from Molière's 'Le Bourgeois Gentilhomme': Monsieur Jourdain Learning to Dance (attributed to W P Frith)*
*P6-1979*

The work is evidently unfinished, rather than an oil sketch. The subject is taken from Molière's most celebrated play *Le Bourgeois Gentilhomme*, act 2 scene 1, first performed in 1670; the quintessential *nouveau riche/arriviste*, Jourdain, is attempting to learn the manners and habits of the aristocracy.

The painting was given to the Museum as a work by C R Leslie; the donor William Mills bequeathed it, through his friend Michael Hall, in order – in his own words – 'to complete the set' of Molière subjects depicted by Leslie, including one of the first paintings given to the Museum, by John Sheepshanks in 1857, showing Monsieur Jourdain learrning to fence (see FA116 below). It seems more likely that the painting is by W P Frith, and this opinion is shared by Robin Hamlyn of the Tate Gallery, who is preparing a catalogue raisonné of Leslie's works. The present painting certainly seems to relate visually to the Molière subjects painted by Frith and exhibited at the RA in 1846 and 1848, of which there are later versions in the V&A collection (see 537–1882 and 538–1882 above). It is possibly identifiable with the sketch for the *Bourgeois Gentilhomme* in the Augustus Egg sale at Christie's 18 May 1863 (143, bt the dealer Cox £52–10–0), but that is described in the *Art Journal* account of the sale (1863, p139) as 'the finished sketch'.

*Male Life Study    1410-1873*

# FROST, William Edward, RA (1810–1877)

Born Wandsworth, Surrey (now in London), September 1810. Early protégé of William Etty, studied at Sass's art school, and entered RA Schools 1829 (won several prizes, including Gold Medal 1839). Won Gold Medal at Society of Arts 1833/4, and a prize in Westminster Hall fresco competition 1843. ARA 1846, RA 1870, honorary retired RA 1876. Exhibited 77 works at the RA between 1836 and 1878, 33 at the BI 1842–67, and two watercolours at the SBA in 1871 and 1875. Early works mainly portraits, then mythological and allegorical subjects usually involving female nudes sometimes in great numbers. Many of his works were engraved; there are eight in the V&A collections, and also several drawings. Redgrave (*Cent*) wote that his female figures had 'none of the vigour of those by Etty, though they have a chaste and graceful character'. Died Fitzroy Square, London, 4 June 1877; his studio sale was at Christie's 14–16 March 1878.

Lit:    *The Times* 8 June 1877 (obit); *Athenaeum* 9 June 1877, p744 (obit); *Art Journal* 1877, pp234, 280 (obit)

**Male Life Study**
1410-1873    Neg HE4968
?Canvas mounted on panel, 72.4 × 38.1 cm (28½ × 15 ins)
Purchased 1873

**Three Female Life Studies**
1411-1873, 1412-1873, 1413-1873    Negs HJ590, HJ591, HE4969
Millboard, 53.5 × 43 cm (21¹/₁₆ × 16¹⁵/₁₆ ins), 46.4 X 36.4 cm (18¼ × 14³/₈ ins), 43.2 × 52.7 cm (17 × 20³/₄ ins) max
Purchased 1873

1413–1873 is inscribed at the left 'Howard – Visitor-/March. 1842/No 13' (in ink, except for the word 'Visitor' which is in pencil); this is presumably Henry Howard RA (1769–1849), who was Professor of Painting at the RA from 1833. It is interesting to see Frost, like his mentor Etty, continuing to study from the nude in the Life School. 1412–1873 has no inscription, but 1411–1873 is inscribed at top right '1843 Oct[ober] –/Leslie [presumably C R Leslie RA] visitor [as above, written in pencil] No 2-[or possibly 1].

Engr:    (1411–1873) chromolithograph by a student of the London College of Printing and the Graphic Arts c1930 (20 proofs and the final state, in the V&A collections E255–275–1954)

*Three Female Life Studies    1411-1873, 1412-1873, 1413-1873*

**Contemplation**
557-1882    Neg HF972
Panel, oval, 18.1 × 13.3 cm (7⅛ × 5¼ ins)
Jones Bequest 1882

Two oval pictures, small to judge from the prices, were in the artist's studio sale at Christie's 16 March 1878: 'Head of a Greek Girl', (349), bought Rousby £2 2s, and 'A Study of a Girl's Head', (361), bought Lilley £5 5s.

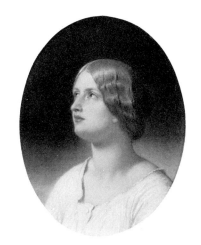

*Contemplation* 557-1882

# GEDDES, Andrew, ARA (1783–1844)

Born Edinburgh 5 April 1783, the son of a customs official and collector of prints. Educated as a classicist at Edinburgh Royal High School and University, and from 1803 worked as a clerk in the Excise Office. After his father's death, he went to London 1806, and entered the RA Schools with Sir David Wilkie. Returned to Edinburgh 1808, worked 1810–14 as a portrait painter, but soon after settled in London. Exhibited 100 works, mostly portraits, at the RA between 1806 and 1845, 28 (mainly landscapes) at the BI 1818–42, and 15 at the RSA 1836–45. He held a one-man show of 70 works in Edinburgh in 1821. Visited Paris 1814 to study in the Louvre, Italy 1828–30, and Holland 1839. Elected ARA 1832. Mainly known for his portraits, but also for 'fancy' pictures, religious paintings (he painted an altarpiece of the 'Ascension' for the church of St James, Garlick Hill, London EC1) and copies of old masters. He was also an accomplished etcher, particularly landscapes in the style of Rembrandt. Married 1827 Adela, daughter of the miniature painter Nathaniel Plimer. Died Berners Street, London, 5 May 1844. A posthumous sale of his work and collection was at Christie's 8 April 1845. His self-portrait of about 1815 is in the SNPG.

LIT:    [Adela Geddes, the artist's widow] *Memoir of the late Andrew Geddes Esq. ARA* 1844; *Art Union* 1844, pp291–2 (obit); D Laing *Etchings by Sir David Wilkie and by Andrew Geddes ARA with Biographical Sketches* Edinburgh 1875; R Brydall *Art in Scotland* 1889, p232; C Dodgson 'The Etchings of Andrew Geddes' *Walpole Society* V, 1915–17, pp19–45; W Martin 'Andrew Geddes, ARA', *Connoisseur* 1935, pp334–8

**A Man Smoking**
FA75    Neg E29
Panel, 38.1 × 30.5 cm (15 × 12 ins)
Sheepshanks Gift 1857

Not identifiable with any exhibited work, and clearly influenced by, if not a copy of, 17th-century Dutch painting in the 'guardroom' genre. Possibly commissioned by Sheepshanks from the artist; they were friends, probably from 1826 (see FA26, p110). Geddes visited Holland in 1839.

**Copy of Giorgione's Triple Portrait**
FA76    Neg E30
Canvas, 24.7 × 24.1 cm (9¾ × 9½ ins)
Sheepshanks Gift 1857

Geddes made several copies after Venetian paintings during his 1828–30 visit to Italy, including Titian's 'Sacred and Profane Love' on his arrival in Rome (now RA collection), Titian's 'Flora' in Florence, and the present painting. Adela Geddes recorded that in autumn 1830: 'At Venice we made a stay of several weeks; and there he copied the celebrated picture, sometimes said to be Giorgione's family, three heads, mentioned by Lord Byron. Venetian Paintings it was what he fully appreciated and delighted in'.

*A Man Smoking* FA75

*Copy of Giorgione's Triple Portrait* FA76

That painting, then in the Manfrini collection in Venice, known in the 19th century as the 'Family of Giorgione', 'at this date the picture by which Giorgione was known all over the world, was a Titianesque portrait group now forgotten by all but the most assiduous art lovers' (F Haskell *Rediscoveries in Art* 1976, pp15–16, repr pl 22). Byron had seen it in 1817 and in the same year wrote of it in *Beppo*, verse xii:

> And when you to Manfrini's Palace go,
> That picture (how so ever fine the rest)
> Is loveliest to my mind of all the show;
> It may perhaps be also to *your* zest,
> And that's the cause I rhyme upon it so:
> 'Tis but a portrait of his son, and wife,
> And self; but *such* a woman! Love in life!

The painting was presumably the 'Triple Portrait' now attributed to a follower of Titian, bought by the Duke of Northumberland in 1856 and still at Alnwick Castle (H Wethey *The Paintings of Titian* II, 1971, pp178–9, cat no x–90) its size being 73.5 × 77 cm (29 × 30¼ ins).

Geddes and the donor, John Sheepshanks, seem to have been friends, perhaps since the artist's gift to Sheepshanks of a portfolio of his etchings in 1826. Laing reproduces a portrait of the collector etched privately, and quotes a letter from Sheepshanks to Geddes in Rome dated 17 May 1830:

> I have also to thank you for the inquiries you have been pleased to make with respect to the Cenci, and, though the result of these puts it out of your power to make a copy from the *original*, I am not the less obliged for the expressed intention to execute this commission had it been practicable.

The 'Cenci' was presumably the 'Portrait of a Young Girl' attributed to Guido Reni, then as now in the Palazzo Corsini in Rome, which in the first half of the 18th century was thought to depict the tragic heroine Beatrice Cenci, and 'enjoyed a degree of adulation fully as genuine as that now accorded the 'Mona Lisa' (Haskell, p109, pl 236). It seems likely that Geddes, unable to copy the famous 'Cenci', copied this equally famous 'Giorgione' for Sheepshanks instead (but see *Prov*: below).

Sheepshanks also gave many of Geddes's etchings to the museum, including various states of his portrait. Geddes's interest in Giorgione is also shown later in his 1841 RA exhibit 'Giorgione Studying from Nature', which according to the *Art Union* (1841, p75), depicted a fair woman and a youth.

PROV: ?Geddes sale, Christie's 12 April 1845 (660, as 'GEORGIONE. Georgione and family – in the Manfrini Palace at Venice: the picture quoted by Byron – believed to be the only copy'), bought in £57 15s; Sheepshanks Gift 1857

LIT: *Memoir* p18; *Laing* pp17, 24, 32; S Whittingham 'Byron and the Two Giorgiones' *Byron Society Journal* 14, 1986, pp52–5 (repr)

# GILBERT, Sir John, RA, PRWS (1817–1897)

Born Blackheath, London, 21 July 1817, the son of a land agent. Followed his father's career 1833–36, when he first exhibited at the SBA and became a professional artist. It seems he failed to enter the RA Schools, but took lessons in colouring from George Lance; otherwise he was self-taught. Exhibited 55 works at the RA between 1838 and 1897, 40 at the BI 1837–67, and 23 (including three watercolours) at the SBA. Most were historical or literary subjects. Elected ARA 1872, RA 1876. He was more active as a watercolourist, exhibiting 260 works at the OWS, elected Associate 1852,

Member 1854, and President 1871. He was knighted in 1872. In 1884 he refused to sell any more work, and in 1893 gave pictures to the municipal galleries of London, Liverpool, Birmingham and Manchester, for which gift he became the first artist to receive the Freedom of the City of London. He was equally well-known as an illustrator and was extremely prolific; it is estimated he illustrated 150 books (most notably the Howard Staunton edition of Shakespeare (1860) for which he designed 829 illustrations) and magazines, particularly the *Illustrated London News* for which he is supposed to have produced 30,000 plates. He died at Blackheath 5 October 1897.

Lɪᴛ: *Athenaeum* 9 October 1897, pp494–5 (obit); R Davies 'Sir John Gilbert', *OWS X* (1933) pp 20–43

## Don Quixote and Sancho Panza

1825-1900   Negs CT8006, HJ592
Canvas, 76.1 × 63.5 cm (30 × 25 ins)
Signed and dated 'J. Gilbert 1840' bl

The work does not seem to have been exhibited. The subject is taken from Cervantes's novel *Don Quixote*; for Gilbert's special interest in the book, see 1856-1900, below. The relevant passage is from part 1 book 1 chapter 7:

> About this time, Don Quixote tampered with a labourer, a neighbour of his, and an honest man, but very shallow-brained. He said so much, used so many arguments, and promised him such great matters, that the poor fellow resolved to serve him as squire. Among other things, Don Quixote told him he should dispose himself to go with him willingly, for some time or other such an adventure might offer, that an island be won in the turn of a hand, and he be left governor thereof.

This is the beginning of the famous association between the Don and Sancho Panza.

Exʜ: *Victorian Narrative Paintings* V&A circulating exhibition 1961

*Don Quixote and Sancho Panza*
1825-1900

## Don Quixote Disputing with the Priest and the Barber

1856-1900   Neg V1935
Canvas, 71 × 90.8 cm (28 × 35¾ ins)
Signed and dated 'J Gilbert 1844' bl
H S Ashbee Bequest 1900

Exhibited at the RA in 1844, it was hung in a room with drawings and miniatures, and the *Art Union* commented that 'It is too bad to see here a work that would do honour to many an artist who "sits in judgement". Mr Gilbert has produced pictures that would put to shame half the contents of the Exhibition, if so placed as to be appreciated'.

The full title given in the catalogue was 'Don Quixote disputing with the priest and the barber the merits of the great knights errant of antiquity. *Don Quixote*, book 1, chap. 1'. The relevant episode is in the first part of Cervantes's novel:

> He had frequent disputes with the priest of his village (who was a learned person and had taken his degrees in Siguenza), which of the two was the better knight, Palmerin of England, or Amadis of Gaul. But master Nicholas, barber-surgeon of the same town, affirmed, that none ever came up to the knight of the sun; and that if any one could be compared to him, it was Don Galaor, brother of Amadis de Gaul'.

*Don Quixote Disputing with the Priest and the Barber*   1856-1900

Gilbert frequently returned to Cervantes's novel for inspiration, exhibiting six other Don Quixote subjects at the RA, and six at the BI; see also 'Don Quixote and Sancho Panza' (1825-1900, above). Three watercolours of Don Quixote subjects are also in the V&A collections. He designed illustrations for an edition of Jarvis's translation of *Don Quixote* first published in 1856.

Exh:   RA 1844 (948)

Lit:   *Art Union* 1844, p161

## GOOD, Thomas Sword, RSA (1789–1872)

Born Berwick-upon-Tweed, 4 December 1789. Worked as a housepainter, then a portraitist, but made his name with small genre paintings in the manner of Sir David Wilkie. Moved to London 1822. Exhibited 19 works at the RA between 1820 and 1833, 43 at the BI 1823–34, two at the SBA in 1824 and 1831, and 17 at the RSA 1815–50 (elected Honorary Member in 1828). Married Mary Evans 1839. For some reason, it is said an inheritance, he gave up painting after 1834. Died Berwick 15 April 1872.

Lit:   *Portfolio* 1889, pp111–3

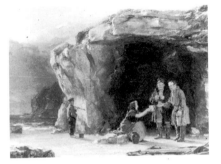

*Scotch Fishermen*   1827-1900

### Scotch Fishermen
1827-1900   Neg 51760
Panel, 27.9 × 37.1 cm (11 × 14⅝ ins)
Ashbee Bequest 1900

Good exhibited several coastal scenes with fishermen, presumably set in and around Berwick, on the coast in the south-east Borders of Scotland. Berwick is famous for its fishing, particularly salmon fishing on the River Tweed; this painting is set on a rocky coastal shore.

## GOODALL, Frederick, RA (1822–1904)

Born St John's Wood, London, 17 September 1822, the son and pupil of the engraver Edward Goodall, best known for his engravings after J M W Turner. Studied at the life school in St Martin's Lane, and exhibited watercolours at the Society of Arts as early as 1836. Exhibited 164 works at the RA between 1838 and 1902 (and 50 Egyptian studies there in 1869), 33 at the BI 1839–41. His early works were mostly village genre scenes in the manner of Sir David Wilkie (whose works he also copied), but after travelling in Egypt in the late 1850s his work was principally Egyptian and biblical in subject, beginning with the ten-foot long painting 'Arabian Encampment at the Wells of Moses' in 1860. After 1889, he painted some English landscapes and a few portraits. Elected ARA 1852, RA 1863. Travelled in Normandy 1838, 1839 and 1840, Brittany 1841, 1842 and 1845, North Wales 1843, Ireland 1844, Venice 1857, and Egypt 1858–9 and 1870. Died St John's Wood, London, 28 August 1904. Two of his sons, Frederick Trevelyan (see below) and Howard, were also artists. Sales of his collections were at Christie's 25 May 1893 and (in the name of his daughter Ricca) 20 February 1905; there seems also to have been a sale at his house in Avenue Road, because of financial difficulties, in November 1902.

*The Village Post Office*   512-1882

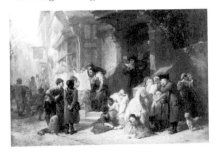

Lit:   *Art Journal* 1850, p213 (a short 'autobiography'), 1855, pp109–12; F Goodall *Reminiscences* 1902; *Art Journal* 1904, pp301–2 (obit); N G Slarke *Frederick Goodall, RA* Peterborough 1981

### The Village Post Office
512-1882   Neg 70215
Panel, 20.3 × 29.2 cm (8 × 11½ ins)
Signed and dated 'F. Goodall/1849' bl
Jones Bequest 1882

Presumably a small version of, rather than a sketch for, the painting exhibited at the BI in 1850 (52, 'The Post Office', measurements given in the catalogue as '53 by 70 inches'). It was engraved by C W Sharpe for the *Art Journal* in 1862, and sold at Sotheby's 22 March 1989 (185).

The three principal foreground groups of figures are posed in the same way (with slight variations of detail) in both paintings, but the backgrounds are completely different, the exhibited picture having a more stage-like setting with fewer subsidiary figures.

The *Art Journal* article of 1862 commented on the narrative: the left-hand group is reading *The Times*, the headline of which is Victory (the words above are illegible in the engraving), while the central group, 'the widow and the fatherless', have received a letter with a black seal that 'tells them the "victory" has made them desolate'. The original *Athenaeum* review of the 1850 BI exhibition more specifically refers to the first Sikh War of 1845–6: the village barber reads aloud from 'a late edition of the Times containing the Indian Mail, which has brought news of one of the victories of Hardinge and Gough on the Sutlej'. Both the *Athenaeum* and the *Art Journal* critics admired the BI picture.

The *Art Journal* in 1862 also commented that 'years back it was no uncommon thing to find a country post-office at the inn of the village or small town'; presumably Goodall printed the sign 'Post Office' in both pictures to make this aspect of the narrative clearer. Both the Indian wars and the development of the Post Office were topics of public interest and appeal in the 1840s. For a full account see J Farrugia *The Letter Box: a history of post office pillar and wall boxes* 1969, in which E V Rippingille's 1837 'A Country Post Office' is reproduced as the frontispiece.

The finished nature of the painting, and the variations in detail, such as the soldier's son in the centre holding a toy sword rather than a drum as in the exhibited picture, suggest that this is a small-scale replica rather than a sketch.

Thomas Falcon Marshall exhibited 'The Arrival of the Coach – a roadside inn a century ago' at the RA in 1850, that is a few months after Goodall's painting was shown at the BI; it has a similar subject and compositional structure. The similarity was not noticed by the critics of the *Art Journal* and the *Athenaeum*; the latter (8 June 1850, p615) merely wrote of 'much merit' and 'a subject rendered of additional interest in these days of rapid locomotion', a comment also suitable to the present work.

Lit:    (BI picture) *Athenaeum* February 1850, p163; *Art Journal* 1850, pp89, 213, 1862, p172 (repr on facing page); *Goodall* p381

## The Irish Piper
530-1882    Neg 68174/10
Panel, 29.2 × 40.6 cm (11½ × 16 ins)
Signed and dated 'F Goodall/1847' br
Jones Bequest 1882

Previously catalogued as 'The Bagpiper', but exhibited under the above title at the BI in 1848, the size given in the catalogue as '20 by 24 inches'. Goodall mentioned it in his 1850 *Art Journal* article as one of the results of his 1844 visit to Ireland. The *Athenaeum* critic thought the flesh tints too red, but the picture was considered the best of Goodall's four BI exhibits: 'It is full of appropriate incident. The several inmates of the dwelling are discriminated with nice gradation of feeling and interest'. The *Art Union* described it as 'exquisite in colour, and admirable in execution'.

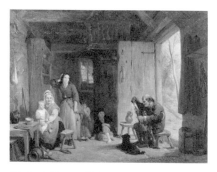

*The Irish Piper*    530-1882

Goodall stated in 1850 that the picture belonged to W J Broderip; it did not appear in William John Broderip's posthumous sale at Christie's 11 June 1859 (nor in Francis Broderip's sale of 6 February 1872). On the back of the panel is written: 'The Original Picture from which was repeated a larger one for The Art Union of London with the permission of W J Broderip Esqr.'.

Like his other paintings of the 1840s and 1850s, this shows the influence

of Sir David Wilkie, particularly in this case 'The Blind Fiddler' of 1806 (Tate Gallery). Redford (*Sales*) lists two other similar subjects in the saleroom, in 1855 'The Blind Piper' and in 1865 'The Piper'; the latter was 'The Piper: a scene in Brittany' sold at Christie's 8 April 1865 (142, 30.1 × 43.1 cm/12 × 17 ins).

EXH: BI 1848 (84)

LIT: *Athenaeum* 19 February 1848, p194; *Art Union* 1848, p82; *Art Journal* 1850, p213

### The Drinking Trough – Scene in Brittany

533-1882   Neg 52994
Panel, 49.5 × 40.6 cm (19½ × 16 ins)
Signed and dated 'F Goodall/1857' br
Jones Bequest 1882

Not identifiable with any exhibited works. Goodall visited Brittany in 1841, 1842 and 1845.

*The Drinking Trough – Scene in Brittany*   533–1882

### Cranmer, at Traitor's Gate

534-1882   Neg 53005
Panel, 45.7 × 74.8 cm (18 × 29½ ins)
Signed and dated 'F Goodall [partly obliterated]/1856' br
Jones Bequest 1882

Previously catalogued as 'Archbishop Cranmer taken to the Tower', but exhibited at the RA in 1856 under the above title. The title was accompanied in the RA catalogue by a quotation from Samuel Rogers' poem: 'On thro' that gate misnamed, thro' which before/Went Sidney, Russell, Raleigh, Cranmer, More'.

Thomas Cranmer (1489–1556), Archbishop of Canterbury, was sent by Mary Tudor to the Tower of London for treason on 8 September 1553. He was removed to prison in Oxford in 1554 and burnt at the stake two years later. Events in his life were quite popular with 19th-century painters; F D Stephenson, for example, exhibited 'Cranmer Revoking his Recantation at Oxford' at the RA in 1835. Slarke implies that the dealer Ernest Gambart commissioned the painting; the *Reminiscences* state that he bought it, presumably from the RA exhibition.

The *Athenaeum* critic wrote that the painting marked 'an advance', but 'The merits of the work are more professional than general, and lie rather too much in the proprieties of colour, tone, and composition. There is certainly no intensity of feeling . . . the *dramatis personae* are almost too dramatic, and are wonderfully unanimous in not looking the same way'. He concluded: 'One ray of faith or religion on his (Cranmer's) brow or forehead would have turned a clearer composition into a work of genius; but that wanting, this is only an "eye feast" of much excellence'. The *Art Journal* reviewer was more admiring:

*Cranmer, at Traitor's Gate*   534-1882

> This is a more solemn subject than any that has yet appeared under this name; . . . the composition is admirably managed . . . A strong feeling of interest and compassion is expressed in the features of the guards and attendants; but there is a monk whose malignant scowl represents the spirit of persecution under which Cranmer and others suffered. It is a work of high merit, different in everything from the buoyant tone of antecedent works . . .'

Slarke records that the artist made many studies at the Tower of London ('much discomforted by the stagnant water of the moat') and 'As usual, he needed his supply of properties – there had to be a model for everything – and a Mr Meyrick, an expert on arms and armour, provided helmets, swords and other paraphernalia'. This was presumably Augustus Meyrick, who had inherited the famous collection of armour – also studied in the 1820s by

Bonington and Delacroix – from his cousin, the antiquary Sir Samuel Meyrick. Much of the collection is now in the Wallace Collection.

What appears to have been a version, or perhaps a finished sketch, of the subject was 'A Small Picture of Archbishop Cranmer taken to the Tower of London', sold by the artist's father Edward Goodall at Christie's 24 June 1864 (186), bought by Grundy for £24 3s.

PROV: Bought by the dealer Gambart 1856; Thomas Graham by 1857; sold Christie's (J M Threlfall sale) 14 May 1864 (194), bought Seguier £703 10; bequeathed to the museum by John Jones 1882

EXH: RA 1856 (359); *Art Treasures* Manchester 1857 (457, lent by Thomas Graham)

ENGR: E Goodall (the artist's father)

LIT: *Athenaeum* 10 May 1856, p560; *Art Journal* 1856, p169; *Goodall*, p382; *Slarke*, p26

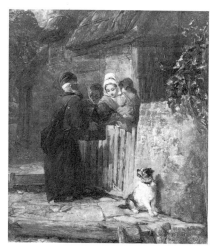

The Pedlar   546-1882

**The Pedlar**
546-1882   Neg 71526
Panel, 19.6 × 16.5 cm (7¾ × 6½ ins)
Signed and dated 'F Goodall/1849' br
Jones Bequest 1882

Not identifiable with any exhibited works.

**An Arab Improvisatore**
1000-1886   Neg 58266
Canvas, 56.4 × 39.3 cm (22¼ × 15½ ins)
Signed and dated 'F G [in monogram] 1872' br
Dixon Bequest 1886

Not identifiable with any exhibited works, but typical of his paintings inspired by visits to Egypt in 1858–9 and 1870. Presumably the title plays on the improvisation of the on-the-spot sketch as well as on the Arab's appeal for money.

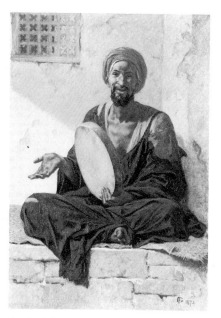

An Arab Improvisatore   1000-1886

# GOODALL, Frederick Trevelyan (1848–1871)

Born 1848, son of the painter Frederick Goodall RA. Studied at the RA, winning a gold medal for 'The Return of Ulysses', 1869. Exhibited 17 works at the RA between 1868 and 1871: landscapes, portraits and genre subjects. Travelled to Italy, where he died in an accident at Capri 11 April 1871. There are three watercolours in the V&A collections.

LIT: *Art Journal* 1871, p166 (obit)

**Sonning, Berkshire**
D1924-1908   Neg HF4877
Paper, 10.4 × 30.5 cm (4⅛ × 12 ins)
Given by Sydney Vacher, ARIBA 1908

Sonning, Berkshire   D1924-1908

**Landscape Study**
D1925-1908   Neg HF4870
Paper, 14.2 × 28.7 cm (5⅝ × 11⅜ ins)
Given by Sydney Vacher, ARIBA 1908

Landscape Study   D1925-1908

## GRACE, Alfred Fitzwalter, RBA (1844–1903)

Born Dulwich, London, 1844. Studied at Heatherley's School of Art and RA, where he won the Turner gold medal. Exhibited 57 works at the RA between 1867 and 1904, six at the BI 1865–67, and 82 at the SBA 1867–88 (elected Member 1875). Most were landscapes, many in Sussex, but a few were portraits, mainly miniatures. Also active as a watercolourist. Published *A Course of Landscape Painting in Oils*, 1881. His wife, Emily M Grace, exhibited paintings in enamel in the 1880s; the three Misses Grace – Anna, Frances, and Harriette – who also exhibited, were presumably his daughters. He died 12 November 1903.

**Hedgerow and Trees**
P22-1918
Millboard, 12.5 × 21.7 cm (4¹⁵⁄₁₆ × 8⁹⁄₁₆ ins)
Signed 'A F Grace' br
Given by R Clarke Edwards 1918

Written on the brown paper backing of the frame was: 'A Hedgerow. Beeding Sussex/By A F Grace/Bought at the Brighton Public Art Galleries/Xmas 1904. No 348 in Catalogue/RR.SSS'. Grace exhibited a work titled 'Beeding, Sussex' at the 1887/8 SBA exhibition (233); Beeding is some two miles from Steyning, where the artist lived from 1888.

## GREEN, Thomas

No artist of this name is listed in the directories of exhibiting artists; he may have been a student at the South Kensington schools (see below).

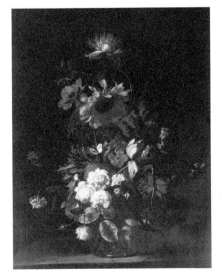

*Flower Piece*   9101-1863

**Flower Piece**
9101-1863   Neg HH3833
Canvas, 101.6 × 81.3 cm (40 × 32 ins)
Signed and dated 'Thos Green/October 1853 bl (concealed by frame)
Purchased 1863

The work is recorded as a copy after Verelst. This is presumably Simon Pietersz Verelst (1644–1721), and F Lewis's monograph of that artist (Leigh-on-Sea, 1979) reproduces an almost indentical composition (in colour, p51, cat no 47a; 75 × 62.3 cm (29½ × 24½ ins), Richard Green Fine Paintings Ltd). However, Lewis also notes two other similar compositions, one nearer the size of the present work (106.7 × 88.9 cm (42 × 35 ins), Broughton collection), the other sold at Bonham's 13 July 1978 (lot 78, 92.7 × 68.6 cm (36½ × 27 ins), present whereabouts unknown).

A label on the back reads 'For Sale price £3 5s'. It may well have been the work of an amateur or a student who subsequently followed another career (although the quality of the painting is good), and was purchased by the Museum, as was the practice, as an example for future students.

## HAGHE, Louis (1806–1885) HPRI

Born Tournai, Belgium, 17 March 1806, son of an architect. His right hand was deformed and he painted with his left. About 1821 studied landscape watercolour painting with Chevalier de la Barrière, and also lithography,

making illustrations for 'Vues Pittoresques de la Belgique'. Came to London 1823, entered into partnership with William Day, making lithographic illustrations for several volumes, notably David Roberts's 'The Holy Land . . . ' (1842–9), and his own 'Portfolio of Sketches in Belgium and Germany' (1840–50). Published 'Travels Through Sicily' (1827). In Paris with David Roberts 1854. As a painter in watercolours, exhibited 217 works at the New Society of Painters in Watercolours 1835–84, (Member 1835, President 1873–84); his subjects were historical (sometimes scenes from the lives of the old masters) and architectural interiors, usually Flemish and medieval. His first success was 'The Council of War in the Hall of Courtray' (1839, Tate Gallery). His first oil painting was 'The Choir of Santa Maria Novella, Florence', exhibited at the BI 1856; he showed seven others there up to 1860, mostly church interiors. Died Stockwell, London, 9 March 1885. His wife exhibited at the RA 1880; his brother Charles was a lithographer.

Lit: *Art Journal* 1859, pp13–15; *Athenaeum* 14 March 1885, pp352–3 (obit); *Illustrated London News* 28 March 1885, p327 (obit with engr portrait)

### Interior of St Peter's, Rome
631-1901 Neg S641
Canvas, 140.2 × 116.8 cm (55¼ × 46 ins)
Signed 'Louis Haghe' bl
Given by Sir Edwin Durning-Lawrence Bt 1901

The painting is unfinished.

There are 13 gouaches of St Peter's by Haghe in the V&A collections, dated between 1863 and 1875. One of these, 'Left-hand Side of the Nave of St Peter's' (310–1886, 114.2 × 90.1 cm (45 × 35½ ins); signed and dated 1864; repr in colour in J Lees-Milne *St Peter's* 1967, p134) shows almost exactly the same view, a few yards further on, but with a different composition of figures. The view is down the south aisle, looking west towards the mosaic copy by Stefano Pozzi of Raphael's famous 'Transfiguration' altarpiece.

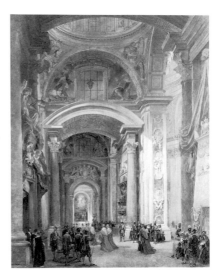

*Interior of St Peter's, Rome* 631-1901

# HANNAH, Robert (1812–1909)

Born Creetown, Kirkcudbrightshire', 3 July 1812. Exhibited 22 works at the RA between 1842 and 1870, mostly domestic and historical genre, one at the BI and two at the SBA 1843. He seems to have been a friend of William Holman Hunt (see the latter's *Pre-Raphaelitism and the Pre-Raphaelite Brotherhood* 1905, II, p204). Died London 5 April 1909.

### Eton College, From the Thames
1040-1886 Neg 57864
Paper, 52.1 × 69.9 cm (20½ × 27½ ins)
Inscribed 'Eton' br
Dixon Bequest 1886

*Eton College, from the Thames* 1040-1886

There are several views of Eton College in the V&A collections, notably a pencil drawing by Constable and a watercolour by Paul Sandby; see G Reynolds *Catalogue of the Constable Collection* 1973 (no 35, repr pl 16), and *British Watercolours in the Victoria and Albert Museum* 1980 (p337, repr colour pl 4). An almost identical view to the present work is the print dated 1821 after William Westall ARA published in 'Thirty-five Views of the Thames . . .' 1824 (V&A E2142-1897).

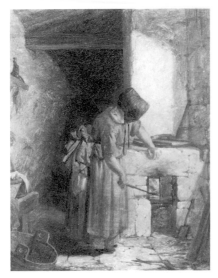

*Cottage Interior*   F14

# HARDY, David (1837–1870)

Born, probably in Bath, Somerset, 1837, into an artist family; son of the miniature and portrait painter James Hardy senior (uncle of Frederick Daniel Hardy, see pxxx), and brother of the landscapist James Hardy junior and the animal and sporting painter Heywood Hardy. Exhibited one work at the RA in 1855, six at the BI 1855–65, and 20 at the SBA 1862–70; all were domestic genre, and sent from Bath or Bristol addresses. Died 1870; his son Paul was also an artist.

### Cottage Interior
F14   Neg HF966
Millboard, 18.5 × 15.2 cm (7¼ × 6 ins)
Forster Bequest 1876

Possibly the 'Interior of a Cottage, Berkshire' exhibited at the BI in 1835, for which the price asked in the catalogue was £10 10s.

# HARDY, Frederick Daniel (1826–1911)

Born 13 February 1826 (not 1827, as in DNB) at Windsor, where his father was a musician in the Private Band of the Royal Household. Attended the Academy of Music in Hanover Square from about 1843 to 1846, when he studied painting with his elder brother George (1822–1909). In 1854 settled in Cranbrook, Kent, with Thomas Webster (to whom he was related) and others; they came to be known as the Cranbrook Colony, specialising in rural genre painting. Exhibited 93 works at the RA between 1851 and 1898, and five at the BI 1851–56, all scenes of cottage life, sometimes humorous. His pictures of children engaged in adult pursuits were especially popular. Died Cranbrook 1 April 1911.

LIT:   *Art Journal* 1875, pp73–6; A Greg *The Cranbrook Colony* exhibition catalogue Wolverhampton Art Gallery 1977

*Children Playing at Doctors*   1035-1886

### Children Playing at Doctors
1035-1886   Negs GK3333, 8834
Canvas, 44.7 × 61 cm (17⅝ × 24 ins)
Signed and dated 'F D Hardy/1863' on toy cart br
Dixon Bequest 1886

Presumably the painting exhibited at the RA in 1863 with the title 'The Doctor', although there are at least two other versions (see *Versions*: below). It was admired by the *Art Journal* critic:

> But of all the pictures given up to child's play, and they are legion, a little work called 'The Doctor' . . . is certainly one of the best . . . The execution is sufficiently minute to give reality to the circumstantial narrative, without falling into excess of elaboration. The quiet humour and quaint character which reign throughout, so closely akin to Wilkie and Webster, and allied indeed to the wit and mirth which flow freely in our native literature, should not be passed without notice.

EXH:   RA 1863 (358); *The Cranbrook Colony* Wolverhampton Art Gallery 1977

LIT:   *Art Journal* 1863, p112

*Versions:* 1 Christie's (L F Loyd Collection) 31 January 1913 (117, panel, 54.6 × 74.9 cm (21½ × 29½ ins), as exhibited at RA 1863 and signed and dated 1863), bought A M Singer 80 guineas; sold by Lady Singer, date unknown; with a dealer in Torquay c1960; private collection, Devon, 1961

2 (Probably identical with the above) Sotheby's Belgravia 24 October 1978 (22, panel, 55.9 × 76.2 cm (22 × 30 ins), as exhibited at RA 1863, signed and dated 1863 on toy cart), sold £22,000. The only difference in detail from the V&A painting is that the two pictures on either side of the mirror hang from cords

3 Private collection, Edinburgh, 1975

## Cottage Interior
F15
Millboard, 19.7 × 29.8 cm (7¾ × 11¾ ins)
Signed and dated 'F D H 1852' on edge of table
Forster Bequest 1876

Presumably the 'Interior from Nature' offered in a letter of 12 July 1852 from the artist to John Forster (V&A Library, Forster Collection, MSS vol XL, no 3). The next letter (no 4) of 26 July 1852, in speaking of a 'second commission', implies that Forster bought this 'Interior' and that it can be identified with F15. A third letter (no 5) of 30 July 1853 refers to 'your Picture' being in the 1853 RA exhibition; it is impossible to say for certain whether it was this work or F16 (see below), but if the former, it could have been 'An Interior' (270), or 'The Labourer's Home' (533). The *Art Journal* (1853, p145) described 270 as 'A back kitchen, or something like it, every brick of which is signalised – but the picture is spiritless for want of a point of light'.

According to the artist's statement in 1907 both F15 and F16 were painted in the neighbourhood of Snell's Wood, near Chenies, Buckinghamshire.

The work has previously been catalogued as 'Still-life', a misleading title in view of its subject although it does not contain any figures, except for a sleeping cat.

Exh: ?RA 1853 (270 or 533); *The Cranbrook Colony* Wolverhampton Art Gallery 1977

## Sunday Afternoon
F16 Neg 73781
Panel, 19 × 29.8 cm (7½ × 11¾ ins)
Signed and dated 'F D H/1852' on wall to r of mantelpiece
Forster Bequest 1876

Presumably the painting commissioned by John Forster from the artist in July 1852 (see F15, above, letter no 4); Hardy wrote 'it shall be as you desire, a cottage interior with a figure', which describes this painting.

It is possible that this work was exhibited at the RA in 1853 (see F15, above, letter no 5); if so, it could have been 'The Day of Rest' (1059).

Like the previous work, F15, it was painted in the neighbourhood of Snell's Wood, near Chenies, Buckinghamshire.

Exh: ?RA 1853 (1059, 'The Day of Rest')

*Sunday Afternoon* F16

# HART, Solomon Alexander, RA (1806–1881)

Born Plymouth, Devon, April 1806, the son of Samuel Hart, a Jewish gold and silversmith and mezzotint engraver. Came to London 1820, worked as a miniature painter, and entered RA Schools 1823. Exhibited 122 works at the RA between 1826 and 1881, 25 at the BI 1828–45, and 34 at the SBA 1826–38. Painted portraits, views of church interiors in England and Italy, and large historical canvases (his 'Lady Jane Grey', exhibited RA 1829, was nearly 14 feet square). Elected ARA 1835, RA 1840. Visited Italy 1841–2. Professor of Painting at the RA 1854–63, and Librarian 1864–81; also Art Examiner to Science and Art Department at South Kensington. He was the first Jew to be elected RA, and his career marks the beginning of the emergence of Jewish artists from the strictly enforced prohibitions against the practice of painting. Died London, unmarried, 11 June 1881. His studio sales were at Christie's 29–30 July and 2 August 1881.

LIT:    *Athenaeum* 18 June 1881, p821 (obit); *Illustrated London News* 25 June 1881, p621 (obit with engr portrait); *Art Journal* 1881, p223 (obit); ed A Brodie *The Reminiscences of Solomon Alex. Hart, RA* 1882; G Pycroft *Art in Devonshire . . .* 1883, pp55–8

*The Scala Santa at the Benedictine Monastery of Subiaco, Near Rome*   61-1905

## The Scala Santa at the Benedictine Monastery of Subiaco, Near Rome
61-1905    Neg GF705
Canvas, 90.8 × 62.1 cm (35¾ × 24½ ins)
Bequeathed by Mr L Van Oven 1905

Probably the painting exhibited at the RA in 1845 with the title 'A Portion of the Interior of the Church of San Benedetto, Subiaco, where St Benedict founded the order which bears his name'. The *Athenaeum* critic thought it had 'all the picturesque grace of the south, but hardly the true southern warmth of colouring'.

The monastery was founded by St Benedict in about 529; the present church is 14th century, and on two storeys, the lower in the form of an extensive stairway with several landings, decorated with wall frescoes.

Hart was in Italy 1841–2, sketching architecture and scenery; two watercolours in the studio sale (lots 130 and 131) depicted the monastery and were dated 22 and 27 April 1842 respectively.

PROV:   Presumably the artist's studio sale, Christie's 30 July 1881 (209, as 'A Staircase, with priests and other figures at prayer. Exhibited at the Royal Academy'), bought Permain £7

EXH:    ?RA 1845 (197)

## Maestro Giorgio
46-1874
Canvas, 265.5 × 87.6 cm (104½ × 34½ ins)
Inscribed 'Solomon Hart, RA' on plinth at r
Transferred to The Department 1921

For details of the history and circumstances of the commission see under Richard Burchett 1762–1869, p14.

Giorgio di Pietro Andreoli, known as Maestro Giorgio, worked between 1492 and 1536 as a potter of maiolica at Gubbio, after which he ceded the leadership of the family workshop to his son Vincenzo, and may have retired. He died in 1553 or soon afterwards. His workshop is most admired for its use of ruby and golden lustre. Very little is known of his life, and nothing of his physical appearance, so we must assume that Hart has invented this portrait. His modelling tools are shown in a pouch fixed to his belt, and he holds up a two-handled vase with lid, identical to one of about 1510 acquired by the museum in 1865 (500–1865, B. Rackham *Catalogue of Italian Maiolica* 1940,

vol II, no 510 pl 79). On the painting table is a bowl identical to one also of about 1510 and acquired by the museum in 1865 (repr B Rackham *Italian Maiolica* 1952, plates 42A and B). Both the vase and bowl have the characteristic lustre.

# HAVELL, William (1782–1857)

Born Reading, Berkshire, 9 February 1782, son of a drawing master. Three of his brothers, George, Edmund and Frederick James, were also artists. Chiefly known as a watercolourist, he travelled in Wales and the Lake District in 1802 and 1803, working with Cornelius Varley and Joshua Cristall; founder member of the OWS 1804. Artist on Lord Amherst's embassy to China 1816, resigned, and worked as portrait painter in India and Burma 1817–25. Visited Italy 1828–9. Exhibited 103 works at the RA between 1804 and 1857, 42 at the BI 1806–56, 32 (including five watercolours) at the SBA 1828–53, and 154 at the OWS. Subjects principally landscapes in Wales, Lake District, south and west England, Italy and China. Died Kensington, London, 16 December 1857. Redgrave believed 'his oil pictures show much excellence, and though rather yellow in tone and monotonous, the effect of sun and sunshine is admirably expressed'. There are fourteen watercolours by him in the V&A collections.

Lit: Redgrave *Dict* and *Cent*; DNB.

### Landscape
3-1866   Neg HF973
Canvas, 34.2 × 51.3 cm (13½ × 20¼ ins)
Purchased 1866

*Landscape*   3-1886

The location has not been identified, and may well be invented. On the other hand, Havell did exhibit such works as 'Castle and Town of Olevano, Near Subiaco, Roman States' (RA 1851), to which he may have added Picturesque figure groups. The mountain setting, the somewhat blasted tree, and the figure group in the foreground are reminiscent of the 'landscape with soldiers' compositions of 17th-century artists, particularly Salvator Rosa (compare, for example, his late painting in the Staatliche Kunsthalle, Karlsruhe).

### The Thames at Datchet Ferry
209-1887
Cardboard, 11.4 × 22.1 cm (4½ × 8¾ ins)
Purchased 1887

*Self-Portrait*   870-1894

The scene is located in Buckinghamshire, near Windsor. The same view, without the foreground figures, was produced in an aquatint dated 1811 (see *Engr*: below) and published in 1812 as plate 11 in a volume of 12 'Picturesque Views of the Thames'. Watercolours of four further Thames views, at Caversham, Cliveden, Henley and Windsor, are also in the V&A collections. Other views of Datchet were published in Ireland's 'Picturesque Views on the River Thames' (1792) and Tombleson's 'Thames' 1834.

Prov:   The artist Thomas Webster, his studio sale, Christie's 21 May 1887 (179), bought by Agnew's for the museum £4 4s

Engr:   Aquatint by R and D Havell, published 1 May 1811

### Self-Portrait
870-1894   Neg GK1964
Canvas, 50.7 × 45.7 cm (20 × 18 ins)

Inscribed on back as below
Given by Mr H Allnutt (the artist's nephew)

Inscribed, possibly by the artist, on a piece of wood on the back of the stretcher: 'given/to/Jane/Havell/portrait/of W/Havell/January/1841/Painted in/1830 by/W. Havell'. To judge from the amount of painted canvas folded at the back, the work was reduced on every side, and particularly by several inches at the bottom, by Messrs Haines in 1895. According to the Departmental files, another portrait, similar in pose but nearly life-size, was recorded in the collection of a Miss Havell some 20 years ago. The pose is based on that devised by Raphael in his portrait of 'Bindo Altoviti' (National Gallery of Art, Washington DC) and used many times in the next 300 years, most notably by Ingres in his self-portraits; a more immediate inspiration for Havell may have been English examples such as the self-portrait by Reynolds now in the Tate Gallery (painted c1773, Tate 306).

*Landscape* 1833-1900

### Landscape

1833-1900    Neg HF974
Paper on mahogany panel, 21.6 × 29.5 cm (8½ × 11⅝ ins)
Ashbee Bequest 1900

The location has not been identified, and like that of 3-1866 (p121) may well have been invented. Havell exhibited what seem to be similar subjects at the RA in 'A Shrine near Gondo, Simplon' (1844) and 'The Roadside Cross, to mark the spot where murder has occurred. – The scenery near Subiaco, Roman States' (1851).

## HAYTER, Sir George (1792–1871)

Born St James's Street, London, 17 December 1792, eldest son of the portrait painter Charles Hayter. Entered RA Schools 1807. Briefly a midshipman in the Royal Navy 1808. Exhibited 48 portraits at the RA between 1809 and 1838, and 40 works at the BI 1815–59. Early works were portrait miniatures; appointed Painter in Miniature and Portrait Painter to Princess Charlotte 1815. Won a BI prize for 'The Prophet Ezra' (1815). Studied in Rome 1815–18, with the 6th Duke of Bedford as his patron, and exhibited thereafter historical, biblical and mythological subjects as well as maintaining a successful portrait practice. Published an essay on the classification of colours, as an appendix to *Hortus Ericaeus Woburnensis* (privately printed 1825). In Italy and Paris 1826–31; visited the Continent in 1844 and 1846. Although he failed to be elected ARA (in 1825) – probably because he lived with his mistress and not his wife, he was a member of several Italian academies, and was appointed Painter of History and Portraits by both King Leopold of the Belgians in 1830 and Queen Victoria in 1837. He succeeded Sir David Wilkie as Painter in Ordinary 1841; knighted 1842. Held a one-man show in the Egyptian Hall, Piccadilly, 1843. Many of his works were engraved; he was also an accomplished etcher. He married three times: in 1809, 1846, and (according to the *Illustrated London News*) 1863. Died Marylebone, London, 18 January 1871; his studio sale was at Christie's 19–21 April 1871. His brother John was also an artist (see below), as was his son Angelo.

LIT:    *Athenaeum* 28 January 1871, p119 (obit); *Illustrated London News* 28 January 1871, p91 (obit); *Art Journal* 1871, p79 (obit), 1879, p180; B Coffey *Drawings by Sir George Hayter . . .* exhibition catalogue Morton Morris 1982

## The Angels Ministering to Christ
60-1872   Neg S643
Canvas, 172 × 136.5 cm (67¾ × 53¾ ins) after relining
Signed and dated 'G. Hayter 1849' indistinctly br
Given by Angelo Collen Hayter (the artist's second son) 1872

*The Angels Ministering to Christ   60-1872*

Painted between 1847 and 1849 (although the composition was designed at least as early as 1841) and exhibited at the BI in 1850, size given in the catalogue as 81 by 68 inches, presumably including the frame. The title given in the catalogue was 'Our Saviour After the Temptation', accompanied by the following quotation from *The Gospel According to St Matthew*, chapter 4 verses 8–11:

> Again, the Devil taketh Him up into an exceeding high mountain, and sheweth Him all the kingdoms of the world, and the glory of them; and saith unto Him, All these things will I give thee, if thou wilt fall down and worship me. Then saith Jesus unto him, Get thee hence Satan; for it is written, Thou shalt worship the Lord thy God, and Him only shalt thou serve . . . Then the Devil leaveth Him, and behold, Angels came and ministered unto Him.

The painting attracted little critical attention, perhaps because of the antipathy of the art establishment towards the artist; the *Art Journal* tersely noted 'the picture is large, and contains much that is beautiful in execution and expression'.

The composition of the figures is 17th-century Baroque in style, but the wild setting and free handling of paint owe more to 19th-century Romanticism. Hayter must have known the work of Delacroix, and this work may be compared with the religious paintings of the French artist such as 'Christ in the Garden of Gethsemane' (1826, for the church of St Peter and St Louis, Paris; it caused a great stir when it was exhibited at the 1827 Salon and when subsequently hung in the church), and the 'Pietà' (1843–4, for the church of St Denis of the Holy Sacrament, Paris; shown at the Salon 1846). Hayter was travelling on the Continent in both the 1820s and 1840s. The pose of Christ may have been adapted from that of Michelangelo's famous 'Palestrina Pietà'.

The painting was sold in the artist's posthumous studio sale (see *Prov:* below), as well as 45 sketches and studies (lot 357) and a 'brilliantly coloured' sketch (lot 635) which is probably for 'Our Saviour After the Temptation (P55–1982, below). The sketch shows the figure of God the Father in the dark clouds at upper left generating a lightning flash, an episode largely invisible in the darkness of the finished picture, until cleaning and conservation in 1987.

The picture is shown hanging on the wall in a pen and ink drawing of the Sheepshanks Gallery in about 1876 by John Watkins (V&A 8089D).

*Sketch for Our Saviour after the Temptation   P55-1982*

PROV:   The artist's studio sale, Christie's 21 April 1871 (634, as 'Christ after the Temptation. The finished picture, 1848. Exhibited in the British Institution'), bought Bazaine £18 7s 6d, perhaps on behalf of A C Hayter, who gave it to the museum 1872

EXH:   BI 1850 (290)

ENGR:   Etching by the artist 1849

LIT:   *Art Journal* 1850, p91; B Coffey *Drawings by Sir George Hayter . . .* exhibition catalogue Morton Morris 1982, pp29, 46

## Sketch for Our Saviour after the Temptation
P55-1982   Neg HE1364
Brown paper, approx, 19.4 × 18.5 cm (7⅝ × 7¼ ins)
Signed and dated 'George Hayter/1848 August.' br and inscribed as below
Purchased 1982

Inscribed with a scale at left, 'scale of feet to my picture', presumably to assist enlargement of the design. It is a sketch for the large painting exhibited in 1850 and also in the V&A collections (see 'The Angels Administering to Christ', 60–1872 above).

PROV:  Probably the artist's studio sale, Christie's 21 April 1871 (635, a 'brilliantly coloured' sketch), bought Permain £1 10s; Morton Morris, from whom purchased 1982

EXH:  *Drawings by Sir George Hayter . . .* Morton Morris 1982 (52G)

LIT:  B Coffey *Drawings by Sir George Hayter . . .* exhibition catalogue Morton Morris 1982, p29

---

# HAYTER, John (1800–1895)

Born 1800, presumably in London where his parents resided, the youngest son of the portrait painter Charles Hayter and brother of Sir George Hayter. Entered RA Schools November 1815; travelled to Italy 1818. Exhibited 126 works, almost all portraits, at the RA between 1815 and 1879, 26 various subjects at the BI 1820–61, and 30 at the SBA 1824–56. His portrait painting practice attracted a distinguished clientele. Published 'Twenty Sketches of Miss Fanny Kemble in the Character of Juliet . . .' (1830), 'The Court Album . . .' (1850), and 'Beauties of the Court of Queen Victoria . . .' Married Augusta Bramley 1822; there were seven children. Died Gillingham, Kent, June 1895. His group portrait of himself, Charles and Sir George Hayter, and Sir Edwin Landseer, was exhibited at the RA 1823 (now Shipley Art Gallery, Gateshead).

LIT:  B Coffey *Drawings by . . . John Hayter* exhibition catalogue, Morton Morris 1982

**Viscountess Dungannon**
227-1871
Canvas, 236.2 × 176.5 cm (93 × 69½ ins)
Signed and dated 'J Hayter 1839'
Given by Viscountess Dungannon 1871

Sophia Irvine, the fourth daughter of Colonel George Marcus Irvine of Castle Irvine, Fermanagh, married in 1821 Arthur Hill-Trevor (1798–1862), who succeeded in 1837 to the title of 3rd Viscount Dungannon (of the second creation in the Irish peerage). This portrait, in the manner of Sir Thomas Lawrence, shows her in her peeress's robes, and was presumably commissioned in the year of the coronation of Queen Victoria in 1838. It does not seem to have been exhibited.

According to an inscription on the back of the canvas, the artist retouched the painting in 1855, presumably on the occasion of the commission of the companion portrait of Viscount Dungannon painted by Stephen Catterson Smith and also in the V&A collections (see below 226–1871, p269).

*Viscountess Dungannon*   227-1871

---

# HERING, George Edwards (1805–1879)

Born London 1805, son of a German bookbinder. Worked first as a bank clerk, then studied at the Munich Academy 1829 and soon after in Venice

for two years. Lived for a time in Rome, toured in the East, and Hungary and Transylvania, before settling in London. Exhibited 87 works at the RA between 1836 and 1880, 86 at the BI 1837–67, and ten at the SBA 1836–41. Most were Italian landscapes, particularly lake scenes, where he visited regularly. Published 'Sketches on the Danube . . .' (1838) and 20 lithographs in 'The Mountains and Lakes of Switzerland, the Tyrol, and Italy' (1847). Drew illustrations for his friend John Paget's *Hungary and Transylvania . . .* (1839). Died St John's Wood, London, 18 December 1879. His wife was also an artist, exhibiting similar subjects at the RA and BI between 1840 and 1858.

LIT:   *Art Journal* 1861, pp73–5; *Athenaeum* 27 December 1879, p856 (obit); *Art Journal* 1880, pp83–4 (obit)

### Bridge Over a Stream

1399-1869
Panel, 26.6 × 49.5 cm (10½ × 19½ ins)
Signed and dated 'G E Hering 1847' br
Townshend Bequest 1869

Not identifiable with the titles of any exhibited paintings; while the landscape has no distinguishing features that indicate the location, it seems probably a Scottish rather than an Italian scene, possibly on the Isle of Arran, which Hering visited. He exhibited Scottish landscapes in 1851 and from 1867 onwards; of 'The Brig Ower the Burn – Perthshire', exhibited at the RA in 1851, the *Art Journal* critic wrote 1861, p75 that it was 'one of the few pictures of home scenery painted by this artist'.

### Arona and the Castle of Angera, Lago Maggiore, Italy

1828-1888   Neg GF704
Canvas, 72.3 × 128.2 cm (28½ × 50½ ins)
Signed and dated 'G E Hering 1856' bl
Given by Mrs Charles Rivaz 1888

*Arona and the Castle of Angera, Lago Maggiore, Italy   1828-1888*

Hering exhibited several paintings of Lake Maggiore at the RA and BI between 1856 and 1866. The present work is possibly the first of these, 'Arona and Angera, Lago Maggiore', judging from the title, shown at the RA in 1856. The *Art Journal* critic wrote (1861, p75) that 'his pictures are not crowded with material, for in the selection of subject he looks after pictorial quality rather than quantity; a bit of mountain scenery, a quiet lake, with a few adjuncts, oftentimes suffice for his purpose'.

Arona is at the southern end of the lake, on the western side. The view is looking north-east across the lake to the castle owned by the Borromeo family which stands on a rocky hill above Angera. A similar view, but seen from further back, by James Baker Pyne and dated 1868, was sold at Sotheby's 18 March 1987 (3).

EXH:   ?RA 1856 (741)

# HERRING, John Frederick (1795–1865)

Herring was born in Surrey, but brought up in London. The fastest mode of transport at any time possesses a unique fascination for the young, and as a boy Herring was absorbed by the glamour of the crack coaches of the turnpike age which he saw daily outside his father's fringe-making shop in Newgate Street. He drew horses for his own diversion from an early age, and had his first lessons in drawing from a family friend, the driver of the London to Woking coach. When aged 19 he went to Doncaster and obtained work as a

coachman for five or six years. While thus employed he painted a series of inn signs and coach panels. In 1815 he was commissioned by a Doncaster publisher to paint the winner of the St Leger: the first of a long series, for print publishers of portraits of winners of the St Leger from 1815–43 and the Derby, 1827–49. In 1830 he moved to Newmarket, and in 1833 returned to London where, conscious of a lack of professional training, he studied at the age of 38 under Abraham Cooper, RA. His paintings had become immensely popular, and he received commissions from George IV, William IV and Queen Victoria. In about 1847 he settled at Meopham in Kent and turned to rural subjects – stables, farmyards, dometic animals and agricultural and hunting scenes. He was the father of three sons who painted after their father's style: John Frederick Junior, with whom he quarrelled; Charles who died at the age of 28, and Benjamin, who specialised in racing scenes. Herring occasionally collaborated with Landseer and John Phillips. He died at Meopham Park, near Tunbridge Wells on 23 September, 1865. His studio sale was at Christie's 3 February 1866. Through the widely disseminated medium of engravings, (many of which have never stopped being produced) his work was known by, and influenced, both Manet and Degas.

LIT:    A M W Stirling *A Painter of Dreams, and other biographical studies*; Christopher Neve *A Victorian Peaceable Kingdom: J F Herring at Meopham Park* Country Life Annual, 1970; O R Beckett *J F Herring and Sons* 1981.

*Seed Time*   P19-1915

**Seed Time**
P19-1915   Neg 50621
Canvas (prepared by Charles Roberson, 51 Long Acre), 106.7 × 183.1 cm (42 × 72 ins)
Signed and dated 'J F Herring. Senr./1854–6' br
Presented by Miss Mercy Mayhew in memory of her late brother Colonel Alfred H. Mayhew of the Bombay Staff Corps 1915

A pair with *Harvest Time* Yale Center for British Art, New Haven, Connecticut, signed and dated 1859 (42 × 72 ins, no 288 in Beckett repr pl 43).

    Together with *Harvest Time* this painting offers a detailed treatment of mid-19th-century agricultural methods, all the accepted cultivation procedures of the time being portrayed simultaneously. On the left the stubble is being ploughed up, in the centre is the cambridge roller, suitably weighted down with stones on the box on top of the equipment. Seed is being sown broadcast by the men walking from left to right, and in the mid-distance a team of horses is being got ready to harrow the tilth after the sowing. In reality it is a little unlikely that all four processes would have taken place simultaneously, although not completely unfeasible, as the pace is dictated by a horse's gait. Indeed the picture can be seen as both a visual lecture on farming methods, and a conscious attempt on Herring's part to eulogise the peace of the Kentish weald after the rick burning disturbances of the 1820s and 1830s.

PROV:    John Tyson, sold Christies 1872, (£252).; Tom Nickalls; sold Christie's 4 June, 1909, Lot 32 (£105).

LIT:    M H Grant *Old English Landscape Painters* 1925, pl 199; Gertrude Jekyll *Old English Household Life* 1925.

# HOLLAND, James, RWS, RBA (1799–1870)

Born Burslem, Staffordshire, 18 October 1799, of a family working at James Davenport's pottery works. Taught first by his mother, a painter of flowers on

porcelain, then worked as a flower painter at Davenport's. Moved to London 1819, gradually turned to landscape painting. Exhibited 32 works at the RA between 1824 and 1865, 91 at the BI 1829–67, and 106 at the SBA 1828–48 (elected member 1842). Travelled abroad several times, in France, Holland, Switzerland, Portugal, and Italy; specialised later in views of Venice. Also painted extensively in watercolours; elected ARWS 1835, RWS 1857. Made drawings for periodical publications. Died London 12 February 1870; his studio sale was at Christie's 26 May 1870. There is an 1828 watercolour portrait of him by W H Hunt also in the V&A collections (451–1887; repr T S R Boase *English Art 1800–1870* 1959, pl 21b).

LIT:    *Athenaeum* 19 February 1870, p267 (obit); *Art Journal* 1870, p104 (obit); H Stokes 'James Holland' *Walker's Quarterly* XXIII, 1927; R Davies 'James Holland' *OWS* VII, 1929–30, pp37–54; M Tonkin 'The Life of James Holland of the Old Society' *OWS* XLII, 1967, pp35–50

### Near Blackheath: Blackwall Reach from Charlton Fields
FA79
Canvas, 49.5 × 80 cm (19½ × 31½ ins)
Sheepshanks Gift 1857

Holland lived at 3 Union Place, Blackheath Road, in south-east London, between 1831 and 1845; he exhibited Blackheath and Greenwich views between 1831 and 1834. The present work is possibly 'A Sketch of Blackwall Reach' exhibited at the SBA in 1834 (43), or 'London from Blackheath' at the BI 1834 (465), of which the size was given in the catalogue as 31 by 44 inches (including the frame, as was usual).

### Nijmegen
FA80    Negs HH1124, HH3966, CT18999
Canvas, 33 × 49.7 cm (13 × 19⅝ ins)
Sheepshanks Gift 1857

*Nijmegen*  FA80

Holland exhibited 'Nimeguen, on the Rhine' at the BI in 1837 (321), the size given in the catalogue as 19 by 27 inches, presumably including the frame. The artist's first exhibited Dutch subject at the RA was 'Scene near the Hague: Sunset' in 1847; he also showed views in Rotterdam at the RA in 1849 and 1854. He is recorded as visiting Rotterdam in 1845. Nijmegen, some 60 miles east of Rotterdam, is on the River Waal, a branch of the Rhine, and there is a view from the quay northwards across the river towards Arnhem, which is presumably that depicted here. There is also a famous view of Nijmegen from the other side painted most notably by Salomon van Ruysdael in 1648 (De Young Memorial Museum, San Francisco; repr W Stechow *Dutch Landscape Painting of the Seventeenth Century* 1966, pl 100) There is a watercolour by Holland of Nijmegen in the V&A collections (FA47) also from the Sheepshanks Gift.

EXH:    *English Landscape Painters* Phoenix Art Museum, Arizona 1961/2 (49)

# HORSLEY, John Callcott, RA (1817–1903)

Born Brompton, 29 January 1817, the son of the organist and composer William Horsley, and great-nephew of Sir Augustus Wall Callcott RA. Studied at Sass's art school and the RA Schools. Painted portraits, literary and historical subjects, domestic genre (often in historical costume), and rural genre scenes. Exhibited 121 works at the RA between 1839 and 1896, and 11 at the BI 1837–50. Elected ARA 1855, RA 1864. Won prizes in the competitions for the decoration of the Palace of Westminster 1843, 1844 and

1847. Some of his works were engraved; he also contributed etchings to the publications of the Etching Club and drawings to *Punch*, and in 1843 designed the first Christmas card. Associated with the artist's colony at Cranbrook, Kent, where he bought a house in 1858. At the RA, he was Rector 1875–90 (his campaign against the use of naked models in life classes earned him the soubriquet 'Clothes-Horsley'), Treasurer 1882–97, and initiator and organiser of the first Winter Exhibitions of old masters. Died Kensington, 18 October 1903. The painter Walter Charles and architect Gerald Callcott were his sons.

LIT: *Art Journal* 1857, pp181–4; *Illustrated London News* 24 October 1903, p608 (obit with photograph); J C Horsley *Recollections of a Royal Academican* 1903 (referred to below as *Recollections*); A Greg *The Cranbrook Colony* exhibition catalogue Wolverhampton Art Gallery 1977

*The Contrast: Youth and Age*    FA81

**The Contrast: Youth and Age**
FA81    Neg 51716
Panel, 45.7 × 40.6 cm (18 × 16 ins)
Signed and dated 'J C H/1839' on tombstone at 1
Sheepshanks Gift 1857

Exhibited at the RA in 1840, with the title 'The Contrast' and the following verse quoted without attribution in the catalogue:

> Youth in its dawn, daring the thorough fare
> Of life with fearless foot and roving eye
> Age in its humbled lustre, breathing prayer
> Upon the threshold of eternity!

According to *Recollections*, it was bought from the artist by John Sheepshanks. On his first visit to Sheepshanks

> I told him I was painting another picture about the same size as the one he had already bought from me ['The Rival Performers', FA83, p129]. He cheerfully told me he would come and look at it. When next in town he at once settled to buy it, and plunging his hand into his very shabby coat-pocket, produced a cheque book, and asking for a pen and ink, wrote the cheque to pay for it on the spot, as was his invariable custom. This picture was called 'Youth and Age', and represents an aged countryman going into church with his little grandchild leading the way.

The *Athenaeum* critic wrote:

> A little school girl is followed by a venerable man, whom she turns round for one instant to survey with gentle curiosity – the arch of the sacred building, by calling the thoughts away from earth, harmonizing these extremes of life, and reminding us how brief is the career just beginning, and just closing, when compared with the measureless past and future.

The *Recollections* note that the model for the child was the artist's young cousin, daughter of the Rev John Wall Buckley, with whom he had been staying in Totherfield, Sussex; the old man was the village sexton. This seems appropriate, for further reference is made to the brevity of earthly life by the tombstone on the left of the painting and the freshly dug grave at the right.

Horsley exhibited another painting with the title 'Youth and Age' at the RA in 1857 (180), showing an old widow and a group of village children.

EXH: RA 1840 (117); *Exposition Universelle*, Paris 1855 (833, as 'L'Enfance et la Vieillesse', lent by Sheepshanks)

LIT: *Athenaeum* 16 May 1840, p401; *Recollections* pp50–2

**Waiting for an Answer**
FA82
Panel, 41.9 × 55.9 cm (16½ × 22 ins)
Sheepshanks Gift 1857

Exhibited at the BI in 1841, the size given in the catalogue as 24 by 30 inches (including the frame, as was usual).

The Departmental *MS Register* describes the subject: 'A retainer while waiting for answer to his master's billet doux to the lady of the mansion is waiting the reply to his own love making to my lady's maid. The picture is very carefully completed in all its details'.

The *Athenaeum* critic described it as 'a cabinet picture, like all his works, delicate, refined, and attractive, – like all of them, stiff and incorrect in its drawing. It is high time this should be amended'. The man's figure was considered 'thoroughly wrong'.

The background setting is the garden door at Haddon Hall, Derbyshire, where Horsley first visited and made drawings in about 1835 (see 'The Rival Performers', below). Another version of the subject was sold at Christie's 12 June 1985 (104, signed and dated 1866, canvas 42 × 59 cm) possibly exhibited at the RA 1866 (251); another was sold at Christie's 14 February 1986 (73, signed and dated 1866, 70.5 × 96.5 cm).

EXH:    BI 1841 (7)

LIT:    *Athenaeum* 6 February 1841, pp117–8

**The Rival Performers**
FA83    Neg 59371
Panel, 45.7 × 40.6 cm (18 × 16 ins)
Signed and dated 'J C Horsley/PINXIT/1839' on music sheet br
Sheepshanks Gift 1857

Exhibited at the BI in 1839, the size given in the catalogue as 26 by 24 inches. According to the *Recollections*, this was the artist's first exhibited subject picture, and was bought at the BI by John Sheepshanks.

The *Athenaeum* critic described the subject:

[The boy is] silenced by his sister that they may listen to a canary on the opposite wall . . . There is a sweet old English quaintness – a genuine touch of Herrick's spirit – about this picture, making it attractive; but not so enchanting as to blind us to faults in its drawing, – whether in the upturned throat and bust of pretty Mistress Alice, or in the whole figure of her brother, with his very long legs and very short arms. The colouring of the flesh, too is factitious; it is pink-and-white porcelain, and not the roses and lilies of England.

*The Rival Performers*    FA83

The *Art Union* was more admiring, and interpreted the couple's relationship differently:

[The artist] whose name is pleasantly associated with both painting and music, exhibits a picture in which he has striven to combine the interest of the two. The old poet's story of the nightingale – who strove to out-do the minstrel's song, has evidently suggested the subject . . . The picture is finely conceived and very ably executed; the effect of light is very striking, but also very true; the sweet imploring look of the maiden as, with a smile of half wonder and delight, she intreats her lover to save the life of his tiny rival, by relinquishing the contest, is especially happy.

The review concluded that the work was 'one of the most agreeable pictures in the collection; and cannot but secure to the artist another step of promotion in the ranks of fame'.

The *Recollections* also note that the painting 'attracted [William] Hilton's notice, and on the varnishing day he spoke to me in the kindest way about it, and said he looked to me to be a really successful artist'.

The background setting for the picture is the alcove of the dining-room (constructed 1500–45) of Haddon Hall, Derbyshire, where Horsley had first visited and made drawings in 1835. He wrote in the *Recollections* (p102) that 'I was naturally filled with yearnings to paint pictures, in which I could use as backgrounds the ancient halls and chambers, and I dreamed many a dream of pictures to be, as I sketched diligently the beautiful scenes before me'. Horsley found Haddon Hall 'absolutely unique, and there is nothing like it in the whole world'. The *Art Union* critic (1844, p21) reviewing an engraving of Frederick Taylor's 'Morning of the Chase-Haddon Hall in Days of Yore', wrote that the house 'has long been fertile of subject-matter to paintings in both oil and water colour, and it is precisely such a place as a lover of romance would celebrate either in painting or in narrative'. The first of a series of paintings with Haddon settings was 'Rent Day at Haddon Hall' exhibited at the BI in 1837 (182); others are 'Waiting for an Answer' (FA 82, p129), and 'Lady Jane Grey and Roger Ascham' (RA 1853, 171) which shows the same alcove.

A copy in enamels of this work was exhibited by Miss Catherine Baines at the SBA in 1860 (721, present whereabouts unknown).

EXH: BI 1839 (2)

LIT: *Athenaeum* 9 February 1839, p117; *Art Union* 1839, p21; *Recollections* p28

## Giotto
20-1874
Canvas, 244.9 × 90.1 cm (96½ × 35½ ins)
Inscribed 'J C HORSLEY, RA' on gold background br
Transferred to the Department 1921

For details of the history and circumstances of the commission, see under Richard Burchett 1762–1869, p14. The design was translated into English glass mosaic by Florence and Mary Cole for Powell & Sons, whose estimate for the work of £120 is dated 8 March 1873.

Horsley depicts the great founder of Italian Renaissance painting as a young shepherd holding his crook and drawing with a stick on a flat stone. The story of the discovery of Giotto by Cimabue is one of the best-known episodes in Giorgio Vasari's *Lives of the Artists*. Giotto (?1266/7–1337) was born in Vespignano, outside Florence, the son of an agricultural labourer. While looking after his father's sheep, he would draw – on flat stones, or on the ground – with a sharp stick. Cimabue was travelling from Florence on business when he came across the youth drawing, with 'no master but Nature'; amazed, he took Giotto to live and study with him.

There is a supposed self-portrait by Giotto in the chapel of the Podesta Palace in Florence. Horsley's source for the artist's physical appearance is more likely to be the portrait attributed by some historians to Uccello on a cassone panel known as 'The Founders of Florentine Art', now in the Louvre (see also Redgrave's 'Donatello', (1707–1869, p245). Although Horsley has idealised the facial features, a resemblance to the cassone image is evident.

See below for the 1872 oil sketch for the design.

## Giotto
7-1879
Canvas, 90.8 × 31 cm (35¾ × 12¼ ins)
Signed and dated 'J C Horsley/72' on rock br
Transferred to the Department 1933

A preliminary oil sketch for 20-1874 above. The pedestal is only outlined in pencil, and the work is inscribed in a cartouche: 'Giotto when a shepherd/boy was found by Cimabue/drawing with charcoal upon/the rocks & stones by the way/side'. Also pencilled bottom left is ' + 4 inches 10' (the rest obscured by an old museum label).

# HUNT, William Henry (1790–1864)

Born London 28 March 1790, son of a tin-plate craftsman. Apprenticed to the landscape watercolourist John Varley 1806; entered RA Schools 1808. Almost exclusively painted in watercolours, and very prolific. Exhibited 12 landscapes and two watercolours at the RA between 1807 and 1825, six works at the BI 1808–29, one at the SBA 1824, and nearly 800 at the OWS 1814–64 (elected Associate 1824, Member 1826). Despite his nickname of 'Bird's Nest Hunt', he painted a wide range of subjects, but especially fruit and flowers much prized by collectors. Elected Member of the RA at Amsterdam. Died London 10 February 1864; his studio sale was at Christie's 16–17 May 1864. Many watercolours are in the V&A collections.

LIT:   *Art Journal* 1864, p114 (obit); F G Stephens 'William Henry Hunt' *Fraser's Magazine* October 1865, pp525–36 (reprinted in OWS XII, 1935, pp17–39); W Collingwood 'Reminiscences: William Hunt' *Magazine of Art* XXII, 1898, pp503–5; C Fry *William Henry Hunt* Maas Gallery exhibition catalogue 1967; T Jones *William Henry Hunt* Wolverhampton Art Gallery exhibition catalogue 1981; J Witt *William Henry Hunt (1790–1864) Life and Work, with a Catalogue* 1982 (with full bibliography)

### Landscape with Elm Trees and a Farm, Near Bayswater
440-1887
Millboard, 13.3 × 20 cm (5¼ × 7⅞ ins)
Purchased 1887

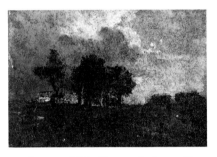

*Landscape with Elm Trees and a Farm, Near Bayswater   440-1887*

One of Hunt's rare paintings in oil. Its authorship was challenged in 1915 by Sir George Clausen RA, who thought it more likely to be by a member of the Barbizon School, but the following correspondence in the Departmental file seems to confirm the attribution to Hunt.

The vendor, Frederick Piercy, wrote to Sir Frederick Burton, Director of the National Gallery, on 2 July 1887:

> I send you herewith a very rare specimen in oil by William Hunt. It cost me sixty guineas, but I am so anxious that the dear old man's name should be in the National Gallery catalogue that I shall be glad to accept whatever you think you would be justified in paying for it. When about thirty years ago I was professor of drawing on board *HMS Britannia*, I sent this picture to Mr. Hunt and received this letter.

Attached is a copy by Thomas Armstrong (then Director of Art, South Kensington Museum) of Hunt's original letter. It is dated April 16 – no year is given, but presumably about 1860 – and states: 'The sketch in watercolour as well as the bit in oil are by me, the one in oil must have been done almost fifty years back.' Sir Frederick Burton, writing to Thomas Armstrong 14 November 1887, notes that 'In another [letter] . . . he [the vendor] said the view was at Bayswater'.

This evidence dates the oil sketch to around 1810; Witt dates it to 1806–10. It is similar in subject and treatment to works by John Linnell and William Mulready (for a similar subject by Mulready, for example, although larger and more detailed in handling, see FA135 p197) of about the same time. The subject is not distinctive enough in detail or character to be precisely identified as Bayswater, which was a favourite semi-rural area for painters to live and work in the early 19th century (see M Pointon *Mulready* V&A exhibition catalogue 1986, p21 etc). Grant suggested it could be Symond's Farm, near what is now Portobello Road, where Linnell also painted.

PROV:   Purchased 1887 from Frederick Piercy for £31

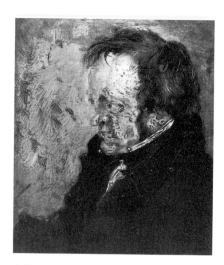

*Self-Portrait*    P16-1921

EXH:    *William Henry Hunt* Wolverhampton Art Gallery 1981

LIT:    M H Grant *Old English Landscape Painters* 8, 1961, pp618–9, repr fig 653; J Witt *William Henry Hunt* 1982, cat no 162

**Self-Portrait**
P16-1921   Neg HJ241
Panel (mahogany), 11.2 × 9.9 cm (4⅜ × 3⅞ ins)
Given by Alfred Jones 1921

Hunt is aged about 35, dating the work to about 1825. There are many self-portraits by Hunt, mostly in watercolour, including one, with his daughter and niece, also in the V&A collections (D271–1905); for a full iconography, see R Ormond *Early Victorian Portraits* 1971, I, pp236–7.

LIT:   J Witt *William Henry Hunt* 1982, cat no 523

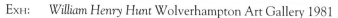

# INCHBOLD, John William (1830–1888)

Born Leeds 29 April 1830, son of the owner-editor of the *Leeds Intelligencer*. Moved to London and worked as a draughtsman in the lithography firm of Day & Haghe; studied watercolour printing with Louis Haghe from about 1847, and probably studied at the RA. Influenced by the Pre-Raphaelites, and by the writings and personal encouragement of John Ruskin. Exhibited 30 landscapes at the RA between 1851 and 1885, one at the BI in 1854, three watercolours at the SBA in 1849 and 1850. Travelled with Ruskin to Switzerland in 1856 and 1858; also visited Spain, Italy and Algeria. Not a prolific artist, and little is recorded of him, although he is the leading landscape painter in the Pre-Raphaelite manner along with John Brett and Thomas Seddon. He published a volume of sonnets, *Annus Amoris* (1876). Died at his sister's home in Headingley, near Leeds, 23 January 1888. His funeral ode was composed by Swinburne. Groups of his works were exhibited by the Leeds Philosophical and Literary Society in 1887, and the RWS Club 1888. Some of his works were engraved.

LIT:   *Athenaeum* 4 February 1888, p154 (obit) and 11 February 1888, p188; *Loan Exhibition . . .* Royal Watercolour Society Art Club, 1888, catalogue pp7–10; A Staley *The Pre-Raphaelite Landscape* 1973, pp111–123

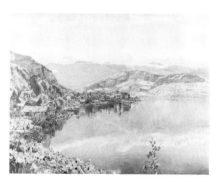

*The Lake of Lucerne: Mont Pilatus in the Distance*    P81-1927

**The Lake of Lucerne: Mont Pilatus in the Distance**
P81-1927   Neg X1901
Panel, 35.5 × 48.8 cm (14 × 19¼ ins)
Signed and dated 'I W Inchbold/57' vertically bl
Bequeathed by James R Holliday 1927

Presumably the work exhibited at the Liverpool Academy in 1860 with the title 'Above Lucerne'. It is the only known surviving work from Inchbold's visits to Switzerland in the 1850s.

    Inchbold was in Switzerland with John Ruskin both in 1856 (they are recorded in Lauterbrunnen, near Berne, a village with a famous view of the Jung pass, presumably inspiring Inchbold's 1857 RA exhibit 'The Jung Pass, from the Wengern Alps'), and in 1858 (at Bellinzona, and at Flüelen which is on Lake Lucerne). Inchbold was in Chamounix in 1857, some 100 miles from Lucerne. Mont Pilatus is to the east of the lake. 'A By-Path to Chamouini [sic]' was owned by the *Art Journal* and engraved in it in 1871 (facing p264); according to the accompanying text, it was 'painted on the spot'.

    Staley points out that 'the effect of the distant mountains, with the outlines crisply drawn and the interiors lost in haze, is close to that in many

of Ruskin's own drawings, and the similarity is heightened by the fact that Inchbold's picture looks so much like a watercolour'. Indeed, Inchbold's method here of allowing his white ground to show through in places, the overal thinness of paint, and the matt surface, led the work for some years after its acquisition by the museum to be regarded as a watercolour. However, Ruskin was highly critical of Inchbold's Swiss scenes, and Staley suggests that this may be why Inchbold did not exhibit any paintings (including the present work) in 1858 and 1859. Ruskin's methods of encouragement could certainly be a trial: he wrote to his father on 9 August 1858 that 'It was a delicate and difficult matter to make [Inchbold] gradually find out his own faults . . . At last I think I succeeded in making him entirely uncomfortable and ashamed of himself, and then I left him'.

Staley also compares the painting with the earlier Alpine watercolours of J R Cozens, and suggests that it anticipates the work of Ferdinand Hodler.

After 1857 Inchbold's work became broader in treatment and more atmospheric; the present work seems to represent 'the end of Inchbold's truly Pre-Raphaelite pictures, but it is the most beautiful of them all' (Staley, p118).

Prov:   Richard Mills (of 34 Queen's Gate Place, SW London); his sale, Christie's 13 April 1908 (46), bought Agnew £10 10s; . . . bequeathed to the museum by James R Holliday 1927

Exh:   Presumably Liverpool Academy 1860 (76, as 'Above Lucerne'); Victorian Painting Agnew's 1961 (49): Victorian Painting Arts Council 1962 (32); 19th Century English Art New Metropole Arts Centre, Folkestone, 1965 (70)

# JOHNSON, Harry John, RI (1826–1884)

Born Birmingham, 10 April 1826, eldest son of the artist W B Johnson. Studied at Birmingham Society of Arts with Samuel Lines, and sometime around 1843 with William Müller. Accompanied Müller to the Levant 1843–4 (he had also travelled in Lycia in 1840, according to Boase), and worked with him at the Clipstone Street Studio. Friend of David Cox: sketched with him in Wales. Exhibited 26 landscapes at the RA between 1845 and 1880, 39 at the BI 1846–67, and six (including a watercolour) at the SBA 1846–71. Many landscapes were views of Italy or Greece. Elected ARI 1868, RI 1870. Died St John's Wood, London, 31 December 1884. His studio sale was at Christie's 5 March 1885.

Lit:   TSR Boase English Art 1800–1870 1959

### Rhodes
P9-1919   Neg 47779
Panel, 22.1 × 37.6 cm (8¹¹⁄₁₆ × 14¾ ins)
Signed and dated 'H J Johnson 45. Rhodes.' bl
Presented by Sidney Vacher 1919

Rhodes   P9-1919

From the inscription, evidently painted during a visit to Rhodes in 1845. The artist exhibited a view of Rhodes harbour at the RA in 1847. The painting has hitherto been titled 'Memento of the Knights Templar, Rhodes', which seems inaccurate; the strongly fortified walls of the city of Rhodes were actually built in the 14th century by the Knights Hospitallers, a religious military order.

Prov:   Sidney Vacher; Sotheby's 26 February 1919 (258), bought in by Vacher; presented by him to the museum 1919 'as a gift of a member of the Walpole Society in memory of the glorious Battle of Jutland'.

*A Garden Scene*  P42–1962

## JOY, Thomas Musgrave (or Musgrove) (1812–1866)

Born Boughton-Monchelsea, Kent, son of a landowner, 1812; studied with the portrait and historical painter Samuel Drummond ARA. Patrons included Lord Panmure; undertook Royal commissions 1841–3. Exhibited 67 works at the RA between 1831 and 1864, 82 at the BI 1832–67, and 50 at the SBA 1832–67. He also exhibited watercolours. Subjects often literary or theatrical, many portraits, including children. Died Pimlico, London, 7 April 1866; his studio sale was at Christie's 18 June 1866. John Phillip RA was his pupil; his elder daughter, Miss M E Joy, exhibited paintings 1866–7.

Lɪᴛ:  *Art Journal* 1866, p240 (obit)

**A Garden Scene**
P42-1962    Neg HF975
Panel, 35.5 × 30.5 cm (14 × 12 ins)
Inscribed in ink on reverse of panel 'T M Joy'
C D Rotch Bequest 1962

Though this is not identifiable with any of the titles of exhibited works or those in the artist's studio sale, it is typical of Joy's portrait groups involving children and an element of genre, and in this case perhaps also a reference to the three ages of woman.

## JUTSUM, Henry (1816–1869)

Born London 1816; he was lame from infancy. Pupil of the watercolourist James Stark 1839. In the 1840s painted landscapes principally in watercolour; elected Member of the NWS 1843, but resigned 1847 to paint in oils. Exhibited 68 works at the RA between 1836 and 1868, 75 at the BI 1836–67, and 19 (including two watercolours) at the SBA 1836–69. His landscapes were English and on a few occasions Scottish, and were usually richly wooded scenery with rustic figures especially children; the *Art Journal* (1865, p75) referred to 'the mannerism of the well-known "Jutsum tree touch"'. Died St John's Wood, London, 3 March 1869. His studio sales were at Christie's 19 February 1870 and 17 April 1882.

Lɪᴛ:  *Art Journal* 1859, pp269–71, 1869, p117 (obit)

**The Foot Bridge**
1419-1869
Canvas, diameter 48.9 cm (19¼ ins)
Townshend Bequest 1869

Jutsum exhibited 'The Old Bridge' at the BI in 1865 (341), for which the price was £50.

## LANCE, George (1802–1864)

Born Little Easton, near Colchester, Essex, 24 March 1802, son of an army officer. Pupil of B R Haydon, with Charles Landseer, from 1816, and entered RA Schools 1820. Exhibited 38 works at the RA between 1828 and 1862, 135 at the BI 1824–64, and 47 at the SBA 1824–35. Most of his paintings

were still-life, usually fruit, but he occasionally showed portraits and subject pictures. Called by the *Athenaeum* critic (17 May 1856, p622) 'the very prince of fruit-painters'. Died Sunnyside, near Birkenhead, Merseyside, 18 June 1864. His studio sale was at Christie's 27 May 1873. There is a miniature portrait of him by Thomas Carrick in the V&A (P1-1953). His daughter, Miss E Lance, was also a painter of fruit, exhibiting at the RA 1859–61; Sir John Gilbert and William Duffield were his pupils.

LIT: *Art Union* 1847, p96 (with engr portrait after G Clint); *Art Journal* 1857, pp305–7; *Illustrated London News* 21 December 1861, pp647–8 (with engr portrait); *Art Journal* 1864, pp242–3 (obit)

*Fruit*   FA86

## Fruit
FA86   Neg 72354
Canvas, 35.5 × 43.1 cm (14 × 17 ins)
Signed and dated 'G L 1842' bl
Sheepshanks Gift 1857

Exhibited at the BI in 1843, the size given in the catalogue as 24 by 28 inches (including the frame, as was usual). Watercolour sketches for this composition were in the possession of the artist's descendants in 1935.

EXH:   BI 1843 (98)

## Self-Portrait
107-1873
Panel, 44.4 × 34.2 cm (17½ × 13½ ins)
Purchased 1873

This may be compared with the self-portrait in pencil and watercolour in the NPG. For the fullest published iconography see R Ormond *Early Victorian Portraits* 1973, I, p252. It is datable to about 1830, judging by the apparent age of the sitter.

The panel is composed of three pieces of wood joined vertically; in 1931 the right-hand join split and was not correctly aligned when reassembled, nor was the loss of pigment along the join replaced.

PROV:   G H Parker; purchased from him by the Museum 1873

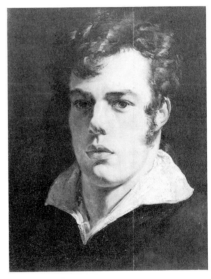

*Self-Portrait*   107-1873

## Fruit
895-1877   Neg 72356
Canvas, 85.1 × 111.1 cm (33½ × 43¾ ins)
Signed and dated 'G L 1848. 1849' on edge of table to r
Bequeathed by C T Maud 1877

The view in the left background was identified by one of the artist's descendants in 1935 as Preston Hall, Lancashire. It is more probably Preston Hall, Aylesford, Kent, the seat of Edward Ladd Betts who was a patron of Lance. Preston Hall was rebuilt in a Jacobean style for Betts in 1850; Lance presumably based his view on the architect's designs. In the catalogue of Betts's sale at Christie's 30 May 1868, lot 62 was 'The Uninvited Guest: a view of Preston Hall in the background'; in another edition of the catalogue, lot 62 is described as "A Peacock, Vase of Flowers and Fruits, under an archway, a view of a house in the background'. Presumably the former is the corrected title; according to Redford (*Sales*) a picture called 'The Unwelcome Guest' was also sold by Isaac, in 1879 (sale untraced). Consequently, and because of the description of the peacock and archway, it cannot be identified with the present painting, but must have been similar.

*Fruit*   895-1877

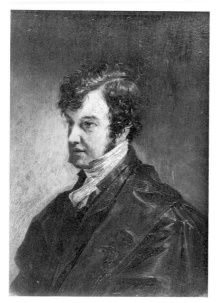

*The Rev William Harness    D82*

**The Rev William Harness**
D82    Neg 72357
Panel, 18.5 × 15.2 cm (7¼ × 6 ins)
Dyce Bequest 1869

In the 1874 catalogue of the Dyce collection by Samuel Redgrave, the work is listed as anonymous and as 'Portrait of a Gentleman in an English Clerical Dress'. The artist and sitter were identified in the 1907 catalogue of oil paintings.

The Rev William Harness (1790–1869) was ordained in 1812. He is best-known as a friend of Lord Byron and author of an edition and biography of Shakespeare published in 1825. The sale of his collection of pictures at Christie's 19 March 1870 included Eastlake's painting of 'The Trajan Forum, Rome' (now in the V&A collections). The donor of the portrait, the Rev Alexander Dyce, also owned a pamphlet by Harness, *The State of the English Bible* (1856), a presentation copy signed by the author; presumably they were friends.

Another portrait of Harness, by John Prescott Knight, was exhibited at the RA in 1838 (10). The present painting may be dated to the 1820s, judging from the apparent age of the sitter.

# LANDSEER, Charles, RA (1799–1879)

Born 1799, son of the engraver John Landseer and elder brother of Sir Edwin Landseer. Taught by his father and B R Haydon, and entered RA Schools 1816. Travelled in Portugal and Rio de Tanciro, making studies and sketches, in the 1820s. Exhibited 73 works at the RA between 1828 and 1879, 26 at the BI 1822–46, and 12 at the SBA 1824–35. Most were genre, historical and literary subjects. Elected ARA 1837, RA 1845; Keeper of Antique School 1851–73. Died London, 22 July 1879. His studio sale was at Christie's 14–16 April 1880.

LIT:    *Art Journal* 1879, p217 (obit); *Illustrated London News* 2 August 1879, pp109–10, (obit with engr portrait); *Athenaeum* 2 August 1879, pp153–4 (obit)

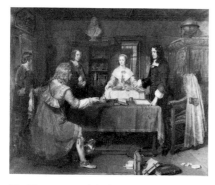

*The Temptation of Andrew Marvell    FA103*

**The Temptation of Andrew Marvell**
FA103    Neg GA1184
Canvas, 101.6 × 126.9 cm (40 × 50 ins)
Sheepshanks Gift 1857

Exhibited at the RA in 1841, with the following unattributed passage quoted in the catalogue:

> Andrew Marvell represented Kingston-upon-Hull in the Parliaments of Charles the Second's time, and the Merry Monarch was much delighted with his lively conversation. On the morning after an evening spent in Marvell's society, the King sent the Lord Treasurer Danby with a particular message from himself, and to request his acceptance of 1,000 guineas. Marvell lodged on the second floor in a court near the Strand; his Lordship found him writing, and delivered his errand. 'Pray what had I for dinner yesterday?' said Marvell, appealing to the servant. 'A shoulder of mutton, sir'. 'And what have I to-day?' 'The remainder, hashed'. 'And tomorrow, my Lord, I shall have a sweet blade-bone broiled; and I am sure, my Lord, His Majesty will be too tender in future to bribe a man with golden apples, who lives so well on the viands of his native country'. The Lord Treasurer withdrew with smiles, and Andrew Marvell sent to his bookseller for the loan of a guinea.

The *Art Union* criticised the narrative: 'It lessens somewhat the merit of the refusal to receive it, that it (the bribe) is given in the presence of two servitors to the briber as well as the domestic of the patriot. Vraisemblance is therefore wanting'. But the work 'has high merits. The figures are carefully drawn, and strongly characteristic; and the picture is boldly and yet delicately coloured'. On the other hand, the *Athenaeum* critic found the 'general sentiment' satisfactory, but

> its features in detail less so. Instead of the bland smile of an easy mind, there is almost a simper upon the lips of the patriot . . . the flesh-colours are pale and paste-like, and the handling wants firmness. In short, here again we feel the want of that earnesness and study which is characteristic of English art, to the deterioration of much bright and available talent.

When the *Art Journal* reproduced an engraving after the painting in 1864, it set aside 'the historical truth of the narrative', commenting:

> 'Artists and poets are permitted certain licenses, and Mr Landseer must be allowed what he has been pleased to take here. The merit of the work consists chiefly in the individuality of each figure, its agreeable expression, and in the extremely careful manner in which both they and all the accessories are painted; in colour, too, it is good'.

Various engraved portraits of Marvell appeared in editions of his poems; Landseer's image of the poet may be compared with that of an anonymous 17th-century painter in the NPG (554).

EXH:   RA 1841 (17); *Andrew Marvell Tercentenary Exhibition*, Guildhall, Hull, 1921

ENGR:   J Stancliffe, in *Art Journal* 1841, p427; *Art Union* 1841, p75; *Art Journal* 1864, p232

## Maria
FA104   Neg Y461
Canvas, 55.9 × 46.9 cm (22 × 18½ ins)
Sheepshanks Gift 1857

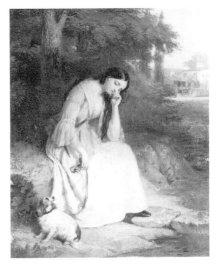

*Maria*   FA104

Presumably the painting exhibited at the BI in 1836 as 'Sterne's Maria', the size given in the catalogue as 32 by 28 inches (including the frame, as was usual).

The subject is taken from Laurence Sterne's novel *A Sentimental Journey through France and Italy*, first published in 1768, and a popular source for pictures thereafter. The story of Maria occurs towards the end, in the chapter 'Maria: Moulines'; Sterne had told it before in his earlier novel *Tristram Shandy*. The passage illustrated is as follows:

> When we had got within half a league of Moulines, at a little opening in the road, leading to a thicket, I discovered poor Maria sitting under a poplar. She was sitting with her elbow in her lap, and her head leaning on one side within her hand:- a small brook ran at the foot of the tree. She was dressed in white, and much as my friend described her, except that her hair hung loose, which before was twisted with a silken net. – She had superadded likewise, to her jacket, a pale green riband, which fell across her shoulder to the waist; at the end of which hung her pipe. – Her goat had been as faithless as her lover; and she had got a little dog in lieu of him, which she kept tied by a string to her girdle.

The image of the disconsolate Maria was especially popular in the later 18th century for its display of sensibility. Angelica Kauffmann's painting of the subject, for example, was made widely known through engravings (see the 1779 print by W W Ryland in the British Museum); the painting, according to a note in the Departmental files, was very similar to the present work, which may also be compared with E F Burney's painting (this does not seem

to have been exhibited) engraved by J Heath (repr *Connoisseur* 1914, p31). J G Strutt exhibited the subject at the RA in 1819.

The dog is traditionally supposed to have been painted by the artist's brother, Sir Edwin Landseer.

Exh:    ?BI 1836 (38)

*The Hermit*    FA105

**The Hermit**
FA105    Neg GA1185
Canvas, 55.9 × 45.7 cm (22 × 18 ins)
Sheepshanks Gift 1857

Possibly exhibited at the RA in 1841, or a repetition perhaps painted for John Sheepshanks. The RA exhibit was accompanied in the catalogue by the following quotation from Thomas Parnell's narrative poem *The Hermit* (published posthumously in 1721):

'Far in a wild, unknown to public view,
From youth to age a reverend hermit grew;
The moss his bed, the cave his humble cell,
His food the fruits, his drink the crystal well.
Remote from men, with God he passed the days,
Prayer all his business, all his pleasures praise.'

A painting of the same title, stated in the sale catalogue as exhibited at the RA in 1841, was sold at Christie's 16 April 1880 (525), bought Grindlay £7 7s.

It was suggested in 1925 by David Lucas, grandson of the engraver of the same name, that this painting represented his grandfather. Lucas was for a time employed at the Cremorne Gardens as a hermit and fortune-teller, wearing a long dressing-gown and false beard. Landseer's hermit may be compared with the lithographed portrait of Lucas in the British Museum.

Exh:    ?RA 1841 (90)

# LANDSEER, Sir Edwin Henry, RA (1803–1873)

Born London 7 March 1803, fourth of seven children of the engraver John Landseer. Studied with B R Haydon, entered the RA Schools 1817 (at the age of 14); won annual prizes of the Royal Society of Arts 1813–17. A precocious and prodigious talent, as both painter and draughtsman, he exhibited – in a long and distinguished career – 179 works at the RA between 1815 and 1873, 94 at the BI 1818–65, and four at the SBA 1826–32. Subjects included portraits, but predominantly dealt with animal and human genre, often based in Scotland. Elected ARA 1826 (at the earliest permitted age), RA 1831. Received the patronage of the Russell family, and – most importantly – that of the Royal family, to whom he was Drawing Master, beginning in 1836 with the Duchess of Kent (Queen Victoria's mother); most significantly, he represented in visual form the Queen and Prince Albert's love for the life and landscape of the Scottish Highlands. Together with George IV's celebrated visit to Edinburgh 1822, and the great popularity of Sir Walter Scott's Waverley novels, Landseer's contribution to the place of Scotland in European culture in the 19th century was considerable. The artist's own popularity was increased by the great number of reproductive prints after his works (Graves alone lists 434 by 126 engravers, see *Lit* below); his 'Monarch of the Glen' (exh. RA 1851), commissioned by the House of Lords but the cost refused by the House of Commons, was eventually bought by Sir Thomas Dewar and reproduced on his family firm's whisky bottle labels. Also significant was his anthropomorphic treatment of animals, particularly dogs; the *Art Journal* obituarist stressed that 'his dogs are not mere

portraits only, they are thinking, almost rational, creatures, wanting only the gift of speech to hold converse with us'. Knighted 1850; offered PRA 1865, but refused, almost certainly because of his poor physical and mental health. Died London 1 October 1873; buried in St Paul's Cathedral. His studio sale was at Christie's 8–15 May 1874; a commemorative exhibition was held at the RA 1874/5. After the Royal Collection, the V&A possesses the largest holding of Landseer's works; there are a great many drawings and prints as well as the oils catalogued below, principally from the Sheepshanks Gift, one of the artist's most important patrons.

LIT:    F G Stephens *The Early Works of Sir Edwin Landseer* RA 1869; J Dafforne *Pictures by Sir Edwin Landseer . . .* 1873; *Art Journal* 1873, p326 (obit); interleaved copy of 1874 RA exhibition catalogue, annotated by C S Mann, with photographs of prints after Landseer, 1874–7, 4 vols (National Art Library, V&A); A Graves *Catalogue of the Works of the Late Sir Edwin Landseer* 1876; C Monkhouse entry in *DNB*; C Lennie *Landseer: Victorian Paragon* 1976; R Ormond *Sir Edwin Landseer* Philadelphia Museum of Art and Tate Gallery exhibition catalogue 1981 (with full bibliography).

## A Highland Breakfast
FA87   Neg GA1186
Panel, 50.8 × 66 cm (20 × 26 ins)
Sheepshanks Gift 1857

*A Highland Breakfast*    FA87

Exhibited at the RA in 1834. The *Athenaeum* commended 'the group of terriers and hounds . . . socially toiling with their teeth . . . [and the] young mother giving her child the breast . . . the innocence of the latter, and the truth and nature of the former are equally striking'. The work is a fine example of Landseer's ability to combine a genre situation with canine studies in an intimate Scottish setting.

A study in chalks for the mother and child is in the National Loan Collection Trust (engr in *Art Journal* 1876, p99, repr Ormond p82); an oil sketch was reproduced by Monkhouse in 1879 (pl 15), and another (of the mother and child, 19.7 × 16.52 cm/7⅞ × 6⅝ ins) was recorded with Spink and Son in 1978.

EXH:    RA 1834 (96); *Exposition Universelle* Paris 1855 (860, as 'Le Déjeuner', lent by Sheepshanks); *Landseer and His World*, Mappin Art Gallery, Sheffield, 1972 (45); Tate 1982 (40)

ENGR:    John Outrim 1840 (Graves no 200)

LIT:    *Athenaeum* 10 May 1834, p355; T Gautier *Les Beaux Arts en Europe* 1855, p76; G Waagen *Treasures of Art in Great Britain* 1854, II, p300; *Landseer Gallery* no 4; Stephens, pp95–6 (repr pl 10); Dafforne, p13; Mann I, p24; Graves p17; J Manson *Sir Edwin Landseer* 1902, p79; Lennie, p53; Ormond, p82 (repr in colour p83)

## The Drover's Departure – A Scene in the Grampians
FA88   Neg 31851
Canvas, 125.8 × 191.2 cm (49½ × 75¼ ins)
Sheepshanks Gift 1857

*The Drover's Departure – A Scene in the Grampians*    FA88

Commissioned by the 6th Duke of Bedford, and exhibited at the RA in 1835. The *Athenaeum* fully described the subject:

> The scene is the Grampians; a long winding line of cattle, on their way to the south, are descending by a picturesque road; an old highlander has come to the door of his cottage, and sits helpless and gazing, like one doomed never to lead a drove again; friend is bidding farewell to friend – parting cups are filling and emptying – parting words of love or of business are uttering – dogs are gambolling – the very cattle seem

conscious of what is passing, and are gathered here and there into groups equally natural and picturesque. Words cannot convey a sense of glory of colours, nor do justice to the expression of the pencil; any account of this excellent picture we feel must be very imperfect; we shall, therefore, say no more in detail . . .

The critic concludes, however: 'The animal nature is, we fear, too strong for the human nature; the clucking hen is equal to the highland wife; and there is a black bull which some come to prefer to the man who drives him'.

This latter view was shared by at least one French critic when the work was shown at the Exposition Universelle in Paris in 1855; 'It is a curious picture of national manners – interesting as a page of Sir Walter Scott. There are a thousand delicacies of detail in this charming picture . . . Here, as is his wont, Landseer has given the place of honour to animals – man is but an accessory on his canvas'.

W P Frith (My Autobiography and Reminiscences) 1887, I, pp204–5) related the acquisition of the work by John Sheepshanks:

> When in the humour Mr Sheepshanks would name the prices that his pictures had cost him. I am afraid to trust to my memory for many instances; but I can well recollect the astonishment with which I heard of the incredibly small sums for which he had acquired some of the most wonderful of Landseer's works. One of the largest – 'The Departure of the Highland Drovers' – was a commission from the Duke of Bedford for £500. When the picture was finished, the Duke said he was very poor, and if Landseer could find another purchaser he (the noble patron) would be glad to resign 'so beautiful a work'. Another neglect of a good investment; for undoubtedly, if 'The Departure of the Highland Drovers' were sold now, it would bring quite as many thousands as the hundreds for which the Duke might have purchased it. Mr. Sheepshanks always chuckled when he told how, having heard of the Duke's wish, he took immediate steps to gratify him.

The work was one of the artist's major successes at the RA; Whitley records the crowds pressing in front of it, and the etching by Watt was extremely popular. As Ormond comments of the subject: 'It draws on traditions that were already passing away rapidly. The great drives of Highland cattle and sheep south to the English markets were part of the reassuring myth of Highland adventurousness and self-sufficiency perpetuated by Sir Walter Scott and other romantic writers, but, in fact, economic conditions were far bleaker'. For fuller details see A R B Haldane The Drove Roads of Scotland (1952); Ormond also refers to a pamphlet of about 1841 – The Highland Drovers – published in connection with the Watt print.

The work may be related in certain aspects of the composition with the later and more dramatic 'Flood in the Highlands' (RA 1860, now Aberdeen Art Gallery); F G Stephens (Sir Edwin Landseer 1881) states that 'Tethered Rams' is a study for the present work, which seems unlikely (see p146). The horse on the left appears in 'A Highland Scene' of about 1834 (now Wallace Collection; see J Ingamells Catalogue of Pictures I, 1985, p113, repr).

According to the pamphlet of about 1841, the location of the setting is the Ochil Hills, south-west of Perth; Ormond thinks this unlikely. According to Stephens, John Landseer, the artist's father, was the model for the old shepherd, and Robert Leslie, C R Leslie's son, for the boy.

PROV:  See above

EXH:  RA 1835 (167); Exposition Universelle Paris 1855 (861); Tate 1982 (41)

ENGR:  J H Watt 1841 (repr Stephens 1869); Herbert Davis 1859; William Roffe 1892, as pl 56 of Works of Sir Edwin Landseer RA (second series)

LIT:     *Athenaeum* 16 May 1835, p379; *The Times* 23 May 1835, p5; *Art Union* 1839, pp6, 149; *The Highland Drovers* pamphlet, nd [about 1841]; *Art Union* 1841, pp127, 141; G Waagen *Treasures of Art in Great Britain* 1854, II, p300; *Art Journal* 1855, p281; T Gautier *Les Beaux-Arts en Europe* Paris 1855, p75; Stephens, p57, repr pl 12; *Landseer Gallery* 1871, pl21; *Dafforne*, pp13–4; F G Stephens *Memoirs* 1874, pp96–7, repr pl 11; Mann I, p105; *Graves* p18, no 207; *Landseer Gallery* 1878, pl 14; F G Stephens *Sir Edwin Landseer* 1881; P G Hamerton *Graphic Arts* 1882, pp242–3; T H Ward *English Art in the Public Galleries of London* nd [1888], II, p163; J Manson *Sir Edwin Landseer* 1902, pp 79, 81–2; A Dayot *La Peinture Anglaise* Paris 1908, p175; E Chancellor *Walks Among London's Pictures* 1910, p251; W T Whitley *Art in England 1821–1837* 1930, p299; *Lennie*, pp54–5, 82; *Ormond* pp84–5 (with further references)

## The Dog and the Shadow
FA89   Neg FH2114
Panel, 45.1 × 54.6 cm (17¾ × 21½ ins)
Signed and dated 'E L [in monogram] 1822' bl
Sheepshanks Gift 1857

Exhibited at the BI in 1826. In the *Art Journal* review of the Sheepshanks Gift, the landscape was described as 'hyper-pre-Raffaelite – valuable and curious as an early work, though less powerful than those of Sir E. Landseer's matured style'. Waagen found the dog 'very true and animated, the colouring clear, and execution careful. The general harmony, however, is somewhat disturbed by the glowing red colour of the piece of meat'. Some 30 years after these comments, *English Art in the Public Galleries of London* called it 'in truth, a landscape painting, weak, commonplace, and ineffective, and may probably have been undertaken as a study of background'. This strange opinion of the work may be corrected by Stephens's account of the 'official description':

*The Dog and the Shadow*    FA89

> 'A dog with a piece of flesh in his mouth is crossing a brook by means of a fallen tree, and stops to gaze at the treacherous image of himself and his prize as reflected by the stream. A worsted cap, and some shoes on the bank indicate that a butcher's boy, who has loitered to fish or bathe, had been plundered of part of his charge'.

This is a characteristic device of Landseer, suggesting a human dimension in animal genre by the introduction of a few still-life details (see for example 'Suspense', FA99 p148).

EXH:    BI 1826 (182)

ENGR:   G Cousen for *Art Journal* 1877, facing p328; James Scott 1885, as pl 50 of *Works of Sir Edwin Landseer RA* (first series 1881–93)

LIT:    G Waagen *Treasures of Art in Great Britain* 1854, II, p302; *Art Journal* 1857, p240; Stephens p47; *Art Journal* 1877, p328; T H Ward *English Art in the Public Galleries of London* nd [1888], II, p161

## A Fireside Party
FA90   Neg M491
Panel, 25.4 × 35.6 cm (10 × 14 ins)
Sheepshanks Gift 1857

Exhibited at the BI in 1829 with the title 'Conversazione'. The dogs belonged to Malcolm Clarke of Inverness, and were described as the Pepper and Mustard dogs belonging to the Cheviot farmer Dandie Dinmont by Sir Walter Scott in chapters 22 and 23 of his novel *Guy Mannering* first published in 1815. Stephens commented that 'the hairy texture of the veritable race of "Pepper" and "Mustard" is given, as it were, hair for hair, yet it was achieved

*A Fireside Party*    FA90

at once by a dexterous use of the painter's brush'.

EXH:  BI 1829 (68, as 'Conversazione'); *Exposition Universelle* Paris 1855 (865), lent by Sheepshanks; *Landseer and His World* Mappin Art Gallery, Sheffield, 1972 (34)

ENGR:  B P Gibbon 1831 (Graves no 153); G Sidney Hunt 1885, as pl 53 of *Works of Sir Edwin Landseer RA* (first series 1881–93)

LIT:  T Gautier *Les Beaux Arts en Europe* 1855, p77; *Stephens*, p52; *The Landseer Gallery* 1871, pl 2; F G Stephens *Sir Edwin Landseer* 1881, p62; J Manson *Sir Edwin Landseer* 1902, p68; *Lennie*, p52.

*There's no Place like Home*   FA91

## There's no Place like Home
FA91   Neg V1931
Canvas, 63.2 × 75.6 cm (24⅞ × 29¾ ins)
Sheepshanks Gift 1857

Exhibited at the BI in 1842. The *Art Union* greatly admired it:

> This is a contritely repentant absentee in the shape of a little rough terrier, that has evidently been sometime astray. His home is humble enough [referring of course to the full quotation from the famous ballad: 'Be it ever so humble, there's no place like home']: a barrel with a hole in it, his dish is empty and broken, and an intrusive snail has written 'solitude' at his very threshold. It is difficult to describe in words the profoundly imploring expression with which the eyes are endowed; the head is raised, and he looks upwards, as in the act of howling. Much of the picture seems to have been painted at once; it has all the clear colouring of the best style of its distinguished author; and of scarcely sufficient to sustain his great and universal reputation, it would make a character for any other living painter.

It may also be seen as an appropriate, canine comment on the so-called 'hungry forties' in Britain.

EXH:  BI 1842 (120); *Victorian Narrative Paintings* V&A circulating exhibition 1961; *Victorian Painting* Mitsukoshi Gallery, Tokyo, 1967 *The Revolt of the Pre-Raphaelites* Lowe Art Museum, University of Miami, Florida, 1972; *Victorian Narrative Painting* Bristol Cathedral 1977

ENGR:  B P Gibbon 1843 for *Art Union* 1844, p72, (Graves no 309, repr *The Landseer Gallery* 1871, pl 5); W T Davey; Alfred Lucas; James Scott 1883, as pl 72 of *Works of Sir Edwin Landseer RA* (first series 1881–93)

LIT:  *Art Union* 1842, p59, 1844, p72; *Dafforne*, p21; T H Ward *English Art in the Public Galleries of London* II, nd [1888], p166; J Manson *Sir Edwin Landseer* 1902, p119

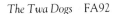

*The Twa Dogs*   FA92

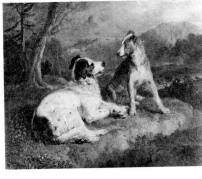

## The Twa Dogs
FA92   Neg M490
Canvas, 43.2 × 54 cm (17 × 21¼ ins)
Signed and dated 'EL/1822' br
Sheepshanks Gift 1857

This early work, despite the Highland landscape of loch and mountain, predates the artist's first visit to Scotland in 1824 by two years. It depicts a Newfoundland and a collie dog, who represent Caesar and Luath, the subjects of Robert Burns's early poem 'The Twa Dogs: a Tale'. Luath was the poet's own dog. According to Graves's *Catalogue*, 'the large dog is Neptune, Mr. W. Ellis Gosling's dog'. Dafforne comments on the subject of both poet and painter:

Two dogs conversing about men and their manners . . . the poem opens with a description of each, as they sit down to a discussion of their respective masters, and their masters' homes . . . animals sitting in judgement on the 'lords o' the creation', and which the artist has represented with such truth and spirit. The debate, if so it may be called, has become lively; the head of each dog shows remarkable animation as they warm up in the discussion – one, as the rest of the poem shows, in no way complimentary to those who are the subjects of this canine debate, but who are not 'in court' to justify themselves either in person or by counsel.

The work thus provides an early example of the artist's anthropomorphic subject matter; the overtly satirical quality of Burns's poem, however, is lacking.

Waagen thought it 'carried out masterly truth, recalling Fyt [the 17th century Antwerp painter Jan Fyt] in the sunny effect'. The text accompanying the 1870 engraving in the *Art Journal* noted 'though a comparatively youthful performance, it shows not a few of the youthful qualities which in after years have given the artist distinction; the dogs are animated and full of character; and the landscape . . . exhibits with fidelity the scenery of the country'.

Another work bore the same title and was exhibited at the BI in 1858 (28); this is described by the Art Journal (1858, p77): 'in this picture we have only the heads – one of a well-conditioned Newfoundland and the other is that of a collie' (see also the Examiner 1858, p101). A painting titled 'The Two Dogs' was exhibited at the RA in 1839, but the Art Union (1839, p21) indicates it showed a different composition.

Mann states that a version was originally bought for £300 was later sold for £2415.

ENGR:   B P Gibbon 1827; Charles G. Lewis, for Art Journal 1870, facing p276; Thomas Landseer, in Mann, 1874; G. Sydney Hunt 1886, as pl. 96 of Works of Sir Edwin Landseer (first series 1881–93).

LIT:   G Waagen *Treasures of Art in Great Britain* II, 1854, p301; *The Landseer Gallery* 1871 (repr. Gibbon engr.); *Dafforne* 1873, pp13–16 (repr. Lewis engr.); Graves no 57; *English Art in the Public Galleries of London* II, nd [1888], p161; J. Manson *Sir Edwin Landseer* 1902, pp47–8.

## The Old Shepherd's Chief Mourner
FA93   Neg 54050
Canvas, 45.7 × 61 cm (18 × 24 ins)
Sheepshanks Gift 1857

Exhibited at the RA in 1837. Admired by the *Athenaeum* critic as 'one of the most simply pathetic things in the Exhibition', the work became both famous and a popular success due to the 1838 engraving and Ruskin's eulogy in the first volume of *Modern Painters* published 1843. Ruskin cited the picture as illustrating his definition of 'Greatness in Art' and his belief that 'the greatest picture is that which conveys to the mind of the spectator the greatest number of the greatest ideas'. Ruskin thought it:

*The Old Shepherd's Chief Mourner*   FA93

One of the most perfect poems or pictures (I use the words as synonymous) which modern times have seen . . . Here the exquisite execution of the glossy and crisp hair of the dog, the bright sharp touching of the green bough beside it, the clear painting of the wood of the coffin and the folds of the blanket, are language – language clear and expressive in the highest degree. But the close pressure of the dog's breast against the wood, the convulsive clinging of the paws, which has dragged the blanket off the trestle, the total powerlessness of the head laid close

and motionless upon its folds, the fixed and tearful fall of the eye in its utter hopelessness, the rigidity of repose which marks that there has been no motion nor change in the trance of agony since the last blow was struck on the coffin-lid, the quietness and gloom of the chamber, the spectacles marking the place where the Bible was last closed, indicating how lonely has been the life, how unwatched the departure, of him who is now laid solitary in his sleep; – these are all thoughts – thoughts by which the picture is separated at once from hundreds of equal merit, as far as mere painting goes, by which it ranks as a work of high art, and stamps its author, not as the neat imitator of the texture of a skin, or of the fold of a drapery, but as the Man of Mind.

'The Poor Dog', otherwise titled 'The Shepherd's Grave', may be seen as a forerunner of the present work; it was exhibited at the BI in 1829 (now private collection, see Ormond p104, repr).

A sketchbook including a drawing for the present work (dated, presumably incorrectly, 1825 in the catalogue) was lot 1001 in the artist's studio sale at Christie's 8 May 1874; a sketch from the collection of the Marchioness of Londonderry was sold at Christie's 20 April 1885 (55), bought Nathan £1 18s.

Exh:   RA 1837 (112); *International Exhibition* Dublin 1865 (19); *RA Bicentenary Exhibition* RA 1968–9 (231); *La Peinture Romantique Anglaise et les Pré-raphaélites* Petit Palais, Paris, 1972 (155); *Great Victorian Pictures* Arts Council 1978 (25); *Zwei Jahrhunderts Englische Malerei* 1979–80 (364); Tate 1982 (66)

Engr:   B P Gibbon 1838; Frederick Hollyer 1869; G S Hunt 1884, as pl 87 of *Works of Sir Edwin Landseer RA* (first series 1881–93); lithograph Jacob Bell

Lit:   *Athenaeum* 6 May 1837, p330; *Literary Gazette* 13 May 1837, p306; *Blackwood's Magazine* September 1837; *Stephens*, p58 (repr pl 13); *Dafforne*, pp16–7; *Cornhill Magazine* 1874, p87; Mann I, pp134–5a; Graves no 233; T H Ward *English Art in the Public Galleries of London* nd [1888], p165 (repr); J Manson *Sir Edwin Landseer* 1902, pp89–91 (repr); G Reynolds *Victorian Painting* 1966, p15, 20, 27 (repr pl 8); Lennie, pp83, 91, 130–1, 133, 149; R Treble *Great Victorian Pictures* Arts Council exhibition catalogue 1978, p47; Ormond, p110

*A Jack in Office*   FA94

## A Jack in Office

FA94   Neg GH1581
Panel, 50.2 × 66.1 cm (19¾ × 26 ins)
Sheepshanks Gift 1857

Exhibited at the RA in 1833. The title is taken from the slang expression for a pompous and petty official. One of the artist's most clearly anthropomorphic treatments of human matters in canine terms, it is described by Ormond as 'enormously popular, providing fable, parody, humour, and narrative in a single image'. He discusses the subject, and possible allegorical and moral content, of the work in some detail, concluding that it is 'highly finished and beautifully painted, with a feeling for light and atmosphere worthy of a Dutch master'. The *Athenaeum* critic simply commented on the 'well-fed and much caressed dog, who, like his friend of the manger, keeps others from testing the food of which he has had too much'. The critic continued that 'we do not profess to be admirers of this sort of animal portraiture, but the works of Landseer are always characteristic and worthy of notice'. In a review of the Sheepshanks Gift, the *Art Journal* in 1857 commented 'the picture is here as brilliant and pure as ever it was . . . it is a gem of canine story – nothing in the way of dogs' tales has every approached it'.

The fame of the painting (and of the breed of the principal dog – see below) was considerably increased by the publication of a political caricature

based on it (one of several 'HB' caricatures based on paintings by Landseer). The print by 'HB' (John Doyle 1797–1868) was published 25 April 1835, shortly after the fall of Sir Robert Peel's Tory administration. Lord John ('Jack') Russell had been appointed Leader of the House of Commons and Home Secretary, so a great deal of patronage was at his disposal. The caricature shows him as the 'Jack in Office', surrounded by the other dogs: Joseph Hume (known for his industry and patience) sitting quietly on the left, Lord Brougham as the whining pointer bitch sniffing at the meat (despite his strong appetite for office, he was not offered again the Chancellorship, which in effect marked the end of his career), O'Connell as a poodle sitting up and begging, and Lord Durham as the alert terrier in the background. Ward in 1888 interestingly noted the resemblance already existing between the politicians and the dogs in Landseer's painting, and that 'one can hardly believe Landseer to have been quite innocent in the matter'.

*Caricature by 'HB'*

According to Redgrave (*Dict*) both Lord John Russell and Sheepshanks enjoyed the joke; in his diary for 12 December 1856, he wrote:

> Lord Palmerston . . . was taken by Mr. Sheepshanks . . . round the rooms till he came to the . . . 'A Jack in Office' . . . Mr. Sheepshanks reminded Lord Palmerston of its being turned into a political squib by 'HB', in which the dog on the barrow became Lord John Russell; the lean hound, Lord Brougham, hungering for the Chancellor's wig . . . Lord Palmerston's merry eye twinkled as he said he thought the caricature should be hung beside the picture. 'Lord J. Russell brought his second wife here', said Sheepshanks, 'just after they were married, and, as they stood before the picture, I saw her laugh and give him a nudge with her elbow'.

Redgrave also notes that Sir George Cornewall Lewis then arrived and disapproved of caricaturing a cabinet minister. Redgrave records the difficulty the French had with the title when the painting was shown at the *Exposition Universelle* in Paris in 1855; 'They could not translate it, nor understand our explanations – I presume, because all the officials are Jacks in Office'.

The principal dog depicted is a Jack Russell terrier, a small deviation of the Wire Fox terrrier, shorter on the leg and with a broader skull. Landseer shows the dog as considerably overweight, to emphasise the meaning of the title. The breed was established by the Rev John Russell (the 'sporting parson', 1795–1883) around 1813, but at the time of the painting was still unrecognised by the Kennel Club.

EXH: RA 1833 (170); *Exposition Universelle* Paris 1855 (859, as 'Jack en Faction', lent by Sheepshanks); Tate 1982 (62)

ENGR: B P Gibbon 1834; C G Lewis; G Sidney Hunt 1885, as pl 63 of *Works of Sir Edwin Landseer RA* (first series 1881–93)

LIT: *Athenaeum* 11 May 1833, p298; *Gentleman's Magazine* 1833, p541; *Examiner* 19 May 1833, p309; G Waagen *Treasures of Art in Great Britain* 1854, II, p306; T Gautier *Les Beaux-Arts en Europe* Paris 1855, pp76–7; F T Palgrave *Gems of English Art* 1869, pp1–2 (repr in colour); *Art Journal* 1869, p334; Stephens, pp53–4; *Dafforne*, pp34–5; Mann I, pp140a, 141a, 148a, 151 (repr Gibbon engr); *Graves no 191*; W P Frith My *Autobiography and Reminiscences* 1887, I, p205; T H Ward *English Art in the Public Galleries of London* nd [1888] pp162, 164; F M Redgrave *Richard Redgrave: a Memoir* 1891, pp168–9; J Manson *Sir Edwin Landseer* 1902, pp78–9 (repr facing p40); *Lennie*, pp51, 82, 88–9, 161; *Ormond* pp104–6 (repr, with further references)

*Tethered Rams* FA95

## Tethered Rams

FA95   Neg GA1187
Panel, 45.7 × 58.4 cm (18 × 23 ins)
Sheepshanks Gift 1857

Exhibited at the RA in 1839 as 'Tethered Rams – Scene in Scotland'. The *Art Union* critic thought it 'a fine picture of a peculiar character; with little of what the general observer will consider interesting; but of large value as a work of art. It is elaborately finished – as if the artist had determined to do his best'. Waagen described it as 'well composed, and of beautiful tone in the landscape; but the treatment too broad and slight'. On the other hand, Redgrave admired the handling:

> The fullest truth of a woolly texture is obtained by simply, with a full brush, applying the more solid pigment into that which has already been laid on as a ground, with a large admixture of the painter's vehicle; days might be spent endeavouring to arrive at a result which the painter has achieved at once'.

Redgrave's comments are indicative of the admiration Landseer's sheer technique inspired in contemporary critics and artists.

Hague, following Stephens, states that the work is a study for 'The Drovers' Departure' exhibited at the RA in 1835 (see p139). This may well be incorrect; the resemblance to any part of the latter's composition is not close, and the present work was exhibited four years after. Hague also comments that the work is a 'good example of the more finished technique Landseer adopted at this time, in contrast to the freer brushwork of his earlier work. His eyesight was failing by 1850 however, so the period of high finish was short'. Hague adds that the high finish 'was probably encouraged by Prince Albert who admired the German Nazarene painters', whose influence also formed part of the background to the precise handling of the Pre-Raphaelites in the late 1840s.

A pen and ink sketch was sold at Christie's 17 March 1873 (101), bought Vokins £33 12s; it later belonged to Capt W H F Palmer, and was exhibited at the RA 1874 commemorative exhibition (30).

EXH:   RA 1839 (145); *Exposition Universelle* Paris 1855 (862, lent by Sheepshanks); *Landseer and His World* Mappin Art Gallery, Sheffield, 1972 (67)

ENGR:   John Burnet 1845 (repr in *Stephens*, p52); Charles J Tomkins 1881, as pl 94 of *Works of Sir Edwin Landseer RA* (first series 1881–93)

LIT:   *Art Union* 1839, p68; G Waagen *Treasures of Art in Great Britain* 1854, II, p306; T Gautier *Les Beaux Arts en Europe* 1855, p77; *Art Journal* 1856, p79; *Stephens*, p52; *Dafforne*, p19; Mann I, p30; *Graves* no 264; Redgrave (*Cent*) p383; J Manson *Sir Edwin Landseer* 1902, pp99–100; J Hague *Landseer and His World* Mappin Art Gallery, Sheffield, 1972, p65–6; *Lennie*, pp55, 83, 95

*Sancho Panza and Dapple* FA96

## Sancho Panza and Dapple

FA96   Neg GA1180
Panel (mahogany), 18.7 × 15.6 cm (7⅜ × 6⅛ ins)
Signed and dated 'EL/1824' br
Sheepshanks Gift 1857

The subject is from part 2 chapter 55 ('Of what happened to Sancho on the road . . .'), of Cervantes's *Don Quixote* (1615). Sancho and his ass Dapple fall into a pit in the dark; 'Then taking a piece of bread out of the saddle-bags, which had shared their unfortunate fall, he gave it to his ass, who did not dislike it. And his master said to him, as if he could understand: "Bread is relief for all grief" '.

Cervantes's characters were popular with 19th-century painters, and although Landseer's Sancho Panza lacks the profundity of Daumier's later

treatment of the character, the present work is more powerful than Frith's of 25 years later (see 513–1882, p101), Sheepshanks also owned three Don Quixote subjects by C R Leslie (see FA119, FA131–2, p168, 174–5). As Ormond points out, this is the only Cervantes subject by Landseer.

EXH: Tate 1982 (18)

ENGR: C G Lewis for *Art Journal* 1877, facing p304

LIT: Mann III, p168A; *Graves p9; Art Journal* 1877, p304; J Manson *Sir Edwin Landseer* 1902, p53; *Ormond* p55 (repr)

### The Angler's Guard
FA97    Neg GA1189
Panel, 12.7 × 14.6 cm (5 × 5¾ ins)
Sheepshanks Gift 1857

The Angler's Guard    FA97

According to Graves, painted in 1824 for John Wilton; it was exhibited at the BI in the same year, framed together with 'Itinerant Performers'. The work shows a St Bernard dog and a white Italian greyhound watching the gear and fish-basket of an angler.

EXH: BI 1824 (170)

ENGR: Wood engraving for *Art Journal* 1876; W P Sherlock lithograph, in Mann III, p66; J W Josey 1892, as pl 33 of *Works of Sir Edwin Landseer RA* (first series 1881–93)

LIT: *Graves* no 81; J Manson *Sir Edwin Landseer* 1902, p53

### A Naughty Child
FA98    Neg 36112
Millboard, 38.1 × 27.9 cm (15 × 11 ins)
Sheepshanks Gift 1857

Exhibited at the BI in 1834. The text accompanying the 1847 engraving in the *Art Journal*, described the work as 'one of the most agreeable and popular of Mr. Edwin Landseer'; it continued:

> It may not be amiss to state that this picture was the issue of an accident. A lady having brought her son to sit to Mr. Landseer, the boy became unruly, sulked, and refused to remain in the position in which he had been placed. His mother having vainly exerted her authority, and finding him still obstinate, forced him into 'the corner' as a punishment. Here his resolute air and sturdy expression struck the artist – who quietly pictured his expression as it is seen here.

A Naughty Child    FA98

Manson states that the sitter was a girl, Lady Rachel Russell (1826–98), whom, it is alleged by Lennie, was Landseer's own daughter, the second child of his liaison with Georgina, Duchess of Bedford, and Lennie cites the support of the present duke for this view. The resemblance of the present sitter to Landseer's 1831 portrait of Lady Rachel Russell as 'Little Red Riding Hood' also supports this suggestion; however, the present work shows a child of about five years, while in 1834 Lady Rachel would have been eight.

The success of the work was remarkable, and led to a number of commissions for child portraits, although he had already painted several for the Russell family.

EXH: BI 1834 (4)

ENGR: W Finden 1843 (dated by Graves 1841), as 'The Naughty Boy' (see *Art Union* 1834, p226, repr 1847, facing p88);, S G Hunt 1890, as pl 13 of *Works of Sir Edwin Landseer RA* (second series)

LIT: *Art Union* 1847, p88; *Dafforne* p18 (repr as frontispiece); Mann I, p136; *Graves* no 201; F G Stephens *Sir Edwin Landseer* 1881, pp70–1; J Manson *Sir Edwin Landseer* 1902, p82; *Lennie* p58

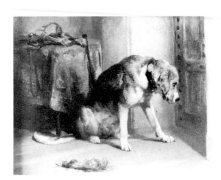

*Suspense*    FA99

## Suspense

FA99    Neg 55767
Panel, 69.9 × 90.8 cm (27½ × 35¾ ins)
Sheepshanks Gift 1857

Exhibited at the BI in 1834. Contemporary and later 19th-century critics offered various explanations of the subject – which Landseer must have intended to be enigmatic, but almost all agreed that it was one of his finest works. The *Gentleman's Magazine*, however, clearly disliked the anthropomorphic treatment:

> The picture represents a dog of the mastiff species watching for the opening of a door, but not in the hope of geting at some unfortunate chickens, as a contemporary has suggested. He is not of a class to chase poultry. He looks as wise as Solomon, but we rather object to the absurd air of sentimentality which Mr. Landseer so uniformly gives to these canine creatures. It may impose on vulgar tastes; but, for our own part, with all our respect for the faithful brutes, we cannot feel the propriety of investing them with the attributes of human wisdom.

In a long passage, Stephens offered two alternative readings of the subject, and ends by rightly emphasising the important role of the viewer of this work:

> A noble bloodhound is watching at a closed door, shut out, one may imagine, from the wounded knight, his master. There are the steel gloves removed from the now powerless limbs – the torn eagle-plume tells of the deadly strife, and the continuous track on the floor shows how his life-blood flowed away drop by drop as he was borne within. Who does not watch with the faithful hound in deep 'suspense' for some token that his master yet lives? Others, again, can read the picture far differently; these may imagine that the dog has tracked the author of some act of violence or deed of blood; the plume, torn from the casque of the struggling victim, lies on the floor sprinkled with the blood shed in the struggle ere the victim was borne within the now closed portal; we recognise the scuffle of the moment, his hand clutching the door-post with fearful energy to prevent the closing, the stifled cries, the hopelessness of resistance. Yet there, like a watchful sentinel, waiting in silence, the animal crouches, whose instinct teaches him untiringly to follow the object of his search; the spectator himself waits in anxious eagerness for the re-opening of the door, anticipates the spring of the animal and the renewed struggle that will ensue.

Redgrave also noted this quality: 'In some cases the invention of the artist is exerted rather to exercise and call forth the imagination of the spectator than to display his own'.

It had been the *Athenaeum* critic who interpreted the dog as being merely hungry: 'A dog watches, with eyes bright with longing, and chops impatient to be employed by the hole of a door, through which he expects prey to come: a bloody feather lies beside him, and we imagine we hear the cackling of cocks and hens'. It is most likely that Landseer intended the Stephens reading of the wounded knight.

As Ormond comments: 'The feather has clearly been torn from a hat or helmet, evoking, like the gauntlets, the romantic and chivalric past'. Ormond concludes: 'It is not the historical context of the picture that is important, but the element of drama, the sheer vitality of the bloodhound, and the feelings of loyalty and love that he displays towards his absent master. The relationship of man and his dog lies at the centre of the subject'. Ormond also notes:

> The splayed feet and rippling back muscles suggest the enormous power of the animal, temporarily held in check, but ready to spring into action at a moment's notice. Few of Landseer's canine subjects are painted with

such power – the paint surface heavily impasted and broadly handled. The accessories are treated in the same taut and simple style. The low, dog's-eye viewpoint is typical of Landseer's dog subjects.

A crayon drawing titled 'Suspense' is recorded on the Departmental files as having been offered to the museum in 1903.

Exh:    BI 1834 (144); Tate 1982 (63)

Engr:   B P Gibbon 1837; C G Lewis, for *Art Journal* 1868, facing p232, as 'The Friend in Suspense'; J Cother Webb 1881, as pl 92 of *Works of Sir Edwin Landseer RA* (first series 1881–1893); Jacob Bell lithograph

Lit:    *Times* 5 February 1834, p4; *Athenaeum* 8 February 1834, p107; *Gentleman's Magazine* 1834, p308; *Stephens* pp55–6 (repr photograph of Gibbon engr); *Dafforne* pp22–3; *Graves* no 205; *Mann* I, p128; *Cornhill Magazine* January 1874, p87; T H Ward *English Art in the Public Galleries of London* nd [1888], p165 (repr); J Manson *Sir Edwin Landseer* 1902, p83 (repr)) E B Chancellor *Walks Among London's Pictures* 1910, p250; *Lennie* pp89–90; *Ormond* pp106–7 (repr with further references)

## Comical Dogs
FA100    Neg GG4951
Panel, 69.8 × 76.2 cm (27½ × 30 ins)
Sheepshanks Gift 1857

*Comical Dogs*   FA100

Exhibited at the BI in 1836, the works shows clearly the increasing whimsical anthropomorphism that interested the artist. The critic of the *Examiner*, who found the painting 'irresistible', went on to comment that the right-hand dog 'who looks up, it is clear, to his master's face, is expressed inimitably. An inferior artist would have made them seem conscious of the ludicrous figure they cut. Mr. Landseer, while he gives them all the intelligence of the canine nature, never plays with the falsehood of a fanciful or humanised expression'. This latter statement, to say the least, is open to question. The *Athenaeum* thought it 'one of the best things in the gallery' but:

> We are perplexed to know whether more to admire the fun of the *party* (to speak as the diplomats do) in the grandmother's cap, with the stump of a pipe in his mouth, or the drier humour of him in the shepherd's bonnet, with the mull *at his paws*. This picture is sure to attract many gazers – who will forget the slightness of its execution in the quaintness of its design.

Lennie calls these dogs 'absurdly dressed-up tykes', and 'though they deliberately exploited quaintness, they did not falsify expression; they were, however, the forerunners of the insufferably cute newspaper photographs showing a litter of puppies or kittens suspended inside a row of socks on a washing-line'. We might update this comment to include the presentation of animals on the television programme 'That's Life!'.

Exh:    BI 1836 (10)

Engr:   Charles G Lewis, for *Art Journal* 1877, facing p80; Samuel A Edwards 1886, as pl 6 of *Works of Sir Edwin Landseer RA* (first series 1881–93)

Lit:    *Athenaeum* 1836, p147; *Examiner* 1836, p213; *Graves* (unnumbered, listed under the year 1836); *Art Journal* 1877, p80; *Mann* III, p115; F G Stephens *Sir Edwin Landseer* 1881, p76; J Manson *Sir Edwin Landseer* 1902, p87; *Lennie* pp88, 182

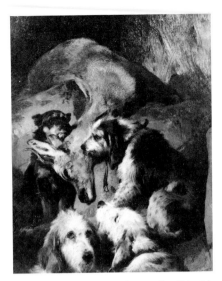

*Young Roebuck and Rough Hounds*    FA101

### Young Roebuck and Rough Hounds
FA101    Neg HJ725
Panel, 53.3 × 43.2 cm (21 × 17 ins)
Sheepshanks Gift 1857

Exhibited at the BI in 1840. Graves states that the roebuck was shot by Lord Cosmo Russell, who was also the owner of the two upper dogs, Melody and Toddy. The work is a spirited example of Landseer's exceptional ability to portray a patron's favourite dogs in an imaginative composition. Landseer had painted Lord Cosmo at the age of seven in 1824 (RA 1825, repr Ormond p63).

Waagen thought 'the truth of detail and masterly character of the execution are here and the chief attractions, for the composition is little interesting'. Twenty years later Dafforne remarked on the 'wonted skill and accuracy of the artist and here self-evident; but the subject is far from agreeable, for the roebuck lies dead among some rocks, and one of the four dogs which surround it is licking up the blood that flows from a wound in its neck'.

An oil study, 'Deer and Rough Hounds', was sold at Christie's 18 November 1911 (59, 29.2 × 21.6 cm/11½ × 8½ ins); bought Schroeder £21 1s; a drawing of 'Roebuck and Rough Hounds' was sold at Christie's 16 May 1913 (11, 50 × 40.6 cm/19¾ × 16 ins), bought Harding £73 10s

Exh:    BI 1840 (1); *Victorian Painting* Nottingham University Art Gallery 1959 (36); *Paintings and Drawings by Sir Edwin Landseer RA* RA 1961 (1); *Victorian Painting* Arts Council 1962 (35)

Engr:    B P Gibbon 1849

Lit:    G Waagen *Treasures of Art in Great Britain* II, p300; *Dafforne* p20; Mann I, p160 (repr Gibbons engr); *Graves* no 277 (repr Gibbons engr); F G Stephens *Sir Edwin Landseer* 1881, p82

*The Eagle's Nest*    FA102

### The Eagle's Nest
FA102    Neg GA1204
Millboard, 25.4 × 35.6 cm (10 × 14 ins)
Sheepshanks Gift 1857

Listed by Graves under the year 1833, and exhibited at the BI in 1834. The work is a fine example of Landseer depicting birds in a vast natural setting, and may be compared with 'Ptarmigan' (also early 1830s, repr Ormond p80) and 'The Ptarmigan Hill' (late 1860s, repr Ormond p217). A crayon sketch of the same subject was in the studio sale at Christie's 11 May 1874 (537, described as a cartoon, 179 × 106 cm/70½ × 41¾ ins), and was shown at the commemorative RA exhibition in the same year.

Waagen thought 'the grand melancholy solitude of the Highlands is here well expressed, though the tone of the colouring is too heavy'. Lennie, writing about the 1869 'A Swannery Invaded by Sea Eagles' as an expression of Landseer's personal psychological condition, commented that the presented work 'had shown the grey, bleak and uncompromising landscape that was the great bird's home: that, too, had been a landscape totally without rest or pity which seemed to reflect the beginnings of Edwin's *angst*'.

Exh:    BI 1834 (276); *Paintings and Drawings by Sir Edwin Landseer RA* RA 1961

Engr:    Woodcut, W Thomas, for *Illustrated London News* 1861

Lit:    G Waagen *Treasures of Art in Great Britain* 1854 II, p305; Mann II, p131 (with photograph of Thomas woodcut); *Graves* no 195; *Lennie* p225

## Sketch in the Highlands
F18   Neg 73667
Millboard, 26.1 × 35.6 cm (10⁵⁄₁₆ × 14 ins)
Forster Bequest 1876

Possibly the work listed by Graves under the year 1837 as 'The Highlands'; if so, it was exhibited at the RA in that year. It was given after his death by the artist's family to John Forster.

Exh:   ?RA 1837 (160, as 'The Highlands'); J. Hague *Landseer and His World* Mappin Art Gallery, Sheffield, 1972 (65)

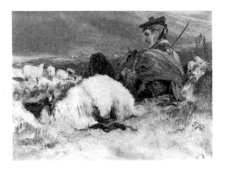

*Sketch in the Highlands*   F18

## The Stone Breaker and His Daughter
508-1882   Neg 76816
Panel, 45.7 × 58.4 cm (18 × 23 ins)
Jones Bequest 1882

Exhibited at the BI in 1830, the work was described by the critic of the *Examiner*:

> The scene appears to be in Scotland; an old man, seated by the roadside, is cracking stones with a hammer, while an innocent-looking and handsome young girl, with an expression of commiseration, is gazing upon the aged and weather-beaten labourer. The dog at her foot, the pieces of cracked granite, and various other objects, are inimitably painted.

*The Stone Breaker and his Daughter*
508-1882

The subject of the stone breaker and his menial and most poorly-paid job seems to have been a new subject for painters; Ormond notes that Landseer's early treatment of the subject 'evidence his originality in choice and treatment of subject matter'. As Lambourne points out, the road and rail systems in England and Scotland had been transformed by Thomas Telford and John L Macadam (see T Coleman *The Railway Navvies* 1967). Lambourne and Ormond also refer to later representations of the subject by Henry Wallis (exh RA 1858, now Birmingham Museum and Art Gallery) and John Brett (1857, now Walker Art Gallery, Liverpool), and – most famously – Gustave Courbet's 'Stone-breakers' (1851, Gemaldegalerie, Dresden, destroyed by enemy action 1945; repr by Lambourne fig 5).

The *Examiner* critic in 1830, and Ormond some 150 years later, refer to the stonebreaker as an old man; Ormond identified the young girl as the grand-daughter of the workman. It seems more likely that the stone breaker is depicted as older than his years, due to the arduous nature of his work.

Prov:   Probably commissioned by William Wells, his sale, Christie's 27 April 1860 (12), bought the dealer Wallis £1144, presumably for John Jones; bequeathed by John Jones to the museum 1882.

Exh:   BI 1830 (53); *Works of the late Sir Edwin Landseer* RA 1874 (447); Tate 1982 (33)

Engr:   John Burnet 1844; F G Stevenson 1888, as pl 84 of *Works of Sir Edwin Landseer RA* (first series 1881–93)

Lit:   *Examiner* 1830, p83; *Athenaeum* 6 February 1830, p76; *Art Union* 1844, p42; *Stephens* p73; *Graves* no 158; *Mann* II, pp103–4 (repr); E B Chancellor *Walks Among London's Pictures* 1910, p243; *Lennie* p63; L Lambourne *Sir Edwin Landseer's The Stonebreaker and His Daughter* (V&A Masterpieces no 17) 1978; *Ormond* p76

*Lady Blessington's Dog – The Barrier*
535-1882

**Lady Blessington's Dog – The Barrier**
535-1882   Neg GG4935
Panel, 29.2 × 38.1 cm (11½ × 15 ins)
Signed and dated 'EL 1832' towards br
Jones Bequest 1882

Exhibited at the BI in 1833, with the following lines from Shakespeare's *Macbeth* act 1 scene 7: 'Letting "I dare not" wait upon "I would"/Like the poor cat I' the adage'. The dog, preventing the mother cat from reaching her kitten, was given to Lady Blessington by the King of Naples and also appears in 'Waiting for the Countess' (1833). Like several of Landseer's works, the present painting combines an animal portrait with a genre scene.

PROV:   Hon Edmund Phipps; his sale, Christie's 25 June 1859 (95, as 'Count D'Orsay's Dog, lying at the foot of a staircase; a cat and kitten near him. Beautifully finished. Signed.') bought Pool, presumably for John Jones, £530 5s; bequeathed by him to the museum 1882

EXH:   BI 1833 (18); *The Works of the Late Sir Edwin Landseer RA* RA 1874 (406, as 'A Dog', lent by Jones)

LIT:   *Graves* (unnumbered, but listed under the year 1833 and titled 'The Barrier'); E B Chancellor *Walks Among London's Pictures* 1910, p243

**Lion – A Newfoundland Dog**
852-1894
Canvas, 149.8 × 195.6 cm (59 × 77 ins)
Bequeathed by Mrs Ann de Merle 1894

According to Graves, Landseer painted the present work in 1824 for the dog's owner, W H de Merle, for £50. The artist delayed painting the background until after his visit to Scotland in the autumn of 1824 (see C R Leslie *Autobiographical Recollections* 1860, I, p83). Graves also states that the picture was 'sent to Paris in a large case at the time of the breaking out of the Revolution [1830 or 1848?] and narrowly escaped being used for a barricade'.

The shaggy coat of the Newfoundland was a texture particularly suited to Landseer's technique of painting, and it is interesting to compare the present work with his two most famous pictures of the same breed – 'A Distinguished Member of the Royal Humane Society' (RA 1838, now Tate Gallery) and 'Saved!' (RA 1856). For a sculptural treatment of a Newfoundland see M D Wyatt's 'Bashaw, the Faithful Friend of Man Trampling Underfoot His most Insidious Enemy' (also in the V&A collections); Landseer had painted the same dog, 'Bashaw, the Property of the Right Honourable Earl of Dudley' (1827, now private collection). Graves lists a study called 'Lion' under the year 1822, in the studio sale at Christie's 8 May 1874 (127, bought Cox £661 10s). However the sale catalogue titled the work 'A Lion', so – if the catalogue is correct – the work is not related to the present painting.

EXH:   *The Works of the Late Sir Edwin Landseer RA* RA 1874 (251, as 'never before exhibited').

ENGR:   Charles G Lewis 1856; A C Alais 1887, as pl 69 of *Works of Sir Edwin Landseer RA* (second series)

LIT:   Mann IV, p45 (repr photograph of Lewis engr); Graves no 80; J Manson *Sir Edwin Landseer* 1902, pp53–4

**Study of a Frog**
P25-1962
Paper, 10.2 × 13 cm (4 × 5⅛ ins)
Bequeathed by C D Rotch 1962

A striking example of the artist's direct studies from nature. A label on the back states: 'This study in oils was formerly in the possession of a member of the Layard family'.

PROV:   Studio sale, Christie's 9 May 1874 (245, 'A Frog: and a Study of Leaves'), bought Agnew £22 1s; Lord Cheylesmore, his sale, Christie's 7 May 1892 (34), bought Vokins £10 10s; Colnaghi's; Dr Jardine

EXH:   *Sir Edwin Landseer RA* 1961 (105) repr in cat; *Landseer and His World* Mappin Art Gallery, Sheffield, 1972 (50)

**SHAKESPEARE'S HOUSE,
STRATFORD-UPON-AVON,
see Henry Wallis, p292**

# LANE, Samuel (1780-1859)

Born King's Lynn, Suffolk, 26 July 1780. Deaf and partially dumb from a childhood accident. Pupil of Joseph Farington, who mentions him several times in his famous *Diary*, then Sir Thomas Lawrence, whose studio assistant he became. Successful portrait painting practice, with several distinguished sitters; some portraits were engraved. Exhibited 217 portraits at the RA between 1804 and 1857, one at the BI 1819, and four at the SBA 1832. Moved to Ipswich, Suffolk, 1853, where he died 29 July 1859.

**Captain H B Murray, as a Youth**
P4-1911   Neg 35313
Canvas, 34.8 × 29.5 cm (13¾ × 11⅝ ins)
Presented by Colonel Sir Wyndham and Lady Murray 1911

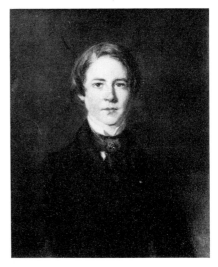

*Captain H B Murray, as a Youth   P4-1911*

The donor was the brother of the sitter. According to a label on the frame, the sitter was aged 17 and his dates are given as 1843–1910; if the attribution to Lane is correct (and there is no reason to doubt it), this information must be slightly inaccurate, as Lane died in 1859. Captain Henry Boyles Murray bequeathed his collection, notably porcelain and metalwork (and including a landscape by Jan van Goyen, P40–1910), to the museum in 1910, together with the sum of £50,000 for future acquisitions.
    Lane exhibited a portrait of the Rev Thomas Boyles Murray (1798–1860) at the RA in 1852 (546); the present portrait is presumably of one of his three sons.

PROV:   Presumably bequeathed by the sitter on his death in 1910 to his brother, the donor

EXH:   *Samuel Lane Centenary Exhibition* King's Lynn Town Hall 1959

# LEAR, Edward (1812–1888)

Born Highgate, London, 12 May 1812. His career has three distinct aspects: ornithological illustration, landscape painting and writing (especially in the near and middle East), and the nonsense writings and drawings for children that brought him fame. Draughtsman at the Zoological Gardens 1831, publishing 'Illustrations of the Family of the Psittacidae' (1832); later assisted John Gould with illustrations for 'Birds of Europe' and other publications. Published his most famous work *The Book of Nonsense* (1846). Exhibited 19 works at the RA between 1850 and 1873, five at the BI 1852–63, and four, including two watercolours, at the SBA 1836–55. A prolific artist in pencil and watercolour (there are examples also in the V&A collections), his oil paintings seem to date mainly from the 1850s. Gave drawing lessons to Queen Victoria, and travelled extensively. Died San Remo, Italy, 29 January 1888.

LIT: P Hofer *Edward Lear as a Landscape Draughtsman* 1967; V Noakes *Edward Lear: the Life of a Wanderer* 1968; V Noakes *Edward Lear* RA exhibition catalogue 1985 (with full bibliography); E Lear, ed P Sherrard, *The Corfu Years* 1988

## Corfu

P19-1946   Neg E953
Paper, 24.7 × 34.8 cm (9¾ × 13¾ ins)
Given by Howard Bliss (through the National Art Collections Fund)

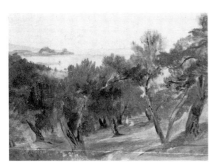

*Corfu*   P19-1946

A letter from the artist 19 February 1856 (published in Lady Strachey *Letters of Edward Lear* . . . 1907, pp32–5; quoted in L Durrell *Lear's Corfu* 1965, p9) records 'I still think of making Corfu my head-quarters, and of painting a large picture here of the Ascension festa in June, for 1857 Exhibition . . .' Corfu was one of Lear's favourite places and inspired several of his finest works; he stayed there regularly from at least 1855 to 1863. Lear wrote in a letter 8 June 1863 'The farther I go from Corfu – the more I look back to the delight its beautiful quiet has so long given me, and I am by no means approaching the filth and horror and noise of London life with a becoming spirit'.

The view in the present work is from above the village of Ascension, looking down to the twin-peaked citadel on the peninsular on the east coast of the island, across the Ionian sea to the distant mountains of Albania. The view may be compared with those lithographed as plates 1 and 3 in Lear's 'Views in the Seven Ionian Islands . . .' (1863), and with the undated oil now in a private collection (repr V Noakes *Edward Lear* 1968, pp136–7). P Hofer (*Edward Lear as a Landscape Draughtsman* 1968, pp49–50) refers to Lear's 1877 list of paintings and notes 11 of this view of Corfu; he reproduces an oil of about 1858 in upright format, two pencil drawings, and a finished watercolour of 1862 (plates 107, 108a and b, 61). A watercolour of a similar view, signed and dated 1856, was exhibited by Spink in 1988; the catalogue quotes a letter of 24 February 1856:

> Yesterday afternoon I walked to find a place called Viro, whence I hear that there were good views of Corfu; & I really think I saw the loveliest of anything one has yet discovered. You see the whole coast and channel, the Citadel, town & lake – immediately above a thick wood of orange trees: – I never saw anything more exquisite, with the millions of oranges glittering in the sun. Won't I paint a large picture from there some day.

The 'large picture' was intended for the 1857 RA exhibition, and was completed and sold in early August 1857.

*View Across Sandown Bay, Isle of Wight*    Richard Burchett (1815–1875)

*Rustic Civility*    William Collins (1788–1847)

*Scene from 'A Sentimental Journey'*    William Powell Frith
(1819–1909)

*The Lake of Lucerne: Mont Pilatus in the Distance*
John William Inchbold (1830–1888)

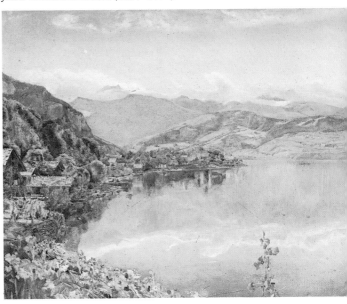

*The Drover's Departure – A Scene in the Grampians*    Sir Edwin Landseer (1803–1873)

*Autolycus*   Charles Robert Leslie (1794–1859)

*Another Bite*   George Smith (1829–1901)

*A Dutch Dogger Carrying Away Her Sprit (On the Dogger Bank)*   Clarkson Stanfield (1793–1867)

*An Italian Mother Teaching her Child the Tarantella*   Thomas Uwins (1782–1857)

*Venice*   J M W Turner (1775–1851)

*Charles II and Nell Gwyn*   Edward Matthew Ward
(1816–1879)

*The Good Harvest of 1854*   Charles Allston Collins
(1828–1873)

*A Village Choir*   Thomas Webster (1800–1886)

*Palpitation*   Charles West Cope (1811–1890)

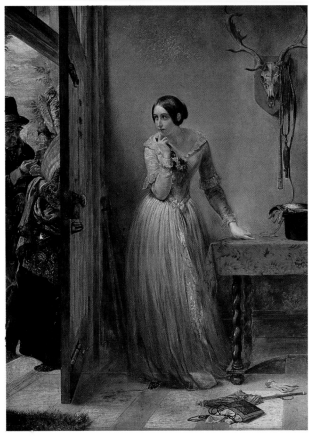

*Children Playing at Doctors*   Frederick Daniel Hardy (1826–1911)

*Land's End, Cornwall*   Thomas Creswick (1811–1869)

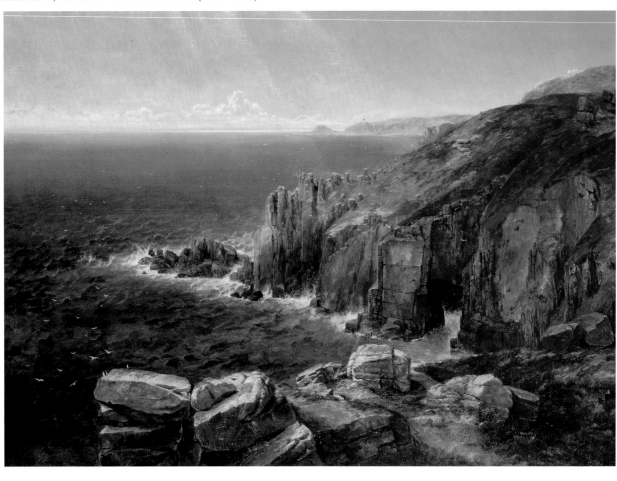

*The Wild Flower Gatherers*   John Linnell (1792–1882)

*The Sonnet*   William Mulready (1786–1863)

*The Sisters*   Margaret Carpenter (1793–1872)

*Young Roebuck and Rough Hounds*  Sir Edwin Landseer
(1803–1873)

*Sancho Panza Tells a Tale to the Duke and
Duchess*  William Powell Frith (1819–1909)

*The Upas, or Poison-Tree, in the Island of Java*  Francis Danby (1793–1861)

# LEE, Frederick Richard, RA (1798/?9–1879)

Born Barnstaple, Devon, 1798 or 1799. Served in the army, retired because
of ill-health, and entered RA Schools 1818. Exhibited 171 landscapes at the
RA between 1824 and 1870, 131 at the BI 1822–55, and 24 at the SBA
1825–37. Subjects mainly views in Devon, but also elsewhere in England,
Wales and Scotland; visited, in his yacht, France, Spain and Italy. From
1847 he collaborated regularly with the animal painter T S Cooper and
sometimes with Sir Edwin Landseer. Elected ARA 1834, RA 1838.
According to Cooper, he saw painting 'more of a pastime than as a business,
and he always gave me the impression that he considered the profession
beneath him'. Retired from the RA 1871, and died at Vleeson Bank, South
Africa, 5 June 1879.

Lit: *Athenaeum* 12 July 1879, p58 (obit); *Art Journal* 1879, p184 (obit); T S
Cooper *My Life* 1890, I, pp325–30

## Near Redleaf, Kent
FA106
Panel, 21.6 × 29.2 cm (8½ × 11½ ins)
Sheepshanks Gift 1857

The collector William Wells of Redleaf was a patron of Lee. Lee painted
several views of and around Redleaf, which is near Penshurst, Kent; most
date from the years around 1830, such as 'A Scene near the Source of the
Medway' exhibited at the SBA in 1829 (380), and 'Redleaf, Kent' at the BI
in 1827 (134, size including frame given in the catalogue as 39 by 48 inches).
In 1840 he exhibited 'River Scene in the Meadows, Redleaf, Kent' at the BI
(163, size given as 27 by 29 inches); the subject, if not the size, seems to
correspond with that of the present work.

It is described in the *MS Register* as 'a sketch from nature on the Med.',
and Richard Redgrave added 'An autumn study of oaks and alders on the
banks of the Medway'.

## Gathering Seaweed
FA107   Neg GA1192
Canvas, 76.1 × 91.4 cm (30 × 36 ins)
Signed and dated
Sheepshanks Gift 1857

Exhibited at the RA in 1836. The *Athenaeum* critic commented: 'The first
two pictures, which struck us on entering the Great Room, though both
landscapes, could not be more strongly contrasted, unless we could find a
pencil more literally true than that of Mr Lee's, or one more rich, sparkling,
and *peculiar* than that of Mr Constable's'. The Constable painting was 'The
Cenotaph' (NG). According to the *MS Register*, the scene is probably on the
Lincolnshire coast.

Exh:   RA 1836 (8)

Lit:   *Athenaeum* 7 May 1836, pp330–1

## A Distant View of Windsor from St George's Hill
FA108   Neg GA1193
Millboard, 25 × 35.2 cm (9⅞ × 13⅞ ins)
Sheepshanks Gift 1857

A label on the back is inscribed in the artist's hand 'No 6/View of Windsor
Castle from St George's Hill/F R Lee RA/16 Norton Street Portland Place'.
Lee was elected RA in 1838, and submitted paintings from that address
between 1824 and 1841. Lee exhibited a large (53 by 77 inches, including
frame) painting of the same subject at the BI in 1840 (149).

*Gathering Seaweed*   FA107

*A Distant View of Windsor from St George's Hill*   FA108

*Wooded Glen   1827-1888*

**Wooded Glen**
1827-1888   Neg 34013
Canvas, 74.8 × 105.3 cm (29½ × 41½ ins)
Signed and dated 'F R Lee RA/T S Cooper ARA 1860' bl
Given by Mrs Charles Rivas 1888

The cattle, and presumably the sheep, were painted by Cooper. The two artists regularly collaborated from 1847; according to Cooper, 'We settled that he should paint the landscape part first, and send the picture up to me in an advanced state, the part where I was to introduce the cattle being only just coloured over (p329)'. The painting does not seem to have been exhibited.

## LESLIE, Charles Robert, RA (1794–1859)

Born London 19 October 1794, eldest son of American parents, with whom he went to Philadelphia 1799. Apprenticed to a publisher 1808, received a few lessons in painting from Thomas Sully. A subscription was raised to enable him to study art in Europe; returned to London 1811, entered RA Schools and studied with Benjamin West and Washington Allston. Visited Paris 1817 with Allston and Wilkie Collins, met G S Newton, with whom he visited Brussels and Antwerp. Also friend and biographer (published 1843) of John Constable. Exhibited 76 works at the RA between 1813 and 1859, and 11 at the BI 1815–32. Some were portraits, but most were his much admired literary subjects, particularly drawn from Cervantes, Molière, Shakespeare and Sterne. Elected ARA 1821, RA 1826. Several of his works were engraved, and he made six illustrations for Sir Walter Scott's Waverley novels 1824. Worked for six months as drawing master at West Point Military Academy, New York State, 1833. Professor of Painting at RA 1848–52; his lectures were published as a *Handbook for Young Painters* (1855). His *Life of Reynolds* was finished by Tom Taylor and published 1865. Died St John's Wood, London, 5 May 1859. An exhibition at the RA of 30 of his works was held winter 1870. His two sons, George Dunlop and Robert, were also artists. The *Athenaeum* critic (9 May 1846, p480) wrote that he was 'unrivalled for the certainty of his powers, the *wit* of his pencil, the deep knowledge of human nature as exhibited in the more ordinary scenes of life'.

LIT:    *Art Journal* 1856, pp73–5 and 105–7, 1859, p187 (obit); C R Leslie
        *Autobiographical Recollections* ed T Taylor, 2 vols, 1860; J Dafforne
        *Pictures by C R Leslie* nd [1875]; *Art Journal* 1902, pp144–8; J Constable
        *The Letters of John Constable and C R Leslie* 1931; ed R B Beckett *John
        Constable's Correspondence* III, Ipswich 1965

**Scene from 'The Taming of the Shrew'**
FA109   Neg 53026
Canvas, 52.1 × 71 cm (20½ × 28 ins)
Sheepshanks Gift 1857

A version of the picture painted for the Earl of Egremont, which was probably the work exhibited at the RA (in the Great Room) in 1832 (140)
    The RA catalogue quoted the following lines from act 4 scene 3 of Shakespeare's play:

*Petruchio:*   Brav'd in mine own house with a skein of thread!
              Away thou rag, thou quantity, thou remnant;
              Or I shall so be-mete thee with thy yard,
              As thou shalt think on prating whilst thou liv'st!
              I tell thee, I, that thou hast marred her gown.

*Scene from 'The Taming of the
Shrew'*   FA109

| | |
|---|---|
| *Taylor:* | Your worship is deceiv'd; the gown is made |
| | Just as my master had direction. |
| *Grumio:* | I gave him no order, I gave [him] the stuff. |

Tom Taylor wrote in his introduction to *Leslie*:

> After the 'Sancho', the most interesting picture at Petworth is the
> 'Catherine and Petruchio'. This is the first version of the subject, of
> which the Sheepshanks picture is a repetition with variations. For
> example, the remains of the meal on the table to the right of the
> spectator are quite different in the two, though touched in both with a
> precision worthy of Teniers. In this case also the colour of the Petworth
> picture is superior in glow and power, and I did not detect in it any sign
> of cracking. In their disposition of colours, the two pictures are very
> much alike; but we have only to compare the satin gown, which is the
> object of Petruchio's rage, in the one and in the other, to recognise how
> much more powerful Leslie was in his management of colour in 1832,
> than at the later date of the Sheepshanks picture.

The Egremont painting was much admired by the critics, both at the RA and
afterwards. The *Athenaeum* thought 'Nothing can be finer than the made-up
look which she has of resistence, and the havoc which her teeth are making
of her necklace, of which she seems quite unconscious'. The critic also
discussed Leslie's accurate interpretation of the character of Katharine. The
*Examiner* described the subject at some length, concluding that 'the picture
confers credit on the hand which produced that charming and perhaps
faultless production, the 'Duchess and Sancho' (presumably the work also
painted for the Earl of Egremont and exhibited at the RA in 1824). The
*Gentleman's Magazine* thought the composition 'full of force and feeling . . .
replete with interest, and the accompaniments felicitously introduced'.
Later, in 1856, the *Art Journal* wrote that the artist 'represents the incident of
the play in a perfectly truthful yet original manner; the attitude and
expression of each figure are really dramatic, yet not overstrained; this close
quality of adherence to nature is one of the great charms of Mr Leslie's
illustrations to Shakespeare'. In a review of the Sheepshanks Collection the
following year, the *Art Journal* believed the present work 'a sufficient basis for
a reputation'.

Taylor mentions (*Leslie* II, p212) that the Egremont painting was
engraved (see *Engr:* below); the *Athenaeum* (30 June 1838, p461) particularly
took 'infinite delight' in the print's 'so excellent an embodiment of that
empress of shrews'. The figures were identified for the print as (from left to
right) Katharine, Hortensio, Petruchio, Grumio, and the tailor's and
haberdasher's assistants (the latter presumably because of their youth). Taylor
also notes another, small, repetition of the subject painted for Joseph Birt.
According to Odette Aubrat (*La Peinture de Genre en Angleterre* Paris nd
[1934], p121), the painter David Wilkie posed for the figure of the tailor
(second from the right); while there is a facial resemblance to Wilkie in his
youth, he would have been 47 in 1832, the year the picture was painted.

EXH: *Exposition Universelle* Paris 1855 (868, lent by Sheepshanks)

ENGR: (Petworth picture) Charles Rolls 1838, for *Finden's Royal Gallery of British Art* (impr in V&A, E133–1971)

LIT: *Athenaeum* 26 May 1832, p340; *Examiner* 1832, p358; *Gentleman's Magazine* 102 pt 2, 1832, p540; G Waagen *Treasures of Art in Great Britain* II, p300; *Art Journal* 1856, p74, 1857, p240; *Leslie* 1, pxxxiii, II, p212–4

REPR: T H Ward *English Art in the Public Galleries of London* 1888, II, facing p138; W Armstrong *Art in Great Britain and Ireland* 1909, p222

*The Principal Characters in 'The Merry Wives of Windsor* FA110

**The Principal Characters in 'The Merry Wives of Windsor'**
FA110    Neg GA1203
Canvas, 93.3 × 133.2 cm (36¾ × 52½ ins)
Sheepshanks Gift 1857

According to Tom Taylor (*Leslie* II, p243), painted for John Sheepshanks, and a version of the picture exhibitd at the RA in 1831 (113); it was exhibited at the RA in 1838. The full title given in the 1838 RA catalogue was 'The Principal Characters in the "Merry Wives of Windsor" assembled at the house of Mr Page (a scene not in the play, but supposed to take place in the first act) – "There's pippins and cheese to come" – Sir Hugh Evans'. The line quoted is the last of the very short act 1 scene 2 of Shakespeare's play. Again according to Taylor (*Leslie* I, ppxlv–xlvi):

> This play, for reasons one can easily understand, was a special favourite with Leslie. Its life-like, genial pictures of English country manners in the days of Elizabeth, and its copious introduction of marked types of humorous character, gratified the painter's peculiar tastes, and suggested capital subjects for his pencil. The play is eminently English in feeling, and Leslie was "ipsis Anglis Anglior". He loved and knew the quiet meadows and shady elms of Windsor . . . I have no doubt he believed, with perfect faith, in the inmates and visitors at Ford's and Page's. They were to him actual men and women, and not clothes-pegs.

Taylor adds that Leslie painted the scene of Slender's courtship of Anne Page three times (there is a sketch in the Tate Gallery), as well as the subject of Anne inviting Slender in to dinner, exhibited at the RA in 1825 (now Yale Center for British Art, New Haven, USA).

The present work has 13 figures (the 1831 painting had 15); they are, from left to right: Mrs Ford, Mrs Page, Bardolph, Sir John Falstaff, ?Nym, Pistol, Ford, Sir Hugh Evans, Justice Shallow, Page, Anne Page, Slender, and Simple. Several contemporary critics, and later Taylor, described in detail the relationship between the characters.

Perhaps particularly in this picture, Leslie's attention to detail anticipates that of the Pre-Raphaelites in the late 1840s and 1850s. This attention was noticed by contemporary and later critics. Leslie shows, for example, the 'pippins and cheese to come' on the side-table in the right foreground, described by Taylor (*Leslie* I pxlviii) as 'painted with that truth and relish which Leslie always puts into the accessories of his pictures, but not so daguerreotypically wrought as to divide and distract attention from more important matters'. Taylor also notes that 'The picture is a fine example of the painter's middle manner, without any dangerous use of asphaltum (of which the visitor [to the South Kensington Museum] may see the charm and danger exemplified in Newton's "Bassanio" [see FA166, p215] in the same room, and equally free from such excess of chalky-white as is apparent in the "Who can this be?" [see FA111, p159] just over it'. Taylor, however, preferred the image of Falstaff in Leslie's painting of 1851 (presumably 'Falstaff Personating the King . . .'), although 'it is surpassed in technical qualities by the Sheepshanks picture', that is, the present work.

Of the first, 1831, version of the subject, the *Gentleman's Magazine* (1831, pp447–8) thought: 'It is beyond question one of the most perfect illustrations of the subject that has ever been produced . . . painted with an accuracy and effect quite of the highest order. The picture is very properly placed [at the RA] in the most conspicuous and favourable situation in the room'. The *Athenaeum* thought the present work 'wanting that clearness and intelligibility, which – prosaic qualities though they be – are essential to the perfection of every work of art, even though it belong to the high fantastic school'. While the critic admired the figures of Falstaff and Mistresses Page and Ford ('more happily rendered than is customary, simply because Mr Leslie has read his author aright'), he disliked the artist's depiction of Anne and Slender, and found the other characters 'less happily designed'. He

concluded with the comment that the picture 'is, as usual, somewhat crude in its colouring, with a tendency to earthy redness in the flesh tints'.

Later, the *Art Journal* critic in 1856 found 'great solidity and firmness of drawing, and with a powerful general effect arising from the skilful management of the two principal colours, black and red', but in 1857 thought the work 'impatiently studied, and this for such a theme were at once perdition', and in 1868, in a description accompanying the engraving of the picture (see *Engr* below), admired the figures and stated that the present work 'is said to be superior in colour to the first Leslie painted . . . the Sheepshanks picture is certainly almost as fresh, we should imagine, as when it came from the artist's easel'.

According to S Redgrave (A *Dictionary of the English School* 1878, p442), the artist Benjamin West's grand-daughter sat for the figure of Anne Page; however, F M Redgrave (*Memoir* p170) states that Lady Fanny Cowper was the model.

EXH:  RA 1838 (185)

ENGR:  W Greatbach, for *Art Journal* 1868, facing p84, J Dafforne *Leslie and Maclise* 1871, facing p33, Dafforne facing p37

LIT:  (1831 picture), *Examiner* 1831, p309; *Athenaeum* 1838; G Waagen *Treasures of Art in Great Britain* II, p301; *Art Journal* 1856, p74, 1857, p240; 1868, p84; J Dafforne pp73–4; *L'Artiste* XX, 1884, pp255–6; F M Redgrave *Memoir . . .* 1891, p170; E B Chancellor *Walks Among London's Pictures* 1910, p262

## 'Who Can This Be?'
FA111   Neg 55168
Canvas, 58.3 × 73.6 cm (23 × 29 ins)
Sheepshanks Gift 1857

'Who Can This Be?'   FA111

Exhibited at the RA in 1839, a pendant to 'Whom Can This Be From?' (see FA112 p158), and according to Taylor (*Leslie* II, p251) painted for John Sheepshanks.

The critic of the *Examiner* thought it:

A very clever painting, which abounds in this artist's best qualities, and exhibits in a less than usual degree his defects. It represents a gay, audacious, and evidently unknown gallant, accosting a burly middle-aged man, on whose arm leans a young maiden. For the sake of which of the twain this unceremonious attempt at the establishment of an acquaintance is made, the spectator cannot doubt. The perplexed, earnest, more than half suspicious stare of the keen, glistening, almost fierce black eyes of the protector of the damsel; the hesitating, startled manner of his return to the profound salutation of the stranger; and his general expression and attitude of blended composure and effort at self-possession, are exceedingly whimsical and effectively delineated. The youth and the maiden are also very cleverly represented; but, of course, are not susceptible of an equal degree of comic character. The taint of Mr Leslie's usual style of colouring is this picture's sole defect; but fortunately, is not sufficiently prominent to be productive of any material injury to it.

But the *Athenaeum* seems to have disliked both the subject and the treatment:

Mr Leslie has four cabinet pictures in the great room. Two of these [that is, the present work, and 'Whom Can This Be From?', FA112, p160] belong to the class of pretty insipidities, being devoted to love passages slily maintained between gentlemen and ladies, tricked out in stage magnificence, neither party the least in earnest, or in the least resembling personages of any age, court, or country whatsoever. We

might lament as we asked, where is Mr Leslie's racy humour? where his feeling for the beauty of youth, and health, and cheerfulness? . . . we are sorry to observe, that Mr Leslie's scarlet fancy in flesh-colouring is rather on the increase: let him carry it a little further, and the critic must needs talk of the geraniums, not the roses, on the cheeks of his maidens.

The *Art Union* also criticised the colouring, but praised the artist's patron:

> A work of the highest merit in design; if he could colour as he conceives, he would be unrivalled in his age. A fair young dame of the olden time is leaning on the arm of an 'approved good senior', to whom a gallant approaches and bows low. That he is the admirer, perchance the lover, of the gentle maiden, who can doubt? This picture and its 'companion' are the property of a gentleman – at once liberal and unobtrusive – who, in a quiet nook at Blackheath, has collected some of the rarest treasures of British art, and who has done more, in his own gentle and generous manner, to advance its true interest than half the magnates of the land; a gentleman whose name every lover of art, except himself, delights to hear mentioned, and whose retiring habits unfortunately prevent the advantages that might arise from the influence of his example. These pictures of Leslie are worthy to be added to the choicest, if not the most extensive, collection in the kingdom. The artists labour for him *con amore*; so highly is he esteemed, that he is sure to possess their best works.

For a fuller discussion of the subject of the work, see FA112, below

Exh: RA 1839 (57); *Victorian Narrative Paintings* V&A circulating exhibition 1961

Lit: *Athenaeum* 25 May 1839, p396; *Examiner* 1839, p359; *Art Union* 1839, p67, 1856, p74; *Leslie* I, plxxiv, II, p251

Repr: M H Bulley *Art and Counterfeit* 1925, fig 169

*'Whom Can This be From?'* FA112

### 'Whom Can This be From?'
FA112    Neg 64831
Canvas, 58.3 × 73.6 cm (23 × 29 ins)
Sheepshanks Gift 1857

Exhibited at the RA in 1839, a pendant to 'Who Can This Be?' (see FA111, above), and according to Taylor (*Leslie* II, p251) painted also for John Sheepshanks.

The *Examiner* saw it as a 'a lady eyeing a letter which is presented to her by an attendant, who is humorously and pleasingly conceived. Both, however, in comedy and character, this picture is very inferior to the other' (that is, 'Who Can This Be?'). The *Art Union* thought it 'a most delightful work, although somewhat cold and "chalky": a defect which is the more apparent because it is placed near paintings of very brilliant colour . . . The contrast between the aristocratic lady and the homely serving wench, who conveys the epistle, is capitally given'. The *Athenaeum* critic's comments are given under FA111 above.

The two paintings, exactly the same size, are clearly intended to give two episodes of a narrative, and their titles are equally provocative. The story seems to be set in the later 17th century, a period considered in early Victorian years as one of especial debaucherie. The costumes date from the 1670s and 1680s, and the coiffure of the lady is similar to those in portraits by Sir Peter Lely, although the ringlets, if not the curled fringe, were experiencing a revival in late 1830s fashion. The image of the lady receiving a letter (presumably from the young lover seen in the first picture) delivered by her servant was especially popular in 17th-century Dutch painting; the presence of the pet dog in the first episode, and the portrait of the husband (presumably) on the wall in the second, also perhaps relate to the use of such symbolism in Dutch art.

It is interesting to note the similarity of the entrance of the servant with that in the portrait of Sheepshanks himself by William Mulready (see FA142 p202). Furthermore the *Athenaeum* in 1862 criticised a slight change in the painting's title, made by the Museum and since reversed:

> 'Accusative' wishes to show cause, in this our Court of Criticism, why the authorities of the South Kensington Museum should be called upon to change the title of Leslie's charming little picture . . . A young lady is receiving a letter from a servant, and appears to be in doubt as to the sender. 'Who can it be from?' Now, Mr Accusative would ask the authorities why a preposition, which governs the objective case elsewhere, should have no power in Brompton? The fair creature is neither a housemaid nor a fishwife, but a young and elegant lady. Mrs Squeers [that is, the appalling headmaster's wife in Charles Dickens' *Nicholas Nickleby*] might very properly ask a question in such terms. But that bright young creature of Leslie's imagination – surely she never made a blunder which would have delighted Mistress Squeers?

EXH:    RA 1839 (82); *Victorian Narrative Painting* V&A Circulating exhibition 1961

LIT:    as for 'Who Can This Be?', FA111, p159

REPR:   T H Ward *English Art in the Public Galleries of London* II, 1888, facing p139

## My Uncle Toby and the Widow Wadman
FA113   Neg 51948
Canvas, 82.5 × 57.1 cm (32½ × 22½ ins)
Sheepshanks Gift 1857

One of the artist's most celebrated and popular paintings, Taylor (*Leslie* II, p212) records three versions of the composition: the first, the present work, painted for John Sheepshanks, and replicas for Robert Vernon, and then, in 1842, for Jacob Bell. In 1860 all three were in the National Collection at South Kensington; the later two are now in the Tate Gallery. There are differences in detail; the most notable difference in composition is that in the Vernon picture the map of Dunkirk on the wall is lowered behind the two heads. Either the present work or the Vernon painting was exhibited at the RA in 1831, although the 1907 catalogue for some reason dates the present work to 1832. Taylor (*Leslie* II, p207) records Leslie working on the present picture in 1830, and the existence of an earlier watercolour (see below) indicates work in the later 1820s.

The title given in the RA catalogue was 'A Scene from Tristam [*sic*] Shandy' with the following quotation:

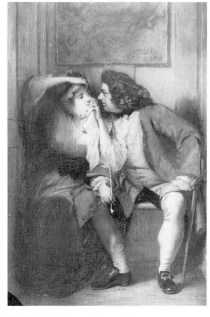

*My Uncle Toby and the Widow Wadman* FA113

> 'I protest, Madam,' said my uncle Toby, 'I can see nothing whatever in your eye'.
> 'It is not in the white,' said Mrs Wadman. My uncle Toby looked with might and main into the pupil.

The lines are from Laurence Sterne's novel *The Life and Opinions of Tristram Shandy, Gentleman* first published 1760–9; the last volume mainly deals with the courtship of Toby and the widow. It was one of Taylor's favourite books.

The *Athenaeum* found the work 'a delightful scene indeed . . . the colouring is extremely good'. In 1834, *Arnold's Magazine of the Fine Arts* noted:

> Exquisite drawing, fine perception of female beauty, and quaint and quiet humour . . . The unsophisticated simplicity of Uncle Toby, the earnestness of his gaze . . . and the [widow's] assumed innocence, and the fascinating *naïveté*, are most graphically portrayed, and may be considered as fully equalling the humour and richness of Sterne himself. It is altogether a faultless work, a real gem of Art, and for the

excellencies pointd out, cannot be equalled by any of the old masters. For it is questionable that if any one of the Flemish painters had treated of such a subject, but it would have been disfigured by some gross conceit or other; whereas such a blemish can never in the remotest degree be attached to any one work of Leslie's . . .

The *Art Journal* in 1856 found the widow in the present work 'more refined in character' than in the Vernon picture, and in 1857 in a review of the Sheepshanks collection thought the sentiment of the whole 'less refined, and partakes little of the playful and sparkling manner which prevails in later works'.

The *Art Journal* in 1869 recorded that the artist Charles Catton RA (1728–98) had given Leslie the idea for the subject through his illustrations to *Tristram Shandy*. Taylor records that the model for Uncle Toby was the actor John (Jack) Bannister (1760–1836), a friend of Leslie; he is described as 'remarkably handsome, even as an old man; his dark eyes, still full of animation', and 'one of the pleasantest of actors, most genial of companions and kindest of men . . . it would be hard to find a better model for him'. The resemblance is indubitable; compare for example the profile portrait by John Varley of about 1816, drawn with a graphic telescope (an early form of camera lucida), in the V&A collections. (For a full iconography of Bannister, see R Walker *Regency Portraits* 1985, I, pp21–3. Interestingly, Bannister had played a character called Uncle Toby in the play *The Devil in the Wine Cellar*.)

A watercolour version (26.7 × 19.1 cm/10½ × 7½ ins) was in the Haldimand collection, apparently formed between 1826 and 1828 (sold Christie's 21 June 1861 and 18 March 1980). A copy in a private collection is recorded in the Departmental files in 1922.

The widespread fame of Leslie's image is demonstrated by the fact that it was reproduced as a polychrome transfer print on the lid of pots of bear's grease manufactured by F & R Pault & Co Ltd.

EXH:    ?RA 1831 (238); *Exposition Universelle* Paris 1855 (869, lent by Sheepshanks)

ENGR:    M J Danforth 1833 as 'The Sentry Box' (impr in V&A collections); (the Vernon version) L Stocks (impr in British Museum)

LIT:    *Athenaeum* 21 May 1831, p331; *Arnold's Magazine of the Fine Arts* III, 1834, p546; *Art Journal* 1856, p74, 1857, p240; *Athenaeum* 1857, p857; *Leslie* I, pplviii–lx, II, pp207, 212; *Art Journal* 1869, p28; *A Gallery of British Art* 1873, p76 (repr); *L'Artiste* 1884 (xx), p260; *English Art in the Public Galleries of London* II, nd [1888], p140; A Dayot *La Peinture Anglaise* 1908, p109; F P Brown *London Paintings* 1933, p101 (repr as by Maclise); O Aubrat *La Peinture de Genre en Angleterre . . .* nd [1934], repr pl xviii

## Florizel and Perdita

FA114   Neg 74190
Canvas, 53.3 × 73.6 cm (21 × 29 ins)
Sheepshanks Gift 1857

Exhibited at the RA in 1837, and according to Taylor (*Leslie* II, p232), painted for John Sheepshanks. The title given in the RA catalogue was 'Perdita', with the following quotation appended:

> – Here's flowers for you;
> Hot lavender, mints, savory, marjoram;
> The marigold, that goes to bed with the sun,
> And with him rises weeping; these are flowers
> Of middle summer; and, I think, are given
> To men of middle age. You are very welcome.

*Florizel and Perdita*   FA114

The subject and the quotation are taken from Shakespeare's play *The Winter's Tale*, act 4 scene 3. In this famous scene, the shepherdess Perdita (really the daughter of Leontes, King of Sicilia) makes her first appearance as an adult; she is accompanied by Florizel (really the son of Polixines, King of Bohemia) and Dorcas, a shepherdness; on the right are the visitors (in disguise) King Polixines and Camillo, a Sicilian nobleman. Leslie does not include the shepherd, the clown, or Mopsa.

The *Athenaeum* critic thought:

> There is a grace and an artlessness, and an inborn nobility, lavished by Shakespeare upon Perdita and Florizel – an overlow of the loveliest, freshest poetry ever poured forth, in the love scenes, where the foundling dispenses her flowers at the shearing feast, and the prince *looks* yet more passion than he can speak – which must distance any painter. Mr Leslie has been happier in the youth than the maiden, and happier in the two disguised strangers, who are ready to drop the flowers she has given to them, in their surprise at discovering such rare beauty and grace clad in the weeds of a shepherdess.

The *Art Journal* twenty years later, while finding it 'one of the most graceful conceptions Leslie ever traced on canvas', believed that:

> Objection may probably be taken to the two more prominent figures in the composition, Perdita and Florizel, on the ground that the character assumed by each is scarcely sustained by their unequivocal high-born physiognomies and general appearance, and especially by the costume of the lady, which, though not of costly materials, certainly indicates a style altogether unusual among shepherdesses'.

In the 1857 review of the Sheepshanks collection in the same journal, the critic also found 'the costumes are rather scenic rather than true; in these it is felt that the painter had yielded rather to stage impressions than endeavoured to originate'.

Taylor was very enthusiastic about the picture: 'The painter has not fallen behind the exquisite sentiment of Shakespeare's scene . . . Perdita herself is one of the sweetest and most graceful creatures ever embodied on canvas; and the painter has never, as far as I know, exceeded this most graceful conception for loveliness and unaffected charm'. However, he adds: 'Exception may be taken to the colour and texture of the scarf over her shoulders, which looks more like oiled silk than any other material. Nor can I admire the disguised Polixenes and Camillo; nor does the Florizel seem to me worthy of such a Perdita'.

According to Taylor in 1860, a study for the work belonged to A J Heugh, and according to the artist J C Horsley's *Recollections* . . . (1903, p54), the figure of the Duke (presumably Camillo) was painted from John Constable; while he and Leslie were friends, the year of the picture, 1837, was the year of Constable's death, and the matter is not mentioned in Leslie's *Memoirs of the Life of John Constable*, or in any of their published correspondence. As Ashton points out, the figure of Dorcas had appeared in the companion picture of 1836, 'Autolycus' (see FA115 p164), 'the only character to appear in both paintings. Leslie has used the same model with the same costume and flowers in her hair, and in both pictures she drapes her hands in a rather self-conscious way'. The artist adapted the figure of Perdita for plate 21 of Charles Heath's 'The Shakespeare Gallery . . .' (1836–7).

Ashton also notes as a possible source for Leslie's work W H Worthington's version of the subject exhibited at the RA in 1831; he lists other later *Winter's Tale* subjects exhibited at the RA perhaps inspired by the success of the present painting.

Exh: RA 1837 (47); *Victorian Painting* Nottingham University Art Gallery 1959 (41); *Shakespeare in Pictures* Ulster Museum, Belfast, 1964 (26); *Shakespeare's Heroines* Buxton Museum and Art Gallery 1980 (17)

ENGR: Lumb Stocks for *Art Journal* 1857, facing p4; R Redgrave *The Sheepshanks Gallery* 1870; and Dafforne *Leslie and Maclise* 1871

LIT: *Athenaeum* 13 May 1837, pp346–7; *Art Journal* 1857, pp4, 240; *Leslie* I, ppli–liv, II, pp232–3, 321; R Redgrave *The Sheepshanks Gallery* 1870; *Dafforne* pp27–31; *L'Artiste* xx 1884, pp257–8; *Shakespeare's Heroes and Heroines* 1891; *The Studio* special spring number ('Shakespeare in Pictorial Art') 1916, p30; G Ashton *Shakespeare's Heroines* Buxton Museum and Art Gallery exhibition catalogue 1980, p38

*Autolycus* FA115

## Autolycus

FA115  Neg GK3334
Canvas, 53.3 × 73.6 cm (21 × 29 ins)
Sheepshanks Gift 1857

Exhibited at the RA in 1836, and commissioned by John Sheepshanks. According to Dafforne the work 'was sketched: and partly painted in 1823, but was not finished and exhibited till thirteen years afterwards: it ranks with the best of his works executed at that period of his career – from about 1833 to 1838'. The following quotation was appended to the title in the RA catalogue: 'Here's another ballad of a fish that appeared upon the coast on Wednesday, the fourscore of April, forty thousand fathom above water, and sung this ballad about the hard hearts of maids'.

The lines are from Shakespeare's *The Winter's Tale* act 4 scene 4, a little after the episode depicted in Leslie's companion work, 'Florizel and Perdita', exhibited the following year (see FA114 p162).

The *Gentleman's Magazine* recorded that 'It is some time since we have had any thing from the pencil of this academician to which we could award the same unqualified praise that we can to the present work. The noisy pedlar is rendered with great judgment and skill, and his auditory, though evidently astonished . . . are well grouped and free from exaggeration'. The *Athenaeum* critic was also admiring:

> After looking long for one of those conversation pieces in which Leslie illustrates so naturally and happily the classical authors of our own and stranger literatures, we found, at last, his *Autolycus*; on the whole, we are content with it. The knavish buxom pedlar, with his mouth wide open to give vent to the new 'ballad' . . . and his box of treasures, open enough to display 'the tawdry lace and the pair of sweet gloves', with the other delights and dainties counted up in his metrical catalogue, surrounded by a parcel of staring, simple rustics, (less of bumpkins, however, than the clodpoles of our own time and country), has been very cleverly hit off: perhaps Mr Leslie did not find it so easy to shadow forth the inimitable sweetness and simplicity of Perdita, as to display the more quaint and clownish personages of the play; for the King's daughter is not to be seen even at a distance.

This last remark may well have prompted Leslie to take up the challenge and paint the Perdita picture for the RA the following year.

Later criticism was more mixed: the *Art Journal* in 1856 found the work 'rather slight in treatment', and in 1857 'Autolycus' shared the same comments as those on 'Perdita'. In 1867, when an engraving appeared in the same journal, the accompanying text claims:

> Of its kind, this is one of the best pictures – considered with regard to its various qualities – that Leslie ever painted. There is a sunny, out-of-door life about it, which is very charming; a freshness of atmosphere, so to speak, that brightens and exhilarates the animate and inanimate world . . . no signs are here of the chalkiness to be found in so many of the artist's pictures, oftentimes contrasted with black or other heavy-coloured draperies.

In Taylor's introduction to *Leslie*, he 'should have been thankful for the absence of the vermilion cap which Autolycus wears; but to Leslie no picture was complete without its vermilion element, though I think, he has seldom managed it with the felicity which gives the colour such value in the De Hooghes and Terburgs, from whose practice he adopted it'. Taylor also refers to the fresh open-air quality of the work, and deals with the influence of John Constable, who was a friend of Leslie. In a letter to Leslie of 26 March 1836, Constable wrote: 'I send you a few "skies". I have looked for such as we most talked of that might suit your delightful picture – a picture full of elegance and *character*. Perhaps a mountain ash, among the shepherds, would be useful. I send a rough sketch of one I saw from a bed room where I slept – they are pretty with the berries'. This letter is quoted by Graham Reynolds, who comments that:

> It is not clear whether the rough sketch of the tree was in oils or a drawing, though the reference to berries suggests that it was in colour. Leslie adopted Constable's suggestion and introduced a mountain ash in the right of his picture. It has not so far been possible to identify the sky study on which Leslie may have based this part of his painting. Constable's help towards the completion of Leslie's picture came at about the time that Leslie was giving him acceptable advice about the handling of the inscription on 'The Cenotaph' (*The Later Paintings and Drawings of John Constable* 1984, I, p289, under catalogue no 36.11).

George Gray exhibited a copy of the work in enamels at the RA in 1861.

EXH: RA 1836 (329); *Shakespeare in Art*

ENGR: Lumb Stocks

LIT: *Gentleman's Magazine* July 1836, pp71–2; *Athenaeum* 1837, p348; *Art Journal* 1856, p74, 1857, p240; *Leslie* I, ppli–liv, II, p230; *Art Journal* 1867, p76; F T Palgrave *Gems of English Art* 1869 (repr); *Dafforne* p23; *L'Artiste* xx, 1884, p258); T H Ward *English Art in the Public Galleries of London* II, 1884, repr facing p138

REPR: R Redgrave *The Sheepshanks Gallery* 1870

### Le Bourgeois Gentilhomme
FA116   Negs 57432, CT8278
Canvas, 61 × 97.7 cm (24 × 38½ ins)
Sheepshanks Gift 1857

*Le Bourgeois Gentilhomme*   FA116

Exhibited at the RA in 1841, and painted for John Sheepshanks. The following quotation was appended to the title in the RA catalogue:

| M Jourdain: | Tout beau |
| | Hola! Oh! Doucement |
| | Diantre soit la coquine! |
| Nicole: | Vous me dites de pousser |
| M Jourdain: | Oui; mais tu ma pousses en tierce, avant que de pousser en quarte, et tu n'as pas la patience que je pare. |

The lines are from Molière's *Le Bourgeois Gentilhomme* (first performed 1670), act 3 scene 3. In demonstrating his new skill in fencing to his maidservant Nicole, Jourdain is immediately struck several times by her foil; his wife watches with amusement on the left.

For further comment on the use of Molière's plays made by artists in the 19th century, see under Frith 537–1882 p103. There were two other versions of the subject; according to Taylor (*Leslie* II, p262), one painted for Lord Holland, (Leslie also exhibited 'The Library at Holland House, with portraits' at the RA in 1841), the other owned by the Birmingham collector Joseph Gillott. The latter does not seem to have been included in Gillott's sale at Christie's 19 April–4 May 1872. A drawing similar to the present

composition was lithographed in 1840 by Maxim Gauci (for 'Evening Sketches by A E Chalon . . .').

The *Athenaeum* critic commented on the popularity of the subject, and admired Leslie's treatment of it:

> We are never tired of laughing at the fencing match betwixt Monsieur Jourdain and the loquacious Nicole, – no wonder then, that artists should never be tired of painting it! Mr Leslie has done his best; and the best of those who have undertaken the subject in our experience. His *femme de chambre* maintains her ground with such a firm foot, and grasps 'her tool' with such a warlike fist . . . Caution, the consciousness of being dressed with a wonderful splendour are in every line of the retired merchant's face and attitude. The colouring, too, is clear, without being gaudy.

The *Art Union* took a more lofty tone, and disliked Leslie's colouring:

> A rich example of character, full of point and humour, and admirably illustrative of the scene. It is in most respects a production of un-approachable excellence, in the class to which it belongs; that class, to be sure, is not the highest; and it is matter for regret that the painter does not deal with more elevated and worthier themes. Mr Leslie's views of life are so shrewd, and his perception, and portraying, of character so strong, that he is borne safely through peculiarities of colour, that would seriously injure a lesser man. We cannot, however, avoid expressing a regret that this 'one fault' appears verging towards an unpleasant extreme. Either all the usual theories of colouring are misplaced, or the arrangements of colour, and the agremens of chiaro-oscuro are mere artistical 'nugae' in the eyes of this accomplished artist.

Taylor (*Leslie* I, plxii) thought the present version of the subject 'slight and sketchy, but full of spirit in the action, and of truthful indication in the light and shadow'. He found the Gillott version 'richer in colour and more solidly painted'. He added 'The Jourdain in both is perfect as a conception of character, and it would be impossible to convey better the suddenness and irresistible fury of Nicole's attack. She has not even thought it worth while to lay aside her besom'. The 'sketchiness' of the present work was also noted by Waagen and Chancellor. But the conveying of character was always admired; the Redgraves, for example, thought the figures in the present work 'the very individuals the author dreamt of, and the spectator anticipated'.

Exh: RA 1841 (52)

*Les Femmes Savantes*  FA117

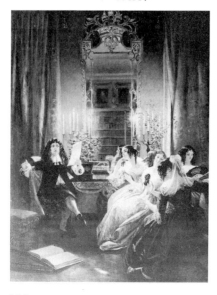

**Les Femmes Savantes**
FA117  Neg 76916
Canvas, 99 × 76.1 cm (39 × 30 ins)
Sheepshanks Gift 1857

Exhibited at the RA in 1845, and, according to Taylor (*Leslie* II, p280), painted for John Sheepshanks. The *Athenaeum* critic simply dismissed the work with the comment 'a repetition, with, at best, very unimportant changes, of his well-remembered piece of humour'; other critics do not seem to note an earlier version of the picture, and none is recorded in *Leslie*. The title given in the RA catalogue was 'Scene from Molière', with the following lines appended (for some reason, a different quotation appears in the 1907 catalogue):

| | |
|---|---|
| *Trissotin:* | Sonnet a la Princesse Uranie sur sa Fièvre. |
| | Votre prudence est endormie |
| | De traiter magnifiquement, |
| | Et de loger superbement |
| | Votre plus cruelle ennemie. |
| *Belise:* | Ah! le joli debut! |

*Armande:*  Qu'il a le tour galant!

*Philaminte:*  Lui seul, des vers aises possede le talent.

The lines are from Molière's play *Les Femmes Savantes* (1673), act 3 scene 3.

Contemporary and later opinions of the painting differed, although the themes of Leslie's humour and chalky 'sketchiness' are common. The *Art Union* in 1845 thought 'This production is less careful than any we remember by its author . . . Compared with what has been exhibited by the artist, this is in manner but a sketch, and the subject is slighted'; the costumes were also adversely noted: 'The male figure is attired according to the manner in which the French dress the character; but the female figures are dressed in what may pass for modern costume, and are decidedly too English in style, to support a scene from Molière as we are accustomed to see the author put upon the French stage'. The *Examiner* found it:

> Charmingly executed, with the usual exceptionable points in colour . . . How admirably conveyed is the conceited admiration of Trissotin's sonnet; and with what a comical gusto of folly the sonneteer sits among his learned admirers. Let us remember how little like Nature, scenes from plays are generally made; and admire Mr Leslie the more.

By 1857 the 'sketchiness' was still more a matter for comment. The *Art Journal*, reviewing the Sheepshanks collection, called it

> A picture in which is set forth the learning of a life-time. It is a full composition, abounding with even, small forms, which would be insufferably impertinent in unskilful hands; but the appositions are so masterly, and the light so brilliantly and beautifully distributed, that we feel that the artist has been guilty of a misdemeanour in not having finished the work more perfectly.

Ten years later, in a text accompanying an engraving after the work, the *Art Journal* admired the 'irresistibly humorous' treatment of the subject, but 'the picture shows the artist's accustomed tendency to "chalkiness" more than usual. This, with the peculiar light from the candelabra, renders the subject difficult to engrave effectively'. Taylor had also found the work 'disagreeably chalky in texture', but thought the expressions worthy of Hogarth. The Redgraves, however, opined that 'a truer effect is given of the brilliancy of candlelight by the slightest means, than in the most laboured work of Schalken or Honthorst'. Maas finds the effect 'delightfully brash'.

The background was taken from the White Library at Petworth, where Lord Egremont was one of Leslie's patrons; the existence in a private collection of a watercolour study for the looking-glass and console table is recorded on the Departmental files.

EXH:  RA 1845 (149); *International Exhibition* Dublin 1865 (148a); *Bicentenary Exhibition* RA 18–9 (175)

ENGR:  P Lightfoot, in *Art Journal* 1867, facing p230, and J Dafforne *Leslie and Maclise* 1871, facing p45

LIT:  *Athenaeum* 10 May 1845, pp466; *Art Union* 1845, p183; *Examiner* 1845, p293; *Art Journal* 1857, p240; *Leslie* I, pplxii–lxiii, II, p280; *Art Journal* 1867, p230; J Dafforne *Maclise and Leslie* 1871, p51; *L'Artiste* 1884, (XX), p254; S and R Redgrave *A Century of British Painters* 1866, pp310–1; J Maas *Victorian Painters* 1969, p109, repr in colour p120

*Le Malade Imaginaire* FA118

## Le Malade Imaginaire
FA118   Neg GA1194
Canvas, 61 × 97.7 cm (24 × 38½ ins)
Sheepshanks Gift 1857

Exhibited at the RA in 1843, and, according to Taylor (*Leslie* II, p269), painted for John Sheepshanks. The title given in the RA catalogue was 'Scene from Molière', together with the following quotation:

M *Purgon:* J'ai a vous dire que je vous abandonné a votre mauvaise condition, a l'intemperie de vos entrailles, a la corruption de votre sang, a l'acrete de votre bile et la feculance de vos humeurs.
*Toinette:* C'est fort bien fait.
*Argan:* Mon Dieu!
M *Purgon:* Et je veux qu'avant qu'il soit quatre jours vous deveniez, dans un etat incurable.
*Argan:* Ah! misericorde.

The lines are from act 3 scene 6 of Molière's play *Le Malade Imaginaire.*

Critical opinions seem to have differed. The *Athenaeum* thought it much inferior to Leslie's other exhibited work, 'A Scene from The Vicar of Wakefield': 'Monsieur Purgon is the best figure; but the Toinette is as far as possible from the clever, arch French *soubrette*, depicted by Molière'. The *Art Union* discussed the subject at some length:

This is the famous scene wherein M Purgon leaves his patient to the merciless course of a list of evils, sufficient to destory a frame of cast-iron. The figures are four, the principal of whom are the *malade* and his physician, who is quitting the room with the words, 'J'ai a vous dire . . .' M Purgon is an incomparable epigram in the characteristics of the peculiars of his class at the period supposed. He is exquisitely dressed, and the bitter denunciation of his look says more than is expressed in the text. He speaks, through Leslie, in a strain of irate emotion, more deep than through Molière. The eye, and the lip, and the bursting fury of the manner say more than the written words. The patient seems already overwhelmed by the catalogue of diseases to which he is resigned; his look is powerfully depreciative of the doctor's wrath. Toinette stands behind his chair, and her phrase, 'C'est fort bien fait', is outdone by her countenance; indeed the picture is entirely one of character, and in the spirit in which it is painted has been very rarely equalled, and never surpassed.

The Redgraves and Waagen admired it, although Taylor, who found the figure of Toinette 'peculiarly successful', thought it 'not one of the pleasantest of its period in colour or execution'. He also records that there was little doubt that Leslie himself modelled for the face of the hypochondriac.

Exh:   RA 1843 (416)

Lit:   *Leslie* I, plxiii, II, p269

*Don Quixote and Dorothea* FA119

## Don Quixote and Dorothea
FA119   Neg CT7617
Panel, 21.6 × 27.8 cm (8½ × 10¹⁵⁄₁₆ ins)
Sheepshanks Gift 1857

A sketch for the picture exhibited at the RA in 1826 (60), and, according to the artist's letter quoted below, painted for the Earl of Essex. The full title given in the RA catalogue was 'Don Quixote having retired into the Sierra Morena to do penance, in imitation of Amadis de Gaul, is prevailed on to relinquish his design by a stratagem of the Curate and the Barber, assisted by

Dorothea'; the title was accompanied by a long quotation from Cervantes' *Don Quixote*, part 4 chapter 2.

Taylor (*Leslie* II, p167) quotes a letter from Leslie to the American author Washington Irving of 12 January 1826: 'I have for the last six months been very busy with a picture from "Don Quixote", . . . Those of my friends who have seen it think it will be my best picture, but I never know well what I am about myself till I have done it'. Presumably the present sketch therefore dates from the latter half of 1825. Taylor thought the RA painting 'another good example of the artist's best time as a colourist; but it is not superior in this respect to the little sketch of the subject in the National Collection, which is quite Venetian in its glow of harmonious colour'.

The present whereabouts of the RA picture are unknown; it does not seem to have been included in the Cassiobury sale of the Essex collection 12 June 1922, but was sold at Bonham's 8 February 1984 (129, repr in catalogue). It is recorded as having been engraved.

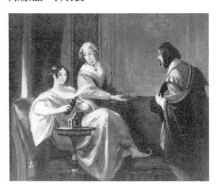

*Laura Introducing Gil Blas to Arsenia  FA120*

Lit: *Leslie* I, ppxxxvii–xxxix, II, pp165, 167, 320

### Laura Introducing Gil Blas to Arsenia
FA120  Neg Y463
Canvas, 21 × 26 cm (8¼ × 10¼ ins)
Sheepshanks Gift 1857

The following passage is quoted in the 1907 catalogue:

Elle était dans un déshabillé galant, et ses belles mains s'occupaient à préparer une coiffure nouvelle pour jouer son rôle ce jour-la. 'Madame', lui dit la soubrette, 'voici l'économe en question; je puis vous assurer que vous ne sauriez avoir un meilleur sujet'. Arsénie me regarda très attentivement . . . 'Comment donc, Laure', s'écria-t-elle, 'mais voilà un fort joli garcon; je prévois que je m'accommoderai bien de lui'.

The lines are from Le Sage's picaresque romance *The Adventures of Gil Blas of Santillane*, first published 1715–35, book 3 chapter 9.

The work may well be a sketch for a larger, more finished painting. Although Le Sage is mentioned in *Leslie* as one of the artist's favourite authors, the only painting of a Gil Blas subject recorded seems to be the 'Gil Blas and the Duchess' in the Phipps sale at Christie's 25 June 1859 (81), bought Lord Lansdowne £144 18s

### A Female Head
FA121
Panel, oval 22.9 × 17.2 cm (9 × 6¾ ins)
Sheepshanks Gift 1857

From the hairstyle, datable to the years around 1840. See also 'Dulcinea del Toboso', FA131, p174

### Queen Katharine and Patience
FA122  Neg GA1195
Canvas, 58.3 × 50.7 cm (23 × 20 ins)
Sheepshanks Gift 1857

*Queen Katharine and Patience  FA122*

The artist was elected ARA in 1821, and presented an earlier version of this subject as his Diploma Work in 1826; the present work shows the same composition but differs in almost every detail of dress, furniture and accessories. It was exhibited at the RA in 1842 (not, as stated in the 1907 catalogue, 1839), and according to Taylor (*Leslie* II, p266) was painted for John Sheepshanks.

The title given in the RA catalogue, and the appended quotation, are as follows: 'Scene from Henry the Eighth. *Queen Katharine*: "Take thy lute,

wench, my soul grows sad with troubles. Sing and disperse them if thou can'st; leave wishing".'

The quotation is from the opening lines of act 3 scene 1 of Shakespeare's *King Henry VIII*. One of the principal plots concerns the estrangement between the King and his first wife, Katherine of Aragon, who acts with dignified resignation; the rest of this scene deals with her confrontation with Cardinal Wolsey.

The *Art Union* critic remembered a very similar subject engraved in one of the illustrated 'Annuals', and thought the painting 'a graceful and beautiful and very touching composition; telling forcibly the sad story of the crowned queen'. The *Athenaeum* however, which also recalled the engraving, found the picture 'not a felicitous effect. Queen Katharine is too young [in reality she would have been about 43], and withal looks sullen rather than sad; and the maiden with the lute shares the sour precision of her mistress. Then there is a mildewy coldness of atmosphere, which takes from this pair of melancholy women their one chance of attracting sympathy'. Later critics were far more admiring. Waagen found 'the expression of sorrow in the Queen is very good, and the gloomy keeping of the whole is congenial'. The *Art Journal* in 1856 thought it 'a beautiful and touching composition', and in 1857 'one of the painter's *chef d'oeuvre*; the subject is sad, and therefore the treatment is without one pencil of the dusty sunshine which illumines other pictures. We wish the queen's cope had been blue; however, the grave dignity of the composition equals the earnestness of the very best masters of pictorial disposition'. In a text accompanying an engraving after the work, the *Art Journal* in 1873 analysed the composition at some length, concluding that 'this is a touching picture, the sentiment of which is forcibly worked out; and it evidences in every particular the mind and the hand of a true artist'.

The composition, details and mood are somewhat similar to those of R P Bonington's 'Meditation' also of 1826 (engraved 1827, now Wallace Collection), but this is probably due to the fact that both artists went to the same sources, in Dutch 17th-century painting by artists such as Terborch. The image of the Queen is recognisable from the various contemporary portraits of her: see for example the work by an unknown artist in the NPG.

EXH:   RA 1842 (148)

ENGR:   C W Sharpe for the *Art Journal* 1873, facing p204

LIT:   *Athenaeum* 14 May 1842, p433; *Art Union* 1842, p122; G Waagen *Treasures of Art in Great Britain* II, p301; *Art Journal* 1856, p75, 1857, p240; *Leslie* II, p266; *Art Journal* 1873, p204

*Amy Robsart*   FA123

**Amy Robsart**
FA123   Neg CT18997
Panel, mahogany, 27.7 × 23 cm (10⅞ × 9¹⁄₁₆ ins)
Inscribed on back as below
Sheepshanks Gift 1857

The work is inscribed by the artist in paint on the back 'C R Leslie./1833', but is listed under 1836 by Taylor (*Leslie* II, p230) as painted for John Sheepshanks, and engraved.

Amy Robsart (1532–60) married Queen Elizabeth I's favourite, Robert Dudley, Earl of Leicester, in 1550; she died in suspicious circumstances in 1560 – suicide or, more likely, murder (by her husband, so he was free to marry the Queen), although a jury returned a verdict of accidental death. Despite the plot of Sir Walter Scott's *Kenilworth* revolving around her story, she never achieved the perpetuity of fame through art that Mary Queen of Scots and Lady Jane Grey enjoyed; no relevant subjects were exhibited at the RA in the 1830s, for example. There does not seem to be an extant contemporary portrait of Amy Robsart.

**The Two Princes in the Tower**
FA124   Neg 69790
Canvas, 33 × 43.1 cm (13 × 17 ins)
Sheepshanks Gift 1857

*The Two Princes in the Tower*   FA124

According to Taylor (*Leslie* II, pp320–1), the artist painted two versions of this composition, the first in 1830 for Mr Rogers (see *versions*: below), and the repetition in 1837, which was recorded as in Sheepshanks's collection but not as specifically painted for him.

In a letter to Leslie from the American author Washington Irving of 21 April 1826, quoted by Taylor (*Leslie* II, p179), the literary source for the painting is discussed:

> The old play about which you inquire, as containing scenes relative to the young princes in the Tower, is by Middleton, entitled the 'First and Second Part of Edward IV'. If you wish the scenes for any professional purpose I can transcribe them for you in a letter, as I have them by me, but I do not wish to put any literary forager on the track of this play, as I have an article on the subject half sketched among my papers, which I intend some day or other to make use of.

In a footnote, Taylor comments that the play is by Thomas Heywood [1599] 'and has been reprinted by the Shakespeare Society. Leslie painted a very touching sketch . . .'. The lines relevant to Leslie's composition are from act 3 scene 5:

*Richard:*  O Lord, methinks this going to our bed,
How like it is to going to our grave.
*Edward:*  I pray thee do not speak of graves sweet heart,
Indeed thou frightest me.
*Richard:*  Why my Lord Brother, did not our Tutor teach us,
That when at night we went unto our bed,
We still should think we went unto our graves.
*Edward:*  Yes, that's true, yet we should do as every Christian ought,
To be prepared to die at every hour, but I am heavy.
*Richard:*  Indeed so am I.
*Edward:*  Then let us say our prayers and go to bed. (They kneel.)

There had always been much interest in the uncertain fate of Richard Duke of York and (the briefly) King Edward V, their imprisonment in the Tower of London in 1483, and their murder supposedly at the order of the Duke of Gloucester, later Richard III. Paintings of the subject were not exhibited at the RA as frequently as might be thought: Strong lists only 17 associated with the story between 1769 and 1893, and only four which seem to deal specifically with the two princes in the Tower (*And When Did You Last See You Father?* 1978, pp159–60). Leslie's most immediate predecessor was Henry Singleton in 1797, and closest successor Millais in 1878. Strong rightly draws attention to Delaroche's painting of 1831 (exhibited at the Paris Salon 1831, now Wallace Collection), and the degree of sentiment in the story (pp119–21); he comments on the Millais painting (now Royal Holloway College) that 'he skilfully married the record of a historical event with another, perhaps even more potent Victorian obsession, the innocence and vulnerability of childhood'. T S R Boase thought the work 'shows how he could turn a tale of horror to prettiness'.

Exh:   *Victorian Narrative Paintings* V&A circulating exhibition 1961

Lit:   *Leslie* I, plxvii, II, pp179, 320–1; T S R Boase *English Art 1800–1870* 1959, p172, repr pl 65a

Version:   Painted for Samuel Rogers 1830; his sale, Christie's 28 April–10 May 1856 (529, as 'The Infant Princes in the Tower'), bought Gambart £225 15s; Joseph Gillott in 1860; his sale, Christie's 19 April–4 May (175, 33 × 43.2 cm/13 × 17 ins), bought Permian £87 3s

171

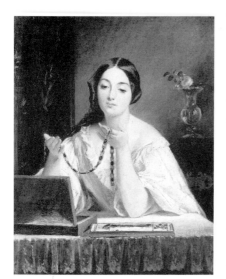

*The Toilette   FA125*

*The Princess Royal   FA126*

*Portia   FA127*

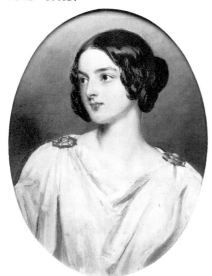

## The Toilette
FA125   Negs 51783, CT19742
Panel, 30.5 × 25.4 cm (12 × 10 ins)
Sheepshanks Gift 1857

Presumably the work listed by Taylor (II, p296) under '1849/Pictures of the Year' as '(Not exhibited). THE NECKLACE. (In the National Collection.)' with the additional note of a 'Repetition – an oval with a locket – in the possession of Richard Newsham, Esq.'. A Mrs Ianthe Gillman informed the museum in 1922 that the sitter for the present work and 'Griselda' (see FA128 p173) was her grandmother Sophia Riley (Mrs James Gillman), of mixed Irish and Spanish descent and famous for her 'raven black hair and arched eyebrows'.

## The Princess Royal
FA126   Neg 67937
Canvas laid on millbaord, circular, diameter 8.9 cm (3½ ins)
Inscribed on back as below
Sheepshanks Gift 1857

Inscribed in ink, probably by the artist, on a label stuck on the reverse: 'H.R.H The Princess/Royal/painted by C R Leslie/Feby 20th 1841'. Leslie recorded:

> 'In 1841, I painted a second picture for the Queen [the first was the Coronation painting, see FA129 below] – The Christening of the Princess Royal. I was admitted to see the ceremony, and made a slight sketch of the Royal personages as they stood round the font in the room. I made a study from the little Princess a few days afterwards. She was then three months old, and a finer child of that age I never saw.

The finished painting, in the Royal Collection, was engraved by H T Ryall in 1849, and is reproduced in H and A Gernsheim *Queen Victoria: a Biography in Word and Picture* 1959, p70.

Queen Victoria's first child was born 21 November 1840, and baptised Victoria Adelaide Mary Louisa on 10 February 1841 at Buckingham Palace. She was to marry in 1858 King Frederick III of Prussia, who was (briefly) Emperor of Germany in 1888; thereafter she was known as the Empress Frederick. She died in 1901. A very similar, but not identical, portrait in miniature of the Princess in her christening robe painted by Miss Ross after a sketch by Sir William Ross is also in the Royal Collection. The 1819 watercolour of Queen Victoria as an infant by J G P Fischer, also in the Royal Collection, presumably shows the same christening robe and bonnet.

LIT: *Leslie* I, pp171–2

## Portia
FA127   Neg 74355
Panel, oval, 25.4 × 20.3 cm (10 × 8 ins)
Sheepshanks Gift 1857

Titled 'Portia' since its acquisition, and with the following quotation appended in the 1907 catalogue: 'Oh me, the word "choose"! I may neither choose whom I would, nor refuse whom I dislike; so is the will of living daughter curb'd by the will of a dead father'.

The lines are from Shakespeare's *The Merchant of Venice* act 1 scene 2. However, Ashton, surely correctly, doubts this subject, as the classical costume is so inappropriate, and suggests that Portia, the wife of Brutus, in *Julius Caesar* as a possible identification. He dates the work about 1848. Ashton also compares the pose, costume, hairstyle and other details, with those of the engraving after John Hayter's 'Helena' in Charles Heath's 'The Shakespeare Gallery . . .' (1836–7). The Hayter depicts the Helena of *All's Well That Ends Well*, but Ashton proposes the Helen of Shakespeare's *Troilus*

*and Cressida*. Another possibility is the Athenian Helena of *A Midsummer Night's Dream*.

The work seems to be a companion to 'Griselda' (see FA128 below), and represents the same model (see also FA125, p172).

EXH: *Shakespeare's Heroines* Buxton Museum and Art Gallery 1980 (18, as 'Helen')

ENGR: Unknown artist (impr in V&A, 18876), also from the Sheepshanks collection)

LIT: *Shakespeares Heroines* Buxton Museum and Art Gallery exhibition catalogue 1980, p40 (repr)

## Griselda
FA128   Neg 51784
Panel, oval, 25.4 × 20.3 cm (10 × 8 ins)
Sheepshanks Gift 1857

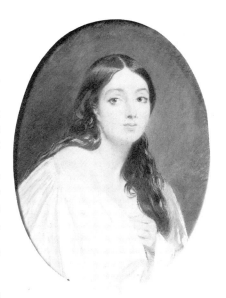

Presumably a companion piece to 'Portia' (see FA127, p172) and representing the same model; according to Taylor (*Leslie* II, p255) painted in 1840. The full title given in the 1907 catalogue was 'Griselda, about to leave her lord's house in obedience to his command', the with following quotation appended: Before the folk hireselven stripeth she/And in hire smok, with foot and hed al bare/Toward hire fadres hous forth is she fare'.

The quotation is from Chaucer's 'The Clerk's Tale' (from *The Canterbury Tales*), part 5 lines 110–2. The patient heroine Griselda was a particularly popular subject with 19th-century artists (and presumably their public), to judge from the number of paintings exhibited, for example Redgrave (RA 1837) and Le Jeune (RA 1843).

An enamel copy on porcelain, signed and dated 'T[homas]. Allen. 1853' is also in the V&A collections.

ENGR: Unknown artist (impr in V&A, 18878, also from the Sheepshanks collection)

*Griselda*   FA128

LIT: *Leslie* II, p255

REPR: *The Bazaar* supplement 6 April 1929

## Queen Victoria in her Coronation Robes
FA129   Neg 59256
Canvas, 45.7 × 61 cm (18 × 24 ins)
Sheepshanks Gift 1857

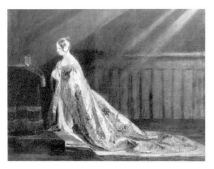

A sketch for the large (94 × 185.4 cm/37 × 73 ins) painting 'Queen Victoria Receiving the Sacrament after her Coronation' exhibited at the RA in 1843 (74) and now in the Royal Collection. The Coronation took place on 28 June 1838; in July the Queen 'heard that Leslie contemplated a Coronation picture. She sat to him in November, 1838, and December . . . The picture was finished early in 1839'. But, according to a letter of 16 June 1839 quoted in *Leslie* (II, p253), the picture was not yet finished; it is recorded as completed in a letter of 19 December 1839. Leslie described the Coronation in a letter to his sister of 24 July 1838, quoted in *Leslie* II, pp237–9 but incorrectly dated to 1837.

*Queen Victoria in her Coronation Robes*   FA129

The RA catalogue gave details of the subject and the principal figures; these were amplified in C Collins Baker's *Catalogue of the Principal Pictures in the Royal Collection at Windsor Castle*. The painting was engraved by S Cousins in 1843. The *Athenaeum* (20 May 1843, pp492–3) thought the picture:

Must rank as History, but it is unavoidably History treated in the *genre* style. The difficulties of the subject have been met, and in great part overcome, with taste and judgement, and the profile of the Queen is one

of the best likenesses we have seen of Her Majesty; the colouring beautiful, bright and harmonious – colour is one of Leslie's excellencies.

The *Art Journal* (1843, p163) thought:

> The merits of this picture place it among the highest of its class; the artist has succeeded in wrapping the scene in a holy interest . . . an appropriate effect is produced by a beam of light which descends towards the altar . . . the figures of the young Queen and her maids of honour are as graceful, ideal, and beautiful as the most poetic fancy could desire . . .

The present work is a sketch for the figure of the Queen kneeling at the altar in Westminster Abbey. The beams of light admired by the *Art Journal* illuminate the altar and the figure of the Queen, a device used later by the photographer Cecil Beaton; Leslie suggests the Divine Right to the throne, and perhaps the presence of God at the moment of Holy Communion.

According to Collins Baker, it was Lord Melbourne who introduced Leslie to the Queen, 'emphasising his superiority to [Sir George] Hayter'.

Exh:   *Exposition Universelle* Paris 1855 (867, lent by Sheepshanks)

Lit:   (the RA picture) *Leslie* I, pp165–71, II, pp244–45; *Dafforne* pp6–7

## A Garden Scene

FA130   Neg GH1580
Canvas, 30.5 × 40.6 cm (12 × 16 ins)
Sheepshanks Gift 1857

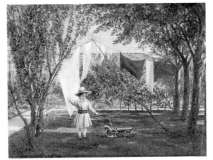

Listed by Taylor (*Leslie* II, p255) under 1840, and described as 'Child in a Garden, with his little horse and cart. (A portrait of George, the painter's youngest son).' George Dunlop Leslie, later a painter and writer, was born 2 July 1835; he died in 1921. The garden was at 12 Pine Apple Place, Edgware Road, London. Taylor lists another 'evening landscape from Mr Leslie's window' under 1836. The work has the character of a personal family snapshot, but may have been painted for Sheepshanks nevertheless, although Taylor does not specify this.

*A Garden Scene   FA130*

Exh:   *Victorian Painting* Arts Council 1962 (40); *Paintings and Drawings by Victorian Artists in England* National Gallery of Canada, Ottawa, 1965 (79); *The Revolt of the Pre-Raphaelites* Lowe Art Museum, University of Miami, Florida, 1972

## Dulcinea del Toboso

FA131   Neg 59129
Panel, 30.5 × 25.4 cm (12 × 10 ins)
Sheepshanks Gift 1857

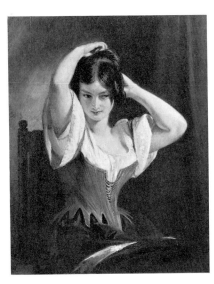

Exhibited at the RA in 1839, and, according to *Leslie* (II, p251), painted for John Sheepshanks. The subject is taken from Cervantes's *Don Quixote*:

> Near the place where he lived, there dwelt a very comely country lass, with whom he had formerly been in love; though, as it was supposed, she never knew it nor troubled herself about it. Her name was Aldonzo Lorenzo, and her he pitched upon to be the lady of his thoughts: then casting about for a name, which should incline towards that of a great lady or princess, he resolved to call her Dulcinea del Toboso (part 1, chapter 1).

The *Athenaeum* critic noted that Leslie shows the woman

*Dulcinea del Toboso   FA131*

> Not as the goddess of the Don's magnificent fantasy, but in her real guise as the peasant girl who rode to mass or market on 'her pied belfry', arranging her hair, not to tempt bold knights to gentle deeds, but to insure the more equal and substantial wooing of the chosen Gil or Juan. We are sorry to observe, that Mr Leslie's scarlet fancy in flesh-colouring

is rather on the increase: – let him carry it a little further, and the critic must needs talk of the geraniums, not the roses, on the cheeks of his maidens.

Other critics seem to have misunderstood Leslie's intentions. The *Art Union* pronounced tersely that 'This is a misnomer. It is not a portrait of the innamorato of Don Quixote; although a very carefully painted picture of a buxom country wench'. The *Examiner* described it as:

> A picture which strikingly exemplifies the disadvantages of a misnomer. It is utterly devoid of the charm of verisimilitude; and, consequently, its appeal to our applause is solely dependent upon its execution, which is sufficiently meretorious. The appearance of this good-looking female as much embodies our ideas of the coarse, garlic-eating peasant as it does those of Teresa or Sanchica Panza. The fact is, that such a subject should never have been selected but as a part of a composition; for a solitary treatment of it, if *vraisemblable*, could never by any art have been rendered attractive'.

The study of a female head, FA121, p169 is possibly the same figure seen from the back. What appears to be a second version of the subject was in the J C Grundy sale at Christie's 4 November 1867, bought Agnew £107 2s.

EXH:  RA 1839 (144)

LIT:  *Athenaeum* 25 May 1839, p396; *The Examiner* 1839, p359; *Art Union* 1839, p68; *Leslie* I, pxli, II, p251; *Bibby's Annual* 1909, p32 (repr); *The Bazaar* 28 September 1929, (repr)

ENGR:  Anon (impr in V&A collections, 18747, also from the Sheepshanks Gift)

## Sancho Panza
FA132  Neg V1940
Panel, 30.5 × 22.8 cm (12 × 9 ins)
Sheepshanks Gift 1857

Exhibited at the RA in 1839, and, according to Taylor (*Leslie* II, p251), painted for John Sheepshanks. Taylor also comments (I, pxl) that 'more truthful humour was never put on canvas of the same dimensions by any painter at any period'. The subject is taken from Cervantes's *Don Quixote*, part 2 chapter 47:

*Sancho Panza*  FA132

> He took his place at the upper end off the table, which was accommodated with one seat only and a cover for himself alone, while close by to him stood a personage, who afterwards proved to be his physician, with a rod of whalebone in his hand . . . A page tucked a bib under Sancho's chin, and another who acted the part of a server, set a plate of fruit before the governor; but scarce had he swallowed a mouthful, when the doctor touching the said plate with his wand, it was snatched from him in a twinkling.

The *Athenaeum* critic described the subject without further comment, while the Art Union thought it 'a capital work'. The *Examiner* dealt with Leslie's powers of comic expression at some length:

> Mr Leslie's picture is small, and presents little more than the bust of the great philosopher seated before his unhappy board; his knife and fork sole occupants of the otherwise naked space; and on his face the most comic fractiousness that ever was portrayed. Instead of the common practice, however, of delineating the lugubrious physician, and a sort of *pendant* of the apothecary in *Romeo and Juliet*, merely the hand and black wand of that despotic functionary are introduced in the corner of the picture. The eyes of Sancho are despairingly fixed on this grim emblem of perpetual disappointment; and the heart-sick discontent which his countenance exhibits is infinitely humorous.

175

In a text accompanying an engraving in 1868, the *Art Journal* analysed the facial expressiveness, concluding that 'all tell the tale most humorously, but with a refinement that only a painter of Leslie's elegant taste would throw into a subject of contrary tendency'. This expressiveness may also be related to the more realistic seventeenth-century re-interpretation of the traditional images of the five senses, in this case of course the sense of taste. The present work may be compared, for example, with José de Ribera's painting of about 1612–5 (now Wadsworth Athenaeum, Hartford, Connecticut; repr R Spear *Caravaggio and his followers* Cleveland Museum of Art, Ohio, exhibition catalogue 1971, p150).

Taylor notes that '[Sir Francis] Chantrey may have aided Leslie as a model for the expression. But the head was painted, his son George tells me, from the family fly-driver'. A larger version of the subject, described by Taylor as the 'scene in full' (*Leslie* I, pxl, II, p310), showing other figures including the physician, was painted for Lady Chantrey in 1855 and exhibited that year at the RA. It may possibly have been the work recorded in a private collection in 1969. Leslie had exhibited heads of Sancho Panza and Don Quixote at the BI in 1819.

Exh: RA 1839 (125); *Victorian Narrative Paintings* V&A circulating exhibition 1961

Engr: J H Baker (repr A *Picture Gallery of British Art* 1873, facing p40; R C Bell, in *Art Journal* 1868, facing p56, and J Dafforne *Leslie and Maclise* 1871, facing p37

Lit: *Athenaeum* 25 May 1839, p396; *Art Union* 1839, p68; *The Examiner* 1839, p359; *Leslie* I, ppxxxix–xl, II, p251; *L'Artiste* XX, 1884, p248; E B Chancellor *Walks Among London's Pictures* 1910, pp260–1

# LINDSAY, Thomas, RI (1793–1861)

Born London 1793. Best known as a watercolourist, especially of views in Wales, he was one of the first members of the NWS 1833, and exhibited 347 works there between 1833 and 1861. Also exhibited four watercolours at the SBA 1833/4. A watercolour and a sketchbook of cloud studies are in the V&A collections. Died Cusop, Herefordshire (where he had settled 1848) 23 January 1861.

Lit: *Art Journal* 1861, p76 (obit)

**Sunset on a Lake (attributed to THOMAS LINDSAY)**
1624-1869  Neg HF976
Millboard, 22.8 × 38.1 cm (9 × 15 ins)
Townshend Bequest 1869

The attribution dates at least from the 1907 catalogue, and presumably earlier, and there seems no reason either to accept or doubt it. Lindsay was especially fond of sunset effects.

*Sunset on a Lake (attributed to THOMAS LINDSAY)   1624-1869*

# LINNELL, John (1792–1882)

Born Bloomsbury, London, 16 June 1792, son of a printseller and frame-maker. Copied works by George Morland, and studied watercolour painting with John Varley. Entered RA Schools 1805. Associated with William Henry Hunt, William Mulready, Dr Thomas Monro, and later William Blake. In a long and prolific career, he exhibited 176 works at the RA between 1807 and 1881, 91 at the BI 1808–59, and 52 watercolours at the OWS (Member 1812, Treasurer 1817). Subjects mainly portraits up to the late 1840s, then landscapes. Worked also in engraving, etching and mezzotint. Surprisingly, he submitted his name unsuccessfully for election to ARA 1821, and withdrew 1842; the RA later offered him membership, which he refused. Died Redhill, Surrey, 20 January 1882; a memorial exhibition was held at the RA 1882–3. Three of his sons (James Thomas, William, and John junior) were also artists, and his daughter married Samuel Palmer.

Lit: Redgrave *Cent*; *Art Journal* 1882, p262 (obit); A T Story *Life of John Linnell* 2 vols, 1892

## The Wild Flower Gatherers
FA133   Neg H1605
Panel, 15.8 × 20.9 cm (6¼ × 8¼ ins)
Signed and dated 'J Linnell 1831' br and inscribed '1834' on the back
Sheepshanks Gift 1857

Exhibited at the BI in 1831, the size given in the catalogue as 13 by 15 inches, presumably including the frame. The critic of *Arnold's Library of the Fine Arts* thought all five of Linnell's paintings at the BI 'admirably true to nature, and painted with the peculiar effect for which he is so celebrated'. Two letters from John Sheepshanks of 20 May and 5 November 1834 deal with the exhibition of two paintings in Leeds ('the little picture' probably being the present work) and its purchase by Sheepshanks; the date on the back presumably refers to this transaction. Story wrongly dated the work to 1830.

*The Wild Flower Gatherers*   FA133

Prov: Probably bought by Sheepshanks from the artist 1834, and given by him to the museum 1857

Exh: BI 1831 (24)

Lit: *Arnold's Library of the Fine Arts* (I), 1831, p157; *Story* I, pp260–2, II, p266

## The Cow-Yard
FA134   Neg Y1305
Panel, 28.6 × 38.1 cm (11¼ × 15 ins)
Signed and dated 'J Linnell f.' br of centre and '1831' further r, and inscribed on the back as below
Sheepshanks Gift 1857

Listed in the 1907 and summary catalogues under the title 'Milking Time'. Exhibited at the BI in 1832 as 'The Cow-Yard', the measurements given in the catalogue as 24 by 27 inches, presumably including the frame. It bears a MS label on the back: 'No 2 The Cow-Yard/By John Linnell/Porchester Terrace/Bayswater/1832'. Similar subjects of about the same time include 'Milking' (BI 1829), 'Dairy Farm' (BI 1830), and Milking (BI 1831).

*The Cow-Yard*   FA134

Exh: BI 1832 (78)

Lit: *Story* I, pp259–60, II, p266

Repr: *The Sheepshanks Gallery* 1870

*Landscape – Driving Cattle* 1407-1869

*Landscape, Evening* 488-1882

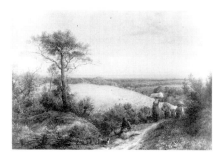

*The Harvest Moon* 554-1882

**Landscape – Driving Cattle**
1407-1869    Neg Y1306
Panel, 29.5 × 38.1 cm (11⅝ × 15 ins)
Townshend Bequest 1869

Not identifiable with any exhibited work. Hamerton comments that:

> Linnell's method of painting is a modern development of that of Rubens.
> The 'Landscape, Driving Cattle' at South Kensington is begun in rich
> transparent brown, and it seems likely that the browns of the earth were
> painted into whilst wet with greens and other colours. The sky is painted
> with a full brush in opaque pigments undisturbed after application, so
> that they retain the expressional power of the brush which Rubens so
> greatly valued . . .'

Lit:    P G Hamerton *The Graphic Arts* 1882, p244

**Landscape, Evening**
488-1882    Neg Y1307
Panel, mahogany, 24.8 × 38.1 cm (9¾ × 15 ins)
Signed 'J Linnell' bl and inscribed on the back as below
Jones Bequest 1882

A MS label on the back reads: 'No 2/The Farm,/Evening/J Linnell/Porchester
terrace/Bayswater/1851', indicating that the work is probably the painting of
that title exhibited at the BI in 1851 and listed by Story as painted in 1850,
size 10 by 16 inches. The size given in the BI catalogue is 19 by 25 inches,
presumably including the frame. Story identifies the location as North End,
Hampstead. The work has suffered from the artist's use of asphaltum.

Exh:    ?BI 1851 (29)

Lit:    *Story* II, p271; E B Chancellor *Walks Among London's Pictures* 1910,
        p243

**The Harvest Moon**
554-1882    Neg 22217
Canvas, 66 × 99 cm (26 × 39 ins)
Signed and dated 'J Linnell f 1855' br of centre
Jones Bequest 1882

Linnell's journal records work on this picture in 1852 and 1853; in September
1853 he was retouching it for the dealer William Wethered, who collected it
on 6 October. He sold it to the collector Louis Huth, who had the figures
retouched in November and the picture varnished 17 December. It seems
that Linnell worked on the painting on at least one further occasion, and this
presumably accounts for the date of 1855 that it bears.

Story lists the work as 'Painted for Mr. Weathered. Sold by Rought [also
a dealer] to Mr. Louis Huth for 400 guineas [£420]'. Huth presumably sold the
work directly to John Jones.

There is a small (37.8 × 46.1 cm/14⅞ × 18⅛ ins) version on panel
dated 1858 in the Tate Gallery; a letter from Huth to Linnell 27 May 1856
indicates he might like to have 'the repetition of the subject on the smaller
size as mentioned by you with one or two alterations which constitute my
only objection to the bigger one'. The Tate version differs principally in the
poses of the foreground figure and his dog and the nearest figure working in
the field above the dog is omitted. A note in Linnell's journal for 30
September 1856 records that 'Mr. Colls [a dealer] came to see Harvest Moon';
this could be either the present work or the Tate version.

Mary-Anne Stevens, in the 1972 Paris exhibition catalogue, commented
on the importance of the quality of light and the work of the gleaners which
recall Samuel Palmer's Shoreham period.

Exh: *La Peinture Romantique Anglaise . . .* Petit Palais, Paris, 1972 (165)

Lit: *Story* II, p273

Repr: *Victorian Paintings* V&A small picture book 10, 1963, pl 27

### Halt by the Jordan

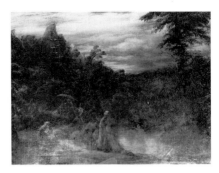

*Halt by the Jordan*   1845-1900

1845-1900   Neg Y1308
Canvas, 97.8 × 135.9 cm (38½ × 53½ ins)
Signed and dated 'J Linnell F. 1840 Ret. 49' bc
Ashbee Bequest 1900

Linnell exhibited a painting titled 'Flight into Egypt' at the BI in 1841 (49),
the size given in the catalogue as 52 by 63 inches including the frame as was
usual, and again in 1849 (58), as 56 by 72 inches. These two exhibits (unless
they were the same picture in different frames, which seems unlikely) fit the
present work in terms of size (more or less) and date (note that the inscription
records retouching in 1849), but it is difficult to identify a 'Flight into Egypt'
subject. Photography reveals the presence of a baptising figure standing in the
water, and it seems likely that the subject is the 'Baptism of the People of
Judah' (related in the New Testament of the Bible, Matthew chapter 2 verses
5–6 and Mark 1, 5). As Julian Litten has pointed out to the present author,
the people of Judah wait by the river Jordan to be baptised, people of all
classes pleading and confessing their sins in various attitudes of supplication.
It remains difficult to explain why the baptising figure is only visible in the
old photograph (albeit dimly), and the coincidence of sizes and dates noted
above.

### On the Beach Near Cullercoats, Northumberland

P58-1980
Paper, 16.1 × 22.8 cm (6⅜ × 8¾ ins)
Purchased 1980

### Rocky Promontory

P59-1980
Paper, 18.7 × 25.8 cm (7⅜ × 25⁵⁄₁₆ ins)
Purchased 1980

The note dealing with the previous lot in the Sotheby's sale catalogue (see
*Prov:* below) describes several oil and pencil sketches – including the present
work – made on the artist's honeymoon in Northumberland. Linnell married
his first wife in 1817. Three other sketches are known: two in private
collections, and one in the Yale Center for British Art, New Haven, USA.

Prov:   Mrs G C Bollard; sold Sotheby's 13 November 1980 (7), bought
with 'On the Beach near Cullercoats, Northumberland' (P58–1980
above), by the museum

---

# MACLISE, Daniel, RA (1806–1870)

Born Cork, Eire, 1806 (baptized 2 February) the son of a shoemaker. Studied
at Cork School of Art 1822; moved to London 1827, entering RA Schools
1828 and won many prizes. Exhibited 84 works at the RA between 1829 and
1870, 20 at the BI 1832–44, and 21 (mostly watercolours) at the SBA
1830–71. Early subjects included portraits, later predominantly literary and
historical. Elected ARA 1835, RA 1840. Visited Paris 1830, 1844, 1850,
Brussels 1845, Italy 1855, Germany 1859. Executed vast wall paintings for
the Palace of Westminster 1846–65. Friend of John Forster and Dickens.
Contributed (as 'Alfred Croquis') caricatures to *Fraser's Magazine* 1830–8;

illustrated several books, including Dickens's Christmas books, Moore's *Irish Melodies* (1845), Bürger's *Leonora* (1847), Tennyson's *Princess* (1860). Declined to be proposed PRA 1866; supposedly refused a knighthood. Died Chelsea, London, 25 April 1870; his studio sale was at Christie's 24 June 1870. His portrait by E M Ward 1846 is in the NPG; there are letters to Forster in the National Art Library, and many drawings and watercolours in the V&A collections.

Lit: 'Autobiography' (MS, RA Library: see E Kenealy in *Dublin University Magazine* XXIX, 1847, pp594–607); *Athenaeum* 30 April 1870, pp586–7 (obit); *Art Journal* 1870, pp 181–2 (obit); W J O'Driscoll *A Memoir of Daniel Maclise RA* 1872, p187; J Dafforne *Pictures by Daniel Maclise* 1871; R L Ormond 'Daniel Maclise' *Burlington Magazine* 1968, pp685–93; R L Ormond *Daniel Maclise* Arts Council National Portrait Gallery exhibition catalogue 1972

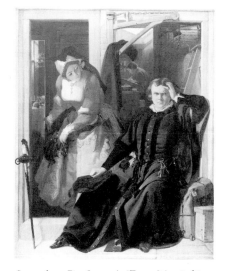

*Scene from Ben Jonson's 'Every Man in his Humour'* F20

## Scene from Ben Jonson's 'Every Man in his Humour'
F20   Neg 57088
Canvas, 63.5 × 52.7 cm (25 × 20¾ ins)
Forster Bequest 1876

Exhibited at the RA in 1848, and, according to O'Driscoll, painted for Forster.

The title in the RA catalogue was 'John Forster, Esq., in the Character of Kitely', with the following quotation appended:

*Dame Kitely*:   Sweetheart, will you come in to breakfast?
*Kitely*:         Troth, my head aches extremely on a sudden.

The lines are taken from the end of act 2 scene 1 of Ben Jonson's comedy *Every Man in his Humour*, first performed in 1598. In this scene, the merchant Kitely, whose 'humour' is jealousy for his young and pretty wife, and his sister, suspects Wellbred, who lives with them, and other young men; he believes his wife has overheard him talking of these suspicions.

The *Art Union* critic commented:

It is a small picture, in which the presumed Kitely is seated looking downwards, and in the expression of his features doing full justice to his aching head. The figure is dressed in blue and is truly one of the most solid and substantial we have ever seen. On his right appears the dame addressing to him the above invitation; she is painted in reflected light, with features of much beauty. It is upon the whole a very remarkable picture, eminently distinguished by powerful and decided execution.

The *Athenaeum* simply thought it 'both in colour and effect, more complete' than another of Maclise's 1848 exhibits, 'Chivalry in the Time of Henry VIII'.

Maclise met Forster in 1830, and they became firm friends: for more details of Forster's life, see P35–1935 p184. Forster's participation in amateur theatricals with Dickens and Bulwer Lytton was well-known between 1845 and 1855. The first of these was 20 September 1845 at Miss Fanny Kelly's small theatre at 73 Dean Street, Soho; Dickens produced *Every Man in His Humour*, himself playing Captain Bobadil and Forster playing Kitely. Other parts were taken by the writer Douglas William Jerrold (Stephen) and the humorous artist John Leech (Matthew). Maclise himself was also invited to take part, but was too shy of performing in front of an audience. Forster scored a great success in his role; it has been suggested that the part of the obstinate Kitely admirably suited Forster's own personality.

Richard Renton (*John Forster and His Friendships* 1912, p117) quotes a manuscript note, collected with the playbills for further performances on 15 and 17 May 1848 (Stratford Birthplace Library): 'The acting was generally good, C. Dickens and J. Forster in particular, but the costumes were awfully bad: Kitely and Cob were the only characters correctly dressed. Very poor audiences on both nights. Expenses heavy'. Renton also quotes (pp134–5)

two letters from Dickens to his friend Wilmott, who had been stage manager at Drury Lane and the Lyceum, one about the costumes on 7 August 1845: '. . . I and some others want our dresses made at once, in order we may be easy in them, as well as in the words . . . nobody can tell us so well as you where we can get them well, and not ruinously made'.

As Ormond points out, the painting is similar in style and composition to Maclise's earlier cabinet pictures, such as 'Gil Blas Dressed as a Cavalier' (1839, NGI), and shows the influence of 17th-century Dutch art. This influence is evident particularly in the device of opening up views into other rooms; see Nicolaes Maes *A Sleeping Maid and Her Servant* (1655, NG) for example.

Ormond also comments that:

> The foreground figures are framed by the rectangular shapes of the doorways. The divergent diagonals of the two interior scenes are the one disturbing element in the design. Some measure of unity is restored by the consistently light tonality and the crisply defined quality of the paint surface. The picture as a whole, however, suffers from its genre derivation, and it is facile in comparison with the nearly contemporary 'Macready as Werner' [see F21 below]. Only when Maclise's imagination was challenged by a large theme could he produce a memorable image.

A preliminary sketch for the painting is in the V&A collections. In the Forster collection in the V&A Library, there are two editions of the play containing production notes by Forster. A painting by C R Leslie of Dickens as Captain Bobadil in the same production was exhibited at the RA in 1846, and was recorded in a USA private collection in 1972.

Exh:    RA 1848 (111); Winter exhibition of old masters RA 1875 (255, as 'Kitely and Dame Kitely', and dated 1846, lent by Forster); *Charles Dickens* V&A 1970 (G15); *Daniel Maclise* Arts Council, National Portrait Gallery, 1972 (84)

Lit:    *The Times* 2 May 1848, p6; *Athenaeum* 6 May 1848, p464; *Art Union* 1848, p167; *O'Driscoll*, p97; *Ormond* 1972, p76

## Macready as Werner

F21    Neg 57089
Canvas, 174 × 100.3 cm (68½ × 39½ ins)
Forster Bequest 1876

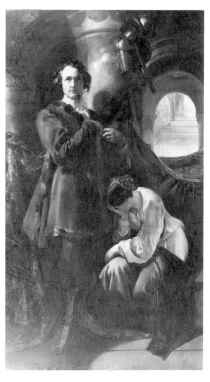

*Macready as Werner*    F21

Painted for John Forster in 1849 and 1850, and exhibited at the RA in 1851. Maclise painted it in exchange for 'Macbeth and the Weird Sisters', which he exhibited at the RA in 1836 and sold to Forster, but it was disliked by the sitter (again Macready) and eventually by the artist himself (see a letter from Maclise to Forster 1 August 1849, Forster MS 44); the present whereabouts of 'Macbeth' are unknown, but there is a drawing in the V&A collections (F88).

Macready, like Forster, was a close friend of the artist. Two sittings are recorded in Macready's diary for December 1849, and the picture seems to have been finished by March 1850, see Forster MSS 54–9. The painting was exhibited first at Hogarth's print shop in 1850, and then toured England and Scotland, to attract subscriptions for an engraving: 'on the track of Macready to Edinburgh and Glasgow' Forster MS 56). Maclise intended to show it at the RA, and was urged by the artist Thomas Uwins to do so, but the tour delayed its exhibition there until 1851. In a letter to Forster in 1856, Lord Lytton recorded 'Ah, those memories of Lincoln's Inn Fields . . . Macready glaring at you across the witch's cauldron . . .' (quoted in Lady B Balfour *Personal and Literary Letters of Robert First Earl of Lytton* 2 vols, 1906); this presumably refers to the present work. See also p295 below.

In the RA catalogue, the title is given as 'Mr Macready, in the Character of Werner', and the following lines appended:

181

Who would read in this form
The high soul of the son of a long line?
Who, in this garb, the heir of princely lands?
Who, in this sunken, sickly eye, the pride
of rank and ancestry? In this worn cheek
and famine-hollow'd brow, the Lord of halls
which daily feast a thousand vassals?

The quotation is from the opening scene of *Werner*, a tragedy by Lord Byron in a Gothic-Romantic style, first published in 1822. It was one of Macready's most famous roles, first performed by him at Drury Lane in 1830. William Charles Macready (1793–1873) was the leading tragic actor of his day; for more details of his career, see the catalogue entry on his portrait by George Clint (D74). He gave a series of 'farewell' performances at the Haymarket Theatre in the late 1840s, each time acting Werner; his final appearance on the stage was in February 1851. The present picture may have been intended as a commemorative tribute.

The *Art Journal* critic commented:

It is a full-length portrait, but not of the usual life size; the features are like those of Mr Macready, characterised according to the spirit of the passage. There is but little colour in the work, and nowhere but in the hair is the artist's distinctive sharpness of touch recognisable; it is throughout painted with much force and freedom.

The portrait, which doubtless records Macready's appearance in the role on stage, owes much to Sir Thomas Lawrence's famous painting of 'John Philip Kemble as Hamlet' (1801, Tate Gallery), which introduced a powerful Romanticism to the image of the actor. Although Maclise's picture is a quarter of the size of Lawrence's the imposing image and deep chiaroscuro are similar. Ormond considers that it 'possesses a genuinely heroic grandeur, which raises it above the level of portraiture or illustrative genre to that of history painting'.

EXH:    Hogarth's print shop 1850; RA 1851 (644); *International Exhibition* 1871 (330, lent by Forster); Winter exhibition of old masters, etc., RA 1875 (267, lent by Forster); *Charles Dickens* V&A 1970 (G69); *Daniel Maclise* Arts Council, National Portrait Gallery 1972 (85); *Royal Opera House Retrospective 1732–1982* RA 1982–3 (158)

ENGR:   C W Sharpe 1852, publ Hogarth

LIT:    *The Times* 3 May 1851, p8; *Art Journal* 1851, p160; O'Driscoll, pp100, 106; ed W Toynbee *Diaries of W C Macready* II, 1912, pp441–2; Ormond 1972, p77

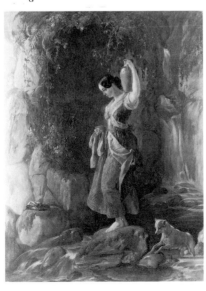

*Waterfall at St Nightons Kieve, near Tintagel*   F22

### Waterfall at St Nightons Kieve, near Tintagel
F22    Neg 61413
Canvas, 94.5 × 70.5 cm (35½ × 27¾ ins)
Signed and dated 'D MACLISE RA/1842' br
Forster Bequest 1876

Painted late in 1842, purchased anonymously by Charles Dickens, and exhibited at the RA in 1843.

The picture was inspired by a visit to St Nectan's Glen during a tour of Cornwall by Maclise with Dickens, John Forster and Clarkson Stanfield. Forster drew Maclise's attention to the waterfall, and the artist made sketches on the spot. Dickens wrote to Felton: 'And they made such sketches, these two men [Maclise and Stanfield] in the most romantic of our halting-places, that you could have sworn we had the Spirit of Beauty with us, as well as the Spirit of Fun' (quoted in Forster, p289).

The hermitage and waterfall in St Nectan's Glen, Tretnevy, near Tintagel, Cornwall, is supposedly the site of the shrine of St Nectan; in about

500, he built a chapel beside the Trevillit River, above the waterfall and 'kieve' (Cornish for basin). There is a tradition that St Nectan rang a silver bell in the chapel tower to warn sailors of danger; before he died he dropped the bell into the basin, where it still rings as an omen of disaster. Various other stories are associated with the site, including, inevitably, the participation of King Arthur (S J Madge, in a 1950 booklet, doubts most of this). Maclise worked on the painting soon after his return to his studio, employing Dickens's sister-in-law, Georgina Hogarth, as his model. B S Long records in the Departmental files seeing her looking at the picture in 1912 (70 years after it was painted); she said the dog in the painting was Maclise's dog Piper. Dickens wrote to his friend Charles Beard on 18 December 1842:

> I want your help in a pious fraud . . . I am very anxious for many reasons, to possess a little picture which Maclise is at this minute painting: and I know very well that if I were to say so, he would either insist upon giving it to me or would set some preposterous price upon it, which he can by no means afford to take.

According to F M Redgrave, Dickens secured the painting, and held a party to unveil it, which – unfortunately – Maclise was unable to attend. (It was suggested by Ley that the correspondence quoted by O'Driscoll (p67) referred to this work and not the 1839 portrait of Dickens now in the NPG, but Ormond finds this unlikely.)

The *Art Union* critic wrote:

> Nothing can exceed the beauty of drawing, painting, and expression, shown by the figure; but, unless it be a portrait thus romantically circumstanced, the dress is by no means in character with the vocation and the condition of life to which the damsel should belong. The dress, arranged in every fold to a nicety, and the style of presence, are those of a maiden rusticating for amusement. The gushing current, the stones, and impending banks, are inimitably drawn, as is also the whining and dripping-wet dog, the faithful *poursuivant* of her infirm footsteps.

When the engraving after the picture was published in the *Art Union* in 1848, it was described as 'The Nymph of the Waterfall': 'Evidently an Irish maiden . . . no "vulgar rustic", but a lovely specimen of nature's aristocracy; her countenance is inexpressibly sweet . . . Mr Maclise's peculiar management of light and shade is here shown to great advantage – a treatment which, in the hands of one of less ability, would be extremely hazardous'. The *Athenaeum* critic had also commented on the colour and light: 'The bluish tint prevails till it is almost spectral: but here the exceeding coldness of tone might arise from the reflected watery lights'.

Ormond relates the subject to paintings of pretty peasant women, particularly Italian *contadine* (see, for example, works by C L Eastlake, FA70 and FA71, (pp75, 76). Ormond also comments:

> 'The wild setting is romantically contrasted with the passive femininity of the model who is treated in statuesque terms, like a figure from a Poussin painting or a Flaxman design. The vertical axis of the girl and waterfall is set off by the round shape of the dark and mysterious cave, which frames her delicate profile. Although the foreground rocks and plants are scrupulously painted, the landscape behind suggests a conventional back-drop, and the musing figure of the girl remains strangely detached. Her mood is echoed in the cool and restrained colour scheme'.

A copy of the work, ascribed to Geddes (presumably Andrew Geddes) was in a private collection in 1913 (photograph in the Department files).

PROV: Purchased from the artist by Charles Dickens via Charles Beard (see above) 1842; his sale, Christie's 9 July 1870 (32, as 'A Girl at a Waterfall', described as 'A very Beautiful work' and bought from the artist 1843), bought Forster £640 10s; bequeathed by John Forster to the museum 1876

Exh:   RA 1843 (472); Winter exhibition of old masters, etc; RA 1875 (258, as 'The Waterfall, Cornwall' (lent by Forster); *Irish Portraits* NPG 1969–70 (III); *Charles Dickens* V&A 1970 (P4); *Daniel Maclise* Arts Council, National Portrait Gallery, 1972 (78)

Engr:  F Bacon 1848 for the *Art Union* 1848 (facing p197)

Lit:   *Athenaeum* 27 May 1843, p512; *Art Union* 1843, p172, 1848, p197; *O'Driscoll*, pp122–3; J Forster *Life of Charles Dickens* ed J W T Ley, 1928, pp289–90; F M Redgrave *Richard Redgrave: A Memoir* 1891, pp314–5; R Renton *John Forster and his Friendships* 1912, pp64–6; ed W Dexter *Letters of Charles Dickens* I, 1938, pp494–5; ed H House and G Storey *Letters of Charles Dickens* I, 1965, p577 (n); *Ormond 1968* p692, *Ormond 1972*, p73.

## The Honourable Mrs Thomas (after Gainsborough)

F22A
Millboard, 32.4 × 22.3 cm (12¾ × 8¾ ins)
Bequeathed by Mrs John Forster 1894

A copy of Thomas Gainsborough's picture (exhibited at the RA in 1777, now NGS; see E K Waterhouse *Gainsborough 1958*, no 323 pl 173).

Gainsborough's painting remained in the Graham family collection until 1859; it was lent by Robert Graham to the exhibition of old masters at the BI in 1848 (138), and it was possibly on this occasion that Maclise made the copy, presumably for John Forster. Forster also owned Gainsborough's portrait of his two daughters, included in his bequest to the museum (F9). Ormond comments that 'Although Gainsborough did not exert a very direct influence on him Maclise was clearly attracted by his painterly style. The vivid brushwork of the copy has parallels in the treatment of several Maclise subject pictures, the *Woodranger* [about 1838, RA collection] for instance'. Maclise also copied Gainsborough's portrait of Jonathan Buttall, the 'Blue Boy'; it was lot 248 in the artist's studio sale in 1870.

Exh:   *Daniel Maclise* Arts Council, National Portrait Gallery, 1972 (27)

Lit:   *Ormond 1972*, p34

## Portrait of John Forster (with Thomas Warrington)

*Portrait of John Forster (with Thomas Warrington)* P35-1935

P35-1935
Canvas, 76.2 × 63.5 cm (30 × 25 ins)
Given by Mr D R Crawfurth Smith 1935

According to an old MS label formerly pasted on the back of the frame, painted by Maclise and Thomas Warrington in 1830.

Maclise met Forster in 1830, the year this portrait was painted, and they became firm friends. Their considerable correspondence is in the V&A Library collection.

John Forster (1812–76), historian, biographer, and collector of books, manuscripts, paintings, drawings and engravings, bequeathed his collections to the museum; the collections notably include 48 oil paintings (both continental old masters and modern British works), and almost all of the manuscripts of Charles Dickens's novels. He first studied law, but from 1832 he was contributing articles and reviews to various publications; he was editor of *The Examiner* 1847–56. His biographies include the *Lives of the Statesmen of the Commonwealth* (5 vols, 1836–9), *Oliver Goldsmith* (1848), *Walter Savage Landor* (2 vols, 1860) and – most famously – the *Life of Dickens* (3 vols, 1872–4). For further details of Forster's career and personality, see H Morley's preface to *Handbook of the Forster and Dyce Collections* (1877), and W Elwin's preface to *A Catalogue of the Printed Books Bequeathed by John Forster* (1888).

Other portraits of Forster in the V&A collections include an oil painting by E M Ward and E M Downard of about 1850 (see P74-1935 p295) and

another of 1887 by C E Perugini, two pen and ink sketches by Maclise of 1840, a watercolour by Clarkson Stanfield of about 1842, and a photograph by Elliott and Fry. Another portrait of Forster by Maclise, in the role of Kitely in Ben Johnson's play *Every Man in his Humour*, exhibited at the RA in 1848, is also in the V&A collections (see F20, p180). For a portrait of his wife, see P36–1935, pxx).

Very little is known of Maclise's collaborator in this portrait, Thomas Warrington; he exhibited seven works at the RA, BI, and SBA between 1829 and 1831.

PROV:  ?Painted for Forster 1830; presumably by descent to his niece Miss Fannie Crosbie; given to the museum by Mr D R Crawfurth Smith 1935

---

# MACMANUS, Henry, RHA (c1810–1878)

Lived in London 1837–44, appointed headmaster of Glasgow School of Art 1845, headmaster of Dublin School of Design 1849–63. Entered Palace of Westminster fresco competition 1843. Exhibited at the RHA 1835–78 (Associate 1838, Member 1857/8), two works at the RA 1839, 1841, four at the BI 1840–43, 15 at the SBA 1839–43, and also at the OWS. Appointed Professor of Painting at the RHA 1873–78. Subjects include landscape, history and genre. Produced numerous book illustrations. According to the *Art Journal*, his work 'showed some peculiarities in the colouring'. Died 22 March 1878 at Dalkey, near Dublin.

LIT:  *Art Journal* 1878, p156 (obit); W G Strickland *A Dictionary of Irish Artists 1913*

### A Study From the Roadside
9099-1863   Neg HF977
Millboard, 16.2 × 22.9 cm (6⅜ × 9 ins)
Purchased 1863

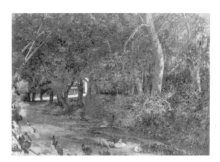

*A Study From the Roadside*   9099-1863

---

# MACNEE, Sir Daniel, PRSA (1806–1882)

Born Fintry, Stirlingshire, 1806, son of a farmer. Apprenticed in Glasgow to the landscape painter John Knox (1778–1845, pupil of Andrew Nasmyth) c1819–23. Worked successively as a lithographer, a painter of snuff-boxes at Cumnock, in the studio of the engraver William Lazars at Edinburgh 1825, and studied with Sir William Allan at the Trustees' Academy, Edinburgh. Exhibited regularly at the RSA from 1825, also 100 works at the RA between 1832 and 1881. Painted principally portraits of an official nature. Elected Member of the RSA 1830, President 1876. President of West of Scotland Academy 1866–76. Knighted 1876. Died Edinburgh 17 January 1882.

LIT:  *Athenaeum* 28 January 1882, p132 (obit); *Art Journal* 1882, p63

### Portrait of Andrew Ure, MD, FRS
421-1869   Neg R1428
Canvas, 90.1 × 69.2 cm (35½ × 27¼ ins)
Given by Mrs Katherine Mackinlay 1869

Macnee exhibited a portrait of Andrew Ure at the RSA in 1828 (159), possibly the present work; the sitter would have been about 50 years old. However, he also exhibited a portrait of 'Dr R F Ure, FRS etc' at the RA in

*Portrait of Andrew Ure, MD, FRS*
421-1869

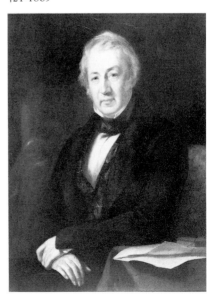

1849 (17), the initials probably a misprint in the catalogue, and this presumably would have shown the sitter at the age of about 71. This is more likely the present portrait; a stipple and line engraving by C Cook after a photograph of Ure by W H Diamond of about 1850 (repr Walker II, no 1277) shows the sitter with similar grey hair, tie, coat and brocade waistcoat.

Andrew Ure (1778–1857) was a Professor of Chemistry at Glasgow, famous for establishing a course of popular scientific lectures for working men – probably the first of their kind – and for several publications including his *Dictionary of Chemistry* (1821). He was elected FRS in 1822, and was a member of other learned Societies; he moved to London in 1830 where he was an analytical and commercial chemist.

The fullest published iconography of Ure is in Walker; there is a watercolour by an unknown artist of about 1820 in the NPG. Another portrait, of 1836, by Macnee of Ure was in the possession of Ure's great great-grandson in 1969 (repr *Country Life* 9 January 1969, p84); the pose is in reverse to that in the present work, and the sitter has dark hair and a different necktie.

Exh:   ?RA 1849 (17)

Lit:   R Walker *Regency Portraits* 1985, I, p515

## MARTIN, John (1789–1854)

Born Haydon Bridge, Northumberland, 19 July 1789; according to the artist, 'by birth, my station could scarcely have been humbler' (quoted in Pendered p21). Apprenticed to Leonard Wilson, a coach painter in Newcastle; left after a year and took painting lessons from the Italian immigrant Boniface Musso (father of the miniature painter Charles Muss). Moved to London 1806. Exhibited 84 works at the RA between 1811 and 1852, 37 at the BI 1813–51, and 62 (including watercolours and prints) at the SBA 1824–48. Subjects mainly literary and biblical, but also landscapes. Won prizes at the BI 1817 and 1821. An opponent of the art establishment, especially the RA, he nevertheless became Historical Painter to Princess Charlotte and Prince Leopold (receiving the Knighthood of the Order of Leopold), and Member of the Academies of Brussels, Antwerp, and Rome. Among his other activities, his elaborate plans for London's sewage disposal were diverting in both senses of the word. Most famous for his vast scenes of (usually) biblical destruction, such as 'Belshazzar's Feast', culminating in the 'Last Judgment' triptych (now Tate Gallery), and for his mezzotint illustrations to *Paradise Lost* (1827) and the Bible (1833). Many of his works were engraved, often by himself. Both famous and notorious in his own day, he was and remains the epitome of the powerfully Sublime type of Romantic artist and personality, dealing with dramas of Nature in conflict with Man. Died Douglas, Isle of Man, 17 February 1854; his studio was sold by Christie's in May and 4–5 July 1854 (see *Athenaeum* report 27 May 1854, p657). His brothers Jonathan and William were equally if not more notorious, as pyromaniac and inventor respectively. Watercolours and many prints by Martin are also in the V&A collections.

Lit:   'Autobiographical Notes' *Athenaeum* 14 June 1834, p459; *Gentleman's Magazine* 1854, vol i, pp433–6 (obit); *Athenaeum* 25 February 1854, pp246–7 (obit); *Art Journal* 1854, p118 (obit), 1855, p195; L Martin 'Reminiscences of John Martin KL' *Newcastle Weekly Chronicle* January–April 1889; M Pendered *John Martin, Painter: His Life and Times* 1923; R Todd 'The Imagination of John Martin' *Tracks in the Snow: Studies in English Science and Art* 1946; T Balston *John Martin 1789–1854: His Life and Works* 1947 (copy annotated by the author in the National Art Library, V&A); *John Martin* Whitechapel Art

Gallery exhibition catalogue 1953; T Balston 'John Martin: New Discoveries' *Burlington Magazine* November XCVI, 1954, p350; J Seznec *John Martin en France* 1968; *John Martin, Artist-Reformer-Engineer* exhibition catalogue Laing Art Gallery, Newcastle-upon-Tyne, 1970; *John Martin* Hazlitt, Gooden & Fox exhibition catalogue 1975; W Feaver *The Art of John Martin* 1975

### Mountain Landscape with Rocks
1423-1869   Neg HH3685
Canvas, 25.4 × 35.5 cm (10 × 14 ins)
Purchased 1869

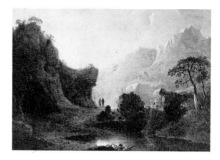

*Mountain Landscape with Rocks*
1423-1869

Feaver dates the work to about 1851, and suggests it is one of the 'small oil pictures' referred to in the artist's autobiographical notes among the various means by which he supported himself and his family 'by pursuing almost every branch of my profession'. In handling, particularly in the distant mountains, it certainly relates to larger paintings such as 'The Bard' of 1817. The mountains, the bizarre formations of the foreground rocks, the cave and pool, and the two figures standing in isolation against the light, are elements that recur in Martin's work throughout his career. The pool and rocks in particular are features that may have inspired other Romantic artists such as Francis Danby: compare for example 'The Enchanted Island' exhibited in 1825.

LIT:   *Balston* p279, no 104; *Feaver* p218 n1

REPR:   *The Queen* 15 August 1814, p303

### Shore Scene, Evening
P67-1968   Neg HF4872
Panel, 7.6 × 10 cm (3 × 4 ins)
Signed 'J Martin' bl
Bequeathed by Thomas Balston OBE through the National Art Collections Fund 1968

LIT:   *Balston* p279, no103

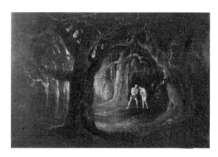

*Shore Scene, Evening*   P67-1968

### Adam Listening to the Voice of the Almighty
P3-1969   Neg GD2436
Canvas, 47.5 × 68.5 cm (18¾ × 27 ins)
Purchased 1969

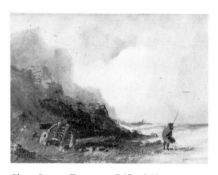

*Adam Listening to the Voice of the Almighty*   P3-1969

An oil sketch preparatory to one of the mezzotint illustrations to Milton's *Paradise Lost* executed and published by Martin in 1827. The commission, probably dating from early in 1823, was from the publisher Septimus Prowett to produce 24 mezzotints for £2000, and an extra £1500 for a second set of smaller plates. Eventually four separate editions were published, as well as issues of proofs and prints without letterpress. The project was the first of Martin's many works in mezzotint, a medium which became an important alternative and a complementary activity for him to painting. The 24 preparatory oil sketches were discovered by the dealer and collector Robert Frank in 1951.

The present work illustrates the passage in book 10, beginning with line 108:

> Come forth.
> He came, and with him Eve, more loath, though first
> To offend discount'nanc'd both, and discompos'd;
> Love was not in their looks, either to God
> Or to each other, but apparent guilt,
> And shame, and perturbation, and despair,
> Anger, and obstinacy, and hate, and guile.

Whence Adam faltring long, thus answer'd brief.
I heard thee in the gard'n, and of thy voice
Afraid, being naked, hid myself.

The story of Adam and Eve, both as told in the Bible and Milton's epic poem, had particularly appealed to Martin since his large painting of 'The Expulsion' exhibited at the BI in 1813. As Feaver comments, Martin's depiction of Paradise was first 'a trim, tranquil, arboretum' in 'The Approach of the Archangel Raphael' mezzotint (repr Feaver, pl 56), while in the present work 'First Eve and then Adam debase themselves and feel ashamed; the oaks writhe sympathetically'. The last of the series, 'The Expulsion' (Weaver, pl 58), shows a rocky, primeval, and threatening landscape. The writhing branches of the trees in the present work follow the twisting figures of Adam and Eve, a feature which is more exaggerated in the mezzotint. The oil sketch also differs from the print in that there is less detail, particularly in the trees, and the contrast of light and dark is less intense.

Sets of three editions of *Paradise Lost* and several proofs are also in the museum collections.

PROV:   Robert Frank 1951; Thomas Laughton, his sale, Sotheby's 18 March 1964 (69); W J F Wing, from whom purchased by the museum 1969

EXH:   *Tyneside's Contribution of Art* Festival of Britain exhibition, Laing Art Gallery, Newcastle-upon-Tyne 1951 (197)

ENGR:   Mezzotint published 1827

LIT:   *Balston* pp95–100; *Feaver* pp72–83

REPR:   (Mezzotint) *Weaver*, pl 57

# MASON, George Heming, ARA (1818–1872)

Born Fenton Park, near Stoke-on-Trent, Staffordshire, 11 March 1818; his grandfather founded the famous Mason's Ironstone Pottery, and his father was a wealthy country gentleman. First studied medicine, then travelled extensively, (supposedly on foot) on the continent 1843–45, settling in Rome where he took up painting, influenced by the work of Giovanni Costa. Returned to England 1858, marrying and settling at the family seat of Wetley Abbey. Visited Paris with Costa 1863. Exhibited 25 works at the RA between 1857 and 1872, and 12 elsewhere, Italian and English landscapes with an idyllic atmosphere and effects of mist and twilight which were both admired and influential. Moved to Hammersmith, London 1864, where he died 22 October 1872. An exhibition of his work was at Christie's 15 February 1873. His portrait by Val Prinsep is in the NPG.

LIT:   Sir J F White 'The Pictures of the late George Mason, ARA', *Contemporary Review* April 1873, pp724–36; 'Holland and Mason' *The Architect* 27 December 1879, pp378–80; Alice Meynell 'George Mason' *Art Journal* 1883, pp43–5, 108–11, 185–8; H Quilter *Pinwell and Mason* Royal Society of British Artists exhibition catalogue 1895; A Chester 'The Art of George Heming Mason, ARA' *Windsor Magazine* (32), 1910, pp491–504; R Haggar *The Masons of Lane Delph* 1952; R Billingham *Life and Work of George Mason* unpublished thesis, University of Leicester 1975; S Reynolds 'George Heming Mason and the Idealised Landscape' *Apollo* February 1981, pp106–9; R Billingham *George Heming Mason* exhibition catalogue Museum and Art Gallery, Stoke-on-Trent, 1982

**At Wetley Rocks, Staffordshire**
309-1887   Neg HF978
Paper, 17.8 × 33 cm (7 × 13 ins)
Purchased 1887

*At Wetley Rocks, Staffordshire   309-1887*

A study made in connection with 'The Gander', a painting exhibited at the
RA in 1865 (31), and now in the Walker Art Gallery, Liverpool (repr A
Staley *Pre-Raphaelite Landscape* 1974, pl 99A).

Wetley Rocks, some ten miles east of Stoke-on-Trent, is near where the
artist's father had acquired the house and estate of Wetley Abbey (built 1824)
inherited by Mason in 1859. He lived there between 1858 and 1864, and
frequently visited thereafter. His friend the artist Giovanni Costa wrote that
Wetley Abbey was 'situated in a smoky rainy country but idyllic in character
and inhabited by a refined race of peasants who (especially the children)
made one think of the Greeks and Etruscans all the more because that part of
the country was called Etruria (G Costa 'Notes on Lord Leighton' *Cornhill
Magazine* March 1897, p377).

The number of finished paintings by Mason is few, but there were several
oil sketches in both the studio sale and the Burlington Fine Art Club
exhibition of 1873, which seem to have been highly priced. At the studio
sale, lot 138 was 'On Wetley Rocks', bought for £152 5s by Leighton,
presumably his friend the artist Lord Leighton. Leighton also bought lot 145,
'A Country Wedding', (see 310–1887 below). It is possible that he bought
them for, or on behalf of, Mason's widow; according to Billingham (1982),
Leighton arranged the studio sale, and continued to help Mason's family.

PROV:   Purchased by the museum from Mrs Mary Mason, the artist's widow,
1887

EXH:   Loan exhibition of works of art, Wedgwood Memorial Institute,
Burslem, 1869 (44 or 45, 'Wetley Rocks', lent by Mrs Mason); *Art
Exhibition* Wedgwood Institute, Burslem, 1879 (98 or 124, 'Wetley
Rocks', lent by Mrs Mason); *George Heming Mason* City Museum and
Art Gallery, Stoke-on-Trent, 1982 (34, as 'Sketch at Wetley Rocks',
on canvas, dated to about 1865)

**A Country Wedding**
310-1887   Neg HF979
Canvas, 10.2 × 23.5 cm (4 × 9¼ ins)
Purchased 1887

*A Country Wedding   310-1887*

A painting of the same title was bought by Leighton for £73 10s at Mason's
studio sale in 1873 (see 309–1887 above); sold in Leighton's studio sale 1896.

PROV:   Purchased by the Museum for Mrs Mary Mason, the artist's widow,
1887

EXH:   *Art Exhibition* Wedgwood Institute, Burslem, 1879 (91, lent by Mrs
Mason); *George Heming Mason* City Museum and Art Gallery,
Stoke-on-Trent, 1982 (39, as on paper and dated to about 1865)

# MILLAIS, Sir John Everett, Bt, PRA (1829–1896)

Born Southampton, Hampshire, 8 June 1829, of a wealthy Jersey family.
Moved to London, studied briefly at Sass's art school and entered RA Schools
1840, its youngest ever student (he was 11). An infant and juvenile prodigy,
he won several prizes in the 1840s. Founder member of the Pre-Raphaelite
Brotherhood 1848. Exhibited 180 works, mainly subject pictures of various
kinds, at the RA between 1846 and 1896, two at the BI 1847–8, 34 at the

Grosvenor Gallery and five at the New Gallery. First popular success was 'A Huguenot . . .' (RA 1852), which also marks an early move away from strict Pre-Raphaelite principles. Elected ARA 1853 (he was elected in 1850, but considered too young), RA 1863. In the 1860s began a series of attractive but (to modern taste) sentimental studies of children, popular through engravings, culminating in 'Bubbles' (1886), which became one of the most famous images of the time through its use as an advertisement for soap. In the 1870s achieved further success and wealth painting portraits of the most eminent people of the day. Illustrated numerous publications 1855–64, notably Moxon's edition of Tennyson (1857), three novels by Trollope (1860–4), and *The Parables of Our Lord* (1864). First artist to be created a baronet 1885; elected PRA 1896. After their marriage was annulled, married John Ruskin's wife Effie 1855. Died Kensington, London, 13 August 1896. His studio sales were at Christie's 1 May 1897, 21 March and 2 July 1898. More than any other 19th-century British artist, from 1850 onwards he has always received mixed critical reactions, ranging up to Ruskin's comment (on 'Peace Concluded' 1856): 'Titian himself could hardly head him now'.

Lɪᴛ: (selected) W Armstrong 'Sir John Everett Millais, his Life and Works', *Art Journal* 1885; M H Spielmann *Millais and His works* 1898; J G Millais (the artist's son) *The Life and Letters of Sir John Everett Millais* 2 vols, 1899; A L Baldry *Sir John Everett Millais, his Art and Influence* 1899; M Bennett *Millais PRB–PRA* RA exhibition catalogue 1967; G Millais (the artist's great-grandson) *Sir John Everett Millais* 1979; M Warner *The Drawings of John Everett Millais* Arts Council exhibition catalogue 1979; M Warner (et al) *The Pre-Raphaelites* Tate Gallery exhibition catalogue 1984

## Lord Lytton, Viceroy of India

F146  Neg H415
Canvas, 114.2 × 74.3 cm (45 × 29¼ ins)
Signed and dated '18 JEM [in monogram] 76' in red br
Bequeathed by Mrs John Forster 1894

*Lord Lytton, Viceroy of India*  F146

Commissioned in 1875 by John Forster (for whom see P35–1935 p184), a neighbour of Millais in Palace Gate, Kensington, and exhibited at the RA in 1876. J G Millais records that 'Forster seems to have been on equally intimate terms with Lord Lytton, for whose character and poetic works he entertained the highest admiration. He [Forster] was himself in failing health, and fearing that he should never see his friend again – for Lord Lytton had just been appointed Viceroy of India – he wrote to Millais in most pathetic terms, begging him as a personal favour to make a portrait of Lytton before he started for the East. This Millais did, but alas! poor Forster died in the following year, before the picture was finished. It is now, by the late owner's bequest, in the South Kensington Museum'. The Rev W Elwin tells the same story in his biographical preface to the 1888 *Catalogue of the Printed Books in the Forster Bequest*, calling Millais 'the artist who could paint him [Lytton] best'.

Edward Robert Bulwer Lytton (1831–91) was the only son of the famous novelist Edward Bulwer-Lytton, also Forster's close friend, and succeeded him on his death in 1873 as 2nd Baron Lytton. His principal career was as a diplomat, culminating in his appointment as Viceroy of India (1876–80) and his elevation to 1st Earl of Lytton in 1880. But he was also a celebrated writer of poetry, at first under the pseudonym Owen Meredith, notably the collection of lyric verse *The Wanderer* (1857), which was dedicated to Forster, and the epic fantasy *King Poppy* (1892). Forster owned copies of his works, and of his father (Forster Collection nos 5557–5608, National Art Library, V&A); Lytton's extensive correspondence with Forster and others was edited by his daughter Lady Betty Balfour and published in 1906. In a letter dated (presumably incorrectly) by Lady Betty to 1875, Lytton described Forster as 'father, brother, and more, much more, to me. No man ever *had*

such a friend as I had in him' (vol I, p346). In a review of that edition, Lytton Strachey assessed Lytton's achievement as both diplomat and writer, and compared his personality to that depicted in the G F Watts portrait (see below; the review was reprinted in Strachey's *Commentaries and Characters* 1933). Richard Garnett, in his DNB article, wrote of Lytton that 'Few have touched life at so many points, have enjoyed such variety of interesting experiences, or have so profoundly fascinated their intimates, whether relatives, friends, or official colleagues'.

The *Art Journal* critic placed the work 'among other notable portraits of the year', along with Millais's portrait of Mrs Sebastian Schlesinger which hung as a pendant to it on the other side of Lord Leighton's 'The Daphnephoria' in gallery 3. The *Athenaeum* admired Millais's Mrs Schlesinger and his portrait of the Duchess of Westminster, only mentioned Lytton without comment, but concluded: 'If Mr Millais will, or must, paint portraits, which seems inevitable, he could hardly be expected to do better than this year shows him to be doing. But where are the fine pictures which made his youth illustrious, and secured the reputation of his manhood?' The *Art Union* had also been disappointed: having praised Millais's 'Over the Hills and Far Away', also exhibited at the RA in 1876, the critic remarked that the artist 'has been often accused lately of doing his work in a slap-dash, careless sort of way' (1876, p216).

To the present writer, Millais's work captures the personality of the sitter in the facial expression, but the rest of the painting (particularly the hands) cannot be compared favourably with the best of the artist's portraits such as 'William Gladstone' (1879, NPG). This may be due to the unexpected – and perhaps unwanted – commission from Forster in the middle of other work in 1875–6 which necessitated greater haste than usual; on the other hand, in his portraits of the 1870s and 1880s Millais does concentrate his skill on the face rather than on the pose, dress, or setting.

Another oil portrait of Lord Lytton, by G F Watts, 1884, is now in the NPG. For the fullest published iconography, see E Kilmurray *Dictionary of British Portraiture* III, 1981, pp128–9).

EXH:   RA 1876 (240); *19th Century English Art* New Metropole Arts Centre, Folkestone, 1965 (78); *An Exhibition for National Library Week*, Central Library, Museum and Art Gallery, Stafford, 1969

LIT:   *Athenaeum* 29 April 1876, p602; *Art Journal* 1876, p231; *J G Millais* II, pp76–7; L Ward *Forty Years of 'Spy'* 1917, p250

REPR:   As frontispiece to vol II of Lady B Balfour *Personal and Literary Letters of Robert first Earl of Lytton* 1906

## Pizarro Seizing the Inca of Peru
121-1897   Neg 55441
Canvas, 128.3 × 171.7 cm (50½ × 67⅝ ins)
Signed and dated 'JEM [in monogram]/1846' indistinctly in red br
Bequeathed by H Hodgkinson 1897

The artist's first exhibition painting at the RA, in 1846, when he was 16. The composition must have been planned by early in the year; Millais received in payment for a sketch a £5 cheque – his first – dated 28 February 1846, and he drew on the back of the cheque a small sketch of himself at work on a painting which is clearly identifiable as the present picture (J G Millais, I, p34, repr p35). The painting was exhibited in the West Room, with the following appended to the title in the catalogue: 'Pizarro himself advanced towards the emperor, whom he took prisoner; while his soldiers, incited by Vincent de Valverde, massacred all that surrounded the Monarch. Vide Luffman's chronology'. (The source is presumably John Luffman's *The Pocket Chronologist, or Authentic register of recent events both foreign and domestic* published in 1806.)

The subject – which seems to be rare – is the capture of the Inca emperor

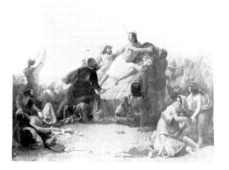

*Pizarro Seizing the Inca of Peru*   121-1897

Atahualpa by the Spanish conquistador Francisco Pizarro at Cajamarca in 1532. As Warner points out, the priest Vicente de Valverde holds aloft a crucifix against a setting sun, symbolising the triumph of Catholicism and the end of Inca religion and power; Warner also links the group of mother and children on the right with the traditional, and appropriate, subject of the Massacre of the Innocents.

Warner draws attention to H P Briggs's painting 'The First Interview between the Spanish and the Peruvians' (RA 1826, now Tate Gallery), which was on public view in the Vernon collection. Honour points out that the famous *History of the Conquest of Peru* by W H Prescott was not published until 1847 (although his similar account of Mexico had appeared in 1843). The most likely source, as Warner claims, is Sheridan's play *Pizarro* (first performed in 1799, and itself an adaptation of von Kotzebue's *Die Spanier in Peru*). The play was performed at the Princess's Theatre early in 1846. Millais frequently attended that theatre, and knew the leading actor James Wallack (whose son Lester later married Millais's sister Emily) who appeared in Sheridan's play there as the Indian hero Rolla. Wallack was the model for Pizarro in Millais's painting. J G Millais records that the artist's father sat for the priest Valverde and for other figures, and Hunt notes that Millais borrowed native costume and jewellery that the artist Edward Goodall had brought back from an expedition he had accompanied in South America. Warner also thinks it likely that Millais borrowed costumes and props from the Princess's Theatre, and that he may have looked at original Inca artefacts in the British Museum.

Hunt described a visit to Millais's studio at his parents' house at 83 Gower Street:

> With his picture of 'Pizarro' on hand, it was necessary to have a large platform placed at an angle to serve for the palanquin on which the doomed Inca was being carried, so that the model serving for the prince should lie correctly on the upset platform, and the position of Pizarro and the adjutant reaching forward from outside be characteristically posed. Notwithstanding this disturbance of symmetry, all the rest of the room was in prim order.

Hunt also mentions the items Goodall had lent, citing the loan as an example of what was later called 'Millais's luck': 'All of these – feathers, beads, etc., – not in actual use on the platform were arranged about the walls as an extra decoration to the small pieces of armour and the swords, which had probably seen their last active service on the fields of Dunbar or Worcester'. Hunt thought the painting:

> 'In every respect remarkable for a young painter, looking more like the work of an artist in his prime; indeed, had he been judged by this production alone, its maturity of style might have seemed discouraging to hope of development. Through life a happy characteristic of Millais in all his different modes of work was, that there were no disorderly scrapings and blotches about the surface . . . parts were obviously unfinished, and others only in a style of preparation: but all, like his room, was in perfect readiness to be shown to the chance visitor'.

After he had discussed the work with Millais, Hunt records him saying 'You'll see I'll make my next much better!'

The *Athenaeum* critic did not notice the painting at the RA exhibition, not surprisingly in the light of the *Art Union* critic's comments:

> 'We regret that the position of this picture deprives us of the opportunity of inspecting its detail. It is a production of much excellence, and is more worthy of a favourable place than many that are better hung. The Emperor, as well as we can see, is reclining upon a kind of litter, and is thus seized by Pizarro: this is the main point of the work, around which all is confusion, pictured in the *melée* of Spaniards and Peruvians –

groups of very spirited figures – drawn with accuracy and placed in relation to each other in a manner most efficiently to support the description. The composition is most judiciously managed: the principal figures are relieved against the sky, while the others are variously distributed, but all contributing to the entirety of the whole. The work is abundantly rich in colour'.

The painting is certainly a remarkable work for such a young artist. Although the composition of the figures is perhaps too reminiscent of the life class as well as of the theatre, H P Briggs's work (cited above) is, if anything, more prosaically 'academic', and that painting was his 27th RA exhibit, painted at the age of 35, the year after his election to ARA.

A small version (or, less likely, a preliminary sketch) was owned by John Miller of Liverpool: it was in his sale of Christie's 22 May 1858 (195) and bought (probably bought in) by the dealer Gambart for £52.10s. It was more recently sold for £3,800 at Christie's 5 June 1981 (40, panel, 41.7 × 49.2 cm (16⅜ × 19⅜ ins), signed and dated 1846); the collection was of a descendant of John Miller.

PROV: The artist's half-brother Henry Hodgkinson by 1872; bequeathed by him to the museum 1897

EXH: RA 1846 (594); Liverpool Academy 1846 (96); Society of Arts 1847 (where it won a gold medal); *International Exhibition* 1872 (130, lent by H. Hodgkinson); *Millais PRB–PRA* Walker Art Gallery, Liverpool, and RA 1967 (4); *The European Vision of America* National Gallery of Art, Washington, USA and elsewhere 1976 (281); *The Pre-Raphaelites* Tate Gallery 1984 (1)

LIT: *Art Union* 1846, p184; J G Millais, I, p18; W H Hunt *Pre-Raphaelitism and the Pre-Raphaelite Brotherhood* 1905, I, pp57–9; H Honour, in *The European Vision of America* exhibition catalogue, under no281; *Warner* (et al) 1984, p48

# MORGAN, John, RBA (1822–1885)

Born Pentonville, London, 14 May 1822. Apprenticed to a show business 1840, designed frames and furniture for Gillow, Jackson & Graham, and the picture dealer Vokins. Studied at School of Design, Somerset House; pupil of Couture and Delaroche in Paris 1853. Exhibited 64 works at the RA between 1852 and 1886, 26 at the BI 1852–67, 114 at the SBA 1853–86, and 17 elsewhere. Most were genre scenes, especially involving children, in the manner of Thomas Webster. The *Illustrated London News* (5 January 1867, pp1–2), reproducing 'Whom to Punish?' exhibited to the SBA, was glad to see the artist return to the humorous from the 'simply picturesque'. Elected Member of the SBA 1875. Moved to Guildford, Surrey, 1872, and in 1882 to Hastings, Sussex, where he died 24 September 1885. His studio sale was at Christie's 1 March 1887. (His birth and death dates are usually given, wrongly, as 1823–1886; the present dates are those given by his son, the artist Frederick Morgan, to TSR Boase).

### A Winter Landscape with Boys Snowballing
999-1886    Neg 58267
Canvas, 61 × 130.7 cm (24 × 51½ ins)
Signed 'J Morgan' diagonally towards bl
Dixon Bequest 1886

Exhibited at the RA (in the North Room) in 1865 as 'Snowballing', and perhaps again at the SBA in 1867, when the price was given in the catalogue

*A Winter Landscape with Boys Snowballing* 999-1886

as £50. The *Art Journal* critic at the RA remarked 'We must not forget to mention, though possibly out of place, that lively scene of "Snowballing" . . . The little mischief-making urchins produce startling effect not only by vivacity of action, but through a force of colour which gains redoubled value by its immediate juxtaposition to the white field of snow'.

Before the painting was acquired by the museum, the rabbet was widened, concealing strips of the painting by about half an inch on the left and three quarters of an inch on the right.

The painting has been reproduced as a Christmas card by the Medici Society, London.

EXH:  RA 1865 (610); ?SBA 1867 (543)

## MÜLLER, William James (1812–1845)

Born Bristol, 28 June 1812, son of a Prussian refugee who was a natural historian and curator of the Bristol museum. His second Christian name is wrongly given as John in DNB. Apprenticed for two years with James Baker Pyne in Bristol; a Member of the Bristol Sketching Club. Exhibited 17 works at the RA between 1833 and 1845, 14 at the BI 1840–45, and ten at the SBA 1836–40. Travelled extensively, making drawings which he used later for finished and exhibited paintings: seven months in Germany, Switzerland and Italy with the watercolourist George Fripp 1834–5, Greece, Egypt, Malta and Naples 1838–9, and Turkey 1843–5. Suffering from a heart condition, he died young in Bristol 8 September 1845. His studio sale was at Christie's 1–3 April 1846, and his work achieved high prices for some years after. A sketchbook and several watercolours are also in the V&A collections.

LIT:  *Art Union* 1845, p318 (obit); *Art Journal* 1864, pp293–5; N Solly *Life of William James Müller* 1875; C Bunt *The Life and Work of William James Müller* Leigh-on-sea 1948; *William James Müller* Bristol City Art Gallery exhibition catalogue 1962; there was an exhibition of Müller's work at the Tate Gallery 1985, but no catalogue seems to have been published.

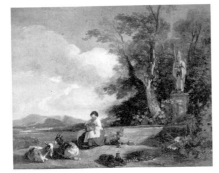

*Girl with a Lamb, near Schaffhausen*
1531-1869

*Landscape with a Horseman*   531-1882

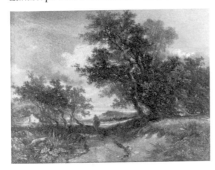

### Girl with a Lamb, near Schaffhausen
1531-1869   Neg GX3997
Copper, 24.8 × 31.7 cm (9¾ × 12½ ins)
Signed and dated 'in Schaffhausen/W J Müller/1835' on conduit centre
Townshend Bequest 1869

Solly describes how Müller visited Schaffhausen on his way to Italy in August 1834: 'From Strasburg they proceeded to Freyburg, and thence to Schaffhausen, situated about three miles above the great falls of the Rhine. The beauty of this spot had been made familiar by Turner's pencil to Müller, and he had determined to spend a week there' (p37). There is a pencil drawing by Müller of the town of Schaffhausen also dated 1834 and in the V&A collections (E1795–1926).

EXH:  *William James Müller* Bristol City Art Gallery 1962 (3)

### Landscape with a Horseman
531-1882   Neg 52960
Copper, 14.6 × 20.3 cm (5¾ × 8 ins)
Signed 'W Müller' bl
Jones Bequest 1882

According to Solly, Müller imitated the work of various old masters, and in this case, particularly in the windswept trees, it may be compared with works

by Jacob van Ruisdael such as the 'Entrance to a Forest' of 1653 (Rijksmuseum, Amsterdam; repr in W Stechow *Dutch Landscape Painting of the Seventeenth Century* 1968, fig 139) which Müller could have known through prints or copies. The work probably dates from the early 1830s.

## Coast Scene with Windmill

1025-1886   Neg 56351
Canvas, 86.6 × 140.7 cm (34⅛ × 55⅜ ins)
Signed and dated 'W Müller 1837' br
Dixon Bequest 1886

Not identifiable with the title of any exhibited work, nor with any of the titles given in Solly's various lists of works. The prices of Müller's paintings rose in the saleroom after his early death, and it seems likely that Flatou (Flatow), a dealer, bought this work and its companion (see *Prov*: below).

*Coast Scene with Windmill    1025-1886*

The general composition if not the detail is presumably taken from Jacob van Ruisdael's famous 'Mill at Wijk near Duurstede' (Rijksmuseum, Amsterdam; repr in W Stechow *Dutch Landscape Painting of the Seventeenth Century* 1968, fig 115).

PROV:   L V Flatou sale, Christie's 29 March 1862 (118, 'A landscape, the companion – equally fine'), bought Cooper £246 15s (but according to Redford (*Sales*) bought in); the companion to lot 117, 'Winter, a grand landscape. A charming example'

## Italian Landscape

1839-1900   Neg 18945
Canvas, 30.5 × 23.8 cm (12 × 9⅜ ins)
Signed and dated 'W Müller 43' br
Ashbee Bequest 1900

## St Benet's Abbey

P63-1917   Neg 18948
Canvas, 52.7 × 73.7 cm (29¾ × 29 ins)
Signed and dated 'W J M[in monogram]üller/1833' br
H L Florence Bequest 1817

On the reverse, an old inscription on the stretcher reads 'The Ruins of St Bennetts Priory Norfolk/now used as a Windmill, for Grinding Corn'. The few remains of the abbey are at Horning, some 15 miles from Norwich; the most conspicuous part of the ruin is the 15th-century gateway. According to Solly (pp12–3), Müller visited Norfolk and Suffolk early in 1831; in 1833, the date of the present work, he toured Wales, Ireland, and Somerset. The painting does not seem to have been exhibited.

*St Benet's Abbey    P63-1917*

PROV:   Presumably in the G R Burnett sale, Christie's 13 February 1875 (141), bought Prance £367 10s (Redford (*Sales*) refers to a 'St Benet's Abbey and Mill, Norfolk' in a G R Burnett sale at Christie's in 1860; it does not appear in the catalogue of 24 March)

## MULREADY, Michael (born c1808, died 1889)

Born London c1808, third son of William Mulready RA. Pupil of his father, and in the RA Schools. Exhibited 21 works at the RA between 1830 and 1851, mainly portraits, and one at the SBA 1835. Very little is recorded of this artist. Lived with his father until the latter's death 1863; died 1889.

### Study of a Hand Holding a Cup
9111-1863
Canvas, 40.1 × 35.6 cm (15¾ × 14 ins)
Purchased 1863

Presumably purchased (for £15 15s) as an example for the students of the South Kensington School of Art to follow. See also 'Study of a Hand Against a Wall', 9112–1863 (below).

### Study of a Hand Against a Wall
9112-1863    Neg 64504
Canvas, 35.6 × 33.1 cm (14 × 13 ins)
Signed and dated 'Michael Mulready/1852' br
Purchased 1863

The hand touches moss growing on a stone wall. Like 'Study of a Hand Holding a Cup', (9111-1863, above), presumably purchased for the benefit of South Kensington students. The work shows similar anatomical detail to that in similar studies by the artist's father.

EXH:   *English Romantic Art* Arts Council 1947 (72)

*Study of a Hand Against a Wall*
9112-1863

## MULREADY, William, RA (1786–1863)

Born Ennis, County Clare, Ireland, 1 April (not 30 as is sometimes recorded) 1786, son of a leather breeches maker and amateur draughtsman. Moved to Dublin 1797, London about 1799; encouraged by the Scottish painter John Graham and the sculptor Joseph Banks, entered RA Schools 1800 (won silver medal for drawing 1806). Pupil and assistant of John Varley, whose sister Elizabeth (also an artist) he married 1803 (separated 1810). Exhibited 78 works at the RA between 1804 and 1862, and five at the BI 1808–9 and 1826. Wide range of subjects in early years, including history and portraits, but by 1815 almost exclusively domestic subjects of precise detail and brilliant colour, and with Wilkie the most popular and admired artist in the genre. He noted his own goals as 'Story, Character, Expression, Beauty'. Elected ARA 1815, RA 1816. Many book illustrations; accomplished draughtsman, particularly perhaps of academic nude studies. Designed first penny postage envelope 1840. Elected member of many distinguished institutions at home and abroad. Died 7 July 1863; his studio sale was at Christie's 28–30 April 1864. His four sons Paul Augustus, William junior (see entry below), Michael (see entry above) and John were all trained as artists. Much manuscript and graphic material in National Art Library and V&A collections, also Tate Gallery.

LIT:   F G Stephens *Memorials of William Mulready RA* 1890; A Rorimer *Drawings by William Mulready* V&A exhibition catalogue 1972; K Heleniak *William Mulready* 1980; M Pointon *Mulready* V&A exhibition book and catalogue 1986. (The three last all have full bibliographies)

The most comprehensive recent *catalogue raisonée* of Mulready's works, arranged in chronological order, has been compiled by Kathryn Moore Heleniak, in her book *William Mulready* 1980, which provides the basis for the following entries. Her numbers have been quoted, and a brief resume given of her listing of alternative versions and related drawings. Further reference should be made to both her book and to Marcia Pointon's catalogue *Mulready* which accompanied the exhibition of 1986 held at the V&A, National Gallery, Dublin and Ulster Museum, Belfast; to Heleniak for more detailed comments on related works and documentation and Pointon for social commentary and aesthetic analysis.

### Near the Mall, Kensington Gravel Pits
FA135 Neg 76917
Canvas, 34 × 47.3 cm (13½ × 18¾ ins)
Sheepshanks Gift 1857

*Near the Mall, Kensington Gravel Pits* FA135

According to the 1907 catalogue, painted in 1813, but more probably 1812, as recorded in the 1844 *Art Union* and the 1864 catalogue. It was originally rejected by the RA, and not exhibited until 1844. According to Stephens, this and FA136 below were commissioned through the painter A W Callcott, but were refused; eventually the present work was sold 'for a very small sum to Mr Welsh . . . a singing master of some reputation'.

The *Art Union* critic called it 'A pendant to "The Mall" [FA136, below] and painted in the following year, 1812. This little picture has much the feeling and character of the other. Both are gems of rare value.' When they were exhibited again, at the Society of Arts in 1848, the *Art Union* found them 'simple in subject, but so extraordinary in execution and feeling, as to place them on a level with the very best productions of the kind that have ever been seen'.

Pointon (pp21–4) discusses this area of Kensington in the 19th century: 'with its gravel walks and unpolluted air [it] was regarded as a resort for health and holidays . . .'. The area was called the Kensington Gravel Pits, now known as Notting Hill Gate. Other artists who lived and worked there in the early 19th-century included A W Callcott, John Linnell, William Collins and David Wilkie. Mulready had moved there by 1811.

A pen and ink drawing, and a pencil sketch of the same area are also in the V&A collections.

EXH: RA 1844 (334); Society of Arts 1848 (XXVII); *William Mulready* South Kensington Museum 1864 (36); *Drawings by William Mulready* V&A 1972 (61a); *William Mulready* V&A 1986 (23)

LIT: *Art Union* 1844, p161, 1848, p208; Stephens 1867, pp66–7, 118; Rorimer pp46–7; Pointon pp24, 28, 47–9, 106, repr. in colour pl V.

### The Mall, Kensington Gravel Pits
FA136   Neg 69197
Canvas, 35.3 × 48.5 cm (14 × 19¼ ins)
Sheepshanks Gift 1857

*The Mall, Kensington Gravel Pits* FA136

Heleniak (78) dates the work to 1811/12. Originally commissioned by A W Callcott on behalf of Mr W Horsley but rejected because of its excessive detail. Stephens claims that the painting went to Mr Thomas Welch before entering the Sheepshanks collection, but Mulready's account book and the Cole manuscript indicate that it went to Mr Welbank. It was originally rejected by the RA and not exhibited there until 1844.

*The Examiner*, 1844, p309, wrote:
'Mulready has two small landscape subjects painted many years back, for which we would gladly give the two finest Ostades we ever saw (if they happened to be ours to give) . . .' Twenty years later in 1864 when again exhibited at the Royal Academy (34), it was described as being 'repaired under Mr Mulready's sanction, but again cracking'.

EXH: RA 1844 (330, 'Painted in 1811); Society of Arts 1848 (XXV, 'Painted in 1812'); *William Mulready* South Kensington Museum 1864 (34); RA 1951–2 (228); 1964 (6); Philadelphia Museum of Art 1968 (147); *John Linnell and his Circle*, Colnaghi 1973 (122); Tate Gallery, *Landscape in Britain*, 1973 (240); *William Mulready* V&A 1986 (22)

*Blackheath Park* FA137

## Blackheath Park

FA137 Neg X1902
Panel, (13½ × 24 ins)
Sheepshanks Gift 1857

A view from John Sheepshanks's house (from the gateway, according to Stephens) at Blackheath, south London, begun in 1832 and exhibited at the RA in 1852. Described as 'a refreshing green bit of nature' by the *Athenaeum* critic, and 'perfect of its kind' by *The Examiner*, it was not admired by the *Art Journal*: 'A Pre-Raffaellesque eccentricity we scarcely expected to see exhibited under this name. It is a small picture – very minute transcript from a locality of no pictorial quality, the work being simply valuable for its intensity of execution . . . the water is a failure. The shaded portions on the right are charmingly felt, and on the left the lively green importunes the eye; but yet in the whole there is an attractive softness and sweetness of execution, which we presume is proposed as a lesson to those youths who "babble of green fields".'

There was more criticism following its exhibition in Paris in 1855: 'In landscape – strictly so called, Mr Mulready is not so fortunate. His "Blackheath Park" all dry and crude, reminds one of a large agate stone, on which a mockery of vegetable life is traced. There is neither greatness nor reality in it; it is cold, poor, and without scope'. A French critic, in *Le Moniteur*, reported in the *Art Journal* in 1855, thought the work 'recalls the prodigiously minute landscape of Buttura [that is, the French painter Eugene-Ferdinand Buttura 1812–1852], where even to the farthest distance one might count the leaves of the trees and the blades of grass. Here the infinite details of daguerrotype are transferred to the canvas, and the artist in his rich and varied creations should only consider this as a tour de force, useless to be renewed, although curious, and requiring for its completion talents of the first order. Let him remember that it is not nature as she is, but as she seems to be, that he is to present to us. That alone is Art'.

The highly finished and intricate detail contrasts with the broader treatment of Mulready's earlier landscapes. As Pointon observes, this may not necessarily be due to the influence of the Pre-Raphaelites around 1850: J F Lewis, Francis Danby and Samuel Palmer were all painting in bright, if not strident colours before 1852. In the early 1850s, Linnell (to whose work the present painting is not dissimilar) was painting minutely detailed landscapes peopled with small-scale rustics and children.

A sketch in pen and sepia wash of the view from the window of Sheepshanks's house is also in the V&A collections (E1800–1910, repr. Lorimer plate 107).

*Seven Ages of Man, or all the World's a Stage* FA138

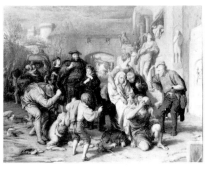

EXH: RA 1852 (96); Exposition Universelle Paris, 1855 (890); *William Mulready* South Kensington Museum 1864 (98); *William Mulready* City of Bristol Art Gallery 1964; *Victorian Painting* Mitsukoshi Gallery, Tokyo, 1967; *Drawings by William Mulready* V&A 1972 (107a); *John Linnell and his Circle* Colnaghi Gallery 1973 (129; *William Mulready* V&A 1986 (24)

## Seven Ages of Man, or All the World's a Stage

FA138 Neg 16916
Canvas, 89.5 × 113.4 cm (35½ × 45 ins)

Heleniak (149) dates the work to 1836–8, and records an oil sketch (location unknown) pen and ink and chalk drawings in the V&A (6268,6426) and a

reverse drawing in pen and ink in the Jupp Royal Academy catalogues. The painting illustrates the soliloquy of melancholy Jacques in Shakespeare's *As You Like It* Act 2, Scene 7. Mulready's account book records the genesis of this work from its commencement to final payment: '1835 Feb 7; First thought of 'Seven Ages' . . . July 11: Comd by Sheepshanks to paint . . . 1839 May 17: Balance for Seven ages (Total payment £787.10s)'. The design was also drawn on wood as a frontispiece to *The Illustrations of Shakespeare's Seven Ages* published by J Van Voorst in 1840.

As Pointon observes, this painting was Mulready's one serious attempt at a large-scale allegorical presentation. It was also his sole venture at the popular genre of pictures with Shakespearean subjects so successfully exploited by C R Leslie and others.

When first exhibited at the Royal Academy in 1838 W M Thackeray, writing as 'Michaelangelo Titmarsh' in *Fraser's Magazine* June, 1838, p759, waxed lyrical on Mulready's success: 'King Mulready, I repeat, in double capitals; for, if this man has not the crowning picture of the exhibition, I am no better than a Dutchman. His picture represents the 'Seven Ages', . . . not one of those figures but has a grace and soul of its own: no conventional copies of the stony antique; no distorted caricatures, like those of your "classiques", David, Girodet and Co. but such expressions as a great poet would draw, who thinks profoundly and truly, and never forgets (he could not if he would) grace and beauty withall).' Thackeray, an accomplished caricaturist, accompanied this panegyric with an engraving of Titmarsh placing a laurel wreath on the brows of a bust of Mulready.

Later critics were less enthusiastic. The *Illustrated London News* (25 July, 1863, vol 43, p93) commented on the 'rather flimsy though elegant mannerism of The Seven Ages', and the *Art Journal* in 1864 (p13) complained that . . . 'it is far below the standard of his pictures from "the Vicar of Wakefield".' The 1864 catalogue entry (78) contains a long and detailed description of each character in the painting.

Exh: RA 1838 (122); Society of Arts 1848 (XXVI); *William Mulready* South Kensington Museum 1864 (78); Arts Council, *Romantic Movement*, 1959, (264); Bristol Cathedral, *Victorian Narrative Painting*, 1977; *William Mulready*, V&A 1986 (118)

**The Fight Interrupted**
FA139   Neg 31856
Panel (on a gesso ground), 71.8 × 93.2 cm (28½ × 37 ins)
Signed 'W Mulrea' (the rest cut off), and, according to the 1864 exhibition catalogue, dated 1816 on the pump at r., although the date is no longer visible
Sheepshanks Gift 1857

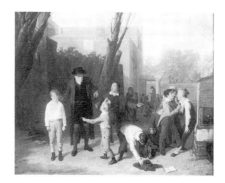

*The Fight Interrupted*   FA139

Heleniak (93) dates the work to 1815/16. The work appears in the *Account Book* under 1815 with the note 'Comp L&D [that is, composition, light and dark] ½ done'; it was exhibited at the RA in 1816, and evidently bought there, according to the *Account Book* entry for 22 July 1816, by Viscount Whitworth for £157–10–0.

The critic of *Ackermann's Repository of Arts* (June 1816, p355), thought that 'this picture, is, in every respect, superior to the last [that is, Wilkie's *The Rabbit on the Wall*]: it has far more expression, better drawing, and chaste colouring. It is, in fact, the point of attraction in the great room'. Such was the painting's success that some later critics overrated its importance: for example, the *Athenaeum* reviewer in 1864 thought: 'The exhibition of this work insured Mulready's election as ARA in the November following its appearance at the Academy', while in fact the artist had been elected ARA in November 1815 (probably on the strength of *Idle Boys* exhibited earlier that year) and RA very soon afterwards ('A course of which there is no subsequent instance' – Redgrave *Century* 1866, II pp310, 11).

The fullest description and analysis of the subject accompanies an engraving by Lumb Stocks in the *Art Journal* of 1875.

The subject matter of the painting has aroused comment since its first exhibition; the *New Monthly Magazines* (July 1816, p355) critic wrote: 'The interest which this picture excites would doubtless astonish, and perhaps disgust a foreigner, who, unused to such scenes, might censure the taste of the artist in the selection of his subject, but for our own parts we prefer the representation of a fight of this sort, which is purely national, to all the pictures of Waterloo which we have yet seen: – in fact, we have now no small authority for our preference, for, at a late public dinner, a gallant general, who has fought and bled for his country, declared that he owed all his success and reputation to the first black eye he received at Westminster; and "no less strange than true", this remark was followed by a similar avowal from a British judge . . .. On the whole, we hesitate not to pronounce this one of the very best pictures in the room.'

Heleniak draws attention to Mulready's interest in boxing, one of the most popular sports around 1800, and encouraged by his father (he seems to have received instruction from the celebrated pugilist Mendoza). W P Frith recorded in his *Autobiography* (III, p228) that Mulready 'always took great interest in street fights when opponents were equally matched. I saw him one day with an intense expression of interest on his face . . . and when I reached him I saw the cause of his interest in the form of two boys who were pummelling one another, displaying what he called true British pluck.' Heleniak seems right to note that Mulready 'was also known to enjoy watching rough street fights between boys'; it is perhaps significant that his drawing 'from the living model' in 1800 was of wrestlers (also V&A collections). A drawing by Mulready in the V&A collections (6633) records a street fight.

Exh:   RA 1816 (65); Royal Hibernian Academy, 1817; Society of Arts 1848 (XXXII); *William Mulready* South Kensington Museum 1864, (46); Guildhall 1904 (115). RA 1951/2 (324); Arts Council, 1933 (103); RA 1968 (193) *Mulready* V&A 1986 (102).

## Giving a Bite
FA140   Neg 7603
Panel, 50.4 × 39 cm (20 × 15½ ins)
Signed and dated 'W Mulready 1834' b1

Heleniak (139), who dates the work to 1834, records five pen and ink drawings at the V&A (6390–6394), a drawing of hands at the Whitworth Art Gallery, Manchester, a watercolour signed WM at the Ulster Museum, and a watercolour in the Eric W Phipps collection.

Listed in the artist's *Account Book* under 15 September 1834 as painted for (or, less likely, eventually sold to) John Sheepshanks for £262 10s, and exhibited at the RA in 1836. It is a version of *Lending a bite*, painted for Earl Grey and shown at the RA in 1819 (143); see Heleniak pp200–1 (cat no 97) for later provenance: it was sold at Sotheby Belgravia 29 June 1976 (63, panel, 77 × 66 (30½ × 26 ins), signed with monogram and dated 1819) and exhibited in *Mulready* at the V&A in 1986 (130) from a private collection (see Pointon pp157–8). The 1819 painting is similar to the present work only in the poses of the two boys (although even they are adapted); the background setting and the other characters in the scene are different.

The narrative was also changed between 1819 and 1834; the *Annals of the Fine Arts* for 1819 (1820, p.308) commented on the earlier picture at some length:

'We have been accused of passing over the merits of Mulready, but are not aware of the justice of the accusation. Mulready, in comparison with Wilkie, exhibits less mind, and therefore is sooner forgotton; and we

*Giving a Bite*   FA140

acknowledge we did forget one of his pictures, a few years since, for which we received several hints. In painting, that is in execution, we think him the first of his class in England, and cite this picture as a proof. As a story, it is simple: one boy who has been successful enough to win an apple of a gambling old dame behind him, is lending a bite to his friend. The expression aimed at, is a pinching regard to the remnant of his apple, by the lender, and a grasping eagerness to obtain as much as possible, by the borrower'.

In the present work, the narrative is further simplified. The fullest description was given by James Dafforne in the *Art Journal* in 1864:

it 'belongs to the humorous class of subjects, that class which forms the majority of Mulready's best-known works. A marvellous faculty he had for developing character in rustic juveniles, and bringing it out in all its varied truthful aspects. Look at the boy who is owner of the apple; he is evidently not large-hearted; awed, in all probability, by the threats of the bigger and stronger boy, he allows him to take a "bite", yet how tenaciously he holds the apple in his two hands, his thumbs just indicating the portion to be absorbed, certainly not as a free-will offering; his elbows are placed close to his sides, the better to resist any attempt to get beyond the limits of his assigned generosity; he shrinks from the attack of the devourer on his property, and his countenance is marked by misgivings and apprehension. The boy who has extorted the unwilling favour is a hungry-looking fellow, his mouth is opened widely, and we may be sure he will make the most of the opportunity. The young lady with the sleepy child looks on to see the result of the operation, and will, doubtless, have something to joke the donor about when it is ended. A kind of repetition of the incident, reversed, appears in the Savoyards' monkey and the rustic's dog; the latter looks at the ape as if he contemplated giving it a bite, and the little animal shrinks back in terror between the knees of his master, who, like the girl, takes no small interest in the fate of the apple.'

The *Gentleman's Magazine* described the present work as 'A juvenile figure-piece in the highly-finished style of the artist. Mr. Mulready has, however, repeated the face of the fighting boy, introduced by him into his celebrated picture of the *Wolf and the Lamb*. So very little as he offers in the way of his art, he has no excuse for doing this twice over in a work of the size of the hand.' It is evident that the fighting boy in *The Wolf and the Lamb* (exh. RA 1820, bought by George IV, now Royal Collection), the boy holding the apple in both the 1819 *Lending a bite* and the present work, and the injured schoolboy in the 1816 *A Fight Interrupted* (see FA139 above), were all painted from the same model, most likely one of Mulready's four sons.

EXH:   RA 1836 (117); Society of Arts 1848 (XLV); *William Mulready* South Kensington Museum 1864 (73); Guildhall 1904 (92)

## First Love
FA141   Neg 7854
Canvas, 76.9 × 61.7 cm (30½ × 24½ ins)

Heleniak (150), who dates the work to 1838/9, records one related drawing in the Ashmolean, Oxford, three in the V&A, (6021, 6401, 6402) and two in the Whitworth Art Gallery, Manchester.

The *Art Union*, 1840, p74 wrote: 'First Love is a delicious composition; a youth is whispering into the ear of as fair a maiden as was ever born of woman; she is too young to comprehend the meaning of the love-words that call the flush into her cheek and brow; the morning of their years and hopes is made to contrast happily with the rich sunlight of a departing day; and just at the moment when some answer must be made, forth rushes from the cottage

*First Love*   FA141

the girl's mother and a noisy boy, with a summons to the supper table. It is a sweet story sweetly told; and negatives the assertion that a painter can preserve but one incident in a tale; what a volume of thought is produced by this single passage in a life!'

More prosaically W M Thackeray as Michaelangelo Titmarsh in *Fraser's Magazine* (June 1840, pp722, 726), broke into 'cod' German: '. . . but dat bigture of First Loaf by Herr Von Mulready ist wunderschon! . . . where in the while works of modern aertists will you find anything more exquisitely beautiful?'

Eight years later *The Athenaeum* on 10 June 1848 (p584) wrote: 'In 1839 Mr Mulready proved again that he could invest a subject drawn from scenes of humble life with the attributes of the highest walks of his art. A poetic spirit breathes through his presentment of First Love.'

In her entry in the 1986 catalogue Pointon points out the complex layers of meaning implicit in the painting's title: 'Is "First Love" the love of the child for its mother or of the youth for the young woman? If this is "First Love" what is second love?'

EXH:    RA 1840 (133); Society of Arts 1848 (XXII); *William Mulready* South Kensington Museum 1864 (81); Dublin, International Exhibition 1865 (44); *William Mulready* V&A 1986 (136)

## Interior with a Portrait of John Sheepshanks
FA142   Neg H1603
Panel, 50.4 × 39.7 cm (20 × 15¾ ins)

Heleniak (133), who dates the work to 1832/4, records two related drawings in the British Museum and four at the Victoria and Albert Museum (FA 75–78). Sheepshanks is shown sitting in the drawing room of his London home at 172, New Bond Street examining his portfolios while his housekeeper approaches with the mail and his morning tea.

EXH:    *William Mulready* South Kensington Museum 1864 (71); RA *British Portraits* 1956–7 (380); National Gallery of Ireland *Irish Portraits 1660–1860*, 1969–70 (108); Columbus Gallery of Fine Arts *Aspects of Irish Art*, 1974 (39); *William Mulready* V&A 1986 (78)

*Interior with a Portrait of John Sheepshanks*   FA142

## Open Your Mouth and Shut your Eyes
FA143   Neg GH1582
Panel, 31.5 × 30.2 cm (12½ × 12 ins)
Sheepshanks Gift 1857

Painted mainly in 1838 and exhibited at the RA in 1839. The artist's Account Book records under the list of works for 1814: 'Open your mouth'; and under 1835: 'July 27 "Open your Mouth" on panel'; and under 1838: 'Oct 17 J Sh:[eepshanks] 78.15 "Open your Mouth" 157.10'. Of the four preparatory drawings exhibited at South Kensington in 1864 (132, 150, 171 and 195 – the last now in the V&A collections E1798–1910), one was dated 20 December 1814.

While *The Examiner* thought it 'has the faults of its companion [that is, 'The Sonnet', see FA146, p206]; but the merits it does not possess in equal degree', the *Art Union* described it as 'Another of his delicious subjects. The lovely girl . . . is beautifully painted'. *Blackwood's Magazine* found that 'The Sonnet and its companion are very beautiful . . . somewhat too hot, but they are gems'. The *Literary Gazette* considered 'The Sonnet' 'a beautiful pastoral', and the present work 'a boyish sport', but that both were 'rendered interesting by their skilfull treatment and the rich and harmonious tone and colour under which they appear'.

The subject is taken from an old nursery saying: for M W Sharp's painting of the subject at the exhibition at the Society of British Artists in 1826 (188), the catalogue quotes also the second line: 'Open your mouth, shut your eyes, and see what Providence will send you'.

*Open Your Mouth and Shut Your Eyes*   FA143

Pointon notes the work as: 'A fine example of Mulready's mature technique – brilliant pigment over a white ground – this is another painting based on a childish game involving oral satisfaction [Pointon is rightly referring to the 'Lending a Bite' of 1819, now in a private collection, 'Giving a bite', a watercolour of 1834 now in the Ulster Museum, Belfast, and 'Giving a bite', exhibited at the RA in 1836, also in the Sheepshanks Gift (see FA140, p200)]. Here, however, the protagonists are a young man, accompanied by a baby, and a nubile girl with exposed shoulders. The image undoubtedly possessed explicit erotic overtones for a contemporary audience and is a reminder of the risqué connoations of games as they occur in a literary narrative tradition, as for example, in the Hunt the Slipper scene in Goldsmith's *The Vicar of Wakefield* [it is perhaps worth remembering here that Mulready illustrated the 1843 edition of that book]. There seems no doubt that the erotic content was very deliberately produced by the artist who possessed a clear understanding of his audience, and of the operation of desire with regard to ownership of paintings with suggestive images such as this.'

Pointon then refers to the entry in Mulready's personal notebook (now National Art Library, V&A) in May 1844; she comments that that 'this extraordinary passage suggests a deliberate strategy and a consciousness about the affectiveness of his subject matter and how to make it acceptable to an audience regarded in a cynical light'. This passage reads: '. . . in the present state of the art almost any subject matter may be raised into importance by truth and beauty of light and shade and colours with an ostentatious mastery of execution. The higher qualities of art, beautiful form, character and expression are chatted about, not felt or understood but by very few. Expression, if strong, or character bordering on caricature are recognised by the people. Female beauty and innocence will be much talked about and sell well. Let it be covertly exciting, its material flesh and blood approaching a sensual existence and it will be talked more about and sell much better, well in the first state, doubly well in the second, but let excitement appear to be the object and the hypocrites will shout and scream and scare away the sensuality, the birds that would be pecking: when the scarecrow hypocrisy is silent, some blessed watchful crow will bear the fruit to his quiet parsonage'.

While it is possible to read the present work as a family group – father/older brother, daughter/younger sister, and son/younger brother – enjoying an afternoon of fruit-picking in the countryside, Mulready does not make this reading very clear. It is worth noting that the pose of the man may well be an adaptation of Michelangelo's figure of Adam in the Creation section of the Sistine Chapel ceiling fresco, although seen from a different angle and in reverse (although this is not so evident in a preliminary drawing also in the V&A collections, E1798–1910, repr. Rorimer fig. 39). The work's companion piece, 'The Sonnet', also used Michelangelesque prototypes. The image of Adam would refer to the Garden of Eden and the Fall. Also, despite Mulready's comments in his Notebook (quoted above) about covert excitement, it seems unlikely that Pointon's reference to 'oral satisfaction' can be interpreted further to encompass fellatio – however common that practice might have been in the nineteenth century. But the subject is unusual, and, if the present work shows an innocent family genre scene, it is very unusually depicted, particularly if one considers the observant Cupid-like child on the right.

Heleniak is surely correct to note 'undertones of sexuality', although the present writer disagrees with her description of the right-hand figure as a 'small baby'; Heleniak also notes the 'inherent sensuality, which was unconsciously acknowledged in the *Art Union*'s commentary' and demands an alternative reading from 'the seemingly innocent theme of rustic family life'. Most tellingly, Heleniak points to the cherries and green apples which indicate 'the pre-adolescent girl's own unripe state as "green fruit", to borrow the 19th-century phrase for girlish virgins'. Heleniak continues to discuss the phenomenon of love scenes between children, and between children and adults, concluding 'This passion for the bud, the unripe fruit, engendered a

flourishing market, in very young girl prostitutes or older women coyly dressed to look like children' (see R Pearsall *The Worm in the Bud: the world of Victorian sexuality* 1969, pp 91, 290). The present work 'can be viewed in this context; its expressive power derives in part from the suggestion of seduction, of innocence violated'.

Exh: RA 1839 (143); Society of Arts 1848 (XLVIII); *William Mulready* South Kensington Museum 1864 (79); *William Mulready* V&A 1986 (135)

Lit: *Examiner* 1839, p486; *Art Union* 1839, p68; *Blackwood's Magazine* September 1839, p316; *Literary Gazette* 1839, p316; Heleniak pp130–2, 212–3 (cat. no. 145, repr. pl 130); Pointon pp93–4, 158 (repr, in colour p137, pl XXIX)

Repr: *English Art in the Public Galleries of London* nd [1888], p129; Rorimer p36 (fig. 39a)

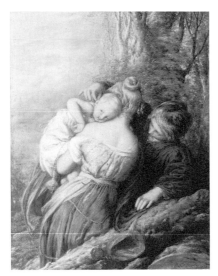

*Brother and Sister* FA144

## Brother and Sister

FA144   Neg GH1583
Panel, 30.2 × 24.6 cm (12 × 9¾ ins)
Signed and dated 'W Mulready/1836' br
Sheepshanks Gift 1857

Also known as 'Pinch of the Ear', the work appears in the artist's *Account Book* under 1835 as 'July 18 "Ear" on Panel'; under 1836 'J. Sh[eepshanks] £152.10 "Ear"', and under 1837 'March 10 J. Sh £157.10 Brother and Sisters: "Ear" [and] Finden. Copyright "Ear"'. It was exhibited at the RA in 1837.

The critic of the *Gentleman's Magazine* wrote of this and 'The Toy Seller' (see FA149, p207) that Mulready 'does not appear to advantage. His pictures are mannered, and though abundantly laboured, they are altogether wanting in originality and effect. So few as he exhibits, he ought to give the public no cause to complain of them upon the score of sameness. Surely he might give a little play to his imagination, and employ his talents on something rather more elevated than he has hitherto done'.

Heleniak rightly groups the painting with 'Open your mouth . . .' (see FA143, p202) and 'First Love' (see FA141, p201), and points out that while the young woman 'could conceivably be the boy's older sister (as the title implies and as contemporary reviewers read the painting), their close proximity and her attractive shoulders suggest, perhaps inadvertantly, another interpretation – one that apparently occurred to the artist as well, for Mulready's earliest sketches for 'Brother and Sister' and 'First Love' were drawn on the same day.' The two sketches are dated by the artist 17 July 1835 (repr Heleniak pl 128–9). However, as Pointon notes, 'In the drawing a darkly hatched male figure reaches over and around the woman's body, trapping her with his knee. In the painting the knee is replaced by a tree trunk and the sexual tension implicit in the sketch is much reduced. Instead the woman's dress is allowed to slip from her shoulder thus moving the emphasis from the male to the female figure.

A larger (76.9 × 62.4 cm), 30½ × 24¾ ins) replica, also known as 'The Young Brother', with a few variations was commissioned by the collector Robert Vernon (1774–1849); it was not finished until eight years after Vernon's death, was paid for by his executors, exhibited at the RA in 1857 (24), included in the Vernon Bequest to the National Gallery, and is now in the Tate Gallery (for full details see Heleniak, cat no 170, p221, repr pl 151). At the 1857 RA exhibition, John Ruskin thought it 'without exception, the least interesting piece of good painting I have ever seen in my life', and that Mulready 'succeeds in using more skill in painting Nothing than any other painter ever spent before on that subject.'

In their reviews of the Sheepshanks Gift in 1857, both the *Art Journal* and the *Athenaeum* compared the two versions: 'apparently the sketch from which the Vernon picture, exhibited this year, has been painted', and [it]

shows how inferior the copy in this year's Academy is. The expression is quite lost in the duplicate, and the beautiful pattern of the girl's gown is changed in colour, but not to advantage.'

Liebreich opined that the difference in colouring between the present work and the later Vernon replica due to the deterioration of Mulready's eyesight, particularly the yellowing of his retinae; the colouring of the later picture can be corrected by viewing it through yellow glass.

A watercolour version of the composition was recorded in a US private collection in 1904.

EXH:    RA 1837 (61); Society of Arts 1848 (XLIX); *Exposition Universelle* Paris 1855 (892); *William Mulready* South Kensington Museum 1864 (77); *William Mulready* V&A 1986 (114)

ENGR:    ? E. Finden (see above)

LIT:    *Gentleman's Magazine* (VII) 1837, p629; *Art Journal* 1857, p240; *Athenaeum* 1857, p857; Dafforne pp47–50; R Liebreich 'Turner and Mulready: On the Effect of Certain Faults of Vision on Painting with Especial Reference to their Works' *Macmillan's Magazine* 1872 (XXV), pp499–508; Heleniak, pp129–30, 213 (cat no 147, repr pl 147); Pointon p129 (repr in colour pl xxxvi)

## Choosing the Wedding Gown
FA145   Neg 7627
Panel, 52.9 × 44.7 cm (21 × 17¾ ins)
Sheepshanks Gift, 1857

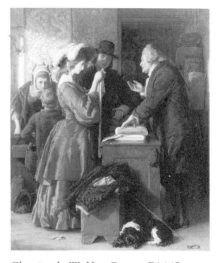

*Choosing the Wedding Gown*   FA145

Heleniak (163) records an oil sketch (location unknown) and a cartoon in red chalk and pencil, private collection (repr pl 136).

The subject is taken from the opening sentences of Oliver Goldsmith's novel *The Vicar of Wakefield* '. . . I had scarce taken orders a year before I began to think seriously of matrimony, and chose my wife, as she did her wedding gown, not for a fine glossy surface, but for such qualities as would wear well.' Mulready had provided a frontispiece for Van Voorst's 1843 edition of the novel – the composition on which this painting is based. When first exhibited at the Royal Academy in 1846 (140) the work scored an immense success, and proved to be one of the artist's most acclaimed paintings.

Oliver Goldsmith's works were one of the most popular pictorial sources for academic painters, so frequently used as subjects that W M Thackeray, whose little-known art criticism is a valuable guide to Victorian taste, refused to review any more paintings on these themes. His resolution was broken however when he saw and admired the 'Wedding Gown' which he described in *The Morning Chronicle* (5 May, 1846): 'For colour and finish it may rank by any cabinet picture of any master. It does not create pleasure merely, but astonishment . . . a blaze of fireworks is not more intensely brilliant: it must illuminate the whole room at night, when everybody is gone, and flare out like a chemist's bottle . . . '. Thackeray's praise was echoed by the *Examiner* (1846, p293): 'a subject which admits of the artist indulging in the deepest luxury of colour without appearing unnatural. The richness of the stuffs in the foreground, the harmonising browns of the counter, the equally rich pure blue in which both are set, are real; only expressed to ordinary eyes as intensely as the painter sees them.'

Like Landseer's *Old Shepherd's Chief Mourner* this famous painting continued to attract many other laudatory commentaries throughout the 19th century. For a more extensive listing, including liberal quotations therefrom, see Arts Council *Great Victorian Pictures* 1978, (39). References chart the progress of the composition in Mulready's account book, and Sheepshank's payments. According to F G Stephens (p95) he received 1000 guineas for the work.

Exh: RA 1846 (140); Society of Arts 1848 (XXXI), 1855 (889); *William Mulready* South Kensington Museum 1864 (93), Guildhall, 1904 (88); Arts Council *Great Victorian Pictures*, 1978 (39); *William Mulready* V&A 1986 (141)

*The Sonnet* FA146

## The Sonnet
FA146   Neg 5889
Panel, 35.3 × 30.2 cm (14 × 12 ins)
Sheepshanks Gift 1857

Heleniak (151), who dates the work to 1839, lists a chalk cartoon in the National Gallery of Ireland.

The *Art Union* (1838, p68) wrote: 'A bit of true character that will tell with all who have been lovers. The youth is fiddling with his shoe tye, but casting upwards a sly look, to ascertain what effect his lines produce upon the merry maid who reads them. His face is hidden, but we can guess his feelings, when he finds her placing her hand before her lips to suppress her laughter. It is admirably painted, but we venture to object to the lavish use of light green to which the artist has, of late, resorted.' Another critic in the same number of the *Art Union*, p81, commented perceptively: '. . . were it permitted to talk of living British artists, I might tell of a little picture called 'The Sonnet', of a spans breadth, which reminds the spectator of the magnificent genius of Michel Angelo in the Sistine Chapel.'

Exh: RA 1839 (129); Society of Arts 1848 (LI); 1864 (80); Guildhall 1904 (89); Whitechapel 1905 (68); RA 1934 (559); Louvre 1938 (97); 1964 (18); Philadelphia Museum of Art 1968 (148); Sheffield, Mappin Art Gallery, *Victorian Paintings* (10); Cork 1971 (83); *La Peinture Romantique Anglais* Paris 1972 (200); V&A 1986 (160)

*A Sailing Match*   FA147

*The Butt – Shooting a Cherry*   FA148

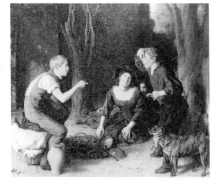

## A Sailing Match
FA147   Neg 5890
'Creeping like snail unwillingly to school'
(Shakespeare *As You Like It* Act II, scene 7)
Panel, 35.3 × 32.1 cm (14 × 12¾ ins)
Sheepshanks Gift, 1857

Heleniak (137), a smaller reduced replica of a painting exhibited in 1831 (location unknown). Heleniak (129) cites related works to both paintings – a cartoon and an outline drawing at the V&A (6322–23), a pen and ink drawing, Auckland Art Gallery; pen and ink drawing, Henry E Huntingdon Art Gallery, California; pencil and chalk drawing, Whitworth Art Gallery, Manchester.

A classic example of Mulready's interest in contrasting the values of formal education with the process of learning through play. The poor idle boys who attempt to blow their boat along with a roughly improvised roll of paper have sent one of their number to fetch a bellows. A wealthy boy who would like to join in the game is being 'led from temptation' by his mother or nurse. Such pictorial analogies have their origin in Dutch 17th-century painting.

Exh: *William Mulready* South Kensington Museum 1864 (72); *William Mulready* V&A 1986 (111)

## The Butt –Shooting a Cherry
FA148   Neg 15043
Canvas, 38.4 × 45.4 cm (15¼ × 18 ins)
Sheepshanks Gift 1857

Heleniak (166) records a related watercolour at Glasgow Art Gallery and a chalk drawing in the V&A (6303)

Stephens reports how John Linnell visiting Mulready's studio in 1847

found the long neglected canvas (begun 1822) with a hole in it and very dusty and encouraged Mulready to work on it again, which he did while staying at Capheaton with Sir John Swinburne. When exhibited the picture was well received, the *Art Union* (1848, p168) commenting: 'There are in this picture qualities which Masaccio and his most distinguished followers did possess; and others for which they strove a life time, qualities which we confess we heartily wish had been bestowed upon another subject'. But *The Examiner* (1848, p293) wrote: 'For power and richness of colour this picture is marvellous. It lights the room all round it . . .'; while the *New Monthly Magazine* (1848 Part II, p230) commented: '. . . one of the gems of the exhibition. If you see a very little picture, with a very large crowd assembled to see it, you may be pretty sure it is by Mulready.'

Exh:  RA 1848 (160); 1855 (891); *William Mulready* South Kensington Museum 1864 (95); Arts Council *English Romantic Art*, 1947 (55); 1964 (23); *William Mulready* V&A 1986 (143)

## The Toyseller
FA149   Neg GX47
Panel, 17 × 22 cm (7½ × 9¾ ins)
Signed and dated WM 1835 lr
Sheepshanks Gift 1857

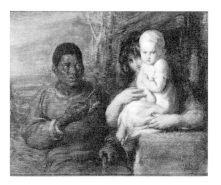

*The Toyseller*   FA149

Heleniak (141) dates this painting to 1835, and records a smaller sketch (location unknown) for the present work. Mulready's last work over 20 years later was to be a nearly life-sized version of the same theme of a black toyseller showing a toy to an alarmed child (National Gallery of Ireland (387)). As Heleniak observes, the present small painting should be regarded as an oil sketch for the later larger version, a subject which clearly possessed a special attraction for a colourist of Mulready's outstanding ability.

Exh:  RA 1837 (74); Society of Arts 1848 (VIII); *William Mulready* South Kensington Museum 1864 (76); 1964 (17)

Lit:  Stephens *List*, Waagen *Treasures* II, p304; Heleniak 141 p211

## The Intercepted Billet
FA150   Neg FH2057
Panel, 25.2 × 20.8 cm (10 × 8¼ ins)
Sheepshanks Gift 1857

The painting grew as the artist worked on it, as the catalogue entry of 1864 explains: 'The centre part of the picture is on panel, screwed into a zinc trough, and the edges filled in with cement of isinglass and whiting, and then prepared for painting, so as to give the artist room to carry out an idea that had grown under his hands.'

The *Art Union* 1844, p156: 'A small picture composed of two heads – one that of an Italian noble of the palmy days of Venetian bravoism; the other that of his servant, who has just delivered to him a bouquet and a billet, intended for any hands other than his. He clenches the flowers, and his eye is fixed in a muttered vow of vengeance. The style of the story is lurid and emphatic.'

Pointon notes that drawings in the Museum collection indicate that the painting relates to John Varley's theories as published in A *Treatise on Zodiacal Physiognomy* in 1828, a tract which combined Le Brun-inspired theories of expression with the principles of astrology that were popular in the Blake-Varley circle.

One of the artist's most powerful small compositions with an intensity which oddly parallels and anticipates a dramatic monologue of Robert Browning, 'The Statue and the Bust'.

Exh:  RA 1844 (145); Society of Arts 1848 (XLIII), *William Mulready* South Kensington Museum 1864 (88); V&A 1986 (82)

Lit:  Stephens *List*; Rorimer, p117; Heleniak (159) p217

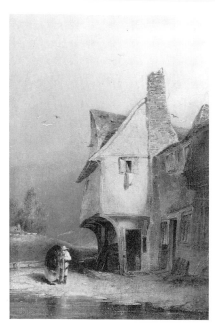

*An Old Cottage, St Albans*   FA151

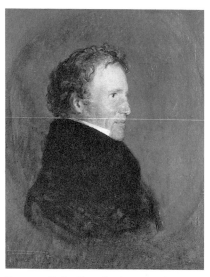

*Portrait of John Sheepshanks*   FA152

*Hampstead Heath*   FA153

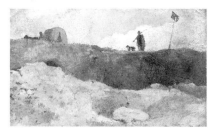

**An Old Cottage, St Albans**
FA151   Neg 52046
Canvas, 35.3 × 25.2 cm (14 × 10 ins)
Sheepshanks Gift 1857

Heleniak (13) dates the work to 1805–6, and records a pencil drawing in the V&A (back of 6236) and a more detailed drawing in her own collection, reproduced pl 52. One of the artist's earliest surviving cottage scenes, a subject very popular around 1800 with painters of the 'picturesque' such as George Morland. This cottage scene is very close to certain works by J S Cotman who is known to have executed a free copy of this composition.

EXH:   RA 1806 (101); *William Mulready*, South Kensington Museum, 1864 (9); 1964 (2); *William Mulready*, V&A, 1986 (25)

**Portrait of John Sheepshanks**
FA152   Neg GX48
Paper laid on panel, 16.4 × 13.2 cm (6½ × 5¼ ins)
Sheepshanks Gift 1857

Heleniak (132) dates the work to 1832, citing the Society of Arts catalogue. The work also appears in the artist's account book for that year, presumably for the sitter who would have been aged about 45. Probably a study for FA142 (p202). For details of Sheepshanks, see Biographies of Principal Donors, pxviii.

EXH:   Society of Arts 1848 (LXVIII): *William Mulready* South Kensington Museum, 1864 (69); *English Romantic Art* 1957 (56); 1964 (16); *William Mulready* V&A 1986 (79)

**Hampstead Heath**
FA153   Neg 82186
Millboard, 16.4 × 25.8 cm (6½ × 10¼ ins)
Signed and dated 'WM 1806' br
Sheepshanks Gift 1857

Heleniak comments that: 'in some respects, Mulready's most important landscape paintings are his bold, painterly, *plein-air* oil sketches of 1806', and notes that they are among the earliest examples of this type of landscape, inspired by John Varley, and intended as independent works of art rather than preliminary studies. This is borne out by the fact that all three of the V&A views of Hampstead Heath (see FA155 and FA161, p209, 210) are signed and dated. Varley's other pupils, John Linnell and William Henry Hunt, also produced similar works in 1806; Heleniak also compares the present work with otudoor sketches of about the same time by Turner and Constable.

Stephens and Heleniak (cat no 19) list another sketch by Mulready of Hampstead Heath datable to about 1806, possibly lot 37 in the John Jeffries Stone sale at Christie's 7 June 1880 (bought by Polak), and belonging to Thomas Woolner in 1890; its present whereabouts are unknown.

EXH:   *William Mulready* South Kensington Museum 1864 (8); *English Romantic Art* Arts Council 1947 (54); *William Mulready* Bristol City Art Gallery 1964 (1)

LIT:   Heleniak pp43–7, 188 (cat no 17) repr pl 34

**Still Life: Utensils and Vegetables**
FA154
Millboard, 12.9 × 13.9 cm (5⅛ × 5½ ins)
Signed and dated WM 1809
Sheepshanks Gift 1857

Stolen from the Museum in the 1950s and never recovered. It was described in 1864 (20) as 'A small, highly finished study of a stone bottle, a glass bottle, earthen pan, etc.'

Exh: Society of Arts 1848 (IX); *William Mulready* South Kensington Museum 1864 (20)

Lit: F G Stephens *List* in *Memorials of William Mulready, RA 1890*; Heleniak (49)

*Hampstead Heath* FA155

**Hampstead Heath**
FA155   Neg GX49
Millboard, 13.9 × 25.2 cm (5½ × 10 ins)
Signed and dated 'WM 1806' br
Sheepshanks Gift 1857

Heleniak (16) reproduced pl 33. See FA153 above.

Exh: *William Mulready* South Kensington Museum 1864 (5); *William Mulready* V&A, 1986 (28)

**The Rattle**
FA156   Neg FH2054
Study, panel 10.4 × 9.8 cm (4⅛ × 3⅞ ins)
Sheepshanks Gift 1857

Heleniak (36, reproduced pl 172) dates this sketch to 1807. It is a study for the larger picture of the same title painted the following year, now in the Tate Gallery. A pencil study is in the V&A (6022). She also noted two oil studies now lost, also probably for the painting (her catalogue 27, 28).

It seems to be the first genre painting by the artist, perhaps inspired by the success of David Wilkie in this 17th-century Dutch style with 'The Village Politicians' in 1806 and 'The Blind Fiddler' in 1807.

Exh: Society of Arts 1848 (LXIII, 'Painted in 1807'); *William Mulready* South Kensington Museum, 1864 (114); *William Mulready* V&A 1986 (101)

*The Rattle* FA156

**Landscape with Figures**
FA157   Neg GX50
Panel, 22 × 18.9 cm (8¾ × 7½ ins)
Sheepshanks Gift 1857

Heleniak (65, repr pl 175) who notes that the panel is seriously cracked.

Exh: *William Mulready* South Kensington Museum, 1864 (37); *William Mulready* V&A 1986 (29)

*Landscape with Figures* FA157

*Landscape with Cottages* FA158

**Landscape with Cottages**
FA158   Neg GX51
Panel, 35.3 × 44 cm (14 × 17½ ins)
Sheepshanks Gift 1857

Heleniak (68, repr pl 45) who dates the work to 1810–12.

Exh: *William Mulready* South Kensington Museum, 1864 (38); *William Mulready* V&A 1986 (30)

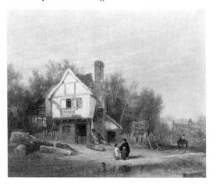

*Sketch for 'Punch'* FA159

*Landscape: A Cottage with Trees and Two Children* FA160

*Hampstead Heath with Cows* FA161

*Mary Wright, the carpenter's daughter* FA162

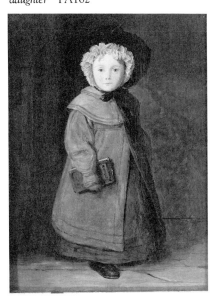

**Sketch for 'Punch'**
FA159  Neg FH2055
Canvas laid on panel, 20.2 × 31.5 cm (8 × 12½ ins)
Sheepshanks Gift 1857

Heleniak (85) dates this sketch to circa 1811–12. It is for a larger painting (location unknown) exhibited at the Royal Academy in 1813. Heleniak records a related pencil and chalk drawing (6565), a chalk, pen and ink and wash drawing (E1859–1910) and a pencil drawing (6066) all in the V&A.

EXH:  *William Mulready* South Kensington Museum, 1864, (39); *William Mulready* V&A, 1986 (31)

**Landscape: A Cottage with Trees and Two Children**
FA160  Neg GX52
Millboard, 32.8 × 26.5 cm (13 × 10½ ins)
Sheepshanks Gift 1857

EXH:  South Kensington Museum 1864 (26)

LIT:  Heleniak p191 (cat no 35) repr pl 171

**Hampstead Heath with Cows**
FA161  Neg GX53
Millboard, 15.1 × 25.8 cm (6 × 10¼ ins)
Signed and dated 'W Mulready 1806' bl
Sheepshanks Gift 1857

Heleniak (18) repr pl 35. See FA153 (p208).

EXH:  *William Mulready* South Kensington Museum 1864 (6), *William Mulready* V&A 1986 (33)

**Mary Wright, the carpenter's daughter**
FA162  Neg 15820
Panel, 2.7 × 17 cm (9 × 6¾ ins)

Heleniak (118) notes that the South Kensington Museum *Register of Pictures* 1862–75 records that the painting was executed 'as a return for some act of kindness, presumably for the carpenter'. The child's name is inscribed on her book.

EXH:  *William Mulready* South Kensington Museum 1864 (60, 'Portrait of a little Girl', dated 1828); South London Art Gallery *Mid Victorian Art, Draughtsmen and Dreamers*, 1971 (19); *William Mulready* V&A, 1986 (83)

**Cottages on the Coast**
FA162   Neg GX54
Board, 16.4 × 21.4 cm (6½ × 8½ ins)
Signed and dated WM 1806 br

Pointon comments on 'a Cuyp like approach to the horizon'

ExH:   *William Mulready* South Kensington Museum 1864 (7); *William Mulready* V&A 1986 (34)

LIT:   Stephens *List*; Heleniak cat. 20

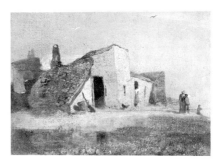

*Cottages on the Coast*   FA162

**The Lesson, or 'Just as the twig is bent, the tree's inclined'.**
FA236   Neg 60365
Panel within oval frame, 44.1 × 34 cm (17½ × 13½ ins)

The quotation is from Pope, *Moral Essays*, Ep 1.150. Heleniak (171) notes 12 related drawings at the V&A and other now untraced studies.

*The Examiner* (1859, p277) wrote: 'Mr Mulready is a contributor of a delightful bit of colouring, a mother with a rather large boy on her knee in naked prayer. The art of the painter has disdained his nightclothes.'

Like several of Mulready's paintings this work deals with the early experiences on the formation of character. Pointon observes that: 'the pose is that of a Madonna and child and the background provides a carefully orchestrated series of images which reinforce analogies between plants and children . . . natural fecundity and motherhood'

ExH:   RA 1859 (167); Society of Arts 1862 (298); *William Mulready* South Kensington Museum 1864 (100); Nottingham University, *Victorian Painting* 1959 (52); *William Mulready* V&A 1986 (113)

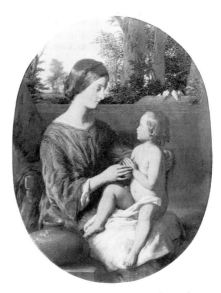

*The Lesson, or 'Just as the twig is bent, the tree's inclined'.*   FA236

**Head of a Woman**
FA243   Neg GX56
Millboard, 40.3 × 30.2 cm (16 × 12 ins)

Heleniak (155) dates this sketch to the 1840s (when, exhibited in 1864, (108) it was described as being 'painted in 1847'), and suggests that this may be an unfinished portrait of Mrs Leckie, Mulready's mysterious housekeeper and confidante for twenty years; however the portrait was not included by Pointon in the 1986 exhibition.

PROV:   Artist's Sale, Christie's 1864 (487) bt Chaffers for South Kensington Museum

ExH:   *William Mulready* South Kensington Museum (108)

*Head of a Woman*   FA243

**The Pool**
1389-1869   Neg GX57
Canvas, 50.4 × 60.5 cm (20 × 24 ins)
Townshend Bequest 1869

Heleniak places this work in her section devoted to paintings attributed to Mulready, noting that this painting does not resemble Mulready's early (pre-1814) landscapes nor his one late landscape *Blackheath Park* (FA137, p198). If it had not been firmly ascribed to Mulready by Waagen as early as 1857 its attribution would be in jeopardy. Although remaining doubtful about its authenticity, Heleniak suggests that if it is by Mulready it may date from the early 1850s and show Blackheath pond from another angle to that shown in *Blackheath Park* (FA137). Pointon did not include the painting in her exhibition.

ExH:   *Irish Art in the Nineteenth Century* Crawford Municipal School of Art, Cork 1971 (85)

LIT:   G F Waagen *Galleries and Cabinets of Art in Great Britain*, 1857, p178; Heleniak 205 p227

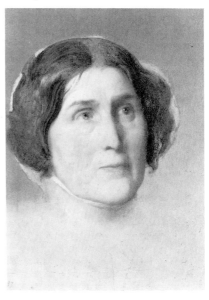

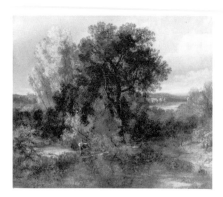

*The Pool* 1389-1869

*The Convalescent from Waterloo* 506-1882

## The Convalescent from Waterloo
506-1882   Neg 32982
Panel, 60.5 × 76.9 cm (24 × 30½ ins)
Jones Bequest 1882

Heleniak (105). Painted in 1822 and exhibited in the same year at the RA; it appears in the artist's *Account Book* under 1822 as 'Convalescent Lord Northwick Painted this year, not sold until 1826 £262.10.' and under 1826 as 'Feb 10 Convalescent Ld Northwick £262.10.'. It was presumably bought at the Northwick sale (see below) by the dealer Wallis on behalf of John Jones.

The critic of *Ackermann's Repository of the Fine Arts* thought 'This picture looks hard and unfinished; but the sentiment of the figures is extremely pretty, and the action of the boys is good. In many parts it is a pleasing example of Mr. Mulready's powers'. The *European Magazine* commented that 'There is considerably more merit in the execution of this picture than in the original design. The principal character is not good, and admits of no superior display of art; and the woman, who forms the second figure, possesses so little of originality, that the most exquisite finish could not render her interesting. The little boy, indeed, is more happily conceived, and his irritation at being defeated in wrestling, more expressively delineated. The colouring of this picture is so sweet, so faithfully true to nature, that it almost compensates for the want of merit in the original design'. The *Examiner* was 'glad that the neat and powerful pencil of Mr. Mulready no longer moves in this morally and personally filthy region of *un*-polite art' and found the present work 'moves in our heart the springs of domestic delight'; the review continues 'The artist's tact for expressing the kindly feelings is seen here to be as good as it has been for shewing the harsher ones; and the well tinted flesh, the transparency, and the pencilling, are worthy of his observance and display of mind and body'. That critic's pleasure that Mulready had abandoned the 'unpolite' subjects of low-life genre was not shared by the *New Monthly Magazine*: 'this is obviously inferior to most of his late works'. However, the review continued: 'the incident of the two children quarrelling, in the foreground, must be considered as totally out of place, since it evidently disturbs and interferes with the kind of interest intended to be called forth by the picture'.

Despite the *Ackermann's Repository of the Fine Arts* comment at the picture's second showing, at the BI in 1826 (where presumably Lord Northwick bought it) – 'Mr. Mulready again exhibits his *Convalescent*, and it cannot be seen too often' – critical opinion was not always so favourable.

The text accompanying the engraving published in the *Art Journal* in 1864 somewhat surprisingly commented: 'The spirit of the story is well sustained, and with considerable pathos, but the canvas is too large for the subject; the picture looks poor, simply because there is nothing in it to occupy a prominent position in comparison with the extent of surface covered'. Stephens remarked in 1867 that the work was 'a little loose and scattered in composition; being, in that respect, of all Mulready's pictures the least worthy of him; it shows, however, that the artist was getting out into the open with his subjects, and thus perhaps was led to desire a change in style. The boys, who in this work, are represented struggling against each other, hint at the war of which the convalescent soldier was a victim.' Stephens also described the painting of landscape as 'one of the most difficult phases of execution' and thought in the present case 'never displayed to greater advantage'; also 'the solidity and genuineness of this work were hardly surpassed even by the artist himself: similar solidity, with a slight excess of greyness, appears in the better-known "Fight Interrupted" [see p199, FA139]. In 1910, Chancellor reported it as 'not a very good picture'.

Some aspects of the painting discussed during the artist's lifetime are worth reconsidering now, notably the relationship between the figures and the landscape. The landscape setting shows an army barracks, including a sentry box, presumably by 1822 used as a convalescent home for the wounded

servicemen of the Napoleonic wars, and probably on the south-east coast of England, perhaps near Deal, Kent, although careful research by the National Army Museum has failed to precisely identify the site. The sea shore shows the tide at its ebb, and the huge felled trees, as Marcia Pointon observes, provide a discreet metaphor for the many comrades who did not survive. The pathos of the scene is emphasised by the uniformed soldier with his wounded arm removed temporarily from its sling, and his daughter who clings to his leg and observes her two brothers wrestling, illustrating the inevitability of struggle. They, and the new baby that forms the centrepiece of the distant family group, reassure us of the health of the nation and its future army.

This depiction of the sad aftermath of war struck an unusual note in 1822. The years after the victory of Waterloo had produced a bellicose euphoria in the arts. On a popular level audiences flocked to Astley's Hippodrome to see equestrian re-enactments of battle scenes, while at Sadlers Wells the marine dramas saw the recreation of mimic battles of the Nile and Trafalgar. At the Royal Academy between 1816 and 1822, paintings showed triumphant battle scenes and portraits of victorious soldiers. The pathos of Mulready's 'Convalescent' struck a discordant note, which may explain why it failed to sell when first shown at the Royal Academy in 1822, the year when David Wilkie's 'Chelsea Pensioners Reading the Gazette of the Battle of Waterloo' scored such a resounding success with the public that it had to be protected with a barrier to prevent damage from the crowds of admirers. In terms of the late 20th century, an analogy might be made between the jingoistic note struck by films celebrating the second world war such as 'The Dam Busters' and the sombre war-weary cynicism of the BBC-TV film 'Tumbledown' made after the Falkland Islands conflict.

EXH:   RA 1822 (135); BI 1826 (51); Society of British Artists, 1834 (137); 1848 (XXXVI): Dublin *International Exhibition* 1953 (163); *William Mulready* South Kensington Museum, 1864 (51)

# MULREADY, William, Jr (1805 – after 1842)

Born London, 1805, second son of William Mulready RA. Exhibited five works (all studies of birds) at the RA between 1835 and 1842, seven at the BI and five at the SBA.

**Teal**
FA163   Neg GE1753
Canvas, 35.1 × 44.5 cm (14 × 17½ ins)
Signed and dated 'W. Mulready jun.' br and '1835' bl
Sheepshanks Gift 1857

EXH:   RA 1835 (116)

**An Interior**
FA164
Panel, 40.6 × 52.1 cm (16 × 20½ ins)
Sheepshanks Gift 1857

*Teal*   FA163

*An Interior*   FA164
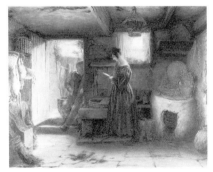

# MUTRIE, Annie Feray (1826–1893)

Born Ardwick, Manchester, 6 March 1826, younger sister of Martha Darley Mutrie (see entry below) and daughter of Robert Mutrie, who was in the Manchester cotton trade. Studied at Manchester School of Design and with George Wallis, and moved with her sister to London 1854, where they lived together until 1885. Exhibited 48 fruit and flower pieces at the RA between 1851 and 1882, six at the BI 1855–59, and also at the Royal Manchester Institution. Died Brighton, Sussex, 28 September 1893. Ruskin admired the work of both sisters, although he wanted them to paint flowers naturally growing; in his *Academy Notes* of 1855, he wrote that Annie's paintings were 'remarkable for very lovely, pure, and yet unobtrusive colour – perfectly tender, and yet luscious . . . I wish this very accomplished artist would paint some banks of flowers in wild country, just as they grow, as she appears slightly in danger of falling into too artificial methods of grouping'.

LIT: *Athenaeum* 7 October 1893, p496 (obit); *The Times* 10 October 1893, p9 (obit); P Gerrish Nunn *Victorian Women Artists* 1987, p125 etc

### Group of Cactus
29-1884
Canvas, 31.7 × 24.7 cm (12½ × 9¾ ins)
Signed and dated 'AF [in monogram] M/68' bl
Purchased 1884

Annie Mutrie exhibited two paintings of cactus: 'Cactus, etc' at the BI in 1857 (295), and 'White Cactus' at the RA in 1872 (119).

# MUTRIE, Martha Darley (1824–1885)

Born Ardwick, Manchester, 26 August 1824, elder sister of Annie Feray Mutrie (see entry above) and daughter of Robert Mutrie, who was in the Manchester cotton trade. Studied at Manchester School of Design 1844–46 and with George Wallis, and moved with her sister to London 1854, where they lived together until her death. Exhibited mostly fruit and flower pieces: 42 at the RA between 1853 and 1878, one at the BI 1859, and also at the Royal Manchester Institution. Died Kensington 30 December 1885.

LIT: *Athenaeum* 9 January 1886, p75; P Gerrish Nunn *Victorian Women Artists* 1987, p125 etc

### Group of Camellias
28-1884
Canvas, 34.2 × 24.1 cm (13½ × 9½ ins)
Signed and dated (indistinctly) 'M D Mutrie 1859' br
Purchased 1884

This artist exhibited three paintings of camellias, two at the RA in 1869 (588) and 1877 (1399); this painting is presumably 'Camellias', exhibited at the BI in 1859 (the date of the present work) and priced at 25 guineas (£26 5s).

PROV: Possibly Christie's 1 February 1884 (129), bought by Agnew's (? for the museum) £19 19s; however Annie Mutrie's painting (FA29, above) seems to have been purchased at the same time but was not in this sale

EXH: BI 1859 (355)

# NEWTON, George H (active 1853–1871)

Head of the Durham School of Art 1853–61, he exhibited 14 landscapes, all but one in watercolour, at the SBA 1858–71, views in the north of England and Wales. Presumably identical with G Newton, who sent two works from the Durham School of Art to the RA 1858–9.

**Jack's Crag, Borrowdale, Cumberland**
9147-1863    Neg HC4048
Canvas, 32.4 × 46.9 cm (12⅞ × 18⅝ ins)
Signed and dated 'G H Newton/1860' bc
Purchased 1863

Acquired with eight other paintings as a series of representative works by art masters; the price was £4.

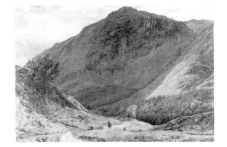

*Jack's Crag, Borrowdale, Cumberland*   9147-1863

# NEWTON, Gilbert Stuart, RA (1794–1835)

Born Halifax, Novia Scotia, Canada, 20 September 1794, of American parents; his uncle was the portrait painter Gilbert Stuart with whom he studied in Boston. Travelled to study in Florence, and visited Paris, where he made friends with C R Leslie (see entry above) and returned with him via Brussels and Antwerp to London 1817. Entered RA Schools. Exhibited 27 works, mostly portraits and literary subjects, at the RA between 1818 and 1833, and 22 at the BI 1819–31. Elected ARA 1828, RA 1832. Several of his works were engraved. Visited America 1831–2 and married there; on return, confined in the Chelsea asylum for the insane, where he died 5 August 1835. The *Art Journal* in 1864 thought him 'not a painter of great originality or power; but his works are characterised by much elegance both in design and execution'.

LIT:    *Gentleman's Magazine* 1835, pp438–9 (obit); *Athenaeum* 15 August 1835, pp625–6 (obit); H Murray *The Gems of Stuart Newton, RA* 1842 (collection of engravings after his works); *Art Journal* 1847, p280, 1864, pp13–15

**Portia and Bassanio**
FA166    Neg 59112
Canvas, 106.7 × 91.4 cm (42 × 36 ins)
Signed and dated 'G S Newton 1831' bl
Sheepshanks Gift 1857

Exhibited at the RA in 1831. Hung in the Great Room, the work was titled in the catalogue 'Subject from the Merchant of Venice' and the following lines appended:

*Portia:*    With leave, Bassanio, I am half yourself;
And I must freely have the half of anything
That this same paper brings you

The lines are from act 3 scene 3 of Shakespeare's play; the episode depicted is after Bassanio has chosen the right casket and so has won Portia's hand in marriage. His friend Solanio brings him a letter with the news of Antonio's financial failure and Shylock's insistence on his pound of flesh. The painting was possibly intended as a pendant with 'Lear attended by Cordelia and the Physician', also at the RA in 1831 (152, now private collection, London). The same model sat for both Cordelia and Portia.

*Portia and Bassanio*   FA166

Newton had exhibited 'Shylock and Jessica' at the RA in 1830 (144, now Yale Center for British Art, New Haven, USA), which was compared favourably by the *Athenaeum* with the same subject by J M W Turner.

'Portia and Bassanio', and the original painting of 'Olivia's Return' (1831–1909, p217) were listed in the *Athenaeum* obituary among seven of Newton's works of especial merit (15 August 1835, p626).

EXH:     RA 1831 (7); *American Artists in Europe 1800–1900* Walker Art Gallery, Liverpool, 1976–7 (45); *Shakespeare's Heroines* Art Gallery, Buxton, 1980 (26)

ENGR:    G T Doo 1837 (impr in V&A collections)

LIT:      *Shakespeare's Heroines* exhibition catalogue, Buxton Art Gallery, 1980, p56

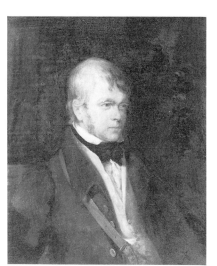

*Sir Walter Scott*   F23

## Sir Walter Scott

F23   Neg 55905
Canvas, 22.8 × 19 cm (9 × 7½ ins)
Forster Bequest 1876

Almost certainly a version, about a third original size, of the three-quarter length oil painted by Newton for the publisher John Murray in 1824, which was presumably the portrait exhibited at the RA in 1825 (102) (Russell, cat no 141). The Murray portrait was engraved by W Finden and published by Murray in 1833; other prints, with variations, were also published.

F G Kitton reproduces the Murray Portrait, but claims the original was that painted at the cottage at Chiefswood on the Scott estate in 1824, the cottage given to Scott's daughter, who lived there with her husband J G Lockhart, Scott's biographer. Russell (see *Lit:* below) is surely correct to see the latter as an oil sketch for the Murray portrait. Kitton also quotes Lockhart's opinion that it was 'the best domestic portrait ever done', and describes Scott as 'seated at table, holding a stick, and wearing his usual country dress – a green jacket, black neckcloth, and a leather belt round his shoulders for carrying a forester's axe' (F G Kitton 'Some portraits of Sir Walter Scott', *Magazine of Art* XIX, 1895, p4; the Murray painting repr XXVI, 1902, p59).

Russell documents the painting of the Abbotsford portrait, beginning with John Constable's note on 10 July 1824 that C R Leslie was going to Abbotsford to paint Scott and 'Newton is going to do the same' (ed R B Beckett *John Constable's Correspondence* II, Ipswich 1964, p359). Newton stayed with Lockhart, who Russell suggests may have commissioned the portrait, at Chiefswood in August. Scott himself referred to Leslie's 'very ingenious countryman Newton'. Russell identifies the Abbotsford portrait as a preliminary sketch for the Murray picture, and the present work as certainly autograph, although the 'realisation of the featues, notably like that of Finden's engraving of the Murray picture . . . is a good deal less faithful than in either of the earlier versions'.

Russell lists several drawings of Scott by Newton. There are many portraits of the famous poet and novelist Sir Walter Scott (1771–1832); the fullest published iconography is in Russell and in R Walker *Regency Portraits* 1985, I, pp442–5. Scott was painted several times in 1824 alone; Sir David Wilkie wrote on 1 November that 'Sir Walter Scott . . . expects me at Abbotsford, and is ready to sit. He has, however, sat so frequently of late to artists . . . that I grudge going on such an errand' (quoted by H Miles *Sir David Wilkie of Scotland* North Carolina Museum of Art exhibition catalogue, 1987, p199). The artists included Leslie and Landseer as well as Newton. There is a small copy of the Murray portrait in the SNPG, another of similar size and format of the present work in a private collection USA, and Russell records a small copy sold in New York 19–24 November 1934.

According to a letter in the Forster collection written 7 March 1866 by

Charles Meer Webb in Düsseldorf, Forster bought the painting in Germany in 1866 for £75. Webb had drawn his attention to it, and stated that it had belonged formerly to a Countess Bernay (or Berney) who had married a waiter. Forster owned editions of Scott's works in poetry and prose, and of the Waverley novels, and seven of his manuscript letters; all were included in the Forster Bequest to the V&A.

LIT: F Russell *Portraits of Sir Walter Scott, a study of Romantic portraiture* 1987, p61, cat no 142

## Olivia's Return
1831-1900   Neg HH2417
Paper on panel, 31 × 40.2 cm (12¼ × 15⅞ ins)
Ashbee Bequest 1900

*Olivia's Return*   1831-1900

Painted over an engraving of his own painting which was exhibited at the RA in 1828 (243), the year Newton was elected ARA. There is no reason to doubt the painting is by Newton himself, unusual as the method is, particularly in view of the work's provenance (see *Prov:* below).

The full title of the RA painting, 'The Vicar of Wakefield reconciling his wife to Olivia', was supplemented in the RA catalogue by the following quotation: 'I entreat, woman, that my words may be now marked once for all: I have here brought you back a poor deluded wanderer; her return to duty demands the revival of our tenderness . . . The kindness of heaven is promised to the penitent, and let ours be directed by the example'. The passage is from chapter 22 ('offences are easily pardoned where there is love at bottom') of Oliver Goldsmith's most famous work, his novel *The Vicar of Wakefield* first published in 1766. Olivia, the vicar's daughter, had run away from home to an unknown man; her father eventually finds her and brings her home. Also in the painting are the two youngest sons, the younger daughter Sophia, and the second son Moses. In the 1820s Goldsmith's reputation was at its zenith, and his works remained popular as subjects for painters (see under Frith, for example FA74 and 511-1882, p93, 100). Another 'Vicar of Wakefield' subject by Newton was engraved for the *Art Journal* in 1864 (p15).

The *Athenaeum* found it:

A very interesting picture, cleverly composed, and well painted. The mother's struggle between pride and tenderness, is admirably expressed, not only in her face and features, but throughout the whole figure; not more in the stiffness and erectness of carriage, than in the clenching of the hand on the knee. The patient and benevolent Dr Primrose, of Goldsmith, is finely characterised in the figure and head of the father: the affectionate sister, kneeling by her mother's side, and anxiously interceding, is a picture of amiable loveliness; while Olivia, abandoned to shame, sorrow, and penitence, neglected in her attire, and with face averted, and concealed on her father's shoulder, while her hand is most expressively held by his, forms, with the figure of the indulgent parent, a group replete with delightful expression. The hobbledehoy simplicity of Moses, and the panting and vague consciousness of the younger urchins, must not be overlooked; they are also most happy. The whole picture, in short, is full of truth, sentiment, and feeling.

The critic of the *Gentleman's Magazine* thought the RA work, which he records as hanging in the School of Painting at Somerset House:

A powerfully conceived and cleverly executed painting; exhibiting all the deep pathos and correct feeling which this interesting and affecting situation requires. The figure of the mother sitting in her chair, the repentant Olivia being at her feet supplicating a return of kindness, is an astonishing portraiture of the conflict of passions, the war of thoughts which afflict and disturb her animal body. The struggle between the

217

yearnings of a parent, and the stern necessities of duty, are to be seen and felt in the tearful eye, the stiffened arm, and hands clenching her garments, more effectively than we have the power of describing. Every living thing in the piece has the appearance of unnatural and unwished for coldness. The two children have left off their amusements, and look a consciousness of something wrong; and the faithful dog raises up his head in recognition of the suffering repentant, but feels a doubt of the propriety of his wonted kindness. The whole reflects great credit on Mr Newton, and the country which gave him birth, as it would on that of any artist of the present day however great his reputation.

The critic of *Ackermann's Repository of the Fine Arts* also admired the painting:

> Everybody knows that this subject is taken from the 22nd chapter of Goldsmith's novel. The pathetic expression of the principal figure, the agonised expression of the supplicant, and the accessories to the grouping, and very appropriately conceived. The story is well told, and the drawing and colouring of the figures are in many respects praiseworthy.

The original painting was in the collection of the Marquess of Lansdowne at Bowood House by 1862; early in that year Richard Redgrave saw it there, and wrote to his family:

> It was a pleasure to me to see 'Olivia's Return to her Parents' again, it was a picture that originally inspired me. I think the figure of Sophia pleading with her mother is charming, the face and the position lovely, the hands perfect in action, quite interceding for her sister, as they gently touch the clenched hands of the mother. It is a picture worthy of Leslie for delicacy and feeling, and you know how much I say in saying this" (quoted in F M Redgrave *Richard Redgrave, A Memoir* 1891, p265).

According to the 1897 catalogue of the Lansdowne collection, the original picture was painted for Lord Lansdowne in 1828, and engraved by Burnett (presumably John Burnet, and the print overpainted in the present work). The RA picture and 'Portia and Bassanio' (see FA166, p215) were listed among seven of Newton's works of especial merit in the *Athenaeum* obituary of the artist (15 August 1835, p626).

PROV:  H A J Munro of Novar by 1865 (662 in W Frost's 1865 catalogue of the collection, p85, marked '(A)', as 'undoubtedly of the first class'); his sale, Christie's 11 May 1867 (57, as 'The Return of Olivia', painted on the engraving'); bequeathed by H S Ashbee to the museum 1900

LIT:  (RA picture) *Ackermann's Repository of the Fine Arts* XI, 1828, p357; *Athenaeum* 21 May 1828, pp473–4; *Gentleman's Magazine* 1828 (vol 98, pt 1) pp447 and 539; G E Ambrose *Catalogue of the Collection of Pictures belonging to the Marquess of Lansdowne, KG, at Lansdowne House, London, and Bowood, Wilts* 1897, no 231, p72

## NICOL, Erskine, ARA (1825–1904)

Born Leith, near Edinburgh, July 1825; apprenticed to a housepainter, but studied art at the Trustee's Academy, Edinburgh, from about 1837. Drawing master at Leith High School. Moved to Ireland in about 1845 (and continued to visit once a year), returned to Edinburgh about 1850. Exhibited 72 works at the RSA between 1841 and 1905 (elected Associate 1855, Member 1859), 53 at the RA 1851–93 (elected ARA 1866), and six at the BI 1861–2. Moved to London 1863. Many of his paintings were engraved. Subjects were popular genre, often humorous. Died 8 March 1904. His son was the artist John Watson Nicol (active 1876–1924).

LIT:   *Art Journal* 1870, pp65–7, 1904, p170 (obit)

*Perfect Content (A man smoking)*
1039-1886

### Perfect Content (A man smoking)
1039-1886   Neg 77125
Millboard, 20.9 × 18.5 cm (8¼ × 7¼ ins)
Signed and dated 'EN[in monogram)icol, A, RSA/56' vertically at r
Dixon Bequest 1886

Exhibited at the RSA in 1857 as 'A Contented Mind's a Continual Feast', lent by J C Bell. An old label on the back is inscribed in ink: 'A contented mind's a continual feast/painted for J C Bell Esq/Dundee/Erskine Nicol ARSA'.

## NIEMANN, Edmund John (1813–1876)

Born Islington, London, 1813, eldest son of a German-born Lloyds broker; worked as a clerk at Lloyds 1826–39. Moved to High Wycombe, Buckinghamshire, to paint landscapes. Exhibited 29 works at the RA between 1844 and 1872, 45 at the BI 1845–67, and 40 at the SBA 1844–69. Returned to London 1848 to be secretary of the Free Exhibition (later Portland Gallery). Landscapes often very large; several river scenes, particularly the Thames. Contributed to a guide book A *Tour round Reading* . . . (1840). Five watercolours are in the V&A collections. Died Brixton, London, 15 April 1876; his son Edward H Niemann was also an exhibiting landscape painter in a similar style.

LIT:   *The Times* 18 April 1876 (obit); *Art Journal* 1876, p203 (obit) 1877, pp201–4; G H S(hepherd) *Critical Catalogue of Some of the Principal Pictures Painted by . . . E J Niemann* 1876

*Landscape – Amongst the Rushes*
1369-1869

### Landscape – Amongst the Rushes
1369-1869   Neg 67084
Canvas, 64.1 × 115.5 cm (25¼ × 45½ ins)
Signed 'Niemann' br
Townshend Bequest 1869

Not identifiable with the title of any exhibited picture.

### Low Tide
1832-1900   Neg 67085
Panel, 35.8 × 45.7 cm (14⅛ × 18 ins)
Signed and dated 'E J Niemann 1840' bc
Ashbee Bequest 1900

A very early work, and not identifiable with the title of any exhibited picture.

*Low Tide*   1832-1900

# O'CONNOR, James Arthur (?1792–1841)

Born Dublin, Eire, probably in 1792, son and pupil of the printseller and engraver William O'Connor; practised as an engraver, and studied painting with William Sadler. First exhibited Dublin 1809. Visited London with Francis Danby ARA 1813, returning there to live 1822. Exhibited 21 landscapes (several views around Dublin) at the RA between 1822 and 1840, 38 at the BI 1823–39, and 17 at the SBA 1829–1838. Visited Brussels 1826–7, Paris and Germany 1832–3. Health and eyesight declined; died Brompton, London, 7 January 1841; his studio sale was at Christie's 12 February 1842 (*Art Union* April 1845 made a financial appeal for his widow). Some of his works were exceptionally large; Bodkin proposed that his best paintings were on a smaller scale but seldom exhibited. S Redgrave (*A Dictionary of Artists of the English School*) in 1878 thought the landscapes 'boldly painted, show great feeling, and are good in tone and colour, but rather green', and Hutchinson in 1985 describes the artist as:

> Until about ten years ago . . . possibly the best loved of all Irish painters. This affection . . . was not based on any real knowledge of his paintings, but on an affinity with the lyrical mood of his most common landscapes, which, it was widely believed, always included tiny figures wearing red waistcoats walking down country lanes on fine summer days.

*Town of Westport and Clew Bay, County Mayo*  30-1873

Lɪᴛ: *Gentleman's Magazine* March 1841, p329, June 1841, p666 (obit); *Dublin Monthly Magazine* April 1842; W G Strickland *A Dictionary of Irish Artists*, II, 1913, pp179–82 (with engr self-portrait); T Bodkin *Four Irish Landscape Painters* 1920, pp17–28; *James Arthur O'Connor* centenary exhibition catalogue, Municipal Gallery of Modern Art, Dublin, 1941; A Crookshank 'Early Landscape Painters in Ireland' *Country Life* 24 August 1972, pp468–72; A Crookshank and the Knight of Glin *The Painters of Ireland* 1978, p209; J Hutchinson *James Arthur O'Connor* NGI, Dublin, 1985

*Morning* F25

**Town of Westport and Clew Bay, County Mayo**
30-1873   Negs GB579, GC3827
Canvas, 51.5 × 77.1 cm (20¼ × 30⅜ ins)
Signed and dated 'J A O'Connor/1825' bl
Purchased 1873

O'Connor visited the west of Ireland in 1818–9 and painted a series of landscapes commissioned by Lord Sligo at Westport. Hutchinson suggests, however, that the earliest of the Westport views is that signed and dated 1817 (repr p98), a smaller variant of the painting in Westport House (repr p99); the former may have led to the Marquis of Sligo's patronage. A signed pen and ink drawing of the subject in the British Museum is inscribed 'The Marquis of Sligo's house and demesne with the town and bay of Westport, Co Mayo'. Another, smaller painting, 'Westport Bay, from the Newport Road, Mayo', the size given in the catalogue, presumably including the frame, as 20 by 24 inches, was exhibited at the BI in 1825 (63).
Hutchinson (p138) notes of the present work

> The colouring in the sky of this painting is considerably more dramatic than in the earlier versions of the view, and may owe something to the influence of Turner. There is at least one other view of Clew Bay that was painted some years after the original series at Westport and it has a similarly colourful sky.

*Night* F26

Exʜ: *English Romantic Art* Arts Council 1947 (64); *James Arthur O'Connor* NGI, Dublin, 1985, (55)

Lɪᴛ: J White 'O'Connor at Westport House', *Apollo* July 1964, pp42–3

## Morning

F25    Neg K1835
Canvas, 35.5 × 43.1 cm (14 × 17 ins)
Signed 'J A O'Connor' cl (concealed by frame)
Forster Bequest 1876

The preparation of the canvas was by Roberson & Miller, 31 Long Acre, according to a stencil on the back, which dates the work to between 1828 and 1840. Bodkin (p25) comments that the artist 'often closely observed and clearly reproduced the misty effects of early morning'.

## Night

F26    Neg K1834
Canvas, 34.2 × 41.9 cm (13½ × 16½ ins)
Forster Bequest 1876

The same size as, and presumably a pendant to, 'Morning' (F25 above). Bodkin (pp24–5) compares his moonlight scenes – of which he painted many – with those of the Dutch 17th-century painter Aert van der Neer. Hutchinson (p181), writing about 'The Poachers' (1835, NGI), finds a distinctive romanticism which 'accentuates the relationship between the individual and the universal . . . The figures' isolation is emphasised both by the dramatic illumination of the poachers, and by the emotional tension that is created by the contrast of their stillness with the implied movement of the clouds'.

## Waterfall

F27    Neg GB581
Millboard, 24.1 × 19 cm (9½ × 7½ ins)
Signed and dated 'J A O'Connor/1838' br, and signed in ink on reverse
Forster Bequest 1876

See under F28, below

## Waterfall

F28    Neg GB582
Canvas, 30.5 × 25.4 cm (12 × 10 ins)
Signed and dated 'J A O'C 1838' bl
Forster Bequest 1876

O'Connor had exhibited a painting entitled 'The Waterfall' at the SBA 1830 (384). Others with the same title were show at the Royal Hibernian Academy in 1843 (523) and at Wrexham in 1876 (496, lent by a Mr Potts). Presumably this, and F27 'The Waterfall' above are scenes in the Wicklow mountains. The view also resembles in some ways that of 'A View of the Dargle – Lovers' Leap' (1837, private collection, repr Hutchinson p186).

## Landscape with Stream and Woods

F29    Neg GB584
Panel, 20.9 × 26.6 cm (8¼ × 10½ ins)
Forster Bequest 1876

## Landscape with Trees in Foreground and Distant Hills

F30    Neg GB583
Panel, 18.5 × 26.6 cm (7¼ × 11½ ins)
Signed and dated 'J AO'C/1840' indistinctly bl
Forster Bequest 1876
An almost identical landscape, identified as a view in County Wicklow, was sold at Sotheby's 17 July 1985 (602).

*Waterfall    F27*

*Waterfall    F28*

*Landscape with Stream and Woods    F29*

*Landscape with Trees in Foreground and Distant Hills    F30*

The Devil's Glen, County Wicklow
1841-1900

**The Devil's Glen, County Wicklow**
1841-1900   Neg GB580
Canvas, 34 × 43.1 cm (13⅜ × 17 ins)
Signed and dated 'J A O'Connor 1828' br
Ashbee Bequest 1900

Other versions of this subject were exhibited at the BI in 1828 (253 'A View in the Devil's Glen, Wicklow', size given in the catalogue as 14 by 16 inches, presumably including frame), and at the SBA in 1830 (466, 'Scene in the Devil's Glen, County of Wicklow'). 'The Devil's Gap' was exhibited at the BI in 1830 (454, size given as 28 by 29 inches). A painting of 'A View of the Devil's Glen' (about 1830, 63 × 76 cm (24¾ × 30 ins), NGI), shows a grimmer and different aspect of the scene.

The Devil's Glen is about a mile from Ashford, in the Wicklow mountains south of Dublin; the wooded glens, mountains, and the winding river Vartry and its waterfalls, seem to comprise O'Connor's favourite type of scenery.

Hutchinson suggests the present work 'gives us some intimation of the way O'Connor's style was to develop in the next decade. It is a skilful picture that has both a cheerful, gentle mood and a suggestion of the melancholy of the coming years'.

PROV:   Henry Spencer; bequeathed by H S Ashbee to the museum 1900

EXH:   *James Arthur O'Connor* NGI, Dublin, 1985 (62)

**Landscape, with Two Men Fishing (attributed to J A O'Connor)**
578-1870   Neg GB578
Millboard, 15.8 × 18.7 cm (6¼ × 7⅜ ins)
Bequeathed by John Meeson Parsons 1870

More 18th-century in style than O'Connor's mature works, both in composition and handling of paint, and in 1923 Basil Long made a tentative suggestion in the Departmental Files that it was painted by Alexander Nasmyth (1758–1840). It may be compared with the small oil sketch attributed to O'Connor and reproduced by Bodkin (pl X).

Landscape, with Two Men Fishing
578-1870

# OLIVER, William, RI (?1804–1853)

Born about 1804. Exhibited 32 works at the RA between 1835 and 1853, 54 at the BI 1835–54, and 36 at the SBA 1829–52. All landscapes, first in England and France, Italy after 1848, and Switzerland. Also painted in watercolours, exhibiting 257 at the NWS (later Royal Institute) of which he was founder member 1834. Published 'Scenery of the Pyrenees', with lithographs by T S Boys and others, 1843. Died Halstead, Essex, 2 November 1853. His wife Emma Eburne (1819–85) was also a watercolour and landscape painter, exhibiting at the RA 1842–68.

LIT:   *Art Journal* 1853, p311 (obit)

**Foligno**
1384-1869   Neg HF4818
Canvas, oval, 24.1 × 34.2 cm (9½ × 13½ ins)
Signed and dated 'William Oliver/1849 [possibly 1844]' indistinctly bl
Townshend Bequest 1869

Oliver exhibited two Foligno subjects, presumably following an Italian visit: 'Faligno [sic] in the Apennines' at the SBA in 1848 (243), and 'On the Road from Foligno Spello, Papal State of Italy' at the RA in 1851 (607). Foligno is

*Foligno*   1384-1869

in Umbria, some 20 miles south-east of Perugia; the present view is presumably on the outskirts of the town, and on the river Topino.

# OWEN, Rev Edward Pryce (1788–1863)

Born March 1788, only son of the archdeacon of Salisbury. Educated St John's College, Cambridge (BA 1810) and was ordained. Designed plates for his father's *History of Shrewsbury* 1825, and published 'Etchings of Ancient Buildings in Shrewsbury' (1820–1), and other volumes of etchings 1826, 1842, 1855. Travelled in Europe, and in Italy 1840. Exhibited eight works at the BI 1839–53 and four (including a watercolour) at the SBA 1837–40; subjects principally landscapes, also biblical subjects. Died Cheltenham, Gloucestershire, 15 July 1863.

LIT:  *Gentleman's Magazine* 1863, pp244, 380

**Landscape Composition (attributed to E P OWEN)**
D16    Neg 58213
Canvas, 64.7 × 90.1 cm (25½ × 35½ ins)
Dyce Bequest 1869

*Landscape composition*    D16

Attributed to Richard Wilson in the 1874 catalogue of the Dyce collection and the 1907 *Catalogue of Oil Paintings*, the Departmental files show that in 1914 M H Grant, the writer on landscape painting, believed it to be by Sir George Beaumont, but that in 1931 Basil Long finally attributed it to Owen. There seems to be no evidence to either support or challenge this attribution to Owen (about whom very little is known), however it is retained here.

The location of the scene is unknown and may well have been invented; the combination of the ?abbey and the ruins behind, the mountain, and the trees on the rocks on the right, seems very unusual. The clothes worn by the man on the right date from the early 19th century. The rather naïve composition is particularly notable for the engaging depiction of the artist and his ?patron with his umbrella.

# PARRIS, Edmund Thomas (1793–1873)

Born Marylebone, London, 3 June 1793; apprenticed as an enameller in firm of jewellers. Entered RA Schools 1816. Exhibited 26 works at the RA between 1816 and 1857 and in 1874, 36 at the BI 1821–65, and 18 at the SBA 1824–68; wide range of subjects including landscape and fashionable portraits. Worked as panorama painter at Thomas Horner's Colosseum in Regent's Park, views of London 1824–9 and of Madras about 1830. Historical Painter to Queen Adelaide 1832. Won prize in Westminster Hall fresco competition 1843. Restored Sir James Thornhill's paintings in dome of St Paul's 1853–6, having designed a special method of scaffolding. Most popular for his female figures; illustrated verses by Lady Blessington in *Gems of Beauty, Flowers of Loveliness* and *The Passions* in the 1830s. Several drawings and two watercolours are in the V&A collections; also made designs for stained-glass, carpets, and tapestry, and invented a paint that looked like fresco called Parris's Medium. Several of his works were engraved, some in *The Keepsake* (1834). Died Bedford Square, London, 27 November 1873.

LIT:  *Illustrated London News* 24 December 1853, pp560–2 (the St Paul's restoration), 6 December 1873, p534 (obit), 13 December 1873, p564 (engr portrait); *The Builder* 13 December 1873, pp979–80 (obit); *Art Journal* 1874, p45 (obit)

*The Rose (A group of women and a child)   57-1908*

*The Lily (A group of women and a child)   58-1908*

**The Rose (A group of women and a child)**
57-1908   Neg GC5637
Canvas, circular, diameter 47.2 cm (18⅝ ins)
Signed and dated 'E T/Parris/pinxʳ./1832' cl
Given by Mrs Elizabeth South 1908

Typical of the artist's 'fancy' subjects, based on the style of Sir Thomas Lawrence, for example 'The Calmady Children' (RA 1824, now Metropolitan Museum of Art, New York), and made popular by 'The Keepsake', for which Parris made designs, and other illustrated periodicals.

The painting was engraved (see *Engr:* below) as *The Rose of the Boudoir*, with the following verse:

> The Rose she loves the Mother blesses
> The Rose she to her bosom presses
> A fairer, sweeter, happier thing
> Than that which shines the Queen of Spring

The verse is similar in form and content to the poetry of Marguerite Gardiner, Countess of Blessington, who edited *The Keepsake* (1841–50). Her poems, *Gems of Beauty*, were published in 1836 with 12 engraved plates after designs by Parris, similar to the present painting, as was her *Flowers of Loveliness*, including a poem *The Rose* different from the verse quoted above.

The painting does not appear to have been exhibited.

Engr:   J Egan, publ J McCormick, 63 Gracechurch Street, London

**The Lily (A group of women and a child)**
58-1908   Neg GC5638
Canvas, circular, diameter 47.2 cm (18⅝ ins)
Signed and dated '1832/E T Parris' on plinth r
Given by Mrs Elizabeth South 1908

Presumably a pendant to 'The Rose' (57-1908 above).

Engr:   Mezzotint G H Phillips

# PASMORE, John F (active 1841–1866)

Exhibited 30 works at the RA between 1842 and 1862, 23 at the BI 1843–62, and ten, including a watercolour, at the SBA 1841–66, and 26 at other exhibitions. Works were sent from various London addresses, and subjects were animals and rustic genre. His wife also exhibited paintings between 1861 and 1878.

**Highland Rams Fighting**
341-1885
Canvas, 121.8 × 205.7 cm (48 × 81 ins)
Bequeathed by Richard Towne 1885

Dated to about 1850 in the 1907 catalogue. Evidently influenced by the work of James Ward, especially 'Bulls Fighting' (also in V&A collections, 220–1871), it is not identifiable with any exhibited work.

# PATTEN, George, ARA (1801–1865)

Born London 29 June 1801, son of the miniature painter William Patten (active 1791–1817) with whom he trained; his brothers C William and (probably) G B Patten were also miniature painters. Entered RA Schools 1816, and again 1828. Exhibited 131 works at the RA between 1819 and 1864, and 16 at the BI 1832–44. Miniatures up to 1830, then full-size portraits (including Paganini 1833), subject pictures of various kinds, historical, mythological and biblical, sometimes on a large scale. Elected ARA 1837. Visited Rome, Venice and Parma 1837, Germany 1840. Appointed Portrait Painter in Ordinary to Prince Albert. Moved to Ross, Herefordshire, about 1859, returned to London about 1864. Died Winchmore Hill 11 March 1865; his studio sale was at Christie's 19 January 1867 and included many exhibited pictures, presumably previously unsold. The *Art Journal* thought he 'evidently aimed at Etty's manner, and though his flesh-painting was fairly good, it cannot for an instant be brought into comparison . . . His designs are not without considerable grace and spirit'. Two miniatures are in the V&A collections.

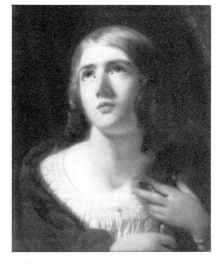

LIT:   *Athenaeum* 18 March 1865, p391; *Art Journal* 1865, p139

### A Woman Clasping a Crucifix to her Breast
1031-1886   Neg HE4758
Canvas, 52.1 × 42.1 cm (20½ × 16⅝ ins)
Signed and dated 1860
Dixon Bequest 1886

Not identifiable with any exhibited work or any lot in the studio sale. The subject relates to traditional representations of the penitent Magdalen, particularly those in 17th-century Italian painting, for example that in the style of Guido Reni acquired by the NG in 1840. Patten had visited Italy to study the old masters in 1837.

*A Woman Clasping a Crucifix to her Breast   1031-1886*

# PETHER, Sebastian (1790–1844)

Born 1790, eldest son of the landscape painter Abraham Pether (1756–1812), with whom he trained, and brother of Henry. Specialised in moonlight scenes, also stormy and 'disaster' landscapes, working mainly for dealers and apparently little financial gain. Exhibited very few works: five at the RA between 1812 and 1826, two at the BI 1818 and 1831; three were rejected by the RA 1842. Genuine works seem to be rare, and they were much copied. Interested in science, he is supposed to have invented the stomach-pump. Died Battersea, London, 18 March 1844; a subscription for his large family was solicited by the *Art Union*. His eldest son William was an artist in mosaic. The *Art Union* obituary described his life as 'full of the most painful privations that any man ever endured'.

LIT:   *Art Union* 1844, pp144–5 (obit); *Grant (OELP)*

### Windsor Castle and Town by Moonlight (attributed to SEBASTIAN PETHER)
415-1887
Canvas, 59.7 × 88.9 cm (23½ × 35 ins)
Purchased 1887

Attributed to Abraham Pether in the 1907 catalogue, re-attributed to Sebastian Pether in 1957. A visitor had noticed in 1931 that the round tower of the castle has a turret that was not constructed until 1828; Abraham

*Windsor Castle and Town by Moonlight   415-1887*

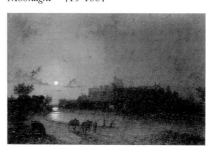

Pether died in 1812. Certain attribution seems impossible, however, in the light of the various versions of the composition by members of the Pether family, and the fact that their works are often understandably confused.

Another version of the present composition appeared at Sotheby's 23 November 1966 (101), Christie's 28 January 1977 (91), Sotheby's 12 March 1986 (97) and 11 March 1987 (100), and Christie's 15 April 1988 (69). Presumably the same painting, it is signed by Henry Pether. A composition slightly different in detail, bearing Sebastian Pether's signature but attributed in the catalogue to Henry, was at Christie's 22 April 1983 (31); a third, also given to Henry, was at Sotheby's 20 November 1985 (77). A version with a slightly different foreground is at Anglesey Abbey (National Trust), and a similar but closer view with a different foreground was at Sotheby's Parke Bernet 17 March 1982 (61) attributed to Sebastian Pether.

# PHILLIPS, Henry Wyndham (1820–1868)

Born (presumably in London) 1820, younger son and pupil of the portrait painter Thomas Phillips RA (1770–1845). Exhibited 76 works, almost all portraits and several of eminent people, at the RA between 1838 and 1868, and 13 of various subjects at the BI 1848–67. Captain in the Artists' Volunteer Corps, and Secretary of the Artists' Benevolent Institution which his father principally founded. Died Sydenham, Kent (now London), 8 (5 according to the *Art Journal* and Rees) December 1868.

LIT:    *The Times* 10 December 1868; *Athenaeum* 12 December 1868, p802; *Art Journal* 1869, p29; T M Rees *Welsh Painters . . .* 1912, pp119–20

*Design by W Wise for the South Court, showing the planned position of the Reynolds portrait on the right*

### Sir Joshua Reynolds PRA
1710-1869
Canvas, 264.2 × 87.6 cm (104 × 34½ ins)
Inscribed 'H PHILLIPS' on gold ground br
Transferred 1921

For details of the history and circumstances of the commission, see under Richard Burchett 1762–1869, p.14.

This cartoon was translated into Italian glass mosaic by Salviati for £140; it was finished in 1869. By January 1931, the cartoon was hung on the south wall of the Lecture Theatre, where it remains today.

Of the 35 artists in the 'Valhalla', the English painters are Hogarth, Mulready, and Reynolds. Presumably Reynolds was chosen as much for his achievement in art education – as founding President of the RA – as for his work as an artist. He is shown wearing the academical robes of a Doctor of Civil Law in the University of Oxford, taken presumably from the artist's self-portrait of the 1770s, now in the RA collection.

### The Royal Commissioners for the Exhibition of 1851
P112-1920    Neg 49160
Canvas, 209.6 × 358.6 cm (82½ × 141 ins)
Given by the Royal Commissioners 1920 (but see *Prov*: below)

*The Royal Commissioners for the Exhibition of 1851*    P112-1920

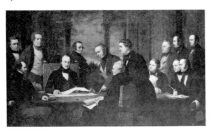

The Royal Commission for the Great Exhibition was established after much debate on 3 January 1850; the Prince Consort was Chairman, the Commissioners were eminent men from Government, the arts, and industry. The Prince publicly announced the project at the Mansion House 21 March 1850, and the Exhibition opened 1 May 1851 (see the painting by H C Selous, 329-1889 p257).

From left to right, the figures are: (standing, all statesmen unless otherwise indicated) Charles Wentworth Dilke, John Scott Russell (civil

engineer), Henry Cole (first Director of the South Kensington Museum), Charles Fox, Joseph Paxton (architect), Lord John Russell, Sir Robert Peel, Robert Stephenson (civil engineer), and (seated) Richard Cobden, Charles Barry (architect), 2nd Earl Granville, William Cubitt (civil engineer), Albert the Prince Consort, and the 14th Earl of Derby. Paxton, the architect of the Crystal Palace, has presented his plans to the Prince Consort.

It seems certain the event depicted did not in fact occur, and was probably painted some time after Paxton presented his plans to the Prince. The figures depicted do not exactly correspond with the composition of any of the committees formed to organise the Great Exhibition. Sir Henry Cole recorded in his diary 21 June 1850 that at 'Palace Yard Paxton D[uke] of Devons[hire's] gardener came with his plans which he said wd cost only £80,000 for the hire'. On the same day, the Royal Commission held its eighteenth meeting under the chairmanship of Prince Albert at the new Palace of Westminster. Further meetings were held on 27 and 29 June, which was the last to be attended by Peel, who died 2 July. Any meeting involving the Prince, Peel and Paxton must have taken place between 21 and 29 June; the present work presumably aims to invent an amplified reconstruction of the presentation on the former date.

The prototype for Phillips for this kind of group portrait was presumably the 17th-century Dutch school, notably the work of Frans Hals. The way in which the figure of Lord John Russell disrupts the flow towards and around the Prince suggests his presence was added at a late stage of the composition; alternatively, it may be an attempt to emphasize his status as Prime Minister at the Prince's right hand. Comparable contemporary group portraits are John Hollins's 'A Consultation Previous to the Aerial Voyage to Weilburg, 1836', Sir John Gilbert's 'The Coalition Ministry, 1854' and the ambitious 'The Fine Arts Commissioners, 1846', by John Partridge (all NPG).

The fact that the artist's widow lent the painting to the International Exhibition of 1871 implies that the work was not painted to commission (or that the picture was not accepted) and indeed had not been sold; however, it seems an unusually ambitious work to be produced without a commission.

PROV: The artist's wife by 1871 (see *Exh:* below); apparently lent by the artist's executors to the museum 1869, and given by the Royal Commissioners 1920

EXH: *International Exhibition* 1871 (231, as 'The Prince Consort in Council over Mr (afterwards Sir) Joseph Paxton's plans for the Exhibition of 1851', lent by Mrs H W Phillips)

LIT: E Bonython *King Cole* nd [1982], p37, repr, pl 29

---

# PICKERSGILL, Frederick Richard, RA (1820–1900)

---

Born 25 September 1820, son of a naval officer and marine and landscape painter Richard Pickersgill. Studied with his maternal uncle W F Witherington RA and at the RA Schools. Exhibited 50 works at the RA between 1839 and 1875, and six at the BI 1841–47. Subjects were mythological, biblical and literary (especially Shakespeare and Spenser), and influenced primarily by Etty. Won prizes in the Westminster Hall competitions 1843 and 1847. Elected ARA 1847 (at a very young age), RA 1857, Keeper 1873. Retired 1888 and moved to Yarmouth, Isle of Wight, where he died 20 December 1900. His cousin Henry Hall Pickersgill (see entry below) and uncle Henry William Pickersgill RA were also artists.

LIT: *Art Journal* 1850, p108, 1855, pp233–6

**Andrea Mantegna**
28-1873
Canvas, 265.5 × 88.9 cm (104½ × 35 ins)
Inscribed 'F R Pickersgill RA' br
Transferred to the Department 1921

For details of the history and circumstances of the commission see under
Richard Burchett 1762–1869, p14.

The design was translated into English ceramic mosaic by Florence H
Cole and Mary J Jennings of the South Kensington mosaic class,
superintended by Samuel Cooper of Minton, Hollins and Company; it cost
£120 and was finished in 1871. A design had originally been prepared by
Edward H Wehnert, but was not accepted (also in the V&A collections,
1144–1868; see also Pickersgill's commission, 127–1885 below). Wehnert's
design is more elaborate, showing accessories which refer to Mantegna's
interests in painting, classical sculpture, and geometry; the present work
includes only a classical relief. Neither portrait seems to relate to the
Mantegna self-portrait – the 'gigantic head' – in the Ovetari Chapel, Padua
(see R Lightbown *Mantegna* 1986, cat no 1, fig 8). The present work now
hangs as part of the decoration of the Lecture Theatre. There is a full-size
copy in oil in the Queen's Park Art Gallery, Manchester.

LIT:   J Physick *The Victoria and Albert Museum: the history of its building* 1982,
pp62–7.

*The Birth of Christianity    539-1882*

**The Birth of Christianity**
539-1882    Neg 48717
Painted photograph laid down on paper, card and panel, 24.1 × 41.9 cm
(9½ × 16½ ins)
Inscribed '. . . P RA 1857' in red bl
Jones Bequest 1882

The original painting, titled 'Flight of the Pagan Deities on the Dawn of
Christianity', was painted in 1857 and exhibited at the Manchester Art
Treasures exhibition (catalogue 496) that year, lent by Thomas Fairbairn and
so perhaps commissioned by him; it was lot 135 in the Fairbairn sale at
Christie's 2 March 1895 (as dated 1856), bought by Misell for £44 2s,
although Redford notes it in a Fairbairn sale of 1866, sold for (or more likely
bought in at) £315. It is not known why Pickersgill should have painted a
photograph of his picture in 1857; perhaps it was a quick and easy method of
making a copy on commission. A print of the photograph is in the National
Art Library; it is by Caldesi and Montecchi, and bears the number 34353.

The subject is treated in a generalised way, with no references to specific
mythological characters. On the left, the bull on a pedestal represents the
object of primitive and pagan worship (perhaps Dionysus), attended by
Maenads and Corybantes with cymbals. On the right, nine classically-draped
figures flee in fear and dismay across a sea; this group is similar to those in
other works by Pickersgill and, for example, Etty and Frost. Between the
pagan groups stands the Virgin Mary (presumably) holding the infant Christ.
The models for the Madonna and Child are supposedly the daughter of
Pickersgill's friend John Tennant and her baby son, although this is very
unlikely. The artist painted a series of religious subjects in the 1850s.

*The Industrial Arts in Time of Peace    127-*
*1885*

**The Industrial Arts in Time of Peace**
127-1885    Neg GD1298
Canvas, 108.3 × 244.2 cm (42⅝ × 96⅛ ins)
Transferred to the Department 1885

The design for a lunette fresco for the South Court of the Museum, which
was not executed. A full-size (198.2 × 457.2 cm/78 × 180 ins) design in
crayon on paper is also in the collections (128-1885). The commission was

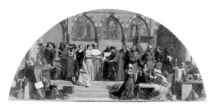

given in 1871, at an agreed fee of £1000, of which £500 was paid in advance for the design, and payment of £4 a day to superintend its enlargement in fresco by students. These payments were agreed in writing in December 1872. The present design was exhibited in the South Court.

The project for the South Court began in 1863, when a design for a mosaic to fill one of the two large lunettes on the north wall was commissioned from G F Watts; the Court was extended to the south in 1869 and resulted in two matching lunettes at that end. The mosaic scheme was abandoned in favour of fresco, and in 1868 Lord Leighton was commissioned to design 'The Industrial Arts as Applied to War'. His subsequent 'The Industrial Arts as Applied to Peace', completed in 1880, presumably replaced Pickersgill's design. Leighton's work is more populated, and the setting deeper and more elaborate. Pickersgill did complete one of the 'Kensington Valhalla' panels (see p228).

The subject of Pickersgill's painting is more particularised than that of Leighton's executed design. A prince, his consort, and members of his court, seem to be visiting a medieval hall and inspecting the design for the frescoes which are in progress on the back wall. Monks (whose predominance suggests Peace) queue up to present their examples of fine workmanship such as book-binding and illumination, and wood-carving. On the left craftsmen inspect pieces of stained glass and decorative metalwork, while on the right women are engaged in embroidery and monks carve wood, both groups inspired by the branch of ivy in the jug.

LIT: R Ormond *Leighton's Frescoes* 1975, p2; J Physick *The Victoria and Albert Museum: the history of its building* 1982, p73, repr in colour pl VIII, facing p49

# PICKERSGILL, Henry Hall (1812–1861)

Born 1812, eldest son of the portrait painter Henry William Pickersgill and cousin of Frederick Richard Pickersgill (see entry above). Studied in The Netherlands and Italy, and lived two years in Russia painting portraits. Exhibited 44 works at the RA between 1834 and 1861 and eight at the BI 1835–62. Subjects included historical genre, literature (especially Shakespeare), Italian and Russian scenes, and, notably after 1855, portraits. Worked in Lancashire, Shropshire and Herefordshire. Died London 7 January 1861; his wife Jane was also a painter, exhibiting at the RA in 1848 and 1862, and the BI in 1863.

LIT: *Art Journal* 1861, p76 (obit); H Ottley A *Biographical and Critical Dictionary*, 1866

**The Right of Sanctuary**
930-1875
Canvas, 195.6 × 264.1 cm (77 × 104 ins)
Given by Mrs Pickersgill 1875

Exhibited at the RA (West Room) in 1848 with the following quotation appended to the title in the catalogue: 'In the reign of Richard II, Lord John Holland, half-brother to the King, slew the Lord Stafford, not far from York. The young Lord took sanctuary at the monastery of St John's of Beverley – Speed'. The source is John Speed's *History of Great Britain . . .* (first published 1611) which tells the true story of John Holland, Duke of Exeter and Earl of Huntingdon (1352–1400); the murder took place in 1385 and Holland was eventually pardoned.

The *Athenaeum* thought the picture 'the best production of an historical class that we have yet seen from the hands of Mr H Pickersgill . . . The

design is excellent – the subdued hues of the colour are in accordance with the subject – the drawing is firm and solid – and a good historic style pervades the whole'. The *Art Journal* was less enthusiastic, and noted historical inaccuracy: 'The picture is large, the figures being nearly life-sized, and the pursuers are equipped in plate harness of a much later period than that of Richard II. Many of the figures seem to have been hastily painted'.

The work appears in the *Summary Catalogue of British Oil Paintings* (in the V&A) 1973, mistakenly under the name of F R Pickersgill.

Exh: RA 1848 (619)

Lit: *Art Journal* 1848, p177; *Athenaeum* 3 June 1848, p562

## POOLE, Paul Falconer, RA, RI (1807–1879)

Born Bristol 28 December 1807, son of a grocer; he was self-taught. Exhibited 65 works at the RA in 1830 and between 1837 and 1879, 13 at the BI 1830–44, and 13 (including one watercolour) at the SBA 1830–41. Sent works from Southampton 1833–5, otherwise resident in London. Subjects were rustic genre, and, by contrast, historical and literary, often of a grim nature. Made reputation as history painter with the powerful 'Solomon Eagle . . .' (1843, Graves Art Gallery, Sheffield). Won prize in Westminster Hall competition 1847. Elected ARA 1846, RA 1861. Also painted in watercolours; elected Member of Royal Institute of Painters in Watercolours 1878. From 1830 lived with Francis Danby's wife whom he married very soon after Danby's death in 1861. Died Hampstead, London, 22 September 1879; his studio sale was at Christie's 8 May 1880.

Lit: *Art Journal* 1859, pp41–3; *Illustrated London News* 23 February 1861, pp175–6 (with engr portrait); *Athenaeum* 27 September 1879, p408 (obit); *Art Journal* 1879, pp263, 278 (obit); *Graphic* 18 October 1879, p376 (engr portrait); Winter Exhibition catalogue, RA 1884; R Garnett 'A Hampstead Painter: the late Paul Falconer Poole RA' *Hampstead Annual* 1900, pp9–24; F Greenacre *The Bristol School of Artists . . .* Bristol City Art Gallery exhibition catalogue 1973, pp235–6

### The Rugged Path
525-1882   Neg 59108
Canvas, 57.1 × 48.3 cm (22½ × 19 ins)
Signed and dated 'PfP 51' on rock cr
Jones Bequest 1882

*The Rugged Path*   525-1882

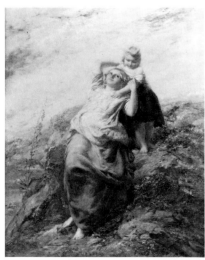

Poole painted many pictures of this kind; the *Art Journal* in 1859 commented that it was 'a class of subject which has always been a favourite with Poole, though he rarely exhibited pictures of this character'. Such works must have been popular with dealers and collectors, certainly more popular than his large historical and literary scenes (see for example the provenance of 'The Death of Cordelia', p231). Garnett (p12) also discussed these works, commenting that the landscape was 'always an important element in the picture, linked to the figures by some subtle bond of spiritual affinity'. Poole may have based his compositions on 'The Swiss Peasant' by Henry Howard RA, engraved by Charles Heath for the second volume of the 1836 *Gallery of British Engravings* (possibly after Howard's 1814 RA exhibit 'Swiss Peasants').

Two examples were engraved in the 1859 *Art Journal* – 'Crossing the Stream' and 'The Mountain Spring'; another 'Crossing the Stream', and 'The Gleaner', are in the Royal Holloway College collection (see J Chapel *Victorian Taste* 1982, pp124–5; see also 'At the Spring' sold Sotheby's 29

March 1984 (177)). There are also a great number of watercolours of rustic scenes depicting a woman and child dating from the later 1830s and the 1840s. The *Art Journal* obituary described such subjects as 'always sweet, simple, and tender'; Graham Reynolds calls them 'routine pieces, smiling country girls with their children posed against the rocky streams of the West Country' (*Victorian Painting* 1966, p142).

PROV:   Collection of Charles Birch, Westfield House, Edgbaston, Birmingham, sold Forter's 15 February 1855 (VII, engr in cat by W Thomas as 'mountain peasants descending the rugged path', 24 by 20 inches), bought Gambart £252; possibly sold at Christie's (Agnew's Galleries, Liverpool) 5 December 1861 (280, as 'The Mountain Path', 'a work of the highest quality'), bought Beaumont £204 15s.

### The Death of Cordelia

322-1887   Neg 48256
Canvas, 144.2 × 187.4 cm (56¾ × 73¾ ins)
Signed and dated 'PF[in monogram]Poole 1858' br
Purchased 1887

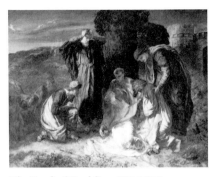

*The Death of Cordelia*   322-1887

Exhibited at the RA in 1858, with the title 'The Last Scene in King Lear', and Lear's lines quoted from Shakespeare's play 'This feather stirs; she lives; if it be so,/It is a chance that does redeem all sorrows/That ever I have felt'. The scene (act 5 scene 3) is the British camp near Dover, and Poole may have intended to indicate Dover Castle in the building on the right, although the resemblance is not close (Barry, in his painting discussed below, had depicted Stonehenge in the background, to suggest a remote period of English history). The characters, who apart from Lear and Cordelia are not clearly identifiable, are probably, from left to right, Kent, Albany, the Officer, and Edgar (the two last, in the oil sketch discussed below, wear the appropriate military helmets).

The picture was not well-received by the critics. The *Athenaeum* thought it:

> Full of a sort of gloating and exquisite light, which is neither moon, star, or sun light and yet beautiful, but still, though not without pathos, not completely successful, let alone the ragged and all but slovenly painting which Mr Poole, by some dreamy hallucination, seems to imagine consistent with high tragedy; whereas finish redeems a low subject and heightens a high one. Not that Cordelia's faded lily of a face does not fill the eyes, – not that the old man's wrung face (though rather beyond the necessary imbecility) is not full of heart-sadness, – not that the gloom and luridness of green and red, or that the rather piecrust castle is not as it should be, – but because there is something wanting both in drawing and management. Serious deep men will fall into the ludicrous for want of a few chilling drops of prudence to check their skipping spirits. At the first glance they seem like tickling a sleeping nymph's nose with a feather.

The *Art Journal* also disliked the free handling of paint:

> By the side of the highly-finished pictures of the present time, this looks like a large sketch painted without reference to models . . . the very prevalent practice of painting from nature makes every passage of landscape that is not so produced appear feeble and unnatural, and such is the feeling with which the site in this work must be regarded. The folds in the draperies are confused and improbable, and in the principal heads there is a deficiency of nobility of character.

A year later, the *Art Journal* commented again on the painting: 'We participate in the regrets, so frequently made in our hearing, when the matter of Mr Poole's works has been under discussion, that he should have departed

from the bold, vigorous, manly, and original style' of his earlier works. Ruskin, in his *Academy Notes* for 1858, dismissed the work, leaving it 'to the admiration of the *Athenaeum*'.

The episode depicted takes place at the end of the play. Lear, in his madness, is desperately hoping that his favourite daughter, whom he has wronged, will live, first applying a mirror to her face to detect her breathing, then thinking he sees her breath move the feather; at his own death, moments later, he seems still to be deluded that she is alive. In the rewriting of *King Lear* by Nahum Tate, first performed in 1681, Cordelia did live, and provided a happier ending by marrying Edgar. That version of the play remained standard in performance until about 1840, but, even expurgated, the subject was very rare in painting. Consequently James Barry's first treatment of the subject (RA 1774, now Countess Plunkett collection) is a highly unusual work. In 1774 at least one critic (in the *Public Advertiser* of 3 May, quoted by W Pressly *James Barry* Tate Gallery exhibition catalogue 1983, p57) expressed his dislike of Barry's work in a passage that presages the *Athenaeum*'s review quoted above: 'Had Shakespeare's Ideas been as demoniac and extravagant as Mr Barry's, we should never have enjoyed those artless Scenes which compose his inimitable Lear. The artist certainly meant it as a Burlesque: Cordelia represented by a Fat Billingsgate Fish-woman overpowered with Gin, and Lear personated by an old Cloaths-man. . .'

The influence on Poole of Barry's second version of the subject, 'King Lear Weeping over the Dead Body of Cordelia' (1786–7, Tate Gallery) engraved for Boydell's *Shakespeare Gallery* 1792, is evident especially in the group of figures on the left carrying the body of Edmund, presumably a reference to the subject of the Entombment of Christ or the Death of Meleager. Poole (?surprisingly) does not include the dead hangman with his noose, barely visible on the right of Barry's picture. Poole may also have admired the contribution of the landscape in Barry's picture; as Pressly (p102) points out, it 'plays a greatly expanded role'. Barry's early enthusiasm for 'King Lear' in its original version was to be shared by 19th-century Romantic writers, such as John Keats, who wrote in 1817 that the play exemplified his belief that 'the excellence of every art is its intensity', Stendhal (in *Racine et Shakespeare* 1823–5), Charles Lamb ('the most stupendous of Shakespeare's dramas', 1834), and Swinburne, who in 1880 discussed the play's grim fatalism and 'darkness of revelation'. Berlioz, in his *Memoirs* (1848–65), referred to Nahum Tate as 'the miserable poetaster' who had ruined Lear, and he wrote incidental music for the play. Verdi planned an opera of *Lear* for London in the 1850s.

Ford Madox Brown seems to have been obsessed by the original version of the play; he made a set of drawings in Paris 1843–4, three paintings, the first exhibited in 1849, and also saw Macready in his own production as Lear in 1848 (which must have been one of the first performances of the original since 1681). It is also significant in this new and Romantic context that several artists, including Poole, chose the death of Lear as their subject for the 1843 Westminster Hall fresco competition. Poole's painting did not win a prize; the *Art Union* (1843, p209) admired it for its originality, but found it too grim, 'so fraught with horror is this figure that it seems to have been dug from the grave . . .' Poole went on to exhibit at the RA several other subjects from Shakespeare's plays, including *The Tempest* (1849, 1871), *Pericles* (1852), *Cymbeline* (1866, 1871), *The Merchant of Venice* (1869), and *A Midsummer Night's Dream* (1876). Another subject from *Lear*, illustrating Cordelia's lines from act 4 scene 7 ('Was this a face/to be exposed against the warring winds?'), was shown by Poole at the RA in 1867.

Poole's painting also seems to reflect European Romantic feeling for Shakespearian tragedy in its similarity to certain aspects of Delacroix's work, particularly in the composition, colouring and handling of paint, although it is not clear how Poole would have seen work by his French contemporary. Delacroix made several comments in his *Journal* about the genius of

Shakespeare, and painted several subjects from *Hamlet* between 1835 and 1859, notably '*Hamlet and Horatio in the Graveyard*', which may be compared with the present work.

Reynolds comments that the work has a savagery of handling, a strange tonality created by the moonlight, and the figures show barbaric facial expressions, all of which suit the nature of Shakespeare's play.

The preliminary oil sketch (45.7 × 59.7 cm (18 × 23½ ins), Tate Gallery) shows a few differences in composition and detail. The poses and arrangement of the principal figures are the same, but the left-hand group is slightly different and the two men to the right of Cordelia and Lear (identified above as the Officer and Edgar) wear military helmets. The castle on the right is replaced by a ?ruined tower, and above Cordelia's head a background landscape opens up which in the finished painting is blocked by a massive tree. Redford records a 'Lear and Cordelia' (58.4 × 71.1 cm/23 × 28 ins), sold by W Cottrill and bought in at £425 5s (a very high price), which may be this oil sketch.

Prov: Possibly the 'King Lear' sold at Christie's 9 March 1861 (98), bought Robson £273, and described in the sale catalogue as 'The artist's chef d'oeuvre; equalling in brilliancy of colour and grandeur of conception anything this truly great artist has yet produced'; Edward Hargitt (presumably the artist of that name) by 1868 (see *Exh:* below); ?Eadon sale, Christie's 4 March 1876 (192, 'Lear and Cordelia'), bought Gilbert £199 10s; Christie's 12 March 1881 (62, 'Last Scene of King Lear', anon property but McLean according to Graves), bought in (according to Graves *Sales*) but bought Scott (according to V&A annotated catalogue) £299 5s; Christie's 7 May 1887 (139, 'Last Scene in King Lear, anon property 'sold by order of the Executors'), bought Lucas £105; bought from J H Lukis by the museum £262 10s June 1887

Exh: RA 1858 (310); Leeds 1868 (1435, as 'Lear and Cordelia', lent by Edward Hargitt); Bristol Art Gallery 1906 (125, as 'Death of Cordelia')

Lit: *Athenaeum* 1 May 1858, p567; *Art Journal* 1858, p166, 1859, p43; G Reynolds *Victorian Painting* 1966, pp142–3

# PRITCHETT, Edward (exhibiting 1828–1864)

Exhibited three works at the RA in 1828, 1840 and 1849, 17 at the BI 1829–60, and three at the SBA 1828, 1830 and 1864. Submitted paintings from various London addresses. Presumably travelled a good deal; his subjects included scenes in Dover, Leipzig and Prague, but predominantly Venice. According to Dubuisson, his works have been mistaken for those of Bonington; Maas notes that 'although he was largely repetitive, some of his work indicates a strong talent for the picturesque'.

Lit: A Dubuisson *Bonington* 1924, p107; C Hughes *Early English Watercolours* 1950, pp80–1; J Mas *Victorian Painters* 1969, p98; M Hardie *Watercolour Painting in Britain* III, p31; Wood *Dict*

**Venice, the Ducal Palace**
587-1908   Neg HF813
Canvas, 25.6 × 35.5 cm (10¹⁄₁₆ × 14 ins)
Signed 'E Pritchett' on boat bl
Bequeathed by George Derwent Radclyffe 1908

*Venice, the Ducal Palace   587-1908*

*Venice, the Piazzetta*   588-1908

**Venice, the Piazzetta**
588-1908   Neg18998
Canvas, 25.4 × 35.7 cm (10 × 14¹⁄₁₆ ins)
Signed 'E Pritchett' bl
Bequeathed by George Derwent Radclyffe 1908

# PROVIS, Alfred (exhibiting 1843–1886)

Very little is known of this artist. Exhibited 48 works at the RA between 1846 and 1876, 35 at the BI 1847–67, and 31 at the SBA 1843–86. Subjects predominantly small-scale domestic genre, particularly interiors of cottages and farmhouses; several Brittany subjects 1852–6, 1865–8, and Welsh scenes 1857–8, 1869–72. Submitted paintings from addresses in Chippenham, Wiltshire, 1843–9, London 1850–2, Brentford, Essex, 1853–73, London 1873, and Wantage, Berkshire, 1874–86. Perhaps influenced by the work of the Cranbrook Colony; the *Art Journal* (1865, p170) listed him among 20 artists who 'follow the varying yet always literal and naturalistic practice of the Dutch cabinet painters'.

*Beg! A Dog's Lesson*   1004-1886

**Beg! A Dog's Lesson**
1004-1886   Neg 57162
Panel, 24.1 × 34.6 cm (9½ × 13⅝ ins)
Signed and dated 'A Provis. 1860' bl
Dixon Bequest 1886

A label on the back is inscribed 'The Beggar'/No 2 Alfred Provis/Elm's Cottage/Brentford'. Provis exhibited a painting with this title at the RA in 1861, which may be identical with the present work. Other similar subjects seem to be 'Boy and Dog', (BI 1853), 'Sit up!' (RA 1863) and 'Sit up, Sir!' (RA 1865). None of these exhibited works, curiously, were noticed by the critics of the *Art Journal* or *Athenaeum*.

The vaulted interior, painted in some detail, was presumably studied from an actual location, perhaps the crypt of a monastery in Essex used as a farmhouse.

LIT:   W Shaw Sparrow 'The Dixon Bequest at Bethnal Green. III The English Oil Paintings' *Magazine of Art* XV (1891–2), repr p408

# PYNE, James Baker (1800–1870)

Born Bristol 5 December 1800. Articled to a legal attorney; taught himself painting. Exhibited seven works at the RA between 1836 and 1855, 28 at the BI 1828–63, and 194 at the SBA 1833–70 (elected Member 1842, and later Vice-President). Subjects principally landscapes, mainly river and lake scenes; his style was much influenced by J M W Turner. Travelled in Switzerland and Italy 1846, and Germany and Italy 1851. Published 'Windsor, With Its Surrounding Scenery' nd [1838–40], 'The English Lake District' (Manchester 1853), and 'The Lake Scenery of England' (1859). There are also several drawings and watercolours in the V&A collections. Died 29 July 1870; his studio sale was at Christie's 25 February 1871.

LIT:   MS *Picture Memoranda 1840–1868* National Art Library collection, V&A; *Art Journal* 1856, pp205–8; 1870, p276 (obit); *Athenaeum* 13 August 1870, pp217–8 (obit);

### The Bay of Naples
498-1870    Neg E760
Canvas, 67.3 × 101.6 cm (26½ × 40 ins)
Signed and dated 'JBPYNE 1868 No 721' br
Parsons Bequest 1870

The number inscribed on the work refers to the artist's manuscript
*Memoranda*; the work does not seem to have been exhibited, and may have
been commissioned directly by Parsons.

The view is recorded as seen from the Villa Rocco Romano, Strada
Nuova. It seems to have been a popular view for artists; Joseph Wright of
Derby, for example, painted a moonlight version, but seen from further down
and to the right (private collection, see B Nicolson *Joseph Wright of Derby:
Painter of Light* 1968, I, cat no 267, repr II, pl 291). The work is also similar,
particularly in composition, to certain early works by J M W Turner, such as
'Lake of Geneva' (exh 1810, Los Angeles County Museum), 'Lake Avernus'
(1814–5, Yale Center for British Art, New Haven, USA), and 'Bay of Baiae'
(exh 1823, Tate Gallery).

EXH:    *Paesaggio Napoletano nella Pittura Straniera* Palazzo Reale, Naples, 1962

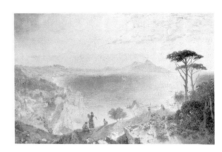

*The Bay of Naples    498-1870*

### Night Fête at Olevano
1018-1886    Neg 57863
Canvas, 64.8 × 90.2 cm (25½ × 35½ ins)
Signed and dated 'JBPYNE 1854 No 357' br
Dixon Bequest 1886

The number inscribed on the work refers to the artist's manuscript
*Memoranda*, in which the subject is described as 'Olevano, Roman States:
The eve of a Festa with fire works etc.'. The artist also notes that it was
painted in Rome in the winter of 1853–4 for the dealer William Agnew, and
sold to him 26 October 1854 for £60. The work does not seem to have been
exhibited.

*Night Fête at Olevano    1018-1886*

### Thirlmere, Cumberland
1020-1886    Neg 58952
Canvas, 85.7 × 131.5 cm (33¾ × 51¾ ins)
Signed and dated 'JBPYNE 1867 No 335' br
Dixon Bequest 1886

The number inscribed on the work refers to the artist's manuscript
*Memoranda*; the artist also notes that the work was originally painted for the
dealer William Agnew in December 1850, but he 'Took up this subj[ec]t
again in July 1867, extensively repainted on it and dated it 1867. for Mr
Hooper'. This is presumably the dealer F W Hooper, but the work does not
appear in the catalogues of his sales at Christie's 21 February 1880 and 10
March 1881. A label on the stretcher is inscribed (probably not in the artist's
hand) 'Lake Scene Thirlmere/Cumberland/J B Pyne/G[uinea]s 300'.

The work may be compared with early extensive landscapes by J M W
Turner such as 'Lowther Castle, Westmorland' (exh 1810, now private
collection). There are drawings and watercolours of Thirlmere also in the
V&A collections by William Green, John Downman, Henry Cole, and John
Constable (see particularly the 1806 'Leathes Water' (Thirlmere)
(G Reynolds *Catalogue of the Constable Collection* 1973, cat 94, repr).

*Thirlmere, Cumberland    1020-1886*

*Venice    1022-1886*

### Venice
1022-1886    Neg 57765
Canvas, 67 × 92.7 cm (26⅜ × 36½ ins)
Signed and dated 'JBPYNE 1860 No 547' bl
Dixon Bequest 1886

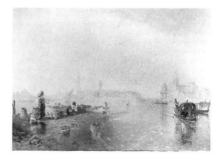

The number inscribed on the work refers to the artist's manuscript *Memoranda*; the artist also notes that the work was painted in August 1860, commissioned by the dealers Agnew and Sons for £80, and is described as painted on 'drawing-paper-ground in Brilliant White' and 'commenced in full colour without preparation'.

The view is from the direction of the Fondamenta Nuove towards the island of Murano, on the left, and, on the right, the cemetery island of San Michele, prominently showing the church described by Paolo Delfin in the 16th century as 'something great and singular' and 'a temple which not only evokes antiquity but actually surpassed it'. The work is reminiscent of similar views of the Venetian lagoon by J M W Turner. There are engravings after Clarkson Stanfield by R Wallis also in the V&A collections (E627–1935, E5243–1910) which depict the island of Murano from different views.

# REDGRAVE, Richard, CB, RA (1804–1888)

Born Pimlico, London, 30 April 1804, the son of an engineer and manufacturer, in whose office he first worked as draughtsman and designer. Entered RA Schools 1826. Worked as a drawing master in the 1830s. Exhibited 141 works at the RA between 1825 and 1883, 17 at the BI 1832–59, and 20 (including four watercolours) at the SBA 1829–35 and 1870–9. Early works were landscapes and costume pieces, mainly 18th-century and in the manner of C R Leslie; from the 1840s he specialised in modern genre and social comment, before returning to landscape, particularly around his home in Abinger, Surrey, relieving the pressure of his administrative duties. Elected ARA 1840, RA 1851; Secretary of the Etching Club 1837–42. In 1847 he began his official career in art education as Master at the Government School of Design, becoming Head Master in 1848, Art Superintendent 1852, Inspector General 1857, and Director 1874. He was Inspector of the Queen's Pictures, compiling a catalogue of the Royal Collection, 1857–79. As he wrote in 1856: 'I regret to find that I am so identified with office work that it is almost forgotten that I am a painter' (F M Redgrave *Richard Redgrave: A Memoir . . .* p171). He published *An Elementary Manual of Colour . . .* (1853), *The Sheepshanks Gallery* (1870), and, most famously, with his brother Samuel, *A Century of Painters of the English School . . .* (2 vols, 1866). He was offered a Knighthood in 1869, which he declined; created Companion of the Bath 1880. Died Kensington, London, 14 December 1888. His daughters Frances (who compiled the *Memoir* of her father) and Evelyn were also exhibiting artists.

LIT: *Art Journal* 1850, pp48–9 (referred to below as the 'autobiography'), with engr portrait; *Art Journal* 1859, p206; *Athenaeum* 22 December 1888, pp854–5 (obit); F M Redgrave *Richard Redgrave, CB, RA: A Memoir compiled from his diary* 1891 (referred to below as *Memoir*); F G Stephens in *Magazine of Art* XV, 1891–2, pp26–9; ed S Casteras and R Parkinson *Richard Redgrave 1804–1888* 1988, V&A and Yale Center for British Art, New Haven, USA, exhibition catalogue

*Cinderella About to Try on the Glass Slipper* FA167

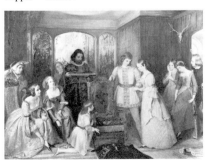

## Cinderella About to Try on the Glass Slipper
FA167   Neg 37940
Canvas, 106.7 × 142.2 cm (42 × 56 ins)
Sheepshanks Gift 1857

Exhibited at the RA in 1842 and bought from the artist by John Sheepshanks. The title given in the RA catalogue was 'Cinderella', accompanied by the quotation (presumably from a translation of Charles Perrault's story): 'That minx, said the step-sister, to think of trying on the slipper'. Redgrave wrote to his sister Margaret 4 October 1840:

I also am trying out a subject which I think will make a good picture it is Cinderella – where the disguised prince is leading her up to the chair to try drawing on the slipper which the herald holds on a cushion the other 2 sisters all envy and hatred just replacing their shoes with the aid of a page. after having tried and failed, & a pert attendant at the other end of the picture looking at her own foot thinking that perhaps she might be able to get on the slipper – of course the point of the picture is the contrast between the meekness & modesty of Cinderella, and the scorn & envy of the handsome but proud sisters – I think it will make a good subject but I wish to paint it without anyone knowing that I am about it if I can . . . (letter in National Art Library).

The *Art Union* critic admired it:

We find here an exertion of those powers which so eminently distinguish this artist . . . We read in this work the fairy tale over again, – not only in its main incident, but all the by-play, in the description of which the imagination of this painter is so rich. The sneer which curls on the features of the envious sisters is rendered with much power, as is also the retiring demeanour of Cinderella. In colour the picture is rich, and in effect most successful.

The *Athenaeum*, however, criticised the drawing: 'Clearly made out as is the story, and attractively handled as are its details, the draftsman's correcting hand is wanted. The enamoured youth, for instance, (to go no further for blemishes) does all but squint. These things must be amended, or we shall have no Age of Cartoons' (presumably a reference to the fresco competitions for the Palace of Westminster in the 1840s, in which Redgrave participated).

The setting and costumes, particularly the tunics and hose and pointed shoes, are intended to give a medieval flavour; the women's clothes are more 18th-century in style, and their hairstyles are contemporary and fashionable for about 1840 (see for example Landseer's 1839 sketch portrait of Queen Victoria in the Royal Collection). Although some 19th-century artists such as Millais used sources like Bonnard's *Costume Historique* on which to base their costume design, no specific borrowings have been identified for Redgrave. The chair in the foreground is Victorian-Jacobethan in style. The model for the bearded servant may have been the artist's brother Samuel Redgrave, whom he closely resembles; the artist used the same model in other paintings. Prince Charming may be the artist himself (see the self-portrait of about 1827 in the Yale Center for British Art, New Haven).

There are studies for various figures in the V&A collections; the small oil sketch is in the Bankfield Museum, Wakefield.

Exh: RA 1842 (244); *Victorian Narrative Painting* Bristol Cathedral 1977 (11); *Richard Redgrave 1804–1888*, V&A and Yale Center for British Art, New Haven, 1988 (24)

Lit: *Athenaeum* 14 May 1842, p434; *Art Union* 1842, p123; *Art Journal* 1857, p240, 1859, p206; *Memoir* p44; *Casteras and Parkinson* pp108, 110

## The Governess
FA168   Neg E467
Canvas, 71.1 × 91.5 cm (28 × 36 ins)
Signed and dated 'Richd Redgrave/1844' br
Sheepshanks Gift 1857

A version with alterations painted for John Sheepshanks in 1844 of the picture 'The poor teacher' exhibited at the RA in 1843 (553). It is presumably the work shown at the RA in 1845 as 'The governess' with the unattributed quotation in the catalogue: 'She sees no kind domestic visage here'. The catalogue to the British Fine Art Collection at the V&A in 1870 also provides a longer paragraph amplifying the quotation and which may

well have been approved (or actually written) by Redgrave himself: 'An orphan, whose mourning dress shows that her loss is recent, condemned to the drudgery of the teacher's office, is seated in the schoolroom at her lonely evening meal. Her task for the day is evidently not ended, for the desk is covered with exercises to correct and work to set right. In her hand is a letter from the home which poverty has obliged her to quit, for labour in which she meets with sympathy neither from the Principal nor the scholars.' The artist's daughter recorded in the *Memoir* that 'This kind of subject was a favourite one with the painter, who longed to fight for the oppressed and to help the weak, and could do it only with his brush. "The poor teacher" was another picture of the same class, and it had a great success. He repeated it four times with alterations. For instance, in the one he painted for Mr Sheepshanks, he added the children in the background, as the purchaser objected to the terrible loneliness of the forlorn governess in the empty schoolroom.' The *Memoir* also records that 'The poor teacher', had the singular good fortune to be placed on the line [that is, at eye level] in the great room in the Academy Exhibition – a privilege which at that time was rarely accorded to the pictures of Associates'. The *Memoir* suggests in the passage quoted above that there is a total of five versions of the subject. The *Poor Teacher* exhibited in 1843 was bought by John H Hippisley of Shobrooke Park and was engraved by William Giller in 1845; its present whereabouts are unknown (it was probably the version exhibited at Agnew's in 1971, signed and dated 1843, 26 × 30″, lent by Miss Diana Anderson). The engraving differs slightly in detail from the painting 'The Poor Teacher', signed and dated 1845 (canvas, 64 × 77.5, 25³/₁₆ × 30½″), now in the Shipley Art Gallery, Gateshead. The Sheepshanks painting differs not only in the addition of the three pupils (whose presence outside is suggested in the Gateshead picture by the shuttlecock flying past the window), but also in the setting. The principal effect of these changes is to enliven the composition. 'The Sempstress', exhibited at the RA in 1844, is more successful than 'The Poor Teacher' at conveying an intense atmosphere using a single figure. The addition of the three girls also serves to contrast their different moods and social status. There seems to be no record of the other versions.

The *Memoir* described the subject of the 1843 painting as one 'which found many sympathisers. All could feel touched by the representation of a young and pretty girl, just at the time when she would naturally rejoice in gaiety and merriment, immured in a vacant schoolroom to take her solitary tea, and left, when worn out with her day's work, to nurse over and long for home and happiness'. Contemporary reviews of the 1843 'Poor Teacher' added their own glosses to this basic interpretation, of which the *Art Union's* was the most extensive: 'The profound sensibility thrown into this figure must render it a theme of applause with all who see it. "The poor teacher" seems to be an orphan of parents who have moved in a superior circle of society. She is seated in the school-room, the theatre of her drudgery, and near her stands a cup of tea and a spare piece of bread and butter. There is in her downcast countenance a burthen of melancholy, resulting from a sinking of the heart; and her pale countenance and attenuated hands proclaim a frame already the prey of disease. This is one of the "side" passages in the melodrama of everyday life, but it is not the less deep and moving . . . this artist searches the human heart for its most touching moods. Rarely do we find a picture, at all tolerable, so simple and so unaided by accessories; this, however, is one which has been so vividly inwrought with the greatest alloy, that its peculiar value must remain undiminished, to what comparisons soever it may be subjected.' The *Athenaeum* critic did not deal specifically with 'The Poor Teacher' among Redgrave's three RA exhibits, but commented that: 'the general style of this painter reminds us of that of Mrs Opie as a writer [that is, Amelia Alderson (1769–1853), wife of the painter John Opie RA, and a novelist and poet]. His forte, like hers, is the pathetic; it is the same manner of appealing to the same class of feelings . . . All Mr Redgrave's pictures *tell a story*, either moral or pathetic, or both; and tell it very significantly: a great merit'.

When the Sheepshanks painting was exhibited at the RA in 1845, less notice was taken by the critics: perhaps they had little that was new to say on the subject. The *Illustrated London News* attacked the principle of exhibiting a repetition: 'when Mr Redgrave became an Associate of the Royal Academy, he promised a good deal more than he has since made good . . . In point of execution he has infinitely improved. He is too apt, however, to repeat himself; and "The Governess" of this year's Exhibition is a copy of "The Poor Teacher" of a prior year, with a new background of skipping-ropes and girls. The painter's excuse will, in all probability, be that it is a commission – a second Mr Hippisley would have a second "Poor Teacher", and, as those that live to please must please to live, he was compelled to paint it, or lose the commission altogether.' The *Art Union* also commented on the repetition: 'If this picture be not an express commission, we can see no sound philosophy in the reproduction of its subject; for it is the same, with very little change, that hung on these walls in a recent exhibition. Despite the want of originality, however, the work cannot fail to prove universally attractive; the story is so touching; it is made so deeply impressive; it is so eloquent an appeal on behalf of a class that demands our best sympathies; it is, in fact, a painted sermon – a large and valuable contribution to the cause of humanity.'

The message is perhaps made clearer in the Sheepshanks painting. The music-sheet on the piano, for example, is ironically Sir Henry Bishop's popular *Home, Sweet Home*. In all the known versions, the teacher holds a black-edged letter (denoting, but not necessarily announcing, a death) which begins 'My dear child'; the rest is illegible. Whether or not she is already in mourning is uncertain; the dress is not first mourning, usually worn for six months or so, and it may simply be her 'uniform'. Neither is it certain that she has just received the letter. Penny notes that she was 'forced no doubt by the death of the family breadwinner to leave home at a tender age' and that 'it would have been clear that her father (or guardian) died at least three months ago, because that was the period prescribed for first mourning for members of the family, and she is wearing silk and therefore in second mourning'.

Christopher Wood has suggested that the artist had a personal reason for painting this subject, as Redgrave's sister Jane was working away from home as a governess when she contracted typhus and eventually died. Redgrave himself worked as a drawing master in a private day school. One of his pupils at Mrs Matthew's school in Westbourne Place recalled that at the age of 12, in 1839, 'One day Mr Redgrave was giving a lesson to three girls in the back-dining-room while I was sitting en penitence in the front one the folding-doors being open. After the lesson the girls told me that Mr R had been sketching me. Within two years after that he painted "The Poor Governess", and her position is that in which I was sitting at the time for I speculated what it could have been that induced him to make the sketch, and made a mental note of it' (MS Memoirs, private collection). It is interesting that the writer herself became a governess.

John Sherer compared the subject of the painting to that of William Shenstone's most famous poem *The Schoolmistress* (1742), although, as he pointed out, that 'poor teacher' was much younger.

The article in the 1859 *Art Journal* sums up the lasting appeal of this well-known painting: 'a picture of such deep pathos and profound sensibility as to excite the strongest feelings of compassion towards the numerous class of individuals to which the subject refers: there are few pictures that have called forth so many involuntary sighs as this . . .'.

There are two black and white chalk studies for the seated and skipping girls, and composition studies, in the V&A collection.

EXH:  RA 1845 (11); *The Poor Teacher: A Painting and its Public* Newcastle
      Polytechnic Art Gallery 1981 (39); *Redgrave* 1988 (36).

LIT:  *Athenaeum* 27 May 1843, p512; *Art Union* 1843, p174; *Blackwood's
      Magazine* 1843, p195; *Illustrated London News* 24 May 1845, p323; *Art*

*Union* 1845, p180; *Morning Chronicle* 12 May 1845, pp5–6; R Redgrave 'Autobiography', *Art Journal* 1850, p49; J Dafforne 'Richard Redgrave', *Art Journal* 1859, p206; W Sandby *The History of the Royal Academy of Arts* 1862, II, pp292, 294; J Sherer *The Gallery of British Artists . . .* 1880, II pp45–9; *Memoir* 1891, pp43–4; G Reynolds *Painters of the Victorian Scene* 1953, pp10, 53; R Lister *Victorian Narrative Painting* 1966, pp21–2, 50–1; G Reynolds *Victorian Painting* 1966, p95; J Maas *Victorian Painters* 1969, pp114, 119; H Roberts 'Marriage, Redundancy, or Sin . . .', in M Vicinus *Suffer and Be Still: Women in the Victorian Age* 1973, pp58–60; L Errington *Social and Religious Themes in English Art 1840–60* University of London PhD dissertation 1973, pp91–3, 95–9, 102, 106–9, 111, 118, 120, 123–4, 126–7; M Waldfogel *The Art and Mind of Victorian England* 1974, p60; C Forbes *The Royal Academy Revisited* 1975, p124; H Rodee *Scenes of Rural and Urban Poverty in Victorian Painting and their Development* Columbia University PhD dissertation 1975, pp126–7, 360; C Wood *Victorian Panorama* 1976, pp10, 129–30; T Edelstein . . . *The Social Theme in Victorian Painting* University of Pennsylvania PhD dissertation 1979, pp131–2, 146–52; C Wood *The Pre-Raphaelites* 1981, pp12, 74; N Penny *Mourning* 1981, pp58, 60; P Usherwood *The Poor Teacher: A Painting and its Public* Newcastle Polytechnic Art Gallery exhibition catalogue 1981, pp3, 4, 12–15; L Lambourne *An Introduction to Victorian Genre Painting . . .* 1982, p38; P Altick *Paintings from books: Art and literature in Britain 1760–1900* 1985, p82; E Johnson *Paintings of the British Social Scene from Hogarth to Sickert* 1986, pp228–9; C Fox *Londoners* Museum of London exhibition catalogue 1987, p193; S Casteras *Images of Victorian Womanhood in English Art* 1987, pp114–6; 1988, *Casteras and Parkinson* pp12, 14–5, 17–9, 21–2, 110–5.

*Gulliver Exhibited to the Brobdingnag Farmer* FA169

## Gulliver Exhibited to the Brobdingnag Farmer

FA169    Neg HD5313
Canvas, 63.5 × 76.2 cm (25 × 30 ins)
Sheepshanks Gift 1857

Exhibited at the BI in 1836 (the size given in the catalogue as 35 × 39 inches, presumably including the frame), and bought by James Mollison in order for him to make an engraving. Redgrave noted in his 1850 'autobiography':

> I exhibited a picture at the British Institution, 'Gulliver on the Farmer's Table', which was bought for the purposes of engraving. It was my first success. It is true the price was a small one, but it led me to hope for better times. The work is now in the possession of my friend, Mr Sheepshanks, of Rutland Gate.

The *Memoir* also records Redgrave's pleasure when the Prime Minister and others saw the painting at Rutland Gate, finding them 'intent on the details of my "Gulliver", which afforded much amusement' and receiving 'a spontaneous compliment or two'. He remarked that he had 'attempted to give Gulliver of the stature of the human race – and to show the Brobdingnags as giants – hence the accessories that surround him . . . are intended to give scale to the background figures.'

The work illustrates an episode from chapter 2 of part 2 of Jonathan Swift's famous satire *Gulliver's Travels* (1726) in which the hero encounters the giant people of Brobdingnag: 'This man [the neighbouring farmer of the hero's master], who was old and dim-sighted, put on his spectacles to behold me better, at which I could not forbear laughing very heartily, for his eyes appeared like the full moon streaming into a chamber at two windows'. Redgrave captures very well the comic if peculiar mood of this episode, and it

is interesting and perhaps characteristic that he subdues the harshly satirical tone of Swift's narrative.

The *Athenaeum* noted the publication of the print in 1838:

> Mr Redgrave's *Gulliver in Brobdingnag* is on a completely opposite plan from Mr Leslie's [presumably C R Leslie's 'Gulliver's Introduction to the Queen of Brobdingnag' exhibited at the RA in 1835]. The latter exhibited Glumdalica and her maids on the scale of common womanhood, – dwarfing down the traveller to the littleness of a dragon-fly. Mr Redgrave has left him in his natural painter's proportions, but surrounded him by faces so gigantic, as, by their monstrosity, to exceed the limits of our credence. We suspect the Captain is one of the many beings who are to be imagined, but not represented. The engraving of Mr Redgrave's picture is by Mr Mollison, and cleverly executed. There is a certain metallic tone about it, however, which is harsh and unpleasing to the eye.

In terms of the subject, Altick comments that the most noteworthy paintings illustrating *Gulliver's Travels* were produced in the 18th century, Sawrey Gilpin's pictures of the Houyhnhnms, for example. In the early 19th century the first two parts of the book, set in Lilliput and Brobdingnag, were particularly popular, but neither Leslie's nor Redgrave's interpretations met with great enthusiasm. Only a few works inspired by *Gulliver's Travels* were exhibited thereafter, artists seemingly preferring to turn to Swift's own life for the subjects of their paintings.

Jeremy Maas has convincingly suggested that the face of the farmer is Redgrave's self-portrait. This is more evident in the full-size study of the farmer's head and hand, also in the V&A collections.

PROV:  Bought 1836 by James Mollison for £21; bought by John Sheepshanks before 1850, and given by him to the museum 1857

EXH:  BI 1836 (456); *Richard Redgrave 1804–1888*, V&A and Yale Center for British Art, New Haven, 1988, (2)

ENGR:  Steel engr, James Mollison 1838; wood engr by Best & Co, in *Album du Magasin Pittoresque* Paris 1862, pl 14.

LIT:  *Athenaeum* 30 June 1838, p461; *Art Journal* 1850, p48, 1859, p205; *Memoir, p172*; R Altick *Paintings from Books: Art and Literature in Britain 1760–1900* 1985, p382; *Casteras and Parkinson* pp100–1

**Throwing off her Weeds**
FA170   Neg 59106
Panel, 76.2 × 62.3 cm (30 × 24½ ins)
Signed and dated 'Richd Redgrave 1846' on hat box br
Sheepshanks Gift 1857

Exhibited at the RA in 1846 as 'Preparing to Throw off her Weeds'. Contemporary critics, while to an extent admiring the artist's technique, found the subject matter vulgar. *The Critic* thought the picture went 'too far for good taste in the lady who, it should be remembered, is yet attired in mourning'. The *Athenaeum* found a 'hardness and the over-eagerness too elaborate', and interpreted the artist's intention as satirical:

*Throwing off her Weeds*   FA170

> Satire upon the follies or vices of everyday life must be accompanied by an evident knowledge in the satirist of the manners on which he pronounces his decision. Faulty in this respect, the conception of the artist bears the germ of its own ill-fortune, – for it is truth alone that can give it pungency. With much clever painting and agreeable effect about this work, it does not, therefore, come into the category of successful hits at human frailty.

The *Art Union* was more specific in its criticism, noting 'with deep disappointment' a loss of the depth of feeling found in 'The Governess' (see FA168 p237) and 'The Sempstress' (Forbes Magazine collection), and 'a retrograde movement'. Moreover, 'the *engagement* of the widow is indelicately announced by the hasty entrance of the officer, which is assuredly ill-timed and ill-judged; and the treatment otherwise is toned with vulgarity'. There was at least a little humour in the response of *The Literary Gazette*, which remarked that:

> The widow, the mantua-maker, and the maid are all well imagined, and the silks and satins are enough to tempt a saint from mournful black, though we do not know that the lady will look a bit better in the gayer colours. The shadowy soldier who, we suppose, is the object of the change, does not appear to be worth the trouble.

When the figure of the officer was visible, entering at the open door on the left, the picture must have had a more Hogarthian quality of commentary on human nature. The unlikely image of the portrait, presumably of the dead husband, looking down from behind the screen with a rueful smile, adds to this satirical interpretation. Presumably the figure of the officer, the lady's new husband-to-be, was painted out by Redgrave after the RA exhibition, in response to the criticisms and perhaps at the request of the purchaser, John Sheepshanks. Infra-red photography has revealed the presence of this figure under the top paint surface, as well as other more minor changes.

As Casteras remarks, although Queen Victoria sustained strict mourning for ten years, 'Victorian painters seemed far more fascinated by the widow who was young, attractive, and vulnerable, a potent formula to excite pathos'. Redgrave's young widow has perhaps been in deep mourning, then in 'modified' and 'half' mourning, for about two years or so; as Penny notes, the picture shows the final phase of returning to brighter colours in dress – 'the deliberations before this step was taken'. Casteras also draws attention to the bridal bonnet in the hat box and the orange blossoms which allude to her forthcoming remarriage.

Edelstein points out how this and *Fashion's Slaves* (1847, private collection) both include traditional *vanitas* emblems, in the mirrors included in the interiors. It is also possible that Redgrave intended another and more erotic level of meaning, although this seems unlikely in view of his personality, in the similarity of the composition to representations of subjects such as 'David and Bathsheba'. The screen has a design which combines a kind of lovers' knot and the birds/grapevine motif also found in Holman Hunt's 'The Awakening Conscience' (1853, Tate Gallery) where a similar symbolic warning is intended.

There is a study of female heads which includes one for this painting, and a watercolour sketch for the whole composition which shows the figure of the entering fiancé, both in the V&A collections. The painting does not seem to have been engraved, perhaps because of the initial controversy surrounding its subject.

Exh:   RA 1846 (240); *The Substance or the Shadow: Images of Victorian Womanhood* Yale Center for British Art, New Haven, 1981 (75); *Richard Redgrave 1804–1888*, V&A and Yale Center for British Art, New Haven, 1988 (67)

Lit:   *Spectator* 16 May 1846, p475; *Athenaeum* 23 May 1846, p527; *The Critic* 20 May 1846, pp622–3; *Art Union* 1846, p177; *Literary Gazette* 1846, p478; W Sandby *History of the RA* 1862, II, p294; C Wood *Victorian Panorama: Paintings of Victorian Life* 1976, pp113–4; T Edelstein '*But who shall paint the griefs of those oppress'd?*' *The Social Theme in Victorian Painting* PhD dissertation, University of Pennsylvania 1979, pp113–7; N Penny *Mourning* 1981, pp58–9; S Casteras *The Substance or the Shadow: Images of Victorian Womanhood*

Yale Center for British Art, New Haven, exhibition catalogue 1981,
pp36, 91; S Casteras *Images of Victorian Womanhood in English Art*
1988, pp69–70, 123; *Casteras and Parkinson* 1988, pp123–5

**Ophelia Weaving her Garlands**
FA171    Neg 74357
Panel, 76.2 × 63.5 cm (30 × 25 ins)
Signed and dated 'Richd Redgrave 1842' in white br
Sheepshanks Gift 1857

Exhibited at the RA in 1842 and, according to the *Memoir*, bought by John
Sheepshanks. The title given in the RA catalogue was simply 'Ophelia', with
the following lines (slightly adapted) from Shakespeare's *Hamlet*, act 4 scene
7:

> There is a willow grows ascaunt the brook,
> That shews his hoar leaves in the glossy stream;
> There with fantastic garland did she make
> Of crow-flowers, nettles, daisies, and long purples.

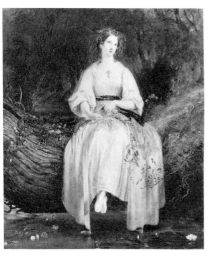

*Ophelia Weaving her Garlands*    FA171

The *Memoir* records that Redgrave's work for the 1842 exhibition was
behindhand and further delayed by his brother Samuel's illness; he wrote to
his sister Margaret that 'I shall finish "Cinderella" and leave the others if I
have not time – "Ophelia" and "Bad News from the Sea".'
   The *Memoir* also indicated that 'Ophelia' 'has been considered to be one
of his best figure-pieces'. After an admiring description, particularly of the
'mournful sweetness' of the face, the *Athenaeum* critic 'could but think of the
incomparable snatches of melody which Shakespeare has put into her mouth,
while standing before this attractive figure; which is all the more welcome, as
displaying a substantial advance made by the painter'. The reviewer also
noted how the disordered clothing, strange 'light in the eyes and a quivering
of the lip . . . declare that Sorrow has done its worst work'. The *Art Union*
would

> not have recognised Mr Redgrave in this picture; not, be it understood
> from a want of excellence, but from its inconsonance with all our
> impressions of its author . . . She is pale – woe-begone – and her restless,
> fevered eyes, bespeak a mind diseased. The painting of her dress, which
> is white, resembles the manner of some of the old masters, a feeling
> which is extended to the banks of the brook, this part of the work being
> enamelled on the canvas [sic] like the foreground of Giorgione's garden
> scenes.

Redgrave recorded in his diary on 20 June 1857 that, on a visit to the South
Kensington Museum, Queen Victoria 'seemed really to like my picture of
"Ophelia"', and two years later the *Art Journal* commented that 'the figure is
an admirable embodiment of the poet's character, and the landscape is
painted with a finish and attention to detail which, in our day, would be
called "Pre-Raffaellism"'.
   Redgrave follows the description of the 'crowflowers, nettles, daisies, and
long purples' in Queen Gertrude's account of Ophelia's death, and Joanna
Dean has kindly identified for the present author no fewer than 30 different
flowers in the painting. The flowers around Ophelia refer to constancy, love,
extinguished hopes and thoughts, purity of heart, ingratitide and mourning;
she wears a garland on her head of reeds, rosehip, nettle and field scabious,
symbolising similar qualities and emotions; in her hands are various other
symbolic plants, notably the poppy bud indicating death. The garland is
presumably also the head-dress of a bride, and she has evidently fashioned for
herself a wedding ring by tying grasses around her finger, relating to her
longing for Hamlet.

The subject of Ophelia for painting was not as popular as might be supposed, probably because of its difficulty. There were two in the 1831 RA exhibition (by John Wood and Lilburne Hicks), and later in 1852 the more famous works by Millais and Arthur Hughes. Redgrave himself painted another Ophelia (sold Christie's 15 June 1973 (65), size given as 20 by 16 inches), which scarcely even suggests the subject's derangement of mind. He also made an etching of a similar subject to illustrate Desdemona's 'Poor Barbara's Song' from *Othello* for the *Songs and Ballads by Shakespeare Illustrated by the Etching Club* published in 1843 (repr *Casteras and Parkinson* 1988, p25).

There are three small sketches and a chalk and watercolour study for the painting in the British Museum; a study for Ophelia's head, and a cartoon in reverse in black and red chalks and squared for transfer to the panel, are in the V&A collections.

Exh: RA 1842 (71); *Exposition Universelle* Paris 1855 (925, as 'Ophelia', lent by J Sheepshanks); *Richard Redgrave 1804–1888*, V&A and Yale Center for British Art, New Haven, 1988 (23)

Engr: Butterworth and Heath, for *Art Journal* 1859, p206

Lit: *Athenaeum* 7 May 1842, p410; *Art Journal* 1842, p121, 1859, p206; W Sandby *The History of the Royal Academy of Arts* 1862, II, p294; *Memoir* pp44, 171, 175; R Altick *Paintings from Books: Art and Literature in Britain 1760–1900* 1985, p115; *Casteras and Parkinson*, pp107–8

*Bolton Abbey – Morning*   FA172

### Bolton Abbey – Morning
FA172   Neg GA1200
Canvas, 31.7 × 77.5 cm (12½ × 30½ ins)
Signed and dated 'Richd Redgrave 1847' on rock to l of centre foreground
Sheepshanks Gift 1857

Exhibited at the RA in 1848 as 'Autumn – Morning' (a companion to 187, 'Spring', which was accompanied in the catalogue by a slightly adapted quotation from Thomson's *The Seasons*: 'The trout's dark haunt beneath the tangled roots/of pendent trees'). Redgrave had contributed designs for wood-engravings to illustrate a 1842 edition of *The Seasons*; they do not relate to the present composition.

The *Art Journal* thought that 'everywhere the picture has been studied with a care that has yielded the best results. It is seldom that so much excellence is displayed in two opposite departments of Art [that is, landscape and figure compositions] as we see in the works of this painter'. The *Athenaeum* critic concurred: 'Mr Redgrave's art is not confined to the transcription of the human form or to indoor effects: – he has also distinguished himself in landscapes . . . [he] has shown so much power in these as to make us desire to see from his pencil some picture combining landcape with human forms'. The artist wrote in his diary on 8 February 1858: 'Went to South Kensington at eleven o'clock, and found the Queen, the Prince, and his brother the Duke of Saxe-Coburg there . . . The Queen was pleased to admire my landscape of "Bolton Abbey"'.

Bolton Abbey, a ruined priory by the river Wharfe in the West Riding of Yorkshire, is located in a picturesque setting of wild moorland much admired by artists. Ruskin wrote in *Modern Painters* in 1846 that 'It is to the association of this power and border sternness with the sweet peace and tender decay of Bolton Priory, that the scene owes its distinctive charm'. The *Memoir* records that up to 1860 it was one of several places Redgrave visited in successive summers. He went on a sketching tour with his friend C W Cope in the late 1830s, and was in the area of the Rivers Greta and Tees some 40 miles north of Bolton Abbey; a visit to the Abbey in the later 1840s is also indicated in the *Memoir*. Redgrave described the view as 'looking down the stream – the portion of the abbey still used as a church being seen on the cliffs'.

EXH:    RA 1848 (189); *Richard Redgrave 1804–1888* V&A and Yale Center
         for British Art, New Haven, 1988 (83)

LIT:    *Athenaeum* 20 May 1848, p512; *Art Journal* 1848, p169; W Sandby
         *History of the Royal Academy of Arts* 1862, II, p294; *Memoir* pp46, 70,
         171, 183; *Casteras and Parkinson* pp128, 130

## Donatello

1707-1869   Neg HA5032
Canvas, 264.2 × 87.6 cm (104 × 34½ ins)
Signed 'RR' in monogram on plinth, and inscribed 'Richard Redgrave RA' on
br of gold background
Transferred to the Department 1921

*Donatello   1707-1869*

For details of the history and circumstances of the commission see under
Richard Burchett 1762–1869, p14. Redgrave's design was translated into
English ceramic mosaic by Samuel Cooper, superintended by William E
Alldridge for Minton, Hollins & Company; it was finished in 1867.

No certain contemporary portrait of the Italian Renaissance sculptor
Donatello (1386–1466) exists, and little is known of his personality.
Redgrave's source for Donatello's appearance is presumably the head and
shoulders portrait by Giorgio Vasari in the Sala di Cosimo il Vecchio,
Florence, which was engraved and which in turn was based on the portrait
attributed by some historians to Uccello on a cassone panel known as 'The
Founders of Florentine Art' (Louvre, Paris). The Uccello portrait is supposed
to be copied from a lost fresco by Masaccio. A 19th-century full-length
sculpture of Donatello by Girolamo Torrini is in the Loggiato of the Uffizi,
Florence (1842–8) and depicts a more youthful figure than Uccello's.
Redgrave carries this rejuvenation process further, but the facial features –
the shape of the eyes, nose, mouth and beard, and the high well-defined
cheekbones – are very similar.

The pose may be an adaptation of a 'Triumphant David', even of
Donatello's drawing of that subject, the only drawing by Donatello widely
accepted as autograph (Musée des Beaux Arts, Rennes). Donatello holds a
mallet in his left hand, referring to his work in marble, and wears a pouch full
of modelling tools for his work in terracotta. In his right hand he holds the
bronze 'Martelli' mirror, purchased as a Donatello by the museum in 1863;
this may not only refer to the museum's recent and important acquisition, but
also to Donatello's own history, as according to Vasari's *Vita* he was brought
up by the Martelli family. The mirror is now considered to be north Italian
and late-15th-century.

EXH:    *Richard Redgrave 1804–1888* V&A and Yale Center for British Art,
         New Haven, 1988 (113, and 165 for an electrotype of the Martelli
         mirror)

LIT:    *Casteras and Parkinson* pp140–1, 165 (repr)

REPR:   M Allthorpe-Guyton *A Happy Eye: a school of art in Norwich
         1845–1982* 1982, p55

## Sweet Summer Time

232-1885   Neg Z155
Panel, 21.6 × 34.9 cm (8½ × 13¾ ins)
Signed and dated 'Richd Redgrave 1869' bl

The location is recorded as Wotton Meadows, very near Redgrave's home in
Abinger, Surrey. The workers on the left are erecting hurdles for the sheep,
while an ?artist watches on the right.

PROV:   George Clark of Sunderland; his sale, Christie's 25 July 1885 (146),
         bought by the museum £21

*Sweet Summer Time   232-1885*

Exh:   *Victorian Paintings* Arts Council 1962 (55); *Richard Redgrave 1804–1888* V&A and Yale Center for British Art, New Haven, 1988 (116)

Lit:   *Casteras and Parkinson* pp141–2 (repr)

*Quentin Matsys in his Studio*    210-1887

## Quentin Matsys in his Studio
210-1887   Neg HH4020
Millboard, 15.3 × 17.7 cm (6 × 7 ins)
Purchased 1887

Presumably an oil sketch for the painting exhibited at the RA in 1839 (377), 'Quentin Matsys, the blacksmith of Antwerp', which had the following explanatory quotation appended to the title in the catalogue: 'Quentin Matsys fell in love with the daughter of a painter, but her father refused to give her to any but an artist. Quentin set himself to learn the art; he painted the well-known picture of the "Misers", and won the maiden. Vide Lives of the Painters'. The finished picture is now in a private collection, USA (see *Casteras and Parkinson* 1988, p104, cat no 13, repr)

In his 1850 'autobiography', the artist records that the picture was well hung at the RA and purchased by Mr D Salomons, marking a turning point in his career: 'Now I truly began to have my own way in Art; the greater portion of my teaching was given up; I had pleasure in my work; some of my early liabilities and difficulties were cleared away, and my progress seemed most hopeful'.

The *Athenaeum* critic noted:

> In this picture, the lover's part is the worst filled, the old man's the best. He gloats with a professional curiosity and eagerness upon the work exhibited to his inspection – thinking rather of tone and contour, and detail and balance of colour, then the miracle which has converted the Romeo of the anvil into the Romeo of the palette, forgetting that there is one behind him, playing with her gold chain to beguile her pretty impatience, till the moment when he must give his consent. This old painter's figure gives good promise for Mr Redgrave.

The *Art Union*, after describing the subject at some length, concluded that Matsys's expression was too much of a 'sly leer', but the painting 'abounds in proofs of true talent', and marks Redgrave as 'a new candidate for fame'.

The 'Lives of the Painters' to which the RA catalogue referred and which provided this tale of Matsys's early development was presumably Carel van Mander's *Schilderboeck* (first published 1604), a principal source of knowledge of Dutch and Flemish artists. Although he refers to a poem in Latin by Lampsonius, which was printed under an engraved portrait of Matsys, van Mander himself doubted the story. Matsys was probably a blacksmith in his earliest years, as was his father, but is seems likely that he received formal training rather than teaching himself to paint. The picture he is showing in Redgrave's work is the well-known 'The Money-changer and his Wife' (signed and dated 1514, that is, when the artist was nearly 50 years old, now in the Louvre); it is perhaps intended as ironic comment on the main subject of the marriage arrangement.

Prov:   Thomas Webster RA; his sale, Christie's 21 May 1887 (181), bought Agnew's for the museum £16-16-0 (with 211-1887 below).

Exh:   *Richard Redgrave 1804–1888* V&A and Yale Center for British Art, New Haven, 1988 (14)

Lit:   (RA picture) *Athenaeum* 25 May 1839, p397, *Art Union* 1839, p70, *Art Journal* 1850, p48, *Memoir* p42; *Casteras and Parkinson* p104 (repr)

## The Thames from Millbank
211-1887   Neg FE1150
Canvas, 24.8 × 43.2 cm (9¾ × 17 ins)
Purchased 1887

*The Thames from Millbank*   211-1887

Exhibited at the BI in 1836, as *The Thames at Millbank*, the size given as 17 by 24 inches, presumably including the frame. It was acquired some time after by the artist's friend Thomas Webster RA.

Redgrave was born and brought up in the area of Pimlico; the family moved from Belgrave Terrace to the King's Road in about 1814. The view depicted seems to be from the north by Lambeth Bridge looking across to what is now the Albert Embankment. Both banks have been transformed in the last 150 years, and none of the buildings in Redgrave's painting seem identifiable, although the church tower on the left is possibly that of St Mary the Less, Black Prince Road (built 1827–8). Before redevelopment, the south side housed Lambeth industries, particularly potteries, while the north side is described by Redgrave in the *Memoir* as a 'succession of osier-swamps'.

John Ruskin, in a lecture to the BI in 1867, described this reach of the Thames as 'a disgrace to the Metropolis'. It is puzzling that the famous Millbank Penitentiary, on the present site of the Tate Gallery, is not visible. As Krzysztof Cieszkowski, of the Tate Gallery Library, has pointed out to the present writer, Redgrave seems to have forsaken topographical accuracy in making the right (north) bank appear more rural than it probably was, as well as eliminating Vauxhall Bridge and the Penitentiary. Vauxhall Bridge (that is, the earlier version built 1811–16) would have been visible; the later (1862) Lambeth Bridge was preceded by a ferry, which may be alluded to by the boat in midstream in the present work. The buildings in the right background may be houses along Vauxhall Bridge Road, the tall chimney part of one of the glue factories mentioned by Ruskin, and the white house an earlier version of the White Swan. (For a fuller discussion of this area, see K Cieszkowski 'Millbank before the Tate' in *The Tate Gallery 1984–86: Illustrated Biennial Report* 1986, pp38–43.)

Prov:   Thomas Webster RA; his sale, Christie's 21 May 1887 (182), bought Agnew's for the museum £16 16s (with 210-1887 'Quentin Matsys in his Studio', p246).

Exh:    BI 1836 (83); *Richard Redgrave 1804–1888*, V&A and Yale Center for British Art, New Haven, 1988 (4)

Lit:    *Casteras and Parkinson* pp101–2 (repr)

## An Old English Homestead
183-1889   Neg FE741
Canvas, 103.5 × 137.1 cm (40¾ × 54 ins)
Signed and dated 'Richd Redgrave 1854' in red br
Given by Mrs Richard Redgrave 1889

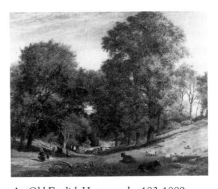

*An Old English Homestead*   183-1889

Exhibited at the RA in 1854, and, according to the *Memoir*, painted at Sutton, Surrey, 'near where my father was staying . . . It is a good example of his minute treatment of woodland scenery'.

Contemporary critics also noted the artist's truth to nature. The *Illustrated London News*, which published an engraving after the picture, compared the faithfulness of Redgrave's art to that of Hobbema: 'He renders truly what is before him; no common merit that he is not attempting to improve on nature'. The *Art Journal* thought

This subject has not been selected for its romantic or picturesque character. As an association of ordinary material, it contains nothing more than what is seen every day, in the country . . . This picture to be estimated, must be examined very closely: it contains in the immediate foreground a patch of weeds and herbage, emulating in curious execution

247

the most minute and accurate details of this kind that have ever been accomplished; but at the distance from the eye at which all this is lost, it is felt that the verdure of the picture is somewhat crude

The *Athenaeum* believed Redgrave's landscapes

> though minute, delicate, and almost too feminine in touch, are the most successful in this year's Exhibition. No other pictures can approach them in amount of labour . . . in infinity of leafiness, variety of depths, air, and multiplicity of local tintings, he is unequalled. We should like to see grander masses of light and shade, and greater firmness in the treatment of the foreground trunks . . . The blue sky is beautifully repeated in a modified form by the blue thin mist of the wood.

An inscription on the back of the canvas, with an elaborate monogram, reads 'Rd Redgrave 1854/Kensington/Painted with Copal'.

EXH:   RA 1854 (212); *Richard Redgrave 1804–1888* V&A and Yale Center for British Art, New Haven, 1988 (107)

ENGR:   *Illustrated London News* 19 August 1854, p160; Butterworth & Heath for the *Art Journal* 1859, p207

LIT:   *Athenaeum* 13 May 1854, p595; *Art Journal* 1854, p162; *Illustrated London News* 19 August 1854, p160; *Art Journal* 1859, p207; W Sandby *History of the Royal Academy of Arts* II, 1862, p293; *Memoir* 1891, p118; G Reynolds *Victorian Painting* 1966, pp152, 158, 175; *Casteras and Parkinson* pp136–7 (repr)

*The Stream at Rest*   P10-1967

**The Stream at Rest**
P10-1967   Neg FG1261
Canvas, 40.6 × 76.2 cm (16 × 30 ins)
Signed and dated 'Rich^d Redgrave 1848' bl
Given by Mr and Mrs Frank M Greco 1967

Exhibited at the RA in 1849; the title was accompanied in the catalogue by the following quotation from Thomson's *The Seasons* ('Autumn'):

> Why should the waters love
> To take so far a journey to the hills,
> When the sweet valleys offer their soil,
> Inviting quiet, and a nearer bend?

Redgrave had contributed designs for wood-engravings to illustrate a 1842 edition of *The Seasons*; they do not relate to the present work.

The *Athenaeum* critic admired the attention to detail, and the *Art Journal* thought it 'one of those shaded passages of river scenery which this artist renders with such natural truth . . . The sentiment of the picture is charming, and the execution masterly'.

PROV:   Probably John Gibbons, his sale Christie's 26 May 1894 (53), bought in £12 12s (the Christie's stencil on the back of the work refers to this lot; the sale catalogue gives the title as 'A place where the jack lie', a picture exhibited at the BI in 1846, and the size as '15½ by 31 inches', which is about correct for 'The Stream at Rest' while the BI catalogue gave the measurements as '17 by 24 inches', including the frame); sold Christie's 11 March 1949 (71), bought Roland (or Young, according to the V&A annotated catalogue) £3 3s; given to the museum by Mr and Mrs Frank M Greco 1967

EXH:   RA 1849 (174); *Richard Redgrave 1804–1888* V&A and Yale Center for British Art, New Haven, 1988, (91)

LIT:   *Athenaeum* 26 May 1849, p548; *Art Journal* 1849, pp168–9; *Casteras and Parkinson* pp131–2 (repr)

**Design or Freehand Drawing**
SKM16
Canvas, lunette
Commissioned as decoration for the museum 1868

In 1863 Redgrave was put in charge of the decoration of the new National Competition Gallery, later the watercolour galleries, now rooms 100–1. The plan was to commission artists to provide designs for the alcoves and lunettes; this was begun in 1865, and some were provided in May 1868. There were to be 18 canvases, several of which were completed and in position in 1869; the subjects chosen illustrated aspects of the arts of drawing, painting, and modelling, with various decorative panels with compositions of children. Two designs were to be by Redgrave himself: one of the compositions of children, which was painted by R C Puckett, and 'Freehand Drawing', showing Giotto's 'round O', which is recorded as unfinished in 1874. All the paintings were removed during the reconstruction of the gallery in 1909–10; they do not seem to have been replaced in position and have been in store ever since. A view of the gallery in about 1876 is recorded in a drawing by John Watkins (repr Physick fig 82, p86); Redgrave's lunette is the fifth from the end (south) wall, on the right (west) wall.

The ability to draw a perfect circle freehand is one of the best-known, and presumably apocryphal stories surrounding the early Renaissance Florentine painter Giotto, and is related in Giorgio Vasari's life of the artist.

LIT:   J Physick *The Victoria and Albert Museum: the history of its building* 1982, pp83–7

# REINAGLE, Ramsay Richard, RA (1775–1862)

Born, presumably in London, 19 March 1775, son of Philip Reinagle RA. Studied with his father, then in Italy (Rome 1796) and Holland. Exhibited 249 works at the RA between 1788 and 1857, 54 at the BI 1807–54, and 67 at the Society of Painters in Watercolours, of which he was Associate 1805, Member 1806, Treasurer 1807, President 1808–12. Elected ARA 1814, RA 1823; asked to resign 1848 for submitting a work not his own for exhibition. Subjects include portraits, animals and historical scenes, but mainly landscapes, many Italian. Also worked as restorer and copyist of old masters. Died Chelsea, London, 17 November 1862. His youngest son was the marine painter George Philip Reinagle (1802–35)

LIT:   *Art Journal* 1848, p280, 1863, p16

**Rydal Mountains – Stormy Day**
1409-1869   Neg GB2598
Millboard, 18.7 × 26.6 cm (7⅜ × 10½ ins)
Townshend Bequest 1869

Rydal is in the Lake District, Westmorland, near Grasmere. Reinagle exhibited several views in Westmorland, the earliest in 1812, the latest in 1857. He also exhibited several stormy scenes. None may be identified precisely with the present work.

On the back of the panel, in an early (?the artist's) hand is '5 gs' (that is, 5 guineas) and '10/9/49, 4 for, s/s/.' (the first figures presumably record a date, perhaps of Townshend's purchase of the work).

*Rydal Mountains – Stormy Day*   1409-1869

# RIPPINGILLE, Edward Villers (1798–1859)

Born King's Lynn, Norfolk, 1798, son of a farmer. First self-taught, then student of Edward Bird at Bristol. Exhibited at the Norwich Society and the RA at the age of 15. Exhibited 41 works at the RA between 1813 and 1857, 19 at the BI 1820–49, and 12 (including seven watercolours) at the SBA 1824–35. Subjects were of English rural life until visits in 1830–2 to France, Germany and Italy; best known for genre paintings such as his first success 'The Country Post Office' (1819). Won prize in Westminster Hall fresco competition 1843. Lectured, established the short-lived *Artists and Amateurs Magazine*, wrote 'Personal Recollections of Great Artists' for the *Art Journal*, wrote fiction for periodicals and poetry (the unpublished *Consolation of Hope*), and claimed to be the first to advocate the formation of Schools of Design. Died suddenly at Swan Valley railway station, Staffordshire, 22 April 1859. His brother Alexander was also an artist, exhibiting 1815–35. The poet John Clare called him 'a rattling sort of odd fellow with a desire to be thought one . . . a man of genius as a painter'.

LIT: *Art Journal* 1859, pp187 (obit), 332; *Athenaeum* 7 May 1859, p187 (obit); F Greenacre *The Bristol School of Artists* Bristol City Art Gallery exhibition catalogue, 1973, pp121–7

*Mendicants of the Campagna*   FA173

## Mendicants of the Campagna
FA173   Neg V649
Canvas, 36.8 × 57.3 cm (14½ × 22⅝ ins)
Signed and dated 'E V Rippingille ROMA 1840/London 1844' on stone bl
Sheepshanks Gift 1857

Exhibited at the RA in 1844 as 'Beggars of the Roman Campagna'. On the back of the canvas is the inscription:

> Beggars of the Campagna Romana/Mem: This picture, sent for exhibition at the/Royal Academy was placed on the/*floor* and has never been seen by the public/painted almost entirely with a/Magnilp or solution of sugar of/lead in Water & Mastic Varnish 1844/Bought of the Artist by John Sheepshanks Esqr.

This anguished inscription provides a vivid reminder of the crowded walls of the Victorian Royal Academy, hung from floor to ceiling with paintings, and the importance of a picture being hung 'on the line'. This term referred to a ledge 5.4 cm (2 ins) deep which ran round the walls in the earlier homes of the Academy at Somerset House and Trafalgar Square, at a height of 243.8 cm (8 feet) from the floor. All large pictures were 'above the line', the weight of the larger being supported by the ledge. Thus the best position was 'on the line', or just above eye level; a contributory factor to the smaller average size of paintings in the second quarter of the 19th century. When the Academy moved to its present home at Burlington House in 1869, the line was abolished and larger pictures again became fashionable.

The critic of the *Art Union* commented

> 'Mendicants of the Campagna Romana. Two females with children, and not in the immediate exercise of their ancient and honoured vocation. We do not, therefore here 'Un qualtrino per l'amor di Dio', for they are lying at length and leisure, abiding their time and their patrons. The figures are highly characteristic, and closely descriptive of the parties.

At the same RA exhibition, Rippingille showed 'Children of Sonnino, Italy' (275), which may be a pendant to the present work.

EXH:   RA 1844 (273)

LIT:   *Art Union* 1844, p159

# ROBERTS, David, RA (1796–1864)

Born Stockbridge, near Edinburgh, 24 October 1796, the son of a shoemaker. Apprenticed to a house painter from about 1808–15, and also worked as a theatrical scenery painter. Moved to London 1822; worked at Theatre Royal and Covent Garden. Achieved a high reputation as a painter in oils and watercolours, mainly of architectural views. Exhibited 101 works at the RA between 1826 and 1864, 32 at the BI 1825–59, and 50 at the SBA 1824–36 (elected Member 1825, President 1830). Elected ARA 1838, RA 1841. Travelled frequently and extensively; from his first visit to France 1824, he toured in Belgium, Holland, Germany, Italy, Spain, and the Near East. Published lithographic reproductions of his drawings, notably 'Picturesque Sketches in Spain' (1837) and 'The Holy Land, Syria, Idumea, Arabia, Egypt and Nubia' (1842–9). Died 25 November 1864; his studio sale was at Christie's 13–20 May 1865, and that of his son-in-law Henry Bicknell 7–9 April 1881.

LIT:   J Ballantine *The Life of David Roberts, RA* 1866; H Guiterman (et al) *David Roberts; Artist Adventurer* Scottish Arts Council exhibition catalogue 1981; H Guiterman and B Llewellyn *David Roberts* Barbican Art Gallery exhibition catalogue 1986

## Entrance to the Crypt, Roslin Chapel
FA174   Neg 57004
Panel, 71.6 × 62.1 cm (30 × 24½ ins)
Signed and dated (indistinctly) 'David Roberts RA 1843' diagonally bl
Sheepshanks Gift 1857

Exhibited at the RA in 1843. The artist was in Edinburgh in 1842 for a public dinner given in his honour on 19 October. Roslin (or Rosslyn), near Edinburgh, was one of Roberts's favourite places: a watercolour study of the chapel is dated 11 October 1842 and part of it was used for the present oil (NGS). There are several oils of the subject recorded, and many watercolours, one also in the V&A collections signed and dated 1830 (1046–1873).

Roslin Chapel, celebrated for its sculpture and elaborate decorative carving, was founded in 1446; it was only partly completed, damaged in 1668, and restored in 1862.

The *Art Union* noted it as:

> One of the class of pictures called interiors, abounding with stone carving of a rich and florid character. The work is remarkable for the softness and transparency of its shadows, and the power displayed in painting the cross lights. The subject is bisected by a heavy column, a little beyond which are two figures who do not support the feelings generated by such work.

The figures presumably serve to draw attention to the famous Prentice Pillar; its unusual design of four strips of foliage spiralling upwards, with a base of entwined serpents, is supposed (according to an unlikely legend) to have resulted in the murder of the apprentice who carved it while his master mason was absent.

EXH:   RA 1843 (78); BI 1844 (12); RSA 1845 (37); *International Exhibition* Dublin 1865 (189); *David Roberts: Artist Adventurer* Scottish Arts Council 1981–2 (44)

LIT:   *Art Union* 1843, p163

*Entrance to the Crypt, Roslin Chapel*   FA174

*Old Buildings on the Darro,*
*Granada*  FA175

## Old Buildings on the Darro, Granada
FA175   Neg 57005
Panel, 44.4 × 59.4 cm (17½ × 23⅜ ins)
Signed and dated 'David Roberts 1834' bl
Sheepshanks Gift 1857

Exhibited at the BI in 1835, the size given in the catalogue as 28 by 35 inches (presumably including frame). It was described by the *Athenaeum* as 'an exquisite thing; we returned to it more than once'. Roberts visited Spain from October 1832 to December 1833, staying in Granada for three weeks in February. Granada, in Southern Spain, is on the Rio Darro which encloses the old Antequeruela district of the city.

Another version, in an upright format and dated 1835, was sold to Artaria of Mannheim; its present whereabouts are unknown.

Exh:   BI 1835 (96)

Engr:  Etching, Luke Taylor, 1900 (impr in V&A collections, RCAL858–1916)

Lit:   *Athenaeum* 14 February 1835, p130; *Literary Gazette* 28 February 1835, p137; *The Times* 10 February 1835, p3; G Waagen *Treasures of Art in Great Britain* 1854, II, p296; *Ballantine* 1866, p73, (cat no 73); J Quigley *Prout and Roberts* 1926, p100 (repr); D and F Irwin *Scottish Painters at Home and Abroad* 1975, p333

## The Gate of Metwaley, Cairo
FA176   Neg 31858
Panel, 76.1 × 62.8 cm (30 × 24¾ ins)
Signed and dated 'David Roberts, RA 1843' bl
Sheepshanks Gift 1857

Exhibited at the RA in 1843 as 'Gate of the Mosque of Metwalis, Grand Cairo' and sold to John Sheepshanks for £105.

The southern gate of the old city, now in the centre of modern Cairo, was built in 1092, the minarets above of the Mosque and Tomb of Sultan Muayyad Shaykh were added 1415–20. The view is from Shavia Darb-al-Ahmar (Red Street). A watercolour of the same view, but omitting the left-hand building, is dated 1838 (private collection; exh Barbican Art Gallery 1986 (138), repr *Guiterman and Llewellyn* p115). Roberts toured the Near East between September 1838 and May 1839, and was in Cairo in December and January. While he was impressed by the Picturesque qualities of the architecture, he found working difficult: 'I have stood in the crowded streets of Cairo jostled and stared at until I came home quite sick no one in looking over my sketches will ever think of the pain and trouble I have had to contend with in collecting them' (MS *Eastern Journal*, 1 January 1839).

The *Art Union* critic found that 'The pencil of this celebrated artist descends to the nicest *minutiae*, where necessary, an example of which is here offered. The street is crowded with figures, camels, etc., in perfect keeping with the Mauresque architecture'.

*The Gate of Metwaley, Cairo*   FA176

Exh:   RA 1843 (210); *David Roberts* Barbican Art Gallery 1986 (146)

Lit:   *Art Union* 1843, p166

*Interior of Milan Cathedral*   79-1881

## Interior of Milan Cathedral
79-1881   Neg Z2199
Paper on panel, 31.4 × 52.7 cm (12⅜ × 20¾ ins)
Purchased 1881

An early version of the larger and more extensive work (oil on canvas, 127 × 104.1 cm (50 × 41 ins), signed and dated 1863), exhibited at the RA in 1863 (35) and now in the Rochdale Art Gallery.

Roberts had visited Milan on his way to Venice in September 1851; he wrote to his son-in-law Henry Bicknell that the cathedral 'in point of the picturesque I found beyond expectation so much that I think I will get more than two or three subjects from it . . . I will commence printing in oil tomorrow'. He thought the cathedral 'vile and cor[r]upt in taste – overloaded with detail but Splendid in colur . . . I think I will devote a week to it' (letter 16 September 1851, private collection). Guiterman thinks the present work is almost certainly one of the studies Roberts made in the cathedral. It was dated to 1851 in the catalogue of the 1881 sale (see *Prov:* below).

Also related to the present work is the version of the subject dated 1857 in the Government Art Collection.

PROV:   Presumably Henry Bicknell (the artist's son-in-law) and his sale Christie's 9 April 1881 (362, 'Interior of Milan Cathedral, showing the Bronze Pulpits', 31.8 × 52.7 cm (12½ × 20¾ ins), dated to 1851) bought Whitehead £89 5s, presumably for the museum (he also bought lot 176, a watercolour by W L Leitch, which was also acquired by the museum in 1881)

## Ruins of Elgin Cathedral

1010-1886   Neg 58210
Canvas, 49.7 × 74.8 cm (19⅝ × 29½ ins)
Signed and dated 'David Roberts RA 1853' bl
Dixon Bequest 1886

On one of his tours of Scotland, the artist wrote from Elgin:

*Ruins of Elgin Cathedral*   1010–1886

> I found it better than I had anticipated, – although – *it is much the worse of the wear* – and although great pains are taken in its preservation this has also its drawback – as the Ruins are very naked – but after all a painter ought to make a subject out of any thing – It is not so often the subject is at fault, as the Artist . . . (letter to Henry Bicknell, 12 September 1848, National Library of Scotland).

The view is from inside the cathedral walls looking towards the east. Elgin cathedral, some 90 miles north-west of Aberdeen, was enlarged from the Kirk of the Holy Trinity after the establishment of the Bishopric of Moray in 1224, and rebuilt after a fire in 1270; by the Reformation it was considered one of the most beautiful churches in Scotland. The last public Mass was held in 1594, and the structure became increasingly ruinous thereafter, encouraged by the occupation of Cromwell's soldiers in the 1650s and the collapse of the great central tower in 1711. The site was treated as an historical monument, with an appointed Keeper, from 1825, which explains Robert's comment that the ruins were 'very naked', presumably, that is, not overgrown with Picturesque foliation.

There are two other versions of this work, both untraced. Graves (*Sales*) records one (possibly the present work, despite the order of the measurements suggesting an upright format) sold in 1858 and bought by the dealer Gambart.

PROV:   Possibly sold Foster's 9 December 1857; ?sold by Messrs Hooper & Wass at Foster's 15 December 1858 (36, 76.2 × 51 cm (30 × 20 ins), as painted for J MacArthur of Bristol), bought Gambart £111 6s

EXH:   *David Roberts* Barbican Art Gallery 1986 (30)

LIT:   *H Guiterman and B Llewellyn* p100, (repr in colour pl 23)

# ROTHWELL, Richard, RHA (1800–1868)

Born Athlone, Ireland, 20 November 1800. Studied at Royal Dublin Society's Drawing School 1814–20, then worked in Dublin as portrait painter. Member of RHA 1826, resigned 1837, re-elected 1847. Moved to London, worked as Sir Thomas Lawrence's studio assistant, completing pictures after Lawrence's death 1830. Successful portrait practice with several distinguished sitters; the *Art Journal* listed him among six most eminent portraitists in 1843 (p570). Exhibited 72 works at the RA between 1830 and 1862, 28 at the BI 1832–63, one at the SBA 1851, and at the Royal Hibernian Academy. Travelled on Continent 1831–4, inspiring Italian subjects. Returned to Dublin 1847–52, then London to 1854, short visits to USA 1854 and 1855, Rome 1856–8, Leamington, Warwickshire, until 1862. Travelled to Belfast, Paris, Brussels and Rome, where he died September 1868. Buried alongside the poet John Keats. According to Strickland, Rothwell wrote he 'was given to the dream of a posthumous fame', but he had 'a high, an extravagant, opinion of his own powers as a painter'.

Lɪᴛ: *Art Journal* 1868, p245 (obit), 1872, p271; W G Strickland, *A Dictionary of Irish Artists* II, 1913, pp300–12

## The Little Roamer
FA177
Canvas, 126.9 × 84.4 cm (50 × 33¼ ins)
Sheepshanks Gift 1857

Exhibited at the RA in 1843, with the unattributed quotation 'her path 'mid flowers' added in parentheses after the title. The *Art Union* critic described it as 'A child who has been gathering flowers, and is now resting against a bank. The assumed ease of her position has an appearance of awkwardness. The head is most forcibly painted, and the background is rich to a degree'.

Exʜ: RA 1843 (257)

Lɪᴛ: *Art Union* 1843, p167

## Novitiate Mendicants
FA178    Neg F74
Canvas, 92.6 × 73.6 cm (36½ × 29 ins)
Sheepshanks Gift 1857

Presumably the work exhibited first as 'The Poor Mendicants' at the RA in 1837, and then as 'The Mendicants' at the BI in 1838, its size given in the catalogue (including frame) as 49 by 40 inches. The *Athenaeum* critic found 'The expression of the girl, melancholy and shy, but not awkward, and the ill-repressed merriment of the sun-burnt boy, who shrinks behind her, are excellently given: the colouring is beautiful'. The text accompanying the Browne engraving after the painting published in the *Art Journal* in 1872 noted:

> Rothwell painted a few *genre*-subjects, of which the 'Novitiate Mendicants' is one of the best. We have no clue as to its date, but in all probability it was painted in Ireland, for the face is decidedly Irish; yet the pair are too decently clad for juvenile beggars of that country; and, indeed, of any other. There appears to be more of sly humour in their faces, as if playing at mendicancy, than of earnest solicitation; but whether or not the composition bears out its title, it is a charming work of its kind, most agreeable in conception, and solid in execution.

A preliminary sketch for the work, and other drawings by Rothwell, were presented to the museum by Miss C Rothwell, the artist's granddaughter, in 1950 (E319–1950). Copies of the Sangster engraving (which was much

*The Little Roamer*    FA177

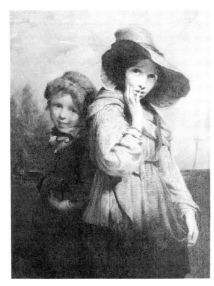

*Novitiate Mendicants*    FA178

admired by the *Art Journal* in 1844, p150) and the Templeton lithograph (see *Engr*: below) are also in the museum collections. Another sketch for the composition for the painting was recorded in a private collection in 1968.

Exh:   RA 1837 (297); BI 1838 (61); RHA 1838

Engr:   Samuel Sangster, as 'Novitiate Mendicants', for the Royal Irish Art Union 1841; Lithograph, John Samuelson Templeton, publ 15 July 1844; H Browne, for the *Art Journal* 1872, facing p271

Lit:   *Athenaeum* 17 February 1838, p129; *Art Journal* 1844, p150, 1872, p271

**The Very Picture of Idleness**
FA179   Neg 77419
Canvas, 76.1 × 71 cm (30 × 28 ins)
Signed 'Richard Rothwell' on shawl br
Sheepshanks Gift 1857

*The Very Picture of Idleness   FA179*

Exhibited at the RA in 1842. The *Art Union* critic described the subject as 'A gay and laughing maiden with an expression of countenance which the pencil of this gentleman seems to reach better than that of any of his contemporaries. The face beckons you with its laughing eyes – everything is resolved into inviting sweetness, in short she is "Not very dashing, but extremely winning"'. The *Athenaeum* also admired the work:

> We presume [it] is to be regarded as a fancy piece. Real or ideal, the nymph is charming – a lazy, bright-eyed girl – leaning upon her arms, with a broad speaking smile, such as Murillo might not have disdained to paint. It gives us great pleasure to see Mr Rothwell at last justifying the predictions of his friends. His colouring has lost none of its delicacy, – while his hand has gained force.

The reference to Murillo's work is just; the concept of Rothwell's painting may be compared with Murillo's 'A Peasant Boy Leaning on a Sill' presented to the NG in 1826, and 'A Girl and her Duenna' (National Gallery of Art, Washington DC) in Lord Heytesbury's collection since 1823.

Exh:   RA 1842 (377)

Lit:   *Art Union* 1842, p125; *Athenaeum* 21 May 1842, p456

# SCOTT, William Bell (1811–1890)

Born Edinburgh 12 September 1811, son of the engraver Robert Scott and younger brother of the painter David Scott. Trained as engraver with his father, then at Trustees Academy. Exhibited 45 works (including two engravings) at the RSA between 1833 and 1870 (elected Honorary Member 1887), seven at the RA 1842–69, nine at the BI 1841–65, and four at the SBA 1840–2. Subjects were historical, literary and biblical. London 1837, entered Westminster Hall competition 1843, Master of Government School of Design, Newcastle, 1843–63. Influenced by the Pre-Raphaelites and friend of Rossetti. Major works are series of paintings for Wallington Hall, Northumberland 1856–61, and Penkill Castle, Ayrshire, 1865–8. Published five volumes of verse, editions of major poets, several books on art, and *Memoir of David Scott* (1850). Died Penkill Castle 22 November 1890; Swinburne wrote memorial verses.

Lit:   *Athenaeum* 29 November 1890, p745 (obit); *Illustrated London News* 6 December 1890, p710 (obit); *Blackwood's Magazine* CLIII, February 1893, pp229–35; ed W Minto *Autobiographical Notes of the Life of William Bell Scott . . .* 2 vols, 1892

*Peter Vischer*  26-1871

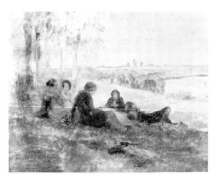

*A Picnic at Hanwell*  P34-1963

**Peter Vischer**
26-1871    Neg HA5035
Canvas, 255.2 × 87.6 cm (104½ × 34½ ins)
Inscribed 'W B SCOTT' on pedestal br
Transferred to the Department 1921

For details of the history and circumstances of the commission see under
Richard Burchett 1762–1869, p14.

Peter Vischer the Elder (about 1460–1529) was the most important
member of the eminent family of sculptors and bronze-casters based in
Nuremberg; his work unites the late northern Gothic tradition with the more
classicising influences of the Italian Renaissance. Scott seems to have much
admired German art, and published a book on Dürer in 1869. Vischer's most
important work was the tomb of St Sebaldus, in the church of that name in
Nuremberg, probably begun in 1508, and finished 1519. A cast of the tomb
had been acquired by the museum in 1864. Vischer included his own
full-length self-portrait among the figures on the tomb, and this is the image
reproduced by Scott: a similar pose, identical full-bearded features, wearing
the same leather apron and holding a chisel and mallet (monogrammed
'PV'). The significance of the Star of David emblem on his cap is unclear.

A copy of this painting, or of the mosaic made from it, was recorded in
the Queen's Park Art Gallery, Manchester, in 1922.

**A Picnic at Hanwell**
P34-1963    Neg FD2055
Cardboard, 22.8 × 30.5 cm (9 × 12 ins)
Inscribed 'Hanwell Sep^r. 1841' br
Given by Miss Sylvia Gosse 1963

A label, once stuck on the back, is inscribed perhaps in the artist's hand:
'John Bell Scott & wife/William Bell Scott & wife/Dr George Napoleon
Epps/& wife Charlotte Epps/Sep 1841/J B S poet & W B Scott painter/
painted by the poet's brother' (last four words overwritten in a later hand 'by
W B Scott'). John Bell Scott is not mentioned among the family in the
*Autobiographical Notes*, nor does any of his poetry appear to have been
published. George Napoleon Epps (1815–74) is not mentioned either, but in
the *Autobiographical Notes* Scott records in about 1850 that he and his wife
were annual guests of the half-brother, also a homeopathic doctor, Dr John
Epps, in whose house he met his wife, Laetitia Margery Norquoy (I, p255);
Mrs John Epps recorded that her husband knew David Scott in Edinburgh in
the 1820s and later became friends with William Bell Scott in London (ed
Mrs Epps *Diary of the late John Epps . . .* 1875, pp142–3).

The manuscripts in the foreground are titled ?'Somne', 'The
Grandchildren', and 'The Day of Four Stories'; these do not seem to be the
titles of any published poems by William Bell Scott, and presumably, in view
of the inscription quoted above, relate to his brother's unpublished work.

Hanwell, Middlesex, is just north of Osterley Park; the river meadows
there were a favourite local beauty spot.

EXH:   *Artists as Collectors* Leicester Galleries 1963 (81, lent by Sylvia Gosse)

# SELOUS, Henry Courtnay (1803–1890)

Born 1803 son of the painter George Slous of a Jersey Huguenot family; changed his name to Selous about 1834. Entered RA Schools, won medals from the Society of Arts. Worked as a panorama painter, won prize in Westminster Hall competition 1843, painted fresco in Law Society library, Chancery Lane, 1844. Exhibited 34 works at the RA between 1818 and 1885, 23 at the BI 1819–58, and nine at the SBA 1827–31 and 1874–5. Subjects include animals, portraits, landscapes, historical and literary. Designed illustrations for books and for the *Art Union*. Published fiction as Kay Spen 1868–72. Married a daughter of the enamel painter H P Bone; and his daughter Miss J Selous was also an exhibiting painter. Died Beaworthy, Devonshire, 24 September 1890.

LIT:   *The Times* 7 October 1890, p9 (obit); *Illustrated London News*
       11 October 1890, p454 (obit with portrait)

**The Opening of the Great Exhibition by Queen Victoria on 1st May 1851**
329-1889   Neg J623
Canvas, 169.5 × 241.9 cm (66¾ × 95¼ ins)
Signed and dated 'H C Selous 1851/2'
Given by Mr Warren W De la Rue 1889

The picture shows a moment in the opening ceremony on 1 May 1851 of the International Exhibition of Arts and Manufactures initiated by Prince Albert in the vast glass structure of the Crystal Palace erected in Hyde Park. Sir Henry Cole recorded in his diary 23 June 1851 'To Mr Selous' Studio for portrait'; he appears in the group on the left. There are further references on 26 June and 5 July, then on 11 July 1851: '[At Great Exhibition] Building. Queen came & inspected Selous picture'; on 23 and 30 July he records having his portrait repainted. Finally, he made two visits to see the painting: on 25 February 1852 'Prince critical about Lloyd's & Wylde's position in the picture of the Exhibition', and again on 24 May 1852. The *Athenaeum* reviewed the painting when it was on display in Trafalgar Square (presumably at the RA, then in the NG building) before it was engraved: 'It is impossible for the spectators not to feel the solemn grandeur of the scene. Yet the airy lightness and vast extent of the building are admirably preserved'. The *Art Journal* noticed the finished painting in August 1852:

*The Opening of the Great Exhibition by Queen Victoria on 1st May 1851*   329-1889

> Pictures of this class, which may be called scene pictures, are, for the most part, of such a character as to leave the artist little room for inventive display; they are facts and must be treated as such, consequently the difficulties by which they are surrounded to render them even pleasing to the tutored eye, are not easily overcome. Mr Selous has painted the subject of the opening of the Great Exhibition, selecting that part of the ceremony when the Archbishop of Canterbury is offering the benedictory prayer. The time could not be more judiciously chosen, as it affords the opportunity of bringing forward the illustrious personages who figured prominently on that occasion, grouped together in all the magnificence of costume and dress, but in an attitude of perfect repose, and the countenances expressive of agreeable and devout expression. The view is taken from a point near where stood the crystal fountain, looking northwards. The centre of the picture is occupied by the Royal party and their attendants, the right by the foreign commissioners, chairmen of juries, &c, and the left by the ministers of state, the royal commissioners, and the executive officers. The artist has done all that could be done with so impracticable a theme, throwing into it as much picturesque display as the subject would admit. Most of the persons introduced, including those of the various members of the Royal

Family, sat to him for their portraits, and we must acknowledge he has been very happy in preserving their likenesses. The picture was, we believe, painted for Messrs Lloyd, who purpose having it engraved. It will form an interesting memorial of an event that for many years to come will lose little of its attractiveness in the estimation of thousands.

Sir Francis Graham Moon (1796–1871), who seems to have been the first owner of the painting, was a printseller and publisher, and it seems likely that he bought – or commissioned – the work to have it engraved: the print by Samuel Bellin was published by T Boys in 1856 (Moon was a partner in Moon, Boys & Graves, of Pall Mall). Moon's obituary in the *Illustrated London News* (28 October 1871, p399) stated that he specialised in prints of contemporary history such as the 'Waterloo Banquet at Apsley House'. The elaborate composition of the picture, and the Queen's sitting for her portrait in it, have bestowed upon the painting an official status.

An engraved key was published, identifying all the principal figures; of particular interest are the portraits on the right of the last owner, Warren De la Rue, together with his wife. A scientist and inventor (he exhibited the first envelope-making machine in 1851) Warren De la Rue was juror and reporter in the 1851 committee for class 29. Also, in the right foreground, is the Chinaman Hee Sing 'who happened to be there on the occasion'; Sir Henry Cole recorded:

> While the Hallelujah Chorus was being performed, a Chinese, touched apparently by the solemnity of the scene, came forward and made a profound obeisance to the Queen. 'This live importation from the Celestial Empire', the reporter of the *Examiner* records, 'managed to render himself extremely conspicuous, and one could not help admiring his perfect composure and nonchalance of manner' . . . A most amusing advantage was taken of his appearance, for, when the procession was formed, the diplomatic body had no Chinese representative, and our stray celestial friend was quietly impounded, and made to march in the rear of the ambassadors.

The artist's daughter, Miss Jane Poyer Selous, wrote on 8 April 1925 that the painting contained 'portraits from life of everyone who was present and gave sittings to my father'. She also recorded: 'I have the original sketch (in oil) made by my father during the progress of the opening ceremony which shown to the Queen decided her to sit for her portrait, with the rest of the Royal family'.

Prov: Sir Francis Graham Moon; his sale, Christie's 13 April 1872 (226), bought McLean £50; Warren W De la Rue, who presented it to the museum 1889

Exh: *?British Empire Exhibition* Wembley 1924–5 (not in Palace of Arts catalogue)

Engr: Samuel Bellin, publ T Boys 1856

Lit: *Athenaeum* 5 June 1852, p633; *Art Journal* 1852, p262; Sir Henry Cole *Fifty Years of Public Work* 1884, I, p179; C Wood *Victorian Panorama* 1976, repr frontispiece and (detail) pl 11

# SEVERN, Joseph (1793–1879)

Born Hoxton, London, 7 December 1793, son of a musician. Apprenticed to engraver William Bond; at early age 'began to find some solace in the study of literature' (*Sharp*, p7). Studied at RA Schools, won gold medal for historical painting (first awarded for 12 years) 1818. Exhibited 53 works at the RA between 1819 and 1857, and nine at the BI 1825–43: portraits, Italian genre, literary and biblical subjects. Most famous for his friendship with the poet John Keats, whom he accompanied to Italy 1820 and nursed until his death 1821. Lived mostly in Rome, appointed British Consul 1860–72. Died Rome 3 August 1879, eventually buried next to Keats. His children Arthur and Walter Severn, and Ann Mary Newton, were also artists.

LIT: W Sharp *The Life and Letters of Joseph Severn* 1892; S Birkenhead *Against Oblivion: The Life of Joseph Severn* 1943; S Birkenhead *Illustrious Friends: the story of Joseph Severn and his son Arthur* 1965

## Scene From Pope's 'Eloisa to Abelard'
1400-1869   Neg GA589
Canvas, 48.2 × 33 cm (19 × 13 ins)
Townshend Bequest 1869

The work does not seem to have been exhibited, and is not mentioned in Sharp's biography.

Alexander Pope's poem based on the history of the 12th-century lovers Abélard and Héloïse was first published in 1717. Severn's painting does not appear to be an illustration of the poem, which is in the form of a rhapsodic letter by Eloisa after she and her lover had entered separate religious orders. The picture shows Abelard's final farewell to Eloisa, and might refer to lines 107–116:

> Canst thou forget that sad, that solemn day,
> When victims at yon altar's foot we lay?
> . . . Yet then, to those dread altars as I drew,
> Not on the Cross my eyes were fix'd, but you.

A highly Romantic subject, particularly in the light of the artist's close friendship with Keats (although the poet did not especially admire Pope's work), perhaps intended to answer Pope's call in the last lines of the poem:

> Such if there be, who loves so long, so well;
> Let him our sad, our tender story tell;
> The well-sung woes will sooth my pensive ghost;
> He best can paint 'em, who shall feel 'em most.

## The Abdication of Mary, Queen of Scots
1402-1869   Neg V1941
Canvas, 48.3 × 33 cm (19 × 13 ins)
Townshend Bequest 1869

A small version of the large painting exhibited at the RA in 1850 (569) as 'The Abdication', and acquired by the 13th Earl of Eglinton (into whose family Severn had married). The large painting was sold at the Eglinton Castle sale on 3 December 1925 (lot 1041, 114.3 × 144.8 cm (45 × 57 ins), £54 12s; present whereabouts unknown).

The *Art Journal* critic noted (1850, p176) the RA painting:

> A large picture, founded on the passage of history which records the interview between Mary, Queen of Scots, and Lords Ruthven and Lindsay, at Lochleven. Mary is seated, and one of the Lords offers her a pen to sign her abdication. The treatment of the subject is literal, its

*Scene from Pope's 'Eloisa to Abelard'*   1400-1869

*The Abdication of Mary, Queen of Scots*   1402-1869

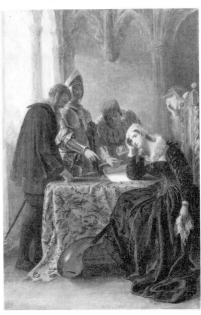

source is at once declared. In this work, there is much of merit, both of conception and execution'.

The *Athenaeum* commented that 'an oft-told story . . . has given occasion to Mr Severn for the production of a forcible composition in which the figure of Lindsay is enunciated with the required severity' (8 June 1850, p615).

The events at Lochleven Castle took place in July 1567, but Severn's scene is based on the account in Sir Walter Scott's novel *The Abbot*, first published in 1820, which centres on the story of Mary from her imprisonment at Lochleven to her flight to England. Severn had met Scott in Rome in 1832. The following was appended to the title in the 1850 RA catalogue: 'Whilst a prisoner at Lochleven Castle, the Queen of Scots was constrained to abdicate, owing to the violence of the lords Lindsay and Ruthven, and by the advice of Sir Robert Melville – Sir Walter Scott's Abbot'. The following passage, from chapter 22 of Scott's novel, more fully describes the scene:

> 'Here, in the castle of Loch Leven, with deep water around me – and you, my lords, beside me, – I have not freedom of choice. – Give me the pen, Melville, and bear witness to what I do, and why I do it'. 'It is our hope your Grace will not suppose yourself compelled by any apprehensions from us', said the Lord Ruthven, 'to execute what must be your own voluntary deed'. The Queen had already stooped towards the table, and placed the parchment before her, with the pen between her fingers, ready for the important act of signature. But when Lord Ruthven had done speaking, she looked up, stopped short, and threw down the pen. 'If' she said, 'I am expected to declare I give away my crown of free will, or otherwise than because I am compelled to renounce it by the threat of worse evils to myself and my subjects, I will not put my name to such an untruth – not to gain full possession of England, France and Scotland! – all once my own, in possession, or by right'. 'Beware, madam', said Lindsay, and snatching hold of the Queen's arm with his own gauntleted hand, he pressed it, in the rudeness of his passion, more closely, perhaps, than he was himself aware of, – 'beware how you contend with those who are the stronger, and have the mastery of your fate!'

Strong discusses (pp128–35) the popularity of Mary subjects in the 18th and 19th centuries. Scott's novel gave further impetus to painters as well as to historical biographers; Strong lists (pp162–3) 53 Mary subjects at the RA in the 19th century, but also states (p133) that 56 works on the theme were exhibited at the RA between 1820 and 1897, and that 'these were just the top of a more sizeable iceberg. In addition, the cult proliferated through thousands of engravings after contemporary portraits and reconstructions of incidents from her life'. Six paintings can be identified as showing the same abdication scene as the present work. Particularly in the middle of the 19th century, the image of the forlorn Queen seemed to be related to the wider question of the position of the Victorian woman in society. As *The Queen's Image* cataloguers point out, quoting the critic Nassau Senior in about 1820: 'history has never described, or fiction invented, a character more truly tragic than Queen Mary. The most fruitful imagination could not have adorned her with more accomplishments or exposed her to greater extremes of fortune, or alternated them with greater rapidity . . . in *The Abbot*, Mary fell into the hands of an author who deserved her'. They go on to comment that 'The reviewer of the 1850 Academy exhibition [see the *Art Journal* note above] – "its source is at once declared" – assumed that an oblique reference to Scott would act as a touchstone, triggering a whole complex of associations. This assumption reveals the extent to which mid-nineteenth-century British artists and their public identified Mary, Queen of Scots as a Scott heroine rather than as an actual historical personage'.

A painting of 1864 of the escape of Mary from Lochleven, by Thomas

Danby, is also in the museum collections (1014–1886), as is a drawing of 1849 by Joseph Severn of another Scott subject, 'The Death of Julian Avenel', from *The Monastery* (also Townshend Bequest, 1402–1869).

EXH: *Victorian Narrative Paintings* V&A circulating exhibition 1961; *The Lamp of Memory: Scott and the Artist* Buxton Museum and Art Gallery 1979 (13); *The Queen's Image* SNPG 1987 (58)

LIT: W Sharp *The Life and Letters of Joseph Severn* 1892, p169; R Strong *And When Did You Last See Your Father?* 1978, p133, repr p132; H Smailes and D Thomson *The Queen's Image* SNPG exhibition catalogue 1987, pp116–8

## Ariel

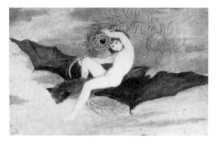

*Ariel* 1410-1869

1410-1869   Neg 69181
Millboard, backed with canvas, 24.7 × 38.1 cm (9¾ × 15 ins)
Signed and dated 'Severn/Rome 1826' bl
Townshend Bequest 1869

Severn exhibited two paintings of 'Ariel' at the RA in 1836 and 1838, but it is not possible to identify either of them with the present work or with the Ashmolean version discussed below.

The image is taken from Ariel's famous song in act 5 scene 1 of Shakespeare's *The Tempest*:

> Where the bee sucks, there suck I;
> In the cowslip's bell I lie:
> There I couch when owls do cry.
> On a bat's back I do fly
> After summer merrily:
> Merrily, merrily shall I live now,
> Under the blossom that hangs on the bough.

George Keats, brother of the poet, had written to Severn in about 1817 that *The Tempest* was a masterpiece of 'fanciful poetry' (quoted by Sharp, pp17–8).

If the date on the present work is indeed 1826, the painting is the first of four with the same composition. The second was commissioned by Robert Finch, the antiquarian collector (1783–1830) who lived in Rome in the 1820s; Severn finished the painting in Rome by 26 February 1830, and payment was raised from £30 to £50; Finch also authorised a duplicate Ariel in 1830 (ed J Stillinger *The Letters of Charles Armitage Brown* 1966, pp315, 319–20), which Gladstone saw in Severn's Rome studio on 4 June 1832 (ed MRD Foot *The Gladstone Diaries* 1968. Finch died on 16 September 1830 and bequeathed his collections to the Ashmolean Museum, Oxford, where the 'Ariel' remains (panel, very damaged, 39 × 53 cm (15 × 20½ ins), lent to the RA 1880 (26)).

The duplicate may well have been the version exhibited at the RA in 1836 (228); its present whereabouts are unknown. However, it may be identical with the fourth version of the 'Ariel' composition, sold to Severn's friend in Boston, USA, James T Fields. Fields wrote to Severn on 15 May 1871:

> Don't I mention your name at least twenty times a week, when I show those two charming pictures which I bore away from your studio in London so many years ago? The 'Ariel' hangs in my library, and the Gainsborough in the reception-room below, and they are both the delight of my eyes and those of my friends. The 'Ariel', being on panel, has warped somewhat, and I am afraid to entrust it to any one in order to bring it back. How I wish you were here to-day, and were going to dine with me, and afterwards give me your advice touching the panel, and how to restore it! (Sharp, pp273–4).

But the Fields picture is signed and dated 1859; it was sold at Sotheby Parke Bernet 12 June 1980 (19) and is now in a New York private collection.

Sharp illustrates two drawings of Ariel: one, described as the 'earliest study', shows the figure in reverse and with both arms in the air (facing p210); the other described as 'first study for the picture of "Ariel", now in the South Kensington Museum' and given in the list of illustrations as 'study for the picture of "Ariel Aflight" ' (facing p272), is very close to the final painting.

The latter drawing reproduced by Sharp indicates an oval format; in the V&A Department of Metalwork is an early-19th-century oval cameo brooch (M274-1921) which is almost identical with Severn's composition.

See 'Ariel – "Where the Bee Sucks" ' (1416-1869, below) for Severn's treatment of the same subject in a different composition. *The Examiner* of 3 October 1824 reported 'many studies from the "Tempest", he may paint them all, for they are in the true feeling for Shakespeare'.

*Ariel – 'Where the Bee Sucks . . .'*
1416-1869

### Ariel – 'Where the Bee Sucks . . .'
1416-1869   Neg GA590
Millboard, 26.1 × 38.1 cm (10¼ × 15 ins)
Townshend Bequest 1869

Included in the 1907 V&A catalogue with the title 'Nymph Gathering Honeysuckle', amended to the above by 1935. There seems little reason to doubt that the image is inspired by Ariel's song in act 5 scene 1 of Shakespeare's *The Tempest*; for other versions of this subject by Severn, see ('Ariel', 1410-1869, p261).

However, it is doubtful whether the present work can be identified with the painting exhibited at the RA in 1838; that picture was titled 'Ariel', with the quotation appended in the catalogue:

> Where the bee sucks, there lurk I;
> In a cowslip's bell I lie:
> There I couch when owls do cry.
> On the bat's back I do fly,
> After summer merrily.

The present work seems to show Ariel as described in the subsequent, unquoted couplet: 'Merrily, merrily shall I live now,/Under the blossom that hangs on the bough'. It might have been the work exhibited at the RA in 1836, simply titled 'Ariel'.

Severn has taken the pose of Ariel directly from Michelangelo's figure of Eve tempted, on the Sistine Chapel ceiling, but in reverse; Sharp records Severn making copies there (pp166–7).

Exh:   ?RA 1836 (228); *Bicentenary exhibition 1768–1968* RA 1968 (235)

## SHARP, Michael William (died 1840)

Probably born in London (? around 1780), studied with Sir William Beechey, at the RA Schools, and (by 1813) with John Crome in Norwich (one of whose sons was named after him). Exhibited with the Norwich School, and member of the Sketching Society; showed 46 works at the RA between 1801 and 1836, 30 at the BI 1806–30 (winning a prize 1809), and four at the SBA 1825–6. Subjects were sent from London addresses, and included portraits, genre (usually humorous), and many theatrical subjects. Redgrave thought his art has 'a tendency to vulgarity'. Several of his works were engraved; four examples are in the V&A collections. His lecture to the Norwich

Philosophical Society in 1820 was published as 'An Essay on Gesture' in the *Annals of the Fine Arts*. Died Boulogne, France, 1840.

LIT:     T Smith *Recollections of the British Institution* 1860, pp33, 51, 59, 85; Redgrave *Dict*; *Portfolio* 32, 1897, pp34, 42; *DNB*

**Miss Duncan in 'The Honeymoon'**
D36    Neg H1607
Canvas, 29.2 × 20.3 cm (11½ × 8 ins)
Dyce Bequest 1869

Maria Rebecca Duncan, later Mrs Davison (1783–1858), played the part of Juliana (her most famous role) in John Tobin's *The Honeymoon* at its first performance at Drury Lane on 31 January 1805. The scene depicted is act 3 scene 4. It is strange that the engraving was published (see *Engr:* below) so shortly before the revival of the play at Drury Lane on 30 June 1827, when the part was taken by a Miss Lawrence rather than Miss Duncan. For another painting of *The Honeymoon*, and further details of the play, see George Clint, FA23, p30.

ENGR:    Robert Cooper, pub 1 March 1827 (copy in the V&A collections, also from the Dyce Bequest, D3084)

*Miss Duncan in 'The Honeymoon'*    D36

# SHAYER, William senior (1787–1879)

Born Southampton, Hampshire, 1787, baptised 14 June, son of a publican. Worked as coach painter in Guildford, Surrey, and Chichester, Sussex, but returned to Southampton by 1820. Exhibited six works at the RA between 1820 and 1843, 82 at the BI 1827–62, and 338 at the SBA 1825–70 (elected Member 1829). Subjects landscapes, many in Hampshire and the New Forest, and coastal scenes, often with figures and animals. Died Shirley, near Southampton, 21 December 1879; his sons William Joseph, Henry, and Charles Shayer were also artists working closely in their father's style.

LIT:     *Art Journal* 1880, p84 (obit); review of Cooling Galleries exhibition *Apollo* XV, 1932, pp139–40; B Stewart *William Shayer Snr 1787–1879* Southampton Art Gallery exhibition booklet 1987

**Buying Fish**
1401-1869    Neg GX150
Panel, 26.1 × 30.5 cm (10¼ × 12 ins)
Townshend Bequest 1869

It is not possible to identify the work with the title of any exhibited work.

**Coast Scene**
429-1887    Neg CX151
Canvas, 34.3 × 44.5 (13½ × 17½ ins)
Signed and dated 1841
Purchased 1887

Shayer exhibited a larger painting, 'Scene on the Sussex Coast, Morning', at the BI in 1841 (312, 39 by 48 inches including frame).

*Buying Fish*    1401-1869

*Coast Scene*    429-1887

## SIMMS, Charles (exhibiting 1840-1870)

Seems to have changed spelling of name from Sims 1844. Exhibited 13 works at the RA between 1840 and 1856, and 1875, 15 at the BI 1840–53, and 32 at the SBA 1841–57. Landscapes, including Devon and Surrey, and Normandy coast 1853, particularly moonlight scenes. Lived in early 1840s at same address as G Sims, presumably his brother, who exhibited in the 1830s.

*Coast Scene at Low Tide – Moonlight*
499-1870

**Coast Scene at Low Tide – Moonlight**
499-1870
Panel, 29.2 × 57.7 cm (11½ × 22¾ ins)
Signed and dated 'C. Simms. 1840' b towards r
Parsons Bequest 1870

## SIMPSON, Philip (exhibiting 1824–1837)

Son of the portrait painter John Simpson who exhibited from the same London address, 10 Carlisle Street, Soho, 1807-45. Student at the RA Schools, exhibited 14 works at the RA between 1825 and 1836, nine at the BI 1824-37, and nine at the SBA 1824-33. Subjects either portraits or children, usually at play.

**I Will Fight**
1395-1869
Canvas, 76.1 × 64.7 cm (30 × 25½ ins)
Townshend Bequest 1869

Exhibited at the SBA in 1824 and presumably painted in that year, and exhibited again it seems at the BI in 1827 (size given in the catalogue as 41 by 36 inches including frame). The *Somerset House Gazette* critic in 1824 described it:

> John [Bull] loves a boy of spirit. 'I will fight' . . . touches the chord of his heart. We behold in this very clever picture, by a promising young painter, a boy of about ten years, determined to *have a round*. One, bigger than himself, and of an amiable countenance, is endeavouring to dissuade him from the encounter; but 'I will fight' is demonstrated indelibly in his look, and in each fist . . . Were we inclined to pun, we should say of this spirited piece, that even without a blow, the painter had made a 'good hit'.

For another painting of a juvenile fight, see William Mulready's 'The Fight Interrupted' of 1816 (FA139, p199). Both works were painted during a period which regarded boxing as an important manifestation of national character, celebrated in the spirited prose of Pierce Egan's *Boxiana* (1812–29).

Exh: SBA 1824 (65); BI 1827 (308)

Lit: *Somerset House Gazette* 1824 (II) p49

# SIMSON, William, RSA (1800–1847)

Born Dundee 1800, son of a merchant, studied at the Trustees' Academy from 1818, taught by Andrew Wilson, the 'Scottish Claude'. Exhibited at the RSA (founder member 1826, resigned, elected Member 1829) 121 works between 1821 and 1849, and 19 in 1863, 1880, and 1887; also 25 at the RA 1830–47, 30 at the BI 1833–48, and one at the SBA 1826. Visited Low Countries 1827, Italy 1834–5. Settled in London 1838. Early subjects mainly landscapes and coastal scenes, then portraits, finally scenes from English and Italian history. Died Chelsea, London, 29 August 1847. His two brothers, George (1791–1862) and David (1803–74), were also artists.

LIT: *Art Union* 1847, p353 (obit); M H Grant *Old English Landscape Painters* vol 8, 1961, pp705–7

## Interior of a Cattle Shed
FA180   Neg GF2748
Millboard, 33.9 × 45.5 cm (13⅜ × 17¹⁵⁄₁₆ ins)
Signed and dated 'W Simson, 1845' br
Sheepshanks Gift 1857

On the back is a manuscript label: 'No 7 [6 written over]/An Interior,/ William Simson/12 Sloane Street/Jany 12ᵗʰ/1846'. Exhibited at the BI in 1846 as 'An Interior', the size given in the catalogue (including frame) as 20 by 24 inches. According to the *Art Union*, the picture was bought by John Sheepshanks at the exhibition. The *Athenaeum* critic wrote of the 1846 BI exhibition that 'Mr Simson's contributions, which are numerous, are distinguished by agreeable colour, and the pleasing arrangement of subject'.

 A small oil study on paper of a hen and four chickens for the present work was also in the Sheepshanks Gift (FA87), and is inscribed 'Chilton July 21ˢᵗ/1845'.

EXH: BI 1846 (188)

LIT: *Athenaeum* 21 February 1846, p203; *Art Union* 1846, p78

*Interior of a Cattle Shed*   FA180

## Gil Blas Introducing Himself to Laura
FA181   Neg V1939
Canvas, 91.4 × 67.8 cm (36 × 26¾ ins)
Signed and dated 1840
Sheepshanks Gift 1857

Exhibited at the RA in 1840 as 'Gil Blas Introduces Himself to Laura as His Master Don Mattias de Silva', with the following quotation appended to the title in the catalogue:

> 'I threw myself in a transport at the feet of my nymph; and the better to imitate the beaus, pressed her in a petulant manner to make me happy. She seemed a little moved by my entreaties, but thought it was too soon to yield; therefore, pushing me gently from her, 'Hold', said she, 'you are too forward, and have the air of a libertine; I am afraid you are no better than a downright rake'.

The subject is from book 3 chapter 5 of the picaresque romance *Gil Blas* by Alain le Sage, published 1715–35 and translated into English by Tobias Smollett in 1749.

 The *Art Union* obituarist in 1847 thought the exhibited works of 1840 'call for little notice: they were scarcely of sufficient importance to increase or even uphold the well-earned fame of the artist; though one of them, "Gil Blas introducing himself to Laura", found its way into the collection of Mr Sheepshanks'. *The Art Union* had been hardly more complimentary in 1840;

*Gil Blas Introducing Himself to Laura*   FA181

with the 'Titian in his Study': 'Two well composed and highly finished works, but of scarcely sufficient importance to increase or even uphold the well earned fame of the artist. He is one to whom we look for some great undertaking that shall be honourable to the country and the arts'. The *Athenaeum* critic wrote:

> The false Don Mathias de Silva drops on his knees, with a delicious air of high-life-below-stairs gallantry, while his nymph keeps him off with her fan, in a manner copied from the best models, which is calculated to attract rather than repel further advances:- both gentleman and lady wearing a whimsical air of make-believe tenderness, thoroughly accordant with the spirit of the wittiest but most heartless of all novels . . . But there is a disproportion in the girl's figure, not merely, as in the case of Mr Knight's 'Melody', between itself and the canvas, but in its several parts; her head is too large, too heavily set upon her shoulders, and, were all as it should be, the clumsiness, which would befit another serving woman – Molière's Nicole, for instance, enhancing the effect of the convulsions of stupid laughter, with which she regards a George Dandin when he parades before her in all the trappings of nobility – is misplaced when a subtle, keen-witted, saucy Spanish girl is the subject. Mr Simson too, has not wholly freed himself from that inkiness of tone in his shadows, which gives his colouring a disagreeable harshness and chillness of effect.

A sketch for the painting was exhibited at the RSA in 1847 (321).

EXH:   RA 1840 (404); *Victorian Narrative Paintings* V&A Circulation exhibition 1961

LIT:   *Athenaeum* 30 May 1840, p435; *Art Union* 1840, p76, 1847, p353

### William Tell
FA182
Panel, 40.6 × 27.9 cm (16 × 11 ins)
Inscribed on back 'Study of a Head. Will^m Tell. W^m Simson 1842'
Sheepshanks Gift 1857

Study for the painting exhibited at the RA in 1845 (523), and again at the RSA in 1846 (270), with the title 'The Arrest of William Tell, for Refusing to Pay Homage to a Cap of Gessler's'. The exhibited picture was sold at Christie's 4 February 1972 (144, panel 129 × 98.9 cm (39 × 51 ins), signed and dated 1845), bought Moore 380 guineas, present whereabouts unknown. The legend of the Swiss hero who defied Austrian oppression was a Romantic theme, most famously told in Schiller's play of 1804; the episode here is described in full in the RA catalogue:

> On the 18th of November, 1307, Hermann Gessler, bailiff of Ari, among other indignities, had the audacity, in the public market of Altorp, to hang his cap upon a pole, and to enjoin the passengers [*sic*] to salute it, under pain of death. William Tell, of Bürglen, in the canton of Uri, having disregarded this order, Gessler caused him to be arrested; but knowing his extraordinary skill as an archer, the tyrant, with the most refined cruelty, offered Tell his liberty, provided he would hit an apple on the head of his son at a hundred yards distance. Tell accomplished this feat, and afterwards roused his countrymen to throw off the yoke of Austria, and give freedom to Switzerland.

The *Art Union* obituary of 1847 called the exhibited painting one of the artist's principal later works, but the *Athenaeum* was not so impressed in 1845, and particularly disliked the figure of Tell, the subject of the present work:

> One of the clever pictures in the *West Room*: though weakest, as might

have been feared, where it should have been the strongest, in the figure of the Liberator. So much animation and earnestness has the artist thrown into the aspects of those who are waiting the consequences of Tell's defiance of Austrian tyranny, that it is vexatious to see how completely the spirit has failed him in his central figure: who is nothing nobler than a wax-work hero. We can better excuse Gessler for being a mere bully in armour. His followers, moreover, have found too little grace in Mr Simson's eyes – who has slighted them in favour of the patriot's. Nor is the execution of the work agreeable. It is more careless and more ineffective than a picture by Mr Simson should be (24 May 1845, p521).

## SMITH, George (1802–1838)

Born London 1802; trained as an upholsterer. Entered RA Schools 1826, won gold medal. Studied in Rome 1830–3, said to have studied with Ingres on his way home. Exhibited five works at the RA between 1830 and 1835, two at the BI 1836, and possibly two at the SBA 1828–9. Childhood friend of Richard Redgrave RA, with whom he visited Wales in the 1820s. Died 15 October 1838.

Lit:    F M Redgrave *Richard Redgrave, A Memoir* 1891, pp24–5, 33–7, 95, 344–5

**Scipio Africanus Receiving his Son**
39-1869    Neg 37602
Canvas, 125.6 × 161.7 cm (49½ × 63¾ ins)
Signed and dated 'Geo Smith 1832 Roma' br
Given by Samuel Redgrave 1869

*Scipio Africanus Receiving his Son*
39-1869

Exhibited at the RA in 1833 with the full title 'Scipio Receiving his Son, who had been taken prisoner during the war, from the hands of the ambassadors of Antiochus the Great'. The subject, which seems uncommon in art, is from Livy's *History of Rome*: the brother of the Roman Consul Scipio, Publius Scipio Africanus, lieutenant in the Roman army, had his young son captured by the enemy, whose leader the Asian King Antiochus, hearing of Africanus's illness, sent ambassadors to return him to his father. The relevant passage dealing with the reconciliation scene occurs in book 37 chapter 37: 'As this present was highly grateful to the mind of the father, so was the satisfaction which it gave no less salutary to his body. At length, being sated with the embraces of his son, he said to the ambassadors, "Tell the King that I return him thanks . . ." ' (translated A A M'DeVitte, vol 4, 1850 pp1693–4).
    The work shows the influence of French neoclassical painting, particularly of David and his school in the use of decisive hand gestures; Smith supposedly studied with Ingres on his way back from Rome, presumably in 1833, which is too late for any effect on the present work, but Smith may have associated with young French artists at their Academy in Rome. The likeness of Scipio was possibly taken from a profile portrait on a coin, such as the example in the National Museum, Stockholm.
    The work is damaged by a long tear, sustained, it is presumed, during the First World War. However a reasonably good photograph exists in the museum's files, and conservation has been started.

Exh:    RA 1833 (537)

# SMITH, George (1829–1901)

Born London 18 April 1829, studied at Cary's school, entered RA 1845, and worked in studio of C W Cope. Exhibited 79 works at the RA between 1848 and 1887, 26 at the BI 1847–67, and 15 at the SBA 1851–9 and 1881/2. Subjects mainly genre, often involving children. Died Maida Vale, London, 2 January 1901.

*Another Bite*   FA185

## Another Bite
FA185   Neg HE4472
Panel, 45.7 × 55.9 cm (18 × 22 ins)
Signed and dated 'GS [in monogram] 1850' in red br
Sheepshanks Gift 1857

Exhibited at the RA in 1850. The *Art Journal* described 'A young disciple of old Izaak, [Walton, author of *The Compleat Angler* (1653)], in a smock frock, seated by the brink of a pond, sees his float moved; and the intense anxiety with which he bides his time draws from every sympathising spectator an expression of his best wishes for the boy's success'.

Exh:   RA 1850 (413); *Victorian England* Mitsukoshi Gallery, Tokyo, 1967

Lit:   *Art Journal* 1850, p172

*Temptation – A Fruit Stall*   FA186

## Temptation – A Fruit Stall
FA186   Neg 59105
Panel, 63.5 × 76.1 cm (25 × 30 ins)
Signed and dated 'GS[monogr] 1850' br
Sheepshanks Gift 1857

Exhibited at the RA in 1850 as 'Temptation'. The *Art Journal* wrote: 'The objects of trial are some children, who are assembled round a fruit stall, presided over by a hard-featured old woman, sensible only to the touch of coined metal. She is a highly successful study. In the face there is a living truth not very often attainable'.

A small oil study for the work was included in a group of studies sold at Christie's 2 February 1923 (111). The artist also exhibited 'The Fruit Stall' at the BI in 1852 (149, size given in the catalogue including frame as 27 by 25 inches). A similar subject, 'The Cherry Seller', with apparently the same female model, was recorded in a London private collection in 1969; this was possibly the 'Cherry-seller' exhibited at the RA in 1855 (1347).

The painting was reproduced in colour as a birthday greetings card published by the Medici Society Ltd.

Exh:   RA 1850 (69)

Lit:   *Art Journal* 1850, p166

*Children Gathering Wild Flowers*   FA187

## Children Gathering Wild Flowers
FA187   Neg 76819
Panel, 45.7 × 55.9 cm (18 × 22 ins)
Signed and dated 'G. Smith/1851' in red br
Sheepshanks Gift 1857

Exhibited at the RA in 1851 as 'Spring Flowers'. The *Art Journal* commented: 'Children decking with flowers their little sister, whom they have drawn forth in her little cart; the picture has much truthful excellence. A picture by the same hand, No 490, entitled "Maternal Instruction" has equal merit'.

A cartoon for the picture, in black and red chalks heightened with white on grey paper, is also in the V&A collections (E58-1961).

The painting was reproduced in colour as a birthday greetings card published by the Medici Society Ltd.

EXH:  RA 1851 (489); *British Art Fifty Years Ago* Whitechapel Art Gallery Spring 1905 (64)

LIT:  *Art Journal* 1851, p158

# SMITH, Stephen Catterson, PRHA (1806-1872)

Born Shipton, Yorkshire, 12 March 1806, son of a coach painter. Moved to London and entered RA Schools 1822; won silver medal for oil painting at Society of Arts 1824. Studied in Paris; lived in Yeovil, Somerset, about 1830–8; moved to Ireland 1839, first Londonderry, then Dublin 1845, becoming a highly successful portrait painter in the style of Lawrence. Exhibited eight portraits at the RA between 1830 and 1858, two works at the BI 1828–33, but principally at the RHA from 1841. Elected ARHA 1844, RHA 1845, PRHA 1859–64 and 1868. Director of NGI 1868. Many of his works were engraved, and his black chalk portraits published in lithograph. Died Dublin May 1872 (20 May in DNB, 30 in Strickland, 31 in *Art Journal*). His wife Anne was a miniature painter, and his sons Stephen and Robert also artists.

LIT:  *Art Journal* 1872, p204 (obit); W G Strickland *A Dictionary of Irish Artists* 1913

### Arthur Hill-Trevor, 3rd Viscount Dungannon
226-1871
Canvas, 243.7 × 165 cm (96 × 65 ins)
Given by Viscountess Dungannon 1871

Exhibited at the RHA in 1856, the work was commissioned as a gift to the sitter's wife by the Viscount's tenantry.
    Arthur Hill-Trevor (1798–1862) was born in London, educated at Harrow and Christ Church, Oxford, and elected MP for New Romney in 1830, Durham 1831 and 1835. He succeeded his father 1837 as 3rd Viscount Dungannon (of the second creation in the Irish peerage), and was elected representative peer for Ireland in the House of Lords 1855. He published several political pamphlets, and a two-volume *Life and Times of William III* (1835–6). He married his wife Sophia in 1821 (she died 1880); the present painting was presumably intended to be a companion piece to the earlier and similar sized portrait of her by John Hayter also in the V&A collections (see 227-1871, p124). A mezzotint portrait of the Viscount as a boy with his brother, by William Say after John Burnet, is in the British Museum.

PROV:  Presented to the Viscountess Dungannon by the Viscount's Irish tenantry 1856

EXH:  RHA 1856 (75)

ENGR:  Mezzotint by James John Chant

# STANFIELD, Clarkson, RA (1793–1867)

Born Sunderland 3 December 1793, son of an actor and wine merchant. Apprenticed to a heraldic painter in Edinburgh 1806, entered Merchant Navy 1808, Royal Navy 1812, discharged through illness 1814. Worked as scenery painter in London and Edinburgh theatres, painted panoramas and dioramas, as well as easel pictures. Exhibited 135 works at the RA between 1820 and 1867, 22 at the BI 1820–53, and 21 at the SBA 1824–29 (elected Member 1824, President 1829). Subjects almost all marine, river and coastal scenes. Elected to Sketching Society 1829, ARA 1832, RA 1835. Curator of Greenwich Hospital from 1844. Toured the Continent 1830 and 1838–9, and France 1832. Illustrated Heath's 'Picturesque Annuals' (1832, 1833, 1834), published 'Coast Scenery' 1836, and 'Sketches on the Moselle . . .' (1838). Friend of David Roberts RA and Charles Dickens. Died Hampstead, London, 18 May 1867. His son George Clarkson Stanfield was also an artist; his studio sales were at Christie's 8 May 1868 and 23 March 1876. Much admired by Ruskin, his skill at rendering both sea and sky – despite sometimes showing his theatrical interests too clearly – make him, after Turner, the most distinguished marine painter in Britain of the century.

LIT:    Art Journal 1857, pp137–9; Gentleman's Magazine July 1867 (obit); J Dafforne Pictures by Clarkson Stanfield RA nd [1873]; P van der Merwe The Life and Theatrical Career of Clarkson Stanfield Bristol University PhD thesis 1979, and The Spectacular Career of Clarkson Stanfield Tyne and Wear County Council Museums exhibition catalogue 1979 (with bibliography)

### On the Rhine, Near Cologne
FA188
Canvas, 106.7 × 87.7 cm (42 × 34½ ins)
Signed and dated 'C. Stanfield 1829' br
Sheepshanks Gift 1857

Stanfield probably made his first visit to Belgium and Germany in 1823; he was in Cologne early in July. He exhibited 'Cologne on the Rhine' at the SBA 1826 (84), possibly the painting now in the Rheinisches Landesmuseum, Bonn ('The Rhine at Cologne' 113 × 168 cm/44½ × 66⅛ ins, repr in van der Merwe's catalogue, p94), which was engraved in 1828. A watercolour copy of the present work was part of lot 168 sold at Christie's 5 June 1930. A similar view was engraved by J T Willmore for Charles Heath's Picturesque Annual 1833, p164 (impr in V&A collections E 879-1918).

*A Market Boat on the Scheldt   FA189*

### A Market Boat on the Scheldt
FA189   Neg Z2223
Panel, 82.9 × 124.4 cm (32⅝ × 49 ins)
Signed and dated 'C STANFIELD 1826' on barrel at l
Sheepshanks Gift 1857

Exhibited at the BI in 1826, and the artist's first exhibited painting to receive critical acclaim. The Times critic noted: 'Mr Stanfield, whose scenery at Drury Lane Theatre it has often been our pleasing task to praise, shows by his picture . . . that he is no less worthy of commendation for his paintings in oil'.
    The subject was presumably inspired by a trip to the Netherlands and Germany in June and July 1823; the river Scheldt runs from northern France, through Belgium, to Holland and the North Sea. Stanfield was to later exhibit two other pictures of similar scenes, 'On the Scheld, near Leiskenshoeck – squally day' (RA 1837) and 'Oude Scheld, Texel Island' (RA 1863). Another 'On the Scheldt' was engraved by R Wallis for Charles

Heath's *Picturesque Annual* 1833, p226 (impr in V&A collections, E881–1918).

The accompanying text to the engraving in the 1871 *Art Journal* (presumably written by Dafforne, as it is repeated in his book) explains the subject and admires the effect:

> . . . a locality which painters of 'sea-scapes' have loved to frequent for more than two centuries . . . Judging from the breadth of water, Stanfield must have sketched this view no very considerable distance from the mouth of the river: the near boat is preparing to cross over with its freight of passengers, fruit, vegetables, &c, for one of the boatmen is unloosing the craft from the buoy, while another close to him hails a similar boat approaching from the other side. Behind is a Dutch schooner tacking up the river; and, moored off the opposite coast, is a large vessel which, so far as the flag at her stern can be made out, is a British ship. The market boat in front, with its contents, is a picturesque bit of composition, and shows much rich and varied colouring, which is partially repeated in the water, the artist skilfully treating the grouped objects so as to let a gleam of bright sunshine fall upon this part of the work; and as the clouds roll away for a few minutes – there is rain coming on in the distance – gleams of sunlight are repeated on the opposite land and water. A fresh breeze is blowing, just enough to keep the masses of clouds in tolerably rapid motion, and to cause a surf on the dwarfish waves as they roll onward to their near shore. The action of the water shows the artist's close study of the elements, while his judicious treatment of light and shade keeps everything in its proper place, and subordinate to a general brilliant result.

Seventeen years later, Ward was less enthusiastic. He wrote of this work and a later painting as:

> Models of careful, precise, and at the same time spirited art; the boats and ships are admirably drawn, the lines of the waves have been followed with the most exact admiration. How it is, then, that they leave one cold? that in comparison with Turner on the one hand, and Henry Moore on the other, these marine-pictures of Stanfield appear inadequate? The truth is that to Stanfield the sea has denied the understanding of her innermost secrets. He cannot attain to the glory of her colours, and her never-resting movement demands a subtler brush than his.

The panel, which is mahogany, is stamped 'R DAVY/16 WARDOUR ST.' A pencil and watercolour drawing, identical in composition, was recorded in an English private collection in 1983.

PROV:  Sir Francis Freeling; his sale, Christie's 15 April 1837 (91), bought Smith £178 10s; John Sheepshanks

EXH:  BI 1826 (102, size given in catalogue as '49 by 65 inches' including frame); *Clarkson Stanfield* Sunderland Museum and Art Gallery 1979 (131)

ENGR:  J P Quilley for *Art Journal* 1857, p137; J C Armytage for *Art Journal* 1871, facing p200, and J Dafforne *Pictures by Clarkson Stanfield RA* nd [1873], facing p23

LIT:  *The Times* 2 February 1826; G Waagen *Treasures of Art in Great Britain* II, p302; *Art Journal* 1857, p137–9; *Art Journal* 1871, p200; *Dafforne*, pp23–4; T H Ward *English Art in the Public Galleries of London* nd [1888] II, p172

*Sands Near Boulogne    FA190*

## Sands Near Boulogne

FA190

Canvas, 71.1 × 110.5 cm (28 × 43½ ins)

Signed and dated 'CS [in monogram]tanfield R.A./1838.' br

Sheepshanks Gift 1857

Exhibited at the RA in 1838 as 'Portel, Coast of Boulogne'. Le Portel is two miles south-west of Boulogne. Chancellor commented that the work 'will repay close examination, because it is so obviously sincere and accurate in delineation, and is instinct with that breeziness which we find in so marked a degree in this painter's work'.

Exh:    RA 1838 (226)

Lit:    E Chancellor *Walks Among London's pictures* 1910, p253

Repr:    Autotype in R Redgrave *The Sheepshanks Gallery* 1870

## A Rocky Bay

1391-1869

Panel, 31.8 × 48.3 cm (12½ × 19 ins)

Townshend Bequest 1869

The view may be identified as the tower and town of Amalfi, on the Gulf of Salerno, south-east of Naples, renowned for its beautiful coastal scenery. Stanfield visited Amalfi during his longest and most productive tour of the Continent between August 1838 and March 1839. Two drawings by Stanfield, of the tower and the town respectively, are in the British Museum Print Room.

The work may possibly be that exhibited at the RA in 1840 (476) with the title 'Amalfi, Kingdom of Naples' (Stanfield exhibited three other Amalfi subjects in 1842 and 1848, but their titles do not relate to 'A Rocky Bay'). The *Art Union* critic said (p74) of Stanfield's 1840 RA exhibits: 'all landscapes of a high order of merit; but it seems to us that the accomplished painter is contracting a hardness of style'. The *Athenaeum* (16 May 1840, p400), having dismissed Turner's 'Slavers . . .' as 'a passionate extravagance', commented:

> With what a double pleasure, after lamenting Mr Turner's downward course, do we turn to Mr Stanfield's landscapes, no want of effect there, – none of colour – none of that delicate and poetical spirit, which adds something of the ideal to the familiar loveliness of nature, – and yet how simple, how unforced, how true they are!

*Ancona and the Arch of Trajan    F34*

## Ancona and the Arch of Trajan

F34    Neg 73785

Canvas, 90.2 × 156.2 cm (35½ × 61½ ins)

Signed and dated 'C Stanfield. RA. 1851' bl

Forster Bequest 1876

Exhibited at the RA in 1851 as 'Arco de Trajano, Ancona'. Stanfield had visited Ancona, on the north-east coast of Italy, in October 1838, and exhibited three earlier paintings of the subject at the RA: 'Ancona on the Adriatic' (1840), 'The Mole at Ancona, with Trajan's Arch' (1845), and 'Ancona' (1848). Of the 1848 painting, the *Art Journal* critic commented (p176):

> This view, or one very like it of the same locality, was exhibited by Mr Stanfield a few years ago. The point of view is from the beach near the triumphal arch, which is taken in profile, raising it against the sky. The material, in the nearest part of the picture, consists of pieces of rock, and sea-beach incidents – beyond that the sea opens and the sea-shore extends on the left. The whole painted and coloured with much sweetness'.

This description suggests that the 1848 painting, and the earlier one (presumably the 1845 exhibit), were similar in composition to the present work. The *Art Journal* critic also noticed the similarity in 1851:

> This is rather a large picture of a subject, which the artist we believe once before painted – that is nearly the same view – the arch rises on the left of the spectator, which with the immediate objects is finished so carefully, that the inscription at the top is legible. The high and rocky coast trending round to the right, affords a beautiful piece of composition, with the near figures, craft, and other material, all of which is painted with a fine feeling for surface.

Van der Merwe notes:

> The picture is a good example of the 'scenic' composition and atmospheric clarity that particularly marked Stanfield's stage work. A general aspect of Stanfield's landscape paintings justifies mention here particularly in connection with the present picture; namely, his employment and painting of figures. One of the manifestations of the fashion for the Picturesque was a general, almost theatrical, prediliction for works peopled with figures in detailed, 'appropriate' and brightly coloured costume; this particularly applied when a picture sprang from the antiquarian fascinations of history, or appealed to the taste for quaint domesticity . . . Though the landscape or seascape itself was always Stanfield's first interest, the carefully planned figure groupings which he put into much of his work show the extent to which he was catering to the fashion for human interest in landscape painting. While able to draw a striking caricature . . . Stanfield's figures, like those of many of his contemporaries, are not often saved from a wooden Swiss doll appearance. The figures in *Ancona* are no exception to this rule but they form lively, picturesque groups of a kind which evidently greatly pleased his public.

The artist presented another large picture of Trajan's Arch, painted on paper laid on canvas, to the Garrick Club in 1847; van der Merwe records that this is now much deteriorated, while the present work has retained much of its original appearance.

Exh:  RA 1851 (435); *Clarkson Stanfield* Sunderland Museum and Art Gallery 1979 (223)

Lit:  *Art Journal* 1851, p158; *van der Merwe* exhibition catalogue 1979, p133 (cat no 223)

### A Dutch Dogger Carrying Away Her Sprit (On the Dogger Bank)
486-1882   Neg R9170
Canvas, 76.2 × 69.9 cm (30 × 27½ ins)
Signed and dated 'C Stanfield. RA. 1846' diagonally bl
Jones Bequest 1882

*A Dutch Dogger Carrying Away Her Sprit (on the Dogger Bank)   486-1882*

Painted for the artist Alfred Edward Chalon, a friend at the Sketching Society, and exhibited at the RA in 1846. Appended to the title (as above) in the RA catalogue were the lines, possibly composed by the artist himself:

> On the Dogger Bank, in the cold North Sea,
> Wearily day and night toil we;
> Weary, wet, hungry and cold,
> Three poor fishermen we, weakly and old.

The artist allowed the painting to be shown at the Exposition Universelle in Paris in 1855, and it has become one of the most famous of Stanfield's works.

The *Art Journal* discussed the subject:

> there is more matter in the picture than the song. It is a charming

273

production, into which the artist has thrown a strong dash of sentiment. The poor little vessel is pitched into a trough, and the seas rise above her on all sides; the sprit has snapped like a twig, and half is gone overboard; but they cannot afford to lose even this, so one of the poor fellows, in his economical distress, is fishing up the splinter. There is so much movement in this picture that we take leave of the vessel with our very best wishes for her safety, and an irrepressible hope that when we see her again it may be in smoother water.

Ruskin especially admired Stanfield's technique: 'He will carry a mighty wave up against the sky and makes its whole body dark and substantial against the distant light using all the while nothing more than chaste and unexaggerated colour to gain the relief. His surface is at once lustrous, transparent and accurate to a hair's breadth in every curve'.

Van der Merwe also comments (p171): 'It was not only the eye but the heart that was pleased by the virtuosity of his sea paintings; like several other marine pictures by Stanfield the sentimental element is not far removed'.

A replica, dated 1847, was sold at Christie's 29 November 1912 (123). A watercolour, also exhibited at the Exposition Universelle in 1855 and lent by Chalon, may be connected with the present work.

PROV: Painted for A E Chalon (not in his studio sale Christie's 11 March 1861); John Jones

EXH: RA 1846 (22); *Exposition Universelle* Paris 1855 (939, lent by A E Chalon)

LIT: *Art Union* 1846, p173; J Ruskin *Works* (Modern Painters I) III, 1903, p535; *van der Merwe* exhibition catalogue 1979, pp169–70 (cat no 311)

### Ischia and the Castello d'Ischia, near Naples
507-1882
Panel, 31.4 × 60.9 cm (12⅜ × 24 ins)
Signed and dated 'C Stanfield. RA. 1857' br
Jones Bequest 1882

Probably the work exhibited at the RA in 1858 as 'The Castle of Ischia'. The *Athenaeum* critic found it 'very characteristic of this vigorous painter', while the *Art Journal* thought it 'has all the best qualities of Mr Stanfield's marine subjects'.

Stanfield was in Naples in December 1838 and visited the island of Ischia, at the north-west entrance to the Bay of Naples. He wrote to his wife Rebecca on 16 January 1839:

Alas, all communication with the Main was cut off, it blowing a gale wind with a sea running sufficiently strong to prevent any boat attempting the passage. This continued from the 22nd to the 28th. I need hardly tell you, dear Beck, what sort of Christmas Day I had on this, alone in a wretched albergo, bitterly cold, without fire and nothing to eat, at least nothing that I could eat. Exceedingly unwell I turned into bed in sheer despondency at 6 o'clock in the evening . . . On the 28th fairly tired out I left Ischia in a large boat with six men to try and make a landing but after getting thoroughly wet I fairly turned tail and put back into Procida (quoted by van der Merwe, p132).

The first result of this visit was 'The Castle of Ischia from the Mole', exhibited at the RA in 1841 (9) and engraved for the *Art Union* in 1844 (present whereabouts unknown, see van der Merwe p132, cat no 221). Several views of Ischia were exhibited at the RA and BI in 1841, 1842, 1843 and 1850 as well as the present work; the artist did not visit Italy again.

Van der Merwe points out that Stanfield's first painting was well-known, quoting from Murray's *Handbook of Southern Italy* of 1853: 'The Castle . . .

274

has been the scene of many remarkable events in the history of Naples . . . Its picturesque beauty requires no eulogy from an English author, since Mr Stanfield has made it familiar to his countrymen by one of the most characteristic productions of his matchless pencil'.

An etching of Ischia by R Brandard after a drawing by Stanfield is also in the V&A collections (E566-1912).

Exh:    ?RA 1858 (359)

Lit:    *Athenaeum* 8 May 1858, p598; *Art Journal* 1858, p167; *Examiner* 1858, p276

## The Seashore at Dover
680-1893
Canvas, 42.6 × 62.9 cm (16¾ × 24¾ ins)
Bequeathed by Miss E Anderson 1893

According to the museum files, the title of the work on acquisition was 'Dover – Shakespeare's Cliff'. The view shows Dover before the erection of the Admiralty Pier.

Stanfield exhibited 'Shakespeare's Cliff, Dover, – 1849' at the RA in 1863 (272), which is possibly identifiable with the present work. Miss Anderson bequeathed the present work to the museum along with 'HMS "Victory" Towed into Gibraltar' (681-1893, below) and 'Shrimping' (682-1893, p277). The executor of her will was Field Stanfield, the artist's son. Another version of the subject, signed and dated 1862, is in the National Maritime Museum (58.5 × 91.5 cm/23 × 36 ins), which is more probably the 1863 RA exhibit.

## HMS 'Victory' Towed into Gibraltar
681-1893    Neg FJ2281
Millboard, 28.9 × 44.5 (11⅜ × 17½ ins)
Bequeathed by Miss E Anderson 1893

*HMS 'Victory' Towed into Gibraltar*
681-1893

The work is described in the 1893 correspondence between the museum and the donor's executor, Field Stanfield, the artist's son, (see the entry for 680-1893, above) as 'an interesting and valuable work of this artist being the finished sketch of the large and well known picture of the same subject now at Somer Leyton'. The large (176 × 262 cm/69¼ × 103¼ ins) painting was exhibited at the RA in 1853 (57); it was commissioned by Sir Samuel Morton Peto MP, who sold his collection in 1862 to Francis Crossley MP, whose son became the 1st Lord Somerleyton, in whose family collection the picture remains.

The RA painting was much admired by the critics. The *Athenaeum* found it 'full of poetry and movement' (7 May 1853, p566), the *Art Journal* 'painted with admirable spirit and precision, constituting this the most interesting marine picture which its author has for some time past exhibited' (1853, p142), and the *Examiner* noted the 'sense of pathos and solemnity', admiring especially the treatment of the sea, concluding that it was 'a triumph of art; for without the use of any melodramatic accessories, or coarse suggestions of gloom, Mr Stanfield has succeeded in conveying the idea of a great sorrow' (1853, pp277, 326). The work was engraved by John Cousen (see the *Examiner* 1853, p358). Dafforne (p18) commented:

> Never, perhaps, was so impressive a subject so touchingly and powerfully painted . . . It is a work not to be seen without emotion; there is grandeur in the conception, and masterly carrying-out of the diversified materials. The water is eminently successful – full, flowing, transparent and deep; the ships and boats are solid and rich in colour, and the aerial perspective of the giant Rock of Gibraltar is well managed, while the whole is brought together in perfect harmony.

The full title of the RA picture was given in the catalogue, together with lines of verse (possibly written by Stanfield himself) and an 'epigraph' by Lieutenant Paul Harris Nicolas:

HMS 'The Victory' (with the body of Nelson on board) towed into Gibraltar 28th of October, 1805, seven days after the battle of Trafalgar. 'Battle stained and tempest tossed, a mighty ship comes on,/No shout of triumph welcomes her for the glorious victory won,/For she carries her dead admiral, killed in Trafalgar's Bay,/And Nelson's flag hangs droopingly on that triumphant day./Sail on, proud ship! thy battered hull proclaims thy place in war,/A fitting bier for him who fell in the fight at Trafalgar.' Disabled ships continued to arrive for several days, bringing with them the only four prizes rescued from the fury of the late gale. The anchorage became covered with ships. In the mole lay six dismasted hulls, whose battered sides, dismounted guns, and shattered ports presented unequivocal evidence of the brilliant part they had taken in the gloriously contested battle; a little beyond, the more recently arrived lay at their anchors. At this proud moment no shout of exultation was heard, no joyous felicitations were exchanged, for the lowered flag which waved on the Victory's mast marked where the mourned hero lay, and cast a deepened shade over the triumphant scene.

Van der Merwe (p163) lists three other versions of the subject: an oil on panel, 45.7 × 69.9 cm (18 × 27½ ins), signed and dated 1854, in the Guildhall Art Gallery; an oil on canvas, 86.4 × 137.2 cm (34 × 54 ins), with Messrs Appleby in 1972; and an oil 41.9 × 53.3 cm (16½ × 21 ins) in an American private collection. Another replica, attributed to Stanfield, 'with signature and indistinctly dated 1842' (which seems unlikely), 70.5 × 91.5 cm (27¾ × 36 ins), was sold at Christie's 1 March 1985 (87). A copy, 44.5 × 58.5 cm (17½ × 23 ins), is in the Greenwich Hospital collection, on loan to the National Maritime Museum.

Stanfield painted three subjects related to the battle at Cape Trafalgar: apart from the present work, 'The Battle of Trafalgar' was commissioned by the United Services Club and exhibited at the RA in 1836 (290, a copy is in the National Maritime Museum, 94 × 152.5 cm/37 × 60 ins), and 'The Morning Following the Battle of Trafalgar; the situation of HMS The Defence and her prize, El Sant Ildefonso' exhibited at the RA in 1863 (123, now National Gallery of Victoria, Melbourne, Australia). M Butlin and E Joll (in *The Paintings of J M W Turner* 1977, I, p208) have drawn attention to the revival in the 1830s of 'interest . . . in the dwindling number of veteran ships from the Napoleonic Wars', with particular reference of course to Turner's "The Fighting Temeraire . . ."' (exhibited RA 1839 (43), now National Gallery) and cite Louis Hawes's opinion that Turner also offers 'a portrayal of the more general theme of the decline of Britain's mercantile power'. Interestingly, Turner also appended lines of verse to the title of his painting in the RA catalogue: the lines were taken from Thomas Campbell's celebrated *Ye Mariners of England* (written 1800) and may be compared to Stanfield's verse quoted above. For a full discussion of the subject of the present work, see van der Merwe's catalogue.

In 1941, the work was displayed near the Exhibition Road entrance of the museum; according to a note on the Department files, a fragment from a German bomb travelled across Exhibition Road, through the oak doors, winged a pilaster, passed through two plywood screens, and through the backboard, millboard, and glass of the painting, finally coming to rest in a pillar of the Octagon Court. The picture was restored after 1945.

EXH:   *British Empire Exhibition* Wembley 1924

LIT:   *van der Merwe 1979, pp163–4*

## Shrimping
682-1893
Millboard, 31.7 × 49.2 cm (12½ × 19⅜ ins)
Signed and dated 'C Stanfield RA 1848'
Bequeathed by Miss E Anderson 1893

One of a number of small oil paintings that may be compared to similar works by Bonington showing figures of shrimpers and inshore fishermen.

## Seascape
1843-1900
Panel, 31.4 × 50.8 cm (12⅜ × 20 ins)
Signed and dated 'C Stanfield 1826' on floating spar br
Ashbee Bequest 1900

A small label on the back is inscribed 'HSA [that is, H S Ashbee]/9'. The ship appears to be flying a Dutch flag. Stanfield exhibited 'A Market Boat on the Scheldt' at the BI in 1826 (102), the size given in the catalogue as 49 by 65 inches including the frame; the present work may be related to that exhibit in some way.

REPR:   *Magazine of Art* XXV, 1900–1, p171

## The Action and Capture of the Spanish Xebeque Frigate 'El Gamo'
364-1901   Neg 59312
Canvas, 132.1 × 183.9 cm (52 × 72⅜ ins)
Bequeathed by Mrs Julia Anne Bonnor 1901

*The Action and Capture of the Spanish Xebeque Frigate 'El Gamo'   364-1901*

Exhibited at the RA in 1845, with the full title given in the catalogue together with an extensive explanation of the subject:

> The action and capture of the Spanish xebeque frigate El Gamo, of 32 guns and 319 men, commanded by Don Francisco de Torris, and H.M. sloop Speedy, of 14 four-pounders and 54 men, commanded by Lord Cochrane (now Earl Dundonald) off Barcelona, on the 6th May, 1801. After a mutual chase and warm action, the El Gamo was carried by boarding; the commander of the Speedy (Lord Cochrane) ordering every soul in the brig to board, leaving only the surgeon, Mr Guthrie, in charge of the helm. The Speedy had eight wounded and three killed; the El Gamo had 45 wounded, and 14 killed, including the Commander, Don Francisco de Torris. From the great disparity of force, this was justly considered one of the most gallant exploits of the last war.

The famous episode was described in detail by William James in *The Naval History of Great Britain . . .* published 1822–6.

The work was painted for Commander Charles Spencer Ricketts RN (the father of the donor) who served as midshipman in the action. A label, perhaps written by Ricketts, on the frame briefly recounts the episode. A visitor informed the museum in 1908 that the figure on the spar was a portrait of the artist's son, while the boy hauling down the Spanish colours was Midshipman Ricketts.

PROV:   Commander Ricketts RN; by descent to his daughter Mrs Julia Anne Bonnor, who bequeathed it to the museum 1901

EXH:   RA 1845 (254)

## View on the Rhine
365-1901   Neg FE1350
Panel, 41.3 × 55.6 cm (16¼ × 21⅞ ins)
Signed and dated 'C. Stanfield 1827' br
Bequeathed by Mrs Julia Anne Bonnor 1901

*View on the Rhine   365-1901*

**View on the Scheldt**
366-1901
Panel, 40.7 × 54.3 cm (16 × 21⅜ ins)
Signed and dated 'C. Stanfield. 1826' bl
Bonnor Bequest 1901

The market boat and its passengers are very similar to those in the larger 'A Market Boat on the Scheldt' (see FA189, p270) also dated 1826. Van der Merwe comments: 'However, this small panel has the subdued colouring and tones of a 17th-century Dutch seascape by van Goyen or Jan Porcellis, and in this respect is quite different'.

EXH: *Clarkson Stanfield* Sunderland Museum and Art Gallery 1979 (132)

LIT: *Van der Merwe* 1979 p94 (cat no 132)

# STANLEY, Caleb Robert (c1795–1868)

Born about 1795, supposedly studied in Italy. Exhibited 32 works at the RA between 1819 and 1863 (as an honorary exhibitor, indicating he was an amateur, surprisingly in the light of his long and prolific career), 87 at the BI 1820–67, 22 (including nine watercolours) at the SBA, and several at the watercolour exhibiting societies. Subjects were topographical views in England, Wales, Scotland, Ireland, France, Holland and Germany. Died Maddox Street, London W1, 13 February 1868; studio sales at Christie's 19 March 1869 and 13 April 1870. His sons Archer and Charles H Stanley were also artists. Three watercolours are in the V&A collections.

LIT: *Art Journal* 1868, p73 (obit); M H Grant *Old English Landscape Painters* vol 8, 1961, pp619–20

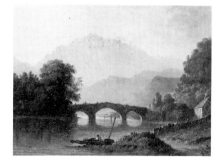

*Callander Bridge, Perthshire   1583-1871*

**Callander Bridge, Perthshire**
1583-1871   Neg HF969
Millboard, 30.2 × 40.6 cm (11⅞ × 16 ins)
Signed 'C.R. Stanley' br
Bequeathed by W S Louch 1871

Stanley exhibited Scottish subjects in 1836 and 1844. Callander is about 20 miles north-west of Stirling, in a picturesque location; the bridge was built in 1764. Grant describes the work as a 'pleasant little picture' but 'not an adequate example, even of this modest and moderate painter'. Two watercolours by Stanley were also in the W S Louch Bequest of 1871.

LIT: *Grant*, p619

# STARK, James (1794–1859)

Born Norwich 19 November 1794, son of a Scottish dyer. Pupil of John Crome 1811–14, exhibited at the Norwich Society of Artists from 1811 and elected Member 1812. Entered RA Schools 1815. Exhibited 65 works at the RA between 1811 and 1859, 136 at the BI 1814–59, 53 (including seven watercolours) at the SBA, and also at the watercolour societies. Subjects all landscapes, often with figures and animals. Published 'The Scenery of the Rivers of Norfolk' (1827–34). Died Hampstead, London, 24 March 1859; his son Arthur James Stark was also an artist. An exhibition of his works was held in Norwich in 1887; several drawings and watercolours are also in the V&A collections.

Lɪᴛ: *Art Journal* 1850, p182, 1859, p135 (obit); H Day *East Anglian Painters* II, 1968, pp56–77

## Fish Ponds, Hastings
FA191
Millboard, 25.4 × 34.2 cm (10 × 13½ ins)
Sheepshanks Gift 1857

Stark exhibited two Hastings subjects at the SBA in 1835 and 1836, 'Near Hastings, Beechey Head in the Distance' and 'Near Hastings'. For other Hastings works see FA193 and FA196, below.

## Lloyd's Pulpit, Festiniog, North Wales
FA192
Panel, 27.3 × 33 cm (10¾ × 13 ins)
Sheepshanks Gift 1857

Presumably the painting with this title exhibited at the SBA in 1837. He exhibited other North Wales subjects there in 1837 and 1838, and another scene near Festiniog at the BI in 1837.

Exʜ:   SBA 1837 (472)

## Ponds and Windmill, Hastings
FA193
Panel, 30.5 × 41.9 cm (12 × 16½ ins)
Sheepshanks Gift 1857

See 'Fish Ponds, Hastings' (FA191, above).

## Landscape
FA194
Millboard, 20.3 × 17.7 cm (8 × 7 ins)
Sheepshanks Gift 1857

## Distant View of Windsor
FA195
Panel, 26.6 × 21.2 cm (10½ × 8⅜ ins)
Sheepshanks Gift 1857

Stark lived at 10 York Place, Windsor, from 1839 to 1849, the *Art Journal* in 1850 (p182) commenting 'the splendid oaks and beeches of the Forest and Park furnishing many subjects for his pencil'. His first Windsor subject to be exhibited was at the SBA in 1833, and there were several others in the 1840s and early 1850s. The present work could possibly be 'Beech Trees near the Statue, Looking towards Windsor Castle' exhibited at the RA in 1841.

Exʜ:   ?RA 1841 (134)

## Landscape – A Woody Lane Near Hastings
FA196
Millboard, 20.6 × 17.7 cm (8⅛ × 7 ins)
Sheepshanks Gift 1857

See 'Fish Ponds, Hastings', FA191 above).

## TOPHAM, Francis (Frank) Williams, OWS (1808–1877)

Born Leeds, Yorkshire, 15 April 1808; moved to London about 1830. Trained and worked first as an engraver; according to R E Graves in the DNB, he taught himself to paint in watercolour, aided by practice at the artists' society in Clipstone Street, London. Exhibited eight works at the RA between 1832 and 1870, three at the BI 1839–46, and three at the SBA 1833–7. Subjects mainly the peasantry of Scotland, Ireland, Italy and Spain. Predominantly a painter in watercolour (there are six examples also in the V&A collections); elected Associate of the New Society of Painters in Watercolours 1842, he resigned 1847; elected Member of the Old Watercolour Society 1848. Several illustrations for books, notably Sir Walter Scott's Waverley novels. Friend of Charles Dickens. Several of his works were engraved. Died Cordova, Spain, 31 March 1877. His son, Frank William Warwick Topham, was also an exhibiting painter.

Lit: *Illustrated London News* 14 April 1877, pp339, 341 (obit, with engr portrait)

*A Spanish Letter-Writer*   485-1882

### A Spanish Letter-Writer
485-1882   Neg HF963
Canvas, 44.5 × 67.8 cm (17½ × 26½ ins)
Jones Bequest 1882

The notice on the wall above the central figure of the old man reads 'Se escriben cartas y memoriales', advertising his services as a professional letter-writer. Topham first visited Spain in 1852, and later painted several Spanish subjects, including Spanish card players at the RA in 1857. The present work does not seem to have been exhibited.

### Sketch for John Forster's 'Life of Oliver Goldsmith'
F36   Neg HF964
Panel, 19.7 × 16.5 cm (7¾ × 6½ ins)
Forster Bequest 1876

Topham was a friend of Charles Dickens, and so presumably acquainted with John Forster; given this, the title of the present work from its acquisition, and its provenance, the painting must be associated in some way with Forster's biography of the 18th-century writer Oliver Goldsmith, first published in 1848 (that edition, and several later editions, were also in the Forster Bequest and are now in the National Art Library).

Forster's biography of Goldsmith was described (by G Rousseau in *Goldsmith: the Critical Heritage* 1974, p325) as 'more than a biography: it attempted a thorough revaluation of Goldsmith's age and contemporaries, and it was also an experiment in literary biography'. Rousseau reprinted the contemporary review by George Lewes from the *British Quarterly* rather than extracts from Forster's text on the grounds that 'the review ultimately presents the view of the 1840s and, furthermore, shows how a biographer used the life of a dead author as a pretext for writing about his own (the biographer's) age'.

The popularity of Forster's biography of Goldsmith is attested by the fact that, after the first four-volume edition in 1848, it was republished several times. The first two-volume edition, also published in 1848, was illustrated; no artists were credited, but the 1855 edition lists them as Clarkson Stanfield, Daniel Maclise, John Leech, Richard Doyle, and Robert James Hamerton.

The present work seems to depict an episode in book 1 of Forster's biography (in which he relates Goldsmith's early life up to 1757); as an unsuccessful student, itinerant and poverty-stricken, the young Goldsmith

*Sketch for John Forster's 'Life of Oliver Goldsmith'*   F36

espouses the cause of the poor – particularly beggars of all ages to whom he gave money and even his own clothes. In this part of Forster's biography, Goldsmith is described as 'hidden by some dusky wall, or creeping within darkling shadows of the ill-lighted streets'. Here, Topham seems to be most likely preparing an illustration of that episode which for some reason was not used. For a fuller discussion of the popularity of Goldsmith and his works in the 19th century see the entry on Frith's painting (FA74, 93. A more highly finished watercolour of the subject was sold by Christie's (Scotland) 27 October 1989 (signed and dated 1859, 71.1 × 62.2 cm/28 × 24½ ins).

# TOWNSHEND, Reverend Chauncey Hare (1798–1868)

Born 20 April 1798, son of a landed gentleman. Educated at Eton and Cambridge. Took holy orders, but ill health prevented him following a clerical career. Encouraged by Robert Southey, published poems 1821, and other volumes of verse; also travel books and tracts on mesmerism. Amateur painter and draughtsman, travelled abroad and lived in Lausanne in later years. Best known as a collector, he left his precious stones, coins, cameos, paintings and drawings to the museum. He was characterised as Mr Fairlie, the fastidious connoisseur, in Wilkie Collins's novel *The Woman in White* (1860). Died London 25 February 1868.

LIT:    *DNB*; M Haworth-Booth 'The Dawning of an Age; Chauncey Hare Townshend: Eyewitness' in *The Golden Age of British Photography 1839–1900* 1984, pp11–21 (and for further references).

**Blea Tarn, Cumberland**
1420–1869   Neg HD1616
Panel, 22.8 × 31.7 cm (9 × 12½ ins)
Townshend Bequest 1869

Blea Tarn is a peak near Ambleside in the Lake District; the farm there was referred to by Wordsworth in his poem *The Excursion*. Townshend, whose parents wrote verse and encouraged their son to write, had visited Keswick as a young man and met the Wordsworths. Haworth-Booth draws attention to Townshend's Romantic love of mountains and lakes both in art and life.

*Blea Tarn, Cumberland*   1420-1869

# TRAVERS, George (exhibiting 1851–1865)

Exhibited six landscapes at the RA between 1851 and 1859, 11 at the BI 1852–1863, nine at the SBA 1854–65, and 14 elsewhere. He sent works from an address in Poplar, East London, and the locations of his landscapes included Essex, Jersey, Wales and Scotland.

**Whitsand Bay, Devon – Rain Passing Off**
1424-1869
Canvas, 45.7 × 61 cm (18 × 24 ins)
Signed 'G Travers' bl
Townshend Bequest 1869

Travers exhibited a painting with this title at the BI in 1853, its price given in the catalogue as £15. It was not noticed by the reviewers of the *Art Journal* or *Athenaeum*. The scene depicted is presumably the Whitesand Bay on the south coast of Cornwall, north-west of Rame Head.

EXH:    ?BI 1853 (62)

# TURNER, J M W, RA (1775–1851)

Born Covent Garden, London, 23 April 1775, son of a barber. Entered RA Schools 1789. In a long and exceptionally distinguished career, exhibited 259 works at the RA between 1790 and 1850 and 17 at the BI 1806–1846, predominantly landscapes, sometimes with historical themes. Generally considered the greatest painter in the history of British art. Died Chelsea, London, 19 December 1851 and buried in St Paul's Cathedral. Bequeathed his extensive collection of oil paintings and watercolours to the nation, now principally housed in the Clore wing of the Tate Gallery.

LIT: M Butlin and E Joll *The Paintings of J M W Turner* 2 vols, 1977 (with full bibliography); A Wilton *Turner* 1979

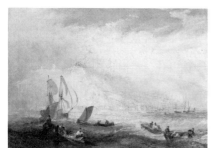

*Line Fishing, Off Hastings*   FA207

### Line Fishing, Off Hastings
FA207   Neg 56729
Canvas, 58.4 × 76.2 cm (23 × 30 ins)
Sheepshanks Gift 1857

Exhibited at the RA in 1835, and bought (or possibly commissioned – see Butlin and Joll, I, p189) by John Sheepshanks. Butlin and Joll note that the work shows essentially the same view as a watercolour in the British Museum signed and dated 1818, which is in turn based on a drawing in the second 'Hastings' sketchbook of 1816. The foreground shipping is composed differently, however, and the oil painting shows the land further away.

Reviews of the RA concentrated on the 'Burning of the Houses of Parliament' (Cleveland Museum of Art, Ohio) and 'Keelmen Heaving in Coals by Night' (National Gallery of Art, Washington DC). The *Literary Gazette* (9 May 1835) thought it 'Decidedly one of Mr Turner's most charming productions', and the *Spectator* on the same day described it as 'a beautiful marine piece'; Waagen in 1854 found it 'very cleverly composed, though slight in execution'.

EXH: RA 1835 (234)

ENGR: W Miller, for the *Turner Gallery* 1859

LIT: *Butlin and Joll*, I, p194 (cat no 363)

### Venice
FA208   Negs GG1756, 33882
Canvas, 61 × 91.4 cm (24 × 36 ins)
Sheepshanks Gift 1857

Exhibited at the RA in 1840, and painted on commission for John Sheepshanks. The commission is confirmed by the existence of a letter from Turner to Sheepshanks of 29 January 1840, noted by Butlin and Joll. The full title given in the RA catalogue was 'Venice, from the canale della Giudecca, chiesa d. S. Maria della Salute, &c'. This and 'Venice, the Bridge of Sighs' (also exhibited at the RA 1840, now Tate Gallery) were the first paintings of the size that Turner thought most suitable for his Venetian subjects.

The *Spectator* critic (9 May 1840) described the 1840 exhibits, which included the famous 'Slave Ship' (Museum of Fine Arts, Boston), as 'flaring abortions' and (16 May) 'rhapsodies of Turner's insane pencil'. The present work was only singled out by *Blackwood's Magazine* in September: 'Turner again? Is there anything to enable us to put in a good word? There is. The sky is very natural, and has its due aerial perspective; all the rest is wretched: buildings as if built of snow by children in sport'. Waagen in 1854 (*Treasures* II, p305) found it 'Admirably conceived; but to my feeling too slight to be satisfactory'. In a text accompanying an engraving after the painting, the *Art Journal* (1864, p22) acclaimed the work as:

A picture resplendent with sunshine, and animate with the bustle of
Venetian commercial life. The view was apparently sketched on the
Canal of the Giudecca; to the left rise the towers and domes of the
church of Santa Maria della Salute; beyond this we have a prospective
view of the Ducal Palace, above which peep the mosque-like domes of St
Marco; and to the left of these the Campanile lifts its tall and graceful
form . . . the combination of *Materiels* is most picturesque, and the
whole is seen under an effect at once brilliant and beautiful.

Butlin and Joll comment on the *Blackwood's Magazine* criticism quoted
above: 'It is true that even today the domes of Santa Maria della Salute
appear glaringly white and chalky', and point out the exceptional state of the
work's preservation due to the air-tight case in which it was placed in 1893
(for fuller details, see N Brommelle in *Museums Journal* 1962 (62), pp337–46,
and *Studies in Conservation* 1964 (9), pp140–52).

    Similar views are 'Bridge of Sighs, Ducal Palace . . . Canaletti Painting'
(exhibited RA 1833, now Tate Gallery) and, from further back, 'Ducal
Palace, Dogano . . .' (exhibited RA 1841, now Dudley Peter Allen
Memorial Art Museum, Oberlin, Ohio). A similar work is recorded in Lord
Grimthorpe's collection at Easthorpe Hall, and another is in the Beaverbrook
Art Gallery, Fredericton, New Brunswick; neither are accepted as by Turner
by Butlin and Joll (for the latter, see J Mayne 'Two Hitherto Unrecorded
Turners', *Burlington Magazine* XCVI, 1954, pp18–19, and Butlin and Joll, I,
p288, cat no 560). A copy of the work, apparently by Henry Scott Tuke, was
recorded in a private collection in 1972.

Exh:    RA 1840 (71); Neue Nationalgalerie, Berlin 1972 (24)

Engr:    E Brandard, for the *Turner Gallery* 1859

Lit:    *Butlin and Joll*, I, pp213–4 (cat no 384)

## St Michael's Mount, Cornwall

FA209    Negs 55141, CT5224
Canvas, 61 × 77.4 cm (24 × 30½ ins)
Sheepshanks Gift 1857

Exhibited at the RA in 1834, and bought (or probably commissioned: see
Butlin and Joll) by John Sheepshanks. Turner drew the subject several times:
in a 1811 sketchbook, in a watercolour of about 1812 for the engraving in the
*Southern Coast* series in 1814 (Wilton 445, repr), as an illustration to *Milton's
Poetical Works* of about 1834 published 1835 (Wilton 1269, repr), and a
watercolour of about 1836 to be engraved for *England and Wales* in 1838
(Wilton 880, repr). The present work shows the same view as the 1812
watercolour, although the height of the Mount is increased.

*St Michael's Mount, Cornwall*   FA209

    *Arnold's Magazine* (July 1834) thought it 'one of the most conspicuous' of
the exhibits, and 'although the scene cannot be said to convey a literal idea
of the object chosen for representation, we have little doubt it corresponds
precisely with that which the artist had conjured up in his imagination'. The
*Morning Post* critic (17 July 1834) described it as 'a favourable specimen of his
new style of painting; but we ourselves are old-fashioned enough to prefer his
discarded one as coming more within the limits of our comprehension, and
nearer, as we think, to nature'. The *Spectator* (10 May 1834) compared it
with Callcott's 'Recollection of the Campagna of Rome': 'The difference of
these, the two first English landscape painters, is made strikingly evident.
Callcott's colours look opaque and heavy, and Turner's painting
unsubstantial and visionary'. Twenty years later, Waagen thought that 'The
bold, precipitous rock, and the manner in which it is lighted, give this
picture a poetical charm' (*Treasures of Art in Great Britain* 1854, II, p305). A
small (16.5 × 22.2 cm/6½ × 8¾ ins) oil sketch was recorded in a private
collection in 1952, as was a copy after the work in 1972. Another copy (87.6
× 113.1 cm/34½ × 44½ ins), supposedly also painted in 1834, was in the

original Russell-Cotes collection given to the museum of that name in Bournemouth.

ExH: RA 1834 (317); *Op de Rede* . . . Stadsfeestzaal, Antwerp, 1972 p25, repr p85); *Turner* Tate Gallery 1977

ENGR: J Cousen in *Art Journal* 1859, facing p240, and *Turner Gallery* 1859, repr in A Hayden *Chats on Old Prints* 1906, p228; W Miller 1866

LIT: *Butlin and Joll* pp188–9 (cat no 358)

### East Cowes Castle

FA210    Negs 37804, CT760
Canvas, 91.4 × 123.2 cm (36 × 48½ ins)
Sheepshanks Gift 1857

*East Cowes Castle    FA210*

Painted for the architect John Nash (1752–1835), who owned the castle, in 1827–8, and exhibited at the RA in 1828. Turner visited from the end of July to September 1827, and Reynolds, and Butlin and Joll, fully discuss the circumstances and progress of the commission.

Nash designed the neo-Gothic castle, which was built in 1798 (since demolished; see the view in the *Polite Repository* 1800, copy in the V&A collections). In the painting it is seen on the hill above the River Medina, at Cowes, Isle of Wight. The Royal Yacht Club was founded at Cowes in 1812, the second series of races being in 1817, in the first week of August.

The full title of the work, given in the RA catalogue, was 'East Cowes Castle, the Seat of John Nash, Esq.; the Regatta Starting for their Moorings'. The painting was admired by the critics, particularly as the subject was preferred to those of Turner's other exhibits in 1828, 'Boccaccio Relating the Tale of the Birdcage' and 'Dido Directing the Equipment of the Fleet' (both now Tate Gallery). In a long passage in *Modern Painters*, John Ruskin analysed the painting with characteristic care for detail, beginning by noting that 'Intensity of repose is the great aim throughout, and the unity of tone of the picture is one of the finest things that Turner has ever done', and concluding that it is 'not only a piece of the most refined truth . . . but, to my mind, one of the highest pieces of intellectual art existing'.

Butlin and Joll compare this painting and its companion (see below) with the pair of Tabley House exhibited at the RA in 1809 (pp61–2, cat nos 98, 99), and the two views of William Moffatt's house at Mortlake exhibited at the RA in 1826 and 1827 (pp130, 133, cat nos 235, 239), which they note as anticipating the present work in that 'although the exhibited titles give prominence to "East Cowes Castle", the castle itself plays an extremely minor role in the finished compositions'. They also draw attention to the figures just discernible in the background, which are sketched in the manner of Watteau, as in the 1822 painting 'What You Will!'

The companion painting 'East Cowes Castle, the Seat of J Nash, Esq.; the Regatta Beating to Windward', also exhibited at the RA in 1828, is now in the Indianapolis Museum of Art, Indiana (see Butlin and Joll p135, cat no 242, repr pl 262). Preparatory oil sketches made on his visit to Cowes are in the Tate Gallery (Butlin and Joll pp142–5, cat nos 260–8); three relate to the present work, and Reynolds suggests two were painted directly on the spot. There is a small (33.1 × 49.2 cm/13 × 19⅜ ins) picture, 'Yachting at Cowes', in the Auckland City Art Gallery, New Zealand, supposedly signed and dated 1835, with a similar composition; Butlin and Joll doubt its authenticity (repr *Connoisseur* March 1959, p91).

Reynolds deals at length with the physical condition of the present work.

PROV: Painted for John Nash; his sale, Christie's 11 July 1835 (87), bought Tiffin acting as agent for John Sheepshanks; given by him to the museum 1857

ExH: RA 1828 (152)

LIT: G Reynolds 'Turner at East Cowes Castle' *V&A Museum Yearbook* I, 1969, pp67–79; *Butlin and Joll* pp135–6 (cat no 243, repr pl 263)

**Life-Boat and Manby Apparatus Going off to a Stranded Vessel Making Signal (Blue Lights) of Distress**
FA211    Negs GE1980, CT3481
Canvas, 91.4 × 122 cm (36 × 48 ins)
Sheepshanks Gift 1857

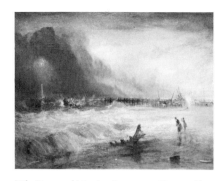

*Life-Boat and Manby Apparatus Going off to a Stranded Vessel Making Signal (Blue Lights) of Distress*    FA211

Like 'East Cowes Castle' (FA120, p284), painted for the architect John Nash, or perhaps bought at the RA where it was exhibited in 1831 (see Butlin and Joll). In the first Sheepshanks Catalogue and later catalogues, the title was given not as in the RA catalogue and above, but as 'Vessel in Distress off Yarmouth'. Although Turner's title does not specifically cite Yarmouth, the location has never been doubted.

The Manby apparatus, named after its inventor George Manby (1765–1854), was a method of lifesaving from a shipwreck by firing a stone at the end of a rope from a mortar on the shore, and was developed after he witnessed a disastrous wreck at Great Yarmouth, Norfolk, in 1807. The marine painter Nicholas Pocock exhibited 'Captain Manby's Methods of Giving Relief to a Ship in Distress' at the RA in 1815 (presumably the work now in the Castle Museum, Norwich); there is also a watercolour of 1811 in the National Maritime Museum (see D Cordingly *Nicholas Pocock* 1986, pp96, 108). Turner passed the Norfolk coast on his way to Scotland in 1822, and visited Yarmouth in 1824. Butlin and Joll refer to the 'Norfolk, Suffolk and Essex' sketchbook (British Museum, Turner Bequest CCIX), and two watercolours also in the British Museum (CCLXII–10 and CCCLXIV–134); Reynolds suggests that the latter work, 'Firing Rockets at Yarmouth', is a study for the present painting, but Butlin and Joll express doubt on the grounds that the handling of paint is so loose that it could well date from after 1831.

The *Library of the Fine Arts* critic (1 June 1831) thought it 'a magnificent picture, warm and all life', and *La Belle Assemblée* (xiii, p289) called it 'a fine picture, full of nature and truth, and more in his manner of the older time, than anything we have seen of late'. Reynolds comments that this greater conventionality in Turner's art in this work would have appealed to its eventual owner Sheepshanks. E B Chancellor in 1910 (*Walks among London's Pictures*, p263) wrote:

> 'Waagen remarks on it that it is "very spiritedly conceived, but the water very conventional". One hesitates to fall foul of so great a critic, but he seems, in this instance, to be less sympathetic in his judgement than the beauty and vigour of the picture deserve, and I confess the rendering of the sky and sea appears to me to reach as high a level as almost anything Turner ever produced.

John Constable also exhibited a painting of 'Yarmouth Pier' at the RA in 1831 (123, present whereabouts unknown; among other versions of the subject is a painting in a private collection dated 1822: see G Reynolds *The Later Paintings and Drawings of John Constable* 1984, cat nos 22, 36, pl 362). Butlin and Joll comment that 'This may have been simply a coincidence but it seems possible that Turner, having got wind of Constable's plans, decided to exhibit this picture by way of competition'. Reynolds also compares the present work with the later 'Rockets and Blue Lights . . .' of 1840 (now Sterling and Francine Clark Art Institute, Williamstown, Massachusetts).

PROV:   Painted for, or bought by, John Nash 1831; his sale, Christie's 11 July 1835 (89, as 'Blue Lights off Yarmouth'), bought Tiffin presumably acting as agent for John Sheepshanks; given by him to the museum 1857

EXH:    RA 1831 (73); *British Art c1000–1860* RA 1934 (161); *RA Bicentenary exhibition* RA 1968–9 (163); *William Turner* Nationalgalerie Staatliche Museen Preussischer Kulturbesitz, Berlin, 1972 (16); *Impressionism: its masters, its precursors and its influence in*

*Britain* RA 1974 (21); *Turner* RA 1974–5 (509); *Turner* Hermitage Museum, Leningrad, and Pushkin Museum, Moscow, 1975–6 (58)

ENGR:     R Brandard, in the *Turner Gallery* 1859, and *Art Journal* 1863, facing p116

LIT:      G Reynolds 'Turner at East Cowes Castle', *V&A Museum Yearbook* I, 1969, pp75–9; *Butlin and Joll* pp171–2 (cat no 336, repr pl 325)

# UWINS, Thomas, RA (1782–1857)

Born Pentonville, London, 24 February 1782, son of a Bank of England clerk. Apprenticed to the engraver Benjamin Smith 1797, entered RA Schools 1798. Worked first as watercolourist, miniature and portrait painter, and book illustrator, including 'Fashions' for Ackermann's *Repository*. Visited France 1817, lived in Scotland 1820–1823/4 and Italy 1824–31, specialising on his return in Italian genre scenes. Exhibited 103 works at the RA between 1803 and 1857, 37 at the BI 1829–53, 13, mainly watercolours, at the SBA 1824–33/4, and at the Old and New Watercolour Societies. Elected Associate of OWS 1809, Member 1810, Secretary 1813, 1817, 1818, resigned 1818; ARA 1833, RA 1838 (the first Diploma signed by Queen Victoria), Librarian 1844. Appointed Surveyor of Queen's Pictures 1845, Keeper of the NG 1847 (resigned from both 1855). Died Staines, Middlesex, 26 August 1857; his studio sale was at Christie's 3–4 June 1858.

LIT:      *Art Union* 1845, p54, 1847, p312 (with engr portrait); *Art Journal* 1857, pp315–6 (obit); Mrs Uwins *A Memoir of Thomas Uwins R.A. . . .* 2 vols, 1858 (reprinted with introduction by R Hamlyn 1978)

*Suspicion*   FA212

**Suspicion**
FA212    Neg V1932
Panel, 41.9 × 57.2 cm (16½ × 22½ ins)
Signed and dated 'T. Uwins. R.A./1848.' on the back, perhaps in the artist's hand
Sheepshanks Gift 1857

Exhibited at the BI in 1848, the size given in the catalogue as 25 by 31 inches (presumably including frame), with the following quotation from the *Storia della Casa Atenolfi*:

> Poor Rosa! To relieve the solitude of the villa she would have her chair taken out on the terrace, where she would sit for hours listening to the music of a wandering minstrel: even this pleasure was at last denied her. *Donna Chiara* the old *monaca di casa* took it into her wise head that the minstrel was a lover in disguise'

The *Athenaeum* critic thought it:

> One of those Italian *costumi* subjects for which his long sojourn in the South has so peculiarly fitted him. The lady on the terrace, listening to the softening strains of the itinerant minstrel, is designed with much sweetness. The power of his art has affected her to so entire an absorption that she sees not the suspicion entertained by her duena, the *monaca di casa*, that the performer may be a lover in disguise. The story was a good one for the canvas – and worthy of a more extended scale. Mr Uwins has given the gay look of the climate; and the look-out on the Campagna, with the sparkling fountain, awakens pleasant memories to those who have lingered amid such scenes'

The *Art Union* found the subject

> Reads upon the canvas not less perspicuously than in the text. The duenna-like figure amply expresses her suspicion, and this is the key to the story. Like all the works of Mr Uwins, it is full of fine and delicate feeling, and a pure appreciation of truth; the lady is beautifully painted; it is an exquisite study, to which all the accessories respond.

'The Minstrel', described in the catalogue as 'the finished study for the picture in the Collection of J Sheepshanks, Esq', was in the artist's studio sale at Christie's 3 June 1858 (141).

Exh: BI 1848 (20); *Victorian Narrative Paintings* V&A Circulation exhibition 1961

Lit: *Art Union* 1848, p81; *Athenaeum* 12 February 1848, p168

## An Italian Mother Teaching her Child the Tarantella

FA213   Neg J839
Panel, the painted surface has rounded top corners, 43.5 × 55.9 cm (17⅛ × 22 ins)
Signed and dated 'Thos, Uwins, R.A./1842' on the back, and inscribed as below
Sheepshanks Gift 1857
Presumably the work exhibited at the RA in 1842 with the title 'The Lesson' with a description of the subject appended to that title in the catalogue:

*An Italian Mother Teaching her Child the Tarantella*   FA213

> 'The cottage stood on the brow of a rock that overhung the Gulf of Salerno. The family of the vine-dresser were out on the loggia. It was a *festa* day. They had attended divine service at the convent chapel: had returned to their frugal dinner, and in the fulness of cheerful enjoyment the mother was teaching her child the steps of the *tarantella*, while the grandmother touched the tambourine, and the father looked on delighted. In a corner, a shepherd was telling his tale to a young girl, who was perhaps a relation or servant of the family'

This detailed description, which would have been provided by the artist, suggests that he might have witnessed the scene depicted.

The *Art Union* critic commented in 1842 that the work was 'One of the beautiful Italian subjects whence Mr Uwins has raised for himself an enduring fame . . . highly successful in character and expression; it manifests a fine feeling for nature – happy nature, in its rich and full and pure enjoyment; and is remarkable for excellent qualities as a production of Art . . .'. The *Athenaeum* criticised the Italian subject:

> The group is pretty: a Tarantella, with its bystanders. The subject, however, is now hackneyed. Seducing as are Italian costume and countenance, we cannot but ask our artists whether they have not been sufficiently painted. Who knows anything of the figures and groups, and various dresses which animate our Welsh market-places? in all of which the poetry of a most poetical peasantry finds more or less evidently an expression?

Uwins exhibited a very similar subject at the RA the following year, with the title 'A Festa Day' (subtitled 'one of the earliest lessons a Neapolitan child is taught by its mother is how to dance the Tarantella') exhibited at the RA the following year. This was also described in the *Art Union*:

> A family of some half-dozen Neapolitan peasants are keeping the *festa* under the grateful shade of a vine arbour, which is open to the seabreeze. The principal actors are a mother and her child, the former teaching the latter to dance the universal tarantella, while the father, grandmother, and others applaud the talent of the infant votaress of Terpsichore. This

Belphoebe in the *Faerie Queene*'. He was evidently disappointed with the reception given to the finished picture; in a letter to John Townshend of 1 January 1850 (quoted in the *Memoir* p123) he wrote 'I am now engaged on a picture from Homer, which will fail as completely as the one from Spenser'. He continued on 14 January (*Memoir* pp124–5):

> You are right, my dear sir, about Spenser. Nobody reads him but the artist; and the artist finds the 'Faery Queen' so full of the combinations which lend themselves to painting, that he loses his chance of pleasing the public in the love of pleasing himself. It was in this view that I spoke of my poor *Sir Guyon* as a failure. When the picture was at the Royal Academy people passed by it as if it was so much blank wall, and went on to a mountain scene, which to my feelings was full of nothingness . . . Poetry is too slow a thing for a fast generation . . .

Although the *Art Journal* critic (1849, p169) thought 'every part of the composition abounds with pointed narrative', the painting remained unsold and was included in the studio sale (150, as 'The Bower of Bliss'). A signed pencil drawing of the same subject but differently composed was exhibited at The Gallery Downstairs 1989 (U89).

PROV: Sold Christie's 3 June 1858 (140, 'A finished study, on panel, for the picture of Sir Guyon'); purchased from Hogarth & Sons, Great Portland Street, for £21 in 1875

---

# VINCENT, George (1796–c1836)

Born Norwich 1796 (baptised 27 June), son of a weaver. Pupil of John Crome. Exhibited at Norwich 1811–23; exhibited nine works at the RA between 1814 and 1823, 41 at the BI 1815–31, and 12 at the SBA 1824–35. Moved to London 1818; was imprisoned for debt 1824. There are several etchings by him in the British Museum, and three, and a mezzotint, in the V&A collections.

LIT: Redgrave *Dict*; M Grant *Old English Landscape Painters* II, 1925, p339

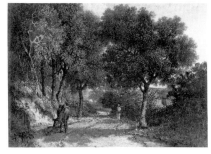

*A Shady Country Road*  20-1888

### A Shady Country Road
20-1888   Neg HF962
Canvas, 20.3 × 25.7 cm (8 × 10⅛ ins)
Purchased 1888

According to Grant, the painting is a copy, but the whereabouts of an original by Vincent are not known. According to Dr Miklos Rajnai, it is certainly not by Vincent, and probably not the work of any member of the Norwich School.

### Landscape
1828-1900   Neg HF961
Canvas, 22.2 × 32.2 cm (8¾ × 12¹¹⁄₁₆ ins)
H S Ashbee Bequest 1900

The composition greatly resembles a work in the Nottingham Castle Museum which is dated 1828 (repr Grant (see above) pl 200). According to Dr Miklos Rajnai, the present work is a fine early example by Vincent.

# WALLIS, George, FSA (1811–1891)

Born Wolverhampton, Staffordshire, 8 June 1811, trained as a coach and heraldic painter before practising as an artist in Manchester 1832–7. Entered Government School of Design 1841; headmaster of Schools of Art at Spitalfields 1843, Manchester 1844 and Birmingham 1851. Organised first exhibition in England of art manufactures at Royal Institution, Manchester, and gave first course of lectures on principles of decorative art 1845. Worked on Great Exhibition 1851 and International Exhibition 1862. Visited USA 1853. Appointed to South Kensington Museum 1858, Keeper of Art 1863, retiring a month before he died; promoted the circulation of works of art from South Kensington to provincial museums. Contributed to the *Art Journal*, lectured extensively, and published several books, from *On the Cultivation of a Popular Taste in the Fine Arts* (1839) to *British Art, Pictorial, Decorative, and Industrial: a Fifty Years' Retrospect* (1882). Elected FSA 1878. The catalogue of the 1919 exhibition of his paintings states that he exhibited at the RA and BI; he may be the G Wallis whose only exhibit was a 'View of Cardigan Bay' at the RA in 1872 (several Welsh scenes were in the 1919 show). Died Wimbledon, London, 24 October 1891; his daughter Rosa was a flower and watercolour painter, his sons George H and Sir Whitworth Wallis were directors of the Bethnal Green Museum and then (respectively) the Nottingham and Birmingham Museums. His studio sale was at Christie's 22 February 1892. His portrait by Alphonse Legros is in the V&A collections (896-1892), as is an etched self-portrait (E5750-1906).

LIT:     *Art Journal* 1891, p384 (obit with portrait); *Magazine of Art XV*, December 1891, p69 (obit with portrait); *Catalogue of Works by the late George Wallis . . .* exhibition catalogue with biographical introduction, Municipal Art Gallery and Museum, Wolverhampton, 1919

### A Study of Flowers
664-1891    Neg GA1201
Canvas, 48.2 × 35.5 cm (19 × 14 ins)
Signed and dated 'G/Wallis/1846' br
Purchased 1891

Presumably purchased in the year of his death to commemorate the artist's long association with the South Kensington Museum, it had possibly been painted for teaching and demonstration purposes. The artist's studio sale included a copy after a 17th-century still-life, and two flower pieces by the Mutrie sisters.

EXH:     *Works by the late George Wallis . . .* Municipal Art Gallery and Museum, Wolverhampton, 1919(8)

### The Great Exhibition of all Nations, 1851
1453-1903    Neg GA1202
Canvas, 18.7 × 61 cm (7⅜ × 24 ins)
Signed and dated 'G/Wallis/1851' br
Given by the Misses Kate and Rosa Wallis (the artist's daughters) 1903

Wallis was a Superintendent of the Great Exhibition (in charge of class B, woven textiles), and deputy commissioner of juries for textiles. The view of the Crystal Palace in Hyde Park is possibly taken from a contemporary print, of which there were many (see, for example, the view reproduced in H Hobhouse *Prince Albert: His Life and Work* 1983, fig 94, p100). The view is from the junction of Exhibition Road, and gives a vivid impression of the length of the building.

*A Study of Flowers    664-1891*

*The Great Exhibition of All Nations, 1851    1453-1903*

*The Old Plane Tree   457-1906*

**The Old Plane Tree**
457-1906   Neg 78948
Canvas, 37.1 × 72.6 cm (14⅝ × 28⅝ ins)
Signed and dated 'George Wallis. 1887.' br
Given by the Misses Kate and Rosa Wallis (the artist's daughters) 1906

The view is towards the south, looking from the Library block, before Aston Webb's new museum building of 1899–1909. The great plane tree was on the site of the present room 43. Wallis made an etching of the composition, evidently also in 1887 (impr in the V&A collections, E5752-1906), and there is a photograph of the tree from the opposite direction of about 1890; both are illustrated by John Physick, *The Victoria and Albert Museum: the history of its building* 1982, p174, figs 203, 204).

# WALLIS, Henry (1830–1916)

Born Henry Thomas, London, 21 February 1830, adopted his stepfather's surname 1845 (from whom he inherited considerable property 1859). Studied at Cary's Academy and entered RA Schools 1848. According to *Who's Who*, also studied with M G Gleyre and at the Académie des Beaux Arts, Paris. Exhibited 35 works at the RA between 1854 and 1877, one at the BI in 1854, and five at the SBA 1854–5 and 1876–7. Also exhibited at the OWS, elected Associate 1870 and Member 1880. Most popular in the 1850s, working in the Pre-Raphaelite style, and particularly for 'The Death of Chatterton' (1856, Tate Gallery). Travelled to Italy, Sicily, Egypt and elsewhere, and collected ceramics, publishing several books and pamphlets on Persian and Italian ceramics 1885–1907. Died Croydon, Surrey, 20 December 1916.

LIT:   *Burlington Magazine* xxx, 1917, pp123–4 (obit); A Van ne Put 'Henry Wallis 1830–1916', *Faenza* V, p 2, 1917 (obit, concerning ceramics); *The Pre-Raphaelites* Tate Gallery exhibition catalogue 1984, p40

*Shakespeare's House, Stratford-upon-Avon   F38*

**Shakespeare's House, Stratford-upon-Avon**
F38   Neg 53591
Canvas, 65.5 × 49.5 cm (25¾ × 19½ ins)
Forster Bequest 1876

Painted by Wallis as a straightforward view of the staircase leading up to the room where Shakespeare is supposed to have been born, it was exhibited at the RA in 1854 and presumably bought there by Forster (although he may have commissioned it – see below). Later, in 1866, Forster accepted Sir Edwin Landseer's offer to make additions of 'memorials of the marvellous man himself'. The *Art Journal* critic noted of Wallis's work: 'This is a daring attempt at a picture: the result is, however, the having invested with an interest, independent of the association of the "Swan of Avon", a portion of a ricketty old staircase, very ingenious in design. But really the lighted surfaces and the shades are described with singular truth'.

Landseer's role is described in a letter Forster wrote to him when the picture was exhibited in 1867 at the RSA:

> Who can explain so well as myself the coupling of another name with your own in the picture of Shakespeare's House you are sending to the Edinburgh Academy?
> The picture in its first state – then an ancient stone staircase wonderfully painted by Mr H Wallis, the painter subsequently of the Death of Chatterton, – was purchased by me fourteen or fifteen years ago. You had often said, as you saw it in my dining-room, that you'd like some day to put something from your own hand into it; and last summer, generously

indulging my earnest wish to possess some memorial of our thirty years of uninterrupted friendship, you desired me to send this particular picture to you. That the staircase as represented had been copied from Shakespeare's House at Stratford-on-Avon, you did not then know, or had forgotten.

After no longer interval I saw in your painting-room, not what had been familiar to me for so many years, but what the Edinburgh Academy will now see. My little picture has been translated indeed – Bully Bottom himself not more completely, only that here the transformation was not from the higher to the lower, but from the lower to the higher life, and the promise of Titania had been really kept –

'For I will purge thy mortal grossness so,
That thou shalt like an airy spirit go'.

Finding, when the picture reached you, whose house it was the staircase belonged to, it had been your fancy to bring about us memorials of the marvellous man himself, – his dog waiting for him at the door, as to imply his own immediate neighbourhood; and objects so connecting themselves with his pursuits, and even pointing at the origin of familiar lines and fancies, as almost to indicate and identify the Play with which his brain might have been busy at the time.

How delightfully this has been done, every one can see for himself; and I have only to add, my dear Landseer, how gratefully I am, your old friend, John Forster.

The letter is dated 2 February 1867, and was published in the RSA exhibition catalogue.

Forster first visited Stratford-upon-Avon and Shakespeare's birthplace there with Daniel Maclise and Charles Dickens in 1840, and in the early 1850s, as chairman of the London committee of the Royal Shakespearian Club, was instrumental in securing the birthplace property for the nation; he corrected and edited the third of Alexander Dyce's editions of Shakespeare's *Works*, and among the many editions of the *Works* in his collection was a First Folio. Consequently he may well have commissioned the present work from Wallis. The artist also exhibited at the RA in 1854 two other Shakespeare subjects: 'The Font in which Shakespeare was Christened' and 'The Room in which Shakespeare was Born'. At the BI in 1854 he exhibited 'The Parlour in Anne Hathaway's Cottage, Stratford on Avon', the price given as five guineas. Wallis's Pre-Raphaelite interest in depicting the actual locations of historical events continued, not least in his most famous work 'The Death of Chatterton' (1856, Tate Gallery; but see also the Tate exhibition catalogue *The Pre-Raphaelites* 1984, pp142–3).

Landseer wrote to Forster on 4 April 1866, reminding him of Wallis's picture 'in which I have a fancy to introduce a something that may be acceptable to you. Bring the Picture with you tomorrow at 4 Oc'. When he realised the location of the staircase, he wrote again to Forster that his

> Value for truth cannot do that which was rather suggested to my fancy when first I noticed the work at your house. It is possible that you may . . .[?] the entrance to that almighty man's home that you would not like a step of the staircase hid, before I venture on my little embellishments I think it due to you to ask your pleasure? – I can do – something that may – rather indicate that the [illegible, presumably referring to Shakespeare] is just about to return to his Studio – you can give the verdict tomorrow' (letters from Forster Collection, National Art Library, V&A).

Landseer had almost completed the additions by August 1866, when he went to France. From Boulogne, he wrote to Forster in September: 'If we don't meet you can have the little Picture suggestive of the Gt Bard's home – I will leave it with Hull who will take it to you – on my return – or whenever I am fit for service you can let me have it again for a final touching'.

Richard Ormond has suggested (unpublished notes on museum files) that

'the finished picture illustrates Landseer's gift of being able to suggest an atmosphere, to create a mystery, with the simplest means'. Landseer has added a terrier at the door apparently sensing someone's (Shakespeare's?) arrival; this is a device similar to that in the 1834 'Suspense', also in the V&A collections. Also added are a breast-plate and round Scottish shield (a reference to *Macbeth*?), a glove, a dead heron, hawks' hoods on the ledge, a skull and spade (*Hamlet*?), and a rat (traditionally a symbol of decay) eyeing a clasped book.

Dr Levi Fox, Director of the Shakespeare Birthplace Trust, confirms that Wallis's depiction is remarkably accurate and remains unchanged today. The view is of the original staircase leading from the first floor back room (originally one of the bedrooms) to the attic floor above the front part of the house; the doorway on the left leads to the front bedroom, which from the 18th century has been traditionally identified as where Shakespeare was born on 23 April 1564.

Exh:    RA 1854 (267); SBA 1854 (69); RSA 1867 (513)

---

# WARD, Edward Matthew, RA (1816–1879)

Born Pimlico, London, 14 July 1816, son of a bank clerk. Studied with John Cawse, entered RA Schools 1835. Studied in Rome in studio of neoclassicist Filippo Agricola 1836–9, visiting Paris, Venice, and studying fresco painting with Peter Cornelius in Munich. Won prize in Westminster Hall competition 1843, commissioned to paint corridor in House of Commons 1853. Exhibited 86 works at the RA between 1834 and 1877, 16 at the BI 1834–43, and 11 at the SBA 1835–77. Subjects mostly historical and literary, particularly 17th-century English and late 18th-century French. Elected ARA 1846, RA 1855. Popular and much admired, several of his works were engraved. Died Windsor, Berkshire, 15 January 1879; his studio sale was at Christie's 29 March 1879. His wife Henrietta Ward, of the other, more famous, Ward family, was also an historical painter; their five children were artists, notably Sir Leslie Ward, the caricaturist 'Spy'.

Lit:    *Art Union* 1847, p260; *Illustrated London News*, xxvi, 31 March 1855, pp301–2 (engr portrait); *Art Journal* 1855, pp45–8; *Magazine of Art* 1878, p18; *The Times* 17, 18, 19 January 1879 (obit); *Athenaeum* 25 January 1879, pp128–9 (obit); *Art Journal* 1879, pp72–3, 84 (obit with engr portrait); J Dafforne *The Life and Works of E M Ward* 1879; ed E O'Donnell *Mrs E M Ward's Reminiscences* 1911

**'Fiammingo' (Francois Duquesnoy)**
29-1873
Canvas, 255.2 × 88.9 cm (104½ × 35 ins)
Inscribed 'E.M.WARD R.A.' br
Transferred from Works to Department of Paintings 1921

For details of the history and circumstances of the commission see under Richard Burchett 1762–1869, p.14; Ward offered his services to Henry Cole, but the present design does not seem to have been translated into mosaic (see J Physick *The Victoria and Albert Museum: the history of its building* 1982, p62).

Francois Duquesnoy (1597–1643), known as 'il Fiammingo', the Fleming, was with Algardi and Bernini among the greatest Baroque sculptors in Europe. The Baroque style was for the most part unacceptable to 19th-century British taste, perhaps because of its association with Roman Catholicism and particularly the Counter-Reformation. The only representatives of the Baroque in the Kensington 'Valhalla' are Sir

Christopher Wren and Grinling Gibbons. Ward's choice of artist may have resulted in the rejection of his design.

Duquesnoy is shown unveiling one of his sculptures, a pair of boy angels, presumably a work in clay to judge from the modelling tool he holds. The work is of a type for which he was famous: as Wittkower states 'it was Duquesnoy's conception of the bambino that became a general European property' (R Wittkower *Art and Architecture in Italy 1600–1750* 1973, p179). The specific source here has not been identified. The image of the sculptor himself is probably taken from Van Dyck's portrait of about 1622 in the Musées Royaux des Beaux Arts, Brussels (repr pl 1 in M Fransolet *Francois du Quesnoy* 1942, and in E Larsen *Van Dyck 1613–1626* 1980, no 384); the portrait had been engraved.

## Charles II and Nell Gwyn
528-1882
Canvas, 34.8 × 29.8 cm (13¾ × 11¾ ins)
Signed and dated 'E M Ward/1854' on wall bl
Jones Bequest 1882

Among several paintings illustrating episodes from the life of King Charles II, one of Ward's favourite subjects, was 'Interview between Charles II and Nell Gwynne, as witnessed by Evelyn' exhibited at the RA in 1848 (587). The RA catalogue appended a quotation from John Evelyn's famous diary for 1 March 1671:

> I thence walked with him through St James's Park to the garden, where I both saw and heard a very familiar discourse between [the King] and Mrs Nelly, as they called an impudent comedian, she looking out of her garden on a terrace at the top of the wall, and [the King] standing on the green walk under it. I was heartily sorry at this scene . . .

According to the *Art Journal* (1855, p46), the RA painting was bought by the collector John Gibbons; it does not appear in any of the posthumous sales of his collection. The museum files refer to a larger version of the subject, different in certain details to the present work, in a Gibbons family collection; its present whereabouts are unknown. The present work is presumably a smaller version of the RA exhibit. An almost identical version was sold at Christie's New York 19 May 1987 (101, signed and dated 1859, 92.3 × 73 cm).

PROV: ?Sold Christie's 22 June 1867 (111), bought Bourne £26 5s, probably for John Jones (he also bought lot 96, Frith's sketch for 'Measuring Heights', also later in the Jones Bequest, 511-1882)

## John Forster in his Study
P74-1935   Neg R2855
Canvas, 63.5 × 76.1 cm (25 × 30 ins)
Purchased 1935

On the back of the stretcher a manuscript label reads 'John Forster in his study – painted by – Ward R.A for himself: bought by Mr Forster – finished later by Mr Downard'. It is not known in what circumstances Ebenezer Newman Downard (exhibiting 1849–89) came to finish the portrait. For fuller details of the sitter, see Daniel Maclise's portrait (P35-1935, p184). Ward was involved with Forster and Charles Dickens in the dramatic performances in aid of the Guild of Literature and Art (see R Renton *John Forster and His Friendships* 1912, pp70–1) in the years around 1850. The present portrait probably dates from about the same time. Between 1834 and 1856 Forster lived at 58 Lincoln's Inn Fields.

*John Forster in his Study*   P74-1935

The larger of the two paintings on the wall behind the sitter is the copy formerly ascribed to Sir Thomas Lawrence of Van Dyck's 'Earl of Strafford and His Secretary', included in the Forster bequest to the museum (F19). Forster's 'metamorphic' library chair, which converts into steps, dates from 1811 and was discussed in *Country Life* (20 September 1920, pxxxiv). The portrait bust on the right has not been identified; it does not seem to represent Dickens, but could be Thackeray (compare the broad nose with, for example Frank Stone's portrait of about 1839 in the NPG).

In a letter to Forster in 1856, Lord Lytton recorded 'Ah, those memories of Lincoln's Inn Fields . . . You with your strong forehead bowed over that relentless *Examiner* [of which Forster was editor from 1847 to 1856] table . . . Macready glaring at you across the witch's cauldron, and Dolly Varden holding her pretty sides and laughing behind you' (quoted by Lady Betty Balfour *Personal and Literary Letters of Robert first Earl of Lytton* 2 vols, 1906). For the latter painting, see under Frith (F8); the former is presumably Maclise's portrait of Macready as Werner (F21).

Ward also painted portraits of Dickens in his study (1854), and of another member of the group, Maclise (1856); he seems to have specialised in such 'study' portraits, and other exhibited examples include Thorwaldsen (1841), Thackeray (1844), Macaulay (1853), Lord Lytton (1854), and Hallam (1858).

PROV:  By descent to Miss Fanny Crosbie (John Forster's niece); bought from Charles J Sawyer Ltd (with 75-1935, anonymous miniature portrait of Forster) £40

EXH:  *Charles Dickens* Victoria and Albert Museum 1970 (D15)

# WATTS, Frederick Waters (1800–1862)

Born 7 October 1800, perhaps in Bath, Somerset. Probably entered RA Schools (a William Watts of the same age is recorded winning medals 1819–21). Exhibited 76 works at the RA between 1821 and 1860, 108 at the BI 1823–62, and 71 at the SBA 1825–38; almost all were landscapes in England, Scotland and Wales, and two Rouen subjects. Based his style closely on Constable and, like him, lived in Hampstead, London. Full-size paintings and oil sketches frequently have been confused with Constable's work, even in their lifetimes, particularly when the subjects are similar. Died Hampstead 4 July 1870.

LIT:  C R Leslie *Memoirs of the Life of John Constable* ed A Shirley 1937, pplxxxiii-iv; *Constable* Tate Gallery exhibition catalogue 1976, pp193–4; I Fleming-Williams and L Parris *The Discovery of Constable* 1984, pp205–11

*On the Wye*   262-1866

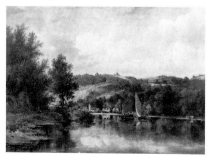

### On the Wye
262-1866   Neg 70948
Canvas, 85.1 × 118.4 cm (33½ × 46½ ins)
Purchased 1866

Watts exhibited several scenes on the river Wye: five at the RA between 1828 and 1848, three at the BI 1824–34, and two at the SBA in 1831 and 1834. The landscape around the river from central Wales to the Severn estuary provided his favourite subjects. The exact location of the present scene has not been identified.

# WEBSTER, Thomas, RA (1800–1886)

Born Pimlico, London, 20 March 1800, son of a member of staff of the Royal Household. Chorister in Chapel Royal, entered RA Schools 1821, winning gold medal 1824. In a long and successful career, exhibited 83 works at the RA between 1823 and 1879, 39 at the BI 1824–44, and eight at the SBA 1825–34. Early pictures were portraits and historical subjects, but following success of 'Rebels Shooting a Prisoner' (showing children at play) 1827, specialised in similar scenes, and of school and village life, comparable to those of Wilkie and Mulready. Influential and much admired, they became popular through engravings. Elected ARA 1840, RA 1846, and Honorary Retired RA 1876.

Contributed illustrations to the Etching Club's 'Deserted Village', 'Songs of Shakespeare' and 'Etch'd Thoughts' (1841–4). Moved to Cranbrook, Kent, 1856; senior member of the Cranbrook Colony of painters. Died Cranbrook 23 September 1886; his studio sale was at Christie's 21 May 1887.

LIT:   *Art Journal* 1855, pp293–6, 1862, p138, 1866, pp40, 330, 1886 pp351–2 (obit); *Athenaeum* 2 October 1886, p439 (obit); *The Times* 24 September 1886 (obit); *DNB*

*Sickness and Health*   FA219

## Sickness and Health

FA219   Neg GD2814
Panel, 50.7 × 81 cm (20 × 32 ins)
Signed and dated 'T. Webster./1843' br
Sheepshanks Gift 1857

Painted for John Sheepshanks and exhibited at the RA in 1843 with the quotation 'The cheerfulness of innocence serves to mitigate distress' from Wordsworth appended to the title in the catalogue.

The *Athenaeum* critic thought it 'a simple subject, treated with infinite grace and pathos, and also carefully painted', while the *Art Union* described the subject at greater length, concluding that 'the children are most successfully pictured, and the organ-boy is a perfect specimen of his class. Altogether, it is one of the most effective and interesting pictures in the collection, fully sustaining, if indeed it does not increase, the high reputation of this excellent artist'. Waagen, in 1854, found 'the execution in some parts is wanting in vigour'.

A 'sketch of Sickness and Health' was sold at Christie's 4 June 1850 (104), bought Birt £50 8s; perhaps the same work was sold as the original study by Sam Mendel at Christie's 24 April 1875 (398, 15.2 × 25.4 cm/6 × 10 ins), bought the dealer Agnew £241 10s; sold by Charles Skipper at Christie's 24 May 1884 (102, 16.5 × 26.7 cm/6¼ × 10½ ins), bought Rendel £53 11s. A picture catalogued as 'English School – A Village Merrymaking', signed and dated 1851, was sold at Willis's Rooms 25 January 1923, and is recorded on the Departmental files as a copy of the present work. Another copy was sold at Christie's 5 June 1987 (114, 55.8 × 86.3 (22 × 34 ins), catalogued as 'The hurdy-gurdy man' and 'English School, 19th century'.

EXH:   RA 1843 (128)

ENGR:   W Finden (impr in V&A collections, 1885)

LIT:   *Athenaeum* 27 May 1843, p512; *Art Union* 1843, p164; G Waagen *Treasures of Art in Great Britain* 1854 II, p300

*Going to the Fair*   FA220

**Going to the Fair**
FA220   Neg 62894
Panel, 55.9 × 76.1 cm (22 × 30 ins)
Signed and dated 'T Webster/1837.' on stool br
Sheepshanks Gift 1857

With its companion 'Returning from the Fair' (see FA221, below) painted for a Mr Flood, and exhibited at the BI in 1838, its size including frame given as 35 by 43 inches in the catalogue. The critic of the *Examiner* thought 'Mr Webster never painted anything better . . . it is a sketch true to nature, firmly painted and full of character'. What seems to be another version was sold at Christie's 9 July 1887 (67), bought Tooth £27 6s.

Exh:   BI 1838 (41)

Lit:   *Examiner* 1838, p102; G Waagen *Treasures of Art in Great Britain* 1854 II, p302; *Sheepshanks Gallery*

**Returning from the Fair**
FA221   Negs HE4630, 59102, CT14379
Panel, 55.9 × 76.1 cm (22 × 30 ins)
Signed and dated 'T Webster. 1837.' br
Sheepshanks Gift 1857

With its companion 'Going to the Fair' (see FA220, above) painted for a Mr Flood, and exhibited at the BI in 1838. It shows the same family, with the addition of a young man the eldest daughter seems to have brought home; particularly well observed is the youngest child – eager to be first out of the house but tiredly returning last. The device of 'before and after' pairs of paintings became increasingly popular with 19th-century genre artists such as Abraham Solomon ('First Class – the Meeting' and 'Second Class – the Parting' (RA 1854), and 'Waiting for the Verdict' (RA 1857) and 'Not Guilty' (RA 1859)). Webster exhibited a different composition with the same title at the RA 1837 (276; sold Sotheby's Belgravia 29 June 1976, 61 × 50.5 cm (24 × 19¾ ins), dated 1836).

Exh:   BI 1838 (30)

Lit:   G Waagen *Treasures of Art in Great Britain* 1854 II, p302; *Sheepshanks Gallery*

**A Village Choir**
FA222   Neg HB1252
Panel, 60.4 × 91.5 cm (23¾ × 36 ins)
Sheepshanks Gift 1857

Painted for John Sheepshanks, exhibited at the RA in 1847, and probably the artist's most famous work.

A pen and ink sketch inscribed 'first idea' is in the Jupp annotated and illustrated RA catalogues (in the RA Library); five chalk studies for heads are in the V&A collections (also Sheepshanks Gift, FA92, 206–8, 210). The subject is set in the old west gallery of the church of All Saints, Bow Brickhill, near Bletchley, Buckinghamshire, (the choir balcony no longer exists), although the accuracy of Webster's depiction of the setting was questioned in an article by J Wyness (*The North Buckinghamshire Times* 12 December 1933); there are further notes on this matter on the Departmental files. Webster stayed for a time with (probably) his sister in the nearby village of Little Brickhill, and supposedly made studies in the area. It also seems that his sister supervised the Sunday School there, and the girls in the painting conform to contemporary rules concerning dress for church (no jewellery, for example). Identifications of the figures have been suggested: the clarinettist was 'Old Tooth', possibly a blacksmith, and/or a Mr Wooton; the figure on his left was a Mr Kent; and the name 'Jane Wyatt' is inscribed in pencil on

the unpainted margin at the bottom of the panel (concealed by the frame) under the figure of the girl on the conductor's right. The granddaughter of the taller of the boys on the conductor's left wrote to the V&A in 1960 identifying them as William (1837–1914) and James Byway. There is also a tradition (noted by W Harvey *Thomas Clark of Canterbury (1775–1859)* Whitstable 1983, p53) that the choir is that of the church in Cranbrook, Kent, where Webster lived, and that the conductor in the painting is John Francis senior and the clarinettist the composer Thomas Clark himself.

The subject was inspired by Washington Irving's *The Sketch Book* published in 1820; this is discussed in some detail by R Conyers Morrell (see *Lit:* below). Irving tells a comic and sentimental episode in which a village squire takes him to the local church, and describes the various 'characters' in the choir and band. In turn, Webster's painting seems to have inspired Randolph Caldecott's illustration to Irving's *Old Christmas* (1876 edition facing p96,, 1886 facing p73). The theme of music in parish churches and the advent of mechanical musical instruments are dealt with in Thomas Hardy's novel *Under the Greenwood Tree* (first published 1872), and, as Harvey points out, in *The Return of the Native* (1878).

Contemporary critics recognised the high quality of Webster's invention and execution. The *Athenaeum* commented at length, and concentrated on the expressive qualities of the work:

> . . . the extreme point to which the delineation of expression in the human countenance may be carried and escape the exaggeration which is caricature. As its title demands, it gives the very ideal of a country choir, – every individual member of which is a village amateur filled with a sense of his own musical ability and accomplishment, vocal or instrumental. With what a visible conviction of his own importance is that clerk conducting the discordant elements of his supposed harmony; and how is his zeal responded to by the musical troup whom he governs with uplifted hand. He of the clarionet is well supported by the bass. The next performer is a wonderful piece of true expression; and never were there three more admirable studies than the three trebles – two little charity girls, simple and unaffected in their looks as plain and primitive in their costume, and the pretty, modest little creature on their right. The figures, in fact, are many – and full of meaning.

The *Examiner* compared Webster's achievement with that of the late Sir David Wilkie, which was indeed high praise:

> 'For truth and diversity of character, and for careful painting, we doubt if there is a more valuable piece in the whole collection [that is, at the RA 1847].' The critic especially admired the contrast between the comic characters and the children and young couple in the right background, who 'carry us out of the region of more laughter into that of gentle character and homely English romance'.

The *Art Journal* also described the subject at length, and referred to its literary source in Irving, concluding: 'If we compare the picture with preceding works in which children are the actors, the preference will be undoubtedly given to the latter; but this is still a most valuable and masterly composition'. The painting was discussed at some length again when it was exhibited in Paris in 1855, and also when it was given to South Kensington by Sheepshanks two years later. French critics particularly admired 'a quiet, almost serious aspect of caricature . . . a life-like reality' (Maxime du Camp, quoted in the *Art Journal* 1856), and 'a biblical seriousness, which never abandons the English', 'faithfully representing nature' (*Le Moniteur*, quoted in the *Art Journal* 1855).

A replica was in the collection of John Tyson in Liverpool and was engraved by H Bourne for the *Art Journal* in 1867 (facing p100); it does not appear in the catalogue of his sale at Christie's 1 June 1872. According to Redford (*Sales*) (II, p127), 'the first study' for the painting was in Mrs Tyson's sale at Christie's 22 June 1872 and fetched the great sum of £766 10s. 'An

admirable finished study' was in the George R Burnett sale at Christie's 24 March 1860 (51). 'A sketch for the celebrated picture' was in the Matthew T Shaw sale at Christie's 20 March 1880 (106); no size was given in the catalogue, but Redford (*Sales*) records it as '8 by 16 inches'. Another version was recorded in an English private collection in 1931. An adaptation of the composition, signed by John Watkins Chapman (a genre painter and engraver exhibiting 1853–1903), 71.6 × 92.2 cm (28¼ × 36¼ ins), was sold at Christie's 5 June 1981 (68). A similar but simpler composition, 'Practising for a Village Concert', signed with Webster's monogram and dated 1866, (22 × 34½ ins), was exhibited at the RA in 1867 (371; see the comments in the *Athenaeum* 18 May 1867, p667), and was sold at Christie's 22 March 1985 (61). A watercolour version, attributed to Webster and described as a replica, was sold at Christie's 12 June 1973 (238, 57.1 × 87 cm/22½ × 34¼ ins).

The popularity of the painting is attested by various notes on the Departmental files reporting the survival, for example, of two of the kerchiefs worn in the picture (in the 1930s), and of the musical instruments (in the 1920s). The work has also been much reproduced; only a selection of references can be made below, and others range from the *Evening News* of 16 March 1929 to the detail on the cover of the Penguin paperback edition in 1967 of George Eliot's *Silas Marner*.

Exh: RA 1847 (104); *Exposition Universelle* Paris 1855 (956, lent by Sheepshanks); *Royal Jubilee Exhibition* Manchester, 1887; *Music and Painting* Norwich Castle Museum 1961 (33)

Lit: *Athenaeum* 15 May 1847, p527; *Examiner* 1847, p357; *Art Union* 1847, p188; G Waagen *Treasures of Art in Great Britain* 1854 II, p299; *Art Journal* 1855, pp297–8, 1856, p78, 1857, p240, 1867, p100; A Dayot *La Peinture Anglaise* Paris 1908, p224; E B Chancellor *Walks Among London's Pictures* 1910, p257; R Conyers Morrell *The Romance of our Old English Choirs* nd [1934] pp12–4; O Aubrat *La Peinture du Genre en Angleterre . . .* Paris nd [1934] repr pl xii; N Boston 'Music of the Eighteenth-century Village Church' *Architectural Journal* XCIX, 1943, p62

Repr: P Ditchfield *The Parish Clerk* 1907; *The Times* special Church and Empire number 25 June 1930, pxxi; *Methodist Times* Christmas supplement 1933; *Church Monthly* February 1934; *The Listener* 30 January 1935, p186; T Boase *English Art 1800–1870* 1959, p96; *The Chorister's Diary* 1960

## Contrary Winds

FA223   Neg 69019
Panel, mahogany, 37.3 × 57.1 cm (14¹¹⁄₁₆ × 22½ ins)
Signed and dated 'T Webster./1843' br
Sheepshanks Gift 1857

*Contrary Winds*   FA223

Exhibited at the BI in 1844, and presumably bought there by John Sheepshanks. The *Athenaeum* critic thought Webster:

> Not in his best school-boy vein this year . . . the pigmy size of the figures in proportion to the canvas is carried to a point at which dreariness is the consequence. Nor are the urchins who are playing the game of Aeolus [who was God of the winds in Greek mythology] versus Auster as keenly in earnest as such small people would soon become. The ancient dame, too, on the other side of the picture, is a figure that merely fills so much space without any adequate occupation.

The *Art Union* found it 'difficult to divine the material of this work from the title', and also criticised the composition: 'Apart, on the left, sits an admirably-painted grandmother, absorbed in her knitting, so much so that

the main interest of the scene does not extend to her; indeed the work is thus, it is to be lamented, divided into two very charming little pictures'. The critic also comments that 'the old woman is equal to the best efforts of the best period of the Dutch school', and concludes 'The artist has offended somebody, for he who usually filled the post of honour is this year thrust down far below the eye; yet the picture has never been shown elsewhere: it is one of Webster's best productions, and ranks among the most attractive contributions to the gallery'. In a review of the Sheepshanks Gift in 1857, the *Art Journal* again admired the work, but thought 'the children with their ship-launch in the washing-tub disturb the depth and tranquillity of the other parts of the picture'. When the painting was shown at the *Exposition Universelle* in Paris in 1855, the *Art Journal* reported the critic of *Le Moniteur*, who noted 'a thousand pretty details, scrupulously studied . . . the most exacting of Dutchmen could not hesitate a doubt against a *batterie de cuisine* so precise and so carefully polished up'.

EXH:   BI 1844 (18); *Exposition Universelle* Paris 1855 (957, lent by Sheepshanks); *International Exhibition* Dublin 1865 (130); *Victorian Narrative Paintings* V&A Circulation exhibition 1961; Mitsukoshi Gallery, Tokyo, 1967

ENGR:   H Bourne for the *Art Journal* 1875 (facing p262)

LIT:   *Athenaeum* 10 February 1844, p139; *Art Union* 1844, p57; 'French Criticism on English Art' *Art Journal* 1855, p297; *Art Journal* 1857, p240, 1875, p262; F T Palgrave *Gems of English Art* 1869, p96 (repr in colour); *Sheepshanks Gallery*; *A Picture Gallery of British Art* 1873, pp11–2 (repr); O Aubrat *La Peinture de Genre en Angleterre . . .* Paris nd [1934], (repr pl xii)

## Reading the Scriptures
FA224   Neg 63518
Panel, 40.6 × 35.5 cm (16 × 14 ins)
Signed 'T. Webster' on stool cr
Sheepshanks Gift 1857

Webster exhibited two paintings with this title at the BI in 1835, their sizes (including frames) given in the catalogue as 27 by 24 inches (no 22) and 30 by 46 inches (no 431). The present work is presumably the former. The critic of the *Examiner* noted it as 'a simple and pleasing thing – and the same title is attached by Mr Webster to another and very different production, which will also be found here. That which we have just noticed (22) shows a child spelling out of the bible at its grandmother's knee'. The facial features of the grandmother are very similar to the various 'portraits' of 'Rembrandt's mother', for example that in the Mauritshuis, The Hague.

EXH:   BI 1835 (22); *Victorian Narrative Paintings* V&A Circulation exhibition 1961

LIT:   *Examiner* 1835, p180

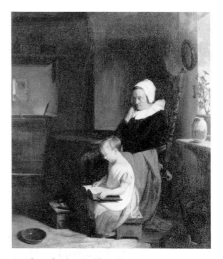

*Reading the Scriptures*   FA224

## The Lesson
509-1882   Neg 52985
Panel, 38.1 × 58.3 cm (15 × 23 ins)
Signed and dated (the date is indistinct) 'T Webster/1831' diagonally bl
Jones Bequest 1882

The background is similar to those in 'Goodnight' (Bristol Museum and Art Gallery) and 'Sunday Afternoon' (Wolverhampton Art Gallery). It does not seem to have been exhibited in the artist's lifetime.

EXH:   *The Cranbrook Colony* Wolverhampton Art Gallery 1977 (64, repr in cat as pl 36)

LIT:   *Sheepshanks Gallery*

*The Lesson*   509-1882

*Beating for Recruits*    536-1882

*Children at Prayer*    573-1882

## Beating for Recruits
536-1882    Neg 76973
Panel, mahogany, 44.5 × 39.4 cm (17½ × 15½ ins)
Signed 'T Webster.' br
Jones Bequest 1882

This work does not seem to have been exhibited, unless under a very different title, which appears unlikely. A small oil sketch, supposedly once owned by Sir Edwin Landseer (it does not appear in his posthumous studio sale at Christie's 8–15 May 1874), was recorded in a private collection in 1934 (photograph in the Departmental files).

PROV:    Presumably Charles Birch collection, sold Foster's 15 February 1855 (IX, as painted for F R Lee RA), bought £372 15s (according to Graves (*Sales*), bought Lloyd £355), repr in wood-engr in cat (according to the *Gentleman's Magazine* XLIII, 1855, pp276–7, the size was 18½ × 16½ ins); John Jones, by whom bequeathed to the museum 1882

REPR:    *Studio* special summer number 1904, pl51

## Children at Prayer
573-1882    Neg G581
Panel, 49.5 × 59.6 cm (19½ × 23½ ins)
Signed and dated (the date is indistinct) 'T. Webster 1835' bl
Jones Bequest 1882

The painting does not seem to have been exhibited. A painting titled 'Children at Morning Prayer' was in the William Llewellyn sale at Foster's 4 April 1855 (71, size given as 24 × 20 ins (which could be width before height), bought by the dealer Gambart), and could be the present work. It has been suggested, however, that the painting is more likely to be an evening scene and therefore possibly a pendant to the Llewellyn picture; on the other hand, evening prayers are more likely to be said by the children in their night-clothes.

# WILLIAMS, Edward (1782–1855)

Born Lambeth, London, 1782, son of the engraver Edward Williams. Pupil of his uncle James Ward RA; also apprenticed to a carver and gilder. Exhibited 36 works, principally river and moonlight scenes, at the RA between 1814 and 1855, 21 at the BI 1815–54, and 37 at the SBA 1826–55. Died Barnes, then in Surrey, 24 June 1855; his six sons were all also artists, including Henry John Boddington.

LIT:    *Art Journal* 1855, p24 (obit); *Athenaeum* 14 July 1855, p817 (obit)

### Landscape with Cattle – Milking Time
584-1886
Canvas, 71.1 × 119.4 cm (28 × 47 ins)
Purchased 1886

Dated in the 1907 catalogue to 1830–40, this work is possibly the 'Landscape and Cattle' exhibited at the BI in 1844 (228), the size given in the catalogue, presumably including frame, as 38 by 54 inches.

## WILLIAMSON, Samuel (1792–1840)

Born Liverpool 1792, son of the portrait painter John Williamson (1757–1818). Exhibited at the Liverpool Academy from 1810 (elected Founder Associate 1810, Member 1811), and at Manchester, Birmingham and Leeds. Exhibited a view in Wales at the RA in 1811. Subjects mainly landscape and marine. Travelled in Europe often. Died Liverpool 7 June 1840.

### Italian Mountain Landscape
1027-1886    Neg 61410
Canvas, 119.4 × 119.4 cm (47 × 47 ins)
Dixon Bequest 1886

Williamson seems to have been influenced by the work of the 17th-century Dutch landscape painter Nicolaes Berchem; the composition of the present work with its ruined buildings, livestock, and distant mountains, may be compared with the 1656 'Italian Landscape' in the Rijksmuseum, Amsterdam.

LIT:    Grant *OELP* 1925, repr pl 189

*Italian Mountain Landscape*    1027-1886

## WILSON, John H, RSA (1774–1855)

Known as 'Old Jock', born Ayr, Scotland, 20 August 1774, son of a shipmaster. Pupil of John Novie at Edinburgh 1787 and of Alexander Nasmyth, practised as drawing master in Montrose. Moved to London 1795, worked as scene painter at Astley's. Exhibited 76 works at the RA between 1807 and 1855, 150 at the BI 1813–54 (where he won a prize 1826), 301 at the SBA (of which he was one of the founders) 1824–56, and 89 at the RSA 1821–48 (elected Honorary Member 1827). Subjects almost exclusively coastal and river scenes. Visited France and Holland. Later lived at Folkestone, Kent, where he died 20 (or 29) April 1855. His son John James Wilson (1818–75) was also a landscape and marine painter in a similar style.

LIT:    *Art Journal* 1855, pp192, 204 (obit)

### Coast Scene, Stormy Effect
126-1882
Canvas, 99.1 × 135.9 cm (39 × 53½ ins)
Purchased 1882

Not identifiable with the title of any exhibited work. In 1914 M H Grant (the writer on landscape painting) owned a small painting which he considered to be a sketch for the present work. There is also a painting by Patrick Nasmyth in the collection (1019-1886) probably begun by Wilson.

# WITHERINGTON, William Frederick, RA (1785–1865)

Born London 26 May 1785. Entered RA Schools 1805. Exhibited 138 works at the RA between 1811 and 1863, 62 at the BI 1808–65, and one at the SBA in 1831; also at the Birmingham Society of Artists. Elected ARA 1830, RA 1840, and Honorary retired Academician 1863. Early works mainly landscapes, then genre; influenced by the work of Morland and Wheatley. Died London 10 April 1865.

LIT:   *The Times* 15 April 1865 (obit); *Athenaeum* 22 April 1865, p55 (obit); *Art Journal* 1865, p191 (obit)

*The Hop Garland*   FA233

### The Hop Garland
FA233   Neg 69196
Panel, 43.2 × 33.7 cm (17 × 13¼ ins)
Signed and dated 'Witherington/1834' bl
Sheepshanks Gift 1857

Probably the painting of the same title exhibited at the BI in 1835, the size given in the catalogue as 28 by 24 inches, presumably including the frame. One of his best known works, its subject seems to have appealed greatly to the artist. Another version, differing in details and with the younger girl turned more towards the spectator, is in the Tate Gallery (from the 1847 Vernon Gift, also panel, 44.5 × 35.1 cm/17½ × 13⅞ ins); it was engraved by H Bourne for the *Art Journal* in 1851 (facing p7). The *Art Journal* (1859, p74) discussed a third version, painted for Mr Wells of Redleaf and exhibited in 1843 at the RA, different in composition from the Tate painting which does not seem to have been exhibited; that version appeared in the Wells sale at Christie's 27 April 1860 as 'Hop-pickers' and was sold to Agnew for £117 12s. A version was also recorded in a London private collection some 30 years ago. What appears to be a similar subject, 'The Hop Garden', was exhibited at the RA in 1828 (274) and again at the BI in 1829 (see the *Gentleman's Magazine* 98, 1828, part 1, pp539–40, and 99, 1829, part 1, p155). The matter is confused by the fact that the present work was received under the title 'The Hop Garden'.

The 1851 *Art Journal* commented on the annual phenomenon of hop-picking in Kent and Sussex, which presented 'features of picturesque attraction which are nowhere else to be met with . . . to this country what the vineyards are to the southern districts of France'.

> At the proper season, men, women, and children are employed in picking the hops, and preparing them for the market. Mr Witherington has selected for his picture [that is, the Tate version] a little episode in the day's work, when the younger labourers are resting awhile from their tasks: a girl, who, from her superior style of dress, we should rather suppose to be a visitor to the garden than a 'picker', is decorating a younger child with a chaplet of the golden flowers. The idea is excellent; so also is the manner in which it has been carried out. The faces of the group are highly expressive, especially that of the little girl, so full of self-complacency at the honours bestowed upon her . . . this group, in all its parts, is admirably painted, and finished with great care; it is brilliantly coloured, yet with perfect harmony of tones . . . the picture is unquestionably one of the best ever painted by Mr Witherington . . .

An unidentified newspaper cutting is stuck on the back of the painting, and reads as follows:

> 51. [which was the catalogue number at the 1835 BI exhibition] *The*

*Hop Garland* . . . This ingenious artist has contributed three pieces – a vigour beyond his usual law, for not painting more than he does is his single and singular fault. The complaint is so rare, that what the public regret he may justly consider as a compliment. *The Hop Garden* presents an incident true to nature, in a little girl standing full of pride and delight, while an older one is decking her head with a crown of hops, and a lad sits in his basket laughing at the sport. The expression of the child's face is not quite so pretty or rustically joyous as we could have wished, but it is arch and good. The boy and his drapery are perfect, both in the painting and character; the back-ground is well managed and the whole rich in harmony of colour and truth of effect.

The sitter for one of the girls was identified some years ago by a descendant as her great-grandmother, either Mrs Sarah Ancketill or Lady Selina Ker.

A watercolour by Witherington of a similar subject but different composition, 'A Hop-Garden', is also in the V&A collections (328-1895); another was in the W H Behrens collection, reproduced in colour in the *Connoisseur* 70, 1924, p107.

There are several paintings of the subject recorded by other artists, for example Charles Landseer's 'Girl in a Hop Garden' exhibited at the RA in 1850.

Exh: ?BI 1835 (51)

Lit: *Art Journal* 1851, p7, 1859, p74; C Collins Baker *British Painting* 1933, repr pl 161; G Reynolds *Painters of the Victorian Scene* 1953, p5n, repr fig 7

# WOOD, John (1801–1870)

Born London 29 June 1801, son of a drawing master. Studied at Sass's art school and entered RA Schools 1819. Exhibited 118 works at the RA between 1823 and 1862 (won gold medal 1825), 68 (including a sculpture) at the BI 1823–59, and 28 (including watercolours) at the SBA 1825–39. Painted portraits, but mainly biblical, historical and mythological subjects. Won competition for the altarpiece of St James's, Bermondsey ('The Ascension') 1844. Several paintings were engraved. Died 19 April 1870; the sale of his collection and his own works was at Christie's 16–18 February 1872 (the catalogue has biographical notes).

Lit: *Art Journal* 1870, p204 (obit); Redgrave *Dict*

### Head of a Lady (After T Lawrence)
374-1872    Neg HF970
Canvas, circular, diameter 38.1 cm (15 ins)
Purchased 1872

An almost exact and slightly smaller copy of Sir Thomas Lawrence's 1827 unfinished portrait of 'Elizabeth, Countess Cawdor' (collection Earl Cawdor; K Garlick *Sir Thomas Lawrence* 1954, p31). It was engraved by C Marr for *The Amulet* in 1832. See also 'Head of a Lady', (375-1872, below).

### Head of a Lady (After T Lawrence)
375-1872    Neg HF971
Canvas, circular, diameter 40.6 cm (16 ins)
Purchased 1872

The head is taken from a large three-quarter-length portrait by Sir Thomas Lawrence of 'Lady Selina Meade' (later Countess Clam-Martinics) exhibited

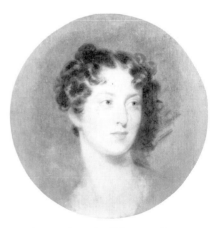

*Head of a Lady (After T Lawrence)*
374-1872

*Head of a Lady (After T Lawrence)*
375-1872

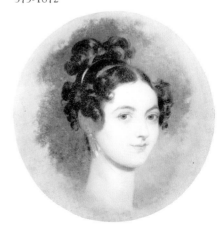

at the RA in 1820 (collection Earl of Clanwilliam; K Garlick *Sir Thomas Lawrence* 1954, p50, repr pl 85). It was engraved by C Heath for the frontispiece of the 1828 *Keepsake*, and by G T Doo in 1835. According to the Christie's sale catalogue of 16 February 1872, Wood as a student at the RA 'obtained the notice of Fuseli and Sir Thomas Lawrence, and under the auspices of the latter he commenced his career in art'. There were several copies after old and modern masters in that sale, including a few after Lawrence portraits. See also 'Head of a Lady', (374-1872, above).

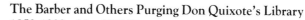

# WRIGHT, John Massey (or Masey) (1777–1866)

Born London 14 October 1777, son of an organ-builder to whom he was initially apprenticed. Introduced to Thomas Stothard RA c1793. Worked as theatrical scenery and panorama painter, notably for Henry Barker. Exhibited nine works at the RA between 1812 and 1818, eight at the BI 1817–36, and five watercolours at the SBA in 1835. From 1820 increasingly painted in watercolours; founder Associate of OWS 1824, Member 1825. Numerous illustrations for books, including Shakespeare, Scott and Burns; many drawings engraved for annuals and magazines. Several engravings, watercolours and drawings are in the V&A collections. Died 13 May 1866; despite a long and industrious life, had received a charitable annuity from the RA since 1858.

Lɪᴛ:   DNB

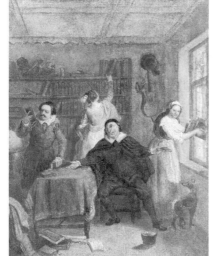

*The Barber and Others Purging Don Quixote's Library*   1852-1900

*Don Quixote Outside an Inn*   1855-1900

**The Barber and Others Purging Don Quixote's Library**
1852-1900   Neg HF967
Canvas, 30.5 × 25.4 cm (12 × 10 ins)
Ashbee Bequest 1900

The subject is taken from chapter 6 of part 1, book 1 of Cervantes's *Don Quixote*, first published in 1605. The episode depicted occurs towards the beginning of the Don's adventures and follows his housekeeper's realisation that his excessive reading of books about knight errantry had resulted in his misadventures so far. The local barber and priest determine to commit the offending books to the flames; the Don's niece comments that 'there is no reason to pardon any of them, for they have all of them caused the trouble'.

Wright had exhibited 'Don Quixote Being Fed by the High-born Ladies' at the RA in 1815 (see 1855-1900, below), and in 1816 exhibited 'The Scrutiny Performed by the Curate and the Barber in the Library of Don Quixote', which seems to have been exhibited again at the BI in the following year, the size given in the catalogue (presumably including the frame) as 24 by 22 inches. Two larger and more highly finished versions of the same subject and its companion (below) were recorded in an English private collection earlier this century; it may be that the present works are preparatory oil sketches.

Exʜ:   ?RA 1816 (32); BI 1817 (36)

**Don Quixote Outside an Inn**
1855-1900   Neg HF968
Canvas, 30.5 × 25.4 cm (12 × 10 ins)
Ashbee Bequest 1900

The subject is taken from chapter 2 of book 1 part 1 of Cervantes's *Don Quixote*. The episode depicted is the Don's first expedition at the beginning of the book. Having encountered no adventures, he stops at an inn and mistakes 'two young women of easy virtue' at the door for 'graceful ladies

taking the air at the castle gate' to whom he offers chivalrous assistance; eventually, they feed him, with appalling salt-cod, through his helmet which he has refused to remove. It is possibly the 'Don Quixote Being Fed by the High-born Damsels' exhibited at the RA in 1815, but see the comments on what might be the companion piece, 'The Barber and Others Purging Don Quixote's Library', (1852-1900, above). There is a watercolour by Wright of a further Don Quixote subject in the V&A collections (also Ashbee Bequest, 1801-1900).

Exh:    ?RA 1815 (244)

## Index of Named Sitters

*(Artists' names are given in brackets)*

# Index of Located Places